Crimea

Peasant Russia, Civil War:
The Volga Countryside in Revolution, 1917–1921

A People's Tragedy:
The Russian Revolution, 1891–1924

Interpreting the Russian Revolution:
The Language and Symbols of 1917
(with Boris Kolonitskii)

Natasha's Dance:
A Cultural History of Russia

The Whisperers:
Private Life in Stalin's Russia

This book is to be returned on or before
the last date stamped below.

WITHDRÁWN

Library of Congress Cataloging-in-Publication Data

Paulson, Ronald.
 Hogarth : the modern moral subject, 1697–1732 / by Ronald Paulson.
 p. cm.
 Includes bibliographical references and index.
 ISBN 0-8135-1694-3
 1. Hogarth, William, 1697–1764. 2. Artists—England—Biography.
I. Title.
N6797.H6P38 1991
760′.092—dc20 90-24569
[B] CIP

British Cataloging-in-Publication information available

To Susan

CONTENTS

LIST OF ILLUSTRATIONS ix

PREFACE xv

FROM THE PREFACE TO THE FIRST EDITION xix

1. SHADES OF THE PRISON HOUSE: A London Childhood, 1697–1714 1

2. "THE MONSTERS OF HERALDRY": Apprenticeship and the Profession of Engraver, 1714–1720 38

3. "THE BAD TASTE OF THE TOWN," 1720–1724 65

4. A NATIVE ENGLISH HISTORY PAINTING: Thornhill and the "English Don Quixote," Hudibras, 1720–1726 95

5. LEARNING TO PAINT: Falstaff and The Beggar's Opera, 1727–1729 155

6. CONTEMPORARY HISTORY AND MARRIAGE, 1729 188

7. CONVERSATION PICTURES, 1728–1732 206

8. THE "MODERN MORAL SUBJECT": A Harlot's Progress, 1730–1732 237

9. CONTEXTS (VISUAL AND VERBAL) FOR THE Harlot 256

10. PUBLICATION, RECEPTION, AND SIGNIFICANCE OF THE Harlot 301

NOTES 337

GENERAL INDEX 389

INDEX OF HOGARTH'S WORKS 405

ILLUSTRATIONS

Unless otherwise indicated, the illustration is an etching-engraving.

FRONTISPIECE. *Self-portrait;* painting; 1730s

1. The Smithfield area, detail of John Rocque's map of London, 1746

2. Artist unknown, *St. John's Gate* (*Gentleman's Magazine*); woodcut

3. Egbert van Heemskirk, *The Quaker Meeting* (engraved by Carel Allardt); date unknown

4. The Fleet Prison area, detail of Rocque's map of London, 1746

5. *A Rake's Progress,* Pl. 7 (detail); 1735

6. Tatton Arms; engraving on plate; date unknown

7. Hogarth's Shop Card; 1720

8. Ellis Gamble's Shop Card; ca. 1723–1728

9. *Hudibras's First Adventure* (small plate); executed ca. 1721, publ. 1726

10. *Fustigatio,* illustration for Beaver's *Roman Military Punishments;* 1725

11. *Beheading,* illustration for Beaver's *Roman Military Punishments;* 1725

12. Benefit Ticket for Spiller; 1720?

13. *A Turkish Bath* (first state), illustration for La Motraye's *Travels;* 1723/24

14. *Charles XII at Bender,* illustration for La Motraye's *Travels;* 1723/24

15. *The South Sea Scheme* (first state); 1721

16. Bernard Picart, *A Monument Dedicated to Posterity;* 1720

17. Jacques Callot, *La Pendaison,* from *Misères de la guerre;* 1633

18. Jacques Callot, *La Roue,* from *Misères de la guerre;* 1633

19. *The Lottery* (second state); publ. 1724

20. *Masquerades and Operas* (first state); Feb. 1723/24

21. William Kent, *Banquet of the Gods;* 1719–1720

22. Frontispiece, *The New Metamorphosis* (second state); March 1723/24

23. Sir James Thornhill, *Self-portrait* (detail of fig. 24).

24. Sir James Thornhill, *George I and His Family;* 1722–1724

25. *Royalty, Episcopacy, and Law;* May 1724

26. *His Royal Highness George, Prince of Wales;* date unknown

27. Sir James Thornhill, *Hercules Defeating Calumny, Detraction, and Envy;* 1707–1717

28. *The Mystery of Masonry Brought to Light by y^e Gormagons* [sic] (second state); Dec. 1724

29. Charles-Antoine Coypel, *Don Quixote Demolishing the Puppet Show* (engraving by Gerard Vandergucht); 1725

30. Sir James Thornhill, Sketchbook, f. 29

31. Sir James Thornhill, Sketchbook, f. 52

32. Sir James Thornhill, *Jack Sheppard* (mezzotint engraving by George White); Dec. 1724

33. *A Just View of the British Stage* (second state); Dec. 1724

34. Sir James Thornhill, *The Landing of George I;* ca. 1722

35. Raphael, *Paul Preaching at Athens* (engraving by Nicholas Dorigny); 1719

36. Raphael, *Paul and Elymas* (cartoon); 1515–1516

37. Sir James Thornhill, *Life of St. Paul,* 1715–1720

38. *A Burlesque on Kent's Altarpiece at St. Clement Danes;* Oct. 1725

39. *Hudibras Wooing the Widow,* illustration for *Hudibras;* executed ca. 1721, publ. 1726

40. Frontispiece, *Hudibras* (large plates); Feb. 1725/26

41. *Hudibras Sallying Forth* (second state)

42. *Hudibras's First Adventure* (second state)

43. *Burning the Rumps at Temple Bar*

44. *Hudibras and the Skimmington* (first state)

45. Annibale Carracci, *Bacchus and Ariadne* (etched copy of the fresco); 1597–1600

46. *The Freeing of the Galley Slaves,* illustration for *Don Quixote* (drawing); ca. 1727

47. *The Freeing of the Galley Slaves,* illustration for *Don Quixote* (engraving, first state); ca. 1727

48. John Vanderbank, *Freeing the Galley Slaves* (drawing), illustration for *Don Quixote;* ca. 1727

49. *The Curate and the Barber Disguising Themselves,* illustration for *Don Quixote* (engraving, first state)

50. *Sancho's Feast* (third state); date unknown

51. *Sancho's Feast* (first state, detail)

52. *Falstaff Examining His Recruits;* painting; 1727–1728

53. *The Committee,* large illustration for *Hudibras* (first state); 1726

54. *Henry the Eighth and Anne Boleyn* (first state); ca. 1727/28

55. *The Punishment Inflicted on Lemuel Gulliver* (first state); Dec. 1726

56. *Cunicularii, or the Wise Men of Godlimen in Consultation;* Dec. 1726

57. *Masquerade Ticket* (second state); 1727

58. The Great Seal of England (from the Walpole Salver); 1728/29

59. *The Beggar's Opera* (I); painting; 1728

60. *The Beggar's Opera* (V); painting; 1729

61. *The Beggar's Opera* (IV); painting; 1728–1729

62. Detail of fig. 61.

63. Detail of drawing for *Hudibras's First Adventure* (fig. 42)

64. *A Committee of the House of Commons;* oil sketch on paper; 1728/29

65. *A Committee of the House of Commons;* painting; 1728/29

66. Detail of fig. 65.

67. Sir James Thornhill and Hogarth, *The House of Commons;* painting; 1730

68. *The Sleeping Congregation;* painting; ca. 1730

69. *Jane Hogarth;* painting; ca. 1738

70. The Covent Garden area, detail of John Rocque's map of London, 1746

71. Thomas Bowles, *A View of Covent Garden;* 1751

72. Sir James Thornhill, *Sketch of His Family;* ink and wash on paper; ca. 1730

73. *An Assembly at Wanstead House;* painting; 1730–1731

74. Philippe Mercier, *A Hanoverian Party on a Terrace with the Schutz Family, Cousins of George II;* painting; 1725

75. *The Woodes Rogers Family;* painting; 1729

76. *The Ashley and Popple Families;* painting; 1731

77. *The Fountaine Family;* painting; ca. 1730

78. *The Wollaston Family;* painting; 1730

79. *The House of Cards;* painting; 1730

80. *A Children's Tea Party;* painting; 1730

81. *The Denunciation, or A Woman Swearing a Child to a Grave Citizen;* painting; 1729

82. Detail of fig. 81.

83. *The Denunciation* (engraved by Joseph Sympson, Jr.); undated

84. *The Christening, or Orator Henley Christening a Child;* painting; 1729–1730?

85. *The Christening* (mezzotint by Joseph Sympson, Jr.); date unknown

86. *Before* (outdoor scene); painting; 1730–1731

87. *After* (outdoor scene); painting; 1730–1731

88. *Before* (indoor scene); painting; ca. 1731?

89. *After* (indoor scene); painting; ca. 1731?

90. *A Midnight Modern Conversation;* painting; ca. 1730

91. *The Wedding of Stephen Beckingham and Mary Cox;* painting; 1729

92. *The Jones Family;* painting; ca. 1730–1731

93. *The Cholmondeley Family;* painting; 1732

94. Shop Card for Mary and Anne Hogarth; 1720

95. *Sketch of a Garret Scene;* drawing in red chalk on paper; ca. 1730

96–101. *A Harlot's Progress* (first state); Apr. 1732

96. *A Harlot's Progress,* Pl. 1

97. *A Harlot's Progress,* Pl. 2

98. *A Harlot's Progress,* Pl. 3

99. *A Harlot's Progress,* Pl. 4

100. *A Harlot's Progress,* Pl. 5

101. *A Harlot's Progress,* Pl. 6

102. Paulo de Matteis (or Mattheis), *The Choice of Hercules,* engraved illustration for the earl of Shaftesbury's *Characteristics;* 1714

103. *The Choice of Hercules,* Emblem, in George Wither, *A Collection of Emblemes* (1635).

104. *Imitatione,* in Cesare Ripa, *Iconologia* (1611).

105. Albrecht Dürer, *The Visitation;* 1511

106. Albrecht Dürer; *The Annunciation;* 1511

107. *Boys Peeping at Nature* (subscription ticket for the *Harlot*) (second state); 1730/31

108. Frontispiece to Henry Fielding's *Tragedy of Tragedies* (engraved by Gerard Vandergucht); March 1730/31 (courtesy of the British Museum, London).

109. *A Harlot's Progress,* Plate 1 (Giles King's copy); 1732

110. *Breakfast,* drawing from the *Five Days Peregrination;* June 1732

111. Frontispiece, *Peregrination*

112. Tailpiece, *Peregrination*

PREFACE

Since the publication of my biography *Hogarth: His Life, Art, and Times* (hereafter *HLAT*) in 1971 I have rethought Hogarth. By this I do not mean that I have made new archival discoveries, though I have corrected a great many small errors.[1] But my picture of Hogarth has grown and shifted with my increased knowledge of his works and his times. Other "Hogarths" have emerged from a series of scholarly explorations into the production and distribution of his art and that of his contemporaries. As I slowly rewrote the biography, I also rewrote *Hogarth's Graphic Works* (*HGW*, 1965, revised 1970), the catalogue of Hogarth's engravings. It was my good fortune to be able to publish this complete revision of the catalogue in 1989.

The Hogarth of *HGW* and *HLAT* was an "Augustan"—the follower of the satirists Swift, Pope, and Gay—and the discovery of a young student of Eng. Lit. who, reading Frederick Antal's "Hogarth's Borrowings," realized that Hogarth's art was based not (as Antal thought) on "borrowings" from his predecessors but on parodic allusions to specific images, sometimes specific works of art, as a vehicle of satire.[2] But this, what might be called a New Critical Hogarth, was only a beginning. Other aspects of Hogarth's art emerged with further experience. The great Hogarth exhibition at the Tate Gallery in 1971 taught me much that I did not know about Hogarth as a painter. It offered the priceless experience (thanks to the generosity of Lawrence Gowing) of spending a week before the exhibition opened studying all the canvases out from under glass.[3] There is no question that the exhibitions that followed—of Constable, Turner, Gainsborough, Reynolds, Zoffany, Hayman, Stubbs—deepened my understanding of Hogarth's position in relation to the tradition. In 1961 when I first began to think about Hogarth, while there was a great deal of important work on the literature of the eighteenth century, there was nothing but Ellis Waterhouse's and Oliver Millar's

surveys of English painting. The map has been considerably filled in since that time.

My rethinking of Hogarth has been largely in terms of his works: as one or another of them showed me its pivotal quality, my understanding of the artist has changed, and—not least important—of his closely linked contemporaries as well. But in each of the books I wrote on the literature and/or the art of the period over the intervening twenty years—books on the satiric genre, popular culture, politics, and aesthetics—I discovered another aspect of Hogarth. Hogarth has changed from being an elitist Augustan satirist to a subversive popular artist and then to something more complex than either.[4] These stages will also suggest (not untruthfully) that I have, on one level of my mind, been thinking of nothing else—even while writing on Fielding or Pope, Byron or Wordsworth, Rowlandson or Stubbs, *Hoyle on Whist* or *Joe Miller's Jestbook*—all these years. There is a sense in which each of these excurses not only returned to Hogarth (as I have noticed with increasing embarrassment) but applied most pertinently to him.

Of course these different Hogarths would not have existed in my writings without the work of revisionist historians of English politics in the period (J.G.A. Pócock, J.C.D. Clark, John Brewer, Linda Colley) or of the underclass (E. P. Thompson, Peter Linebaugh, Douglas Hay), or the work of literary and art historians of the period (Martin Price, Claude Rawson, W.J.T. Mitchell, John Hayes, Michael Fried). I should add that, closer to home, David Dabydeen's *Hogarth, Walpole and Commercial Britain* (1987) led me to address more precisely the status of Hogarth's political commitment in the 1730s, and Sean Shesgreen's *Hogarth and the Times-of-the-Day Tradition* (1983) made me see *The Four Times of the Day* as the important transitional work it was. The one incisive short biography of Hogarth, which often clarified the thoughts I had expressed in *HLAT,* was Jack Lindsay's *Hogarth: His Art and His World* (London, 1977).

Some parts of the present book retain the words (more or less) of *HLAT,* but by far the larger part has been completely recast and rewritten. The project has taken the form of three self-contained narratives, or studies, which will be published as three books:

1. *Hogarth: The "Modern Moral Subject" (1697–1732)* chronicles the emergence of Hogarth the man and the genesis of his first, paradigmatic "progress." This is in many ways the story of his coming to make *A Harlot's Progress*—which means the way he evolved the sa-

tiric "illustration" on the scale of a mock history painting in *Hudibras;* the way he developed a distinctive reportorial mode in the conversation picture; and the way these and other events contributed to his creation of the mythic Harlot.

2. *Hogarth: High Art and Low (1732–1750)* will play out Hogarth's conflicting aims of producing a polite or a popular art, for patrons or for the general public. The book hinges on *Marriage A-la-mode* and *Industry and Idleness,* the one an ultimate sophistication of the *Harlot's Progress* mode and the other, by contrast, a radical simplification of the "Modern Moral Subject" to a "popular" print series. This volume is also concerned with the central issue of Hogarth as painter *and* as engraver and the antithetical qualities of the two media in his practice.

3. *Hogarth: Art and Politics (1750–1764),* covering the last decade of Hogarth's life, will center on three related issues: the aesthetic ideas he distilled from his practice in *The Analysis of Beauty,* the controversy among the artists over a national academy, and the political struggle he both witnessed and experienced in this crucial decade of British history.

Contextually, the first period reflects contemporary art in the practice of Thornhill and Kneller, of Kent and the Burlingtonians, and the aesthetics of Shaftesbury (vs. the foreign model of Watteau in France, the Ricci and others in Italy). The second period introduces the French émigré Gravelot and the artists in the St. Martin's Lane Academy, and Hogarth's role as their spokesman in his war with the connoisseurs, picture dealers, and piratical printsellers. The third introduces a new generation of artists: Reynolds, Ramsay, Chambers, and the supporters of a national academy along French lines, with the aesthetics of Burke, Gerard, and Gilpin, pitted against Hogarth's *Analysis of Beauty* and his idea of an empiricist academy along English lines. The story here is of the emergence of an English tradition in art, the struggle over the founding of a national academy, and in Hogarth's case the merging of his aesthetic concerns with national politics as he saw politics destroying the microcosm of his beloved St. Martin's Lane Academy.

Hogarth was an artist (like Blake, even Reynolds) who signifies at least as powerfully in relation to the English literary tradition as to the graphic. The three periods also correspond to three phases of literary history, the first focusing on the writers who influenced Hogarth as a youth, the "Augustans" Butler, Dryden, Swift, Pope, and

Gay. The second deals with the origins of the novel and the writers influenced *by* Hogarth (as he was then influenced by them): primarily Fielding and Richardson. And the third introduces the new generation: Burke, Johnson, Sterne, and Churchill.

I have attempted to balance the agency of the artist-maker against the political, moral, and aesthetic determinism of the time—the discourses of social and material culture of which Hogarth was a part. I remain, as a biographer must, on the side of the battling ego who shapes these discourses to his own end, at least in certain ways (admittedly not in others). But my aim in this biographical study has been to establish—within the coordinates of time and place, character and society—the man *and* his works (and the man *in* his works), and to sort out, as much as is possible, the active from the passive, what Hogarth thought he was doing from what he was so immersed in his times or in his own unconscious as to not know he was doing.

The list of acknowledgments in *HLAT* still stands, but for the present version I have benefited from corrections pointed out to me over the years by Lawrence Gowing, Robert Halsband, F. R. Hillis, John Ingamells, Derek Bowman, David Kunzle, and David Dabydeen. At the Rutgers University Press I want to thank Leslie Mitchner, Dina Bednarczyk, and Jane Dieckmann (who both copyedited and indexed). For assistance all along the line, I want to thank Morris Golden, Brian Allen, Michael Kitson, Arnold Stein, and Ann Stiller.

Note: Dates designated with two years, 1725/26, for example, refer to the period between 1 January and 25 March of the Old Calendar (in which the year began on 25 March). The Old Calendar came to an end in 1752.

Baltimore
April 1990

FROM THE PREFACE
TO THE FIRST EDITION

The sole researched biographies of Hogarth are John Nichols's *Bio-graphical Anecdotes of William Hogarth* (1781, with revised editions running to 1817) and Austin Dobson's *William Hogarth* (1879, last edition 1907). Nichols based his on contemporary memories, manu-scripts, and collections, and Dobson, though seldom venturing beyond him, corrected a number of the errors that resulted from hearsay testimony and guesswork. The many other "lives" of Ho-garth have been based almost exclusively on Nichols and Dobson, and their contributions have been mainly interpretive; the "Hogarth" who has emerged is approximately the caricature Nichols (or per-haps, to give him his due, his collaborator George Steevens) perpetu-ated, toned down somewhat by Dobson. The only scholars since Dobson who have appreciably augmented our knowledge of Ho-garth's life, as opposed to his works, are Charles Mitchell, who went to primary sources to produce some new facts about Hogarth's "Per-egrination" through Kent in May 1732 (*Hogarth's Peregrination,* 1952), and the late Colonel William Le Hardy, a professional archivist who began a careful search of the London parish registers and records: a task, inexplicably, never before undertaken. This research, hardly begun at Colonel Le Hardy's death, was brought to my attention, and subsequently published, only after I had independently covered the same ground. The present biography is the first attempt to estab-lish the facts of Hogarth's life from a large range of primary sources: public records (rate books, baptismal and burial registers), records of banks and insurance companies, memoirs and letters of contempo-raries, and notices in contemporary newspapers and magazines (in-cluding his own advertisements).

Hogarth's manuscripts, the fullest source of information about his character and thought, also disclose a great deal about his life.

Except for separate pages scattered in libraries all over the world, the vast majority of these writings are in the British Museum, to whose trustees I am grateful for permission to publish long passages. John Ireland, who owned most of them (more, apparently, than the collection now in the British Museum), rewrote Hogarth's notes, constructing whole sentences and sometimes paragraphs of his own in order to make a narrative out of them. The result, published in the third volume of Ireland's *Hogarth Illustrated* (1798), loses a good deal of the sense of a mind in action expressed in the scribblings; but Ireland, to a remarkable extent, does make the correct intuitive leaps. He writes what he thinks Hogarth meant to say, filling out hints and incoherencies: the phrase "water arising," crossed out by Hogarth, becomes the saying "water rises to its own level," toward which Hogarth was probably groping. If Hogarth had lived to polish his notes, they might have sounded something like Ireland's version. But most of his thoughts in the notes are only half-formulated; for all his sensitivity, Ireland sometimes distorts Hogarth's meaning, and exact transcription of the manuscripts tends to distort it even more. Hogarth was jotting down notes in what is virtually a shorthand, and his mind often raced ahead of his hand.

When only the facts are at stake, I have slightly regularized the manuscripts to facilitate reading, deducing what I think he *intended* to say from the abbreviations, ellipses, and erratic spelling that served as his shorthand. But I have retained his words and syntax, and so also the allusiveness lost in Ireland's expansions. I feel free to do this now that the great majority of the manuscripts, accurately transcribed as they stand and published by Joseph Burke and Michael Kitson, are readily available to anyone who would like to check my readings. However, when the actual arrangement of words affects Hogarth's tone and meaning, and when it is useful to illustrate his thought processes, I have transcribed them exactly, with all the false starts, omissions, repetitions, and confusions. I have uncovered a number of Hogarth's letters, and quotations from these, with his public utterances, have been transcribed exactly.

In the case of George Vertue's manuscripts, another extensive source of information about Hogarth, I have not found the same regularizing necessary. Vertue almost always makes good, if somewhat crabbed, sense, and the crabbedness is part of his charm. I am grateful to the Walpole Society for permitting me to quote from

its invaluable edition of Vertue's notebooks (also in the British Museum).

There is relatively little information that might inspire speculation on Hogarth the man. To see him as clearly as possible, it is necessary to examine the caricatures and unflattering literary portraits and trace his reflection in the mirrors of his friends and contemporaries. Vertue, Thornhill, Fielding, and Garrick in their different ways illuminate certain aspects of Hogarth no other source could reveal, as do the institutions to which he dedicated himself—St. Bartholomew's Hospital, the Foundling Hospital, and the St. Martin's Lane Academy. A life of Hogarth is also to some extent an account of his friends, of the politics of London art in the eighteenth century, and of various social and political developments. I hope that the flow and ampleness of this biography will convey, as I intended, the feeling of the entire era.

Finally, there are the paintings and prints themselves. The scholarly works that make a biography like this possible are the catalogues of the artist's oeuvre. Without Beckett's compilation of the paintings, Oppé's of the drawings, and my own of the engravings a biography would have been impossible. I have not tried to work in all of Hogarth's paintings, let alone all of his prints and drawings; and I have generally avoided discussing works not certainly by Hogarth. However, I did locate a number of paintings not known at the time Beckett made his catalogue, and some are included. This biography is intended to complement my catalogue and study of the engravings, *Hogarth's Graphic Works,* and whenever possible I have avoided repeating myself. Engravings that are problematical, requiring more discussion to establish a date than is merited in a biography, can be examined there. I have not, however, inserted all the cross-references to *HGW* unless the context demanded: it is thoroughly indexed and anyone interested in more complete information on a given print can easily find it.

The need to establish biographical fact would not in itself have inspired me to write this book; I also wanted to show how Hogarth's background, milieu, personal life, and aesthetic ideas contributed to produce and define his unique kind of art. Of critical works on Hogarth, the only serious and sustained one is Frederick Antal's *Hogarth and His Place in European Art* (1962). Antal's book, despite its rigid Marxist framework, its unrestrained adulation of Hogarth, and

its carelessness with regard to fact, is a valuable critical work and a mine of insights. (For documentation, see my remarks, *Journal of English and Germanic Philology,* 66 [1967]: 594–95.) Many times a casual remark of Antal's has divulged an aspect of Hogarth's character or work that had never occurred to me. Had he lived to complete and edit his manuscript, I am sure it would have been a much more compact and compelling work.

Most historians of English art place Hogarth in the transition period between the reign of foreign (Lely and Kneller) and clumsy native artists and the rise of the great Reynolds and Gainsborough. But this is to see him strictly in terms of portraiture, and then to oversimplify. He is a much more significant figure than such a generalization allows and, I think, far more interesting than Reynolds and (though never so exquisite a painter) than Gainsborough. My tendency has been to see the so-called modern moral subjects as the central fact of his career, with portraits and other works a secondary concern. While upon occasion he took portraiture very seriously, it was a matter of intense interludes—1728–1732, with a few scattered portraits over the next few years, and 1738–1742, with a few reaching to 1745, and finally a scattering from 1757 on. At any rate, I would like to correct the emphasis of Beckett's catalogue of Hogarth's paintings in which the divisions are "Single Portraits," "Portrait Groups," and finally "Miscellaneous," under which fall the "modern moral subjects" or "comic histories" and Hogarth's most original and important work.

The research for this book was begun in 1965 during a sabbatical year spent in England. I wish to thank the John Simon Guggenheim Foundation for its aid during 1965–1966, the American Council of Learned Societies for a grant-in-aid for the summer of 1965, and the Penrose Fund of the American Philosophical Society for a grant-in-aid for the summer of 1967. For trips to various spots where Hogarth paintings may be seen I am grateful to the Paul Mellon Foundation for British Art, which encouraged and subsidized the manuscript and also supplied many of the photographs.

I wish I could name all of the people who have personally assisted me in all the libraries and museums I have visited. But for the help and encouragement of the following I would still be floundering: Jean Adhémar, Hugh Amory, Geoffrey Beard, G. E. Bentley, Jr., Mrs. Mavis Bulmer, Mrs. Genevieve Butterfield, Harry Carr and Lt. Col. Eric Ward of the Quatuor Coronati Lodge of London, Eric Cham-

berlain of the Fitzwilliam Museum, J. L. Clifford, H. S. Cobb, the Rev. James R. Copeland, Sir Francis Dashwood, Lt. Col. Alan Faith of Bridewell Royal Hospital, W. Fox of St. Bees School, W.E.H. Fuller of the Sun Life Assurance Company, Gerald O'Grady, the late H. A. Hammelmann, C. M. Hancher, John C. Harvey, M.D., Dr. Albert Hollaender of the Guildhall Library, Martin Holmes of the London Museum, Sidney Hutchison of the Royal Academy, Mrs. Donald F. Hyde, B. C. Jones of the Cumberland-Westmorland Record Office, George M. Kahrl, Dr. D.J.M. Kerling of St. Bartholomew's Hospital, John Kerslake of the National Portrait Gallery, the late R. W. Ketton-Cremer, Kenneth W. Labaree, the Rev. G. A. Lewis Lloyd, Hugh Macandrew of the Ashmolean Museum, Richard Macksey, Sheila G. MacPherson of the Kendal Record Office, Oliver Millar, W.M.F. Oliver of the London Hospital, David Piper of the Fitzwilliam Museum, H. Prevett of the Haberdashers' Company, Robert Raines, M.D., George Rousseau, Henry Rowell, Charles Ryskamp, Sidney Sabin, Col. Sir Douglas Scott of the Coram Foundation, Miss A. H. Scott-Elliott, J. B. Shipley, John Todhunter, John Velz, Robert W. Wark of the Huntington Library and Art Gallery, Ellis Waterhouse, John White, Calhoun Winton, and J. W. Woolley of the Merchant Taylors Company.

I am particularly happy to mention my friends Lawrence Gowing, Michael Kitson, Roy Strong, and J. B. Trapp, who were kind enough to introduce me, a novice, to the art world of London, opening doors and cutting red tape, thereby facilitating my work and increasing my enjoyment in the task. Basil Taylor deserves a category of his own: from the beginning he extended encouragement, advice, hospitality, and friendship on my many trips to London. It was he who shepherded me into my happy relationship with the Paul Mellon Foundation. I want also to thank Paul Sharp, Angus Stirling, and Colin Sorenson of the Foundation, who assisted in many ways while the manuscript was in their hands, and Mrs. Patricia Barnden, who personally gathered most of the photographs and permissions. My old friends at Yale, Maynard Mack and Louis Martz, who read the manuscript and offered valuable suggestions, Jules Prown of the Mellon Center, and Chester Kerr and Anne Wilde of the press, understand, I am sure, the particular debt of gratitude I owe each of them. Jennifer Alkire was the best of all copyeditors.

Finally, Earl R. Wasserman, who generously took time to read crucial parts of the manuscript: long before I knew him personally

his critical essays on the poetry of Dryden and Pope taught me how Hogarth's works should be approached. In the later stages of writing this book I was fortunate enough to spend many hours sharing with him what Hogarth called the "love of pursuit" in the prints, re-creating, I believe, the pleasure Hogarth intended and that his contemporaries enjoyed when they "read" him.

London
May 1970

HOGARTH
THE "MODERN MORAL SUBJECT"

1.

SHADES OF THE PRISON HOUSE

A London Childhood, 1697–1714

RICHARD HOGARTH IN LONDON

> There is a Beauty in these Things at a distance, taking them *en Passant,*
> and in *Perspective,* which few People value, and fewer understand. . . .
> Behold, to crown all, a fair Prospect of the whole City of *London* it
> self; the most glorious Sight without exception that the Whole World
> at present can show, or perhaps ever cou'd show since the Sacking of
> *Rome* in the *European,* and the burning of the Temple of *Jerusalem* in the
> *Asian* part of the World.

Daniel Defoe is describing London as it must have looked to Richard
Hogarth arriving from the country in the late 1680s. Up close, "this
great and monstrous Thing, called London" was another matter. It
was a very different thing from Westmorland, whence Richard is
supposed to have traveled: "a Country eminent only for being the
wildest, most barren and frightful of any that I have passed over in
England, or in *Wales* it self," wrote Defoe.[1]

Richard Hogarth, the painter's father, was born on 24 January 1663
or 1664 somewhere in the north country, possibly in the Vale of
Bampton in central Westmorland.[2] In one way or another, apparently
without attending more than a good local grammar school, he ac-
quired a solid grounding in Latin and Greek and set up a school of his
own. Rising out of a family of farmers or shepherds to be a school-
master, he must have seen himself as a self-made man with a future.
Westmorland was the kind of place an ambitious and scholarly young
man would have left for the metropolis.

He made the trip south in his mid-twenties, perhaps in the com-
pany of Thomas Noble (a friend and student) and Edmund Gibson,

both of the Bampton area.[3] Noble and Gibson traveled south to be-
come students at Oxford, and in the latter case to begin a brilliant
scholarly and ecclesiastical career ending as bishop of London, the
most powerful clergyman in England. Gibson is alluded to in the first
plate of William Hogarth's *Harlot's Progress* (1732) as the source of
ecclesiastical preferment that interests a clergyman just arrived from
the north of England more than the fate of a defenseless girl being
corrupted by a bawd, and in the third plate as the author of pompous
Pastoral Letters (figs. 96, 98). Richard Hogarth went south to earn a
living, make a name for himself, and begin the descent into failure,
debtor's prison, obscurity, and death.

The earliest trace of his presence in London is a little textbook pub-
lished in May 1689, *Thesaurarium Trilingue Publicum: Being an Intro-
duction to English, Latin and Greek.*[4] Though unsigned, its author is
identified in a laudatory poetic epistle by one J. H., who commends
the "Victrix *Hogarthica* Penna" (victorious Hogarthian quill). An in-
troductory letter, complimenting the author on his guide to spelling
and hoping it will be useful to women, who are especially in need of
it, is signed T. N.—Thomas Noble, who was still at Oxford. From
the introductory testimonials, the book appears to be aimed at young
ladies and gentlemen who might "wish to make the acquaintance of
correct writing" ("scripturam si forte velis cognoscere rectam") or
wish to compose verses or little songs. It could equally have served
for a "petty" or elementary school of five- and six-year-olds, where
English spelling, pronunciation, and grammar were taught and chil-
dren were made to memorize moral aphorisms. The first part (as
Richard explains in his preface) treats "the true Spelling and Division
of Words, which is the first step an English Scholar makes after he
has learn'd his A, B, C." In the second part, devoted to Greek, he is
more concerned with his peers, the scholars. After explaining that he
has written in English here only to be consistent with the first part of
the book, he adds: "Notwithstanding, if that be the only Fault, I shall
enlarge it, and make it Latin, and bind it up alone, if God prosper it
to the end intended, which is the Promotion of good Learning."

The *Thesaurarium* strikes a number of characteristic "Hogarthica"
notes. Richard writes as forcefully and polemically, as opinionatedly,
as his son. Explaining his own peculiar method of dividing words
into syllables to facilitate the teaching of spelling, he asserts that the
credit of good education "would soon grow into Contempt, if (after

the Opinion of some careless Men) we should spell every word according to the Pronunciation that time by Corruption has given them." (Strong words if his son's erratic spelling is considered.) He defends his use of the vernacular, "for that upon serious deliberation I judged would be the best, as supposing it to be of more general use; my purpose being chiefly the Education of the English Scholar. . . . Neither," he adds, "would I have thee disgusted at the unevenness or unpleasantness of the Style, for that the Subject would not admit of better." The commonsense approach, the use of the vernacular, the strong feeling for decorum (rough style for rough subject), and the outspokenness, even crankiness, may recall Richard's north country origins. He was a conventional pedagogue of his time in his emphasis, and overemphasis, on rules and memorization; but after a long list of such rules, he ends cheerfully: "I cannot think of any further Rule [that] can be given; so that the Writers Fancy must only guide him in the rest" (17).

Richard was also conventional in his relish for sententiae. In the middle of the book he inserts a series of little "Lessons for Children," each written out first and then divided into his system of syllables. They demonstrate the Augustan assumption about literature, "for wheresoever the Speech is corrupted, the Mind is so too"; reflect the Roman Stoic values instilled in English education (indeed may have been cribbed from ancient authors); and yet are distinctive and often crotchety enough to suggest the personal voice of Richard:

> To persist in Opinion, I mean, not to be given to Change, is the certain Mark of a wise Man, for Fools are various, one while Thrifty and Grave, another while Profuse and vainly Conceited: But happy is that Man that sets himself right at first, and continues so to the end. A prudent Man carries all his Treasure within him; what Fortune gives she can take, therefore he so providently orders the Matter as to leave nothing to her Mercy: He stands firm, and keeps his Ground against all Misfortunes, without so much as changing Countenance: He will not murmur at any thing that comes to pass by Gods Appointment: He is not only Resolute but Generous and good Natured, and for the publick Safety is ready to sacrifice his own. (71)

Richard's inclination to treat grammar, Latin, and learning in general as a game is also notable. He includes a list of homonyms, he says, so that children can make a game of their study by quizzing

each other—which "will be the greatest spur to their proficiency in learning." Such a technique, besides using dulce to promote utile, depends upon a love of play in general and of puns in particular which may have been characteristic of the father and certainly was of the son.

Finally, Richard reveals a marked tendency to theorize and build systems. When he turns to the subject of orthography, he explains that he would dispense with the letters H, K, Q, Y, X, Z, W, F, and G—though, he adds in his preface, he offers such theories only "to the consideration of the nicer sort, not being so Ambitious as to desire their passing into Practice."

The *Thesaurarium* was an ambitious undertaking. Richard's attempt to combine textbook and self-help manual, incorporating a theory of an improved, phonetic alphabet, may explain why the book does not appear to have succeeded. In his second book he has been reduced to drudging for the booksellers as a scholarly popularizer. The *Gazophylacium Anglicanum,* an abridgment of Stephen Skinner's *Etymologicon Linguae Anglicanae* (1671), was published in November 1689, six months after the *Thesaurarium*—enough time for the hack work required to eliminate Skinner's elaborate introduction and shorten the dictionary. Although again unsigned, it fits the account in the superscription (in another hand) to Richard's letter of 25 May 1697 to his friend Noble: "Mr Hogarth writ of the Greek accents in English (recommended by Mr Noble Prebendary of York) and an abridgmt of Dr Skinner's Etimologicon."[5]

Richard uses the preface to assert himself: "The chief Reason why I busied my self herein was, to save my Time from being worse employed"—which may suggest he was not earning a decent living. He has, he says, made the abridgment short, omitting many Latin-derived words,

> it having been the only Fault of those that have hitherto writ upon this Subject, to be both voluminous, high-priced, and in *Latin;* so that many Well-wishers to the Mother-Tongue could neither reach the value nor Knowledge thereof: All which I hope I have remedied, by doing this in *English,* and in a small Volume, fitted to a small Price.

But, in case we might think he is not a Latinist, he has "(that the Reader might not be at a loss in such Words as are purely from the *Latin*) prefix'd a few easie Rules, whereby many thousand *English*

Words coming therefrom may most easily be known, and made *Latin* again." Sounding alarmingly like the Grub Street "author" of Jonathan Swift's *Tale of a Tub* (1704), he adds some words

> in defense of the Weakness and Inequality of this Performance; as namely, its being collected at diverse Times, and in haste, because of my other more necessary Business; as also, its being printed from a foul Copy, and the like; which first may have alter'd the Style, and the two last let many things pass Muster, which, upon more mature deliberation, would not: But I hope the discreet Reader will pass by such Failures, without carping at them (as considering that no Man is infallible;) and as for the Ignorant and Envious, I value not their Censures; but, with *Martial, In invidum,* count them unfit for Humane Society.

And again, as in the *Thesaurarium,* foreshadowing the words of his son, he hopes the reader will not "be offended at the unpleasantness of the Style, but rather consider what the Subject will bear."

Reminiscences jotted by William over half a century later indicate that he thought of his father not as a schoolmaster but as an author. "His Fathers Pen," he writes, "like that of many other authors was incapable of more than putting him [i.e., William] in a way to shift for himself"; and in another draft he writes that his father's "dependence was cheifly on his Pen."[6] Though Richard designated himself as a schoolmaster in the ratebooks, in his letters, and as late as 1711 on the title page of his *Disputationes Grammaticales,* he does not appear to have been licensed with the bishop of London.[7] He may have begun in London as a submaster and later established one or more of the many fly-by-night private grammar schools that flourished in London in the 1680s and 1690s.

What is certain is that in 1690 he was lodging in a house in Bartholomew Close, just off Smithfield Market (see fig. 1), occupied by John Gibbons and his wife Anne, who had themselves moved in only within the last year.[8] The house was located in the close to the right of the passage to Middlesex Court, one of a row of dark and shadowy timber, lath, and plaster houses, probably in no very good condition, having escaped the fire of 1666 and therefore the opportunity of rebuilding. It was in this house, some seven years later, that William Hogarth the painter would be born.

John Gibbons had a family of at least nine children, but by the time he settled in the house in Bartholomew Close only three still re-

outpost of the established church in a center of nonconformists. In Bartholomew Close, besides Richard the schoolmaster, there lived (and in most cases worked) a joiner, a tobacconist, a physician, a chandler, a baker, an upholsterer, a tailor, a plasterer, a draper, a victualler, a stonecutter, a printer, and even a painter (one John Dalton). They were all nonconformists; the bishop of London also owned a house in the close, though probably it was let to yet another nonconformist.[12]

In May 1695 St. Bartholomew's, apparently under pressure from higher authorities, had instituted a separate parish register for nonconformists, which remained in effect until 1710, drawing most of its sustenance from Bartholomew Close. Unlike the regular register, which has nothing in it but baptisms, the nonconformist register was apparently instituted to register births only; the children were baptized elsewhere, by their own clergy. One of the few exceptions, a birth entry for 12 October 1697, is followed by a separate entry for the child's baptism on 1 December "by a minister of ye Parish Church"—that is, by an Anglican divine. This entry is immediately followed by the registry of William Hogarth's birth *and* baptism in a single entry. Only a few families, including the Hogarths, allowed their children to be baptized by the parish minister.[13] Before 1695 the Hogarth children had been listed in the regular baptismal register of St. Bartholomew's. Richard the younger, born just before the new register was instituted, was entered in the margin of the regular register as an afterthought, but William's birth and baptism were both entered in the nonconformist register: "William Hogarth was borne in Bartholomew Closte next doore to Mr Downinges the printers November ye 10th 1697 & was baptized ye 28th November 1697." The next child, Mary (possibly named for the late queen), was registered as "borne in Bartholomew Closte ye November 23th [sic] 1699" in the nonconformist register, but notice of her baptism was entered in the regular register, on 10 December.[14] The next Hogarth child was born in a different parish.

To judge by the listing of the earlier Hogarth children in the regular parish register, as well as the baptism of William and Mary, Richard could have been anything from a moderate Presbyterian to a freethinker. (The Deist John Toland came down from Scotland a few years after Richard in order to scrabble for a living in London by his pen.) There is no telling how rigorous or separatist Richard's fore-

bears were, but southern Presbyterians were not as opposed to the established church as other nonconformist sects, and they often attended Church of England services and took communion, as did "Deists" such as Anthony Collins. The facts are these: Richard lived among Presbyterians who refused to allow their children inside the established church to be baptized. He and Anne were not married in the parish church, and he taught without a license (which was dependent on swearing to the 39 Articles). Records may not have survived and enforcement of the teaching license was lax, but these lacunae could be explained by Richard's conscience. On the other hand, it is evident that he permitted William to be baptized, and some years later (although he had named two of his children William and Mary), he was willing to compile a Jacobite catalogue of the great men from sacred and Roman history which omitted William III as well as Cromwell. Perhaps hoping that his *Disputationes Grammaticales* (1711) would be adopted by one of the church schools such as St. Paul's, he appended a list that included Charles I, who "Suffer'd Martyrdom for Religion and the Laws," Charles II, and James II. Like many in his precarious situation, he sought patrons and wrote what he thought would please them.

We must not lose sight of the context: the period between 1660 and the accession of William III had been a time of almost unrelieved persecution of nonconformists. This persecution, and men's behavior in the face of it, was in the background of all dissenting thought. And while in the 1690s the question of conformity to the establishment was primarily a social matter, the grimmer memory remained something to live with, like the general unpopularity of the Dutch Presbyterian king.

There was a Presbyterian meetinghouse actually adjoining St. Bartholomew the Great, in an old building called Middlesex House, just around the corner from the Hogarths' house. It had been occupied by Independents during the days of nonconformist persecution and was noted for its secret doors through which parishioners could make quick exits in case of raids. From 1681 to 1706 it served as a meetinghouse for the Reverend John Quick's Presbyterian congregation. Built smack against St. Bartholomew's south side, the meetinghouse had a window, used at least during times of persecution, "which opened from the meeting-house into the adjoining church. It was situated directly opposite to the pulpit, in the latter building; so that a

person in the gallery of the meeting-house could clearly discern the congregation in the church and watch the different parts of divine worship. . . . The meeting-house is a small inconvenient building and accessible by a flight of several steps. There are three galleries of tolerable depth, and the roof is supported by large beams, after the old manner." The congregation was never large, "nor indeed would the size of the meeting-house admit of it."[15] The window through which nonconformists could watch the Anglican services in St. Bartholomew's may have been emblematic of Richard Hogarth's religious position.

Among all the Hogarth legends, there is none about William's religion. His wife Jane Hogarth is portrayed in late life going to, and lording it over, the Chiswick parish church (she also sanctioned the Reverend John Trusler's attempt to bowdlerize and sermonize Hogarth's prints). But although he supported many charities, William left no record of any active participation in a church. The traces of a Puritan heritage are certainly evident in the moral framework of his art, in his concern with the spiritual biography, in his deep sense of the individual's responsibility for his choices, and in a powerfully iconoclastic drive that is apparent in all of his graphic work. But so too are traces of the rationalism and skepticism associated in those years with Deism.

He did not escape the Puritan mythology which, surviving in nursery tales in even the most secularized families, told of the man who conducted business instead of worshiping on Sunday, stayed too long in an alehouse, and, riding home, fell off his horse and drowned in a river. The visible world was to a Puritan full of symbolic significance: every object, every act, was both consequential and capable of being spiritualized. When someone fell on an icy patch of road, it reminded the thoughtful Puritan that the unwary man sets his feet in slippery places; it led him to search out the act that had produced this consequence.

Puritans analyzed texts—both Scripture and Nature—in terms of example or precept, promise and threat, the reward of virtue and the punishment of error. This sequence, embodied in Interpreter's House in John Bunyan's *Pilgrim's Progress,* is reiterated in book after book of Puritan narrative. There is much talk about the importance of example over precept, and example was often most effective when made visual and sensuously present. The emphatic pictorialism of the Puritans is evident in John Robinson's wish that he could "present

this lively to your eyes, which I am fain to do now only to your minds and understandings."[16] These visible examples take the form of "*Promises* whereby we are encouraged to our Duty, or *Threatenings* whereby we are awed so as to keep within the bounds of it." Interpreter, after showing Christian the reprobate who has dreamed of. the Last Judgment, counsels: "Let this mans misery be remembered by thee, and be an everlasting caution to thee."[17]

Bunyan's works, especially *Pilgrim's Progress,* appeared on the bookshelf beside the Bible in the most meager library. Here was the ordinary man's "progress," or spiritual biography, which Hogarth was to echo in his earliest print cycles. There are four types of character-as-example in Bunyan's allegory: the sincere wayfarer like Christian, the insincere wayfarers who are his foils (Hypocrisie and Formalist), the threats and temptations along the way (Flatterer, Worldly Wiseman, and the people of Vanity Fair), and the wayside memorials, those erstwhile wayfarers who are preserved as admonitions in the symbolic poses of their failure. Hogarth's emphasis—with the Puritan authority of such works as *The Life and Death of Mr. Badman,* but also with important satiric precedents—falls on the insincere wayfarer, though he replaces hypocrisy with vanity and delusion (and avoids a Mr. Badman), and the sincere wayfarer becomes a foil, often a minor figure; the denizens of Vanity Fair fill the rest of the scene, and frozen above in pictures on the walls of the rooms are the wayside memorials.

There is, however, a significant difference between the worlds of Hogarth and Bunyan: Bunyan at the outset of his narrative leaves the "wilderness of this world," the waking life, and enters the world of dream, an ordered spiritual realm of clearly demarcated good and evil. Hogarth begins his career in this allegorical realm, but very soon, trained by an already classicized source, his father, and drawing upon other non-Puritan traditions—Augustan satire, certain strains of rationalist skepticism—he enters the waking world of "wilderness" with its ambiguities, paradoxes, and confusions.

In 1697, the year of William's birth, Richard Hogarth was working for a printer, correcting the Latin of Marcello Malpighi's *Opera Posthuma,* at the same time commending the work to Thomas Gale, who had given up the chair of Greek at Cambridge to assume the high mastership of St. Paul's School, and who he hopes will show it to the Royal Society (and adopt one of his texts for St. Paul's). He

says he has been correcting "an infinity" of errors in his author, and compares himself to Hercules cleaning out the Augean stables. (He signs the letter "Keeper of the Press," "Preli Curator," possibly a pun since *prelum* was literally a winepress.) However grandiose his claims to Gale, the most obvious trace of Richard's hand on the *Opera Posthuma* is the latinizing of the publication line as "Londini, Impensis A. & J. Churchill, at Insigne Negri Cygni in Vico dicto Pater-noster Row."[18] The letter shows that Richard was no stranger to Gale and wished to keep his name before him. Gale was a noted classical scholar, though his chief fame now rests on the inscription he composed for the London Fire Monument blaming the Roman Catholics for the conflagration. Bad luck for Richard, a few months later in September 1697, Gale was appointed dean of York and was succeeded at St. Paul's School by one John Postlethwaite.

A second letter of 1697, this time in English, went to his old friend Thomas Noble, now chaplain to Anne, countess dowager of Carlisle (grandmother of the present Lord Carlisle).[19] Gale was a Yorkshire-man by extraction, and Noble may have acted as intermediary. Richard seems to be pushing one of his textbooks, collecting letters of approbation from noted scholars and teachers who might adopt it in their schools. The style is coyly indirect: "Reverend Sir, / I am extremely obliged to you for the Honours of yours to Mr Heplinstall in behalf of my particular friend." From the context "my particular friend" is one of Richard's books, commended also (he tells Noble) by schoolmasters including Gale, who "has given the Author [Richard's way of referring to himself] some particular directions, and promiss'd him the promotion thereof by something of his own. This is all at present in relation to that Matter."

The letter also indicates, however, that Richard is now augmenting his earnings, or at any rate his prospects, by running errands and acting as a London factotum for the countess dowager (presumably, although the reference could be to the present countess). He has consulted an upholsterer about two screens and shown them to Lord Carlisle, who, however, claims "that he had no instructions or Order from my Lady, and therefore he could say nothing to it till he heard from her Ladyship." Richard continues:

> Yesterday the Upholster in Pauls Church-yard where your good Lady bought the two Schreens was with me, desiring that I would represent him as a person fit and willing faithfully to serve my Lady or

any of the Honourable family upon occasion. He gives his humble Service to your good Lady and to you unknown. My wife gives her most humble Service to your self and Lady; and I must take leave to subscribe myself

> Yours and your Lady's
> most humble Servant
> Richard Hogarth.

It is clear from the letter that he was at least acquainted with Charles Howard, third earl of Carlisle, whose London townhouse was in Soho Square, being decorated at the time by Louis Cheron, Henry Cook, and Thomas Highmore. Carlisle dabbled in Deism and wrote poetry, and in 1699 engaged John Vanbrugh to build for him Castle Howard. These were important and hopeful connections, but they came to nothing.

Another book perhaps by Richard, signed "By R. H. Philomath," was published in November 1701, this one *A Compendium of Geography; containing a Description of most Kingdoms and Countries in the World, with short Historical Observations of each Kingdom: designed as an easie Preparatory for Youth and others to understand History. Also an Account of the Lines of Succession from Adam till this time, and the Succession continued; with an Account of the Protestant Line* (printed for G. Conyers, J. Sprint, and T. Ballard, in Little Britain, not far from their residence). The "Lines of Succession" may anticipate the "short Chronological Index of Men and Things" at the end of Richard's *Disputationes Grammaticales*.[20]

By April 1701 the Hogarths had moved from Bartholomew Close to a smaller house at the bottom of St. John's Street, just above Smithfield and only a short way from their former residence.[21] The last of the Widow Gibbons's daughters, Mary, had married one Timothy Helmesley around 1700 and begun raising a family in her mother's house; this may have induced the Hogarths, with their three children and a fourth expected, to move out.[22]

In the St. John's Street house in October 1701 was born another daughter, Anne, who would remain with William, selling his prints and keeping shop for him, till his death. She was baptized in St. Sepulchre's Church on 6 November.[23] By 12 November 1703 the Hogarths had moved again and were settled somewhere in St. James's ward, a little farther north than their last location. On that day another son, Thomas, was baptized at St. James's Church. It is quite

possible that the family was already settled into St. John's Gate, but it can definitely be placed there at the beginning of the next year.[24]

THE COFFEEHOUSE

By January 1703/04 Richard Hogarth was the proprietor of a coffeehouse that specialized in Latin conversation. He seems by this time to have given up his hopes of rising in the usual way in an academic or scholarly career. In the *Post Man* for 8–11 January Richard ran an advertisement for his new line of business:

> At *Hogarth's* Coffee House in St. Johns Gate, the mid-way between Smithfield Bars and Clerkenwel, there will meet daily some Learned Gentlemen, who speak Latin readily, where any Gentleman that is either skilled in that Language, or desirous to perfect himself in speaking thereof, will be welcome. The Master of the House, in the absence of others, being always ready to entertain Gentlemen in the Latin Tongue. There is likewise design'd a Society of Trades to meet every Monday night in the Great Room over the Gateway, for the promoting their respective Trades.

In the issue for 15–18 January "daily" is elaborated to "Every day at 4 a Clock."

It appears that the family lived in one of the rooms in the old gate, originally the south gate of the Priory of St. John of Jerusalem, built about 1504 (fig. 2). The "great room" was the room where Edward Cave later had his presses in the 1730s when St. John's Gate housed the *Gentleman's Magazine*. Richard claims to be always on hand in the coffeehouse, by genteel implication in order to teach adults Latin. This would leave little time for a regular school of his own, and if he had a school in conjunction with his coffeehouse, he would surely have alluded to it in his advertisement. Richard was, however, an energetic man, and there was at this time a school in St. John's House, in nearby St. John's Court, which employed a Latin teacher. The wording of its advertisement, claiming to teach "the *Propriety* of the *Latin Tong,* (pretended to by many, understood by few:)," could be the work of Richard.[25]

Richard Hogarth's coffeehouse, like some of his son's enterprises,

had an idealistic as well as materialistic aim. Eilhardus Lubinus in 1614 had proposed setting up Latin-speaking colonies or colleges, and was only waiting for some "Emperor, or King, yea, even some Prince or Magistrate in any Commonwealth" to "vouchsafe to light a taper or torch" to materialize the plan—one manifestation of the "great experiment" toward making Latin the standard language of civilized communication. The primary object of English schools was to make Latin live again, and spoken Latin traditionally distinguished the learned from the unlearned. But it was as practical as it was humanistic: Latin offered a literary style and a storehouse of proper and eloquent expressions, essential to the man of law or medicine as well as the clerk and the Englishman traveling abroad. Striking Latin phrases were always useful, and the habitués of a Latin coffeehouse would have collected them in commonplace books.[26] In this sense, Richard's coffeehouse expresses exactly the aim of his *Thesaurarium,* the list of great Romans in his later *Disputationes Grammaticales,* and his adaptation of Robertson's *Latin Phrases.* And, of course, it also casts light on his son's use of Latin tags in some of his prints.

There was nothing remarkable about Richard Hogarth's conception. One of the early pamphlets on coffeehouses relates that patrons liked to quote the classics and show off their pedantry; even the apprentice "doth call for his coffee in Latin," and learned quotations were so numerous as to "make a poor Vicar to tremble."[27] By 1700 there were over two thousand in London and becoming increasingly specialized, as Richard's specialized in Latin and "trade."

For the young William Hogarth the coffeehouse represented a microcosm of contemporary life. A wide range of social types, of various professions and educational backgrounds, gathered here — from the lesser tradesmen to the great merchants, including brokers and stockjobbers—to drink coffee, tea, and cocoa, and exchange news, gossip, opinions, and stocks. Coffeehouses, subscribing to weekly and daily newspapers, were the center of opinion and information. Political argument and printed propaganda met here, as we read in a pamphlet of 1711:

> You may go into a coffee house and see a table of half an acres length covered with nothing but tobacco, papers and pamphlets, and all the seats full of mortals leaning on their elbows, licking in tobacco, lies and laced coffee, and studying for arguments to revile one another with.[28]

The coffeehouse was a gathering place to read newspapers or pamphlets, to look at prints and often paintings as well.[29] It demonstrated a principle of distribution: a single copy of a paper or pamphlet was read by many more than the purchaser, and by a socially and politically diverse group; it was even listened to by the illiterate. The immediacy of news promptly read and discussed, the exchange of opinions, and a mixed, heterogeneous audience: all these implied, besides an intense excitement, a wide potential audience and a sort of publicity that spreads an artist's fame and stimulates sales. As a social phenomenon the coffeehouse served as a middle, mingling area between the private and public realms. Built into its discourse was precisely the merging of domestic and political matters that allowed Hogarth in his "modern moral subjects" to present one and mean the other—that is, to code political issues as narratives of gender and class.

The coffeehouse borrowed some of its significance from its opposite, the alehouse. Here, where coffee rather than ale was drunk, "this wakeful and civil drink" supposedly produced wit, sense, and clear thinking, not drunkenness, folly, and uncontrolled bodily functions.[30] This, the world of John Dryden, Joseph Addison, and Richard Steele, reflected a strong Protestant influence with rules against swearing and gaming. But it was also, of course, a fiction largely created by these writers—one into which Hogarth was born, and whose life and clientele he used as a model for the society, the audience, and the mode of production of his prints of the 1730s, a model based on reading followed by the give-and-take of discussion, extending out to further discussion in other locales.

Not just the place to hear news and see pictures or become familiar with Latin, with learned puns and allusions, the coffeehouse was also a place where one went to engage in financial talk and often speculation—betting on price futures and stock trading. For Hogarth the coffeehouse made a permanent association between letters and money. Just before his birth, the two events had come together: in 1694 the chartering of the Bank of England and in 1695 the lapse of the Printing Act which required the licensing of newspapers, with a subsequent flood of papers and pamphlets. The result was the publishing and financial revolutions, which enjoyed a nexus of operations in the coffeehouse.[31]

It was a center not so much for buying and selling stocks as for betting and speculating based on predictions of future value rather than on real goods. The associations with the market were therefore

of paper credit, of illusion and danger and suspicions of skulduggery. The market was largely in government bonds, and so the stability of the state itself was at stake. And surrounding these activities was the aura of disrepute attached to stockjobbing by Defoe's *Review* and other journals that would have been available there. As a theme, the financial revolution and the South Sea Bubble of 1720 offered Hogarth a satiric vocabulary he would employ in his prints into the 1730s at least.

To the print explosion and the economic revolution must be added the rise of party politics.[32] As politicians were quick to realize, the coffeehouse, as a place with a regular, clublike clientele, created a cohesive body and so a potential political force. Public opinion was becoming a subject of conscious thought in the years after 1700, assisted by such propagandists of genius as Defoe and Swift, and Addison and Steele; it came to a focus in the 1720s in the opposition to Sir Robert Walpole. The potential of this readership was grasped by Hogarth and helps to explain the power his prints wielded and the respectful deference and angry fear accorded them by politicians.

Coffeehouses also had the reputation for "free conversation and blasphemous dispute"; they were places (the Grecian was a notorious example) where freethinkers could discuss their ideas without the fear of reprisal that accompanies a printed text—"where God could be denied in an afternoon, and the Church destroyed in the intercourse of a week."[33]

CHURCH AND FAIR, HOSPITAL AND PRISON

The area of London in which Hogarth lived, bounded by Newgate Street on the south and open country to the north, left its unmistakable mark. The center, the heart, the point of origin, was Smithfield, which consisted of a church, a marketplace that for a few weeks each year became a fairground, a hospital, and not far away two grim prisons, Newgate and the Fleet, one for murderers and thieves, the other for debtors. Across the open square of Smithfield Market from the church of St. Bartholomew the Great was St. Bartholomew's Hospital, equally ancient, an old rambling structure which in the 1730s would be reconstructed into a beautiful Palladian quadrangle by James Gibbs, embellished with huge paintings from the New Testa-

ment by William Hogarth. The third element of this paradigm was the great marketplace, crowded with cattle and livestock brought down from the north, thronging with people buying and selling. This marketplace was anciently famous for its executions by burning and for its fairs. The last fire went out in 1611 over the ashes of one Bartholomew Leggatt, a Unitarian who would not accept the Athanasian and Nicene creeds.

On this same ground was spread each year, during the first days of August, a fantastic world that was both an escape from the London of the rest of the year and a London in microcosm.[34] Trading was displaced by entertainment, and the shows overlapped onto the grounds of the other two institutions that bore the name of St. Bartholomew. As time passed, the duration of the fair also stretched from days into weeks. Hogarth, in later life, remembered that "shews of all sort gave me uncommon pleasure when an Infant." He was referring to Bartholomew Fair, and his own graphic works he referred to as a "dumb shew," invoking the world of theater (AN, 204).

A vivid picture of the fair at the turn of the century is projected by Ned Ward in his *London Spy* (1698–1709) as he strolls through Long Lane and the Cloisters, past the waiting prostitutes and through the St. Bartholomew's Hospital gates into the fair.[35] First he stops at a quack's or mountebank's booth around which the crowd is waiting "ankle deep in filth and crowded as close as a barrel of figs, or candles in a tallow-chandler's basket, sweating and melting with the heat of their own bodies." He comments on "the unwholesome fumes of such a crowd mixed with the odoriferous effluvia that arose from the singeing of pigs." Above on his platform, the Merry Andrew blows his nose on his audience and then "begins a tale of a tub which he illustrates with abundance of ugly faces, and mimical actions, for in that lay the chief of the comedy, with which the gazers seemed most to be affected."

For a few weeks every summer, the great actors of the West End theaters played at the fair. As a child, William could have seen John Mills, who played serious gentlemen, or the low comedians William Bullock, Henry Norris, and William Penkethman. Bullock (tall) and Norris (short) often appeared together, "*Bullock* in a *short* Coat, and *Norris* in a *long* one," seldom failing to elicit laughter.[36] Thomas Doggett too, one of the best comic actors of the day and joint manager of Drury Lane, kept a booth at the Hosier Lane end of Smithfield,

where he presented new drolls and "Also Variety of Comick Dances and Songs, with Scenes and Machines never seen before."

In the early years of the century William could have seen *The Old Creation of the World* at Heatley's Booth, always being supplied with supplementary dramas of current interest: "the glorious Battle obtain'd over the French and Spaniards, by the Duke of Marlborough," as well as "several *Figures* dancing *Jiggs, Sarabands,* and *Country-Dances,* to the Admiration of all Spectators; with the merry conceits of Squire *Punch,* and Sir John *Spendall.*" In 1704 *Jephtha's Rash Vow* was at Doggett's Booth, with Penkethman and Bullock playing the farcical characters of Toby and Ezekiel. In 1707 Mrs. Mynn's booth played Elkanah Settle's popular adaptation of *The Siege of Troy,* in which heroic scenes involving Menelaus, Ulysses, and Sinon were followed by scenes between Bristle the cobbler and his wife; she wants to go out to Troy "to see the great Horse the *Grecians* have left behind 'em," and he will not let her. In all of these entertainments William Hogarth must have noted with pleasure and instruction the contiguity of the spectacular biblical scenes and the domestic squabbles of Noah and his wife, scenes with Jephtha and his daughter alternating with Toby and Ezekiel, Paris and Helen with Bristle and his wife. When he painted his "Humours of a Fair," *Southwark Fair,* twenty-five years later he included all of these (*The Siege of Troy* had in fact not been played for some years).

The spectators or participants in these marvelous theatricals were Hogarth's chief interest in the fair: the pickpockets, quacks, whores, charlatans, and actors, engaged in the playacting he observed both onstage and off. Associated by many writers with Babel and Babylon, the fair was attractive precisely because there people of whatever age or class could project their most anarchic and aimless desires and lose themselves in a world where their imaginary projections seemed momentarily to coincide with reality. The fair was the last place available for the people of London as an escape from the heavy burdens of daily life.

But it served also, for their betters, as a living moral exemplum. As Sir Robert Southwell wrote in 1685 to his son Edward, in London with his tutor, one "cou'd convert that tumult into a profitable book." He advises the boy to climb up into a high window "in order to survey the whole pit at once": "The main importance of this fair is not so much for merchandize, and the supplying what people really

want; but as a sort of Baccanalia, to gratifie the multitude in their wandring and irregular thoughts."[37]

This Vanity Fair became metaphorically, when not literally, Hogarth's subject matter. It is easy to imagine him caught between his father's Roman morality, as expressed in the sententiae of his *Thesaurarium* (and the high plots of the plays), and the lure of the booths and the comic subplots. This tension is stretched to the breaking point with the fall of the Hogarth family from the pretensions of a profession and scholarship to the fugitive existence of debt and imprisonment; the ambiguity of the crowd as both release and moral admonition must have drawn Hogarth in both directions. And so in his graphic work a strong moral intent does not conceal, and is often subverted by, a sympathy for the plebeian joys of the fair.

If the fair was the most important place of Hogarth's childhood, it becomes visible and understandable only in the context of its neighbors, St. Bartholomew's church and hospital. One can only guess at what these institutions meant to Hogarth: his father might have said the church was an alternative to the fair, the hospital a sign that the life of the fair had consequences. His own return to St. Bartholomew's Hospital to paint murals and to serve as a governor points to his firm roots in the place (his mother and sister continued to live within its precincts, operating a milliner's shop in the Cloisters, until the 1730s). And his paintings and prints are about restless people who are always shuttling between hospital, church, and fair.

Although Hogarth never really left Smithfield, at the age of seven his horizons were expanded to include Clerkenwell, a few streets north, a thriving suburb into which many people had moved to build new homes after the Great Fire. St. John's Street, where the Hogarths first lived, was the main thoroughfare between Smithfield Market and the north. The gatehouse was in a somewhat better neighborhood. St. John's Square, into which the gatehouse opened to the north, was a spacious, pleasant place.[38] On the west side of the square was the town house of Gilbert Burnet, low-church bishop of Salisbury, who lived here in retirement from 1708, visited by the great Whig lords. Early in 1710 a mob rioted in the square and threatened Burnet's house. Shouting "The [High] Church and Sacheverell!", these were the Tory partisans of Dr. Henry Sacheverell, whose sermon excoriating the Godolphin Ministry had led to his trial.[39] Although the Hogarths had by this time moved again, the riot (repeated

in other parts of London) would have had special meaning for them, implanting in William's mind the images of the incendiary preacher and the restless London mob, both of which would serve (or weigh upon) him in later years.

While to the north of the gatehouse stretched an elegant square, to the south the Hogarths' windows looked down on the narrow gutter of St. John's Lane, which centuries earlier had led to the entrance of the priory. The contrast between the romantic past of the gatehouse with its ancient escutcheons and the reality of the muddy, shabby, crowded street beneath encouraged the sort of homily the Latinist might have passed on to his son. From what is known of Richard, the reading matter available in his house would probably have included romances—the fare of the aristocracy—and sophisticated antiromantic satires like those of Samuel Butler, John Dryden, and Sir Samuel Garth, abounding in mock-heroic contrasts. We know from a surviving copy inscribed with William's name that he knew the satires of John Oldham.[40]

Looking down from the coffeehouse windows, William would have seen the Old Baptist's Head Tavern with a sign of John the Baptist's head on a charger, like the one he later painted in *Noon*. On the other hand, if he raised his eyes he would have been able to watch St. Paul's dome rising amid scaffoldings in the distance over the jagged rooftops. When after the Fire Sir Christopher Wren's plan to lay out London like baroque Rome was rejected, he adapted his design for the cathedral to the existing medieval street pattern. St. Paul's was not designed to be seen from a distance, as a prospect or panorama, but was fitted into old London's setting of intimate spaces, allowing unexpected glimpses, partial views, from different directions. To this end Wren had enlivened its exterior with projections and recessions as well as rich sculptural detail. Hogarth noted years later in his *Analysis of Beauty* (1753) that in St. Paul's "you may see the utmost variety without confusion":

Whence the eye is entertain'd throughout with the charming variety of all its parts together; the noble projecting quantity of a certain number of them, which presents bold and distinct parts at a distance, when the lesser parts within them disappear; and the grand few, but remarkably well-varied parts that continue to please the eye as long as the object is discernible . . . (63)

From a distance one caught glimpses of the dome or part of the side walls down a narrow street. The west front slowly unfolded as one walked up Ludgate, with the whole suddenly emerging at the top where the churchyard opened out. Growing up in the streets leading to St. Paul's would have planted in Hogarth's mind a distinctive architecture, characteristic of what came to be called the Picturesque (which Hogarth was to call the Beautiful).

In the lap of the cathedral, St. Paul's churchyard was another source, like the fair, of low entertainment. For centuries it had been the heart of London's printing and publishing trade, and the houses around the yard were shops for the sale of printed material of all kinds and quality. Here lived and operated the Bowles family of printsellers, soon to pirate works by Hogarth; others could be found in Paternoster Row and in Ave-Maria Lane and Warwick Lane, the little streets leading north to Newgate, the Old Bailey (where Henry Overton, another famous printseller, vended at the White Horse), and beyond the City gates to Long Walk, Duck Lane, Little Britain, and into Bartholomew Close itself. In these printshops Hogarth would have obtained his first glimpses of the gaudy world of London and St. Bartholomew's Fair translated into the comic or moralizing black-and-white of engravings and block prints.

One other area, yet further south, must have been sometimes visited by the Hogarths: Edmund Hogarth's shop at the foot of London Bridge. Richard's more successful brother had followed him to London. Just when he arrived is uncertain, but in 1705 he settled in the city as a victualler at the Red Cross at the foot of London Bridge near the Waterhouse, in the parish of St. Magnus Martyr. (William's newest brother, Edmund, was named for his uncle in August.) Unlike Richard, he seems to have prospered in business and, when he died a year after Richard in 1719, was comfortably well off.[41] It goes without saying that visiting his uncle, William would have seen the great stone gate at the southern end of the bridge (where Edmund lived) with the exhibited heads of traitors and other malefactors—much replenished after the rebellion of 1715. When he wanted a prototypical merchant in *Marriage A-la-mode,* he returned to Uncle Edmund's neighborhood and showed London Bridge, with displayed heads, through the merchant's window. The fact that Edmund cut off Richard's family (then in dire straits) from his will might have led William to recall his uncle in his portrayal of the miserly merchant and his mean quarters.

North through St. John's Court and Jerusalem Passage led to the old parish church of St. James, the Anglican church where the most recent Hogarth children were baptized. Beneath a squat square tower eighty feet high, the main entrance was reached by a passage under houses very like the approach to St. Bartholomew the Great, which the church in general resembled. "The walls are lined with oak of different height," Edward Hatton recorded about this time, "that round the communion table is about 9 feet high. The pews and pulpit are also of oak, tho' pretty old; as is also the altar-piece, where the painting of the commandments is somewhat decayed. They are placed between the Lord's Prayer and Creed, and over are the Queen's arms painted."[42] This is more or less the interior Hogarth painted thirty years later in the fifth plate of *A Rake's Progress*. Anglican churches, as he portrayed them, are either running to seed or filled with sleeping parishioners. It was in this church on 10 August 1705 that his brother Edmund, another short-lived Hogarth child who was born on 28 July, was baptized. And on 17 December of the same year, Richard, William's only surviving elder brother and child playmate, was buried here; he had lived just ten years.[43] William was then eight; these deaths must have weighed heavily on a sensitive child, demonstrating better than Puritan homily that man's suffering was not necessarily commensurate with his guilt.

Young Richard survived only in the pages of the family Bible. One note in the hand of his cousin Richard Helmesley, son of Mary Gibbons and Timothy Helmesley, says "Richard Hogarth ditto Helmesley." The two seem to have written notes back and forth in the Bible margins, presumably during Sunday service. "I like my cosen Ann Hogarth," young Helmesley wrote on another occasion, followed by, evidently in Anne's hand, "Poor dear Dick." William, however, makes no appearance on these pages, unless the occasional pencil lines marking passages were his indications, made years later, for use in his engravings.

Londoners did not take much advantage of the countryside which lay a short walk to the north. Even if they had been interested in the beauties of nature, the highways of 1706 were to be avoided and the ditches were noisome with stagnant water and garbage. All around the edges of the city were smoking brick kilns, vagabonds and highwaymen, cow and hog keepers, and market gardeners. If William walked out to the open fields, it was not to observe nature but to watch one of the less savory public sports, such as the baiting of ani-

mals or pugilists fighting with bare fists and broadswords. Hockley-in-the-Hole, the most famous bear garden, is where Hogarth would have seen the bear he depicted so forcefully in *Hudibras's First Adventure* (figs. 9, 42). In later years he depicted at least two famous pugilists, John Broughton and George Taylor (James Figg appears once or twice in crowded compositions). Although these bouts, like the bearbaitings and the fair, were viewed as a public nuisance and occasionally suppressed by the Middlesex Grand Jury, they continued to take place and attract large crowds, which by the time Hogarth was grown included royalty.

This then was the London of William Hogarth's childhood. The strange new territory he was to explore would be to the west: first Covent Garden, then Leicester Fields, and finally a country villa in Chiswick. The city, however, remained the primary setting for his imagination.

The social position Richard Hogarth attempted to maintain was that of a schoolmaster and scholar. Even as a coffeehouse proprieter (a tradesman) he emphasized the intellectual focus of his establishment. His daughters, when they were old enough, went into a trade that supplied luxury items (in a class with makers of chocolate, perukes, and the like) and, at least when they moved to St. Anne's Parish, catered to a polite clientele. From William's remarks there is every reason to think that his father wanted him to pursue a learned career and therefore inculcated in him an ambivalent attitude toward trade long before he encountered Sir James Thornhill.

It would be surprising if Richard had not taken a major part in the education of his son. Whatever the exact arrangements, schooling would have implied "language" and, particularly, Latin. Given Richard's Latin-speaking coffeehouse, we can assume that his son's schooling probably involved conversations restricted to Latin with his enthusiastic father. It is clear from his inscriptions (in particular in *Boys Peeping at Nature*) that he knew Latin and loved to pun on it. This was to be important to Hogarth's sense of status: he had the advantage over Joseph Andrews, who (Fielding tells us) was denied "Instruction in *Latin* . . . by which means he might be qualified for a higher Station than that of a Footman." He also had at least a good reading knowledge of French.[44] There are signs throughout the

prints and writings that he did not forget the vocabulary, the *sententiae,* and the *topoi* he ingested in these early years. But being brought up by a schoolmaster who was also his father may have intensified the striking contrast between the regimentation of the grammar school and the freedom of the practical education of the London streets.

In his autobiographical notes he refers to having been in a school of some sort. He recalls that he "drew the alphabet with great ease" but had a "natural turn" for drawing rather than for "learning a language": "When at school my exercises were more remarkable for the ornaments which adorn'd them than for the Exercise itself." And he adds, speaking of his lessons and his drawings: "I found Blockheads with better memories beat me in the former but I was particularly distinguished for the latter." More important, he would have us think, he liked "shews of all sort" and "mimickry common to all children was remarkable in me" (AN, 204). Drawing and acting are closely connected in his autobiographical writings, as are his "pleasures" and his "studies."

Who first turned him toward art remains a mystery. He testifies himself that "an early access to a neighbouring Painter drew my attention from play" and thereafter "every opportunity was employed in attempts at drawing" (AN, 204). It is tempting to speculate on the identity of this painter, who presumably lived near the Hogarths sometime before 1713; almost any painter would have served. Judging by his later admiration for the work of good sign painters, it could have been someone of that profession.[45] It would be pleasant to think that he had encountered the Dutch painter of drolls, Egbert van Heemskirk, who died in London around 1704, when Hogarth was seven (his son, also Egbert, was apprenticed to Sadler's Wells as a singer but also produced drolls like his father's). Heemskirk was the one painter in England at the time who could have served as a contact with the tradition of Brouwer and Teniers. Paintings attributed to him, often by his son or by imitators, were easily seen about London shops in the years when Hogarth was growing up. Thornhill owned seven.[46] Hogarth seems to have been aware of Heemskirk's Quaker Meeting paintings, at least in their engraved versions (which anticipate in some respects his own style of engraving; see fig. 3), and he was certainly aware of the satiric designs of the younger Heemskirk in the late 1720s.[47]

THE FLEET PRISON

In the summer of 1707 Richard Hogarth was still operating his cof-
feehouse, advertised now as headquarters for one George Daggastaff
and his poetic miscellany called *The Diverting Muse*. Anyone with
contributions of poetry, epigrams, or satire might "direct them for
Mr. George Daggastaff, to be left at Mr. Hogarth's Coffee-house in
St. John's Gate-way near Clerkenwell."[48] The literary tone of the
Hogarth establishment was still being asserted in these last notices of
its existence. Sometime between the summer of 1707 and the end of
1708 the coffeehouse failed and Richard was confined for debt in the
Fleet Prison. In January 1708/09 Mrs. Hogarth was advertising her
home remedies "next Door to the Ship in Black and White Court,
Old Bailey":

> In pity to Infants that cannot tell their Ails, there is now publish'd
> (having been many Years in private Practice) a most Noble and very
> safe Medicine, call'd the GRIPE OINTMENT, which by outward Use
> only, and in the very moment of Application, Cures the GRIPES in
> Young Children, and prevents FITS, one half Crown Pot whereof will
> bring up a Child past all danger from either. Sold only By Mrs. Anne
> Hogarth next Door to the Ship in Black and White Court, Old Bailey.
> (*Daily Courant*, 13 Jan.)

In March, an auction of a library of Latin and Greek books was held
at the Black-Boy Coffee-House, a few blocks away in Ave Maria
Lane.[49] No mention is made of the owner, but the disposal of Richard's
library may have taken place around this time. The money to keep
the family afloat and Richard out of the "common side" of the Fleet
must have come from the sale of everything that had any value.

Two years later, on 23 September 1710, Richard was writing a let-
ter from "Black and White Court in the region called the Old Bailey
within the bounds of the Fleet" to Robert Harley, then the queen's
chancellor of the exchequer, pouring forth the woes of his imprison-
ment and seeking assistance. Richard must have overextended him-
self, bought the supplies for his coffeehouse and perhaps books and
household supplies on credit, and when the coffeehouse did not
flourish, unable to pay his debts, he was faced with ruin.

The situation of a debtor was appalling and his courses of action

frought with dilemmas. He could simply go into hiding, in which case he was considered a felon and was liable to capital punishment. He could surrender himself to his creditors, who could declare him bankrupt, if he did not do so himself, and take his all (he had to swear to the sum) or a composition of so much per pound. Or they could put the debtor in prison until he paid his debt in full or promised a satisfactory composition. The creditors might never let him out again since, once in prison, he would be unable to earn any money toward repayment. Bankruptcy was equally dangerous because the debtor had no assurance that the creditor would not take his all *and* leave him to languish in debtors' prison. Once inside the Fleet, a debtor could only hope that his creditors would relent or accept terms such as his promise to work off the money, or that someone would settle the debt for him. None of these possibilities was open to Richard Hogarth.

The Fleet was surrounded with walls twenty-five feet high with palisades on top. The horror of the common side is hardly imaginable. There were sometimes thirty or forty prisoners in a room not sixteen feet square, locked in at 8 P.M. in winter, 9 in summer, and the door not opened until morning. There were no sanitary facilities and there were times when the rooms were so crowded that half had to sleep in hammocks slung from the walls. The prison was run as a not very genteel lodging house with the warden the host who lived off the rents. Prisoners paid 2s 6d a week for a room of their own, and the fee "for liberty of the house irons at first coming in" was £1 6s 8d, augmented by extra fees to the chaplain, porter, chamberlain, and turnkey, amounting altogether to £1 6s 4d (by John Huggins's time as warden this had risen to £3 5s 4d). To gain the freedom of the Rules—to move outside the prison walls—one paid around 5 guineas and gave security. The Rules extended south from the prison on the east side of Fleet Canal to Ludgate Hill, east to Cock Alley, north on Old Bailey as far as Fleet Lane, west on Fleet Lane to the canal, and from thence south to the prison again: an area that included Black and White Court, where the Hogarths lived in 1709 (see fig. 4). Further, for 5s 6d a prisoner could be granted Day-Rule, or a pass to go abroad beyond the Rules, for a day during term time.[50]

We may infer that sometime before the end of 1708 Richard took refuge or was imprisoned in the Fleet. By the beginning of the new year he had acquired enough money, through selling household items or borrowing from his brother Edmund, to secure the freedom of the Rules and had settled in Black and White Court, in the Old

Bailey Precinct of St. Sepulchre's Parish, from whence he wrote his petition to Robert Harley. A Benjamin (or Benoni) Gibbons, who lived in Black and White Court until 1712, rented the house next to Deputy Collins's to an unnamed tenant. He may have been sheltering the Hogarths.[51]

Although an insolvent debtor could not legally earn a living while under arrest, his wife could, and his children also. William, being between eleven and fifteen at the time, probably worked. His mother seems to have been a sturdy and reliable woman, who must have carried a large part of the burden in these years. Richard himself may have kept some sort of a school while living within the Rules: At any rate, many complaints of debtors working are found in the records of the prisons.[52]

The hardships must have been intense. The winter of 1709, for example, was one of the coldest in memory, with post boys found dead, frozen to their horses; fuel grew outrageously expensive, and the cold lasted till the end of April. During this time two more children, William's surviving brothers Thomas and Edmund, died.[53]

One way out of debtors' prison was supplied by an act of Queen Anne's first and second years, which contained a clause to the effect that "Every Prisoner, that could swear himself not to have 5*l.* left in the world to pay his debts, and actually entred or listed himself a Soldier in the Queen's Army, or furnish'd a Man in his Room, was to be discharg'd." Richard, of course, would have found no advantage in enlistment and could not have afforded a surrogate.

He apparently saw hope in the influence of the queen's first minister, Robert Harley, a great bibliophile and collector of manuscripts, patron of Swift and friend of Pope. His religious background (stressed in many party pamphlets) of dissenter turned moderate Tory may also have suggested to Richard a sympathetic ear. In January 1708 Harley's fall from Godolphin's ministry, almost coincident with Richard's fall, had been followed by Whig calumnies and accusations of treason with a consequent threat of the Tower, which continued into 1709. He may have seemed to Richard a man who, though hounded like himself by implacable enemies, managed to emerge victorious: he became chancellor of the exchequer in August 1710, with the collapse of the Godolphin ministry. His first and most pressing duty was to deal with the national debt, which had grown to such alarming proportions that the civil list was nearly £700,000 in

arrears and the Bank, the stockbrokers, and many City men were attempting to strangle the new ministry by refusing to advance money. Various plans were offered Harley at this time, including several by the indefatigable Defoe (in August he wrote his *Essay upon Credit*) and one by Richard Hogarth.

Richard's remarkable letter of 23 September is a reminder of his proposals to save the economy, an address to a man of learning written in Latin of a most flowery kind, and a plea for patronage (presumably of the sort Defoe enjoyed) or at least for assistance in extricating himself from his troubles:

To the best of Maecenases [*Optimo Mecaenas*]:

In accordance with your perceptive character and from my name which I have inscribed below, you will easily recall that not long ago I sent you by post two proposals, harmful to no one, by which the royal revenue can be raised for the following year. I beg you, seeing that I am ever most respectful of you, not to forget me. I would willingly run to you if I could do so through this window. But I cannot, wherefore I beg you to have pity on my condition. Others (I mean Charles H——— and his brothers, with others) have fished these proposals out of me, and, as I hear, are showing them to some who are close to the Queen. I would be astonished, however, if credence were given to these nobodies [*terrae filiis*], ignorant butchers and cobblers, since whatever they have, they have taken from me. Moreover, they are the most insensible enemies to all monarchy and its friends and to you in particular; for which reason I avoid contact with them.

I have no few friends in this city, clergymen of the first class, unprejudiced [*liberatos*] people who, if asked, will be guarantors of my trustworthiness, diligence, talent, and soundness of thought, if you deign at length to remember me.

My particular talent lies in investigating most abstruse matters [*rebus difficilioribus*], inasmuch as I have spent thirty years in correcting papers and I have not yet passed my forty-sixth year, and I was virtually born for every kind of difficult business, but now I am jailed by perverse misfortune, and my soul wastes away under the weight of twenty-two children, those born to me, those entrusted to me, and still living, without any forthcoming prospect of assistance from my friends, but entirely abandoned. Alas! pity me!

I am now completing a most splendid dictionary compiled from all those previously edited, much fuller than any of them, together with Roman antiquities, a general phraseology after Smetius, and other nec-

essary things, in the manner of Elisha Coles. While I struggle to produce it, I perish [*pario pereo*]. I therefore supplicatingly implore your aid

I who am the least of your
servants and yet most faithful
Richardus Hogarth

Posted from Black and White Court
in the region called the Old Bailey
within the bounds of the Fleet,
7–23.1710.[54]

The "twenty-two children" (*viginti duorum liberorum*) must have included the family of his brother-in-law William Gibbons, who was confined in Ludgate Prison for debt, or the pupils of his school.

Although Richard's project has not survived among the Harleian Manuscripts, Harley did save his cheeky letter (because of its elegant Latin? because he knew the author? because of Richard's reputation?).[55] The date refers to September, according to the old calendar that began in March. In fact, by the end of August Harley had solved the immediate crisis and provided for the army pay, and no more is heard of Richard's proposals. Harley put together his ministry during September, and on the 20th he had the queen dissolve Parliament; he left London in October, and the new Parliament sat at Westminster in December. But on 3 January 1710/11,

A Petition of the poor insolvent Debtors belonging to the *Fleet* Prison, in behalf of themselves, and great Numbers of distressed Persons, now under confinement in the respective Gaols of the Kingdom of *England,* was presented to the House, and read; setting forth, that by their long Confinement, and Necessities, they are reduced to the last Extremity, and must inevitably perish, unless relieved by the House: And praying, that a Bill may be permitted to be brought in, to oblige their Creditors to accept the utmost Satisfaction they can make, and to restore them to their Liberty.[56]

If not a coincidence, the sequence might suggest that the enterprising Richard and his letter to Harley were somehow involved with this petition. That it reached the House and was acted upon might further suggest that Harley had in some way encouraged Richard, or others like him, to draw up the petition at this time. There was in any case a precedent here for the action taken by William Hogarth twenty-five

years later when he carried his disagreement with the printsellers to Parliament and engineered the Engravers' Act.

As soon as word got around that a bill was pending, petitions poured in from gaols all over England.[57] In the *Review* for 24 February 1710/11 Defoe (who himself had suffered imprisonment in the Fleet and throughout these years wrote about the subject) mentions the bill approvingly as one that would relieve insolvent debtors "by obliging their creditors to accept of all the Satisfaction they are able to make," but adds that it is limited to debts of only £20. The bill was, however, held up in Lords and did not finally clear both houses until May 1712, over a year later, by which time the debt limit had been raised to £50. On 14 May the bill was back in Commons, and on 22 May it received the royal assent. The "Act for the Relief of Insolvent Debtors, by Obliging their Creditors to Accept the most Satisfaction they are capable to make, and Restoring them to their Liberty" emphasizes the fact of the war and the need to free able-bodied citizens in such dangerous times.[58] By the terms of the act all debtors in prison since 7 December 1711 were given the opportunity to appear in court and present a schedule of their whole estate, with the names of creditors and amounts owed, and swear that their statement was true and that they were not withholding anything to defraud their creditors. Notice was to be inserted in the *London Gazette* thirty days before the meeting of the Quarter Sessions for debtor and creditor; and if the justices of the sessions were satisfied, the debtor would be released.

Before the end of May the names and lists of names began to appear in the *London Gazette* for the Session of 15 July. Richard Hogarth is listed in the issue for 31 July–2 August with a number of other debtors as discharged. The Session Books, in a special ledger for Insolvent Debtors in 1712, record under 9 September:

Discharged Richard Hogarth in the Fleet
 James Langdon proves him prisoner and
 summoned Creditors, due Notice
 in Gazette
 Debts & Effects Delivered in Court

The second person named swore that the debtor was a prisoner on 7 December 1711 as per the act. On 14 September Richard himself

was serving as a witness for William Gibbons, who had been a pris-
oner in Ludgate, to prove him prisoner on the above date; and their
brother-in-law Timothy Helmesley was witness to prove that notice
had been given to his creditors to appear in court. This William Gib-
bons was a younger brother of Anne Hogarth, a freeman of the Cut-
lers' Company, and possibly involved in the coffeehouse venture
with Richard.[59]

After nearly four years of virtual imprisonment, Richard Hogarth
was again free to come and go as he liked, and, with his family, could
try to return to his old neighborhood and pick up the threads of his
former life. When he emerged, he was a man of fifty, his hopes behind
him, though he still worked on his dictionary.

Remembering Charles Dickens's reaction to his experience as a
youth in the blacking factory, one can hardly overemphasize the im-
portance of Richard's collapse and confinement on his son William.
He never mentions, in any surviving writing, that his father went to
prison, although his account of those early years does suggest some-
thing of the hardships his family suffered. The record, however, may
be deduced from his works, and it is a detailed one.

In the seventh plate of the *Rake's Progress* (fig. 5) Tom Rakewell has
been confined in the Fleet Prison for debt. The warden stands by wait-
ing for more garnish, and the other desperate or demented inmates
with whom he shares the cell are apparently obsessed with impos-
sible plans of escape (including Daedalus's wings and an alchemical
oven). One of these is a bearded, unkempt man, wearing a wig that is
too small for him and a dressing gown rather like the Distressed
Poet's. A paper is falling from his pocket labeled "Being a New
Scheme for paying ye Debts of ye Nation by T: L: now a prisoner in
the Fleet," and another paper, sticking out of his pocket, is marked
simply "Debts."[60]

The despicable Colonel Francis Charteris (or Chartres) also en-
tered William Hogarth's consciousness while his father was fighting
to free himself from the Fleet. Charteris, later notorious as a rapist
and represented in Plate 1 of *A Harlot's Progress* (fig. 96), was taking
up insolvents, listing them in his company, and discharging them for
up to 40 guineas a man. On 28 February 1710/11, precisely when the
debtors' petitions were pending, Charteris was "brought to the Bar
[of the House of Commons]; where, upon his Knees, he received a
Reprimand from Mr. Speaker; and was discharged out of Custody,
paying his fees"—with essentially a slap on the wrist.[61]

One day William was free in the wide expanse of London's fairs and markets, its games and illusions; the next, he was plunged into the restrictive world of prisons, sponging houses, courts, and Rules. His father was a prisoner, without employment or resources, his mother was trying to support the family by selling home remedies. At home he found himself in crowded, uncomfortable quarters, probably shared with the family of William Gibbons, and outside he was among some of the shadiest of London characters, including not only the shabby-genteel debtors just managing to avoid the utter squalor of the inner prison—sometimes innocent victims, often rogues, and almost always men who by trying to live up to some hypothetical standard had exceeded their means—but also the habituated denizens of this demimonde who exploited them, supplying them with food and comforts at exorbitant rates and criminal interest.

This was the world that Hogarth later captured in his prints. It is easy in the light of these years to understand why the 1729 House of Commons inquiry into the management of the Fleet was important to him. His paintings of the Commons Committee meeting in the prison, together with another prison scene, *The Beggar's Opera* (figs. 60, 65), first brought him to the attention of the London picture buyers. The emphasis throughout his work is on prisons, real and metaphorical. Even when he is not dealing with people who are in a prison of one sort or another he portrays rooms that are more like prison cells than boudoirs and parlors. He constantly returns to the subject of the accused or convicted person who is less guilty than the warden, magistrate, and constable, or the genuine criminal who has gotten off. His basic assumption seems to have been that society should be seen from the point of view of the prisoners rather than their judges and warders: ultimately from the marginal point of view of the child, or of the child locked up in prison with his parents.

Although they did not extricate him, the booksellers had not altogether abandoned Richard, and he had continued to write. While within the Rules of the Fleet he completed and saw published another Latin textbook, *Disputationes Grammaticales or Grammar Disputations* (December 1711), now with his full name on the title page, and a title, Schoolmaster. The publisher, William Taylor, was bringing out several Latin and Greek texts at this time and gave Richard's a good deal of advertising.[62] The little book is made up of a bilingual dia-

logue in English and Latin, with an index of men and objects appended. It was in this list, significantly, that Richard demonstrated his orthodoxy (his "soundness of thought," as he wrote to Harley) by celebrating the Stuarts and omitting regicides and dissenters.

The book is a grammar, probably intended for the first form (Lily's was still used in the second), apparently based on Richard's classroom experience ("By Richard Hogarth, *Schoolmaster*"). The Latin dedication "To the Scholars, Schoolmasters, and Under-teachers of Great Britain," however, remains a characteristic utterance with its argument that games are the best instruction, its implication that here is a new and revolutionary system which will supersede the old, and its promise that something even better ("quiddam majus et magis vobis accommodum") is to follow. The success of the book can only be conjectured—Richard does not appear among the 186 writers of Latin grammars enumerated in Solomon Lowe's *Grammar of the Latin Tongue,* published in 1726;[63] but on the other hand, when a book survives in only one or two copies there is some evidence that it was used.

In 1711/12, just after he published Richard's *Disputationes Grammaticales,* Taylor brought out a so-called sixth edition of William Walker's popular *Dictionary of English and Latin Idioms* (1670), "Corrected and Improved with above 3000 Phrases, collected from the best Authors" (*Post Boy,* 5-8 Jan. 1711/12). The correcting and improving may have been accomplished by Taylor's chief Latin expert, Richard Hogarth, who apparently did this sort of thing. If so, Taylor may have used his work unacknowledged, driving Richard to another bookseller, John Wyat (or Wyatt), for publication of his promised "quiddam." (Unlike the presumably Jacobite Taylor, Wyat, who sold at the Golden Lion, St. Paul's Churchyard, was a publisher for the nonconformists.)[64]

For in April 1713, above Wyat's imprint, appeared *New School Dialogues, English and Latin; partly collected from Walker's Idioms and adages, Terence, Coderius, Erasmus, and other Writers of Colloquies: Partly Composed and digested by R. H. and now the first time Made publick, for the use of the Lower Forms in Schools* (*Daily Courant,* 21 Apr. 1713). In publishing this book and its source, Walker's *Dictionary of English and Latin Idioms,* Wyat was in direct competition with Taylor. The rest is supposition since no copy of the *New School Dialogues* has been found, but another advertisement of Wyat for 1715 notes that a

book called *School-Boys Dialogues* has been adopted by St. Paul's School (*Post Boy*, 31 Mar.–2 Apr.).

Thus, if Richard was allowed to profit from Wyat's success, the Hogarth family may have lived in somewhat greater security during the last years of Richard's life. They are listed as householders in Long Lane during these years, and the Widow Hogarth continued to hold the house after Richard's death in 1718. But booksellers, to judge by William's later assertions, were not to be trusted; they made the profits and let their authors starve. Moreover, they apparently prevented Richard's masterwork from being published.

The *New School Dialogues* was probably not the "something even more to your liking" he had promised in *Disputationes Grammaticales*. It was more likely the dictionary along the line of Elisha Coles's which he told Harley he was working on while imprisoned in the Fleet. Coles's was an English-Latin, Latin-English dictionary "containing all things necessary for the translating of either language into the other," first published in 1677. Richard's manuscript itself survived, kept by William as a bitter remembrance; it passed after Jane Hogarth's death to Mary Lewis, who sold it to John Ireland. According to John Nichols, who had seen it, it was "a thick quarto," containing an early edition of Adam Littleton's *Linguae Latinae Liber Dictionarius Quadripartitus* (originally published in 1673) and William Robertson's *Phraseologia Generalis, or A Full, Large, and General Phrase Book* (1681). Coles's dictionary had been superseded by Littleton's Latin-English and Robertson's English-Latin dictionaries, so it was reasonable for Richard to use these as his working copy. There were many corrections written into the text and in addition four hundred pages of closely written manuscript. In the first volume, in William's hand, was inscribed: "The manuscript part of this dictionary was the work of Mr. Richard Hogarth."[65]

This was the work William referred to in his autobiographical notes many years later as the source of his distrust of booksellers. Explaining why he turned to drawing (implying that his alternative was a learned profession), he writes that besides his natural talent,

I had before my Eyes the precarious State of authors and men of learning[.] I saw not only the difficulties my father went through whos dependance was cheifly on his Pen, the cruel treatment he met with from Bookseller[s] and Printers [but] particularly in the affairs of a lattin

Dictionary the compiling had been [the] work of some years. which being deposited in confidence [in] the hands of a certain printer, during the time approbation letters on the specimen were obtained from all the great schools in England Scotland and Ireland, who were in short pleased but several of those also of his acquaintance who were by the correspondance he held as appears by letters I have still by me were of the first class.

He believed that his father died "of Illness occationd by partly the useage he met with from this set of people . . . and partly," he adds enigmatically, "by disappointments from great mens Promises" (AN, 204–5). The last must refer to subscriptions, without which many booksellers would not have undertaken so large a project. Certain "great men"—those patrons whom Hogarth was ever to distrust—may have encouraged his father's hopes with promises of support and subscriptions from their friends, which were unfulfilled.[66] Certain booksellers probably held back because Richard's dictionary would have detracted from sales of a dictionary whose copyright they already owned (Littleton or Robertson); others probably thought the project unprofitable. It must have seemed to his son that London was one great set of rogues preying on the individual who struggled to survive and maintain his own standard of excellence. The decent, hardworking scholar went to prison, while the roguish booksellers picked his brains and scavenged his writings without adequate recompense, and, when they could, cheated him outright. This image, together with that of the unhelpful patron, remained with Hogarth all his life, affecting at crucial moments his own actions as well as being thematized in his graphic works. In his autobiographical notes he makes the narrative of his own life parallel his father's: He presents his own early experience with the printsellers who pirated his prints and stole his livelihood (until he succeeded in getting an engravers' copyright act passed in 1735), and his later experience in the 1750s and 1760s with patrons, politicians, and fellow artists which prompted him to write the autobiographical notes. By means of this paranoid fiction, at crucial points in his career, he linked himself with his father.

Richard and his various "academies" come to mind in considering William and his strong opinions about artists' academies. Here are Richard the self-made man, not of a university, making his way unaided in the great city—and being, or feeling himself, beleaguered—

and Richard's itch to systematize and place before the world a written text, let alone his leading motive to teach: all of these follow in the son. And while William's Line of Beauty and his aesthetic precepts are in some ways antirules, they are presented in as dogmatic a manner and spirit as Richard's. William's mind, however great his ability with graphic forms, worked like his father's verbally. One part of his father—his failure—he had to push out of his consciousness. His obsession with success, his attachment to Sir James Thornhill, and his lifelong emulation of him can only be adequately explained as an attempt to satisfy a need left unfulfilled by his father.

2.

"THE MONSTERS OF HERALDRY"

Apprenticeship and the Profession of Engraver, 1714–1720

ELLIS GAMBLE

On 2 February 1713/14 the Registry of Apprentices of the Merchant Taylors' Company records the binding of William Hogarth to Ellis Gamble, engraver, for seven years. The four years in the Fleet may have been the factor that delayed Hogarth's apprenticeship from 1712, his fifteenth year when it would ordinarily have begun, until January 1713/14; he probably had to work to help keep the family afloat. Years later he recalled the relatively advanced age at which he took up engraving. While delaying his apprenticeship, Richard's financial disaster may have determined it as well: if he had intended his son for something better, perhaps a learned profession, these hopes dissipated with his confinement in the Fleet. It seems likely that William stopped attending school entirely, unless he was intermittently tutored by his father.

His master, Ellis Gamble, at his own apprenticing twelve years before, was described as the son of Robert Gamble, a "gentleman" of Plymouth.[1] He had been apprenticed to Richard Hopthrow of Orange Court, also an engraver, in 1702. According to the age given on his marriage allegation and the usual age of apprenticeship, Gamble must have been born around 1685 and thus was Hogarth's senior by only a dozen years. Though his apprenticeship to Hopthrow was concluded by 1707 at the latest, he did not purchase his freedom of the Merchant Taylors' Company for another five years. He may not have had sufficient money before that; and on 15 September 1710 he took a

wife, one Margaret Smalbone, at St. Martin-in-the-Fields: in the marriage register Gamble's signature and handwriting are clear and literate.[2] Finally on 3 March 1712/13 he purchased his freedom of the company, when he was described as an "engraver" of Blue Cross Street, Leicester Fields.

Gamble, of course, could not have taken William before that time, but the delay until February 1713/14, when Hogarth was sixteen years and three months, is probably explained by the movement of the Hogarths from the Rules of the Fleet Prison to Long Lane. Though there is no indication in the Registry of Apprentices that any money exchanged hands (as was usual at an apprenticing), perhaps at this point Edmund Hogarth came to the rescue. Through his wife Sarah he was in some way related to Ellis Gamble, and he may have arranged for the apprenticeship and either persuaded Gamble to take William gratis or paid him to do so. All that Hogarth himself had to say about the matter in later years was that his father was too poor to do more than put him "in a way to shift for himself," and so "*accordingly* he serv'd a prentiship to a silver plate engraver" (italics added). In another version he noted that he was "taken early from school" to serve his apprenticeship (AN, 201, 205).

At this time many goldsmiths and (like Gamble) goldsmiths' engravers chose to be members of other companies than the Goldsmiths'. The prestige of the Goldsmiths' Company had declined. The large influx of Huguenot goldsmiths from France also contributed to the overcrowding of the companies. The well-known Huguenot goldsmith Peter Archambo was a freeman of the Butchers' Company, and the engraver Simon Gribelin became a freeman of the Clockmakers' Company—perhaps because he could not get into the Goldsmiths' at that time, or perhaps because much of his work was initially on watchcases. Legally, the assay and touch of the Goldsmiths' Company was allowed to freemen of other companies; in the mark registration books there are marks registered by members of Drapers', Merchant Taylors', and Clockmakers' companies.[3]

Apprenticeship was undertaken with a public ceremony. In the presence of the company officers, the apprentice, and his master, the register was entered in the guild book, to cancel the possibility of fraud by either master or apprentice. If, for example, the boy had been bound to an unqualified master, or if the boy were in some way unqualified, it would have come out at this point. Merchant Taylors'

Hall in Threadneedle Street was entered by "a handsome large Door-case adorn'd with two demy columns, their Entablature and Pediment of the Composite Order," and here in the great hall, hung with tapestries telling the history of their patron John the Baptist, Hogarth's indenture was read and approved by the court, and he was enrolled in the book. The emolument charged was upwards of 30*s*, but "Nil" is written in the register opposite William Hogarth's name and many others. The apprentice now swore to serve his master truly and to keep his conduct morally above reproach, while the master promised to instruct the apprentice in his craft, provide him with room and board, and uphold a moral standard as his guide. The indenture, usually drawn up by the clerk of the company to which the master belonged, was written twice across a sheet of parchment or paper; the two copies were then cut apart so as to leave on each a jagged or indented edge, from which the document took its name.[4]

The apprenticeship ended with another public act: seven years later the apprentice appeared again before the assembly court, this time to ask for his freedom. According to the Statute of Artificers, he had to be no less than twenty-four years of age, but this rule was not often observed, twenty-one seeming to have been the lower limit. He went with his master to the Guildhall, and the master publicly testified to the apprentice's "true service." He had to pay fees for admittance: the legal sum was 3*s* 4*d,* but the beadles, clerk, and other guild officers also received small fees, raising the total considerably. In Hogarth's day, these fees often amounted to £10, £20, or £30 and it was common for the new freeman to give a breakfast or dinner for the company. It was customary for the master to help fit out the apprentice for his start in life. In the seventeenth century he often gave him a double suit of apparel at the end of his term, or the tools he would need; in the eighteenth, the master more often simply paid a sum of money to clear himself of all further obligations. By that time the capital necessary to set up in business was much greater, which might explain Gamble's waiting five years to take his freedom.

During the apprenticeship Gamble was occupying a whole house on the south side of Blue Cross Street between Whitcomb and St. Martin's Street (not far from his master Hopthrow, who lived in Orange Court). Hogarth would have moved into this house as a member of the family.[5] At least one other apprentice was in the Gamble house when he arrived (a Stephen Fowler), and another (a Flemish lad named

Felix Pellett) joined them in 1717, by which time Gamble's increasing importance had raised his fee for the apprenticeship to £30.[6]

The master replaced the apprentice's father; he was responsible for the apprentice's physical and moral development, and one of the qualifications guilds looked for in a master was a wife and family of his own.[7] It was not an easy life for the apprentice. The work hours were long, defined by statute for artificers who worked by the day as from 5 A.M. to 7 or 8 P.M. from the middle of March to the middle of September, taking not more than two and a half hours for all meals. From mid-September to mid-March the hours were those of daylight. He received no wages, and the master was entitled to all the apprentice's products and earnings. As the indentures state, the master supplied instruction, meat, drink, and lodging, the apprentice obedient service.[8]

Sports and pastimes were frowned upon: no dice or cards, no football, in some places no plays; no mumming and dancing, use of music, or entertaining of friends. Extravagance in dress and personal adornment was suppressed: clothes had to be plain but decent— sober garments with hair neatly trimmed, not in curls or hanging about the ears. It is worth listing these because in later years Hogarth was noted for his flashy dressing.

During these years the newspapers were full of accounts of unruly apprentices and advertisements for runaways. One master told his guild court that his apprentice "did threaten him in an unusuall manner, and often swore he would be his death, and would crush his head against the table, with many such like provoking expressions." Most annoying of all, apprentices were constantly running away before their term was up, "just when their work was beginning to repay their masters," as Defoe put it. And whenever there was a riot it was assumed that it began with unruly apprentices.[9]

"STUDIES" AND "PLEASURES"

Looking back from the 1760s, Hogarth recalled the life as constricting: "he soon found that business too limited in every respect." As an apprentice to a silver engraver (as opposed, for example, to that printer's apprentice who made good, Samuel Richardson), Hogarth

was an "artist," and yet also a mere copyist of patterns on plate, condemned to the drudgery of mechanical reproduction. The latter he was to despise in others and condemn as a principle of taste (as in the "ditto" Old Master paintings of *Battle of the Books*, 1745). It is easy to imagine him chafing under the long hours, straining his eyes over tiny heraldic engravings, and impatiently looking forward to the little time he was allowed away from the shop.

But during these formative years, from sixteen to twenty, he soaked up more than the technique of engraving coats of arms. There can have been few more alert observers of London life; and he embarked on his apprenticeship in the pivotal year Queen Anne died and the Hanoverians arrived from Germany, the Tories went into exile, retirement, or prison, and the Whigs emerged triumphant. There was constant talk of the Stuart Pretender returning—as indeed he attempted to do in 1715, with consequent treason trials and executions. In addition, the ordinary routine of London life deserved contemplation. A month before Hogarth started his apprenticeship he might have read in the *Post Boy:*

> *London,* Dec. 19. The Sessions at the Old Baily did not end till Monday last; and it has not been known for many Years, that so many Persons receiv'd Sentence of Death at one time, there being then Condemn'd 23 Persons, being 6 Women, and 17 Men, . . . 7 for Burglary, 5 for Shop-lifting, 4 upon the late Statute for Entring of Homes, and Stealing Goods above the Value of 40*s*. and the rest for several Capital Offences.[10]

Such notices showed Hogarth the onus of capital punishment on thefts of property; the number of women as well as men condemned to hang; and—for someone interested in details—the publication of the Session Papers recounted the trials, the Ordinary of Newgate's potted biographies moralized their last days, and the subsequent biographies by such writers as Defoe fictionalized their careers.[11]

From the evidence of later years, it seems likely that Hogarth, despite apprentice rules, spent a great deal of time at the theater, and at print shops, book stalls, and generally around London, surveying and mentally recording the sights. A well-known story, from a few years later, concerns a friend who saw him "draw something with a pencil on his nail. Enquiring what had been his employment, he was shewn

the countenance (a whimsical one) of a person who was then at a small distance."[12] He may already have begun the practice of catching the forms of what he saw in a linear shorthand and expanding them, back in his room, into full figures.

The importance to him of his mnemonic technique, at least in retrospect, cannot be overemphasized. The account of his life he drafted as an introduction to a commentary on his prints (ca. 1760) centers on the function of memory. These pages begin in a rejected passage for *The Analysis of Beauty* (184–85) and continue in the so-called Autobiographical Notes, where they appear as the climactic and emphatic element in a biographical sequence that is repeated, more or less, eight times. This sequence (AN, 201–13, emphasis added) begins with the fact of apprenticeship:

"As the chief part of my time was lost (till I was three and Twenty)" in apprenticeship—"my time was cheifly lost till I was three or four and twenty"—"So much time being gon"—, he was employed merely copying designs for plate, a "business too limited in every re-[s]pect." Therefore, "drawing object[s] something like *nature* instead of *the monsters of Heraldry* became necessary to attain which the common methods were much too tedious for one who loved *his pleasure* and that *came so late* to it." Again, "he never accustomed himself to *coppy* but took the *short way* of *geting objects by heart* so that wherever he was [he] cau[gh]t some thing and thus united his *studies* and his *pleasure*[.] by this means he was apt [to] *catch momentary actions and expressions.*" He repeats the words "studies" and "pleasures" over and over. In some versions of the story he emphasizes the self-taught aspect: Belatedness "put me upon an Enquiry if a nearer way of coming at these arts [of painting and engraving] than that usually Taught by artists might not be got at."

Since he needed to have both his studies and his pleasures, including a penchant for idleness,

I was naturally (as I could not help prizing the time best suited to the common enjoyments of life) thrown upon an enquiry after a *shorter way* of attaining what I intended to aim at than that usually taught among artists. and having first consider'd what various ways and to what different purposes the Memory might be managed and addapted I fell upon one i thought most suitable to my situation and *Idle disposition.* (208)

Thus he "hit upon a Method more suitable to my disposition which was to make my *studies* and my *Pleasures* go hand in hand."

Hogarth's mnemonic technique combined these by sending him out "strolling" around the London streets and "catching" what he saw. This system allowed him to saunter about London and "make use of whatever my Idleness would suffer me to become possest of." It seems likely that he internalized the flaneur protagonist of John Gay's mock-georgic *Trivia* (1716)—a work that had a lasting effect on his imagination, helping to explain the *London Baedecker* quality of his graphic work. What he demonstrates, however, is that "by this Idle way of proceeding I grew so profane as to admire *Nature* beyond *Pictures* and I confess sometimes objected to the devinity of even Raphael Urbin Corregio and Michael Angelo for which I have been severly treated" (209).

Other artists (by which he probably means his colleagues of the 1730s–1740s) could not understand his method, and so his exaltation of nature was taken as such a "*Blasphemous* expression that I fear I fear [sic] *Persecution*"—and "I have suffered a kind of *persecution*. nevertheless from the *bigots*." He defines those "bigots": "my notions of Painting differs from those Bigots who have taken theirs from books, or upon trust" and he refers to "the old *religion* of pictures." This story, with the vocabulary of specifically religious persecution, ties in with the other narrative of his father and *his* persecutors.

An interesting fact about this biographical narrative is that it ignores the Puritan story of conversion—a story Hogarth reserves for his "progresses," where he parodies it. All of its aspects were embodied indirectly in his art: the "monsters of heraldry" is only another term for the decorative high art (certain kinds of history painting) he constantly played off against forms of low or empirical reality. The dichotomy of "pleasures" and "studies" appeared in his obsessive use of the Choice of Hercules (which is between Virtue and Pleasure) and his ambivalence about his "idleness" was manifested at a moment of crisis in his career by his prints about an industrious and idle apprentice. But the two cruces of the narrative require elaboration: "Nature" and Hogarth's mnemonic method.

One of the traditional stories of artists was of Lysippus, who (incidentally) began his career as a coppersmith but became a great sculptor by following the advice that "Nature, and not the manner of some other artist, is alone worthy of imitation" (*Naturam ipsam imitandam*

esse, non artificem). It was also mentioned that he was self-taught. Plutarch adds that Alexander the Great wanted his portrait sculpted only by Lysippus because of Lysippus's accuracy of observation.[13]

Another anecdote of Hogarth's apprenticeship, told by a fellow apprentice, was of "an excursion" on a Sunday to Highgate: there, in a public house, he witnessed a quarrel in which one man hit the other on the head with a tankard:

> The blood running down the man's face, together with the agony of the wound, which had distorted his features into a most hideous grin, presented Hogarth, who shewed himself thus early "apprised of the mode Nature had intended he should pursue," with too laughable a subject to be overlooked. He drew out his pencil, and produced on the spot one of the most ludicrous figures that ever was seen.

Significantly, he is remembered as having rendered "an exact likeness" of the battered man, of his "antagonist," as well as "the figures in caricature of the principal persons gathered round him."[14] This is the structure of action Hogarth develops imaginatively in his serious work: the wounded figure, his "antagonist," and the various spectators. His earliest fame was for "exact likeness," and his contemporaries were (to his dismay) to persist in confusing "likeness" with "caricature."

In going out into the streets of London to collect ("study") a stock of new images, from nature, while enjoying his "pleasures," Hogarth shows that he was (at least in retrospect, if not at the moment) reacting against "pictures," that is, "art" and the "beautiful." He was denying the almost universally held doctrine of art, embodied in the writings of both Shaftesbury and Jonathan Richardson, summed up at the beginning of the tradition in Leon-Battista Alberti's criticism of the ancient painter Demetrius, "who failed to obtain the highest praise, because he paid much more attention to making paintings which were true to nature than to making them beautiful."[15] But he was also contesting the conception of nature as the general, summed up at the other end of the tradition by his eventual antagonist, Joshua Reynolds, in his seventh *Discourse* (1776):

> The terms beauty, or nature, which are general ideas, are but different modes of expressing the same thing. . . . Deformity is not nature, but

an accidental deviation from her accustomed practice. This general idea therefore ought to be called Nature, and nothing else, correctly speaking, has a right to that name.[16]

For Hogarth "nature" includes everything observed with his senses, however flawed—and not from a distance (seen with the detachment Shaftesbury required of the aesthetic experience) but close up, as an active participation in the artist's "pleasures." But as he realizes, and will express in his subscription ticket for *A Harlot's Progress* (fig. 107), the first full materialization of his theory, this direct contact is no more than a peep or glance at what is hidden under Nature's skirt.

What *was* Hogarth's mnemonic technique? The story of his thumbnail sketch ties in with his writing that the method involved "retaining in my mind lineally such objects as fitted my purpose best." Some sort of a linear code, which at one point he associates with an alphabet, could refer to notation that catches a particular nose or other physical feature (as in a story told of Leonardo). But if we are to accept his words ("to draw by memory," "the retaining in my minds Eye without drawing upon the spot," AN, 208, 210), his point is precisely that he memorizes without making a drawing of any sort; he makes a literally mental note, which he can transcribe in his studio, or perhaps summon up much later—part of a visual repertoire—when it is needed for a particular composition. Referring to this theory, "an arch Brother of the pencil gave it this turn That the only way to learn *to draw well was never to draw at all*" (185). It is evident in his paintings that Hogarth used only the most rudimentary sketches prior to applying paint to the canvas.

In one draft he extends the discussion of his mnemonics to the "theater of memory": "my Picture was my Stage and men and women my actors who were by Means of certain actions and express[ions] to Exhibit a dumb shew." This suggests that he carries the image of a stage around in his mind recalling the story of Simonides and the visualized room used by orators as an aide-mémoire.[17] Hogarth's scenes—invariably constructed as a single-point perspective box, essentially a proscenium arch stage, filled with furniture and emblems—can be seen to serve as the traditional memory structure *turned away from* the orator toward his audience, seen from the spectator's point of view. But it is also possible to see the room from the artist's point of view as a basic structure to be "furnished" in his memory before being set down on paper. With this architectural

model, Hogarth could walk the streets of London mentally filling a stage set: with the composition given, always the same, he could arrange and dispose the figures as he experienced them, later putting them in their proper places on his canvas.

The theater audience, as Hogarth realized, represented a microcosm of London society, in terms of whose response he attempted to structure his prints. But it was a model that supported the dichotomy of study and pleasure with (as in his *Beggar's Opera* paintings) the motto emblazoned over the stage: *Utile et dulce*.

THE BUSINESS OF SILVER ENGRAVING

While the life of an apprentice would have seemed tedious to one of Hogarth's temperament under any circumstances, he was further hampered by a master who was fundamentally an artisan. Hogarth's dilemma was not unique; artists had been fighting since the Renaissance to clarify the distinction between craft and liberal art. It is not certain whether Hogarth yet thought of himself as an artist, or whether his comic drawings were merely an escape from the long hours of careful silver engraving; but coming from his father's scholarly house he cannot have been too happy thinking of himself as less than a gentleman.

As so often seemed to happen, Hogarth found himself in a borderline situation, apprenticed to a goldsmith's engraver whose status fell somewhere between merchant and artist. The goldsmith himself cast the plate; the ornament could also be cast, cast separately and applied, or embossed (hammered out of the body of the metal), and all of this was done by the gold- or silversmith. Engravers such as Gamble were called upon to do any additional decorative engraving. Only the simplest engraved borders were done at the goldsmith's shop; any work requiring a higher degree of skill was sent to a specialist, and this work might extend from a cypher or a coat of arms to an elaborate allegorical design.

Silver engravers formed a specialized branch of the engraving trade. Variations in the types and levels of skill required, added to seasonal variations, led to their working in networks. They were accordingly subcontractors to the retailing (not the manufacturing) silversmiths. All other factors being equal, the retailer would choose the nearest

good silver engraver as his link into the network. We know that Gamble formed a kind of partnership with Paul de Lamerie, the greatest silversmith of his day, between 1723 and 1728: Lamerie placed his stock in Gamble's shop and insured it at that address.[18] It seems probable that even before this official relationship Gamble had been Lamerie's link with an engraving network. While the partnership was in existence, Gamble was the engraving coordinator, besides being one of the practitioners. It was during this time when Gamble's shop was at the Golden Angel in Cranbourn Street that Hogarth, now on his own as an engraver, engraved a shop card for his ex-master (fig. 8) announcing that he "Makes, Buys & Sells all sorts of Plate, Rings, & Jewells &c." The inscription is, significantly, repeated in French, but there is no mention of Lamerie. Since Gamble would surely have advertised his connection with the great Lamerie, we must suppose that the shop card was made either just before (1723) or just after (1728) the partnership.

The gist of the shop card is that Gamble is now a retailer; that his engraving skills have been subordinated to those of a merchant. Hogarth left him at the height of prosperity, rapidly rising in the profession. On 23 May 1718, toward the end of William's term, Gamble (then listed as "ingraver by the Mews," which was nearby) was elected a liveryman of the company, an honor which entitled him to purchase larger shares of its stock than were available to the company's yeomen. He was also privileged to wear the company's robes at public ceremonies, and a year after the payment of the fine, he was entitled to vote in the City elections for both higher officials and M.P.s. But the defection of Lamerie in 1728 must have been significant, since by 1732/33 Gamble was declared bankrupt at the petition of Lamerie. Bankruptcy did not, however, put him out of business nor involve resignation as a liveryman; in 1737 he took another apprentice, though his fee had been lowered by this time to £10.[19]

Gamble offered one option for the young silver engraver, simply to engrave plate, watchcases, and sometimes bookplates, primarily with heraldic designs. We know that Hogarth learned this sort of silver engraving and hated the drudgery and the "Monsters of Heraldry." The usual task assigned to apprentices, this meant the dull repetition of reproducing a coat of arms on *every* plate, knife, fork, and spoon of a service. George Vertue, writing at the time of Hogarth's sudden emergence in the 1720s, notes that he was "bred up to small gravings of plate work & watch workes" (6: 190). If tradesman is

writ large on Gamble's career, the other class of engraver included those such as Gribelin, who, while decorating silver for a fee, were basically illustrators of books. They had made the essential rise from silver to copper.

It is not clear how Hogarth learned the more congenial skill of etching. The softer copper was easier to engrave with the burin than silver; but the etching needle, cutting through a thin layer of varnish, was a much faster, smoother, and more fluent medium. Perhaps he taught himself, or perhaps it was another skill he learned from Gamble. He was adept by 1720 when his shop card appeared (fig. 7).

Historically, the important phenomenon during these years was the influx of the Huguenot refugees from France, who stole business from English workmen, forcing them to lower their prices, but who also introduced changes in the style of smithing and engraving.[20] Their presence may have contributed to a pair of not altogether consistent characteristics for which Hogarth was to be noted: his xenophobia and at the same time his absorption of foreign styles and iconographies.

The Huguenot influence was in fact to the advantage of the English engraver, shifting from the elaborate embossed decoration of the Dutch to simpler forms with a minimum of decorative details—the "Queen Anne" style. In seventeenth-century England ornament had been almost entirely embossed, and engraving, except for coats of arms, was out of fashion. The new style, with its plain, unembossed surfaces, allowed for a return to engraving; as a result engraved decoration reached a higher standard of excellence than ever before. Within the years of Hogarth's apprenticeship the complexity of the engraving increased as the Queen Anne style developed into early Georgian. Specifically this change involved the replacement of the square shield (in which the coat of arms was enclosed) by the circular or oval cartouche, surrounded by acanthus foliage and strap-and scrollwork, and later by swags of flowers, grotesque masks, and palmettes—the beginning of the so-called rococo style that in the 1720s would reach to subject pictures as well.

Another result was the influx of French pattern books. English engravers and their apprentices learned from the great French masters of late baroque design, Jean Berain and Paul Ducerceau. But almost every other conceivable sort of design reached England from France. While, for example, the general forms and motifs used by Berain appear in the early engravings of Hogarth, his style—his use of line—

owes more to Jean Barbet's *Livre d'architecture d'autels, et de cheminées* (1641). Hogarth would have known the books of Simon Gribelin (who came from Paris in the 1680s): *A Book of Ornaments usefull to Jewellers, Watch-Makers and all other Artists* (1697)—designs intended for the decoration of watchcases, snuffboxes, and the like—and *A Book of Ornaments usefull to all Artists* (1700). These models would also have led Hogarth toward mythological subjects and the conventional iconography of putti, herms, satyrs, savage men, and heathen gods.

Nothing is known of Gamble's style except as Hogarth may reflect devices learned from his master—which, however, were utterly conventional. Hogarth's style, insofar as it tends to humanize the heraldic forms, is easier to recognize, but only in supporters and allegorical figures, which were by no means always included in commissions. Several pieces have been attributed to him, but none with any certainty to the period of his apprenticeship (fig. 6). Besides the relative anonymity (for the most part) of such work, the family plate, regarded largely as a reserve of capital easily realizable in times of emergency, often ended in the melting pot.[21]

Hogarth made no effort himself to foster the memory of this time, preserving no impressions of his engravings and referring to it only as a waste period that kept him from copper engraving and prevented him from ever mastering its refinements. As an apprentice to a silver engraver he was taught the handling of the tools of his trade, not the principles of art; he was made to copy or to adapt at best allegorical figures and emblems, at worst purely decorative patterns, and this imitation of art to the exclusion of nature prejudiced his attitude toward "art" and copying for the rest of his life. His "impatience" is another characteristic he recalled alongside his need for recreation and play. The luck of his failing to attain "that beautiful stroke on copper" also proved to be important: beauty was something he learned to convey in oil paint, where it sometimes jars against the meaning of the monochromatic "modern moral subject"; in engraving it was to his advantage not to have learned the "beautiful stroke."

Gamble's final influence is hard to assess. Of course, Hogarth reacted against all that he stood for: mechanical copying from art rather than nature, and by extension "art" in general, especially as expanded in the decorative tradition of history painting and the use of remote mythological subjects. His constrictingly precise work on these subjects for Gamble taught him a great deal about baroque forms, which he would repeatedly parody in his own work. At the

same time, it started him toward refining these forms in the direction
of the delicate rococo curve—the effect that he ultimately called his
Line of Beauty—which, as the apprentice's development came full
circle, became almost obsessive in some of his later works. It may
have helped to lure him into an elaboration of detail which is the
glory and confusion of his art. The dull copying itself gave him an
opportunity to store up images, emblems, and motifs for later use
that supplemented his extracurricular interest in Dutch engravings of
carousing parties and fairs.

Although he did not realize it at the time, and preferred to over-
look it in later recollections, his having been trained as an engraver
rather than a painter was a piece of good fortune. This training put
Hogarth in a unique position, when the time came, to appeal beyond
the verdict of the connoisseurs and collectors of paintings and sculp-
tures, who he felt kept a stranglehold on taste and patronage in En-
gland, to a larger public for judgment.

By 23 April 1720, nearly a year before its completion, Hogarth
had abandoned his apprenticeship. This is the date on his shop card
(fig. 7). Evidence for a break with Gamble as an act of rebellion de-
pends entirely on the passages in his autobiographical notes and the
ambiguous text of *Industry and Idleness* (where we see Idle's half of his
indenture discarded); and of course on his giving up his rights to
membership in the Merchant Taylors' Company. These bits of evi-
dence tend to make the most important aspect of his apprenticeship
his failure to complete it. The ordinary reason for a forfeit of inden-
tures was that the apprentice got into trouble and his master expelled
him; another, which Hogarth himself suggests retrospectively, was
that he became so fed up with the life that he broke off—out of pride,
ambition, or mere boredom with the business of silver engraving.
Although he does not say so, a third possibility is that other prob-
lems made it necessary for him to get out and support his family.

In 1714 when William was apprenticed, Richard Hogarth was de-
scribed in the Apprentices' Register as "of St. Bartholomews," so
had presumably by then moved to the south side of Long Lane,
where he remained until his death in 1718. He first appears in the par-
ish rate books for St. Bartholomew the Great in 1716, rated at 13*s*.
He must have died suddenly, on 11 May 1718, without time to write
a will. There was no mention of his death in the papers, no advertise-

ments for debts outstanding or for an auction of his library (if any books remained). He simply vanished from the London scene as quietly as he had arrived, to be replaced in the rate book by "widow Hoggarth," who continued to live in the house until 1728.[22]

William may have been compelled to leave off his apprenticeship at this point to help his mother, but more likely she continued to hang on by herself, perhaps with the millinery business that she was later operating with her daughters. She may have been aided by Richard's brother Edmund, the prosperous merchant. At the beginning of 1719, however, Edmund too died, and his will specifically cut off (among others) the Widow Hogarth with "one Shilling if lawfully demanded & nothing else of mine." The will, written on 14 February 1718/19, just before his death, made clear that he wanted no such liabilities as the family of his unfortunate brother to burden his own widow.[23] It may have been at least partly as a result of the double catastrophe that William forfeited his indentures.

Thus by April 1720 he was back living with his mother "near the Black Bull" in Long Lane and setting himself up, outside the context of any guild, as an independent engraver. On the 23rd of that month he dated his own shop card with his name and the above address prominently displayed, flanked ambitiously by figures of Art and History, with some of the cherubs he had grown accustomed to making for Gamble filling in the top (fig. 7).

The break with Gamble was not necessarily an unfriendly one. In a few years Hogarth made him a shop card (fig. 8), a competent piece of work as such things go: an angel in a cartouche, with some signs of Hogarth's hand not only in the angel herself (with too many fingers) but in the irregular execution of the brickwork ornament. He compensates for his unprofessional lack of precision, however, with a lively representation of the angel. In 1723 or 1724 he engraved arms on plate for the duchess of Kendal, one of George I's mistresses, and this must also have been through the Gamble–Lamerie connection.

GEORGE VERTUE

Our prime witness to Hogarth's career, and to the general plight of the arts and the artist in his lifetime, is the engraver and antiquarian George Vertue. Born in 1684, Vertue reached apprenticeship age

about 1699, and coming, like Hogarth, "from parents rather honest than Opulent" (as he recalled in his autobiography), "after propper School learning. he was put apprentice to a Master who chiefly practized Engraving of Silver plate &c. Ornaments, Coats of Armes in which profession he at this time had the top reputation of any in Town." Reputation notwithstanding, Vertue's master went bankrupt in a few years. The boy took up drawing briefly, but soon turned to copper engraving, which he studied "for about 7 years till about 1708/09 when he made some two or three Specimens of work, which giving much hopes to those his Friends who were skilld in the Art, encouraged him to begin for himself" (I: 1). After leaving Michiel Vandergucht, his master in copper engraving, Vertue spent his first year on his own engraving book illustrations, until he was recommended to Sir Godfrey Kneller and introduced to the business of reproducing portraits.

Vertue's career was typical of the ordinary, successful engraver—and, up to a point, was parallel to Hogarth's. Both were apprenticed to silver engravers, craftsmen rather than artists, and both then went on to study copper engraving. Both started with book illustration. From this point on, however, their careers diverged. Vertue remained all his life dependent on printsellers or patrons, and since printsellers got rich at the expense of their engravers, his hopes rested largely on patrons. As a copyist-engraver, whose specialties ran from portraits to antiquarian objects, his best bet was the wealthy collector who wanted his family portraits or collections perpetuated in good engravings. The patron might offer a munificent reward based on the difficulty and value of the workmanship itself, but the print dealer was interested only in what he could sell, and the less he paid for the plate the more his profit. Vertue secured noble patrons, but (as his expressions of dismay at the deaths of the second earl of Oxford and Frederick, Prince of Wales show) he was not very lucky in keeping them; they seemed to die just as his future appeared to be assured.

Vertue lists the rewards of artists from history painters down to enamelers, limners, gold chasers, wood-carvers, frame makers, even coach painters: "all these are fully paid honourd and rewarded for their skill & their works.—but the only unregarded—and unpittyed is the poor copper Engraver." Vertue's elegy for the engraver is accompanied by a careful analysis of the reasons why engraving "is the least profitable—most evidently & certainly"—of the arts (3: 146–47). They all derive from one chief cause: "he is the labourer for

other mens vending or proffit" and therefore "must be contented with low prices and small reward"; and the reason for this is that engraving is a reproductive rather than an original art form. Gerard de Lairesse's *Art of Painting* (1707) expressed the generally accepted view that engraving "respects Painting, as Painting does Nature: For as the latter has Nature for it's Model or Object, which it faithfully imitates with the pencil; so Engraving likewise copies Painting." Its aim was to spread the fame of paintings by the sight as word-of-mouth description does by the ear. Jonathan Richardson, a critic whom Hogarth read and later knew, in 1719 pointed out the inferiority of prints compared with originals: "a sort of works done in such a manner as is not so proper as that whereby paintings or drawings are performed; it not being possible by this to make any thing so excellent as in the others"; the only advantage—the one Hogarth would seize upon—being that "thereby great numbers are produced instead of one, so that the thing comes into many hands; and that at an easy price."[24]

Accuracy of form, tone, and texture, not expressiveness, were the requisites of engraving, and these were only slowly and laboriously achieved with tiny networks of lines. For the reproductive plate the convention was a virtually continuous series of lines, very like the halftone of present-day newspapers. The importance of Marcantonio Raimondi, and to some extent of Lucas van Leyden, in the history of printmaking lies in their method of shading, which could be reduced to an easy representational convention.[25] A wonderfully adaptive technique, this organized linear web was suited to the ability of the average engraver and was learned as a routine. Of course, it also strictly limited any possibility of conveying the engraver's personality. Of the final product, neither the copperplate nor the impression on paper ("a sheet being a small value") carried any intrinsic value. The sheet carried even less than the copperplate since it was "subject to be multiplyd. and consequently more in number so each of less value." Engraving, Vertue argues, is different from all other works of art in that it is never "*exhibitted* to view in fullest perfection" but rather filed away in a cabinet for purposes of reference.

It follows that unlike a painting, "where the work done is rewarded or paid for—at once the value of it," engravings are only valuable in proportion to the quantity sold. They are thus "also subject by workmen the printers. (common Ignorance) to be marr'd or ill printed," and "to be sure the more in number printed. is worse

and worse." With insult added to injury, "the painters allwayes gives [sic] every body to understand. their reputation is rather sulled than illustrated—thro' perhaps their great Vanitys of their own self productions." Finally, the printsellers "squeeze & screw. trick and abuse the reputations of such Engravers—to raise their own fortune by devouring that of the Sculpture-Engravers. who cannot dispose of the necessary numbers of prints from the graved plates" without the printsellers' help.

The print publisher was an entrepreneur who paid men to engrave prints for him, and published and stocked them as if they were pots and pans; he had his own shop where he retailed the prints, and he sold them wholesale to other printshops. The printseller was inevitably interested in exactly repeatable images—hence burs and other irregularities that distinguished one impression from another were polished off; engravings were preferred to etchings because they could better approximate paintings, were more easily standardized, and allowed many more impressions. The print publisher had to have a plate that would continue to produce dividends over a long period of time. These plates represented the most important part of his invested capital; witness the advertisements of print dealers boasting of a new stock of plates purchased from a bankrupt or defunct rival. From the print publisher's point of view there was no room for a contemporary Rembrandt who made original etchings. The "artist" himself was subdivided into the painter who made the painting, the draftsman who copied the painting in black and white for the engraver, and the engraver who rendered the drawing on the copperplate. "The engravings in consequence were not only copies of copies but translations of translations." [26]

The vicissitudes of the engraver's lot and the printseller's trade in these years can be pieced together from Vertue's notes and the newspaper advertisements. The basic changes that took place around the beginning of Hogarth's apprenticeship involved a market for London-based engravers as opposed to total reliance on imported engravings, and a shift from the Netherlands to France as the source for prints, engravers, and engraving style—the same developments already noticed in silver engraving.

When Vertue embarked on his career at the beginning of the century the great Wenceslaus Hollar had been dead for twenty-five years and William Faithorne for ten. Vertue accurately describes the situation as "at a low ebb." Robert White, a portrait engraver, was within

a few years of his death, and Vertue's master, Michiel Vandergucht, was never sought after by Englishmen. Simon Gribelin was the only French engraver of any ability working in England at the time. An engraver of copper as well as silver, with some of the French delicacy of style, Gribelin's most famous works were the *Tent of Darius* after Charles Le Brun (which Hogarth years later used as the basis for his composition of *Garrick as Richard III*) and seven prints after the Raphael Cartoons—the first of a long series of copies of this masterwork. The reason for the "low ebb," Vertue believes, was the continuing wars between France and England, "so violently carry'd on that little or no Correspondence of ye Art of graving, from France hither, [was] brought over, nor no Artist from that part in Several years came over." As a proof he notes that none of the history painters, such as Antonio Verrio and Louis Laguerre, could find an engraver fit to reproduce their designs. The Dutch influence, which would not have served Verrio and Laguerre, nevertheless was felt in a large influx of engravings emphasizing portraiture and domestic scenes. The most important Dutch commission of Queen Anne's reign was the engraving of the Anthony Van Dyck portraits in English collections: Arnold Houbraken came over from Holland to make the drawings, from which Pieter Van Gunst, remaining in Holland, made the engravings—one of which Hogarth later described in *The Analysis of Beauty* as "thoroughly divested of every elegance" (9). Though commissioned long before, they were not finished until after the Peace of Utrecht.

The great subject to be encountered in printshops was Italy—its palaces, gardens, sculptures, and paintings. Travelers who wanted pictures of what they had seen bought them nostalgically in London printshops, and those who had never been out of England wished to know what they had missed. The influence of the Italian Renaissance artists, then of the Dutch, and finally of the French, was disseminated through these reproductive prints. During these years, therefore, the print industry was largely an import business. An individual would buy a lot (often including paintings, which were also usually copies) from one of the great international print centers, Amsterdam or Paris. He would exhibit his prints in a coffeehouse, or sometimes in a private house, and after a week or so conduct an auction. The usual names mentioned included Raphael, Titian, Michelangelo, Rubens, and the Carracci. These prints were invariably advertised as "lately brought from France and Italy" or simply as "by several foreign mas-

ters," "fit," as all of these advertisements say, "for Hall, Stair-Cases, and Closets."[27] There were relatively few retail print dealers, and they most often advertised maps and the like, securing what art prints they carried from the auctions. Those dealers who did advertise illustrative prints seldom mentioned native English works prior to the South Sea Bubble of 1720–1721.

While the engravings of High Renaissance paintings and sculpture were the most sought after, there was also a ready market for the original prints of foreign engravers—Callot, Ostade, Teniers, Rembrandt, and others. One shop that specialized in northern prints was the Anchor, perhaps significantly a bookseller's shop, under the south portico of the Royal Exchange. Such shops, in which the young engraver could find examples of all the current styles of printmaking as well as reproductions of most of the great works in the continental tradition, were the real school of such aspiring young artists as Hogarth.

A word should also be said about the paintings that were to be seen in London. Every week or so an auction was advertised with "original works" said to be by Titian, the Carracci, Pietro da Cortona, Bassano, Viviano, Claude, Salvator Rosa, Gerard Dou, not to mention less plausible names such as Raphael, Michelangelo, Correggio, and Guido Reni. Such paintings were sold at the same coffeehouses as the engravings and came from the same sources. Hogarth thus had an opportunity to see an enormous body of paintings and engravings of the European Renaissance, north and south, and, as his own works indicate, he took advantage of the opportunity. But most of the paintings were obviously copies, at best "school of" or studio works. While introducing him to many forms, motifs, and themes in the great tradition of European art, these pictures must also have demonstrated the sham at the center of the art trade. These copies—indifferently good or bad, painted or engraved—were valued highly, an index of the public's subservience to foreign fashion and lack of interest in native English art.

Because the great majority of engravers depended for their living on this demand for copies, they were often no more than employees of the print publishers. A few engravers (Vertue was one) advertised, and presumably sold, their own work at their own shops, but their profits were shared with the printsellers, who offered the main outlet for their wares.

Three landmark engraving projects of the years following the

Peace of Utrecht began with Nicholas Dorigny's engravings of the Raphael Cartoons—a foreigner's copy of an Italian masterpiece that Charles I had secured for the English (fig. 35). The second was Claude Dubosc's engravings of Laguerre's paintings of the *Battles of Marlborough:* a foreigner's engraving of another foreigner's decorations made for an Englishman's house to celebrate great English victories over the French. The concatenation is interesting and reflects a gradual shift toward the English side of the equation. According to Vertue, Dubosc undertook these engravings for printsellers at £80 for each plate, to be completed in two years. Whether this arrangement paralleled Dorigny's is not certain, but it was the usual one until Hogarth published his *Harlot's Progress.* To meet the printseller's deadline, Dubosc was forced to follow Dorigny's lead and bring in other engravers to assist him and share the profits.

A third project was the engraving of Sir James Thornhill's paintings in St. Paul's cupola: an Englishman's paintings in a great English public building (though still largely based on designs of Raphael). The engraving was done by Dubosc and one of his imported engravers, Bernard Baron, with the aid of a young engraver of Hogarth's age, Gerard Vandergucht (son of Vertue's master, he had come as a youth from Antwerp). Vandergucht's early recognition is explained by Vertue's comment that he "became equally forward in Etching and graving after the French manner, as those who were bred there" (6: 188). He was no longer guilty of that stiff approach, so common among the English as well as the Dutch, which Hogarth noticed in Van Gunst's copies of Van Dyck.[28]

Between 1714 and 1720, then, the whole direction of reproductive engraving in England changed: the French style replaced the Dutch, and French engravers came to London to practice their trade with less competition and greater rewards. The engravings that brought recognition were those that accurately reproduced the great paintings in English buildings or collections, again by foreigners—with the one notable exception of Thornhill.

The style developed by Hogarth, however, owed less to these artists than to the French Berain (already mentioned), Jacques Callot, and Abraham Bosse, all of the seventeenth century. He never developed the light touch of the etchers who transmitted Antoine Watteau's paintings and drawings in the 1720s, let alone the mastery of tone and texture of the reproductive engravers. When he finally felt

that he needed the latter, in the 1740s, he hired them away from Paris to engrave his *Marriage A-la-mode* paintings for him.

Vertue stresses that engraving "requires much Labour study juvinile strenght & sight, to arrive at any excellence" (6: 184), and Hogarth later admitted that he had not had this careful training early enough. Etching, on the other hand, could be mastered with less experience, great speed, and far less expense. All that was needed, one source notes, was "*Imprimis,* a bottle of aquafortis, being the only kind of spiritous liquor not drunk and sold at Abridge. 2dly, a burnisher, 3dly, some soft varnish for stopping up. 4thly, and lastly a hand-vice, to melt off the varnish. . . . All these materials ought honestly not to cost you more than 10*s.*"[29] But it was also to avoid the stigma of being a mere copyist, and because his natural talent lay this way, that Hogarth focused from the beginning on etching. The first noticeable influence was Jacques Callot, a professional etcher, not a painter who also etched or a copyist of paintings by others. Callot not only produced the small, lively genre works that appealed to Hogarth, but also offered a solution to the etcher who must pass as an engraver. Callot achieved the effect of engraving by using a specially designed etching point, the *échoppe* (which he may have invented), and by occasionally applying an engraving tool to the etched line while the etching ground was still on the plate.

It was probably from Abraham Bosse, who wrote the first technical treatise on engraving and etching, that Hogarth learned the secret of Callot's swelling and diminishing line. William Faithorne, whose translation Hogarth would have read, explains that to make an etching look like an engraving the artist must employ deep biting on the important lines ("wherein the *Aqua fortis* eats in full and deep") and in some cases add pressure on the needle so as to cut through the varnish into the plate itself. He reproduces a plate showing heavy scoring in the foreground which, though etched, could pass for engraved lines.[30]

Hogarth attempted this method at the very outset of his career in his small illustrations for Samuel Butler's *Hudibras* with unsatisfactory, or at any rate different, results (fig. 9). The heavy lines were too deeply bitten, the contrast too great between the "engraved" and the etched lines. By the time he made the illustrations for Beaver's *Roman Military Punishments* (published in 1725; figs. 10, 11), however, he was able to produce a respectable imitation of Callot's *Misères de la*

guerre (figs. 17, 18). Something of the mannerist forms that were peculiar to Callot—long thin bodies tapering up to minute heads—appears here, but Hogarth could not, or did not wish to, duplicate the graceful, overstylized swell that Callot achieved with this *échoppe;* his lines and his forms are blunter and flatter. The small bookplates made a few years later for his friend George Lambert and for a member of the Paulet family reflect a more mature, personal use of the Callot style, and these are pure etchings with no attempt at an illusion of engraving.

In the works where sustained reproduction, repetition, and the appearance of an engraving were required, he again followed Bosse, who explains in his treatise on engraving the way etching can be used for the preliminary work on a plate, which can then be finished with an engraving tool—a time- and labor-saving device that by Hogarth's day was in common use among engravers (Vertue notes that Vandergucht, Dubosc, and Baron employed it). Hogarth first utilized this method with success on a large plate with his *Lottery* (1724) and his second set of *Hudibras* plates (1726). He continued, however, to leave sizable areas of white exposed. Not until the end of the decade and *Henry the Eighth and Anne Boleyn* (ca. 1728) did he completely fill the plate with the engraved system of lines, imitating the tonalities of a painting. Before the *Harlot's Progress* (1732), at any rate, he was consciously attempting to produce independent prints, and not to reproduce a work in another medium.

EARLY CARDS AND BOOK ILLUSTRATIONS

When Hogarth set himself up as an engraver in 1720, he doubtless accepted any commission that would earn enough to support him. While continuing to do the same silver engraving he had done for Gamble, he also turned out ephemeral announcements and business cards, such as those for the actor James Spiller and the undertaker Humphrey Drew. His own mark is already on these prints. Not only does he enliven them with humanizing and incongruous detail, but he introduces the first of many references to prisons—a debtors' prison and the instruments of punishment for debt, here transferred to the spendthrift actor Spiller (fig. 12). This is an emblematic work in which realistic figures are displayed alongside allegorical and ideal-

ized ones, amid contemporary buildings and explanatory inscriptions. In the ticket for Spiller he represents a commonplace world of a spendthrift and duns, a tavern and a debtors' prison, tailors' and tavern bills, but he places it in an emblematic context with a huge pair of scales topped by Fortune and her wheel and a pyre being built around Spiller's feet for an auto-da-fé.

There had been a British auto-da-fé as recently as 1697 in Edinburgh—a medical student named Thomas Aikenhead was burnt for denying the Trinity and the authority of Scripture—and in London the Deist John Toland was compared to Aikenhead. One wonders if this had anything to do with Hogarth's representation of Spiller. In the context of Richard Hogarth and his coffeehouse, Toland was another young man who came down from the north to make his way in London as a tutor and man of letters. His *Christianity Not Mysterious,* written in the ambience of the Grecian Coffeehouse and published as soon as the Licensing Act lapsed in 1695, was a great succès de scandale. Toland, an ambitious man, made the mistake of attaching his name to a later edition, thus exposing himself to persecution.[31]

Three modes—the emblematic, the reportorial, and the droll—are established at the outset of Hogarth's career, perhaps learned from the current influx of Bubble satires from the Netherlands (see Chap. 3). His first effort at book illustration seems to have been the seventeen small illustrations he made for Samuel Butler's *Hudibras.* That they are very early is suggested by their being copied and by the uncertain use of the etching-engraving combination, in contrast with his mastery of the technique in works published in 1724. They were either made on spec or commissioned and rejected. Though an improvement on the illustrations he copied from an edition of 1709, they were coarse compared to Vandergucht's fluent engravings of the same period. They were at length sold and published in 1726, after Hogarth had successfully published his larger, much more elaborate series of *Hudibras* plates. It is significant that he begins, however tentatively, with a homage to Samuel Butler, one of the great English satirists in the tradition that included Dryden, Pope, Swift, and Gay.

The first important commission for book illustrations came early in 1721, for Aubrey de La Motraye's *Travels through Europe, Asia, and into Parts of Africa;* it was advertised for subscription on 2 April (*Daily Courant*) as "adorn'd with Maps, Cuts, and other Representations proper to the Eastern and Northern Nations." The enterprise was also important because it was executed entirely by English artists:

Hogarth, David Lockley, Robert Smith, and George Vertue himself (who mentions the project, 3: 41). They based their plates on the illustrations of the *Recueil de cent estampes représentant différentes nations du Levant tirées sur les tableaux peints d'après nature en 1707 et 1708 par les ordres de Mr. de Ferriol ambassadeur du roi à la Porte et gravées en 1712 et 1713 par les soins de Mr Le Hay* (1715 ed.). They closely copied single figures or small groups from these plates and arranged them in larger compositions (as in *The Greek Dance,* 1: xi, or *The Armenian Marriage,* 1: xix), sometimes combining single figures, sometimes groups, presumably to La Motraye's specifications.[32]

The chief exception was Hogarth, who took only the costumes and created his own poses. For example, in *A Turkish Bath* (1: x, fig. 13), based on "La Fille turque à qui l'on tresse les cheveux au bain" (*Recueil,* pl. 49), Hogarth retains the shell-shaped fountain device on the wall but varies the composition and pose of the two figures undressing the bathing woman: Hogarth's only engraved nude. His changes correspond to the details in La Motraye's text. The *Marriage Procession* (*Recueil,* 1: xv, pl. 100), one of the foldout plates, was copied by Hogarth as to composition, but he varied each group, humanized and enlivened each figure, and replaced the conventionalized background with a realistic one—the latter presumably reflecting La Motraye's firsthand knowledge of the locale.

So in 1722–1723 Hogarth distinguished himself from the other engravers employed on the project by his humanizing and particularizing. He organized and invented to a much greater extent than any of his colleagues in all of the work he contributed. On the other hand, he only put "W. Hogarth invt et Sculpt" on one design, the drawing (attached to one of the maps) of Charles XII at Bender (fig. 14). It is an outdoor composition, showing western soldiers and oriental potentates on horseback, in the general manner of the Laguerre *Battles of Marlborough,* engravings of which had been published in 1717. Charles XII was by this time (as he would be for Samuel Johnson in "The Vanity of Human Wishes") an exemplum of the overreacher who is led to destruction by illusions of military greatness and empire. Among other works, Hogarth might have read Defoe's *History of the Wars, of His Present Majesty, Charles XII, King of Sweden* (1715), which sets the antimilitary theme that Hogarth would develop comically with parodies of the Laguerre sort of composition in his large *Hudibras* plates a year or so later.

The La Motraye plates, with the influence of Bernard Picart's *Céré-*

monies et coutumes religieuses de tous les peuples (published as he was working on the *Travels* plates), are important in Hogarth's development because they gave him a chance to deal with contemporary (though foreign and strange) customs in compositions involving large groups of people in architectural settings or closely reported interiors. Some of Picart's own plates in *Cérémonies et coutumes,* especially in his satiric delineation of Jewish customs, are comparable to the mode Hogarth was now approaching.

The two fat La Motraye volumes, for which he executed at least a dozen plates, were delivered in February 1723/24.[33] Most of the plates were used again for the French edition, but the plates were doubtless paid for outright and Hogarth can have received no more than his original payment.

If there is any truth in them, the stories of his struggle to make ends meet refer to this time. The earliest published anecdote of his life, in the *Public Advertiser*'s obituary of 8 December 1764, is one of these:

> I have heard it from an intimate friend of his, that being one day arrested for so trifling a sum as twenty shillings, and being bailed by one of his friends, in order to be revenged of the woman who arrested him (for it was his landlady,) he drew her picture as ugly as possible, or, as Painters express it, in *caricatura;* and in that single figure gave marks of the dawn of superior genius.

The conclusion is fairly typical. Nichols, who passes the story on two decades later, thinks it may not be true because a friend of Hogarth's once told him that "had such an accident ever happened to him, he would not have failed to talk of it afterwards, as he was always fond of contrasting the necessities of his youth with the affluence of his maturer age."[34] However, if he had been "arrested" (in Nichols's version he was only "distressed to raise so trifling a sum"), Hogarth, who never mentioned his father's arrest and incarceration, may not have wished to recall his own.

On the other hand, he would have stressed his hardships, and another friend remembered hearing him say of himself,

> I remember the time when I have gone moping into the City, with scarce a shilling in my pocket; but as soon as I had received ten guineas there for a plate, I have returned home, put on my sword, and sallied

out again with all the confidence of a man who had ten thousands pounds in his pocket.[35]

The detail of the sword too is significant if we recall the sword affected by the Distressed Poet, the hack who wishes to pass for a gentleman: Hogarth tends to look back on himself with this double focus.

Beyond survival, however, he was determined to rise above the circumstances not only of a goldsmith but of an engraver too; having turned from silver engraving to copper, it now became necessary to study art—to draw "object[s] something like nature instead of the monsters of Heraldry" (AN, 201). To achieve this end, he turned (even before executing *The South Sea Scheme*) to the new art academy opened by John Vanderbank and Louis Cheron in St. Martin's Lane, where a young artist could find instruction in the formal aspects of art which would elevate him above the level of a mere mechanic, and could draw from the life. This was no casual undertaking: he had to be able to afford a two guinea fee and spend a part of his time at the academy and at home working out academic problems that had nothing to do with the day-to-day problems of survival. But in October 1720, in the initial list of subscribers for the new academy, Hogarth's name appears (Vertue, 6: 170).

His first twenty years offered Hogarth a range of possibilities he might choose to exploit; and while developing them to the utmost, he never completely transcended them. He was destined to remain not simply within the geographical confines of London (with only a few trips away, largely unrecorded), but within the limits staked out by the accidents of his life, from coffeehouse to prison, and within the narrow liberties of an apprenticeship to a silver engraver, the assumptions promulgated by the art treatises and portrayed in the wares of printsellers' shops, and the economic supply and demand of the London art market. He tried often to extend these limits, but managed only to push to the furthest boundaries, apparently not wishing or daring to break through. The next phase of his life, leading to *A Harlot's Progress,* is essentially the dual story of his rise to prominence and the evolution of his own characteristic mode out of the talents he possessed and the limits he faced.

3.

"THE BAD TASTE OF THE TOWN," 1720–1724

The years of Hogarth's apprenticeship were politically a time of unrest and widespread dissatisfaction, manifest in disorders ranging from the Jacobite uprising of 1715 to riots and pamphleteering. Into the 1720s the Hanoverian-Whig regime continued to pursue members of the fallen government and citizens suspected of involvement in the uprising of 1715, retained the suspension of Habeas Corpus long after the threat was past, and introduced a "Riot Act" which made participation in public demonstrations a capital offense—all of this in the name of a fear of "Jacobitism." Social protest was in effect equated by the government with Jacobitism.

There were various outlets for the feelings of oppression and exploitation, specifically in social satire directed at the regime. The plebeian (popular) political consciousness utilized the "crowd ritual" with its parodic symbols of government overturned. Popular demonstrations of a subversive nature were synchronized with the public calendar of anniversaries—a favorite being the coincidence of George I's birthday and Restoration Day—and these, even if domesticated from above as a sort of "theater," were used to its own ends by the anti-Whig crowd.

The catastrophic South Sea Bubble of 1720–1721 offered a focus of outrage and an outlet for these feelings of disaffection with the Whig establishment. Moreover, broadsides and prints imported from abroad opened up a particular graphic mode for expressing political symbolism hitherto limited to the crowd rituals. The stage was set for an artist who could utilize the popular imagery in the graphic mode, and at just this moment Hogarth emerged with a genius for

comic representation and a mastery of both popular political symbolism and the imagery and sophisticated iconography of high art. The timing could not have been better for this particular artist. He might have risen gradually through competent book illustration and other engraving-to-order, but he preferred to gamble on attracting the attention of the general public of print-buyers—and indeed, as it happened, he helped to *create* it.

The spring and summer of 1720 unfolded before his eyes the boom and accompanying madness of the South Sea Bubble. As stock values rose, so did the number of buyers who thronged Exchange Alley and the number of schemes floated in the wake of the South Sea Company, which had shouldered aside the Bank of England, assumed the national debt, and become a powerful political force. The rage for speculation had begun in Paris, with the Scotsman John Law's Mississippi Company (and Bubble), and then from Amsterdam, which enjoyed a greater freedom of the press, came a great outpouring of graphic satires which began to reach London in the spring of 1720. When the English Bubble burst during the autumn, these satires were rapidly copied and adapted, the verses and the allusions translated into English.[1]

The situation itself was new and inspiring for an artist of Hogarth's imagination. The public was obsessed with money—more specifically with the notion of acquiring pieces of paper (stocks in the South Sea Company, but also in numerous other companies) months before payment was due and gambling on vast increases of nominal value in the interim. The "South Sea" Company itself represented a dream of bringing the treasures of South America to London. Fortunes were being made in the summer of 1720. The painter Sir James Thornhill, whom Hogarth was soon to meet, was decorating a luxurious house for Robert Knight, the cashier of the company, and on 27 June he sold £2000 of South Sea stock on the Exchange.[2] Everyone was buying and selling and buying again, expecting the stock values to continue rising. The nobility, including some closest to the crown, were among the most deeply involved.

In August the market began to fall. Ominously, as summer came to a close the plague was ravaging southern France. Supposedly transmitted by dockers unloading a merchant vessel in Marseilles harbor, the plague was interpreted by the superstitious as a divine judgment on their materialism. In early September English investors first began to fear that the price of stocks might continue to fall,

though on the 8th the South Sea Company was still putting on a great show of confidence. A few days later it was evident to many that fortunes were being swallowed. People who had bought stock at £1000 for October delivery were watching prices fall below £600. As panic grew in September and October the king remained in Hanover, and this further shook public confidence. There were rumors of a Jacobite coup. The plague continued to move northward in France along with talk of God's judgment.

October, November, and December saw an unparalleled economic confusion in England. New mansions and ships stood half-built, and the luxury trades of tailoring, watchmaking, and not least silversmithing and engraving suffered as orders were canceled or forfeited. In November George I finally returned from Hanover, but the Bank of England still refused to intervene for its rival and the opening of Parliament was deferred a fortnight. When Parliament convened in December a coalition of Whigs and Tories pressed for a Committee of Inquiry. The committee met in January and interrogated the company cashier Knight, who thereupon fled to France. At that point panic broke out, first in the House of Commons and then throughout England. If it had all seemed a horrible accident before, now the suspicion of malfeasance was emerging. Death—natural or by suicide—and disgrace followed within the next few months for several of the principals, including the king's chief minister, with rumors extending the blame to a royal mistress, the Prince of Wales, and possibly even the monarch himself.

What Hogarth saw, from the vantage of his precarious career as a young engraver, was the quick rise and fall of people unrelated to labor or talent, a phenomenon especially piquant to him in the light of his father's recent failure and death. It probably was not lost on him that the South Sea Company's bid for preeminence had come when in 1719 it had offered to settle the national debt by converting it in the form of annuities into South Sea stock.

He also saw the influx of emblematic political satires from Amsterdam which served the same function as the migration of the Huguenot silversmiths and reproductive engravers: they set English engravers first to copying and then to inventing their own versions, the ultimate consequence of which was an indigenous tradition of graphic satire. The craze for speculation was imaged in the satires by bubbles, clouds, and wings that correspond to heavenward flight. The wheel of fortune appears prominently. The setting is a contem-

porary street (the rue Quincampoix or its London equivalent, Exchange Alley) in which reality and illusion are juxtaposed. Delusions of grandeur are brought down to earth and closely observed contemporaries are led about by allegorical figures of Fortune and Folly.

This was a mode for which, to judge by his experience with the "Monsters of Heraldry" and the stories of his early talent for catching likenesses, Hogarth already knew himself to be equipped; he would have seen as a challenge the rather crude stuff that was coming in from the Continent. Moreover, besides the terms set up by the flood of prose, verse, and graphic satires, he had a working knowledge of the great English satires, primarily mock-epics or travesties, of Butler, Dryden, Swift, Pope, and Gay. These had developed from the satires linking politics, religion, and art in the 1680s to the more refined social satire of Pope's *Rape of the Lock* and, most immediately relevant, Gay's *Shepherd's Week* and *Trivia* between 1712 and 1716. *Trivia* in particular—focusing on London and its popular pleasures and diversions versus the ideal world of high art and Burlingtonian patronage—served as the literary model for Hogarth's graphic satires of the 1720s. The basic principle of this satire was mock-heroic, or the juxtaposition of an ideal literary form in the past (epic, georgic, pastoral) with the decadent actions of contemporaries, often lowborn but sometimes also highborn.

Hogarth's *South Sea Scheme,* an ambitious (8 × 12 in., fig. 15) retrospect of the events of 1720–1721, was the one original Bubble print by an English artist. His graphic sources are obvious. He derives its elaborate architectural setting and mixture of real and allegorical figures, as well as its figural style, from the Dutch satires. The closest model among the many Bubble prints was Bernard Picart's elegantly drawn *Monument Dedicated to Posterity in Commemoration of yᵉ Incredible Folly Transacted in the Year 1720* (fig. 16). Hogarth's general composition may have originated here, including the gambling group at the left and the motif of the wheel of fortune. Characteristically, his perspective is shaky: each building has its own vanishing point; the false perspective, however, gives a surrealist autonomy to each structure that images the speculating principle of every man for himself. In this stagelike but chaotic setting Hogarth has arranged groups of figures, in about the same relation to the architecture as the figures in many Dutch prints but drawn with a firmer line (the influence of Jacques Callot is apparent) and with a much greater sense of grotesque individuality.

He has placed the Guildhall at one side, the London Fire Monument at the other, with St. Paul's Cathedral almost hidden behind the Monument. All three are historic structures, normative symbols, of church and state. The Monument, inscribed as erected in memory of the destruction of the City by the Great Fire in 1666 by the Roman Catholics, has been reinscribed: "THIS MONUMENT WAS ERECTED IN MEMORY OF THE DESTRUCTION OF THIS CITY BY THE SOUTH SEA IN 1720," words that serve as an emblem of the usurpation of religious by financial interests.[3] For one clergyman rides the South Sea merry-go-round and a second lends his authority to the breaking of Honesty on the wheel (of fortune), and three others—Jew, Quaker, and Catholic—crouch with their backs to the "flocks" that call for their attention.[4] In a perversion of religious ritual, they play pitch-and-toss under the porch of the Guildhall, far from the nearest church.

Hogarth may have read the Bubble poems of the Scottish satiric poet (and later the dedicatee of *Hudibras*) Allan Ramsay, especially "The Rise and Fall of Stocks in 1720: An Epistle to Lord Ramsay," in which "Clergy, and lawyers, and physicians, / Mechanics, merchants, and musicians" are all presented, with the clergy singled out because "Some reverend brethren left their flocks, / And sank their stipends in the stocks." Hogarth's image of the gambling clergymen is accompanied by his own couplet: "Thus when the Sheepherds are at play, / Their flocks must surely go Astray." The clergy figured as a chief villain in many South Sea satires, visual and verbal.[5] The names of important clergymen were to be found in the subscription lists of South Sea stock (the archbishop of York had invested £1000). Their presence implies the *absence* of a civil authority. The government is (discretely or ironically) out of sight, while the clergy have accepted the stockjobber's business ethos concerned with profit regardless of moral or patriotic duty.

The South Sea Scheme introduces in its simple emblematic form motifs of the South Sea satires which will play their part ten years later in the genesis of *A Harlot's Progress*.[6] One is the clergyman, who is satirized in Plates 1, 2, and 6. Another is the association of both the clergy and the excitement of financial speculation with sexual stimulation: Hogarth gives the merry-go-round a goat as its finial and the punning inscription, "Who'l Ride." The two "riders" on the left are a whore and a clergyman; she is chucking him under the chin and carries a bundle of switches for stimulating jaded lechers. The

employments of a prostitute and a stockjobber were equated, for example, in the lines of one satire: "What I gain in my good Calling / By rising things, I find I lose by falling."[7] The conjunction of whore, clergyman, and the great world driven by purely financial desires will reappear in the *Harlot's Progress,* Plates 1 and 6 (and the switches in 3).

In the foreground, a pickpocket serves both as an emblem of the larger thievery taking place and a contrast to the more "respectable" thievery of the South Sea directors and other "great men."[8] The ape wears a gentleman's sword and wraps himself in the cloak of Honour. There are two aspects to this figure: the hypocrite's masking of vice as virtue and the poor's rogue's emulation of the "great," which will be summed up in the *Harlot's Progress* (especially 2). The real Honour is being whipped, while Honesty is broken on the wheel. For the same newspapers that reported the amassing of huge South Sea fortunes reported soldiers being stripped and publicly flogged in St. James's and Hyde parks for petty theft. Weavers were in desperation attacking their masters and being condemned to transportation.[9] In the same way, the other side of the whore who thrives by the South Sea (the woman on the merry-go-round, the women lined up for a "Raffle for Husbands with Lottery Fortunes") appears in the helpless female figure of Fortune being hacked to pieces and the sleeping figure of Trade.

What distinguishes *The South Sea Scheme* from the simple reportorial-emblematic constructs of the Bubble satires is its clear juxtaposition of an ideal and its corruption. From the scourging of Christ to the clergymen's casting for his robe in the game of pitch-and-toss—even perhaps the Adoration of the Magi in the Quaker's gesture toward the coins being gambled for—Hogarth explores a satiric stratagem that had been elaborately developed in the literary satires of Dryden, Pope, and Swift. Thus the Fire Monument (associated with City business) nearly blots out St. Paul's Cathedral. Even the conventional emblem of the wheel of fortune (depicted by Picart and other Bubble artists) has been transformed first into a merry-go-round, then into a torture instrument: not as two stages in the speculating process but as what happens to the wicked and to the good respectively.

The figures of Honesty and the clergymen recall paintings of the flagellation and the casting for Christ's robe. The merry-go-round specifically recalls Callot's etching *La Pendaison* and the wheel recalls

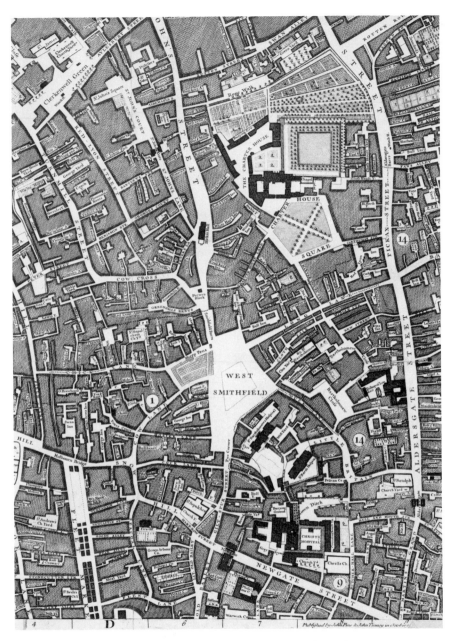

1. The Smithfield area, detail of John Rocque's map of London, 1746 (courtesy of the British Museum, London). At the very bottom (at *D*) is the Fleet Prison, which is continued on fig. 4.

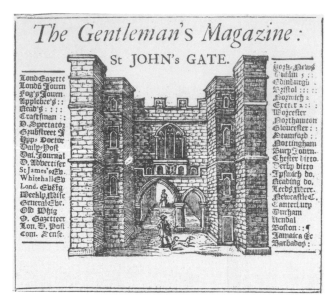

2. Artist unknown, *St. John's Gate* (*Gentleman's Magazine*); woodcut (courtesy of the British Museum, London).

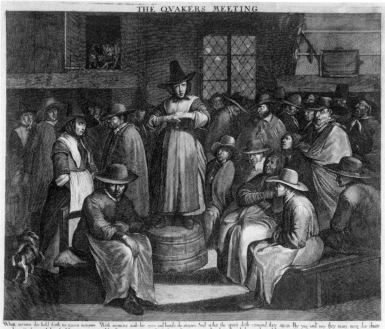

3. Egbert van Heemskirk, *The Quaker Meeting* (engraved by Carel Allardt); date unknown (courtesy of the British Museum, London).

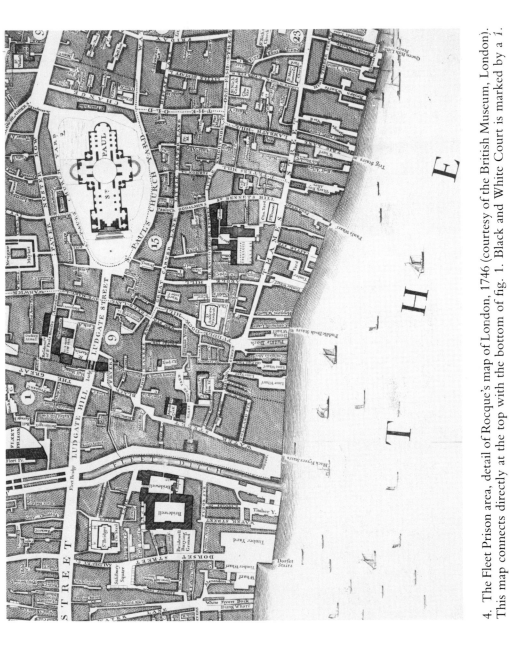

4. The Fleet Prison area, detail of Rocque's map of London, 1746 (courtesy of the British Museum, London). This map connects directly at the top with the bottom of fig. 1. Black and White Court is marked by a 1.

5. *A Rake's Progress,* Pl. 7 (detail); 1735 (courtesy of the British Museum, London).

6. Tatton Arms; engraving on plate; date unknown; 2⅜ in. diam. (courtesy of the British Museum, London).

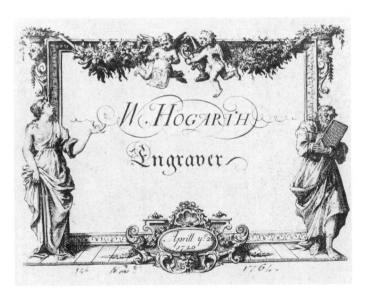

7. Hogarth's Shop Card; 1720; 3 × 3¹⁵⁄₁₆ in. (courtesy of the British Museum, London).

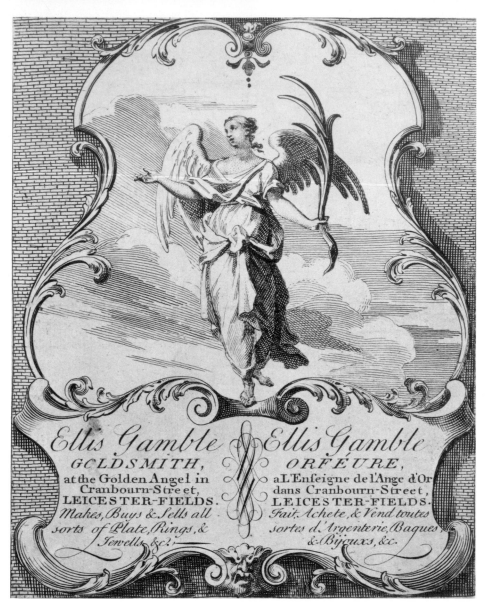

8. Ellis Gamble's Shop Card; ca. 1723–1728; 7⅜ × 5⅞ in. (courtesy of the British Museum, London).

9. *Hudibras's First Adventure* (small plate); executed ca. 1721, publ. 1726; 4½ ×
4¹⁵⁄₁₆ in. (courtesy of the British Museum, London).

10. *Fustigatio*, illustration for Beaver's *Roman Military Punishments;* 1725; 1½ × 2¹³⁄₁₆ in. (courtesy of the British Museum, London).

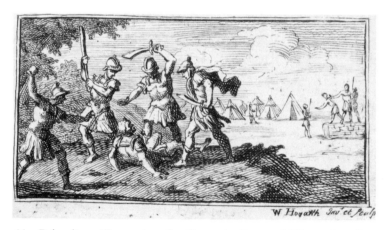

11. *Beheading*, illustration for Beaver's *Roman Military Punishments;* 1725; 1½ × 2¹³⁄₁₆ in. (courtesy of the British Museum, London).

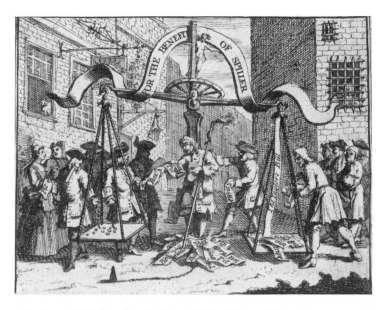

12. Benefit Ticket for Spiller; 1720?; 3⅜ × 4⅜ in. (courtesy of the British Museum, London).

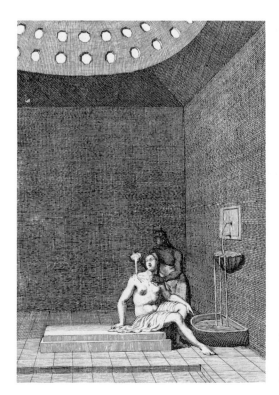

13. *A Turkish Bath* (first state), illustration for La Motraye's *Travels;* 1723/24; 9⅞ × 6¹³⁄₁₆ in. (courtesy of the British Museum, London).

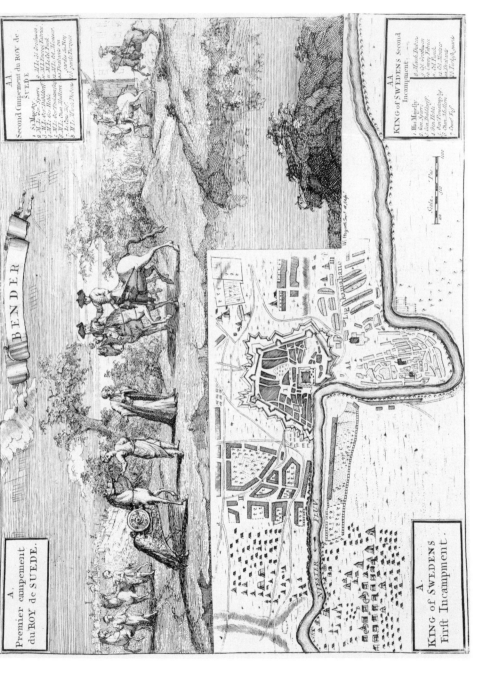

14. *Charles XII at Bender*, illustration for La Motraye's *Travels*; 1723/24; 9¾ × 13⁹⁄₁₆ in. (courtesy of the British Museum, London).

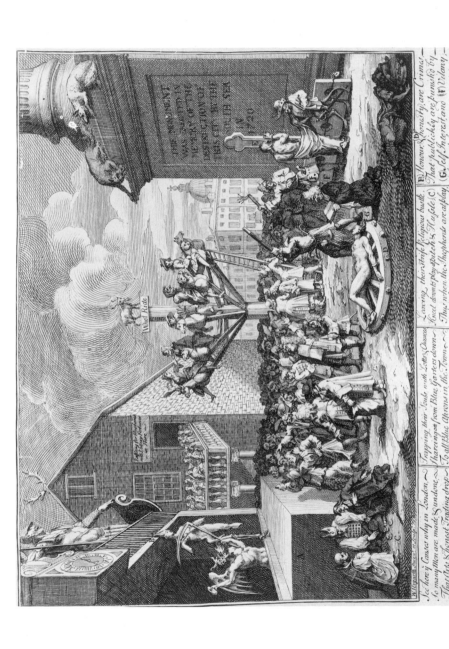

15. *The South Sea Scheme* (first state); 1721; 8¾ × 12½ in. (courtesy of the British Museum, London).

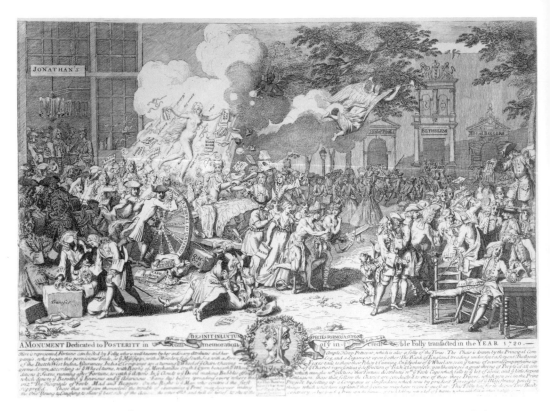

16. Bernard Picart, *A Monument Dedicated to Posterity;* 1720 (courtesy of the British Museum, London).

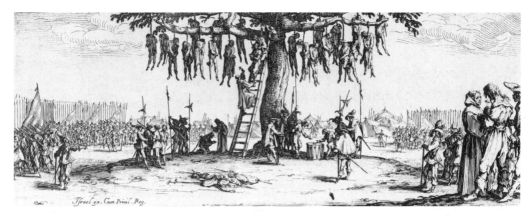

17. Jacques Callot, *La Pendaison,* from *Misères de la guerre;* 1633 (courtesy of the British Museum, London).

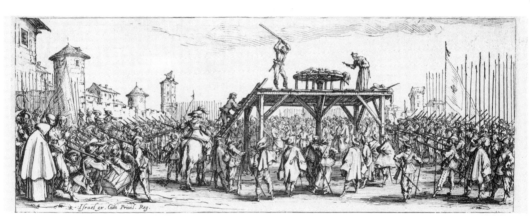

18. Jacques Callot, *La Roue,* from *Misères de la guerre;* 1633 (courtesy of the British Museum, London).

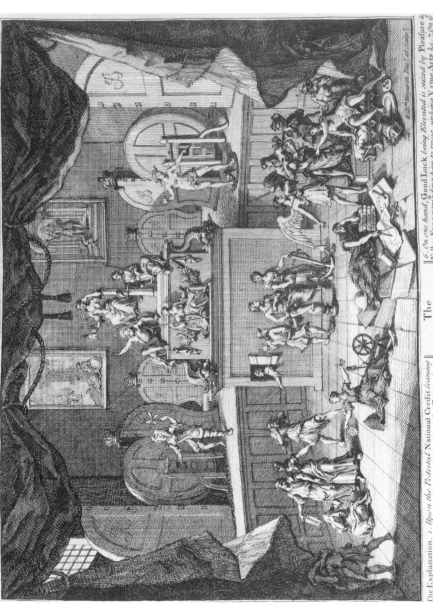

19. *The Lottery* (second state); publ. 1724; 8¹³/₁₆ × 12⅝ in. (courtesy of the British Museum, London).

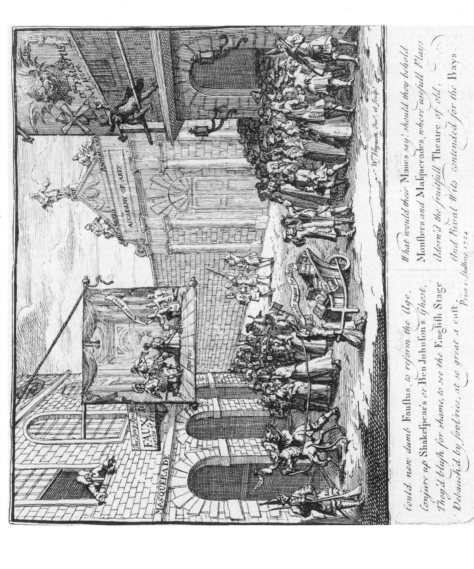

O could new dumb Faustus, to reform the Age,
Conjure up Shakespear's or Ben Johnson's Ghost,
They'd blush for shame, to see the English Stage
Debauch'd by fool'ries, at so great a cost.
 Price 1 Shilling 1724

What would their Manes say? should they behold
Monsters and Masquerades, where useful Plays
Adorn'd the fruitful Theatre of old,
And Rival Wits contended for the Bays.

W. Hogarth Inv.t et Sculp.

20. *Masquerades and Operas* (first state); Feb. 1723/24; 5 × 6¹¹⁄₁₆ in. (courtesy of the British Museum, London).

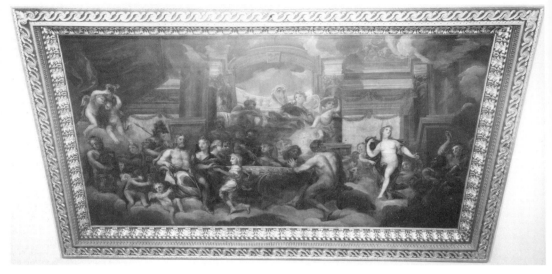

21. William Kent, *Banquet of the Gods;* 1719–1720 (Royal Academy of Arts, London).

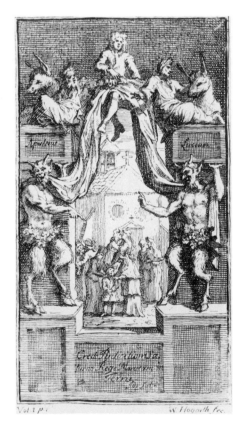

22. Frontispiece, *The New Metamorphosis* (second state); March 1723/24; 5⅜ × 3 in. (courtesy of the British Museum, London).

La Roue (figs. 17, 18) in his *Misères de la guerre*. Both images, unlike the forms and ideas that are borrowed from Picart's print, are graphic allusions. Hogarth expects his viewers to recall Callot's prints and to see this contemporary English scene as another *misère de la guerre*, as Pope expected the reader of *The Rape of the Lock* to recognize the parallels to the *Iliad* and *Paradise Lost*—or Gay expected the reader of *Trivia* to recognize the echoes of Virgil's *Georgics*, the tragedy of Oedipus, and the fall of Troy.

Another characteristic note is struck by Hogarth with the last line of the long explanatory "key" inscribed under the print: "Guess at the Rest you find out more." These words imply added significance (what he will picture in *Boys Peeping at Nature* as beneath the "veil of allegory") and likenesses of contemporaries: both to be *pursued* in a kind of pictorial *hunt* (terms he will use in his *Analysis of Beauty* of 1753). For example, there is good reason to think that the small deformed figure picking a fat man's pocket (emblem of the South Sea Scheme as thievery) is also a likeness of Alexander Pope. The fat man could be John Gay;[10] the build and features correspond to contemporary portraits, and the alphabet slate tied to his waist could refer to an anti-Catholic *chronique scandaleuse* of 1720 in which Pope is said to be Gay's tutor. This work, called *The Life of the Late Celebrated Mrs. Elizabeth Wisebourn, Vulgarly call'd Mother Wybourn*, says of Pope that "his *Form* is the best *Index* of his *Mind;* nor can the Drawings of Sir *Godfrey Kneller*, or [Michael] *Dahl*, give one so just an Idea of the former, as *that it self* does of the latter."[11] Although Pope was rumored to have made money from South Sea investments, the only reason for his picking Gay's pocket would be to steal his poetic ideas. In any case, the poet lining his pockets represents, like the clergymen, an ideal from which the fallible man has fallen away.

Pope was the Great Poet of the time, the object of many satires, including some disinterested ones. Hogarth's inclusion of him was a cheap shot and perhaps only an indication of where he thought his audience lay (unless he was working for an anti-Pope print- or bookseller).[12] But besides expediency, given the later evidence of Hogarth's (and his friend Henry Fielding's) ambivalence toward Pope, the reasons could have been his much-touted financial success, his profits from his *Homer* subscription, his Roman Catholicism, and his supposed Jacobitism.

While Swift (b. 1664) was clearly of his father's generation, Pope (b. 1688) was only ten years older than Hogarth, and while Pope was

by the 1720s the Great Poet of high art, it was because of his transla-
tions of Homer, secondarily because of his *Pastorals, Windsor Forest,
Rape of the Lock,* and *Eloisa to Abelard.* The satires lay ahead. During
the 1720s Hogarth was producing South Sea satires at the same time
as Swift; between *Trivia* in 1716 and *The Beggar's Opera* in 1728—the
two crucial literary works for him—Hogarth developed a satire, em-
blematic but also relying on allusion and mock-heroic analogy,
which prefigured, possibly even contributed to, that of Pope's *Dun-
ciad* (1728). He responded to *Gulliver's Travels* with his own graphic
commentary (fig. 55); he participated in the *Craftsman*'s Scriblerian
war against Walpole; and after 1728 departed from this emblematic
satire in favor of narrative. In the 1720s when Pope was moving from
the emblematic satire of *The Dunciad* to a conversational (a more
naturalistic) mode that passed for Horatian epistles, Hogarth was
developing the "modern moral subject" that passed for a history
painting.

It is not clear whether Hogarth tried to sell the print of *The South Sea
Scheme* or even finished it before it lost its immediate topicality. Im-
pressions survive that are signed and priced but without a publication
line or an address. Whatever his luck in 1721, he sold it in 1724, along
with *The Lottery* (fig. 19), a print of the same size, to the printsellers
Mrs. Chilcott and R. Caldwell, who put their names on both. From
the absence of a publication line on the first states, it seems likely that
Hogarth attempted to sell *The South Sea Scheme*—and then both
prints—from his own shop.[13] This attempt may have followed the
resoundingly successful publication earlier in the year of a third sat-
ire, which he called "The Bad Taste of the Town" (fig. 20), and the
fact that the South Sea Bubble still remained topical in antiministerial
satire. The South Sea satires, and the South Sea imagery of bubbles,
masquerades, and legerdemain, continued to be invoked during the
heyday of Walpole, partly because of Sir Robert's financial expertise
and partly because he had risen to power as the political "Screen" that
protected from prosecution the highest-ranking malefactors in the
scandal.[14]

The size and detail alone of the *South Sea Scheme* and *Lottery* prints
suggest that with these two Hogarth was making a bid for attention.
As with *Masquerades and Operas,* he succeeded in attracting attention

but not in making a financial profit, which went largely to the printsellers.

In conception and execution, however, there is a marked difference between the *The South Sea Scheme* and *The Lottery*. Drawings survive for both, one plainly before and the other after Hogarth had learned the "academic" style in Vanderbank's academy. The prints themselves reflect different modes, the first disorderly and vitalized by the anarchic energy of the London crowd, modeled not only on such South Sea prints as Picart's *Monument Dedicated to Posterity* but on Dutch genre scenes, ranging from packed interiors to Kermises. *The South Sea Scheme* represents the life of contemporary London, with recognizable likenesses, but it mixes (as in the mock-heroic of Gay) genre subjects with allegory and allusions to religious iconography of the sort found in North European painting (the crucifixion, the flagellation, the casting of lots). The Dutch style—with its reputation as the industrious "aping" of everyday life—was of course appropriate to the "Dutch" obsession with trade Hogarth saw unfolding in 1720. It satisfied decorum in the same way as the parodies of a Deist or a dissenting preacher in Swift's satires.

The second print, *The Lottery,* is based on Raphael's *Disputa* and *School of Athens* and the idealization of High Renaissance history painting. The allegory and the allusions are classical. The Dutch emblematic and the Italian allegorical were the two successive modes that Hogarth attempted in various ways to join over the next decade and that came together in the merging of biblical and classical allusions first in *Hudibras* and then, definitively, in *A Harlot's Progress.*

Although the image of a lottery recalls the South Sea satires, the print aspires to a higher level, evoking the *Spectator*'s dream visions, in particular the one in No. 3 (3 Mar. 1710/11) which allegorized England's financial revolution and from which Hogarth may have taken his image of National Credit as "a beautiful Virgin, seated on a Throne of Gold." His Credit, like Addison's, has the attributes of Fortuna; the setting predicates chance and radical change (from rich to poor, from glowing health to drooping illness). So while she seems to be a presiding deity of order, she contains within herself—within the dubious entity Credit—the flux that was the South Sea Bubble, here assuming the form of a national lottery.

But Hogarth's most striking change is from the ideal of the New Testament Christ to the classical Hercules. The Choice of Hercules is

played out at least three times within the general composition of Raphael's *School of Athens*. Most literally, the figures at the right of Good Luck between Fame (the Virtue figure) and Pleasure-Folly directly quote the third earl of Shaftesbury's frontispiece to his *Notion of the Historical Draught or Tablature of the Judgment of Hercules* (1714; fig. 102).[15] Pleasure is in the supine pose recommended to the history painter by Shaftesbury, with the appurtenances he suggests: "certain vases, and other pieces of embossed plate, wrought in the figures of satyrs, fauns, and bacchanals . . . and certain draperies thrown carelessly on the ground." Hogarth's modifications already anticipate the first plate of *A Harlot's Progress:* he materializes the satyr and adds the figure of Folly, pitting three agents of Pleasure against the single reasoning figure of Fame. (Another characteristic touch is his inclusion of a mask; as *Harlot* 2 shows, masquerades are one aspect of pleasure seeking in all of his cycles.) On the left side of the print "Misfortune opprest by Grief, Minerva supporting him points to the Sweets of Industry" amounts to the same, as does the central group of "Suspense turn'd to & fro by Hope & Fear." Again the Virtue figure is associated with wisdom (here the Minerva–Athena figure recommended by Shaftesbury) and the alternative is supine and passive. The print is virtually constructed of such pairings. On the platform Credit herself is flanked by figures of good and evil, Wantonness drawing the number and Fortune drawing a blank from the lottery wheel.

Among other things, these two prints remind us of Hogarth's sympathy for the Dutch mode but his awareness by 1724 (now that he was studying "art") that the proper mode was Italian—and yet, as "The Bad Taste of the Town" of the same year showed, he distrusts the Italianate, operatic, allegorical mode and seldom fits it into his work except as parody.

"THE BAD TASTE OF THE TOWN"

In February 1723/24 Hogarth published a more modest print, referred to in the papers as "The Bad Taste of the Town" (5 × 6 in., now generally called *Masquerades and Operas,* fig. 20), which proved a great success, being eagerly bought up, pirated, and copied.[16] The subject was not politics but "taste," catching by analogy not only

masquerades, operas, and pantomimes, the spectrum of middle to low entertainments, but Burlington House, the citadel of the Palladian style in architecture and the Italianate in painting: not only citizens but connoisseurs.

Hogarth may have felt he was responding to a letter to the *Spectator* which asked: "I wish, Sir, you would do us the Favour to animadvert frequently upon the false Taste the Town is in, with Relation to Plays as well as operas" (No. 22); and again: "I would wish you would take some other Opportunity to express further the Corrupt Taste the Age is run into . . ." (No. 140). Hogarth's title grew out of a nexus of references to "taste" in the *Spectator*: popular theater and the opera "only compl[y] with the wretched Taste of [their] audience" (No. 13).

The *Spectator* (1711–1714, but constantly reprinted) was the source, or at least the shaping influence, of many of Hogarth's ideas. He accepted the general position on art that Addison expressed in No. 5:

> An Opera may be allowed to be extravagantly lavish in its Decorations, as its only Design is to gratify the Senses, and keep up an indolent Attention in the Audience. Common Sense however requires, that there should be nothing in the Scenes and Machines which may appear Childish and Absurd.

"Common Sense" and "requires" are the operative words and represent the *Spectator*'s aesthetic standard. How laughable, for example, to see the opera's hero "exposed to a tempest in Robes of Ermin, and sailing in a open Boat upon a Sea of Paste-Board"; or, in No. 18, to listen to music sung in a language no one understands; or, in No. 29, to hear a lover *singing* his billet-doux, including the superscription, alone in a desert accompanied by musical instruments and a chorus. Addison's conclusion in this essay, linking the opera with the other arts, including painting, is that

> Musick, Architecture and Painting, as well as Poetry and Oratory, are to deduce their Laws and Rules from the general Sense and Taste of Mankind, and not from the Principles of those Arts themselves; or in other Words, the Taste is not to conform to the Art, but the Art to the Taste. Musick is not design'd to please only Chromatick Ears, but all that are capable of distinguishing harsh from disagreeable Notes. A Man of an ordinary Ear is a Judge whether a Passion is express'd in proper Sounds, and whether the Melody of those Sounds be more or less pleasing.

Hogarth was still illustrating these sentiments (in particular the last two sentences) in *The Enraged Musician* of 1741. For better or worse, the *Spectator's* simple aesthetic of the primacy of nature over art served Hogarth throughout his career: he tried to ignore convention or rule when it did not stand the test of common sense, and he never trusted the taste of connoisseurs against that of the average man.

In *Masquerades and Operas* Hogarth adds the one commonsense Englishman (a figure utilized by James Gillray in his satires of the 1780s and 1790s): he is plainly from the country, with a rustic staff, set against the intellectual and aristocratic pretensions of the Italianate opera, architecture, and drama. He is, in fact, another anticipation of the young woman who appears in the first plate of *A Harlot's Progress,* fresh from the country but with little hope of survival in the heart of sophistication.

Like the good Englishman he was, Hogarth wanted not theatricality but drama, with plot, speeches, and motives that could be understood. Such formal, disturbingly unreal operatic conventions as the da capo aria were diametrically opposed to his artistic aims; and at the outset of his career the contrast between his desire for "nature" or "life" and the opera's rendition of form is telling.

In the year 1723 he could, like the *Spectator,* measure the operas, puppet shows, pantomimes, masquerades, and other popular amusements against a standard of common sense. Masquerades were topical throughout the 1720s; in 1723, while they were not getting any worse, they were attracting more unfavorable attention. The accusations against masquerades[17] remained much the same as those made by the *Spectator* a decade earlier: "In short, the whole design of this libidinous Assembly seems to terminate in Assignations and Intrigues." By wearing inappropriate costumes and masks, coquettes disguised themselves as Quakers, whores as fine ladies, rakes as Roman senators, and grave politicians as rakes. "The Misfortune of the thing is, that People dress themselves in what they have a mind to be, and not what they are fit for," says Mr. Spectator, also anticipating the theme of *A Harlot's Progress,* which pins down the Harlot's error to a masquerade costume in Plate 2.[18]

Hogarth may have begun his print in December, but the final incentive—the final assurance of its topicality—came on 6 January of the new year, when Bishop Gibson preached the annual sermon before the Societies for the Reformation of Manners, and used the occa-

sion to attack masquerades.[19] He called them the chief of "the various engines contrived by a corrupt generation" to undermine public morality, "being neither better nor worse than an opportunity to say or do there, what virtue, decency and good manners will not permit to be said or done in any other place." They gave both sexes "the freedom of profane discourse, wanton behavior, and lascivious practices without the least fear of being discovered." The court, in lending itself to such designs, he argues, acts as a dangerous model for the rest of the nation. He can envisage masquerades "spreading and growing into a fashionable diversion, which was usually the case of such diversions as were favoured and countenanced by persons of figure and standing, by whom they were generally carried from thence into all parts of the kingdom." Here, as in the *Spectator* attacks, are the implications explored in Hogarth's print and persisting in his later satires.

Masquerades and Operas makes three points: that the high art of Shakespeare is being driven down by a kind of Gresham's Law into low (and for Hogarth this included the Burlingtonians as well as Rich, Fawkes, and Heidegger); that all of these diverse entertainments "of the town," high and low (including whatever goes on inside Burlington House), are one; and that the chief corruption of "taste" is based on emulation of the Burlingtonians.

It was John Jacob Heidegger, the masquerade impresario, who served as the link between masquerades and operas. A Swiss émigré, he came to be associated with an entertainment that had originally come over from France; both lent a foreign cache—and Heidegger had taken over the management of the Haymarket Opera House in 1713 when Owen MacSwiney absconded, leaving the actors unpaid. Realizing that the Italian opera was enjoyed in England only by the cultivated few, he alternated dramatic and operatic productions with subscription balls and masquerades.[20] Notices such as the following—"The Opera House in the Hay-Market is now painting and adorning, not at the Charge of Mr. Heydegger, but of the Royal Academy of Musick"[21]—reiterated that Heidegger, the man who was synonymous with masquerades, was also thought of as running the opera; in fact, they shared the same building. When the Royal Academy of Music, Handel's opera company, was established in 1719, none other than Lord Burlington was the principal sponsor, guaranteeing £1000 toward the £10,000 required. He was an early and con-

tinuing supporter of Handel, who was housed at Burlington House, where he performed private concerts on the harpsichord. Also suggestive of the centralization of foreign and delusionary entertainment in England was the notice that "At the New Theatre, over-against the Opera-House in the Haymarket," the "New Company of Comedians" from France were performing "with Entertainments of Singing and Dancing." Apparently even lotteries were drawn on the stage of the Opera House at this time.

If masquerades and operas constituted one popular source of entertainment, another was the pantomimes performed at Lincoln's Inn Fields Theatre by John Rich, the consummate pantomimist who called himself "Lun." As a serious-minded moralist in the *Spectator* vein, Hogarth must have felt, anticipating Pope in *The Dunciad* of 1728, that the drolls and spectacles of Bartholomew Fair were invading and displacing the classic English theater of the West End. The situation became critical in the autumn of 1723 when Drury Lane, the rival company which specialized in Shakespeare, Jonson, and the classical English dramatists, tried (or was forced by financial pressures) to exploit the popularity of the Lincoln's Inn Fields productions. On 26 November Drury Lane produced *Harlequin Dr. Faustus* (by John Thurmond), and on 20 December Rich replied with *The Necromancer; or, Harlequin Dr. Faustus,* one of his most successful productions, which proceeded to draw people away from Drury Lane to such an extent that the patentees, Colley Cibber, Robert Wilks, and Barton Booth, were in a very bad way before the end of the year. Thus in November and December pantomimes were topics of discussion, and the subject for a satiric print began to emerge in the new popularity of *The Necromancer* and its victory over the serious theater: a subject easily dramatized by showing, as Hogarth does, the plays of Shakespeare, Jonson, and Congreve being carted away from the Lincoln's Inn Theater, where *The Necromancer* is playing.[22]

Another name familiar to Londoners of the 1720s was Isaac Fawkes (or Fawks or Faux), the sleight-of-hand artist. Advertising his "Dexterity of Hand," Fawkes describes his act as follows:

[He] performs his most surprising Tricks by Dexterity of Hand, who far exceeds all that ever show'd in Europe before, with the Cards, &c Corn, Mice, curious India Birds, and Money; and also several curious Fancies different from what has been perform'd before, being entirely

new, which has given Satisfaction to all Persons that have seen him perform.

He also exemplifies the movement of sleight-of-hand entertainments from the fairs to the patrician West End. His summers were spent at the fairs, and his winters consisted of a progress in the direction of Westminster. In 1723 he spent the winter and spring in "the Fore-Room at the French Theatre, over against the Opera-House in the Hay-Market"; in May he removed to a "Great Booth in Upper Moor-fields" and he divided the summer between the fairs; in the autumn he had a booth on Tower Hill. Then on 18 December he was performing in the same building with Heidegger, Handel, and his Italian operas, in the same room as the masquerades; indeed his advertisement announced his times of performances as "beginning every Evening precisely at Five, excepting Tuesday and Saturday, being the Opera Nights, when there will be no Performance at all."[23]

Hogarth at this point may have been reminded of the *Spectator* (No. 31) in which a projector explains that "he had observed the great Trouble and Inconvenience" entailed in going from one show to another in different parts of the town: the puppet shows were in one place, the dancing monkeys in another, and the opera in a third, not to mention the lions, far off in the Tower. His solution—which Hogarth notices is now a *fait accompli*—was to bring them all together in one place in a single opera.[24]

Most of the newspaper accounts of these entertainments are summed up in the *Daily Courant*'s description of the lottery held on the stage of the Opera House—"at which," it is said, "were present a great Appearance of Nobility and Gentry."[25] The Italian opera stars continued to be feted by the English upperclass, much as foreign painters were or (perhaps to Hogarth's mind) such English artists as William Kent who went to foreign countries and came back Italians. Madam Cuzzoni, a paper noted, "is visited and entertained by our Nobility and Gentry [and] is duly receiving valuable presents from them."[26]

Fawkes too was patronized by the great: "On Thursday Night last [7 March 1722/23] his Royal Highness the Prince, and several Noblemen and Gentlemen, went to see the famous Mr. Fawks in the Haymarket, who were extremely well pleas'd with his extraordinary Performance." The refrain is: "for which he has received consider-

able Rewards from the Nobility of this Kingdom who have seen him perform." Thus Fawkes, on a lower level, would have reminded Hogarth of the opera, pantomime, and masquerade and their disguising or distorting of nature celebrated by noble patrons. Fawkes's advertisements, like the one above, often mention his "Rewards from the Nobility," and a notice in a paper for October 1723 reads: "The famous Mr. Fawks, as he modestly stiles himself, has since Bartholomew and Southwark-Fairs, put seven hundred Pounds into the Bank"; and it adds that he "may certainly challenge any Conjuror of the Age to do the like,"[27] extending the satire to bankers, stockjobbers, and politicians.

Fawkes emerges from the papers as a symbol of misdirected patronage and degenerating standards of aristocratic taste. But he also invokes, with his "Trick of raising Money by Legerdemain" as well as his "Mystery," the vocabulary of the South Sea satires. His performing before the great, before Lord Townshend and soon before the king,[28] implicates the great men with ribbons designating the Order of the Garter or the Bath, with their ladies, shoving to get into the pantomime. Royal approval is directly implied by the grenadiers who guard the doors of both theaters. The "£1000" waved by the devil who leads the crowd into the masquerade may refer either to the king's annual grant of that amount to the Royal Academy of Music, or to the Prince of Wales's donation of that amount in support of Heidegger's masquerades.[29]

As well as the magician Fawkes, *The Necromancer; or, Harlequin Dr. Faustus* (on the theater show cloth) recalls how Sir John Blunt and the other South Sea directors had been associated with Faustus and Mephistopheles, with necromancers and conjurers and "monys magick power."[30] Operas, pantomimes, and masquerades were all utilized in the imagery of stockjobbery. The windmill, the Harlequin suspended in the air above the crowd, and even the carting away of wastepaper (which in 1720 had alluded to the worthless South Sea stock) carry the same associations in 1724 as in 1721.[31]

Day by day in the months leading up to the publication of his print Hogarth (and his audience) would have followed in the newspapers the juxtaposition of articles on the South Sea directors (prosecutions, expropriation of their estates) and the triumphal arrival of Cuzzoni from Italy (great enthusiasm "as . . . usual at the Arrival of Foreigners"), or the gambling mania for South Sea stock recalled by the current mania for opera tickets.[32] Recent news of Robert Knight, the

South Sea cashier who had fled to the Continent, is juxtaposed in the newspapers with the financial success of Rich's *Harlequin Doctor Faustus*.[33]

But the title "Bad Taste of the Town" in Hogarth's advertisement puts his emphasis on "Taste": the idea of foreign invasion via the new financial notions coming from France also funneled into the assumptions about foreign art driving out English (with memories also of Juvenal's third satire, in which the last Roman is driven from Rome). If the degeneration of aristocratic taste is one subject, the other is the emulation of this taste by the lower orders, who both ruin themselves accordingly and offer only pale simulacra of their much worse models. And this is the subject that Hogarth will make his own.

The compositions of *Masquerades and Operas* and *South Sea Scheme* are roughly the same: the Guildhall is replaced by the Opera House, Gog and the Devil by Heidegger (the latter appears at the window in the same position as the devil who throws meat—stocks—to the hungry crowd of speculators), the Monument by Lincoln's Inn Fields Theatre, and St. Paul's by Burlington Gate. The last is the most significant substitution because it represents the temple of this secularized cityscape. The crowd that was before wasting its money on worthless financial projects is now wasting its money on cultural projects.

The overarching concern of the print appears in the gate of Burlington House, an Italian palace transplanted to London's West End, and surmounted by a statue of the painter-decorator William Kent, with the figures of Michelangelo and Raphael as slaves at his feet. The implications are that Burlington House is the very citadel of bad taste in London and, as *Pasquin* (No. CIX, 18 Feb.) pointed out in its description of the print, that the door of the "Academy of Arts" is shut. The basic contrast offered by the print is between the open doors of the two theaters, into which people are being lured, and the closed door of the exclusive Burlingtonians. The verses accompanying the earlier state of the print do not mention Burlington Gate; but *Pasquin* No. XCV, being carted away on the wheelbarrow, draws attention to Burlingtonian architecture (this issue attacked the new Palladianism, contrasting mechanical subservience with commonsense approaches to the "orders").

In the second state Hogarth removed *Pasquin* No. XCV and placed an indirect allusion in the concluding line of a new set of verses:

"Good Gods! how great's the gusto of the Age." Any reader of art manuals or the *Spectator* would recognize "gusto" as an art term (sometimes defended, sometimes attacked) designating the fine excess that distinguished great art.[34] By the 1720s the term "taste" itself was part of the Shaftesbury discourse of civic humanism, and this connoisseur's sense of taste is included by the presence of Burlington Gate.

WILLIAM KENT

None of this explanation quite justifies the prominence of William Kent atop Burlington Gate. A fellow member of Vanderbank's academy, where Hogarth must have met him, Kent (twenty years his senior) had spent time in Italy and was patronized by the earl of Burlington. More to the point, he was the man who toppled Sir James Thornhill: appropriately an Englishman but an Italianized one (called "Signior"), who thus embodied the best of both English chauvinism and English reverence for Italy. This formidable man, to whom Hogarth must have taken an instant dislike, came from a poor Yorkshire family who could not support his artistic inclination and so apprenticed him at eighteen to a coach and house painter; at twenty he ran away to London—"without leave, or finishing his apprenticeship." Vertue adds, however, that already he had made friends among the Yorkshire gentry and that he went to London with a contribution from them and letters to the proper people. If he arrived in London around 1704, the following years are undocumented until 1709, when he sailed for Italy, and his path diverged forever from Hogarth's. One wonders what course Hogarth would have followed had he made the trip to Italy when he broke off his apprenticeship. It is certain that he never echoed poor Jonathan Richardson's cry, "would to God however I had seen, or could yet see Italy,"[35] and an Italianate Hogarth is hard to imagine. On the other hand, the experience proved a richly rewarding one for Kent.

In Italy he attracted patrons among the young English gentlemen on their grand tours, and when in 1713 he won the pope's prize for painting (actually, as Vertue notes, "the second prize in the second class"), his friends made sure it was publicized back in England (3: 14). The first great patron to whom he attached himself was the

rich young orphan, Thomas Coke of Norfolk, not yet seventeen and on his grand tour. They appear to have met in the spring of 1714 in Naples, and by June Coke's account books begin to record payments to Kent, who thereafter accompanied Coke's train as an adviser and friend. They parted temporarily in Padua, and Kent returned in October to Rome, there making the most important contact of his career: Richard Boyle, third earl of Burlington.[36]

Burlington, who set out on his grand tour in May 1714, at twenty, was "a good natured pretty gentleman, but in Whig hands," who as he passed through Hanover struck up a friendship with Prince George Lewis which would stand him in good stead when later in the same year that prince succeeded to the English throne.[37] He was a great Yorkshire landowner whose seat, Londesborough, was not far from Kent's birthplace, and he may have been drawn to him accordingly. Kent, however, was ingratiating and ambitious, and Burlington was an aspiring Maecenas in need of tutoring. By November Kent had secured Burlington his first "old master," a *Temptation of St. Anthony* after Annibale Carracci, which was followed in December by a Viviano. In February, Burlington left Rome with a large number of pictures, which probably reflected Kent's taste as well as his own, and included a Domenichino, two Marattas, another Viviano, and a Pietro da Cortona—or whatever passed for these. This was a short tour, and Burlington was back on English soil on 30 April (1715).

Kent carried on in the same happy way for two more years, until the fall of 1719 when Lord Burlington, now an ardent Palladian, returned for his second tour. Again they met, toured, and this time returned to England together, with Kent settling in Burlington House, the earl's new Palladian townhouse in Piccadilly. His patron began immediately to employ him at painting decorations for the house and, as Vertue recalled, "promotted him on all occasions to every thing in his power, to the King, to the Court works, & Courtiers declared him the best History painter—& the first that was a native of this kingdom" (3: 139).

By June 1720, three months before the opening of the St. Martin's Lane Academy, Kent was already "upon y^e greatest works in England," as he wrote to Massingberd, painting historical works for "Lord Burlington, Lord Duck Shandoes [Chandos] and Lord Castlemaine untill I have fix'd these work a little I am afraid shall not be at liberty to [go] into y^e North." By this time he had met his literary

champions Alexander Pope and John Gay, doubtless through Burlington. In 1720 Gay's *Poems on Several Occasions* was published with illustrations by Kent in the Italianate manner; in this instance his shaky draftsmanship was combined, in the frontispiece, with his own engraving—a mistake he was wise enough not to repeat. Gay responded with a fulsome tribute in an "Epistle to Paul Methuen," another patron of artists, attributing to Kent's painting "Titan's strong fire and Guido's softer grace" and recommending that Kent return to Rome and decorate its palaces with his history paintings: "There on the walls let thy labours shine, / And Raphael live again in thy design." Burlington subscribed for fifty copies, partly at least for the sake of Kent. Hogarth was almost certainly a reader of Gay, and must have remembered these lines when he drew *Masquerades and Operas,* showing Kent as "Raphael Secundus."

At the St. Martin's Lane Academy Kent stood out among his peers in his Italianness, his familiarity with the great, his important projects, and his incredible reputation; he was further distinguished, no doubt, by his positive opinions and air of self-importance. The exaggeration of his merit as an artist would have been apparent to one aware of his surprisingly feeble draftsmanship and feebler painting technique. It seems probable that Hogarth took an instant dislike to Kent, long before his career began to threaten Thornhill's.

The parallels between Kent and Hogarth are no less instructive than the contrasts: both were poor boys from the north country and apprentices who failed to complete their apprenticeships. Both were in appearance patently plebeian (Kent fat and florid, Hogarth short and stocky), and in temperament ambitious, self-seeking, and finally not overly scrupulous in achieving their ends. Kent's easy sophistication—his ability to get along with and manipulate the great—was a talent Hogarth never developed, and one he must have regarded with mixed envy and contempt. His dislike of Kent may have contributed to the irritation with foreigners, smoothness, and patronage that remained with him throughout his career, long after his skirmishes with the Yorkshireman.

The Thornhill–Kent confrontation took place in early 1722 when Thornhill asked £800 to decorate the Cube Room in Kensington Palace (part, he felt, of his prerogative as Serjeant Painter), and Kent, underbidding him with £300, was given the job instead. As Vertue wrote, "a mighty mortification fell on Sr James Thornhill." His

prices had proved too high (as in one or two earlier cases); but, Vertue added, "besides the Lord Burlington forwarded Mr Kents Interest as much as layd in his power at Court. & strenuously oppos'd Sr James" (1: 100; 3: 139).

As to the quality of Kent's painting, Vertue describes in some detail the five rooms at Kensington that he eventually decorated and concludes: "all these paintings are so farr short of the like works. done here in England before by Verrio. Cook. Streeter Laguerre. Thornhill. Richi. Pellegrini. &c. in Noblemens houses in Town & Country." The contrast between the history painting of the novice Kent and the great Thornhill was no doubt discussed among the artists of the St. Martin's Lane Academy.

But Hogarth represents the rise of Burlington/Kent in *Masquerades and Operas* according to Thornhill's account (or his own hero-worshipping myth of Thornhill): Burlington's influence got Kent the job, and this was a reflection of the Burlingtonian take-over of the Board of Works and the replacement of Wren's baroque (Wren, Hogarth wrote in the *Analysis of Beauty,* 63, was "the prince of architects") with Burlington's Palladian style. Thornhill's own view, although he continued to reap rewards from his various posts, was that his career was the victim of Burlington's seizure of power. In a petition of 1730 he wrote of himself that, though history painter to George I, "Yet instead of ever receiving one shilling; [he] Has been disgraced and supplanted in his Royall Masters favour and Business by the overbearing power of the late Vice Chamberlain Coke & the present Earle of Burlington by obtaining signs manual privately for others to the great detriment of your petitioner not only in painting for the king's but in all his other business both publick and private." [38]

The myth as a whole had foundation in the earl of Shaftesbury's *Characteristics* (1711) and Colen Campbell's *Vitruvius Britannicus* (1717 ff.), followed in 1718 by Sir Christopher Wren's replacement as surveyor general to H. M. Board of Works by the amateur Palladian William Benson. Shaftesbury's *Characteristics* equated beauty and morality, with the common characteristics a Palladian order, harmony, and proportion. The ideal set forth—which through its popularizer Jonathan Richardson (*Science of a Connoisseur,* 1719) would have a great influence on the English nobility as a whole—was the "man of breeding," the "connoisseur" who knew the "right models" for art, the literature and art of classical antiquity. Then in 1712

Shaftesbury had prefixed to his *Notion of the Historical Draught of the Judgment of Hercules* a polemical "Letter concerning Design" addressed to Lord Somers, which attacked the "models" of Wren's Board of Works. Although it did not get beyond manuscript at the time (publ. 1732), it must have been known to the Whig circle of virtuosi.[39] Shaftesbury foresees a time in the near future when Britain will be "the principal seat of arts," and she must be ready. He recalls how the great English public buildings have "miscarried": "through several reigns we have patiently seen the noblest public buildings perish (if I may say so) under the hand of one single court-architect." And he questions "whether our patience is like to hold much longer."[40] He lumps Vanbrugh with Wren and his school, and as to those graceful church steeps which Hogarth so admired: "it is like we shall see from afar the many spires arising in our great city, with such hasty and sudden growth, as may be the occasion perhaps that our immediate relish shall be hereafter censure, as retaining much of what artists call the Gothic kind." Shaftesbury—a great Whig name—was laying the foundations for a Whig aesthetic to replace what he considered the Tory and baroque aesthetic of Queen Anne's Board of Works; this aesthetic, surmounted with the discourse of civic humanism, gained currency soon after the Whigs assumed power in 1714. Hogarth was not to forget Shaftesbury's principles or his *Judgment of Hercules;* they remained central objects of his parodic imagination.

The first volume of Colen Campbell's *Vitruvius Britannicus* appeared in 1717, arguing that the old baroque style with its "capricious ornaments" was obsolete, and Burlington promptly commissioned Campbell to begin work on Burlington House, ousting the Tory James Gibbs. The interior decoration had been started by the Italians Marco and Sebastiano Ricci on the entrance hall and staircase, but as soon as Kent returned from Italy Burlington set him to work on the ceiling pieces for the apartments to which the staircase led. Thornhill, and later Hogarth, were undoubtedly aware of the large histories Kent (not Thornhill) painted in Burlington House. Besides a *Glorification of Inigo Jones* (the English father of Palladianism), Kent painted a large *Banquet of the Gods* (fig. 21) and an *Assembly of the Gods,* scattered with awkward figures, some of them with large Pellegrini features and others with the long puppetlike bodies of Ricci figures (without their elegance). The *Banquet* looks as if Kent may have drawn upon some antique paintings or reliefs; otherwise his style is

lush Venetian with Sebastiano Ricci's flair reduced to carelessness. The Kent–Burlington kind of history painting may have contributed significantly to Hogarth's rejection of the mythological mode during his crucial years at the academy.[41]

If this was the Thornhill myth, embodied in *Masquerades and Operas* and later Hogarth satires, the facts were more complex. Thornhill had made an arrogantly (or greedily) high bid on decorating the Cube Room, and Kent had offered to decorate the room for a third as much. At that point—Thornhill having put himself in a vulnerable position—Burlington and Thomas Coke, now vice chamberlain, brought their influence to bear; but it was hardly decisive: money was, as was often the case, in short supply.[42] Too late, Thornhill made a counterbid.

Vertue stresses the ganging up of the people Thornhill had offended and threatened by his attempt in 1719, following William Benson's resignation, to seize the surveyorship of the king's Works for himself. Having been appointed History Painter in Ordinary in 1718, he laid claim to architectural patronage as well. His act alarmed Vanbrugh and other architects. He had some chance of success, enjoying the favor of Charles Spencer, third earl of Sunderland, the first lord of the treasury, who controlled the post.[43] Had he been successful, he would have controlled virtually all phases of royal building and patronage—precisely the power Burlington desired for himself. He lost the surveyorship, and when he overbid on the Cube Room commission, his enemies closed in on him.

As to Thornhill's assertion that it was his right as Serjeant Painter to paint the new apartments at Kensington, the Serjeant Painter only repaired old work, did not undertake *new*. A more relevant fact is that his patron Sunderland died in 1722 and at the moment he no longer had a strong advocate at court.

But another fact is also relevant. Thornhill had already begun to shift away from the baroque toward the Palladian style—Kent's kind of Palladian decoration, which subordinated painted walls to architectural frames in which canvases could be subordinated—and he continued to do so in his commission for Benjamin Styles at Moor Park (1725–1727). While he had made his reputation as a painter of huge wall spaces with allegorical scenes and architectural surrounds, he was shifting with the fashion and with his ambitions as an architect. His designs for the Cube Room were essentially the same as

Kent's in that they removed the history from the setting, leaving only architecture, subordinating history to part of a decorative scheme on the way to Robert Adam's complete relegation of it to innocuous decorative insets, subservient to his architectural scheme.[44]

The Thornhill–Kent contretemps may have inspired *Masquerades and Operas*. But the English literary tradition (Shakespeare, Jonson, Congreve) represents the standard against which the false and foreign influences of music, drama, and architecture are judged. And Hogarth's self-identification with the literary is in part because literature enjoyed an independence from private patronage—of the sort he pillories in Burlington House and that he sought to supersede with the sale of his prints *as if* they were books (later subscribed for as if they were Dryden's *Aeneis* or Pope's *Iliad*). Books habitually reached a wider public than Rich's pantomimes, Burlington's Palladian buildings, or Kent's paintings could ever reach (though part of the Burlingtonian hegemony was the result of the wide dissemination of Palladian designs through pattern books).

In *Masquerades and Operas* Hogarth introduced a mode of satire—emblematic, about the decline of the "taste of the town"—which would be elaborately developed in Pope's *Dunciad* and Fielding's farces of the 1730s. The more general events that elicited this response from Hogarth—the politico-economic factors and demands that he succeeded in satisfying to the extent of establishing his reputation as a satirist—include the increase in expendable income, the expansion of pleasure and leisure and above all consumption, as discussed by Neil McKendrick, John Brewer, and J. H. Plumb.[45] The audience created here, and for whom Hogarth made his satire, consisted of those who could feel the superiority of the consumers of high art, the readers of Dryden's Virgil and Pope's Homer, of Newton and Locke, who also understood the satiric models of Swift, Pope, and Gay. But it also—and more significantly for Hogarth—included those irresistibly drawn to emulative consumption, while at the same time burdened with feelings of guilt at the spending, the emulation (inveighed against by both clergymen and moralists), and their own low tastes.

That Hogarth himself fitted into this second category gave him an insight lacking in the work of Pope but emergent in the recent poetry

of Gay (and soon to be fulfilled in his masterpiece, *The Beggar's Opera*). For if from Hogarth's point of view, as from Pope's a few years later in *The Dunciad,* high art was being driven down into low, from another point of view art was being stretched to include a much larger audience, less affluent and more heterogeneous—one not yet claimed by an artist. One side of Hogarth was attracted to this sort of low art, and he sought to capture its audience in his major prints.

As Jack Lindsay reminds us, "Hogarth is not attacking popular shows as such" but only the art patrons who are perverting values through them (26). He utilizes much that he learned from watching Rich's pantomimes, whose style is described by Thomas Davies: "his gesticulation was so perfectly expressive of his meaning, that every motion of his hand or head, or of any part of his body, was a kind of dumb eloquence that was readily understood by the audience." Characteristic of his performance was the interweaving of a "serious representation" of a story from Ovid or Virgil with "a comic fable, consisting chiefly of the courtship of Harlequin and Columbine."[46]

The parody of religious iconography in *The South Sea Scheme* remains in the attitudes of the noblemen on the show cloth who approach Madam Cuzzoni like Magi and in Heidegger's blessing the crowd as if he were a Roman pope. The situation of men offering Cuzzoni money suggests, as in the South Sea satires, a connection between her profession and prostitution: the rise in wealth and social status that followed from her singing recalls the whore who overnight becomes a lady, as the lady (through bad investments) descends as precipitously to being a whore.

Given the Italianate opera, the allusions include a papist reference, which also incriminates Burlington's and Kent's "taste" for Italian, probably "Roman" art. But the religious echoes primarily indicate once again the association of clergy and sexual corruption. The masquerade bishop provocatively chucks his female companion under the chin, recalling the clergyman on the merry-go-round (and anticipating the clergyman in Plate 6 of the *Harlot*).

By connecting art with politics in *Masquerades and Operas* Hogarth attacks the personal problems of his own profession in terms of the acknowledged evil he attacked in *The South Sea Scheme*. But he is also, to judge by his later interest in the hazards of selling prints and paintings, concerned with the common denominator of commercial exploitation and control. The directors of the Royal Academy of

Music, we read in the *London Journal* of 16 February, were paying a 7 percent dividend. All of the cultural operations he depicts were organized, like his own profession, on commercial principles.

THE PRINTSELLERS

Masquerades and Operas was published by 18 February, when *Pasquin* described it approvingly, but within a week the print was so popular it had earned the dubious compliment of a piracy—the first of many in Hogarth's career. On Monday 24 February Hogarth ran an advertisement in the *Daily Courant:*

> N. B. The Original Prints representing the Bad Taste of the Town, are sold at the principal Print-Shops, viz. Mr. Hennekin's, the Corner of Hemming's Row; Mr. Regnier's, in Great Newport-street; Mr. Bolle's [Bowles'], in St. Paul's church-yard; Mr. Gautier's, in the Piazza in Covent-Garden; Mr. Overton's, at the Market; at the Corner of Pall-Mall; at Wm. Hogarth's, the Engraver thereof, at the Golden Ball in Little Newport-street, and no where else. Price 1s. Copies as well done as the present Copies sold at other petty Print-Shops, will be sold for a penny a piece in three Day's Time.

"Original" and the ironic last sentence are Hogarth's reply to the cheap copies already in circulation. Evidently one passing for an original was advertised the very next day, and on Thursday the 27th he replied in the *Daily Courant:*

> On Monday last it advertised that the Original Prints, called the Bad Taste of the Town, to be sold at a Shilling a Piece; this is to confirm it, and to certify it will never be sold for less; and to prevent the Publick's having the Copy impos'd on them at certain Print Shops, by means of a sham Advertisement on Tuesday last. Note, Wm. Hogarth, Inv. et Sculp. is engraved at the Bottom of the Original.

Hogarth's earliest known advertisements, with their barely repressed indignation, already have that directness and vigor which were to characterize all his subsequent notices to his public.

The immediate culprit would appear to have been Thomas Bowles,

who was advertising a pirated copy on 6 March for 6*d,* and was one of those to whom Hogarth had consigned his print for sale. Although Bowles and his younger brother John appear to have been unscrupulous, it should be remembered that prints were merely a commodity to them, that there were no laws protecting the artist, and that their contemporaries included such legendary scoundrels as the bookseller Edmund Curll.

To Hogarth, looking back on his youth, this betrayal by the print-sellers was to constitute one of the important parallels between his life and his father's:

> I found this Tribe as my father left them when he died ⟨which was⟩ about four or five years before this time of Illness occationd by partly the useage he met with from this set of people ⟨and partly by⟩ disa-pointments from great mens Promises. So that I doubly feelt their usage which put me upon publishing on my own account but here again I [met] a monopoly of Printsellers equally distructive to the Inge-nious for the first plate I Published called the Tast of the Town in which the then reigning follies were lashd, had no sooner begun to take run but I found coppies of it in the print [shops] selling for half the price whilst the originals return'd [to] me again in which I [was] obliged to sell my plate [for what] these pyrates pleasd to give me, as there was no place of sale but at their Shops. (AN, 205)

But only a decade after this experience, in 1734, petitioning Parliament for redress, he (or one of his close associates) put it more systematically: the engravers' expenses, labor, and invention could only be rewarded "by the Profits arising to them from the Sale of their Prints; and the Reputation they acquire by them in their Profession; which gradually enhances the Value of what they shall afterwards produce."[47] The situation described is actually much closer, as regards Hogarth, to that of 1724 when he published *Masquerades and Operas* than of 1734 when, a phenomenally successful printmaker, he prepared to publish *A Rake's Progress.*

The artist lacks a house where he can conveniently exhibit or sell his prints, and so he is at the mercy of the printsellers, who form a monopoly, there being perhaps a dozen of note in the whole of London. "Hence it is easy to conceive, how it comes about that they are all agree[d] and stand firmly by one another, in oppressing and keeping in their Power the very Men, without whom their Shops wou'd

soon become unfurnish'd." First, the engraver takes his print to the printseller, who insists "upon a most unreasonable Share of the Profits for selling the Prints, near double what a Bookseller ever demands for publishing a Book. It is in vain for the Artist to remonstrate, or try any other Shop. They are all agreed, and no less is ever to be taken. So of Consequence he must submit."

The next step follows when the printseller discovers that there is a demand for the print. Then he procures cheap copies, which he sells to the ordinary buyer as originals, or sends them to the provinces, where there is less chance to compare them with the originals.

> When the Artist returns to make Enquiry into the Number of his Prints, that are sold, and expects a Return to his Labour and Expence; He is told, with an insolent and careless Air, "His Prints have been copied—The Copies sell as well as the Originals—Very few of his have gone off" and is presented with a large Remainder, which he is forced to take home with him.

Nor is this the end of the artist's misery: "though at first he may complain of [the printseller] wherever he comes, and stand out in Opposition against him, [he] must of necessity at last fall into his unmerciful Hands."

> His Share of the Profits falling so short of the Expence of Time and Money which he was at in the Execution of his Design; he is first driven by his Necessity, and for a present supply, to part with the Original Prints returned upon his Hands, his Plates, and all to these very Men at their own Price; which, you may be sure, will be very low, as they know he has no other Chance of disposing of them.

At this point in the pamphlet Hogarth's own story ends, but the possible fate of the engraver, which he studiously avoided, is projected:

> And soon after, seeing how vain it is to attempt any thing New and Improving, he bids farewel to Accuracy, Expression, Invention, and every thing that sets one Artist above another, and for bare Subsistence enters himself into the Lists of Drugery under these Monopolists; where if he has Strength of Constitution to Work Night and Day, (no matter whether well, or ill,) he may perhaps be able to bring the Week about, but never is suffered to Thrive, or grow Rich, lest he should grow out of their Power.

He thus joins those hacks who engrave the cheap copies for the printseller who originally cheated him.

By 1724 Hogarth had left his mother's house and moved to a room or a floor in a house in Little Newport Street, evidently used as a shop, with the sign of a golden ball. (In April 1720, according to his shop card, he was living and working "Near the Black Bull, Long Lane," that is, in his mother's house. By February 1724 he was "at yᵉ Golden Ball yᵉ Corner of Cranbo[r]ne Alley little Newport Street," according to a later state of the shop card and the advertisement for *Masquerades and Operas*.)[48] He cannot have been very well off. The money, as well as the reputation, from such a plate as *Masquerades and Operas* would have been of the utmost importance to the young artist; the experience undoubtedly contributed to his continued outrage over piracies in the 1730s, and it remained fresh in his mind nearly forty years later when he wrote his autobiographical notes.

But if he did not make the profits he anticipated from his print, he at least brought himself to the attention of the public. Nicholas Amhurst, for one, praised the print in *Pasquin* and in 1726 employed him to make a frontispiece for his collected *Terrae Filius* papers; subsequently, as editor of the *Craftsman,* he may have brought Hogarth's work to the attention of Bolingbroke. On 20 February a prologue spoken at the new theater next to the Opera House in the Haymarket alluded to Hogarth's print and "the Taste of this fantastick Town," and on 4 March when Charles Gildon's *New Metamorphosis* was published, Hogarth's name was in the headline of the advertisement (*Daily Courant*): "Just published, printed in two Pocket Volumes, and adorned with Cutts engraved by Mr. Hogarth."

Gildon's work represented a simple travesty of a classic: it updated Apuleius's *Metamorphoses* replacing the ass by "*a fine* Bologna *Lap-Dog,*" which is more readily "admitted to the Closets, Cabinets, and Bedchambers of the Fair and the Great" than an ass. Gildon's satire had been published in 1708, and Hogarth was apparently employed to copy the plates for that edition and add a few of his own, none of which is very distinguished. His frontispiece (fig. 22), however, is of great interest, especially since it was copied from the anonymous frontispiece of 1708. It presents in one plate the interplay of story and frame, present and past, real and fictional which (very crudely) informs Gildon's fable; this kind of interplay will reappear in Hogarth's

Hudibras frontispiece and, somewhat modified, in much of the work that follows. The frontispiece shows a contemporary scene framed by a windowlike structure; on the viewer's side, two satyrs are pointing to it and indicating its satiric nature (they reflect the popular derivation of satire from satyr). Above the window are the figures of Lucian and Apuleius (authors of the classic stories of Lucius transformed into an ass), each with his ass, and between them is Gildon, who had modernized them. Thus the contemporary story is presented as seen through a window (the draped curtains barely suggest a theatrical effect), with clear reference to its sources and analogues, its satiric intent, its ancient authors, and its modern adapter. All are presented as part of the historical context for the contemporary action with its lapdogs and loose women; the operation of Hogarth's mature compositions, though enormously elaborated, will not be very different.

This illustration, appearing at the same time as *Masquerades and Operas,* announces in its own way Hogarth's aims as a satirist and as a modern. As a satirist he was now a known force on the London scene. He had not only launched his career and experienced pirating, but had also produced a print that was to influence Pope's conception of *The Dunciad* and thereafter a whole stream of satires, culminating in Fielding's dramatic farces. Satire was a form that was much appreciated in the 1720s; Hogarth came upon the scene at just the right moment, when the English satiric tradition had reached its ultimate fruition in the writings of Swift and Pope and prepared the public for a graphic satirist of comparable stature. Hogarth filled that need. As this timing explains something of Hogarth's very rapid rise, so the waning of interest in satire in the 1750s explains something of his realignments in that decade.

4.

A Native English History
Painting

Thornhill and the "English Don Quixote,"
Hudibras, 1720–1726

SIR JAMES THORNHILL

It was, Hogarth remembered in his autobiographical notes, "the Painting of St Pauls and greenwich hospital which were during this time"—the years of his apprenticeship—"running in my head" (AN, 205). Thornhill, the painter of these huge projects, was one of the chief influences of Hogarth's life—on his style of painting as well as of living, a figure against whom he measured himself, and whose image he protected assiduously. In the family Bible he proudly inscribed himself as marrying the "daughter of Sir James Thornhill"; years later when he wrote his notes on the English academies he identified Thornhill as his father-in-law; he probably accepted the serjeant paintership, or at least inscribed the title in his final self-portrait, largely because Thornhill had been Serjeant Painter before him; and if he coveted a knighthood, it was to match Thornhill's.

Even if one takes into account his perspective of over forty years later, by which time he wanted to establish a clear line of succession from Thornhill to himself and needed at the same time to defend Thornhill's diminishing reputation, it is not difficult to see why this artist at the outset became his ideal. Thornhill was a history painter in the grand manner and an Englishman—the living reply to William Aglionby's complaint that "we never had, as yet, any of Note, that was an *English Man,* that pretended to *History-Painting,*" a circum-

stance he attributed to "the little Incouragement" which the art "meets
with in this Nation; whose *Genius* more particularly leads them to
Face-Painting."[1] Most of all, Thornhill's career dramatized for Ho-
garth the success of an indigenous artist in the England of Queen
Anne and the failure (from one point of view at least) of personal pat-
ronage in the England of the Hanovers and Sir Robert Walpole—the
England Hogarth inherited.

It took a particular kind of man, as well as a particular kind of
talent, to win this victory for the English artist. Thornhill was born
in Wollands, Dorset, 25 July 1675 or 1676, a decade after Richard
Hogarth.[2] Thornhill too made the trip to London but was rewarded
with all the success that eluded the elder Hogarth. His situation was,
however, somewhat different: He came from a good family fallen
on evil days; his father had abandoned his family and he was sup-
ported by an uncle.[3] Through family connections he was apprenticed
in 1689 to Thomas Highmore of the Painter-Stainers' Company.
Highmore's official connections, and Thornhill's own assiduity,
brought the young artist into contact with Verrio and Laguerre, the
two most prominent decorative painters of the day. He appears to
have assisted Verrio with the Hampton Court decorations in 1702–
1704. By 1 March 1703/04 he had purchased his freedom of the
Painter-Stainers' Company, and in the same year he received the
commission to decorate Stoke Edith, Herefordshire, followed in
1706 by his decoration of the Sabine Room at Chatsworth and
his painting of *The Fall of Phaeton* on the dome over the adjacent
staircase.

These were important commissions for a young man of thirty-
one, but in 1707 he obtained the greatest history painting commis-
sion in England—the allegory of the Protestant Succession in the
Great Hall at the Royal Naval Hospital in Greenwich. Although
the reason for his being chosen is not certain, probably nationality
and timing were the important factors. He was the only qualified
Englishman available for such an undertaking; Verrio, the obvious
choice, had just died, and it may have seemed a good time to let an
English artist—who had the endorsement of the duke of Devonshire
for his work at Chatsworth—decorate this building commemorating
England's seamen and built by her great architect, Sir Christopher
Wren. It is also likely, considering their later parsimony, that the
governors thought Thornhill would come less dear than Laguerre or
another foreign artist.

The time was ripe for the sort of nationalism that called for an English painter to decorate the great English public buildings; Thornhill seems to have grasped this fact and exploited it. The competition between him and the foreigners is best documented, however, by the second great commission of his career, the cupola of St. Paul's Cathedral.

St. Paul's, unlike the distant Greenwich Hospital, was a part of Hogarth's life from the beginning, easily visible to him from the room over St. John's Gate as it rose above Little Britain. By the autumn of 1708 the dome and both towers were completed. In October the ball and the cross were in place on the lantern and the coppersmith paid, and by early 1709 the governors were seeking an artist to decorate the cupola. The contending artists were, besides Thornhill, the Italians Antonio Pellegrini and Juan-Batiste Catenaro and the Frenchmen Pierre Berchet, Louis Cheron, and Louis Laguerre. According to a tradition recorded in the *Gentleman's Magazine* in 1790, Archbishop Tenison, one of the trustees of the building, was supposed to have said, "I am no judge of painting, but on two articles I think I may insist; first that the painter employed be a Protestant; and secondly that he be an Englishman."[4]

The only English candidate, Thornhill was chosen in June 1715 and was promised £4000 for his work. Another Italian, Sebastiano Ricci, Vertue wrote, "left England" once and for all "when he found it was resolvd Mr. Thornhill shou'd paint the Cupolo of St. Pauls" (1: 39). It was a victory Hogarth would recall in later years as he romanticized Thornhill as the English artist who had carried off the greatest of contemporary commissions, both royal and ecclesiastical.

The stories about Thornhill have to do with his sharp eye for payment, the steep rise in the prices he charged, and the elaborate stratagems he sometimes employed to get his money out of his patrons (in the case of the crusty duchess of Marlborough at Blenheim, his prices led to a complete break and suspension of work). In 1717, for example, he insisted, before starting on the Upper Hall at Greenwich, on further payment for the Lower Hall, for which he felt he had received too little. The adjudication that followed was favorable to Thornhill. He haggled over prices, and it is never quite clear whether in doing so he was standing up for the rights of the English artist or for himself. This ambiguity was later to be identified by some observers in Hogarth's "schemes" (as Vertue called them).

By the end of the decade Thornhill was a public figure of some

prominence. In June 1718 he was appointed History Painter in Ordinary to the king, and in March 1720 Serjeant Painter, replacing his late master, Thomas Highmore. The latter was the post Hogarth would himself hold late in life: it was an honorable and lucrative but unproductive position, carrying with it the prerogative of painting and gilding all His Majesty's residences, coaches, banners, and whatnot, which grossed over £1000 in a good year. But the work itself, for which assistants were employed, involved (as critics were to aver about Hogarth forty years later) no new work but only repairing the old.[5] In May 1720, Thornhill was knighted—the first English-born painter to be so honored. Finally, in October he was installed as master of the Painter-Stainers' Company.[6]

Thornhill's influence at court seems to have come from the powerful Lord Sunderland, perhaps (Vertue claimed) through Thornhill's association with John Huggins, "a noted Soliciter":

> Thornhill being intimate with Huggins and aspireing to Honour & Ambition—greatly got Huggins to propose to Lord Sunderland to get Thornhill Knighted by the King and made his History painter. which this nobleman did procure for Thornhill, who was Knighted by this means and Huggins Solicitation . . . besides his merit distinguishd him as an ingenious history painter & Serjeant Painter to his Majesty— (3: 114)

Huggins had a reputation for cunning, and his administration of the Fleet Prison was to give him an unfortunate notoriety. It is not known exactly what Thornhill had done for Huggins, beyond decorating a ceiling of his country house, Headley Park, though a friendship there certainly was, one extending later to Hogarth, who became an intimate of Huggins's son William.[7] As Vertue points out, merit mixed with intrigue brought about Thornhill's advancement. Unlike Addison and Steele's Captain Sentry, he was willing to add the bit of political oil that made such honors possible.

Thornhill's plan to become an architect had emerged by this time, at least partly because an architect enjoyed more prestige than a painter, dealing in drawings rather than the manual labor of painting. For example, while Thornhill was the first English painter to be knighted, there were plentiful precedents among the architects. Having now all the posts except the surveyorship, he began to do

architectural work of his own: in 1720–1721, he had submitted designs for St. Martin-in-the-Fields and worked on a plan for a bridge across the Thames;[8] and in his painting projects at Greenwich and Moor Park he began to practice painting in the more gentlemanly fashion of delegating authority.

Between 1712 and 1722, Thornhill grossed about £30,000 from his commissions alone, not to mention the income from the serjeant paintership, and he could afford to live as a country squire. In March 1722, having bought back his family estate near Stalbridge, he was returned to the last parliament of George I, representing Weymouth and Melcome Regis (he painted a *Last Supper* in the Weymouth church).[9] On his estate he erected a tall obelisk in honor of George I, visible from all the surrounding countryside, and painted on the ceiling of the drawing room an allegorical representation with his own head in the center.[10] In May 1723 he was elected a fellow of the Royal Society.

The effect of Thornhill's reputation and his works on the impressionable young Hogarth, toiling over silverplate, filling in escutcheons, and then trying to make a living as an engraver, may be conjectured. Until he joined the St. Martin's Lane Academy, and (later) met Thornhill personally, the painter was presumably only a great name and a vague ideal. Nevertheless, the paintings were there for Hogarth to see and absorb. Greenwich's Painted Hall was available when he began his apprenticeship in 1714, and in October 1717 the cupola of St. Paul's could be examined. While he continued work on other parts of the dome, Thornhill had his major designs—the history paintings of St. Paul's life—engraved and sold by subscription. They were engraved by well-known professional engravers (Simondau, Vandergucht, Beauvais, Baron, and Dubosc), the finished plates delivered in May 1720, just a month after Hogarth printed his shop card.

Subscription was a common procedure, which not only enabled such artists as Hogarth to obtain manageable copies of the paintings for study, but also offered a model for the engraving and distribution to a wide public of his own history paintings. He would follow Thornhill's advertisements almost point for point: They are to be "delivered . . . to Subscribers only, no more being to be printed than shall be subscribed for." But Thornhill's subscription was still controlled by the printsellers, whose shops are listed, each of which took

in subscriptions ("at half a Guinea down, and half a Guinea at Delivery," the same terms Hogarth used for his *Harlot's Progress*). "N.B. If any are printed after [i.e., the subscription], not to be sold under 25*s*."[11]

On 2 May 1720, when he was knighted, Thornhill presented a set of the prints to the king, and they were delivered to subscribers on the ninth (Vertue, 1: 65). It is doubtful whether Hogarth could have afforded a set at this time; but a framed set of the prints was among the pictures he kept on the walls of his house long after Thornhill's death.[12]

Thornhill's St. Paul's and Greenwich designs were divided between the biblical and the mythological-allegorical modes. The Greenwich forms were the first to be reflected in Hogarth's engraving, perhaps because they were allied in a way to the popular Dutch emblematic prints that were a part of his professional experience. Just a touch of this world appears in his *South Sea Scheme,* in the figures of Honesty and Honor, isolated among all the grotesque figures that swarm over the plate. It may have been a wish to improve his rendering of the human figure and to understand the allegories of history painting which led him to turn toward academic training; and this offered itself with the opening of the St. Martin's Lane Academy in October 1720.

VANDERBANK'S ACADEMY

When Hogarth joined the academy, he not only came into contact with the world of "serious" art in London, but found himself in the middle of its broils and confusions—a battleground from which he never completely withdrew in the decades following. Thornhill was momentarily out of the picture in the autumn of 1720, which may explain why Hogarth's first contact with the art academies was (according to the available evidence) in St. Martin's Lane. But even a contact with this anti-Thornhill academy was indirectly a contact with the great man.

When the first academy of painting in England was founded in 1711, Thornhill had just returned from his first trip to the Continent. On St. Luke's Day (18 October)—which the English considered an

auspicious moment for the start of painterly projects—a large group of artists met in a house in Great Queen Street, where, as Vertue (a member of the academy) wrote, "formerly many great noblemen had livd. (& once the Land-bank was kept there) but gone to decay and uninhabited."[13] Artists and connoisseurs subscribed at a guinea each and elected Sir Godfrey Kneller governor. Thornhill was elected one of the twelve directors, who included Michael Dahl, Jonathan Richardson, Laguerre, and Pellegrini. The academy was evidently no more than a place where artists could assemble at night to draw or paint from casts or from the life. Following the precedent of Continental academies, connoisseurs were also admitted, and there must have been a large quotient of socializing.

Vertue hints that within two or three years some dissidence arose in the academy, centered in Thornhill and Louis Cheron. Stories have survived of personal difficulties between Thornhill and Kneller—both proud, self-important men. One evening, for example, Kneller discovered the model in an unusual pose and when he questioned Thomas Gibson, who supervised the life class, he learned that Thornhill was using the model and Gibson's drawings for figures he was painting on the ceiling of the Painted Hall. "I see, I see!" Kneller is supposed to have cried. "Mr. Dornhill is a wise man. But if I was Mr. Dornhill I should let Mr. Gibson draw *all* my figures for me."[14] Another story relates that Kneller had decided to employ Thornhill to paint the staircase of his house at Whitton near Twickenham but, when he heard that Thornhill was painting portraits in his spare time, he withdrew the commission and gave it to Laguerre, saying "no portrait painter would decorate his house."[15] The first story reveals Thornhill, the second Kneller; the aging portrait painter and the rising history painter, the last of the great foreign portraitists descended from Van Dyck and the first of the native English painters, were bound to jockey for position.

There are hints of trouble in a letter Kneller wrote in 1713 shortly before the annual election held on the Monday before St. Luke's Day. From this letter to Gibson, in Kneller's almost impenetrably obscure English, it appears that a faction ("some few are out of humour") had attempted to frame new bylaws; and Kneller, having just been informed, was plotting to quell the rebellion. From a second letter it is clear that he secured a majority and retained control of the academy.[16] Thornhill's general plan for reform centered around the hope of secur-

ing royal or governmental backing for the academy. He approached Lord Halifax, who had earlier secured him a commission at Hampton Court.[17]

Worn down by factionalism or by age (he was now 67) Kneller resigned as governor in 1715, and at the meeting the Monday before St. Luke's Day the new governor was elected: according to Vertue, Laguerre was the logical choice, but Thornhill's assiduity, and Laguerre's apathy, secured Thornhill the election. In his letter of acceptance (29 October) he refers to the artists as "a Society, who, if they were as publicly encouraged as in Nations round us, would not fail to do service and credit to our King and Country"—words very like those of the men who forty years later sought a state academy.[18] It is not certain what changes Thornhill brought about, but before long he too came under attack; "Partyes rose against him," as Vertue put it. Hogarth himself recalled this period, doubtless secondhand from Thornhill:

Jealousys arose, parties were found and president [i.e., Thornhill] with all adherents found themselves comically represented in procession all around the walls of the room, the first proprietors soon put a padlock upon the door, the rest as subscribers did the same and thus ended this academy.[19]

Thornhill, "at the head of one party," then set up a new academy in a "place he built at the back of his own house in the piazza" of Covent Garden; both Hogarth and Vertue affirm that this academy was "furnish'd gratis to all that requir'd admition." But, Hogarth adds, so few artists were attracted, or remained, that it soon closed. Vertue suggests more specifically that Cheron (Thornhill's old ally against Kneller) and John Vanderbank, "growing tired with" Thornhill's management of the academy, withdrew. Hogarth writes: "Mr. Vanderbank headed the rebelious party and converted an old ⟨presbyterian⟩ meeting house into an academy upon a footing with the addition of a woman figure to make it the more inviting to subscribers." This was opened in October 1720.

Vanderbank, only three years Hogarth's senior, at seventeen had been a member of Kneller's original academy, and by 1720 was a joint proprietor of the new academy. At the death of his father, John Vanderbank the wealthy tapestry weaver, he inherited £500 in cash; and his leadership in the academy was at least partly due to his financial

contribution, several times the ordinary subscription of two guineas. He was, however, already known as an artist. In 1719 he had painted a portrait of Nicholas Sanderson, professor of mathematics at Cambridge, which was followed by a long succession of stiff, Kneller-like portraits. He attempted a decorative history painting in 1720, on the staircase of No. 11 Bedford Row, which still survives, and was working on a huge (22 by 8 feet) copy of Raphael's *Marriage of Cupid and Psyche*. At the same time he collaborated with Cheron, Parocell, Tillemans, Angelis, and others on the ten paintings of the Life of Charles I, at least one of which (*The Apotheosis of Charles I,* now in a private collection) was his work. So little is yet known about Vanderbank that it is hard to assess his impact on Hogarth, but (as is evident from his *Don Quixote* paintings) it may have been almost as important in its way as Thornhill's. Vertue comments in 1723 on Vanderbank's combination of natural talent ("having never travell'd abroad") and free living, which must have made him an interesting teacher for Hogarth, who also claimed to like his pleasures as well as his studies.[20]

Cheron, the other partner in the academy, was at this time a man of seventy, chiefly noted for his designs for engravers, especially book illustrators—that is, for his talent as a draftsman rather than as a colorist. Vertue especially commends his academy figures and his drawings after Raphael's works in Rome. His coloring in the surviving oil sketches is Venetian and not unlike Thornhill's; his handling too is light and bravura. Vertue adds that "he was of an affable good natur'd temper. very communicative of his Art with a plain open sincerity that made him agreeable & belov'd." And, unlike Vanderbank, he lived "regular & sober. was healthful to his end." He died in May 1725, and his will lists a number of his works to which Hogarth would have had access: a "Galatea of Raphael, a Bacchanalia after Poussin, and Jupiter after Carachio," and his own versions of a *Brazen Serpent, Ecce Homo,* and *Charity.*[21]

The academy was located, as Hogarth noted, in an old Presbyterian meeting house; presumably the building in Peter's Court, just off St. Martin's Lane, that appears in the rate books as "Russell's Meeting House" and was rented by the sculptor Louis-François Roubiliac in the 1740s.[22] It was this academy, a splinter of a splinter, that William Hogarth joined in October 1720, appearing on Vertue's list of original subscribers next to one Alexander Gamble, "enameller," apparently a relative of Ellis Gamble. Hogarth was now twenty-three

years old, only recently out of his apprenticeship, and the subscription fee of two guineas must have worked a hardship on him. Although he apparently came upon the scene too late to have benefited by Thornhill's academy (he would surely have mentioned it), he must have been aware of the advantages to a poor struggling artist of the free room for drawing.

In December, as Vertue put it, they were "at a stand to make & settle orders. For yᵉ propper government of this Accademy of Painting." From Hogarth's later comments on academies, it appears that a group of directors controlled the academy and made all the decisions; and if Vertue's proposals had any effect, or reflected the usual procedure, the directors arranged the drawing sessions, set and disposed the model, and instructed the "young persons." The usual instruction for young persons who wished an academic training was to work backward from standard idealized shapes to shapes in nature, which could then be seen in terms of these idealized shapes—a method distressingly similar to that of the engraver of heraldic arms. The academy separated its young persons from the more experienced artists, and the student began by copying pages from books of eyes, noses, mouths, faces, hands, and feet; then progressed to books that contained outlines of whole bodies of men, women, and children. Vertue is very precise: "after each student has drawn or copied *each* ⟨without omission⟩ of these figures or examples. then to proceed to another degree of Learning" (2: 126, 150–55). Next he copied drawings after statues, and finally casts of actual statues. Only then could he turn to life study.

The model for English academies was the French Academy's school, in which the young artist was set to copying the works of the Old Masters, first in drawing, then in painting; then casts from the antique (the Farnese Hercules, Apollo Belvedere, and so on); and finally from the life. To grasp how ridiculous it must have seemed to Hogarth, one can look at a handbook of 1720, Thomas Page's *Art of Painting,* which demands in its preface that beginners

proceed . . . exactly and in the same Order as the Rules are set down in the Book . . . [i.e.] being perfect in drawing Hands, Feet, and other parts of the Body (making your draught ever more exactly like your Copy before you leave it, and so as you may scarce know one from the other) before you undertake the drawing of Heads; and Heads before you meddle with an whole Figure.

And even when the student reaches the whole figure, proportions are similarly defined: figures are divided into 10 faces, some into 9, 8, or 7. Prophets, prophetesses, and sibyls, for example, are 7 heads high. In all of this, it must be remembered, the student saw neither cast nor living body: he imitated copies of Greek and Italian works, "for they . . . are the perfect Rule of Beauty, and give us a good Gusto, carrying an Air of Divinity in them beyond the rest of the Operations of Mankind"; and "gusto" is repeated over and over as the quality that elevated the Old Masters above mortal painters. Most important perhaps for Hogarth, the face was approached through Le Brun's "Characters of the Passions," copies of copies, reduced to stereotypes;[23] as Page insists, mastery of the face will be achieved "by little and little" "by good Prints and diligent Practice."[24]

The assumption behind this academic procedure was that by the time the student had made all these copies "his taste would have been sufficiently formed by his study of the masters for him to be able to select from the model before him according to taste and reason."[25] But it is evident that Hogarth came to associate the Old Masters with the "classics" of Latin and Greek literature; the rote copying of the one may have fixed in his mind the traditional myths of the other. Copying other men's works, he argued, was like pouring wine out of one vessel into another: there is no increase of quantity and the flavor of the vintage is liable to evaporate. He wished to gather the fruit, press the grapes, and pour out the wine for himself. But he also felt his studies had nothing to do with "nature": "what is copied for example at an academy is not the truth, perhaps far from it, yet the performer is apt to retain his perform'd idea instead of the original." The Medici *Venus* may be a referent against which truth can be judged, but for Hogarth, the eighteenth-century Londoner, it would never be truth itself.[26]

He remembered that at the academy he had begun "copying in the usual way and had learnt by practice to do it with tolerable exactness." Even when he reached the point of drawing from life, with that female nude who was supposed to attract subscribers, he was still taught to copy "a bit at a time"—the eye moving back and forth from sitter to paper, losing the sense of the whole. As we saw above (43–46), instead of copying he "took the short way of getting objects by heart so that wherever he was [he] caut some thing and thus united his studies with his pleasure by this means he was apt [to]

catch momentary actions and expressions"[27]—as opposed to the eternalized ones of the casts and the classically observed and posed models. These he captured, not by what is ordinarily defined as sketches from life, but rather by a shorthand of a few lines from which memory would later supply the rest. The stories of his interest in the way to draw St. George and the Dragon in three lines, or of his sketching faces on his fingernail, give some indication of the system of "visual mnemonics" he developed. Another sign of his method is the paucity of surviving sketches: he tended to rely on mental notations which he developed, perhaps much later, directly in oil. The great majority of the drawings that have survived are studio compositions, preparatory to an engraving. The exceptions are a few life class drawings that appear to serve no purpose beyond demonstrating that he could do as well as the other conventional copiers if he desired, and the occasional candid sketches of such friends as Gabriel Hunt or Ben Read—sketches that were made for their amusement.[28]

If he was in some sense rebelling against the methods used by such teachers as his father in promulgating the classical education, he nevertheless formulated his solution in verbal terms. His aim, he said, was not to copy objects "but rather read the Language of them ⟨and if possible find a grammar to it⟩ and collect and retain a remembrance of what I saw by repeated observations only trying every now and then upon my canvas how far I was advanc'd by that means." The artist must be adept at recording these memories, in order to be prepared when the time comes to use them; otherwise he will be like the man who might "know the words and their meaning and yet never be able to write, lacking the hand to perform."[29]

If one theme Hogarth reiterates in his notes is the verbal quality of his method, the other is the need to have *both* his "studies" and his "pleasures": "if I have acquired anything in my way it has been wholly obtain'd by Observation by which method be where I would with my Eyes open I could have been at my studys so that even my Pleasures became a part of them, and sweetned the pursuit." When he wrote this sentence he was, of course, looking back over his life and seeing his youth as he wanted to see it. And so his application of the theory to history painting may be an afterthought. But "this way of painting," he remembers thinking,

might one time or other become in better hands more usefull and en-

tertaining in this Nation than by the Eternal proposition of beaten sub-
jects either from the Scriptures or from the old ridiculous stories of the
Heathen gods as neither the Religion of the one or the other require
promoting among protestants as they formerly did in greece and more
lately in Rome.[30]

HISTORY PAINTING, THE CROWN

The memory had at least this foundation in fact: the academy no
doubt established in his consciousness the hierarchy in which history
painting takes the crown (his story of the apprentice thinking of the
paintings at Greenwich and St. Paul's suggests that he already knew
it). As one critic put it, "History-Painting is that Concert, com-
prising all the other Parts of Painting, and the principal end of it is to
move the Passions"—"a Complication of all other sorts of Painting,"
story, figure painting, portraiture, landscape, and therefore obviously
greater in the aggregate.[31] It also stood higher on the absolute scale of
value: history painting showed man performing at his most heroic.
Every manual on painting worked up, chapter by chapter, to history.
Descending on this humanistically oriented scale, next came por-
traits, concerned with human character; then lower down, landscape,
sea pieces, animal pictures, fruit and flower pieces, still lifes, and in-
animate objects; and at the bottom "drolls" and grotesques, which
showed man as less than he was.

A treatise Hogarth must have looked into was the English trans-
lation of Gerard de Lairesse's *Art of Painting:* its emblematic fron-
tispiece shows a pile of books (Horace, Ovid, Homer, and Virgil)
mingled with palettes, brushes, and rules, an idea he was to explore
in his own self-portraits. An allegorized figure of "Painting," being
crowned by the three Graces, holds a panel with a portrait she has
just finished of the many-breasted goddess Nature. Lairesse, like
some of the copyists Hogarth was to show in *Boys Peeping at Nature,*
omits much of nature from his "Painting"—certainly those parts
Hogarth thought the artist cognizant of his pleasures as well as his
studies should be aware of. Lairesse, himself painted frankly in all his

grotesque ugliness by Rembrandt, sums up the sort of theories that opposed the inclinations of a man like Hogarth (and, a hundred years earlier, a man like Rembrandt):

> The *modern painting* can therefore not be accounted *art, when nature is simply followed;* which is a meer imperfect imitation or defective aping her. Even, were a thing represented ever so natural, well-designed and properly ordered; the condition, manners and custom well observed, and the colouring most exact, yet the knowing will not think it artful: but when nature is *corrected and improved* by a judicious master, and the aforesaid qualities joined to it, the painting must then be noble and perfect.

Within this unsatisfactory category of "modern painting," he distinguishes between the domestic interiors and daily occurrences of de Hooch and Vermeer and the far less satisfactory cottages, brandy shops, alehouses, and bawdy houses of Ostade and Brouwer.[32] Such works, Jonathan Richardson noted in Hogarth's own time, "may please, and in proportion as they do they are estimable . . . but they cannot improve the mind, they excite no noble sentiments; at least not as [history painting] naturally does."[33] History painters continued to be the ranking artists in any academy. And Hogarth never forgot this crucial fact, even as he recognized the diminishing possibility of finding a subject commensurate to the style or (as Thornhill's story unfolded) a patron who would commission such a picture.

It is also clear that Hogarth learned the fundamentals of academic drawing and theory and, whatever he may have said later to the contrary, began to apply them soon after matriculating in St. Martin's Lane. The change is immediately apparent if *The South Sea Scheme* (fig. 15) is placed alongside its ostensible pendant, *The Lottery* (fig. 19), which could have been constructed out of his academy sketchbook. Nevertheless, it is probable that he was something of a rebel within the academy, telling his colleagues about his mnemonic system and perhaps about "nature." It is also probable that the conventional pedagogic methods of Vanderbank's academy helped to foster in him the impression that Thornhill's new academy, where one simply went and painted from a model or did as one pleased, offered more scope to the students—as the authoritarian structure established by Vanderbank confirmed his growing distrust of intolerance. At either academy, the

classical preoccupation with the nude body, reflected in the emphasis on the life class, had the simultaneous effects on Hogarth of strengthening his already precocious grasp of the human body and of scanting another subject very necessary for the history painter: perspective. The simple stage setting of *The Lottery* is a great improvement over earlier works, but if he ever fully grasped the problems concerned with the architectural components of a composition—which is doubtful—it was only through his own study and experience.

The subscribers' list to the St. Martin's Lane Academy in 1720 reads like a roll call of the artists between Kneller and Reynolds. Besides the old Louis Laguerre and Louis Cheron, and the young John Vanderbank, there were, of the older generation, the Swede Hans Hysing, an established portrait painter who lived with and painted like Michael Dahl; and Louis Goupy, a less successful portraitist, noted for the "neatness & care" of his drawings.[34] George Knapton, a year younger than Hogarth and related to the Knapton booksellers, was studying at this time with Jonathan Richardson; he went on to Italy in 1725, returning to England seven years later to set up a fashionable portrait practice. Bartholomew Dandridge, born in London in 1691, son of a house painter, had at twenty attended Kneller's academy; he was beginning to produce portraits that resembled Vanderbank's, though they were less free, and in the late 1720s he painted conversation pictures similar to Hogarth's. Another subscriber, Arthur Pond, though never much of an artist, became what Vertue called "the greatest or top virtuoso in London." His father was a merchant of some kind—Vertue says "a wealthy citizen"—who lived "on the Middle of London Bridge," and on the strength of this wealth Pond traveled on the Continent until 1727, when he settled in Covent Garden and set up as a portrait painter and art expert, copyist of Old Master drawings, print and picture dealer, purveyor of painters' materials and picture frames.[35] Others included the Sympsons, Joseph Sr. and Jr., Hogarth's special friend John Ellys, and William Kent.

The St. Martin's Lane Academy flourished for a short while. The annual advertisement appeared in the *London Journal* for 12 October 1722 and again for 12 October 1723. The academy cannot have endured much beyond the 1723–1724 season, however. Vertue writes

that it survived "a few years," and Hogarth recalled that "this lasted a few years but the treasurer sinking the subscription money the lamp stove etc were seized for rent and the whole affair put a stop to." [36]

With this collapse in mind, Thornhill in November 1724 made another attempt to get up an academy, again at his house in Covent Garden and gratis—again perhaps with a national academy, headed by himself, as his object. Whether Hogarth remained with the St. Martin's Lane Academy until the end is uncertain, but he must at this point have joined Thornhill's free academy. He writes ironically of both of Thornhill's attempts: "so few would [lay themselves] under that obligation," that is, to come and draw gratis, that it failed; and again he explains that Thornhill had "at his sole expense given the liberty on application for any one to draw every evening gratis." [37] At this time Thornhill lived in the last private house on the north side of the piazza, in the northeast corner adjoining the building that would be the Covent Garden Theatre. He had added a large room to his house, where the students painted. [38]

A few years later (in 1726) Vertue wrote of the Covent Garden Piazza: "inhabited by Painters. A Credit to live there," and listed Ellys, Russel, Murray, Thornhill, Swarts, Wright, Smibert, Angellis, Vander Vaart, and Zincke. [39] At this time Covent Garden, center of the theater district, and with many artists living in or near it, became the center of Hogarth's London even before he actually lived there, and remained so until his move to Leicester Fields in 1733.

Thornhill, when Hogarth probably first met him, was in his late forties, not as sober and staid as he appears in all the surviving portraits and self-portraits (fig. 23). Not many years before, he had described himself:

> The one they call'd MONTE SPINOSA I think
> A Brownish Complection, a lover of drink
> A drawer of Devils they say was his Trade
> My Landlard drew worse in his House, I'm afraid. [40]

To this one may add the look of cool detachment in his eyes and the long nose, and assume that his ambition and hard work were tempered by conviviality as well as charm. Besides revering him as an artist, Hogarth must have liked him as a man. Hogarth himself, though no portrait survives from this period, can be visualized by working back from the Roubiliac bust of 1740: a short, brisk young

man with sharp features, more like a terrier than (as later) a pug. His acquaintances, if they had written about him, would have noted his great energy and, probably, his cocky self-assurance. Moving unhesitatingly up the ladder of acceptable artistic types, he was a person who found it necessary to prove his merit. The Thornhills were his first important and knowledgeable audience.

In the Thornhill house he found a collection of paintings that included works by (or attributed to) Caravaggio, Veronese, Annibale Carracci, Guido, Domenichino, Albani, Poussin, Rubens, Giordano, Sebastiano Ricci, Luti, and Pannini. Before long he became acquainted with a son named John and a daughter Jane, aged about fifteen then. In this household the great world of history painting and artistic polemic, of Burlington and Kent, was the center of discussion; and it was to become Hogarth's own world.

About this time Thornhill's work begins to make itself felt in Hogarth's prints: for example, Hogarth based a satire on the huge figures of George I and his family, which Thornhill was undertaking at this time on the wall of the Upper Hall (1722–1724, fig. 24)— and/or the Queen Anne and Prince George on the ceiling (1721–1722). He represents a king, a bishop, and a judge consisting of the same baroque robes and accoutrements, in the same cloudy surroundings.

The occasion for this etching, usually called *Royalty, Episcopacy, and Law* (fig. 25), had arisen in the spring of 1724 when a flurry of articles and pamphlets appeared anticipating a solar eclipse on 11 May. By the first of May specially prepared glasses were being advertised by William Rodwell, and, predictably, the Bowles brothers were touting rival glasses "judiciously prepar'd to preserve the Eye in looking at the Eclipse." Amid all this excitement, Hogarth imagines what one might see through a telescope when the moon intervened between earth and sun: "Some of the Principal Inhabitants of ye Moon, as they were Perfectly Discover'd by a Telescope brought to ye Greatest Perfection since ye last Eclipse."[41] The satiric device of the telescope reveals what was not visible at the great distance that stretches between these regal figures and the public (whether on a Greenwich ceiling or in fact)—that they are only robes hung over armatures, the king's head being no more than a guinea.

The etching uses the forms and scale of the Thornhill royal family, while the details are drawn from the most venerable emblematic tradition of graphic satire, reaching back to the Reformation portrait

of the pope's head which, on close scrutiny, proves to be constructed of symbolic popish objects such as wafers and chalices. Indeed, the bishop (still marginal in *South Sea Scheme*) is now the central figure and most complex element. The tongue of this mitred Jew's harp (that is, the bishop's head) controls a rope weighted by a Bible and tied to the handle of a pump resembling a church steeple. Pumping the handle (the Bible) rings a bell in the steeple and pours coins into a chest stamped with the bishop's amorial bearings, knife, fork, and spoon below a mitre. The steeple is capped with a weather vane, at the moment shifting with the wind toward the crown. The fact that the bishop's head is a Jew's harp picks up the connections made in South Sea satire between the Jews, the business interest, and the Anglican clergy. Hogarth's focus on the clergy, especially bishops, will become even more intense in *A Harlot's Progress;* Edmund Gibson, who is referred to more than once in the *Harlot,* had by this time become bishop of London and dispenser of ecclesiastical preferment for the Walpole ministry.

The image is more directly traceable to the verbal tradition, the clothes-worship of Swift's *Tale of a Tub,* in which suits of clothes come to replace the humans who wear them:

> If one of them be trimm'd up with a Gold Chain, and a red Gown, and a white Rod, and a great Horse, it is called a *Lord Mayor;* If certain Ermins and Furs be placed in a certain Position, we stile them a *Judge,* and so on, an apt Conjunction of Lawn and black Sattin, we intitle a *Bishop.*[42]

But Hogarth uses Swift to make an artist's point. With the increased size of the figures relative to the picture space, he has moved some way from the tiny, crowded figures of his earlier "drolls." If in *The Lottery* he progressed from purely emblematic satire to an equivalent of allegorical history painting, in *Royalty, Episcopacy, and Law* he uses these baroque shapes that appear to be king, bishop, and judge to betray the reality beneath the trumpery robes of power.

The clouds tell us that the figures are in the sky, where the sun should be, but they also recall the clouds on which hovered the imaginary castles of the Bubble satires, still being evoked by Swift in the floating island of Laputa in *Gulliver's Travels* (1726). Bubbles serve as the king's orb and chain, keeping fresh the memory of George

I's alleged involvement in the South Sea Company. The circle decorating the king's dais is another bubble and/or a zero of the sort found on moneybags in the Bubble prints for both the huge sums and the insubstantiality of the money value involved. Telescopes and spectacles were also a continuation of the imagery of distorted perception associated with speculation.[43] Hogarth's allusion to the Bubble satires serves as a reminder that the present government was founded on South Sea corruption: Walpole the "Screen" is evoked by the screens (simulating shields) that serve as the king's retainers and courtiers.

One other print needs to be mentioned, *His Royal Highness George, Prince of Wales* (fig. 26). This engraving-etching (5-3/4 × 7 in. about the same size as "The Bad Taste of the Town") plays upon Thornhill's ceiling of the Upper Hall. The Hercules figure, which Thornhill calls in his *Explanation* "Heroic Virtue," appears, seated on a cloud bank like the one in *Royalty, Episcopacy, and Law,* supporting the portrait of Queen Anne and Prince George. On the ceiling of the Painted Hall he appears with Pallas Athena banishing Calumny, Detraction, Envy, and others (fig. 27). It is appropriate that Hercules should figure centrally in Thornhill's allegory of the Protestant Succession; as Heroic Virtue, Hercules was iconographically associated with William III, fighting the Hydra of France.

The prince's oval portrait (based on the Kneller portrait, engraved in 1717) is flanked by Hercules and a figure representing Peace—references to the battle of Oudenard and to the Peace of Utrecht that brought the war to an end. The three Graces of Trade, the Arts, and royal power pay their respects. But the central, stand-in figure—the princely attribute—is Hercules, who makes the connection between George Augustus and (skipping a generation) William III. The print presumably expressed the hopes of the Opposition in the Prince of Wales, who was expected to change ministers on his father's death (a hope recorded in 1727/28 in *Henry the Eighth and Anne Boleyn,* fig. 54).[44]

Hogarth's print celebrates the Prince of Wales, and so implicitly follows *Royalty, Episcopacy, and Law* in attacking the king. This is the earliest indication that Hogarth was (as would be evident by December 1726) connecting himself with the Opposition, centered around the Prince of Wales and the Hanoverian hatred between sons and fathers, the earliest example of his support of the sons against their fathers who possess the authority of the robes, crown, and orb.

FREEMASONRY

The dating of *George, Prince of Wales* is doubtful, the terminus ad quem being the king's death in 1727. *Royalty, Episcopacy, and Law* must have been published in May or June 1724 (though no advertisement survives); *The Lottery* was announced for sale on 19 September in the *Daily Post*. Not long after, Hogarth began to conceive another print which bears a devious, problematic relationship to Thornhill: *The Mystery of Masonry Brought to Light by the Gormogons* (fig. 28), which he published in December 1724. Also his first reference of many to Don Quixote, the print was completed during the first month of Thornhill's new free academy, by which time Hogarth was almost certainly a member.

Thornhill was a prominent Freemason. He appears in the earliest surviving records of the lodge that met at the Swan in East Street, Greenwich, and became master in 1725. In 1728 he was elected senior grand warden of London's Grand Lodge.[45] Hogarth was himself a Freemason at least as early as 27 November 1725, in the lodge that met at the Hand and Appletree in Little Queen Street. This lodge had been constituted 10 May of the same year, but may have met earlier; and Hogarth was probably a member when he made his print in the late autumn of 1724.[46] The print ridicules not Freemasonry but its "mysteries," excesses associated with the Jacobite faction and Philip, first duke of Wharton.

The Masonic lodges, "those peculiarly English forms of socializing" (as Margaret Jacob has remarked), represented "business contacts . . . , not to mention good food, drink and song."[47] For one thing, they were convivial clubs similar to the Sublime Society of Beefsteaks and others with which Hogarth later associated himself. But the Masonic lodges combined merrymaking with an esoteric philosophy and hermetic symbolism. Politically they were associated with Whig rather than Tory interests and expressed a tendency toward nonconformity, even "heresy and republicanism" in the form of egalitarianism: in the lodge "brothers" could meet "upon the level." They were "ruled by grand masters drawn from the peerage, strictly hierarchical in structure yet curiously egalitarian at their meetings and banquets" and—most important—in admissions.[48] But at the same time the lodges contained within their copious embrace royal-

ist, though Protestant, elements, and even a Jacobite strain—in short, radicals from both ends of the spectrum.

In 1723 the original operative Masons—convivial clubmen—were resisting the takeover by newcomers—scientists, historians, and reformers led by John Theophilus Desaguliers and James Anderson—who viewed the organization in a more modern and idealistic way. During his term as grand master, John, second duke of Montagu, had appointed Anderson to amalgamate the "history" and records of the Freemasons into a document that was presented to the Grand Lodge and accepted in 1723 and published the same year as *The Constitutions of the Free Masons*. The social architects sought to reelect Montagu in 1722–1723, but the convivial clubmen responded by electing the erratic duke of Wharton, who carried with him (as did the clubmen) suspicions of Jacobitism. At a special meeting in January 1722/23 a compromise was devised by which Wharton was elected grand master by both factions and, for compensation, Desaguliers was elected deputy grand master and Anderson warden; as well, Anderson's *Book of Constitutions* was approved. In 1724 Wharton attempted to retain the grand mastership but he was replaced (by a single vote) by the earl of Dalkeith.

It was at this point, with rumors of the Jacobite faction's withdrawal, that someone of the Desaguliers–Anderson faction invented the ironic fiction of the "Gormogons" as a splinter Freemasonry being carried off by Wharton and his friends. In the *Daily Post* of 3 September the following mock notification appeared:

> Whereas the truly ANCIENT NOBLE ORDER of the Gormogons, instituted by Chin-Quaw Ky-po, the first Emperor of China (according to their account), many thousand years before Adam, and of which the great philosopher Confucius was Oecumenical Volgee, has lately been brought ino England by a Mandarin, and he having admitted several Gentlemen of Honour into the Mystery of that most illustrious order, they have determined to hold a Chapter at the Castle Tavern in Fleet Street, at the particular Request of several persons of Quality. This is to inform the public, that there will be no drawn Sword at the door, nor Ladder in a dark Room, nor will any Mason be receiv'd as a Member till he has renounced his Novel Order and been properly degraded. N.B.—The Grand Mogul, the Czar of Muscovy, and Prince Tochmas are enter'd into this Hon. Society; but it has been refused to the Rebel Meriweys, to his great Mortification. The Man-

darin will shortly set out for Rome, having a particular Commission to make a Present of the Ancient Order to his Holiness, and it is believ'd the whole Sacred College of Cardinals will commence Gormogons. Notice will be given in the Gazette the Day the Chapter will be held.

Mireweys, the Czar, and Prince Tochmas were prominent figures in the news that summer. Mireweys (or Meer-Vais) was the son of an Afghan chief (i.e., analogous to George I, the Hanoverian) who had deposed the "Sophy" or head of the "Sufawi" dynasty in Persia (James II) and Prince Tochmas (or Thaumas, the Young Pretender) was the rightful heir, the "Young Sophy," now in exile but supported by the czar of Russia (Louis XV). The allegorical relationship to contemporary politics was obvious, pointing at Wharton's alleged Jacobitism and the Jacobite element within Freemasonry.

Aaron Hill, a Freemason himself, published an essay on the subject in his *Plain Dealer* of 14 September, arguing that the Freemasons had better heed these symptoms of decay and reform themselves. He is appalled at the leniency of admissions—vintners, drawers, wigmakers, and tailors have been admitted, and before long, he fears, women will be; all of which has brought contempt upon the order. Stories have been spread, as in such books as *The Grand Mystery of Freemasons Discover'd* (1724) and in the Gormogon notice, about some lodges: "Alarming Reports, and Stories of Ladders, Halters, Drawn Swords, and Dark Rooms. . . . Unless the Grand Master puts a Stop to these Proceedings, by a peremptory Charge to the Brotherhood, I wish I cou'd honourably enter into Another."

This essay, in a periodical that had joined him in attacking pantomime, may have been Hogarth's point of departure. His print criticizes the emphasis on mystery and hermetic symbolism associated with the Roman church. The Freemasons drew their symbolism from the building of Solomon's Temple, and by 1724 the system's complexity and flamboyance—to judge by *The Grand Mystery of Freemasons Discover'd*—might have reminded Hogarth of pantomimes or Italian operas. As an insider, he would have observed the posturing and mysteries as folly, while at the same time as an artist he may have seen that they offered ways of "delineating a system of morality veiled in allegory and illustrated by symbols."[49]

Freemasonry was supposed to bring together men regardless of class. The *Constitutions* state the Masons are recruited from "good

and true men, free-born, and of mature and discreet Age, . . . of good Report." Freemasonry was a meritocracy in which advancement was through achievement, based on "the idea of work as a source of status, instead of a calling."[50] But Aaron Hill had complained of admitting vintners, drawers, and tailors. So Hogarth introduces a butcher with his butcher's apron (as opposed to the Freemasons' "aprons") who stands outside the procession, showing his amused detachment. He is accompanied by Don Quixote and Sancho Panza: Quixote, taking this "puppet show" for real, is preparing to attack it, while Sancho echoes the butcher's amusement/amazement. These observers are borrowed from Charles-Antoine Coypel's *Don Quixote* plate, *Don Quixote Demolishing the Puppet Show* (fig. 29, published in Paris earlier in the same year), an image that will be central to Hogarth's "modern moral subject."

Hogarth is against exclusivity as well as Roman ritual: "But Mark Freemasons!" he exclaims in his inscription, "what a Farce is this?" These Whartonian "Gormogons" are being disgorged from the lodge, accompanied by an ape (associated with "apish" *Imitatio*) wearing a Freemason apron and gloves.[51] The ass that carries the Masonic emblems and the old lady came to Hogarth from Gilden's *New Metamorphosis,* an adaptation he had illustrated (published earlier the same year, fig. 22) of Apuleius's *Metamorphoses.* At the end of Apuleius's work, and in any of a number of emblem books, Hogarth would have come across *Asinus portans mysteriam,* which was central to the Eleusinian mysteries and, in Apuleius, carried the image of Isis.[52]

The old lady (another aspect of Aaron Hill's fear of open admissions) derives specifically from a Gormogon satire, attached to the second edition of *The Grand Mystery of Freemasons Discover'd* (published 28 Oct.). One "Verus Commodus" uses the Gormogons to attack the Desaguliers–Anderson faction:

> The Report is this, That the *Mandarin* [Hang Chi] has declared, that many years since, Two unhappy busy persons who were *Masons* [Anderson and Desaguliers], having obtruded their idle Notions [*Book of Constitutions*] among the *Vulgar Chineze,* of *Adam,* and *Solomon,* and *Hiram.·.·.*Being Crafts-men of their Order; and having besides, deflower'd a venerable OLD Gentlewoman, [taken unwarrantable liberties with the Operative Charges and Regulations], under the Notion of making her an *European* HIRAMITE (as they call'd it).·.·.they were

hang'd Back to Back, on a Gibbet.∴∴.And ever since, it has been an Article among the *Gormogons,* to exclude the Members of that Society, without they first undergo a solemn *Degradation.*∴Tho' methinks, The Business of the OLD Gentlewoman affords, as our Weekly Politicians say, Matter of Speculation; and at the worst, I hope the inraged Matron went too far in her Evidence, and was rather *saluted* than *violated.*

These figures have the particularity of portraits, and it has been suggested that the figure kissing the old gentlewoman's posterior is Anderson, ridiculed by Verus Commodus for his *Book of Constitutions;* that the "old gentlewoman" is a portrait of Desaguliers, who with Anderson was responsible for the *Constitutions* (there is a distinct resemblance to Hans Hysing's portrait); and that Don Quixote resembles the duke of Wharton.[53] Though the resemblance to Wharton is slight, Quixote would have been an appropriate form to give him.

Hogarth borrows his graphic image of the old woman, ecstatic atop an ass like Isis, being "saluted" by one of the Freemasons, from Coypel's *Don Quixote Demolishing the Puppet Show* (fig. 29). In Coypel's print she is transported by wonder at the scene: she, Sancho, and the other figures are all responding to Quixote's demolition of the puppet show. In Hogarth's version they *and* Quixote are responding to the Gormogon parade. Hogarth's Quixote is no longer attacking the puppet show; he wears a Freemason's apron and pays homage to the "mysteria" on the ass.

A Freemason, whose head is caught between the rungs of one of the "ladders in a dark room," hankering after such "mysteries," "salutes" the old woman. He represents the Freemasons' sense of elitism which excludes the sensible butcher. In fact, the print itself is addressed to the unrefined London citizen, though only such sophisticated and discerning gentlemen as Sir James Thornhill would have recognized and appreciated the learned allusions to the *Asinus portans mysteriam* and *Don Quixote Demolishing the Puppet Show.*

There are a few additional facts: the Freemasons celebrated their connection with architecture and with artists; which helps to explain Thornhill's prominence (and Hogarth's joining). The connection was in particular with English architecture of all types, by Inigo Jones, Wren, Vanbrugh, and, as the ultimate end of the principles initiated with the Temple of Solomon, Lord Burlington. The Freemason songs and poems emerging in the 1720s celebrate a progression of architects leading up to, as a kind of climax, Burlington (himself not a

member).[54] Hogarth's only indication of an architectural theme is in the crude antiarchitectural lines of the tavern. There are no classical orders here.

Hogarth represents a scene of Londoners dressed in the fantastic Freemason and Gormogon regalia as in one of Picart's *Cérémonies et coutumes*. He thus preserves both the allegorical and realistic levels and approaches a theme concerned with disguise and playacting which, in his next print, *A Just View of the British Stage* (fig. 33), he will place on a real Drury Lane stage. And the print itself, whatever else it may say, affirms the importance of mock processions, anticipating the "crowd rituals" of the Skimmington and the burning of the rumps at Temple Bar in *Hudibras*.

JACK SHEPPARD AND THE LANDING OF GEORGE I

The next event that brought Hogarth and Thornhill together was the death of the robber and escape artist Jack Sheppard. Sheppard's last and most spectacular escape had been from Newgate Prison on the night of 15 October—"to the great Admiration of all People," as the *Weekly Journal* said, "he being chain'd down to the Floor in the Castle of the Jail, with Fetters on his Legs of a prodigious Weight." He was quickly recaptured, however, and did not escape again. *The History of the Remarkable Life of John Sheppard* was advertised on the 19th, and on the 24th a portrait "drawn by a Painter who went to see him" was advertised by Thomas Bowles. On 10 November the *Daily Journal* noted that "Sir James Thornhill, the King's History Painter, hath taken a Draught of Sheppard's Face in Newgate."[55]

It is interesting to surmise why Thornhill decided to draw a convicted criminal at this particular time, and what Hogarth had to do with it. The Sheppard portrait was a unique phenomenon in Thornhill's career, but not completely inexplicable. In his huge sketchbook (now in the British Museum) allegorical designs in the grand style are jostled, occasionally on the same page, by sketches of intimate, realistic, sometimes grotesque characters in the manner of Dutch "drolleries" (figs. 30 and 31). This was not an unusual predilection, or sideline, for a history painter like Thornhill. Karel van Mander,

who in *Het Schilderboek* agreed that the noblest subjects for a painter were a religious or historical theme and the idealized nude figure, himself painted genre pictures like Bruegel's as well as history paintings; Annibale Carracci of course mingled caricature and genre studies with history paintings. But Thornhill never allowed this predilection to get the upper hand. He painted a number of portraits, but except for the one of Sheppard they were all conventional, as David Piper has said, "the most truly Baroque essays in portraiture by an English painter."[56]

Thornhill's hobby, as it might be called, explains the origin of his regard for Hogarth and perhaps the pleasure with which he received *Masquerades and Operas.* Whenever he and Hogarth first met, they would have recognized a mutal taste for "drolleries" and a reaction against the idealized world of history painting. By 1724, with the rise of Kent and the Burlingtonians, and the paintings by Ricci and Kent in Burlington House, Thornhill may well have been looking for diversion. A germ of interest in the Sheppard portrait, then, was apparently nourished by recent events and a recent contact, and it seems within the realm of possibility that Hogarth accompanied Thornhill to Newgate, as Thornhill later accompanied him to the same prison to paint Sarah Malcolm. The place, of course, was hardly new to Hogarth. During the years of his father's insolvency he must have become all too familiar with such landmarks as Newgate's tower straddling Newgate Street and its emblematic statues: Justice, Fortitude, and Prudence on the east side; Liberty, Peace, Security, and Plenty on the west side. He evidently read as a boy *The Memoirs of the Right Villainous John Hall* (1708), to which he alluded in *A Just View of the British Stage*—a pamphlet containing a long and horrendous description of Newgate, pointing out, among other things, that one could amuse oneself by pausing under the gate near the grate of the Women Felons' Apartment and listening to them swear extempore.

Around the first week in November Thornhill went to Newgate and drew his powerful picture of the thin, almost childlike criminal, alone in his cell (fig. 32).[57] Sheppard himself, whether Hogarth saw him in person or only in Thornhill's likeness, may have interested him as a distorted mirror image of himself: a Tom Idle, born miserably poor but taught to read and write, he was apprenticed to a cane chair maker, ran away from him, was aided by the kindness of a Mr. Kneebone, a woolen draper in the Strand, and apprenticed to Owen Wood, a carpenter in Wych Street, Strand. After four tedious years

with Wood, he neglected his work, fell into bad female company, committed several robberies, quarreled with his master, and once free of his apprenticeship joined a gang of thieves and squandered the two years of life remaining in thievery, imprisonment, escapes, and recaptures. He was hanged on 16 November, aged twenty-two.

On the 28th the *British Journal* published a poem celebrating Thornhill's immortalizing of Sheppard, which ends:

> *Appelles Alexander* drew,
> *Caesar* is to *Aurellius* due,
> *Cromwell* in *Lely's* Works doth shine,
> And *Sheppard, Thornhill,* lives in thine.

The last stanza indicates the unique appeal of Thornhill's portrait; he has represented an actual criminal, poor, alone, and about to be hanged, and not the metaphorical criminal Alexander, Caesar, or Cromwell. But such lines, reminiscent of many popular rogues' biographies, imply an ironic relationship between high and low criminals which would remain with Hogarth.

On the day the *British Journal's* encomium appeared, the patentees of Drury Lane—Cibber, Wilks, and Booth—produced their own exploitation of Sheppard, a pantomime called *Harlequin Sheppard,* intended to out-pantomime Rich. On the same night Dryden's "dramatick Opera of Dioclesian" was staged at Rich's theater: "the Decorations were magnificent and new, and the Musick new set, which was received with extraordinary Applause." *Harlequin Sheppard,* however, "was dismiss'd with a universal Hiss.—And, indeed, if Shepherd had been as wretched, and silly a Rogue in the World, as the ingenious and witty Managers have made him upon the Stage, the lower Gentry, who attended him to Tyburn, wou'd never have pittied him when he was hang'd."[58]

On 5 December the Bowles brothers and George White published White's mezzotint of Thornhill's portrait at a shilling.[59] On the 10th Hogarth's own response to Sheppard, to Drury Lane's pantomime, and in some sense to Thornhill's portrait too was published: "A Print representing the Rehearsal of a new Farce, call'd three Heads are better than one, including the famous Entertainments of the Harlequin Doctor Faustus, and Harlequin Shepherd . . . Sold at the Print Shops in and about London and Westminster. Price 6*d*."[60] It is reasonable to assume that Hogarth returned to a proven subject when the occasion

offered itself, and in *A Just View of the British Stage* (fig. 33) produced an adjunct to *Masquerades and Operas*. Why, however, did he pick on the patentees of Drury Lane, when Rich was the more blatant offender—the Father of the Evil, so to speak? These attacks began in 1718 and continued more or less up to 1724.[61] One answer is that Hogarth attacked not the obviously reprobate but the hypocritical, the disappointing, or the pretentious. Steele had been made governor of Drury Lane with great hopes that he would implement the strictures against bad theater he had published in the *Tatler* and the *Spectator*; theatergoers hoped for a Jeremy Collier to purge the stage of indecency and the prevalent pandering to the lower instincts of the rabble. Alas, in order to survive Drury Lane was forced from the outset to imitate Lincoln's Inn Fields and even the opera: introducing a pair of pantomimists from France for harlequinades, singers for operas (albeit in English), dancers, jugglers, and tumblers to follow the play, and other examples of what Addison and Steele regarded as irrational entertainment. The same plays that Steele had attacked also continued to be performed, and in the early days at least, Drury Lane was successful in its rivalry with Lincoln's Inn Fields. In 1724 Drury Lane was still professing the high ideals of art and morality, while trying to outdo Lincoln's Inn Fields in the sensationalism of its harlequin pantomimes. It was accordingly an obvious target, and the irony of the motto displayed above its stage, "Vivitur Ingenio," is obvious: to the patentees their plays alone are art, the rest is consigned to oblivion. So also the words put in the patentees' mouths: "Poor R—ch Faith I Pitty him," and "Assist ye Sacred Nine"—all underline Hogarth's comic contrast between their high-flown pretensions and their real pandering.

While Thornhill knew all there was to know about decorative and history painting, he was also intrigued by the present, which he could express only from time to time in portraits, sketches, or a jeu d'esprit like the portrait of Sheppard. The test for Thornhill's orthodoxy came in his subjects for the opposite walls of the Upper Hall at Greenwich. These were, as a continuation of his general subject of the Protestant Succession, the landings of William III and George I. The problem was the way he should portray George I landing as recently as 1714. Thornhill was thinking seriously of representing the event as it occurred, but within the conventions of history painting. Along the top and down the side of the drawing, which shows the participants in contemporary dress, he has written:

Objections yt will arise from ye plain representation of ye K. Landing ⟨Sbr 18th 1714⟩ as it was in fact, & in ye modern way & dress.

^1First of all it was night, wch to represent would be hard & ungraceful in Picture.

No Ships appearing, & boats make a small figure.

^2Then who shall be there to accompany him[?] If the real nobles that were there, then, some of them are in disgrace now. & so will be so much Party in Picture.

^3To have their faces & dresses as they really were, difficult.

^4The King's own dress then not graceful, nor enough worthy of him to be transmitted to Posterity.

^5There was a vast Crowd wch to represent would be ugly, & not to represent would be false.

Here, neatly arrayed, are the conflicts involved in eighteenth-century history painting: ugly facts versus the ideal, the timeless, and the general. A part of Thornhill may have wished for an entirely realistic portrayal, but Thornhill the professional history painter has written his compromise solution down the right side of the sheet:

^1Take Liberty of an evening sky, & torches.

^2Make only 5 or 6 of ye Chief Nobles; ye rest in ye Crowd.

^3Inquire their dress ye best you can & get their faces from ye life.

^4Make ye Kings dress as it now is, & as it should have been then, rather than what it was.

^5Take ye Liberty to lessen ye Crowd as they ought to have been then.

He adds at the bottom, "Take ye Liberty to bring in ye yacht that brought over ye King & ye Barge & Guns firing &c." The sketch and notes are impossible to date; they may have been done as early as December 1717 when Thornhill first submitted sketches for the Upper Hall, or as late as October 1722, when he had finished the ceiling and began work on the walls.[62] But the sketch shows that before he had met Hogarth Thornhill was thinking seriously about the problem that Hogarth was to see as the central one of his career: how to treat a modern subject in history painting, or, conversely, how to make history painting relevant to the contemporary world. For Thornhill the

problem was theoretical only; the final version (fig. 34) of the landing of George I was fully allegorical, with even a scalloped chariot to replace the ship, executed in grisaille in imitation relief, and matched by the allegorical entry of William III on the opposite wall.

The problem still existed for Thornhill, however, as he began planning and blocking out the remaining wall of the Upper Hall. By May 1725 he was ready to begin the painting, and had probably by then reached a solution, again a compromise: he decided to portray George I and his family in contemporary dress but surrounded by allegorical figures, some on a larger scale than the human figures (fig. 24). It is also some indication of Thornhill's feelings about history painting that he included himself—standing on the steps leading to the royal family, dressed as a contemporary gentleman, pointing to the conclusion of his masterpiece (with St. Paul's dome looming in the background, as a further reminder of his works). This self-portrait should be contrasted with Verrio's self-portrait on the wall of the Heaven Room in Burghley House, where he shows himself in classic undress, sketching the scene, with Iris above, sending him his colors in a rainbow shaft of light.

When Hogarth met him, Thornhill was no longer anchored in his baroque, Greenwich phase. The Greenwich ceiling reflects the influence of Pietro da Cortona, modified by Venetian colors. With their rigorously conceived and executed allegories, these paintings exerted considerable influence on Hogarth's engraved work of 1724—in one instance as a direct imitation, in the others as parodic forms. The panels at St. Paul's, however, and the side panels of the Upper Hall at Greenwich, all grisaille, are quite different. They are modeled in general on the Raphael Cartoons—at St. Paul's they use the same subject—and are clearly defined, sculpturally composed, and largely classical, though not without Rubensian overtones. The designs at St. Paul's (fig. 37) are taken from Raphael and his French imitators and, in one instance, from Peter Paul Rubens.[63]

THE RAPHAEL CARTOONS

Hogarth's graphic sources were basically of two kinds: the history paintings available in England (and to a lesser extent, the engraved reproductions of other history paintings) and the subculture signs he

found around him in London in everything from popular prints to signboards. With the model of Thornhill before him, Hogarth saw himself as an English painter who wished to achieve greatness in history painting in a country where churches avoided religious images, where his chief national models were not painters but writers (Shakespeare, Milton, Bunyan). An English Protestant painter would not turn to continental prototypes, especially baroque and Roman Catholic models in the descent from Michelangelo, but rather to the one series of High Renaissance paintings that was in England, was about *New* Testament subjects, was susceptible to English Protestant, indeed dissenter interpretation, and was painted in an unbaroque, relatively classicizing style.

Thornhill had already made the choice in his St. Paul's paintings: in England the tradition of history painting would be based on the historical accident that put the original Cartoons for Raphael's Tapestries of the Lives of the Apostles at the disposal of English artists. Because of Charles I's good taste and the lucky timing that saved the Cartoons from the sale of his collection during the Commonwealth, English artists found that the one monument of High Renaissance art available to them without traveling to the Continent was this, the great model of history painting. (Raphael represented in the eighteenth century the pinnacle of painterly achievement.) The original Cartoons were accessible at Hampton Court Palace and engraved reproductions were even more easily accessible in London printshops (the tapestries were in the Sistine Chapel in Rome). Even when Shakespeare was illustrated for John Boydell in the 1790s, the Raphael Cartoons remained a primary model for certain kinds of scenes. For biblical illustration they remained authoritative. Their overwhelming presence, however, made it even more difficult for a serious English painter to escape the need to distinguish himself in the line of painting they exemplified.

There was also a second, alternative model for history painting at hand. This was Rubens's ceiling of the Whitehall Banqueting House, another product of the connoisseurship of Charles I. The differences between Rubens's ceiling and Raphael's Cartoons were crucially important. Rubens's panels were baroque and operatic in their illusionism, Catholic and monarchical in their politics, a series seen unfolding upward and away from the viewer as if ascending into the sky. Their subject was the sovereign; they presented an allegory of divine right in which the court is the center of patronage, the per-

spective is seen properly only from the throne with the king implicitly on a vertical axis connecting him with the deity Himself. The king's father, James I, is portrayed thrice, twice in the bestowal of a divine fiat lux and once in the process of his apotheosis. He is sole source of interest, power, and beneficence. The ceiling of the Banqueting House could serve as a rehearsal for the decorative program of Earl Squander's chamber in *Marriage A-la-mode* 1.

Rubens's florid iconography is from the Old Testament with James I related typologically (as he had made clear he wished to be) to King Solomon. James's learning and wisdom are related to Solomon's by the use of the twisted columns of Solomon's Temple in one panel and by the composition of a Judgment of Solomon in another: a story twice illustrated by Raphael (in both the Vatican Stanze and the Loggia) and equally authoritatively by Poussin (Louvre). James–Solomon is shown passing judgment on two women, England and Scotland, both of whom claim as their child the infant between them, the young Great Britain produced by the accession of the Stuart James I. This judgment will also serve as the ironic iconography of Hogarth's *Marriage A-la-mode* 5 and *Moses Brought to Pharaoh's Daughter*.

Rubens's monarch-oriented designs did not grip the English artist of post–1688 with the same power as the Protestant-oriented stories of Raphael's Cartoons, with their discrete scenes of human interaction and horizontal progression through spiritual conversion of the self to the conversion of others. The Rubens, however, served as a model for the decorative history painting that was undertaken in England from the Restoration of the Stuart (and probably crypto-Catholic) Charles II onward, and in Hogarth's time not only by Thornhill in Greenwich Hospital, but by such foreign rivals as Pellegrini, Jacopo Amigoni, and the Ricci.

Although not too much should be made of the fact, there is an interesting slippage in some of the Rubens paintings which will become significant in the hands of Hogarth. I refer to the fact, ignored by Rubens and I am sure unnoticed by Charles I's courtiers, that the two women England and Scotland who contest the child Great Britain and are reconciled by the monarch James I are in the biblical story prostitutes.

The aim of High Renaissance art, as Sydney Freedberg has written, was "to achieve a harmony of regular, clear, and proportionate relations that is not evident in nature and, at the same time, to assert that this harmony pertains to an existence which is compellingly

true."[64] This idealism was plainly something that English artists, brought up on the works of Shakespeare and other English writers (both poetic and political), could not countenance and at the same time talk about "nature." So long as art was accepted as a closed system between patron and painter, questions of slippage did not arise. So long as one looked at the Whitehall Banqueting House ceiling from the perspective of the royal presence, in the way it was painted, one saw from the point of view of Solomon, the patron, and the high culture itself. But as soon as an artist like Hogarth separated himself from the commissioner of the paintings, turning from the patron to the public, he began to notice the discrepancies.

What I have been outlining is a baroque model based on Old Testament (OT) or Greek or Roman mythological motifs, which was to serve Hogarth for parodic purposes. For most English men and women the Old Testament carried associations, as in the Rubens ceiling, of monarchy, the OT law, and (for Hogarth at least) Shakespeare's Shylock and his bond. Classical myths carried associations of lascivious behavior and arbitrary justice at the hands of fickle, self-centered deities (whom Hogarth also associated with the OT Jehovah). The Raphael Cartoons, however, offered a positive alternative because they embodied the opposing New Testament values, which were more closely in line with the English Protestant tradition and were increasingly honored in the aftermath of the Glorious Rebellion of 1688. Indeed, there is a noticeable shift among writers on art: from Dryden, who puts much emphasis on classical mythology and "history" (although he also includes the Bible), to Jonathan Richardson, who takes most of his examples from the Bible. For Hogarth, at one extreme was contemporary life, at the other the Bible; and the middle ground of classical mythology was shunned.

As a series, whether as cartoons or as tapestries, Raphael's story of the Apostles was hung horizontally, not vertically overhead like the Michelangelo ceiling, and of course they were "read" in the same way in the engraved reproductions. They produced a model reading structure in secular (or popular) rather than divine (or royal) time. Each panel was a planar composition, enclosed, delimited, constructed on a boxlike single-point perspective—the antithesis of the infinite recession and exfoliation of the ceiling paintings. And yet if the Cartoons/Tapestries told a chronological story that evolved in human time, they were also synchronic: if they related Paul to Peter at each stage of their travels, these two were related in turn upward to

the lives of Moses and Christ (literally in the Sistine Chapel, implicitly in the engravings).

The subject was New Testament and Protestant, essentially about conversion—conversion among the low as well as the high, which could easily be fitted into a sensibility that included such indigenous literary works as Bunyan's *Grace Abounding* and Defoe's *Robinson Crusoe*. (To Hogarth they were of particular interest because the plot of personal identity involving conversion pits the apostle against mobs of heathens.) Raphael presents a complex interplay of comparisons and contrasts between the two parallel series on opposite walls, the careers of Sts. Peter and Paul, balancing one against the other, based on the schemata of preaching and healing, words and deeds, faith and charity, which Hogarth in various ways had in mind when he painted his progresses of a Harlot and a Rake—both as parody series (lives, careers, progresses) and as parallel lives like those of Peter and Paul, two apostles who go out to spread the word of Christianity and either convert or are swept away (ironically themselves worshipped) by idolators and the avaricious. (See figs. 35, 36.)

Thornhill chose the life of St. Paul and the model of the Raphael Cartoons for the cupola of the eponymous cathedral. For Hogarth as for Thornhill it was significant that St. Paul was the patron saint of London, for whom its cathedral was named, and therefore a Protestant, English symbol. Francis Bird's bas relief on the west pediment (1706) shows Paul's conversion, and scenes from his life appear around the west door (1712–1713).[65] And Steele's popular *Christian Hero* singles out St. Paul (incidentally, telling the story of Paul and Felix, which Hogarth will illustrate in the 1740s).

The different relationships of the spectator to the ceiling and to the Cartoons/Tapestries distinguish the two kinds of history painting. The first, essentially rejected by English artists (as we see, rejected by Thornhill himself in St. Paul's), is the infinitely recessed painting that places an insurmountable gap between the spectator and the protagonists of the scene. The second, portrayed roughly on a level with the spectator, includes the spectator within the composition not as an upward-aspirer but as a human witness to human actions. In the scene most imitated by Hogarth, for example, Elymas is blinded by Paul, reacted to by the proconsul who is thereby converted, and both are reacted to by the bystanders (fig. 36). The spectator to the tapes-

tries/cartoons/engravings then relates to the witnesses rather than the protagonists.

These panels represent a model for history painting in which the heroic action is seen at a little distance, framed, placed, and related to other realities (in a way, as Hogarth was to demonstrate, analogous to a stage set). It is neither an action from which the spectator is separated as by a gulf nor one in which he is simply absorbed or immersed. In this respect, they represent principles of theatricality which are distinct from the painted staircase or balcony of the country house with men and women represented illusionistically as if looking down on us. The difference is between a spectator to someone else's drama and an actor who participates in the drama and is still in the privileged position of a courtier, a patron, or even the royal presence itself in the Banqueting House. The experience of the Cartoons is less personal, more detached; it involves a moral choice or decision by the spectator and not the empathetic ecstasy expressed by the patrons in their galleries above the ecstatic St. Theresa in Bernini's Cornaro Chapel.

In Thornhill's panels in St. Paul's the figures are planimetrically presented, flattened into a relief, their movement slowed down; but, on the other hand, Thornhill is more dramatic than Raphael and his figures are somewhat Rubensian (fig. 37). His version of *The Blinding of Elymas* for example, emphasizes the contrast between the quiet Paul and the groping Elymas; and Sergius Paulus, impassive in Raphael's Cartoon, is gape-mouthed and gesturing in Thornhill's— on the way to the expression of a Hogarth character. Thornhill has also increased the agitation of the draperies and broken up the forms, in general enlivening the elements. Again, in *The Sacrifice at Lystra,* where Raphael's altar has a rectangular plinth, Thornhill gives his a baroque form (and Hogarth, when he introduces the motif into *Strolling Actresses Dressing in a Barn,* follows Thornhill). In every case, however, Thornhill has contained this agitation within a relatively planimetric composition, and the effect—one that Hogarth explores and extends to great lengths in his own works—is of a baroque content controlled by classical order.[66]

Neither the Greenwich ceiling nor St. Paul's cupola was an extreme to be confused with certain examples of Continental baroque on the one hand or Poussinesque classicism on the other. Rather, each represented an attempt to adopt the best of both worlds as the

context—mythological fancy and political glorification in one case, religious worship in the other—demanded. Hogarth was initially influenced by the Greenwich ceiling, but as he developed a personal style of engraving and worked up to *Hudibras,* he seems to have preferred the grisaille Raphaelesque biblical subjects, whose monochrome may have contributed to the needs of an engraver, over the classical mythology and swirling, Venetian forms. Thornhill himself seems to have been moving in this direction at the time. The more serious, Raphaelesque Thornhill, while adopting, in his sketches, the Venetians' color and their freedom of brushwork, must have objected to their essentially decorative conceptions and played down their influence in his own didactic histories. Indeed, in these years of his contact with Hogarth, Thornhill can be seen moving from the elaborate allegories of the Painted Hall to the paintings in St. Paul's, the Upper Hall, and the Wimpole House chapel, his easel paintings of religious subjects, and ultimately his copies of the Raphael Cartoons, the final testament with which he occupied his last years.

But he also sets a precedent with his colorful modelli and monochrome public paintings for Hogarth's later practice of painting brilliant oil sketches for the austere black-and-white line engravings he sold to the public. The first were for dulce, the connoisseurs, and himself, while the second were for utile and the general populace.

The second wellspring of Hogarth's art was the subculture shopsigns of London, its processions and "crowd rituals," and penny prints of the sort John Gay gloomily sees as having replaced the Raphaels and Titians that used to hang on the walls of aristocratic town houses.[67]

Linking the high and low art were the printed lexicons of symbols, Alciati's *Emblemata* and Ripa's *Iconologia.* The intention of the emblem was to be both popular and erudite—to teach wisdom "not only to the mind but the eye, thus benefiting those who are unable to read," and so produce a sugarcoating, an amusing picture puzzle, for the large public.[68] This was the aspect of the emblem that was exploited by the propagandists of the Reformation in their popular prints. But Claude Mignault, who began the annotating of Alciati's *Emblemata,* explains that the task of the emblematist is to avoid obvious symbols, which are valueless, and employ dark conceits that circle and wind the meaning out of obscurity.[69] To which we might add the testimony of Cesare Ripa, another founding father of iconography: the emblematist works with signs that "present one thing

to the eye but meaning [sic] something other to the mind"; and he further praises these because they provide the learned with arcane wisdom while providing the ignorant with enjoyment.[70] There is a contradiction between the desires to avoid "obvious," specified, formulated meanings and to comunicate with the general public. The result is a puzzle which is the contrary of a sign that presents the *same* meaning to eye and mind simultaneously and immediately.

Difficulty (*difficultas*) in Thornhill's Greenwich paintings refers to his complicated iconography, which had to be explained in a pamphlet published to accompany the experience of the paintings. Nothing of the sort was, of course, needed in St. Paul's where the source was the New Testament. In Hogarth's work, however, *difficultas* lies not in the use of esoteric iconography but in his intellectual play with commonly known iconographies and sign systems, high *and* low, from all sources.

THE SPECTATOR

Thornhill must have urged Raphael's Cartoons on Hogarth and stressed a view of history painting that was best summed up in the *Spectator*'s essays on art. It is no coincidence that the essays that most influenced Hogarth were by Thornhill's friend, and perhaps student in things artistic, Richard Steele, who sat for his portrait to Thornhill, was a member of the Queen's Street Academy, and reported an elaborate exegesis of the completed Painted Hall in one of his periodicals.[71] He had two preoccupations: the moral purpose of art and the importance (especially in moral terms) of the Raphael Cartoons as a model for English artists.

If, as the *Spectator* constantly reiterates, opera, pantomime, puppet shows, and similar entertainments invariably replace reality with monsters and magicians, the same is certainly true, Steele shows, of most of the history paintings praised and bought by English connoisseurs to decorate their houses and public buildings. Instead of "charming Portraitures, filled with Images of innate Truth, generous Zeal, courageous Faith, and Tender Humanity," artists paint and connoisseurs recommend "Satyrs, Furies, and Monsters." Such works as the Raphael Cartoons, he writes in another essay, "with the great and venerable Simplicity of the Scripture Stories, had better Effects

than now the Loves of *Venus* and *Adonis,* or *Bacchus* and *Ariadne* (Nos. 172, 142). And finally, in No. 226, wholly devoted to the subject, he begins by referring to his earlier complaint "that the Art of Painting is made so little Use of to the Improvement of our Manners" and argues that "Images of Virtue and Humanity" should be instilled in painting:

> Who is the better Man for beholding the most beautiful *Venus,* the best wrought *Bacchanal,* the Images of sleeping Cupids, Languishing Nymphs, or any of the Representations of Gods,˙Goddesses, Demygods, Satyrs, *Polyphemes,* Sphinxes or Fauns? But if the Virtues and Vices which are sometimes pretended to be represented under such Draughts, were given us by the Painter in the Characters of real Life, and the Persons of Men and Women whose Actions have rendered them laudable or infamous; we should not see a good History-Piece without receiving an instructive Lecture.

And he adds that the best proof of this assertion is "the Testimony of every reasonable Creature who has seen the Cartoons in Her Majesty's Gallery at *Hampton-Court.*" Paintings such as Raphael's, he argues, express themselves "in Manner much more forcible than can possibly be performed by the most moving Eloquence."[72] On these grounds an engraver (as opposed to a painter) might think of himself as an inheritor and clarifier of (and ultimately capstone to) the tradition of the great Augustan moralists, without losing touch with the tradition of history painting. Hogarth frequently echoes the sentiment, insisting that his prints embody "what cannot be conveyed to the mind with such precision and truth by any words whatsoever," and that "occular demonstration will convince and improve man sooner than ten thousand Vols" (AN, 215). A case is also implied for the readily duplicated reproduction over the single original.

Moreover, history painting is now merely decorative and operatic, concerned with satyrs and nymphs, out of touch with real people and real problems; to be proper history painting the mythological subjects should be replaced by meaningful ones—"the character of real Life, and the Persons of Men and Women whose Actions have rendered them laudable or infamous." Steele here seems to prefigure Hogarth's "modern moral subjects"; although his theory (like his theory of stage comedy) seems to seek the representation of good examples rather than bad, in his analysis of the Raphael Cartoons he

singles out for praise the portrayal of the "mercenary Man" who falls down dead in *The Death of Ananias* and the "graceless Indignation of the Sorcerer, when he is struck blind" in *The Blinding of Elymas*.[73]

Steele's coadjutor, Joseph Addison, presented the conventional assumptions about the European schools of painting, and Hogarth hardly deviated from them. In the description of an art gallery in *Spectator* No. 83, we are told that among the living artists, a painter (French) named Vanity paints all his faces with smirks, glaring colors, and fluttering garments. Stupidity (a German) copies him. Fantasque (a Venetian) produces "agreeable Monsters," pictures full of "Distortions and Grimaces" (like Italian opera). Industry (a Dutchman) puts in every single hair and candle effects. And Time passes from picture to picture varnishing them to make them seem (but only seem) greater.

Steele repeats the same stereotype: "*Italy* may have the Preference of all other Nations for History-Painting; *Holland* for Drolls, and a neat finished manner of Working; *France,* for Gay, Janty, Fluttering Pictures; and *England* for Portraits" (No. 555). But Steele emphasizes the last fact, that the English are the best face painters, in spite of their tendency to downgrade themselves. England was famous for the production of "character," "humors," and expressive faces. And so, though the English at present fall short of the ancients in painting, as in poetry, oratory, history, and architecture (No. 249), England has the natural assets for the portrait painter:

> what the Antique Statues and Bas-reliefs which *Italy* enjoys are to the History-Painters, the beautiful and noble Faces with which *England* is confessed to abound, are to Face-Painters.

Steele writes about the need for "charming Portraitures, filled with Images of innate Truth, generous Zeal, couragious Faith, and tender Humanity," instead of the "satyrs, Furies, and Monsters"—including Hogarth's "Monsters of Heraldry"—that have dominated the art scene (No. 172). English artists will find this not in European galleries but at home, in the Raphael Cartoons.

Steele goes on to analyze the expressions of the characters in the Cartoons, in the manner of Le Brun's *Conférences* and the doctrine of *l'expression des passions:* each face in a group should be meaningful in itself.[74] What one infers is that a *modern* history painter goes not to

Italy and ruined bas-reliefs but to contemporary English faces. Steele is laying out a kind of painting based on portrait-painting in the sense of contemporary English men and women—which will also be a *modern* version of history painting, strongly Raphaelesque and (by implication) Protestant.

Steele was by no means alone in his praise of the Raphael Cartoons: Sir Richard Blackmore praised them for the same reason in his *Hymn to the Light of the World* (1703).[75] But the chief authority for Hogarth (attending Vanderbank's Academy) would have been Jonathan Richardson, whose praise of the Raphael Cartoons was obsessive; the last word in the *Works* is "Raphael."[76] Richardson's three treatises (all, despite his attempt at generality, about painting) were crucial to Hogarth's understanding of the art: *The Theory of Painting* (1715) and the *Essay on the Art of Criticism, as far as it relates to Painting* and *The Science of a Connoisseur* (1719). From these he would have imbibed certain basic assumptions he never shook off; he would have disagreed with and parodied certain other ideas; but the books remained part of his baggage. He carried with him the notion of the preeminence of the Raphael Cartoons; he was never to forget Richardson's constant repetition of the need for an "English School" of painting, though he would come to contest the wisdom or practicality of encouraging gentlemen to become "connoisseurs" and therefore "judges" of the art of this school.

He would have remembered Richardson's argument in *The Science of a Connoisseur* that "Instead of importing vast quantities of pictures," England should produce its own and "supply other nations with better than now we commonly take off their hands: For," he goes on, extending the market from gentleman connoisseurs to the middling and even lower sorts,

> as much a superfluity as these things are thought to be, they are such as no body will be without; not the meanest cottager in the kingdom, that is not in the extremest poverty, but he will have something of [a] picture in his sight. . . . These ornaments people will have as well as what is absolutely necessary to life, and as sure a demand will be for them as for food and cloaths.[77]

Hogarth took these words seriously, though, being an engraver by profession, he saw and exploited the most obvious way to extend his audience.

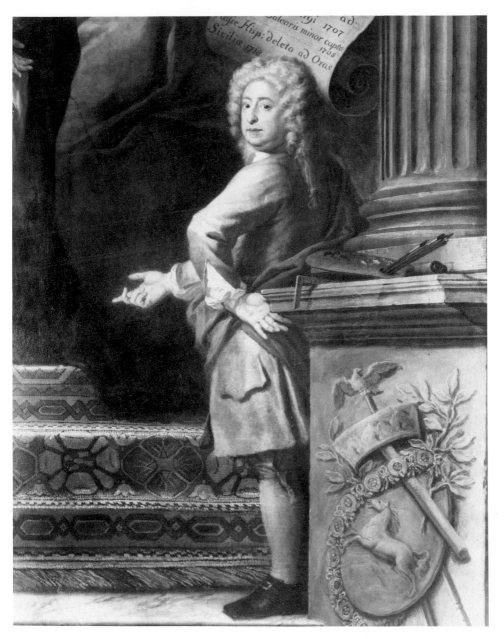

23. Sir James Thornhill, *Self-portrait* (detail of fig. 24).

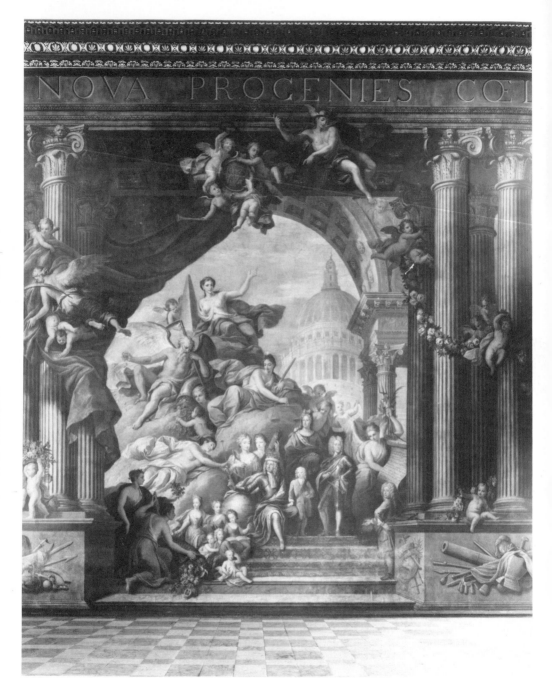

24. Sir James Thornhill, *George I and His Family*, Upper Hall, Royal Naval Hospital, Greenwich; 1722–1724 (British Crown Copyright).

25. *Royalty, Episcopacy, and Law;* May 1724;
7¼ × 7 in. (courtesy of the British Museum,
London).

26. *His Royal Highness George, Prince of Wales;* date un-
known; 5¾ × 7 in. (courtesy of the British Museum,
London).

27. Sir James Thornhill, *Hercules Defeating Calumny, Detraction, and Envy:* detail of the Painted Ceiling, Lower Hall, Royal Naval Hospital, Greenwich; 1707–1717 (British Crown Copyright).

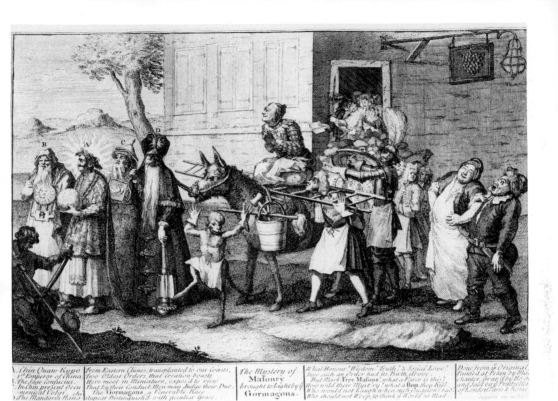

28. *The Mystery of Masonry Brought to Light by yᵉ Gormagons* [*sic*] (second state); Dec. 1724; 8½ × 13½ in. (courtesy of the British Museum, London).

*Don Quixote takes the Puppets to be Turks, and
Attacks them to rescue two flying Lovers.*

29. Charles-Antoine Coypel, *Don Quixote Demolishing the Puppet Show* (engraving by Gerard Vandergucht); 1725 (courtesy of the British Museum, London).

30. Sir James Thorn-
hill, Sketchbook, f. 29
(courtesy of British
Museum, London).

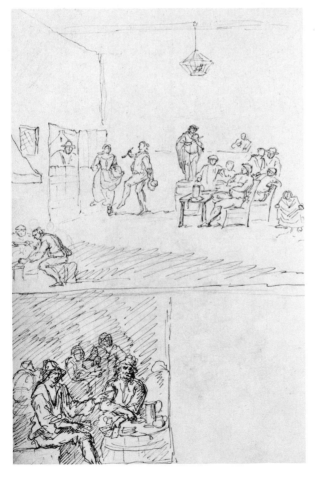

31. Sir James Thorn-
hill, Sketchbook, f. 52
(courtesy of the British
Museum, London).

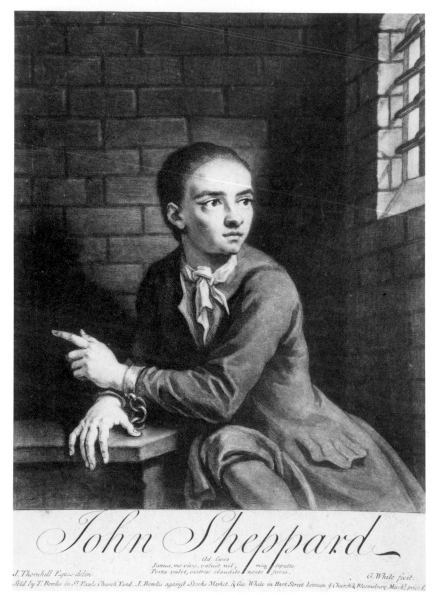

John Sheppard

Ad vives

Janua, me vivo, valuit nil, meq, sepulto
Porta valet, vestras claudite nocte fores.

J. Thornhill Eques delin.

G. White fecit.

Sold by I. Bowles in St Pauls Church Yard. J. Bowles against Stocks Market. & Geo. White in Hart Street between ye Church & Bloomsbury Mark.t price 1.

(Above)
32. Sir James Thornhill, *Jack Sheppard* (mezzotint engraving by George White);
Dec. 1724 (courtesy of the British Museum, London).

(Facing page, top)
33. *A Just View of the British Stage* (second state); Dec. 1724; 7⅛ × 8⅜ in. (courtesy of the British Museum, London).

(Facing page, bottom)
34. Sir James Thornhill, *The Landing of George I,* Upper Hall, Greenwich; ca.
1722 (British Crown Copyright).

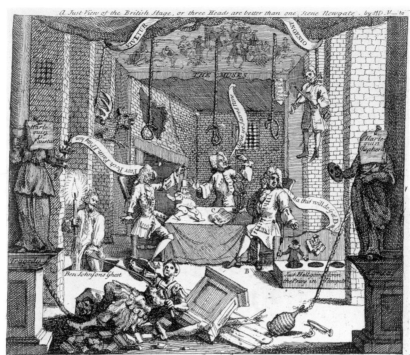

A Just View of the British Stage, or three Heads are better than one. Scene Newgate. by MD V— to

This Print Represents the Rehearsing a new Farce that will Include y two famous Entertainments Dr Faustus & Harlequin Shepherd to w will be added Scaramouch Jack Hall the Chimney Sweeper's Escape from Newgate through y Privy, with y comical Humours of Ben Johnsons Ghost, Concluding w the Hay-Dance Perform'd in y Air by y Figures A.B.C. Assisted by Ropes from y Muses, Note, there are no Conjurors concern'd in it as y ignorant imagine y The Bricks, Rubbish &c will be real & y Excrements upon Jack Hall will be made of chew'd Gingerbread to prevent Offence. Vivat Rex. price six pence

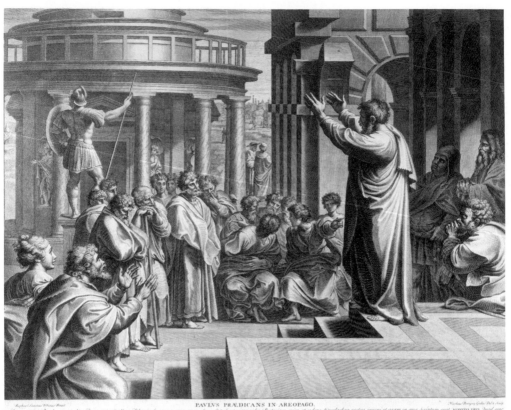

PAVLVS PRÆDICANS IN AREOPAGO.

35. Raphael, *Paul Preaching at Athens* (engraving by Nicholas Dorigny); 1719 (courtesy of the British Museum, London).

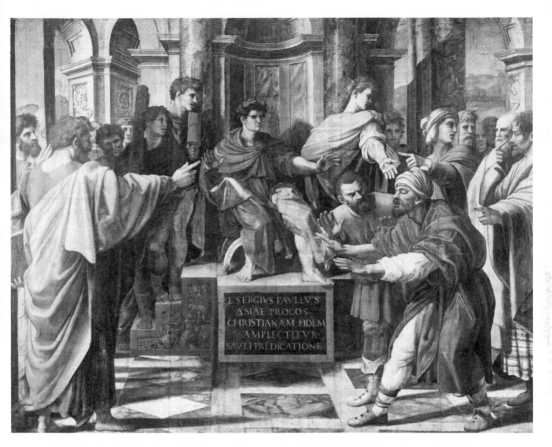

36. Raphael, *Paul and Elymas* (cartoon); 1515–1516 (Victoria and Albert Museum).

37. Sir James Thornhill, *Life of St. Paul,* Cupola of St. Paul's Cathedral; 1715–1720 (reproduced by permission of the dean and chapter of St. Paul's Cathedral).

38. *A Burlesque on Kent's Altar-piece at St. Clement Danes;* Oct. 1725; 11⅛ × 7 in. (courtesy of the British Museum, London).

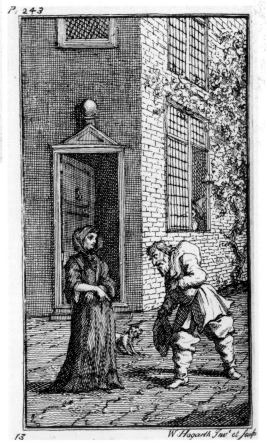

39. *Hudibras Wooing the Widow,* illustration for *Hudibras;* executed ca. 1721, publ. 1726; 4⁹⁄₁₆ × 2¹¹⁄₁₆ in. (courtesy of the British Museum, London).

40. Frontispiece, *Hudibras* (large plates); Feb. 1725/26; 9⅜ × 13⁹⁄₁₆ in. (courtesy of the British Museum, London).

41. *Hudibras Sallying Forth* (second state); 9¹¹⁄₁₆ × 13¼ in. (Royal Library, Windsor Castle copyright 1990. H. M. Queen Elizabeth II).

42. *Hudibras's First Adventure* (second state); 9 9/16 × 13 in. (courtesy of the British Museum, London).

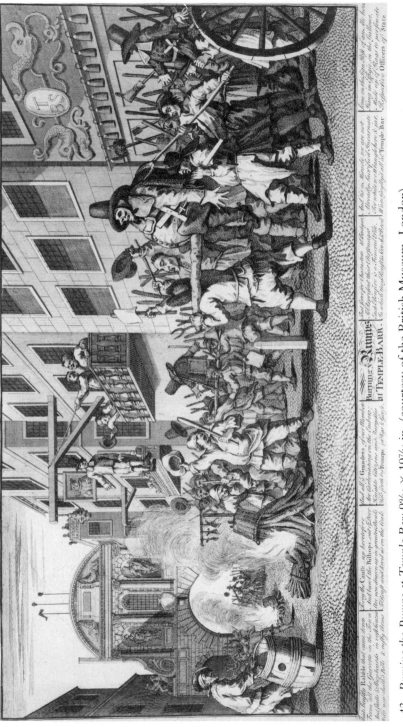

43. *Burning the Rumps at Temple Bar*; 9⁹/₁₆ × 19⁷/₁₆ in. (courtesy of the British Museum, London).

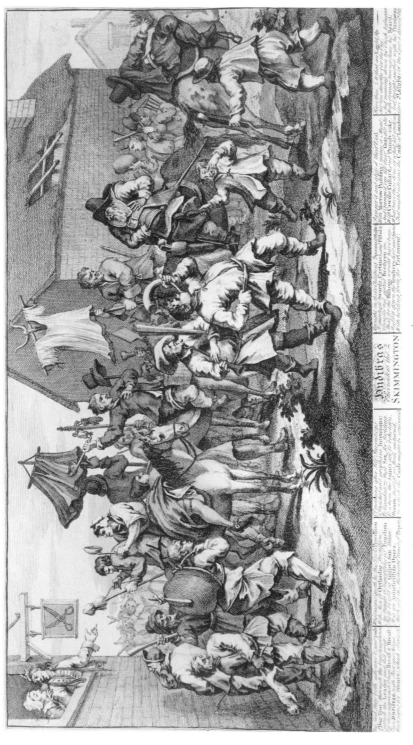

44. *Hudibras and the Skimmington* (first state); 9¹¹/₁₆ × 19½ in. (courtesy of the British Museum, London).

45. Annibale Carracci, *Bacchus and Ariadne* (etched copy of the fresco); 1597–1600 (courtesy of the British Museum, London).

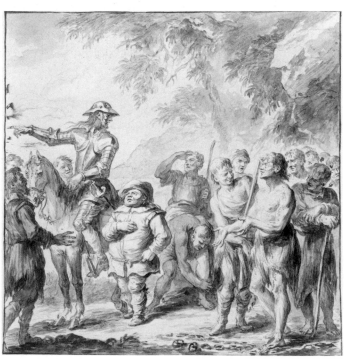

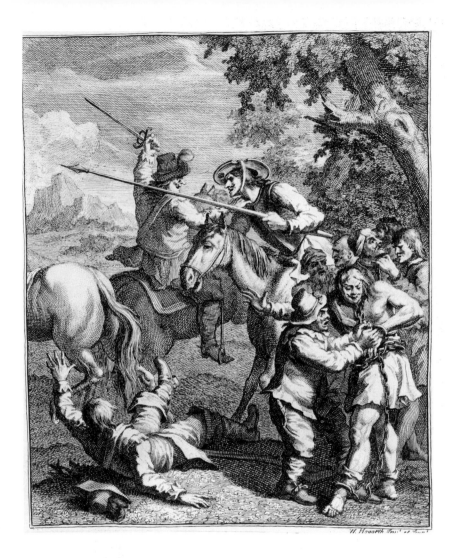

(Facing page, top)
46. *The Freeing of the Galley Slaves,* illustration for *Don Quixote* (drawing); ca. 1727; 9⅜ × 7⅜ in. (Royal Library, Windsor Castle copyright 1990. H. M. Queen Elizabeth II).

(Above)
47. *The Freeing of the Galley Slaves,* illustration for *Don Quixote* (engraving, first state); ca. 1727; 8¹¹⁄₁₆ × 7⅛ in. (courtesy of the British Museum, London).

(Facing page; bottom)
48. John Vanderbank, *Freeing the Galley Slaves* (drawing), illustration for *Don Quixote;* ca. 1727 (courtesy of the British Museum, London).

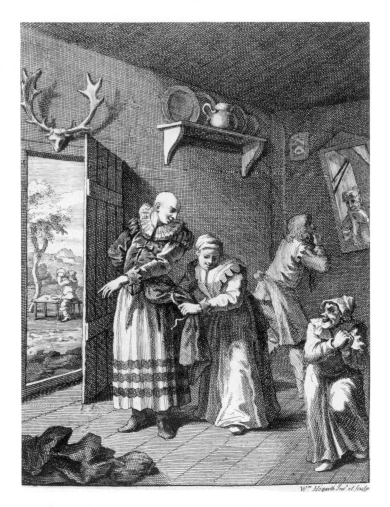

W^m Hogarth Inv^t et sculp

SANCHO *at the Magnificent Feast Prepar'd for him at his government of* Barataria, *is Starved in the midst of Plenty,* Pedro Rezzio *his Phisician, out of great Care for his health ordering every Dish from the Table before the Governour Tasts it.* Printed for H. Overton & J. Hoole *at the White Horse without Newgate.*

W. Hogarth Inv. et Sculpsit.

(Facing page, top)
49. *The Curate and the Barber Disguising Themselves,* illustration for *Don Quixote* (engraving, first state); 9 × 6⅝ in. (courtesy of the British Museum, London).

(Above)
50. *Sancho's Feast* (third state); date unknown; 10⅞ × 11⁹⁄₁₆ in. (Royal Library, Windsor Castle copyright 1990. H. M. Queen Elizabeth II).

(Facing page, bottom)
51. *Sancho's Feast* (first state, detail) (courtesy of the British Museum, London).

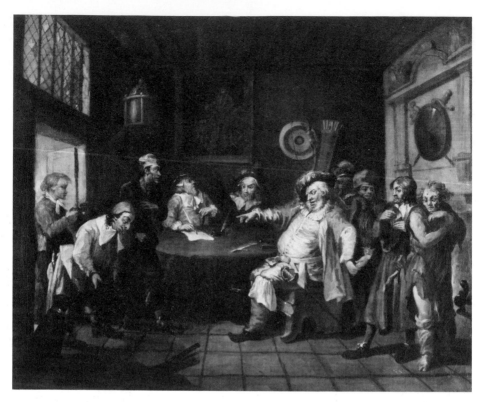

52. *Falstaff Examining His Recruits;* painting; 1727–1728; 19½ × 23 (private collection).

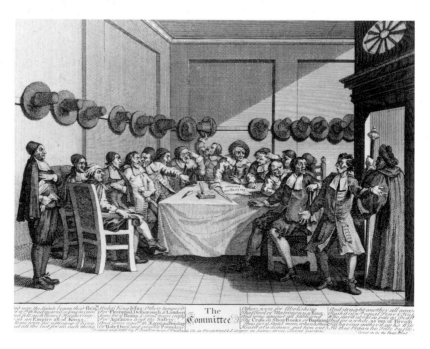

53. *The Committee,* large illustration for *Hudibras* (first state); 1726; 9⁷⁄₁₆ × 13¼ in. (courtesy of the British Museum, London).

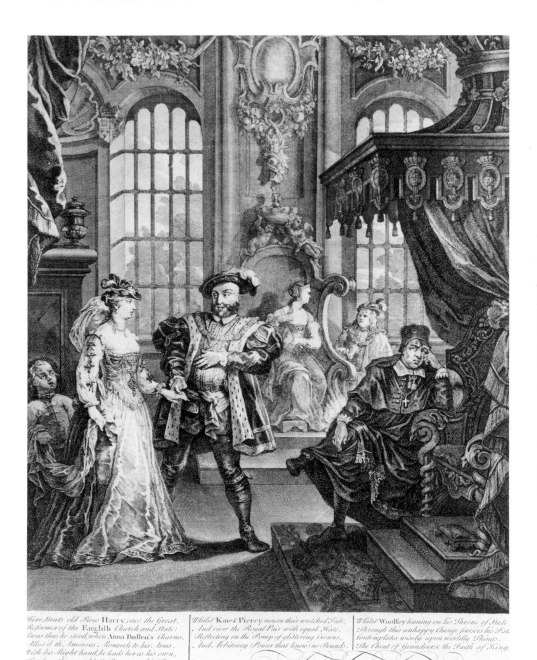

Here Struts old Pious Harry, once the Great,
Reformer of the English Church and State:
'Twas thus he stood, when Anna Bullen's Charms,
Allur'd th' Amorous Monarch to her Arms.
With his Right hand, he leads her as his own,
To place this matchless Beauty on his Throne;

Whilst Kate & Piercy mourn their wretched Fate,
And view the Royal Pair with equal State,
Reflecting on the Pomp of glittering Crowns,
And Arbitrary Power that knows no Bounds.

Whilst Woolsey leaning on his Throne of State
Through this unhappy Change forsees his Fate
Contemplates wisely upon worldly Things,
The Cheat of Grandeur & the Faith of Kings.

54. *Henry the Eighth and Anne Boleyn* (first state); ca. 1727/28; 17⅜ × 14⁵⁄₁₆ in. (courtesy of the British Museum, London).

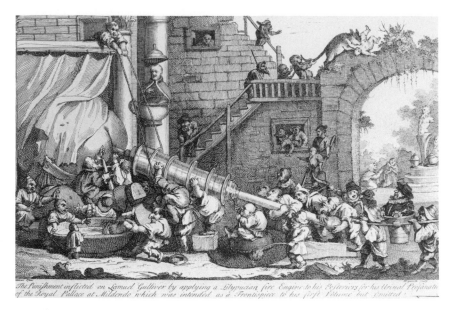

The Punishment inflicted on Lemuel Gulliver by applying a Lilyputian fire Engine to his Posteriors for his Urinal Profanation of the Royal Pallace at Mildendo which was intended as a Frontispiece to his first Volume but Omitted

55. *The Punishment Inflicted on Lemuel Gulliver* (first state); Dec. 1726; 7⁷⁄₁₆ × 12⅛ in. (courtesy of the British Museum, London).

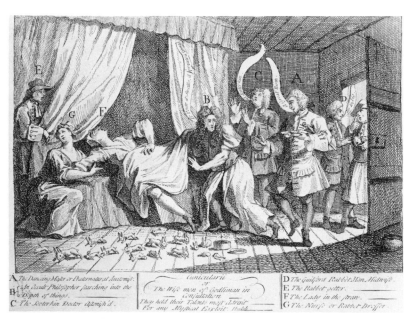

A *The Dancing Master or Praeternatural Anatomist.*
B *An Occult Philosopher searching into the Depth of things.*
C *The Sooterkin Doctor astonish'd.*

Cunicularii
or
The Wise men of Godliman in Consultation.
They held their Talents most Adroit
For any Mystical Exploit

D *The Guilford Rabbet Man Midwife.*
E *The Rabbet-getter.*
F *The Lady in the strain.*
G *The Nurse or Rabbet Dresser.*

56. *Cunicularii, or the Wise Men of Godlimen in Consultation;* Dec. 1726; 6⁵⁄₁₆ × 9⁷⁄₁₆ in. (courtesy of the British Museum, London).

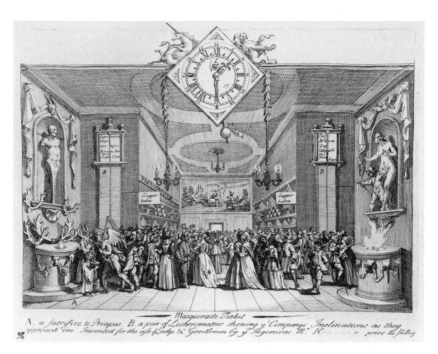

57. *Masquerade Ticket* (second state); 1727; 7³⁄₁₆ × 10 in. (courtesy of the British Museum, London).

58. The Great Seal of England (from the Walpole Salver); 1728/29; 9¼ in. diam. (courtesy of the British Museum, London). This is an impression taken from the silver plate, now in the Victoria and Albert Museum.

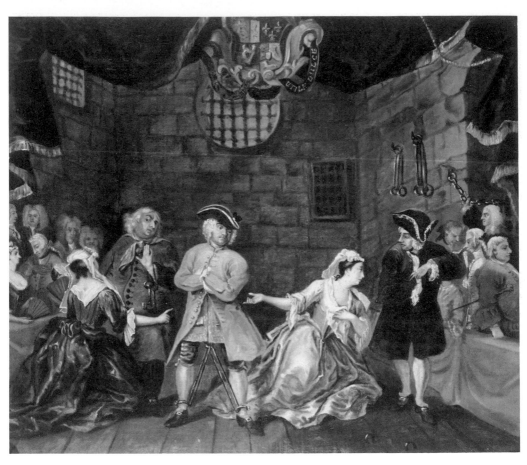

59. *The Beggar's Opera* (I); painting; 1728; 18 × 21 in. (courtesy of the Lewis Walpole Library, Yale University).

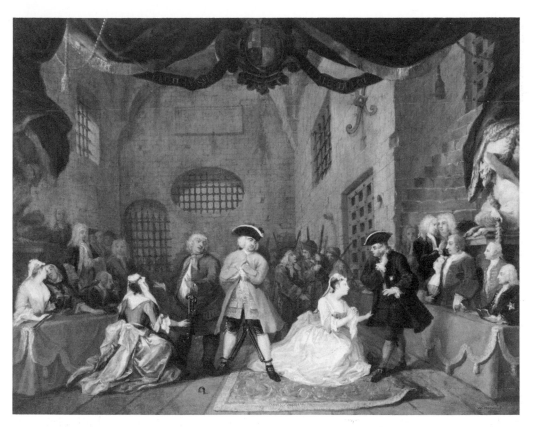

60. *The Beggar's Opera* (V); painting; 1729; 23¾ × 28⅞ in. (Yale Center for British Art, Paul Mellon Collection).

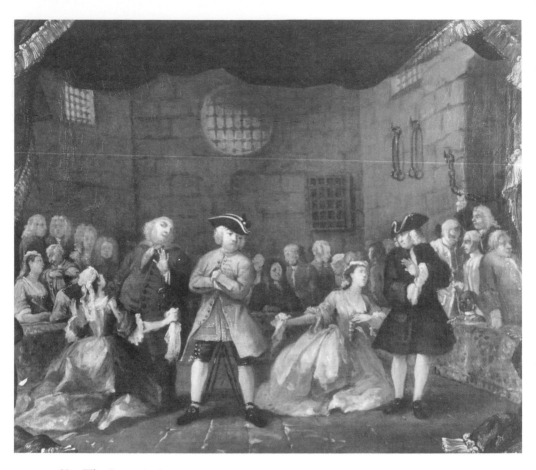

61. *The Beggar's Opera* (IV); painting; 1728–1729; 19 × 22½ in. (National Gallery of Art, Washington, Paul Mellon Collection; photograph: Courtauld Institute of Art).

62. Detail of fig. 61.

63. Detail of drawing for *Hudibras's First Adventure* (fig. 42) (Royal Library, Windsor Castle copyright 1990. H. M. Queen Elizabeth II).

THE FRENCH CONTEXT

The *Spectator* was expressing a view of art that found a parallel expression in some quarters in France. A new model for the aesthetic transaction and the art world had been developed in Paris by the early 1720s, based on popular fairs and theater, on the mingling of elitist and popular elements, and primarily on the example of Antoine Watteau (who visited England in 1720). Much of what Hogarth was doing in the 1720s and early 1730s had been undertaken roughly a decade earlier in France.

First, there was the sketching in of a new concept of audience, of the "public" that Thomas Crow describes as a space in which the administration of art began to change—from above to below and from the patron to the "public," with the salon offering an opportunity for transition. The chief phenomenon was the breaking down within the salon's exhibition space of "all the boundaries and distinctions which demarcate a ranked society." [78] Because of the political situation in England, especially the nature of its court, the salon did not emerge as a viable picture space. But at the same time the French were also developing alternative public spaces (to the salon, but also the salesroom, church, and court of law) in the festival, fair, marketplace, and theater.

Crow shows that in France the "public" expression connected with these public exhibitions of art ("shifting, heterogeneous, largely anonymous, unstable in its demands if it had any, and for the most part not in the market for pictures," 13) was essentially of *un*official, subculture opinion. Conversely, we might suspect that its opinion merely reflected filtered-down fashion, the most retrograde taste. But whether the artists or the public created this "public" opinion, there was a change in the *kind* of painting called for: private painting, for the connoisseur, was "learned and difficult, artificial and self-referential in style, aspiring to the sophistication of literary classicism and the audience that all this implied." But to this was opposed the "care-worn merchant or apprentice clerk" who was more interested in "everyday life, its physical imprint on the body, its costume, texture, and grit" (17). In England the latter was the low audience fit for "mechanics" posited by Shaftesbury.

These were the French equivalents of the two audiences Hogarth sought to attract in England between the 1720s and 1740s. What

L.-S. Mercier wrote late in the century of the "popular" event ex-
perienced by the nonelite audience attending a salon applies to the
audience Hogarth cultivated: the art "provides an occasion for the
manifestation of a popular identity and assertiveness opposed to
the elite and propertied."[79] But this is an audience that delights in art
that draws upon their own "popular" materials. It "draws on a reser-
voir of 'popular' materials distinct from the elite culture on display—
Gargantua, demons, Christian legend" (in England, the materials of
Bartholomew Fair). Because these spectators are free of the filtered-
down fashions from above, they enjoy a range of interpretation and
evaluation of the works of high art: they have "an alternative culture
at their disposal" in the light of which they can deflate the preten-
sions of the high art.

The Paris fairs were places to display art of this sort, but (in com-
mon with London fairs) they were also the *subject* of this art—includ-
ing the Italian theater, tightrope acrobats, farces, and pantomimes. In
France, the disreputable quality was attractive, as it obviously was
with even those, like Addison, Pope, and Hogarth, who attacked the
phenomenon of farces and pantomimes. (The transference of these
farces in Paris from the fair to the aristocratic salons paralleled the
move from Smithfield to St. James chronicled in Hogarth's *Masquer-
ades and Operas* and Pope's *Dunciad*.) "For it was the very imperfec-
tion of their performances, the outlandish and seemingly artless mix
of genres and effects that attracted fashionable spectators" (Crow,
53): the same sort of mix that led Thornhill to paint the Allegory of
the Protestant Succession, the Life of St. Paul, *and* a portrait of Jack
Sheppard.

One can follow the same process of public exhibition of art in En-
gland one decade later than in France, from the later 1730s to the
1750s, largely the work of Hogarth. The utilization of the theater and
fair, however, was already part of Hogarth's strategy in the 1720s,
first as satire in *Masquerades and Operas,* then as mimesis in *Hudibras*
and the paintings of theatrical scenes that followed. But clearly Ho-
garth knew the French émigrés and was certainly aware of the prece-
dents and differences in the Paris art scene.

He would also have known the scenes drawn from well-known
plays by Claude Gillot (who taught Watteau) as early as the *Scène des
carosses* of ca. 1707, which he later echoed in *Rake* 4; Gillot was also a
set painter and had close theater contacts. The fair theater in Paris,
like the West End theaters in London (also drawing upon the fairs),

depended on such travesties of the classics as *Harlequin-Aeneas, or The Fall of Troy* (first performed in 1711 at the St. Laurent Fair).[80] This was the unofficial theater, parallel to the unofficial exhibitions with their still lifes and hunting scenes, which expressed a popular preference for nonhierarchical works. Something like a "popular taste" emerges, characterized most generally by antihierarchical genres, a love of illusionistically treated everyday subjects, and morality.

Finally, the 1720s series of prints-after-paintings (Poussin's *Sacraments,* Le Sueur's *Life and Death of St. Bruno,* and Le Brun's *Battles of Alexander*—like the English series that included Dorigny's *Raphael Cartoons* and Laguerre's *Battles of Marlborough*) was augmented by Julienne's *recueil* of prints after Watteau, a model for the presentation of the oeuvre of a contemporary (in this case recently deceased) French painter. This series of etchings and engravings was completed in 1729, issued in bound volumes.[81] Hogarth's bound volumes of his own oeuvre began to be advertised in 1737. The French series were popular with a cosmopolitan elite, a financial elite, including well-off merchants, who wished to slum and replace the official art of the past with the new art that was Rubeniste, inspired by the contemporary art of Watteau, and indeed served as propaganda for that new art.

KENT'S ALTARPIECE

The question of what constitutes history painting arose in a somewhat different form in 1725, when Thornhill and Hogarth clashed a second time with William Kent. It was a year of minor irritations for Thornhill. In May he demanded more money for the painting of the Upper Hall at Greenwich, stating that "the three sides of the Upper Hall are nearly finished and the painting of the front wall far advanced." In June, after unsuccessfully trying to bring down his price, the board agreed to pay £500 for the whole work, which was finished by July 1726. According to Hogarth's story, told in *The Analysis of Beauty,* Thornhill was not happy with the settlement—£500 does seem little for the Upper Hall—and so retaliated by turning over the unfinished "front Wall" with the portraits of the royal family to his assistant.[82]

Then on 26 June, Kent, who had been making handsome profits from the Kensington apartments since 1722, was notified by his

friend the duke of Grafton that he had been commissioned to paint the ceiling and wainscots of the Gallery and the Great and Little Closet. A Mr. Howard, evidently one of Kent's assistants, was commissioned at the same time to do the gilding and provide scaffolds for the painters. Thornhill was quick to respond and succeeded in quashing this infringement of his rights as Serjeant Painter to the king.[83] It was a small victory; the war was going to Kent, who succeeded Ripley as master carpenter in 1726 and became surveyor of the king's pictures.[84]

Meanwhile, however, Burlington and his other enthusiastic friends had been pushing Kent toward the chimera that was history painting. On 23 July 1724 he had written to Burrell Massingberd that he was engaged to paint an altarpiece for the new church in George Street near Hanover Square. In 1725 a commission was secured for him to paint an altarpiece for St. Clement Danes Church in the Strand, which was finished and in place by August—around the time Thornhill was trying to wrest the gilding away from Kent at Kensington Palace. On the 25th the *Daily Post* noted:

> The Altar Piece at the Church of St. Clement Danes, being a musical Representation, variously explain'd, some finding in it St. Cecilia and her Harp, and some, Princess Sobieski [the Pretender's wife] and her Son, but the Generality agreeing it was not a Thing proper to be placed there; upon Complaint to the Bishop of London at his last Visitation of the said Church, we hear his Lordship, in order to secure the Solemnity of the Place and Worship, and to preserve Peace and Unity among the Parishioners, hath lately very prudently order'd the Church Wardens to take it down.

A Letter from a Parishioner at St. Clement Danes to the Right Reverend Father in God Edmund Lord Bishop of London[85] reveals that the painting cost £80 and that the church was "thronged with spectators" when the word about its peculiarities got around, some of them Jacobites who "came not to join in prayer with the rest of the congregation, but to worship their Popish saint and hug themselves with the conceit of being alone in the secret" (a secret reminiscent of the Jacobite allegory behind the Gormogons). The only allusion to the painter appears in the sentence "When your Lordship shall examine, who is the Painter, and of what principle? how long he had been from the Court of Rome, before he painted that Picture? and whether he

brought no Picture or resemblance of the Princess Sobieski over with him?" The reference is clearly to Kent, who, though no Jacobite, was influenced by Italian art, known to have been awarded the pope's prize while in Italy, and apparently so influenced by Italian art that he unthinkingly produced a subject at odds with Protestant tradition—a saint and a musical party—and through sheer clumsiness stumbled into a likeness of the Pretender's wife.

One clergyman and several of the St. Clement parishioners tried to stop the bishop's order, but on 4 September the picture was taken down and hung in the vestry room.[86]

Hogarth was so intrigued by this event, nicely timed with Thornhill's small victory over the gilding, that he took time off from the *Hudibras* plates (of which six or seven must have been finished), to get in another dig at Kent and to express himself on the matter of religious art. His reaction must be gauged from his version of the altarpiece (fig. 38), a scathing commentary with its great, lumpy, totally bungled bodies (no doubt a final memory of drawing sessions at the academy), its conventional cherubs and clouds, and its total lack of spiritual significance.

The feelings of Kent and the Burlington circle about Thornhill were also recorded, not long after the altarpiece fiasco. On 28 August 1726 John Gay wrote the countess of Burlington, then on the Continent, to describe how he and Kent, having exhausted all the delights of London, sought entertainment one night at Bartholomew Fair. There they attended *The Siege of Troy,* in which, Gay noted, Settle undertook to correct Virgil in favor of poetic justice:

> for Paris was kill'd upon the spot by Menelaus, and Helen burnt in the flames of the town before the Audience. The Trojan Horse was large [as] life and extreamly well painted; the sight of which struck Kent with such astonishment, that he prevaild with me to go with him the next day to compare it with the celebrated paintings at Greenwich. Kent did not care to reflect upon a Brother of the Pencil; but if I can make any judgment from hums, & hahs, and little hints, he seem'd to give the preference to Bartholomew Fair.

He reports the explanation of the guide, who confuses cardinal virtues with Roman cardinals, the Princess Sophia with the princess of Savoy, and the queen of Prussia with the queen of Persia—the results being analogous to the misunderstandings over Kent's altarpiece.

"This is a proof that a fine puppetshow may be spoild and depreciated by an ignorant interpreter."[87] It is well to remember that Hogarth's opponents included satirists as sophisticated as he—and some who were his masters. It must have particularly delighted Kent and Gay to observe the ignorant detecting the same absurdities in Thornhill's paintings that Hogarth had recently pointed out in Kent's altarpiece. The parallel with puppet shows makes the attack all the more biting. Gay's letter also suggests that he knew the Burlingtons liked to hear such stories at Thornhill's expense, without any reflection being made on Kent as the storyteller.[88]

HOGARTH'S *HUDIBRAS* ILLUSTRATIONS

The precepts and conventions of history painting were first tested by Hogarth in twelve large engraved illustrations for Samuel Butler's *Hudibras,* which he executed during 1725. Appropriately, Hogarth made his initial statement about history painting as an engraver— before he could have considered himself a painter, perhaps before he had even touched brush to canvas. His *Hudibras* fitted into the tradition of history painting because history was understood in England primarily through engraved reproductions rather than the paintings themselves; these engravings implied large painted originals that did not exist. In a real sense the print, not the painting, was always Hogarth's history.

His progress was from the text on the opposite page in the illustrated book to the large independent engraved illustration that assumes the text in the viewer's mind. The illustration of books was, in Joseph Burke's words, "the underground channel by which traditions of *istoria* were kept alive in England at this period when the supply of patrons willing to give over the walls and ceilings of their mansions to grandiose decorative painting was a dwindling one."[89] But book illustration was also one way artists in the eighteenth century could make a break with great subject, great style, and great patronage. Book illustration permitted the artist to introduce other, more immediate or contemporary texts than those relied on by the history painter. Hogarth could shift his attention from Homer, Virgil, or the Bible to Cervantes, Molière, or even Samuel Butler, and

thence to his real interest, which was the contemporary scene, England in the 1720s.

The texts Hogarth illustrated were significant: his earliest choice was *Hudibras* (the small plates, for example, fig. 39), but his first published work was the set of documentary, descriptive plates for La Motraye's *Travels* (figs. 13, 14). These were followed by illustrations for a French romance, La Calprenède's *Cassandra* with its prototypical romantic lover Oroonadates and his passion for Statira; and then, by contrast, for a modern version of Apuleius's satiric antiromance *The Metamorphoses* (fig. 22). Two illustrations for *Paradise Lost* (unpublished) and a set of small Callot imitations illustrating Roman military punishments (figs. 10, 11) rounded off his apprenticeship for the large *Hudibras* illustrations.[90] The lessons of romance and antiromance, of baroque and grotesque styles, had been learned, and the form of the small vertical book illustrations was now exchanged for the large horizontal sheet that recalled a history painting, or rather one of the engravings after the Raphael Cartoons, Laguerre's *Battles of Marlborough,* Thornhill's *Life of St. Paul,* not to mention Coypel's *Don Quixote.*

Hogarth's subject was appropriately a modern Quixote, the figure described by Addison (*Spectator* No. 413) who wanders in an illusion of secondary qualities such as color but exists in a real black-and-white world like that of the engraver's lines. For the illustrator of *Hudibras,* the "English *Don Quixote,*" had a text that opened up the possibility of mock-heroic satire, juxtaposing the heroic, the romantic, and the plainly fictional with the low events of everyday English life.

What *Don Quixote* embodied for Hogarth (as for Butler, Swift, Fielding, and others) was the essence of comic structure, the incongruous. Quixote (or Hudibras) is satirized by contrast with an ideal, or at least normative, figure (as in *The South Sea Scheme* Hogarth contrasted the gambling clergymen with St. Paul's); two figures or realities are comically juxtaposed.[91] But the incongruity was between the aspiration or delusion of a Don Quixote and the reality (or normality) of his surroundings, between the image of a knight-errant with his heroic steed and the tall, bony, decrepit Quixote and Rosinante, and in formal terms between these lanky shapes and the short, mundane, well-fed shape of Sancho, amid inns, herds of sheep, and windmills. In one sense Quixote is being satirized as mad; but in an-

other—certainly as the novel develops in its second part—the worlds of chivalric romance and contemporary "reality" merely illuminate each other.

Sometime before the autumn of 1725, Hogarth came to an understanding with the printseller Philip Overton about producing a set of large illustrations for *Hudibras*. He made careful drawings that reflect both his recent academic training and his need for a finished product to show Overton. The drawings are equally polished but executed in different styles: one is begun in a pale yellow wash and finished with a delicate pen line; another is done more boldly in red chalk. The drawings become sketchier and less complete as they near the end of the series: they have served their purpose with Overton, and now Hogarth can work for himself. His own sketches are more often private notations; only the ones made for submission to a publisher or for another engraver are relatively finished.

Overton may have been impressed with the success of *Masquerades and Operas,* or Hogarth may have approached him with samples; whoever conceived the idea, Overton's reluctance to attach Hogarth's name to the advertisements suggests that he considered the subject more important than the artist. The scheme also played on the popularity of Coypel's recent *Don Quixote* plates. Hogarth had seen the French edition, engraved by Nicholas de Beauvais, before he copied some of the figures in his *Mystery of Masonry;* Overton published large copies, engraved by George Bickham and J. Mynde, in 1725, and their success must have suggested to either Hogarth or Overton that "the don Quixot of his Nation," as they called Hudibras in the ads, could profitably be treated in the same way. When Hogarth's *Hudibras* prints appeared, Overton advertised them along with the *Quixote* prints, and continued to do so as late as 1728.[92]

Hudibras was the satire Hogarth had turned to earlier, as perhaps his first attempt at book illustration, and it is easy to imagine him experimenting, copying, elaborating, gradually inventing his own style and designs with this book which may from childhood have stimulated his impulse toward satire. *Hudibras,* as distinct from *Don Quixote,* offered him two elements: an emblematic satire, full of puns and symbolic objects, and travesty—the sustained point-for-point reduction of religious pomposity and the outmoded heroic ethos. The small illustrations were closer to the method of Butler himself;

based on designs in the wooden style of English book illustration of the 1700s, they were rough but forceful versions of Dutch low-life pictures—an experiment in the grotesque. The Hudibras of the 1710 edition is simply a deformed little old man going through the paces indicated by Butler's verses.

In the large plates Hogarth associates the illusory world of Quixote–Hudibras with the idealizing of history painting, which was aimed primarily at glorifying kings, wars, and the values of the aristocracy. (Coypel's delicate rococo illustrations for *Quixote* did not supply a model for the comic juxtaposition of contemporary and ideal, grotesque and heroic.) Hogarth makes his departure clear in his frontispiece (fig. 40), which includes in one design the satyrs, fauns, putti, and goddesses of baroque book illustration—and, for that matter, of the mythological history paintings attacked by Steele—with the grotesque shapes of Butler's characters. A satyr lashes Hudibras and Ralpho, yoked to the scales of Justice and drawing his chariot around the foot of Mt. Parnassus, and leading, as in a triumphal procession, the allegorical figures of Hypocrisy, Ignorance, and Rebellion. The putto who sculpts this scene has for his model not ideal Nature (portrayed by Britannia) but a copy of Butler's satiric poem, held before him by another satyr. This group is balanced on the other side of the frieze by a faun holding up to Britannia's face a mirror which reflects an undistorted image, implying that England under the Hanovers no longer resembles Butler's picture (the caption refers to the "Vices of his Times"), and also that Hogarth has deliberately turned for his subject from ideal Nature to satire—yet still within the conventions of history painting, exemplified by the putti and satyrs.

But in the frontispiece these conventional putti and satyrs are the fully realized figures, moving about in the picture space, while Hudibras and Ralpho are artifacts carved in bas-relief. In the subsequent plates Hudibras and Ralpho take over and the conventional emblematic figures disappear, although references remain in the size and relative monumentality of the contemporary figures and the heroic compositions in which they perform. The result is what might be called a grotesque history painting, one step on the path to what Steele seemed to be defining as modern history painting.

The putti of the frontispiece introduce the history-painting context (as they will in the subscription ticket for *A Harlot's Progress,* fig. 107). Even Shaftesbury recognized that the low or grotesque was not

out of place in history, as with "often Raphael himself; a cook, a pharisee, a thyrsides, amidst the other homerical forms." If used by itself, as in Dutch painting, the grotesque is "detestable and odious," but it can be an effective way to *set off* the heroic.[93] The beggars in Raphael's *Healing of the Lame Man,* the usual example of the grotesque within history painting, were cited later by Hogarth when he distinguished this sort of representation from "caricature" in *Characters and Caricaturas* (1743).

Given the large-sheet format, Hogarth finds a graphic equivalent for Hudibras's Quixotism in the sweeping baroque forms (readily available to Londoners in engraved copies) of continental history painting. He places Hudibras, looking like the small misshapen figure he is, hump and all, in the midst of a group of English rustics carrying out a Skimmington procession (fig. 44); but he depicts them in the forms and poses of the procession of heroic revelers in Annibale Carracci's *Marriage of Bacchus and Ariadne* (fig. 45). The specific choice was appropriate: what better heroic parallel for a Skimmington, in which the mock husband and wife are carried in procession, than a Bacchus and Ariadne? Ariadne, jilted by Theseus and rescued by Bacchus, is here replaced by the scold and her probably cuckolded husband. But—the important point—the swirling forms of the baroque serve as the graphic equivalent of Quixote's madness. And this model will serve Hogarth for placing his own contemporaries, who are also Quixotes in their poses of heroic (sometimes of biblical) delusion in the *Harlot's Progress,* followed by the *Rake's Progress* and *Marriage A-la-mode*. For *Hudibras* was also a historico-political poem, showing the whole world of the English civil war as unheroic, in both its gross reality and the illusions of heroism projected by the combatants and those who remembered and sentimentalized it.

If Hogarth refers to the baroque of Rubens and the Carracci as subject for parody, he uses the Raphael Cartoons as a normative structure of history. The plates of *Hudibras* are more clearly defined, more expressive and articulated, than Hogarth's earlier prints. The influence of academy drawing classes is evident, but Hogarth's principal model is the Cartoons, recalled by the rectangular plates and the horizontal band of figures, relatively large in relation to the picture space, with space above and one or more repoussoir figures below. (The most strikingly Raphaelesque plate is *Hudibras's First Adventure,* fig. 42.) The division into separable units and the clarity of each, the planar structure, the density of masses, the emphatic gestures of

the figures, the simple almost popular imagery, and the ordinary humans turned into symbols of universal applicability: all represent an English eighteenth-century version of the Raphaelesque High-Renaissance principles of pictorial composition. The monumentality and the planimetric, almost classical composition set off the *Hudibras* plates from the rollicking low-life scenes of the Dutch baroque as well as the delicate rococo of Coypel's *Don Quixote*.

Raphael's style dignified his subject matter, which was low—if not fishermen and tax collectors (as well as a Roman proconsul), then doctors, magistrates, clergymen, and prostitutes, but not kings and gods. Hogarth has not yet found a need—or a way—to show the dignity of his ordinary people, the positive Raphaelesque dimension. But he does make a distinction that is on the way to the mode of *The Beggar's Opera* and *A Harlot's Progress:* he uses the heroic level not to degrade the rustics but to suggest a level of misinterpretation and aspiration on the part of Hudibras, who sees in these peasants the gaudy show of an ornate processional or in a harmless bearbaiting a great battle. The history painting composition serves as a psychological referent, while at the same time helping to define the kind of picture Hogarth has produced. He is criticizing the baroque profusion and operatic quality by associating them with Hudibras's distorting imagination, as they psychologically define Hudibras. Far from a norm, the baroque shapes represent delusion, pretension, perhaps hypocrisy. But the norm against which this excess is presumably to be judged is found in the Raphaelesque shapes of true history painting which define the acts of ordinary folk.

The use of, and attitude toward, history painting may seem somewhat equivocal in the *Hudibras* plates. The history is, of course, religious and not mythological; Hudibras is a *religious* hypocrite. Interestingly, it is through the religious hypocrite that Hogarth broaches the character of those pretenders who are the subject of his various progresses. Hudibras's progress is a series of confrontations with the sane, if disorderly, secular world of bearbaiting, tippling, and cuckolding. The two oversized plates emphasize the conflict: the first shows Hudibras in futile combat with the Skimmington mob (fig. 44) and the second—the climactic plate (fig. 43)—depicts the populace rejoicing at the overthrow of Puritanism and the Restoration of Charles II, launching a Saturnalia that includes the burning of Hudibras and his followers in effigy. The confrontation of Carnival and Lent is a motif that runs, in one form or another, through Ho-

garth's work and reappears ten years later in *Night*—the climax of *The Four Times of the Day*—which also takes place on Restoration Day.

There was another fundamental difference between Hogarth's and the High Renaissance modes: details in Hogarth always seem additive rather than conforming to the High Renaissance principle of simplicity. Unlike the Cartoons, in each of which, "regardless of the quantity of forms, each design seems, in its entirety, simpler," Hogarth's quantity of forms complicates.[94] The principle of discrepancy and contrast is far stronger than unity in Hogarth's designs. There is a sense in which he was regressing to the quattrocento *copia* from which the Raphael Cartoons had completely diverged. He retained the demand on his viewer to read the parts before the whole comes clear, though he sometimes played with the first general impression of the whole in order to contradict it by a reading of the parts, thus producing a new whole.

These large independent plates also contribute the complex sense, which Hogarth of all his contemporaries grasped best, of a page of mixed engraving and type with intricate relationships between words and images. Each plate is his reconstitution of the poem itself, in his own visual terms, often based on visual puns corresponding to the words. In *Hudibras Sallying Forth* (fig. 41), for example, Hogarth illustrates the lines, "When civil Dudgeon first grew high, / And Men fell out they knew not why" (I.i.1–2), which refer in Butler's poem to upheavals both physical and political, to the king and Parliament, the High Church Anglicans and Puritans, and so forth. He transforms "high" into the size and position of the two figures Hudibras and Ralpho elevated on horseback, in relation to the rustic spectators. "Men fell out they knew not why" is dramatized in the literally falling fruit baskets and the figurative falling out between the two rustics. The latter is a result of the farmer's awe of the heroes; he backs into his wife's table, spilling the produce, for which she blames him; and so indeed he will never "know why" they began their quarrel. In a domestic metaphor Hogarth projects a small tableau of the country, its produce, its simple tenants, and its civil war, caused in fact by the grandiloquent gestures of heroic fools.[95]

The lines are reprinted under the design to allow a comparison between verbal and visual texts, in effect serving as part of an emblem, whose riddle is to be solved by the viewer. With Butler's text in mind, the viewer goes from the lines quoted to the visualization and

back again. Each stage, as Hogarth reveals his own interpretation of Butler's words, produces an incongruity or metamorphosis which should amuse. Indeed Hogarth's transformation is so thorough that another text is projected forward which is read emblematically out of the constituents of Butler's text, Hogarth's quotation, title (motto), and image—which is now the subject of a whole new construct put together by the viewer. And in this intellectual play lies the "comedy" of Hogarth's *Hudibras*.

There are, however, plates that do not invoke the model of Raphael. *The Committee,* for example, derives from a tradition of popular political prints (see fig. 53 below). But in *Hudibras Vanquished by Trulla,* where the Raphaelesque discipline is absent—perhaps Hogarth felt it indecorous in this case—he has trouble relating separate groups scattered across the plate. The scattering also brings out his inability to render the architectural elements as decisively as he does the figures.

Hogarth *needs* the Raphaelesque style, not only for formal reasons but, above all, to render the representation of contemporary English life respectable and to elevate it. If he has not yet found a need to show the dignity of the plebeians, he does seek to show the importance of his subject and, with it, his genre. For *Don Quixote* was taken as a paradigm by the artist who had two quite incompatible desires: to paint idealized history as the art treatises told him he should and to represent his own local, contemporary country and culture. For the writer *Don Quixote* served as the paradigm for the transition from similar literary forms—the epic, the romance—to the novel, which was the important new form to emerge in eighteenth-century England. The vehicle in both cases was the same, the mock-heroic mode that included the heroic and the realistic in the same frame, one as figure and the other as ground.

Something more of Hogarth's intention in these plates can be seen in his title page dedicated to the Scottish poet Allan Ramsay. Unfortunately one cannot be certain whether the surviving title sheets were used with the first (subscribed) impression or later. Ramsay, both a poet and an Edinburgh bookseller, subscribed for thirty sets, and evidently sold them in his shop.[96] There may have been some Scottish family connection, but Ramsay's north country background, certain aspects of his career, and the kind of poetry he wrote would them-

selves explain the dedication (considering the profession that Ramsay's son Allan, then twelve years old, was to follow, there was some prescience in it). Ramsay's poetry served as an inspiration to an art based on the familiar; Hogarth's dedication was at least partly for this reason (but with an eye to business as well).

Ramsay was born in 1684 or 1685, twelve years Hogarth's senior. After his apprenticeship he set up in Edinburgh in 1710 as a periwig-maker.[97] His first poems began to appear in 1713, and by 1718 he had established himself as his own publisher, an idea that might have had some influence on Hogarth. In 1719—another interesting parallel—he began a campaign against literary pirates, successfully appealing to the town council. In 1720 he published the octavo edition of his collected works and issued proposals for a subscribers' edition, which was published in Edinburgh 27 July 1721, calf-bound, on fine paper, with a frontispiece portrait of Ramsay and a list of subscribers that included such English literary figures as Steele and Pope. At a guinea a copy, this subscription brought Ramsay 400 guineas (he claimed that the South Sea crash prevented him from making more). The book must have been much talked of in London, and Hogarth would have seen it. More poems came rapidly from Ramsay's press: the first collection of *Fables and Tales* in 1722, the first volume of the *Tea-Table Miscellany* and *The Ever Green* (collections edited by Ramsay), and *The Gentle Shepherd* in 1725. Between 1723 and 1725 he gave up wigmaking for bookselling.

To Hogarth, he would have appeared a Scottish Samuel Butler, with overtones of William Hogarth in his generally heroic treatment of objects both commonplace and symbolic (as in "Tartana, or the Plaid"). Works such as "Lucky Spence's Last Advice," the deathbed speech of an old bawd, might seem Hogarthian, but the main exhibit would be *Christ's Kirk o' the Green.* There is a valuable truth in the remark by one of Ramsay's editors that Butler's forte was wit, Ramsay's humor: Hogarth's *Hudibras* resembles the spirit of Ramsay more closely than Butler in that it lies closer to ordinary reality. Butler is still a metaphysical poet at heart, though turning metaphysical fancy to his own satiric ends; Ramsay is "closer to nature."[98] Hogarth would have been especially interested in Ramsay's tailnote to *Christ's Kirk,* in which he offers a critical self-justification: "The main Design of Comedy [is] to represent the Follies and Mistakes of low Life in a just Light, making them appear as ridiculous as they really are, that each who is a Spectator, may evite his being the Object of Laughter."

Already Hogarth was picking and choosing, singling out those contemporaries with whom he felt a close link and in relation to whom he could define himself.

The co-dedicatee of the *Hudibras* plates was William Ward of Great Houghton, a London barrister, a man of about forty-four. He reputedly commissioned Hogarth to produce a set of *Hudibras* paintings for his country house, East Haddon Hall; there is no other recorded connection between them.[99] Although it may be placing the cart before the horse to see this commission as the reason for the dedication, such a theory would conform to Hogarth's later practice; he was likely to dedicate a series to the first subscriber, or to someone who subscribed and was so taken by the seven or eight plates he saw that he commissioned the series painted.

Proposals for the subscription to the *Hudibras* plates were published 6 October 1725, and the set was promised for Christmas; at this time "seven Plates" were "already done, and Specimens of them to be seen" at Overton's and Cooper's printshops.[100] It is evident from the dimensions given that two of the seven plates finished were *The Skimmington* and *Burning the Rumps at Temple Bar*. There is no mention of the artist's name, and the set was subscribed for only 15s, with 5s paid down. By 30 November, when a new advertisement appeared, the price had gone up to 18s. The increase was not explained, and only two more plates were finished. Some sort of disagreement or crisis must have arisen. It is difficult to imagine Hogarth being dilatory or turning to some other work (except briefly) when this important project was under way; an argument with Overton over the business aspect of the subscription, or illness, would be the most reasonable explanation. The Christmas publication date was not met, and there were no advertisements between 7 December and 3 February, when the plates were finally announced as ready for subscribers on the 24th (the subscription for the first impression was closed on the 12th). At this point the information that they were "Designed and Engraved by Mr. Hogarth" was added, and the price was once again reduced to 15s. The inclusion of the name at this late date can only mean that Hogarth insisted on it, or that the fame of the plates, seen in Overton's and Cooper's shops, had spread. (The unsigned *Kent's Altarpiece,* his only achievement in the interim, would hardly have drawn attention to him.) But his name was removed from the

ads once the plates were finished and announced ready for the sub-
scribers. This can only mean that there was some trouble over the
ownership of the plates.

On 3 May the seventeen small plates were also published, illustrat-
ing an octavo edition of *Hudibras*. Their belated publication was
clearly prompted by the success of the large plates; in the advertise-
ments and on the title page Hogarth's name appears prominently.

DON QUIXOTE

In the wake of the *Hudibras* plates, another major engraving project
was undertaken and abandoned; perhaps it was inevitable that the
"English *Don Quixote*" would be followed by the Spanish. Jacob
Tonson, who had seen but not used Hogarth's two illustrations for
Paradise Lost, was publishing a series of ambitious works in the
mid-1720s. An elaborate edition of Racine in 1723 was followed by
Tasso's *Gerusalemme Liberata* in 1724, both in the vernacular, both il-
lustrated luxury editions. Sometime in 1726 Tonson and Lord Car-
teret, the Whig politician, then lord-lieutenant of Ireland, projected a
similar Spanish-language edition of *Don Quixote*. If the story that
Queen Caroline complained to Lord Carteret that she could find no
edition of *Don Quixote* worthy of her library is true, she must still
have been Princess of Wales at the time;[101] Vanderbank's set of prelim-
inary designs is dated as early as 1726. She was to be disappointed,
for the book did not finally appear until 1738, the year after she died.

Carteret, known as an accomplished Spanish scholar and admirer
of Cervantes, apparently assumed responsibility for all aspects of the
edition. The Tonson edition of Tasso had simply used reengravings
of the Bernardo Castello designs (first printed in 1590), but Carteret
wanted original designs, and furthermore disapproved of Coypel's
rococo illustrations. One can only conjecture on what happened at
this point. Six finished engravings by Hogarth survive, and innum-
erable drawings by John Vanderbank eventually engraved by Gerard
Vandergucht, who had also engraved small copies of the Coypel il-
lustrations for another edition.[102]

It is easy enough to reconstruct Vanderbank's progress. Although
there are sometimes six or eight versions of a single scene leading up
to the engraved design, two main sets show the way he worked. A set

of sixty-two preliminary designs in the British Library is dated between 1726 and 1729 (five, however, are marked 1730) and signed with his full name and "invenit." A set of sixty-five in the Pierpont Morgan Library replace "invenit" with "fecit" to distinguish them from the preliminary designs; these are the finished drawings from which the engravings were made. They are all dated 1729 in Vanderbank's hand, some with the exact day of August and September. The tailpiece of two fighting horsemen, the last to be completed, is signed "December 22, 1729." This must have been the cutoff date; after that, Hogarth can have had no more contact with the project.

In fact, he was probably out of the picture by the end of 1727 when he began to devote himself to oil painting. His six illustrations are for the beginning of the book and deal, with one exception, with the same episodes as Vanderbank; but the precise moment and the interpretation are different. There is no way of knowing now whether they were asked to collaborate or to compete for the commission; whether Carteret invited one and Tonson the other; or whether Hogarth began the project (perhaps shortly after he finished *Hudibras*) and lost interest or was found wanting, at which point Vanderbank was employed. Hogarth could be rather slow with a project that proved uncongenial, such as the tapestry cartoon commissioned by Joshua Morris and some of his conversation pictures.

The commission was obviously impossible for Hogarth from the start, less because of the subject than the sponsorship. To begin with Carteret himself, it is difficult to say how much of a Burlingtonian he was politically, but aesthetically his taste had been conditioned by Shaftesbury and the Burlington circle. Although he was a friend and admirer of Swift, he makes clear in his "Dedication" published with *Don Quixote* that he admires Cervantes as "one of those inestimable figures who, by the fertility of their immortal genius, have produced (albeit through burlesque) the most serious, valuable and salutary effects which one can imagine." The operative words are "albeit through burlesque": his doubts are further exposed in the eight-page "Advertisement concerning the Prints" written by Dr. John Oldfield, a friend of Carteret's who evidently served as his intermediary with the artists, especially since he had to spend part of his time in Ireland. This attached essay stated the policy of the editor as to the illustrations, indicating how important this aspect of the project was to Carteret. Coypel's illustrations were rejected, Oldfield says, because of their "injudicious" choice of subject, that is, "gross and un-

likely" incidents such as the attacks on the windmill and the flock of sheep. It is difficult to imagine Carteret or Oldfield, with this philosophy, turning to the illustrator of *Hudibras* for designs. According to Oldfield, the illustrator should concentrate instead on the scenes which give "occasion for some curious and entertaining expression," which are "the most desireable and amusing." Indeed, he sees book illustration as a kind of history painting and would raise it from a supplementary status to the level of an art form.

The Carteret-Oldfield ideas would have interested Hogarth with their overtones of Jonathan Richardson's *Theory of Painting;* to judge by the engravings he produced, he was trying hard to avoid burlesque, to illustrate the proper scenes, and to follow instructions. As to the designs, Oldfield, according to Carteret, "invented most of them" himself, and gave the illustrators detailed descriptions.[103] Vanderbank's designs, surviving as they do in various versions, show him falling into line with Oldfield's strictures until they have reached the ideal expressed in the "Advertisement." It is not difficult to imagine Hogarth chafing at such an arrangement, and as he proceeded, at the prospect of so many dozens more. They were, after all, mere illustrations of a text.[104]

If Hogarth did not withdraw, he was rejected; but some sort of a contract had been made, and he was paid, for the finished drawings remained the property of Tonson, passing to Dodsley when the publishers merged, and were eventually published long after Hogarth's death. Two drawings have survived, one on the blue paper used for *Falstaff and His Recruits* and *The Beggar's Opera* paintings early in 1728, the other in the style of some of the *Hudibras* drawings (and the Vanderbank drawings [cf. figs. 46, 47, 48]). The decision to discontinue, however, must have been made on the basis of the prints. The etching style itself isolates the figures, making them stand out much more than Hogarth's subsequent works of the 1730s. They were perhaps too Coypelish in design and not delicate enough in execution for Carteret, suffering the disadvantages of a rococo design without the saving grace of Vandergucht's smooth style.[105]

Both Vanderbank and Hogarth felt constrained to juxtapose Quixote and Sancho not as comic extremes but as ideal and real; Quixote wears a dignity quite at odds with the reality around him. Hogarth's Quixote images are far more elevated than his small *Hudibras* plates, in which cheap printing and a popular audience allowed him a freer rein. *The Adventure of Mambrino's Helmet* contrasts the heroic figures

of Quixote and Rosinante (a surprisingly well-formed horse) with those of the shaggy donkey and cringing barber. The effect is pathetic rather than comic. However, Hogarth also introduces a larger contrast between the encounter itself and, at a great distance, the round figure of Sancho on his roundish mule merely watching, two quiet observers from another world. Hogarth has not only made the point nicely but suggested something of the difference in shape as well as distance and attitude.

Only in *The Curate and the Barber Disguising Themselves* (fig. 49, a scene which Vanderbank did not choose to illustrate) did Hogarth find a more congenial subject. The costuming of these unprepossessing figures, and the juxtaposition of the antlers above the inn door, the chamber pot on a shelf, the coat of arms, and the mirror in which the barber regards himself, broach some of Hogarth's own central themes: these can be summed up as the comedy of masquerade.

Decorum seems to have limited the extensive use of such detail to large independent plates like those of Coypel. Hogarth made only one such independent illustration for *Don Quixote,* and this followed the interests explored in the *Curate and Barber.* However, as if still unwilling to sully the Don's dignity, he chose a scene involving the delusion of Sancho, *Sancho's Feast* (figs. 50, 51).[106] Sancho, who is himself playing a king, is in the midst, unknown to himself, of play-acting at his expense. As a witness to the charade, one courtier uses the tablecloth (which is supposed to hold food) to stifle irreverent laughter, and a fat woman laughs outright. If Hogarth had continued a set of illustrations on this scale, we can be sure he would have included "Don Quixote and the Puppet Show": he alludes more than once to Coypel's illustration of the scene, borrowing from it the figure of Sancho, in that case the amused bystander to madness.

But this scene is typical of Hogarth in that he takes the plebeian Sancho rather than the aristocratic Quixote and shows him deluded into thinking he is the king of Barataria, with his vanity being exploited by his "subjects," who are starving him. Here he is, as the caption tells us, "Starved in the midst of Plenty": because he sees himself, and thinks he is seen by the others, as king. This rather than Hudibras and the bearbaiters or Don Quixote tilting against windmills is the precise situation of Hogarth's mature works. It is also significant that Jane Hogarth (probably in the 1780s) told the etcher Richard Livesay that "Hogarth's portrait" appears in the print "in the person of Sancho."[107] There is an unmistakable resemblance.

Hogarth may have submitted the print as early as 1724 or 1725 to Henry Overton, who at that time was planning a set. Overton's *Quixote* consisted of nine engravings, five dated 1725, by Bickham and Mynde. Sancho's feast was not illustrated. Hogarth's *Sancho* was close enough to the size of the others to have fitted the format. At that point he may have gone to, or come to the attention of, Henry Overton's brother Philip, who reached an understanding with him for the series of plates of his own invention based on Butler's *Hudibras*. The copperplate of *Sancho's Feast* remained with Henry, who, perhaps stimulated by the success of the *Hudibras* plates or, more likely, *A Harlot's Progress,* published it under the inscription, "This Original Print was Invented and Engraved by Will^m Hogarth."[108]

With the publication of *Hudibras* George Vertue first took notice of Hogarth as an engraver in his notebook. Though unfortunately undated, the reference summarizes Hogarth's career:

> another work appeared which was well enough accepted. being undertook by printsellers the several Stories of Hudibrass being designd in a burlesque manner humoring very naturally the Ideas of that famous poem. these designes were the Invention of W^m. Hogarth a young Man of facil & ready Invention, who from a perfect natural genius improvd by some study in the Academy. under the direction of cheron & Vand^r bank. has produced several charicatures in print, if not so well gravd, yet still the humours are well represented. whereby he gain'd reputation— from being bred up to small gravings of plate work & watch workes. has so far excelld; that by the strenght of his genius & drawing, & now applying himself to painting of small conversation pieces, meets with good encouragement. according to his Meritt. (6: 190)

In Vertue's notes we find the first reference to Hogarth's work as caricature; already the myth (corresponding closely to his own words in his autobiographical notes) of his remarkable rise from "small gravings of plate work & watch workes"; the professional engraver's view that his prints are "not so well gravd"; and the credit given him for "facil & ready Invention," "a perfect natural genius improvd by . . . study in the Academy," and the "strenght of his genius & drawing." Finally, there is the fact that he has begun to paint.

5.

LEARNING TO PAINT

Falstaff and *The Beggar's Opera,* 1727–1729

Vertue says specifically that it was only after completing the large *Hudibras* plates that Hogarth started to paint:

> afterwards [he] got some little insight & instruction in Oyl Colours. without Coppying other Paintings or Masters immediatly by the force of Judgment a quick & ready Conception. & an exact immitation of Natural likeness became surprizingly forward to be the Master he now is ⟨Jan. 1730⟩. (3: 41)

Though Vertue's note does not rule out Hogarth's having experimented with paints before, it does strongly suggest that he did not devote himself to painting until 1726. For one thing, the years 1723–1725 must have been largely devoted to engraving as he tried his utmost to rise above plate decoration and make a name for himself as a copper engraver. Only with his earnings from the large and demanding *Hudibras* project (still based entirely on drawings) could he afford to spend most of his time painting, turning out only an occasional print. William Ward's request for a painted version of *Hudibras* may have set him off,[1] but his principal motivations were a general desire to rise above engraving and a particular eagerness to emulate and prove himself to Sir James Thornhill (with by this time perhaps a further incentive in Thornhill's daughter Jane).

Hogarth's career as a painter begins on 20 December 1727, when he was commissioned by Joshua Morris, the tapestry weaver of Great Queen Street, Soho, to paint a cartoon of "The Element of Earth." Morris was at this time preparing hangings for the duke of Chandos's princely country house, Cannons, and Hogarth's cartoon may have

been intended as part of that project (in which, perhaps significantly, Thornhill was involved).[2]

Someone—possibly Thornhill, possibly Vanderbank—recommended Hogarth to Morris "as a person skilful in painting patterns for that purpose."[3] Hogarth "accordingly," as related in Morris's deposition, went to see the tapestry maker, who informed him "that he had occasion for a tapestry design of the Element of Earth, to be painted on canvas"; Hogarth replied that "he was well skilled in painting that way, and promised to perform it in a workmanlike manner; which if he did, [Morris] undertook to pay him for it twenty guineas." Not long after, Morris discussed his commission with a knowledgeable friend (presumably an artist) and learned that Hogarth was not a painter but an engraver. Being therefore "very uneasy about the work" he had commissioned, he sent a servant to Hogarth's studio to tell him what he had heard; to which Hogarth offered the sanguine reply "that it was a bold undertaking, for that he never did any thing of that kind before; and that, if his master did not like it, he should not pay for it."

It would be interesting to know what this design, now lost, consisted of; it may have been related to one of the Dutch series representing "Four Elements" or to Le Brun's cycle *The Elements,* which were copied in the Soho tapestry factory.[4] The discrepancy between his two statements to Morris sounds the cheeky, confident note that carried Hogarth through most of his enterprises. The challenge to produce something along the lines of the Raphael Cartoons must have been singularly stimulating to the novice painter, and he accepted.

According to his deposition (December 1727), Morris waited patiently for Hogarth to finish, sending several times to inquire after the work; which, when finally completed, Hogarth left at one of Morris's shops rather than his house, being ashamed to let him see it. More probably, Hogarth found the project less to his liking than he had thought, had trouble with the painting, put it off, and when he finished it took it to the first place he thought of, forgetting Morris's instructions (if there had been any). At any rate, Morris heard that it had been delivered and sent for it; he "consulted with his workmen whether the design was so painted as they could work tapestry by it; and they were all unanimous that it was not finished in a workmanlike manner, and that it was impossible for them to work tapestry by it." The absence of "finish" suggests that it lacked the firm

outlines of a cartoon, and is not inconsistent with the appearance of some of Hogarth's early paintings. They would have looked strange indeed to a tapestry weaver accustomed to careful, essentially linear cartoons.

Morris sent a servant back to Hogarth with his painting and word that it would not do but that "if he would finish it in a proper manner," he would still take and pay for it. Hogarth now promised to finish the cartoon in a month, but again ran into difficulties and took three months. When he finally showed it to Morris, the latter, "when he saw it, told him that he could not make any use of it, and was so disappointed for want of it, that he was forced to put his workmen upon working other tapestry that was not bespoke, to the value of £200 which now lies by him; and another painter is now painting another proper pattern for the said piece of tapestry."

Hogarth did not, however, let the matter rest. He promptly went to court, asking £30 for his fee plus the materials required ("which Defendant faithfully promised to pay when demanded"). The case was tried before Lord Chief Justice Eyre at Westminster Hall, 28 May 1728, with Morris producing weavers and fellow craftsmen to testify that it was impossible to make tapestry from the cartoon Hogarth had submitted; and Hogarth producing Thomas King, Vanderbank, John Laguerre, Thornhill, and one Collumpton to testify to the quality of his painting. Vanderbank was probably John Vanderbank of the academy, although it is just possible that Hogarth secured his brother Moses, who had succeeded their father in charge of the tapestry works in Great Queen Street in 1727 and would have been a more impressive witness in this particular case.[5] Hogarth's argument was presumably that the agreement had been made (Morris did not contest this) and that the painting was a competent piece of work. The point at issue was whether "competence" implied simply a painting or a work on which a tapestry could be based. Hogarth, arguing the former, won his case, and had his first taste of the law as a recourse in controlling unruly patrons.

Thornhill may have advocated this particular line of action, based on his own experiences in wringing money from his patrons; he had already gone to court to secure money promised for the work done for Knight, the South Sea cashier, with only middling results.[6] Hogarth's success may have stimulated Thornhill to follow the same course a month later when he took Benjamin Heskin Styles to court. Thornhill, according to Vertue, had been working "for the last five

or six years" on Moor Park, the house near Rickmansworth, Hert-
fordshire, that Styles, a successful South Sea speculator and M.P. for
Devizes, bought from the duchess of Monmouth and had rebuilt by
Leoni. Thornhill had supervised the decoration and himself painted
the Hall and Saloon. One stipulation made by Thornhill when he
undertook the project was that he be paid "at the same price each pic-
ture as Mr Kent had for the Altar peice at St Georges Church, Hano-
ver Square. church. proportionable to which price of Mr Kent. or
any other work done by him Sr James is resolved to take no less."
This telling detail offers another precedent for his future son-in-law,
who demanded as much for his *Sigismunda* as the Old Master *Sigis-
munda* had brought at Sir Luke Schaub's sale; and provides some
grounds for the Burlingtonians' effort to get the pictures rejected.
"Mr Kents friends & interest, no doubt endeavourd to foment this
difference & slurr the reputation of Sr James," Vertue noted. Styles
accordingly decided to reject Thornhill's work, saying that "he was
inform'd that Sr James had not done his part with care nor finisht his
workes as he was capable to do." Thornhill brought the matter to
trial in July, and came equipped with artists to testify as they had suc-
cessfully done in Hogarth's case: his witnesses included Michael Dahl
and Thomas Murray. Styles saw the way things tended and made a
settlement out of court, which, however, must not have proved satis-
factory; Thornhill evidently brought a second suit against him, this
one actually taken to court and decided in Thornhill's favor by the
same Lord Chief Justice Eyre who had found in favor of Hogarth.[7]

Styles's response, after paying Thornhill, was simply to remove his
eight heroic virtues and set into the wall four huge paintings by
Amigoni—"no doubt intended as a mortification" to Thornhill.
They depict Zeus's seduction of Io, Hera's changing Io into a heifer,
Argus her guard being lulled to sleep by Hermes, and Hera receiving
the head of Argus and endowing the peacock's tail with its hundred
eyes.[8] Thornhill's classical restraint was replaced with a baroque de-
piction of the loves of the gods—a lesson not lost on Hogarth, who,
already aware of Steele's admonitions, returns frequently to this par-
ticular aspect of fashionable history painting.

There is some question as to whether he assisted Thornhill with
any of his decorative work in 1726 or 1727. According to Nichols, he
was responsible for a satyr in the *Zephyrus and Flora* ceiling at the
Huggins' house in Hampshire (of course a satyr would be attributed
to Hogarth); and helped with the staircase pictures at No. 75 Dean

Street, Soho.[9] It is evident from his own testimony that Hogarth did not work on the portrait of the royal family at Greenwich, which was in progress when he first became acquainted with Thornhill. The Greenwich paintings were finished by November 1726, but Thornhill had to keep petitioning for payments for several more years. As he was completing the Upper Hall and the cupola, the ceiling of the Painted Hall, only ten years old, was given its first cleaning—to eradicate the effects of the sea air in an attempt to make the whole interior look fresh and new. Hogarth knew all the circumstances and recounts them in his "Britophil" article and *The Analysis of Beauty*.[10] On the one hand, his lack of training would have made him a liability on such a project; but on the other, he was a talented and eager learner.

FALSTAFF EXAMINING HIS RECRUITS

We do know that in the winter of 1727–1728 Hogarth painted two representations of stage performances, which can be dated, in origin at least, from two pencil sketches apparently made in the theater on paper from the same pad.[11] The choice was of crucial significance. One was of Shakespeare's *Henry IV, Part 2,* and the other of John Gay's *Beggar's Opera*.[12] It seems clear that he chose these subjects, first, because he was drawn to the genre of the conversation picture, and second, because he recognized the theater as the distinctive English contribution to art, especially in the 1720s when it seemed to be dominated by foreign operas and entertainments of the sort he had satirized in *Masquerades and Operas* and *A Just View of the British Stage*.

King Henry IV or the Humours of Sir John Falstaff opened at Drury Lane Theatre on 21 February 1726/27, the first production of this play since 1722. It was performed again on 25 February, 14 March, and 9 September, and then not again until the autumn of 1728, on 18 October and 3 and 30 December. The play Hogarth saw was Thomas Betterton's adaptation, which cuts many of the scenes unrelated to Falstaff (making the scene Hogarth paints IV.iii, not III.ii).[13] There is no compelling argument for Hogarth's having seen or represented one performance rather than another. He may well have seen more than one. It would only be of some interest to know in which order *The Beggar's Opera* and *Falstaff* were painted. The first *Beggar's*

Opera painting (fig. 59) must have been done shortly after the opening on 29 January 1727/28, and the quick succession of versions between then and 1729 shows the phenomenal maturing of Hogarth's painting technique. The *Falstaff* painting (fig. 52) is signed and dated 1730, but parts have been reworked and, as often was Hogarth's practice, the date probably refers to completion and delivery. (The Morris case shows that Hogarth was slow to deliver paintings.) The style is an uneasy amalgam of the early and late *Beggar's Opera* paintings.

The crucial difference lies in the theater curtain. The drawing of *Falstaff Examining His Recruits* retains a vestige of the stage curtain, omitted in the finished painting. Whereas in the *Beggar's Opera* Hogarth is unambiguously painting a stage production, and indeed a play that is about playacting based on the metaphor of "life as a stage." In the *Falstaff* painting he lays groundwork for the later scenes he painted from Shakespeare's *Tempest* and *Richard III* in which he uses a stage representation of a Shakespearean play as a text for a history painting, seeking a balance between what was literally seen on the stage (with, as Steele recommended, portraits of the actors) and the forms of the graphic tradition (Raphael, and others): he combines two kinds of heightening, of the theater and of art.

The only precedents in England for Hogarth's *Falstaff* were one or two single portraits of actors in their roles (Anthony Leigh as Father Dominic in Dryden's *Spanish Friar* by Kneller). There was no tradition of group scenes on a stage, or of actors playing in a Shakespeare play, before Hogarth.

Falstaff begins as a "conversation picture [or piece]," and—Hogarth's original point—one involving actors playing roles in a history play by the great English dramatist. The conversation picture Hogarth inherited from Watteau and Philippe Mercier (and their Netherlandish precursors) was a small group portrait of people involved with each other in a psychological relationship of some sort, often with a strongly theatrical slant. It is easy to see the way that Hogarth, with his training in Vanderbank's and Thornhill's academies, saw a connection between these portrait groups and the history painting doctrine of *l'expression des passions,* the spectrum of responses analyzed by Le Brun and the members of the French Academy. He saw that history could be painted as portrait groups and (with the authority of Shakespeare's practice) as English history groups. His own comic histories of the next two decades could be

regarded as the equivalent of Betterton's *Humours of Falstaff* in that he retained the comic incongruities of Shakespeare's *Henry IV* and omitted the high-sounding speeches of the polite characters, though not the memory of them.

But he also saw that the conversation picture answered the challenge of the full-length portrait. European portraiture in the eighteenth century was still dominated by the aesthetic bias of Renaissance and French classicism toward idealized portraiture. Naturalistic portraits, however much enjoyed, were felt to be a lower art as well as somewhat unfair to the sitter. Hogarth's own comments show that he regarded portraiture as a lower branch of art than history painting. But there was also a hierarchy among portraits: the greater the idealization, the more the portrait was esteemed. As all artists aspired in that direction, there was a marked tendency toward the stereotyped and general, resulting in those interchangeable portraits of the Restoration and early eighteenth century. To catch a speaking likeness was, in fact, both to miss the point and to vulgarize, unless in offbeat pictures such as drinking or clubbing scenes. The moral function of the portrait painter, analogous to that of the history painter, was to laud virtue, and his social function was to describe ideal types of kings, statesmen, soldiers, courtiers, and scholars.

The portrait stereotype had been produced by Van Dyck and transmitted by Lely and Kneller and all the lesser painters, English and foreign born, who imitated them. This model, designed for aristocrats, was by Kneller's time standardized as a long, vertical figure (Lely's had tended to be more horizontal and reclining) wearing a close-fitting coat, with a plump but equine face and an especially long nose, further standardized by a typical wig (the Kit Cat portraits were said to be no more than "a lot of wigs with Whigs inside them").[14] The women all had narrow eyes, double chins, and identical lips. The face was as polite and urbane as the Augustan poets' personae or their use of parallel and antithesis. These were essentially social portraits. Their own standardization was further emphasized by the mass-production methods of the painters' studios and by the bland mezzotints, reproduced in a quantity that even the studio hacks could not match.

One feature that must have struck Hogarth (the painter of *The Beggar's Opera*) was the strong elements of emulation and disguise in portraiture: aristocratic women were painted as shepherdesses and goddesses; middle-class women then were painted as if *they* were

shepherdesses, that is aristocratic ladies. If royal mistresses in the Restoration were painted as goddesses, Mary Magdalen, and even the Virgin Mary, then (as David Piper remarks), "following them, more reputable ladies were disguised as royal mistresses, only slightly more buttoned-up, and so on down the social scale, the designs set by the most fashionable painters, especially Lely, being repeated verbatim except for the head."[15]

For Hogarth the conversation picture simply sidestepped the issue and ignored the portrait tradition of full-length or half-length life-size single portraits. In what may have been his first experiments in the genre, by turning to the stage, he painted a group of people, each a strong likeness, who were literally acting out different, sometimes appropriate and sometimes inappropiate, roles.

In the *Falstaff* Hogarth is painting a group of actors absorbed in their roles, with no indication of the transitional stages between on and off stage, between actor and spectator. Falstaff is played by, and is a portrait of, the actor John Harper; Shallow is Colley Cibber; and Silence is Josiah Miller. All of these, as it happens, also appear on the showcloth in Hogarth's Southwark Fair painting of 1733, which represents a copy of a theatrical satire by John Laguerre (ill., vol. 2). Whether the stage blocking came first or the conventions of the conversation picture, Hogarth finds a close equivalent between the two forms. Falstaff's gesture anticipates the gesture of the conversation picture host (as in Hogarth's *Wollaston Family* of 1730, fig. 78) who binds together different groups of his guests, or his guests and his family, into a single "party."

The seated-around-a-table composition, however, derives from one of his *Hudibras* plates of 1726 (*The Committee,* fig. 53), which shows the squabbling parliamentary rebels trying to rule England and at the same time being informed of the Burning of the Rumps (of beef and, in effigy, of themselves, the Rump Parliament) at Temple Bar. The verses illustrated begin:

> And now the Saints begin their Reign
> For which th' had yearn'd so long in vain
> And felt such Bowel Hankerings,
> To see an Empire all of Kings.

Hogarth's scene, in this case, alludes to a popular print called *The Committee,* a graphic equivalent more appropriate to this particular

passage of Butler's satire than the baroque history painting he used to illustrate *Hudibras and the Skimmington*. But to this scene of power usurped by clods and riffraff, "an Empire all of Kings," Hogarth adds the conversation picture host, Falstaff, and moreover gives him a gesture that derives from the God of Michelangelo's *Creation of Adam* or from Raphael's God creating the sun, moon, and stars—and makes Falstaff the "king" figure lacking in *The Committee*.

The scene Hogarth chose to represent is III.ii, in which Falstaff and Bardolph come to Justice Shallow's country residence in Gloucestershire to impress (the technical term was "crimp" in Hogarth's time; Shakespeare calls it "pressing") recruits for the war against the rebels, and, with Shallow and Silence witnessing, Falstaff examines the local citizens. Then, while Shallow and Silence are out of earshot chatting with Falstaff, his lieutenant Bardolph accepts bribes from two of the recruits, passing on the word to Falstaff, who, releasing these two, impresses the others who had not bribed him, regardless of their physical decrepitude.

Hogarth conflates these scenes into one action, with Bardolph passing the bribe to Falstaff behind his back. The bribing citizens are on one side, the honest ones, being crimped, on the other: Shadow, a "half-fac'd fellow" in gaunt profile, and Feeble, the "Woman's tailor," behind him. Hogarth joins two or more moments, two or more actions, suggesting both before and after in the "fruitful moment" Shaftesbury had advocated as the subject of history painting in his *Judgment of Hercules* (1713).[16]

The idea of "improving" Shakespeare, as in Nahum Tate's happy ending for *King Lear* or Betterton's revision of *Henry IV,* meant crafting a "Shakespeare for our times." This is one way of describing Hogarth's intention. But it is well to remember that this painting was created in 1727–1728 when Hogarth was also pursuing a career as a political satirist. Of all the scenes he could have chosen, Hogarth chose this one of Falstaff impressing local citizens for a militia against rebels (for Harry Hotspur, read the Young Pretender), and he portrayed it so as to show the culpability of Falstaff, the man with the power to condemn or free, to accept or reject—and to do so by means of bribery.

We need only compare Hogarth's with Francis Hayman's versions of the same scene, painted in the 1760s. The latter play primarily on the comic contrasts of bodily shapes, formulated by Hogarth in his *Analysis of Beauty* (1753), where Falstaff is used to illustrate the idea

that incongruous juxtapositions make us laugh. Falstaff says *"stand before me boy I would not be seen* to his little page when the lord Chancelor was passing by, and again *this sighing and grieving blows a man up."* Hogarth refers to the visual effects of stage performance and adds that Hudibras and Don Quixote in their verbal texts "afford" confirmation. As he says, "it is plainly the Inconsistency and mixture of incompatible matter that causes involuntary laughter" (180). A second reference is to Falstaff's reply to Hal's query, "How long is't ago, Jack, since thou sawest thine own knee?" "A plague of sighing and grief!" replies Falstaff, "It blows a man up like a bladder" (*1 Henry IV,* II.iv). In the jovial Falstaff's gaining weight from sorrow Hogarth sees a humorous "inconsistency," a "mixture of incompatible matter," which amounts to the incongruity of the knight's size and his sly fabricated fantasies about it.

But this is not the Falstaff he uses in his painting of 1727–1728. He turns instead to the theme of power and justice. The target directly above the figure of Falstaff (with bow and quiver of arrows) is an emblem of justice—straight on the mark, a bull's-eye. There is also a picture on the wall overlooking the action which shows the Gloucester Giant or some such local hero from the past. (The tree and the small man establish scale for the other, much taller man, who is holding a cudgellike pole—a house with smoke coming out of its chimney is at the right.) Perhaps he is a memory of Double the archer, whom Falstaff and Shallow remember from the heroic past; certainly he is the English yeoman who stands in overwhelming contrast to the ragtag recruits whom Falstaff has "pressed." He represents the glorious English past—which includes the memory of Shakespeare too—against the money-dominated present of Falstaff and Bardolph.

POLITICAL SATIRE, 1726–1728

Hogarth produced another Shakespearean representation in 1727–1728, an engraving of *Henry the Eighth and Anne Boleyn* which shows Cardinal Wolsey in the process of falling from Henry's favor—or plotting to keep from falling (fig. 54). The stage again was probably the inspiration. Colley Cibber's production had opened at Drury Lane on 26 October 1727 (*Henry IV* was played on 9 Sept.) and en-

joyed a long run, partly because the coronation scene replicated the recent coronation of George II. Hogarth's engraving, however, is political rather than illustrative of a performance of the play—although it may also have been that. On 18 November 1727, less than a month after Cibber's *Henry VIII* opened, the *Craftsman* drew attention to the resemblance between "the Character of this ambitious, wealthy, bad Minister," Cardinal Wolsey, and Sir Robert Walpole.[17]

The size and scale of the *Henry the Eighth* engraving (no painting survives) imply that it was intended as more than a topical political print. Already Hogarth suggests something of the interest—also present in both of the paintings we are discussing—in history, in particular national history, with here an immediate source in a stage play by an English playwright. Nevertheless, between 1726 and 1728 Hogarth participated significantly in the campaign of anti-Walpole satire inaugurated by the publication of the *Craftsman* by Henry St. John, Viscount Bolingbroke, and his circle. Within a short period at the end of 1726 he published three engravings with a distinctively political cast.

Before 1726 there had been no concerted propaganda effort undertaken by the Opposition. William Pulteney had made a few unsuccessful forays, but the first important action came with the intervention of Bolingbroke and the meeting of Tories and disaffected Whigs—the two Pulteneys, Bathurst, Chesterfield, Pope, Swift, Arbuthnot, and Gay—in the summer of 1726 at Dawley, Bolingbroke's country estate.[18] Swift was in England to prepare for the publication of *Gulliver's Travels,* which appeared on 28 October. This could be said to inaugurate the campaign, followed by the publication on 5 December of the first number of the *Craftsman,* put together by Bolingbroke and William Pulteney, with contributions by the Scriblerians and some of the most powerful political polemicists of the time, to expose "how craft predominates in all professions" and particularly "the mystery of statecraft." As one pamphleteer described the frantic activity on the eve of battle: "All hands were employed and engines set to work, manuscripts were circulated, the press loaded, coffee house talkers, table wits, and bottle companions had their instructions given them."[19] There is no evidence as to whether Hogarth was solicited by the Opposition or merely climbed onto the bandwagon. Nicholas Amhurst, editor of the *Craftsman,* however, was already associated with Hogarth (who had illustrated his satire, *Terrae Filius,* published June 1726) and may have served as a connection.

It was no coincidence that the same week that ushered in the *Crafts-man* saw the announcement ("speedily to be published") of Hogarth's engraving *The Punishment of Lemuel Gulliver* (fig. 55), itself an allusion to the anti-Walpole satire of Swift's work published a few weeks earlier.[20] Hogarth's "illustration" was out by 27 December, not long after the earliest responses to *Gulliver's Travels:* such pamphlets as *The Brobdingnagians: Being a Key to Gulliver's Second Voyage* and *The Key to Gulliver's Voyage to Lilliput* were followed by keys to the other voyages and *Gulliver Decipher'd* (all advertised on 5 December).

The "Voyage to Lilliput" was full of particular and general reflections on the government, and Hogarth's purpose in his print was apparently to point them out as clearly as possible. His own contribution was to define Gulliver's punishment for putting out the fire in the queen's chambers: appropriately, considering that Gulliver's crime was ejecting liquid, an enema. *The Punishment of Lemuel Gulliver,* plainly aimed at the Walpole ministry, is about an England in decline. Again, as in *Royalty, Episcopacy, and Law,* created in the wake of the South Sea scandal, corruption extends from state to church. The purging is overseen by a first minister carried in a thimble, and a clergyman is officiating from his pulpit, a chamber pot. Together they are shown supervising this purging of a heroic and harmless Gulliver while ignoring the rats who devour their children and the term of Priapus being worshiped by their backsliding congregations. In Swift's text Gulliver's Lilliputian home was a ruined temple; if the pulpit's position is indicative, Gulliver's posteriors are where the altar should be, and the ceremony of purgation becomes another form of religious perversion (directly anticipating the anonymous anti-Walpole print of 1737, *The Golden Rump*). As in *Royalty, Episcopacy, and Law,* the satire is still general, but the implications are sobering. Significantly for Hogarth, as in Swift's satire itself, the print comments on the gullibility of Gulliver as much as the corruption of the Lilliputians: Gulliver (or John Bull) is stupidly tolerating the enema. He is related to the protagonist of Hogarth's later progresses as the First Minister, the ecclesiastic, and the other Lilliputians are to the surrounding figures in those works. As was characteristic of him, Hogarth explores his own subject as well as expressing himself on the state of England. He no doubt found satisfaction in aligning himself with Swift (to whom he attributes the invention of the plate, spelling his name backward), as earlier with Samuel Butler and Allan Ramsay, for practical as well as symbolic purposes.

In shape, composition, scale, imagery, and style this is the first mature "political cartoon" in England—or for that matter in Europe: from this one print, with the important addition of "caricature" faces (a new issue, introduced in the 1730s), derives the Gillray tradition that reaches to David Low, Vicky, and Pat Oliphant.

Two days before the appearance of *The Punishment* Hogarth published another print, this one topical journalism rather than emblematic satire, called *Cunicularii, or the Wise Men of Godlimen* (*Post Boy,* 24 Dec., fig. 56). A tradition, probably initiated by Hogarth, had it that he was approached by some London physicians to present the figures involved in the Toft case, but the underlying purpose again is political.[21] The story of Mary Toft went back to 19 November: "From Guildford comes a strange, but well attested piece of News." A woman of Godalming, who had a husband and two children, had been delivered a month before by the man-midwife John Howard of a rabbit "whose Heart and Lungs grew without its Belly." Fourteen days later she was delivered of a perfect rabbit, and later four more; one came each day until they totaled nine, all dead at birth and pickled by Mr. Howard to show to the Royal Society in London. The total delivery as of 19 November was fourteen, and "Mr. Molineux, the Prince's Secretary, is, we hear, gone thither by his Royal Highness's Order, to bring a faithful Narration of the Affair."[22]

By 3 December Mary Toft had been ordered to London by the king and was lodged at a bagnio in Long Acre, where many people of fashion came to see her, and, as another birth was expected momentarily, physicians were constantly examining her. The *British Journal* adds to its account: "A fine Story! *Credat Judaeus Apella*" (3 Dec.). But it was all over by the 10th, and Toft had been exposed. "The Woman" was at the bagnio in custody of the High Constable of Westminster; on the seventh she had confessed but would not name her confederates until assured of the king's pardon. "Several Noblemen have been very active therein, not willing that so vile an Imposture, a Blemish on human Nature, should pass for Truth, and as such be inserted in our Histories" (*Weekly Journal,* 10 Dec.). The *London Journal* adds that Mr. St. André, the surgeon who had published a gullible account, including the assertion that he had delivered five of the rabbits himself, "has promised a particular Account of the Frauds she used, and by what Means she impos'd upon him and the publick."

Around the laboring Mary Toft Hogarth shows all the chief par-

ticipants in a comic conversation picture. But he also absorbs the story into the *Craftsman's* anti-Walpole campaign, recalling with his stagelike composition the parallel between farce on the stage and in politics (an analogy Fielding picked up and developed a few years later). This parallel in the Toft scandal had been suggested in one of the pamphlets, *The Political Stage of Great Britain,* which referred to Toft and the other participants as "guilty Actors" and the "Actors of this Fraud." Toft was also connected in the satires of the time with Isaac Fawkes by the "magic" and "legerdemain" she practiced, which, once again, had attracted "Great Numbers of the Nobility." The involvement of court figures on the side of both fraud and gullibility allowed for memories of the South Sea scandal and the imagery of the South Sea quack doctors and theatrical deception.[23] The *London Journal* (30 Mar. 1727) claimed that Toft "was equal to [Madam Cuzzoni] in every Respect; but she was not born in Italy." The fiddle Hogarth shows St. André carrying under his arm reminds the spectator of his equal interest in anatomy and in music and dancing.[24]

The print proves to be political in a way that relates it to the paintings of 1727–1728. Under the influence of the *Craftsman* satirists Hogarth finds political analogies in both high and low materials, in both historical plays such as *Henry IV* and *Henry VIII* and current events that involve hoaxes and scams. These analogies take him a step further from emblematic political satire toward a social satire that reencodes the political. The stagelike composition, with Toft in her tester bed and the credulous Londoners approaching from the doorway (a blasphemous parody of Wise Men), recalls Madam Cuzzoni in *Masquerades and Operas* and anticipates the Harlot in the third plate of *A Harlot's Progress.*

Hogarth followed these two prints sometime in 1727 with the *Masquerade Ticket* (fig. 57), which shows worshipers adoring a figure similar to that in the *Punishment* print with a Venus added for balance; and sometime later in the same year (or early 1728) appeared the *Henry the Eighth and Anne Boleyn.* Both prints were unsigned and unadvertised. Both are relevant to the accession of the new king, George II. The Prince of Wales had been associated with the masquerades because of his patronage of Heidegger (Hogarth may have alluded to this in *Masquerades and Operas*). On his accession in June

1727, therefore, masquerades would have seemed to receive the royal sanction. The newspaper notices of that autumn would have been sufficient to merit Hogarth's print with its prominently displayed "1727." *Mist's Weekly Journal* for 21 October, for example, notes that "His Majesty was at the Masquerade on Monday Night at the Haymarket, and 'tis said, there will be 7 more this Winter." A social phenomenon stands secondarily for a political one; the point can be read either way: politics is reducible to sexual desire, or sexual desire is at the bottom of Britain's troubles. The lion and unicorn of the royal arms are now part of Heidegger's escutcheon, turned over on their backs and playing with their tails in a masturbatory fashion. As in *Masquerades and Operas,* the royal imprimature sanctions the masquerade mentality by a process of imitation or mediated desire. The crowds are there, all "supping below," the print says, *because* the monarch and nobility are their models. But the significant fact (given Hogarth's *George, Prince of Wales* print, fig. 26) is that he has not found the new reign an improvement. The hopeful prediction of Walpole's dismissal has not been fulfilled, and (as Pope was to write) Dunce the First has only been succeeded by Dunce the Second.

In this context, Hogarth's *Beggar's Opera* paintings present a Macheath who resembles contemporary portraits of Walpole (or who resembles Walker the actor strutting as if he were Walpole).[25] The analogy with Macheath (supported by numerous verbal references) was based on two facts, both of them implicit in Hogarth's paintings: Walpole's association with more than one "wife," Maria Skerrett as well as Lady Walpole; and his dismissal at the accession of George II followed by his sudden reappointment when it became clear that the king could not do without him. Macheath is shown between his two "wives" Polly and Lucy but in prison, from which prison and sentence of death he is reprieved at the end by the play's venal author. The same issue was stressed in the engraving of Henry VIII and Cardinal Wolsey. Wolsey, misadvising the king, was also one of the bad clergymen Hogarth portrayed in his works (as in *The Punishment of Lemuel Gulliver*).

The other painting, *Falstaff Examining His Recruits,* is therefore the portrayal of the bad judge and also the bad adviser who is turned away by Prince Hal upon his accession to the throne. The imperious gesture Hogarth has given his Falstaff—of Michelangelo's God the Father creating Adam—recalls the remainder of the Falstaff story,

in particular his relationship to Prince Hal in the scene in Part 1 in which he plays the role of the king:

> *Prince.* Do thou stand for my father, and examine me upon the particulars of my life.
> *Falstaff.* Shall I? content: this chair shall be my state, this dagger my sceptre, and this cushion my crown. (IV.iv)

Hogarth re-creates this scene, itself a parody of the true scene between king and subject, at a lower remove in Shallow's house, thereby pointing toward the end of the play and Falstaff's rejection by Hal, now King Henry V. (There were differences as well as similarities. Falstaff was friendly with the Prince of Wales before his accession, Walpole not. But then of course the Walpole–Wolsey analogy was only approximate too: Walpole like Falstaff was dismissed by the new king, Wolsey by the old.)

We then recall the other associations of Falstaff, with the whore Doll Tearsheet and with conviviality, and we may suspect that Hogarth also chose him because he shared these traits with Walpole. The anti-Walpole *Craftsman* of 29 July 1727 quotes the scene in which Falstaff plays the king and describes himself in flattering terms, ending with the words "Banish plump Jack, and banish all the world."[26] In the same way Walpole is Macheath, not Peachum (who also represents aspects of Walpole in Gay's play). Macheath is a more likable, even heroic figure than the wretched Peachum. Both Walpole and Falstaff were charming as well as corrupt figures; this was the Walpole of Pope's *Epilogue to the Satires,* Dialogue 1 (1738), and of Fielding's satires in *The Champion* (1739–1741). Hogarth does not lose sight of these complications in his painting, but when he alludes to Falstaff in his writings it is to associate him not with himself but with the Other: for example, with the critics who, when confronted with his theory of the Line of Beauty, were puzzled "till it came to be explain'd but then indeed they all knew it before as well as falstaf knew the prince when he was robd upon gads hill" (AN, 181–82).

Hogarth's old, corpulent Falstaff is a figure he implicitly contrasts with Don Quixote—thin, ascetic, blindly heroic in the face of an unheroic world, and with the reality principle embodied in his short pudgy companion Sancho. Falstaff is all conformity but with some awareness of his shabby complicity. Hogarth shows him taking his bribe with little care for concealment. If the Hogarthian protagonists

(with whom he does sometimes associate himself) are Quixotes, intense desirers of illusion at odds with the world in which they find themselves, his villains may owe something to Falstaff.

Some time after the death of George I the Great Seal, returned by the chancellor of the exchequer at the king's death, was melted down. Walpole received the new seal on 15 August 1728, long after he had been reappointed, and some time after that he had the superseded matrix converted into a salver, as was the custom. Hogarth engraved it—a great honor, or at least an impressive commission for an engraver (fig. 58). The goldsmith who cast the plate was Paul de Lamerie (with whom Hogarth's master Ellis Gamble had worked). Although a goldsmith ordinarily chose his own engraver, it seems quite possible, considering what is known of Walpole, that he approved if he did not personally select Hogarth. Walpole would have been less than his usual astute self if he had not recognized two facts: that graphic satire was far more dangerous than literary, and that Hogarth was potentially the most potent graphic satirist of the age. In any case, Hogarth's references to Walpole became very discreet thereafter. The paintings of *The Beggar's Opera* and *Falstaff* were never engraved nor publicly disseminated.

In the salver Hogarth returns to the allegory Thornhill had taught him at Greenwich; there the older artist depicted "*Wisdom* and *Virtue* represented by PALLAS and HERCULES destroying *Calumny, Detraction,* and *Envy,* with other Vices," and here Hogarth (who had represented the figure in *George, Prince of Wales*) shows Hercules holding in subjugation Calumny and Envy, and supporting the sky to help Atlas.[27] The design shows Hercules balancing two worlds, two circles, containing the two sides of the Great Seal (perhaps readable as two sides of a coin, recalling the royal face in *Royalty, Episcopacy, and Law*). The image is positive and flattering. Hogarth may have intended some comment by having the figure of Justice avert her face from the monarch (he will play similar tricks with Justice in *Industry and Idleness* 10 and *Paul before Felix*); but the main point is that Walpole, the subject of the salver, is holding up both the monarch and the Great Seal. Envy and Calumny are chained at his feet (conceivably also in the secondary, satiric sense of censored). Walpole must have been pleased to see himself celebrated as Hercules, Heroic Virtue, and would not have objected to the trope that suggests that

he holds up the monarchy, as in some ways he did. This was the reality Walpole made clear to George II on his accession, which caused his (at the time reluctant) reappointment as chancellor of the exchequer.

By 1728 Hogarth had also begun to paint some of the court party, and he may have felt that he could not in any overt way mix politics and painting (by 1732 he had painted Walpole's daughter and her family). Always desirous of reaching the largest possible audience, he may have seen the advantage of assuming a nonpartisan position. Finally, it is not unlikely that Thornhill, a Walpole supporter, exerted some pressure on him to dissociate himself from the *Craftsman* circle. The new mode, in which politics is replaced as the vehicle of the painting but remains within the tenor, was introduced in the *Falstaff* painting and, simultaneous with it, the several versions of *The Beggar's Opera*.

THE BEGGAR'S OPERA

The first months of 1728 marked in some ways the denouement of the "Augustan Age": in January *The Beggar's Opera,* in February Fielding's first play, *Love in Several Masques,* and in May Pope's *Dunciad*. Hogarth's *Beggar's Opera* paintings were equally significant. Even if only Gay's ballad opera and Hogarth's paintings had survived, 1728 would still be one of those pivotal years in English culture. What *The Beggar's Opera* in its various forms represents is the transition between the literary world of Dryden, Swift, and Pope and that of Fielding, Richardson, Sterne, and Johnson. Together Gay and Hogarth showed the way that satire, irony, allusion, and analogy could be modified into a more generous and wide-ranging, in some ways more sentimental but in others more questioning and skeptical, mode.

The Dunciad and its world of emblem and allegory represented for Hogarth the past, and indeed he had anticipated many of its assumptions and themes in his graphic satires for the 1720s. But *The Beggar's Opera* offered him a double inspiration. As the fashionable gathering place of the season, it was a practical setting for an experiment in group portraits, usually shown at card parties and other social occasions: one reads of people who had guests to their house "and after-

wards entertain'd them at the Playhouse with the Beggar's Opera".[28]
More important, Gay's play contained the blend of realism and styli-
zation, fact and symbol, which appealed to him.

The very nature of the English theater was as significant to Hogarth
the painter as it was to Gay the dramatist, the one concerned with
overblown history paintings, the other with overblown operatic en-
tertainments. Like Continental history painting, Continental theaters
emphasized spectacular and operatic style and elaborately painted
scenery. They created a baroque illusion of unlimited space within
the limited area of a proscenium-arch stage. The English theater of
the early eighteenth century adopted the proscenium arch and the
painted scene but maintained in essential ways the principle of the
apron stage. It was much smaller, accommodating relatively few
spectators, some sitting on the stage itself, and so possessed an im-
portant feeling of intimacy. While Continental drama was operatic
and stylized, English drama, from the Elizabethan Age on, catered
(in the words of Richard Sothern) to "the native taste for quick action
and close, vivid characterization [which] led to a more concentrated
show with a great importance attached to spoken dialogue and the
humanity of the characters."[29] Thus a small auditorium was needed,
where the characters could be seen and heard; also, of course, fre-
quent changes of scene were indicated, as opposed to the single set of
classical French theater observing the unities of time and place. *The
Beggar's Opera,* for example, shifted from Peachum's counting house
to Lockit's prison to the thieves' den and so on, producing a rapid
series of tableaux very like those represented by Hogarth a few years
later in his "progresses."

It would also have been extremely important to a theater lover like
Hogarth, one who wished to combine his "pleasures" and "studies,"
that Jonathan Richardson in his *Theory of Painting* (1715) had made a
comparison between painting and the theater. Contrasting words
and pictures, he writes that the "Theatre gives us representations of
things different from both: there we see a sort of moving, speaking
pictures, but these are transient; whereas Painting remains, and is al-
ways at hand." A painting, while no less vivid than a stage produc-
tion, has the added advantages of permanence. A second problem
with the stage, Richardson continues, is that it "never represents
things truly"; one is always aware of the discrepancy between the
actor and the Oedipus or Caesar he plays. While on the stage the
viewer's "just notions of these things are all contradicted and dis-

turbed," in a painting the idea itself can be projected from the painter's imagination.[30]

The first of Richardson's points provided a kind of sanction for the theater as a central inspiration for painting, and the second suggested a likely subject for a painter who took the first seriously: not the idealized Oedipus or Caesar, as traditionally painted, but the actor *playing* Oedipus or Caesar on a stage—whether a real one or one of the artist's imagining. This was Gay's subject in *The Beggar's Opera*.

Hogarth chose the eleventh scene of Act III in which all the principals appear in a complex conversation picture relationship: Macheath in chains, standing uneasily between his two "wives," sings, "Which way shall I turn me?—How can I decide?"—which to an educated English spectator would have suggested a parody of the Choice of Hercules topos in which Heroic Virtue chooses at the crossroads between two attractive women, Virtue and Vice. Macheath presumably stood on the stage between Polly and Lucy precisely as Hogarth painted him. But Hogarth alludes to the graphic tradition and compositions like the well-known Carracci painting in the Farnese Palace and the headpiece Paulo de Matteis made for Shaftesbury's *Judgment of Hercules* (fig. 102). Shaftesbury's precedent invoked art, but Hogarth's own engraved Hercules, representing him as Walpole on his own salver made from the Great Seal, furnishes the significant political context: this is Macheath, the actor Walker, the hero Hercules, and (to conclude Gay's analogy) the Great Man Walpole.

Anyone looking at Mr. Peachum and Polly would recall another image from the graphic tradition—as surely as they recalled the earlier incarnations of Gay's ballad songs. This was the *Noli me tangere,* best known in engravings after Correggio's painting (Prado). Peachum has assumed the role of Christ to Mary Magdalen, saying, "Touch me not; for I am not yet ascended to my Father"—in Peachum's terms, "I am holier than thou" is what he is saying to his erring daughter. This graphic quotation may be completely Hogarth's (there is no pretext for it in Gay's play), but it illustrates the method of the play: in an earlier scene Jenny Diver betrays Macheath with what is clearly a Judas kiss, and we may presume that the scene was directed as a parody of the betrayal of Christ (as the opening scene of the act, in the thieves' den, may have been blocked out as a Last Supper with Macheath in the center).

We cannot leave Macheath standing between Polly and Lucy, who is also Hercules standing between Virtue and Vice, and Walker the actor between the actresses Lavinia Fenton and Mrs. Egleton, and Walpole between Lady Walpole and Maria (Molly) Skerrett, without adding that the audience would have recognized the scene as a literary parody—of Antony standing between Octavia and Cleopatra in Dryden's *All for Love,* and beyond that a long series of triangles in heroic tragedy, beginning with Dryden's Montezuma torn between the love of Zempoala and Orazia in *The Indian Queen.*

But the scene is much more. For the tableau of Macheath, Polly, and Lucy is immediately followed on stage by Polly and Lucy turning to their fathers to plead for Macheath: "Dear, dear Sir, sink the material Evidence, and bring him off at his Tryal," says Polly to Mr. Peachum, "*Polly* upon her knees begs it of you." And Lucy kneels to her father making the same plea. Both sing arias. Hogarth has conflated these two actions, giving us both the egotistical "Great Man" Hercules between his two "wives" *and* the two women interceding with their fathers for their lovers. He will make use of both groupings in his mature compositions, and the technique of the double gestalt will be central to his reading structure.[31]

John Rich, the play's producer, either commissioned the earliest of Hogarth's *Beggar's Opera* paintings or was solicited by the artist. Whether the picture established or was a result of their acquaintance, their friendship grew and was sustained until Rich's death over thirty years later. Rich's acceptance of Gay's play after Drury Lane had rejected it was a piece of luck: it was not a characteristic Lincoln's Inn Fields production, and Rich played no part in it himself. But it was the play that, making him gay and Gay rich, earned him enough profits to build a new theater in Covent Garden, next door to Thornhill's house.

He bought Hogarth's small, rather ungainly picture of *The Beggar's Opera,* and before the end of 1729 had commissioned a larger and more elaborate version dated 1729. By 5 November 1729 Sir Archibald Grant, a shady M.P. with whom Hogarth had other connections we shall examine, saw the picture, complete or nearly so, and ordered a copy for himself.[32]

As a picture destined for Rich, Hogarth's first version tried to re-

capture the first night (fig. 59). It is seen from the point of view of the actors, who are painted as portraits, while the audience is reduced to good-humored caricatures. Horace Walpole identified the fat man in profile on the right (with riding crop under his arm) as Sir Robert Fagg, the noted breeder and racer of horses, who is turning his back on the performance. The long-visaged man on the left he identified as Sir Thomas Robinson of Rokeby, famous for his lavish entertainments and amateur architectural exploits. The thin, pointed-faced beau standing next to Fagg is Major Robert Paunceford.[33] In the final version (fig. 60) commissioned by Rich these figures are normalized into realistic portraits like those of the actors. Included are not only Rich's players but his most influential friends, and of course Rich himself and Gay (who may have been the face just above Fagg's in the earlier version). The performance seems to be idealized with an audience selected by Rich, including the duke of Bolton, whose eyes meet Polly's across the stage.

Only with this version does Polly's right arm, which made her psychological tie with Macheath, drop and point toward Mr. Peacham—but also Bolton, to indicate *their* relationship. The allusion was to the well-publicized love affair between Lavinia Fenton, the Polly of the cast, and Bolton—she twenty, he forty-three and married. He sat in a stage box at the first performance and was said to have been one of those enamored of Polly—Lavinia's rendition of "Oh, ponder well," returning again and again to watch and hear her. At the close of the first season he took her off the stage to become his mistress—and eventually, a quarter of a century later, when his wife died, she became his duchess.

The final version also shows a completely different, and much larger, more spacious and baroque stage, with a crouching satyr at each wing. (The satyr stands for both sexual desire and satire, as in the first *Hudibras* plate.) One might imagine that this painting was commissioned for Rich's new theater in Covent Garden, to celebrate the play that financed it; the subscription for the new theater was not, however, begun until 1730. It is possible that Rich wanted a painting of the way his theater *should* look or that Hogarth idealized the composition. Something new is being projected, though the particular revision may have been inspired by the gigantic project for an opera, *La Prison d'Amadis* by Daniel Marot, in his *Livre de décoration différante* (1702), which it closely resembles.

The influence of Watteau's theatrical *fêtes* is unquestionable. Wat-

teau had been in London, painting and recuperating, in 1720–1721, and if Hogarth saw his *French Comedians* and *Italian Comedians* (both with central Macheath-like figures) at the house of Watteau's physician and collector Dr. Richard Mead, he would have had a starting point for the first version of *The Beggar's Opera*. These paintings were accessible to such painters as Thornhill—and thus to Hogarth. For example, *The Italian Comedians* (now in the National Gallery, Washington), shows the actors on a stage, taking a curtain call. They are outside the play's action, though it is not clear whether they take their curtain calls as outside or inside their commedia dell'arte roles. Hogarth shows his actors within both their roles and the play's action, but they are individual portraits that distinguish Walker from Macheath and Fenton from Polly; and in the case of Polly, he represents an actress who, like Watteau's figures, is both inside and outside her role. If he had seen one of the versions of Watteau's *Bal champêtre* (Dulwich Gallery), he would have had a precedent for the large stage structure of the final version. By the later 1720s etchings after Watteau's paintings and drawings were appearing, offering a large repertoire of theatrical scenes of the sort Hogarth explores in *The Beggar's Opera*.

The six paintings Hogarth made of *The Beggar's Opera* are, for lack of other evidence, the best chart available of his development as a painter between 1728 and 1730. Only with the second painting (collection, the Hon. Lady Anstruther-Gough-Calthorpe) does he succeed in relating the central figures to each other, making them a single tight unit; and even then Peachum remains clumsy, with his hat wrong and his head not set correctly on his body. The second and third paintings come closest of any to the monumental simplicity he seems to have been seeking and which he finally achieved in the *Harlot's Progress* compositions of 1730–1731. At this point he has created a kind of history painting composition of his own which does not require crowd scenes or echoes of battle scenes or processionals (as in *Hudibras*). The effect of his actors blocked out on the stage, in contemporary dress, is one of solidity and monumentality, all the more remarkable considering the small (Watteauesque) size of the canvas.

Perhaps because it is unfinished, the fourth version is the most expressive of all (figs. 61, 62). There is no wrong note, no distortion for effect: Hogarth has solved the problem of Peachum's hat by canting it toward Polly (instead of down at his finicking hands), and rais-

ing his left hand in a negative gesture. Polly's face is turned from profile and is more expressive, less posed and statuesque, than in the earlier versions. Even Lucy is for once expressive, her face (usually averted) partly in view; and the spectator at the far left too has turned her face toward us (in the final two versions her pose follows Lucy's).

Actors in the play gave Hogarth exactly the freedom to improvise denied him in conventional portrait groups of the ladies and gentlemen whose business he now wished to attract. The *Beggar's Opera* figures are certainly better related to each other and less isolated than those of, say, the *Woodes Rogers Family* (fig. 75) conversation, painted around this time, or *The Wedding of Stephen Beckingham and Mary Cox* (fig. 91), painted a little later; and yet they were real people and not the inventions of traditional history painting or his own imagination. Moreover, the actors could be juxtaposed on the stage with their roles and with aristocratic members of the audience; thematic and psychological tensions could be suggested. A brilliant possibility for a conversation picture was offering itself. He could peddle his modello—one of the small versions perhaps—and suggest that around the actors he would introduce portraits of Lord X and his party. He evidently followed up this idea only in the last two paintings, however, and they repeat the same group of onlookers.

The final version (fig. 60) is a remarkable synthesis of the virtues of the overly finished early paintings and the freely painted, indeed unfinished expressiveness of the fourth version. This freedom dominates the canvas (some of which was lost in the final copy made for Sir Archibald Grant [Tate Gallery, London]), but the faces and figures of the main characters approach a high finish. The secondary figures are more casually rendered, and the background figures are only indicated. In this version Hogarth has reached maturity as a painter.

The composition is much wider, more panoramic, elaborate, and in every sense mature than that of the earlier paintings. Before, the actors filled the picture space and were themselves surrounded by spectators who were lightly indicated or mere caricatures. Now the actors are reduced to neat little figures on a gigantic stage (made more so by the illusionistic recessions of the elaborate stage set); the crowd behind has become a group of actors (presumably getting ready to participate in the Dance of Prisoners in Chains of scene 12); and the spectators appear in two neat rows on either side of the actors, developed here into careful and not unflattering likenesses. If

the third painting emphasized the psychological involvement of the characters, these last two paintings emphasize panoramic and decorative effect. The characters speak out as part of a thin, undulating chain reaching from one side of the stage to the other, unified by the salmon red of the spectators' boxes on either side and Macheath's coat in the middle—and further emphasized by Polly's light salmon sash, bodice, and arm ribbon.

The two conceptions reflect essentially different interpretations of Gay's accomplishment in *The Beggar's Opera*. The first group, with large figures dominating the picture space, recreates Gay's play as an alternative to opera (or, in Hogarth's terms, to decorative history painting), with its small, intimate stage, subdued set, and contemporary costumes. The last two paintings put a great deal more emphasis on the play as parody of opera. They reduce the size of the players in their contemporary dress and emphasize the theatricality of the trappings that surround them. The effect is more clearly mock-heroic, reflecting Gay's intention to make thieves sound like opera singers playing gods and heroes.

Here were two possibilities, quite different, for history paintings. One is a model (based on Steele's program in the *Spectator*) for a native art as an alternative to such nonsensical foreign entertainments as Italian opera; the other is a mock-epic in which characters are placed in relation to the heroic poses of Handelian opera and contemporary English assumptions about heroism (and politics). In the sequel Hogarth produces two kinds of painting: one shows large figures dominating the picture space with a small intimate stage, subdued set, interpersonal relations, contemporary costumes, and a subject concerning playacting, and explores Gay's play as an alternative to history painting. The other puts a great deal more emphasis on the play as parody of opera, reducing the size of the players in their contemporary dress and playing up the theatricality of the trappings that surround them. One would become the unit for a series of related scenes in the *Harlot's Progress,* and the other would provide the scale for a large independent composition like *Southwark Fair* or *Strolling Actresses Dressing in a Barn.* In one a person playing a role is observed and reacted to by bystanders, like the spectators at a play, some indifferent and others all too interested; in the other the theme of illusion-reality, "life as theater," is played out in a delicate, fragile performance with spectators who impinge upon and destroy the illusion—or produce their own dramas.

The performance of *The Beggar's Opera* was, then, the decisive aesthetic event for Hogarth between his *Hudibras* plates of 1726—in which he had already begun to experiment with the idea of modernizing history painting—and the "comic history" of the *Harlot's Progress* in the 1730s. Besides the structure and conventions of the stage itself, which were already evident (sometimes physically present) in his engraved work, Hogarth made use of two crucial elements in *The Beggar's Opera*. One was the reduction of the opera heroes and heroines—with the arias, high-flown speeches, and other stereotypes—to the figures of contemporary robbers and prostitutes. This of course was obvious to Hogarth's contemporaries, and the only distinctive Hogarthian insight was that the transference could apply also to the equivalent of operas in history paintings, which had become as decorative and overformalized as operas. This insight was already part of Hogarth's equipment (witness *Hudibras*), but Gay's ballad opera may have reinforced his interest and suggested the idea of an original subject instead of illustrations for an extant text.

The second element of importance in *The Beggar's Opera* was Gay's device of having his thief employ the jargon or diction of a gentleman. Lockit, the Newgate jailor, fits Macheath with leg irons: "Those, I see, will fit the captain better," says Lockit. "Take down the further Pair. Do but examine them, sir," he says to Macheath.

> Never was better work.—How genteely they are made!—They will sit as easy as a glove, and the nicest Man in England might not be asham'd to wear them. If I had the best Gentleman in the Land in my Custody I could not equip him more handsomely.

As the similes and the diction throughout suggest—starting with the curtain rising on Peachum sitting in his countinghouse at a ledger, as if he were a merchant and not a receiver of stolen goods, and in his song comparing himself to lawyers and statesmen—these are people who are acting up to a respectable social class to which they do not belong (but to which, Gay implies, they have as much right to belong as anybody else). The thieves constantly align themselves with their betters ("Sure there is not a finer gentleman upon the road than the captain!"); they employ similes (if Polly Peachum marries Macheath, she is told, she will be "used, and as much neglected, as if [she] hadst married a lord"); and, more generally, they assume an inappropriate diction: Macheath talks like a gentleman, Peachum and

Lockit like merchants, Polly like a romantic heroine, and the whores like ladies.

What Hogarth saw that his contemporaries apparently missed—or at least did not exploit—was the complex effect produced by the thief's adopting the style of the gentleman or merchant. In terms of the mock-heroic mode, Gay was adapting the heroic level to parallel rather than contrast his low subject:[34] as if Theobald's heroic view of himself in *The Dunciad* incriminated Virgil's Aeneas rather than polarizing and elevating him. In *The Beggar's Opera* the diction and the mock-heroic similes in the mouths of thieves do not, as in Dryden and Pope, allude to an ideal; they indicate a correspondence between the depredations of robbers and the heroic activities their own words evoke.

One implication is that opera heroes and politicians, under their rhetoric and respectability, share the cutthroat values of Macheath and Peachum, the highwayman and fence. As the beggar tells the audience at the end, he wanted to show "that the lower Sort of People have their Vices in a degree as well as the Rich, *and that they are punish'd for them*" (emphasis added). The punishment makes the difference. By embodying the mock-heroic relationship in a characteristic diction, Gay reveals the character's self-rationalization and upward aspiration—his desire to emulate the more respectable, and successful, citizen and courtier. The "superior sorts" are closer to Gay's real game, not these poor rogues; the rich whose imitation of a false ideal is only dimly reflected in the whore and highwayman who mimic and hang for their crimes. But the real game is the imitation itself—and the fact that models (literary or political) are now repressive and negative.

Thus Hogarth shows actors playing parts (of other actors— Macheath playing the roles of gentleman or faithful lover vis-à-vis Polly playing a romance heroine) on a stage where they are juxtaposed with the very gentlemen and ladies they are (as characters) imitating. Hogarth exploits the fact that the gentry had seats on the stage in order to achieve one obvious effect: Lavinia Fenton, playing Polly, looks away from her supplicating stage lover, Macheath, toward her real lover, the duke of Bolton. Hogarth must have seen this situation (even if Bolton did not) as a realization of Gay's central proposition about the relationship between thieves and gentlemen, between actors and the roles they play, between models and the fools who imitate them. It very clearly conveys the play's theme, placing

criminals next to the equally culpable gentle folk who are watching and serving as their models.

Governing both play and painting is the basic metaphor of life as a stage. *The Beggar's Opera* illustrates the preference Addison held in *Spectator* No. 219 (1711) for the metaphor of life as a stage over the moribund metaphor of life as a journey. The social, moral, and providential implications of life as a stage fit the circumstances of life in eighteenth-century England better than the Christian pilgrimage or the epic journey with its destination. For Addison the theatrical scene replaces the determinedly teleological pilgrimage with a series of provisional structures, roles, and scenes, which are more appropriate to man's life in society. For the *Spectator* creates a "Fraternity of Spectators," as Mr. Spectator tells us—"every one that considers the World as a Theatre, and desires to form a right Judgment of those who are actors on it." And the element of the metaphor given greatest emphasis by Addison is that of imitation, and the relation between copy and original:

> Instead of going out of our own complectional Nature into that of others, 'twere a better and more laudable Industry to improve our own, and instead of a miserable Copy become a good Original. (No. 238)

Quite different from the Puritan insistence on the need for rebirth or conversion into another role, the *Spectator's* assumption of an original nature that is good in the sense of authentic leads to the imminent danger of losing oneself which Gay and Hogarth describe. "Consider all the different pursuits and Employments of Men," says Mr. Spectator,

> and you will find half their Actions tend to nothing else but Disguise and Imposture; and all that is done which proceeds not from a Man's very self is the Action of a Player. For this Reason it is that I make so frequent mention of the stage. (No. 370)

In Hogarth's earlier versions of the painting the respectable spectators are all over the stage, more or less surrounding the small group of actor-thieves; their faces are distorted into caricatures, some looking as though they were paper cutouts. Hogarth has made the actors appear more real and substantial than the respectable spectators, who come as close as any figures in his work to caricature. In the final version of the painting they are regularized to seem more like por-

traits, and segregated to either side of the stage. But there are still a great many of them; their number is threatening.

The relationship between actors and spectators is supported by Hogarth's use of color. The black suit and hat of Peachum are connected by color, texture, and cut with that of a standing figure among the audience on the stage (John Rich, the theater manager, or Gay according to early identifications); the brown suit of Lockit connects him with another man in the audience (Sir Robert Fagg), and the salmon suit of Macheath with yet another (Major Paunceford).

In this final version Hogarth also added to the motto *Utile dulce* (Plays should be both entertaining and instructive), which has appeared on a ribbon attached to the royal arms over the stage, a second motto, a direct reference to the audience: *Veluti in speculum* (Even as in a mirror), including both audience and actors within the prison, extending the *Veluti* to the audience on this side of the proscenium arch, and beyond to the viewers of the painting.[35] The final version is, in fact, an extraordinarily complex study in the nature of illusion and reality based on the metaphor of life as a stage. An expanded version of the *New Metamorphosis* frontispiece, it contrasts the "rather clumsy, bourgeois stability of the actors"[36] with the theatrical quality of the baroque, billowy curtains, the royal arms, the set itself (which dwarfs them), and the sculpted satyrs.

When Polly–Lavinia turns toward the duke of Bolton, whose status is somewhere between audience and actor, partaking of both, we have to ask: is he acting according to stage conventions or is Polly acting according to *his* aristocratic conventions? At the same time Gay the author and John Rich the producer watch both dramas unfold. The actors who have been added at the back of the stage (they were audience in the first version) are shown talking among themselves, oblivious of the play, like some of the spectators; they represent an intermediate state between these aristocrats and actors in their roles, for they are not yet "on stage," their scene has not yet begun. Even the satyrs on either side of the stage (one pointing down at Bolton to indicate the sexual involvement), contrapposto in different directions, seem alive in relation to the sculpted heads of deities, part of the stage structure, before which they crouch. The satyrs become observers analogous to the satyrs in the frontispieces of *The New Metamorphosis* and *Hudibras,* drawn perhaps from those ambiguous human-statues Watteau painted in his gardens. Here, of course, Hogarth has gone far beyond Gay's intention, producing in a sin-

gle picture almost all the themes with which he will be concerned throughout the rest of his career.

Finally, the importance of the phenomenon of *The Beggar's Opera* to Hogarth included its demonstration that *new* plays of a certain sort (vs. revivals) had a large potential audience.[37] The audience Hogarth was consciously tapping into, especially with his prints, included these theatergoers, for whom he had already made theatrical prints: and for whom he was to make what essentially are views of stage sets.

Sensing something but by no means all of Gay's strategy, contemporary critics attacked his play for offering criminals as ideals for ordinary citizens to copy. Gay, of course, meant to illustrate how the respectable models of politicians, judges, and lawyers lured people into criminality. Hogarth must have noted these censures, in particular a book called *Thievery A-la-mode; or The Fatal Encouragement,* which came out toward the end of 1728. In it a young man vainly seeking his fortune in London attends a performance of *The Beggar's Opera* and afterward notices everywhere portraits of Macheath and Polly—which were indeed reproduced on fans, playing cards, screens, and snuffboxes. Seeing that these characters are universally admired, he becomes a highwayman, comes to grief, and, dying, confesses his crimes, "concluding with a hearty Prayer, that he might be the only Person seduced by the extravagant Applause the Town gave the Character of a Thief in the *Beggars Opera*."[38] It is a portrait of Macheath which the Harlot keeps on her wall near her bed, a pinup, a role model with, of course, the hope that her punishment will, like Macheath's, be prevented by a reprieve. And, as if to demonstrate that he has grasped Gay's meaning, Hogarth places next to it a portrait of Dr. Henry Sacheverell, the respectable clergyman-politician who generated riots with his incendiary sermons and then rose from one lucrative benefice to another, and above that an engraving of a history painting showing Isaac saved by the angel from Abraham's sacrificial knife (fig. 98).

It has been argued that the satyr's hand, indicating lechery, is pointing down toward the duke of Bolton, and that this was the reason Hogarth did not engrave the painting—he did not want to make the allusion public.[39] But if the painting was hanging (as it presumably was) in the Covent Garden Theatre, it was already public. Hogarth engraved none of his conversation pictures. By publishing this one he would have been demonstrating its public dimension, certainly to Walpole, perhaps also to Bolton. An engraving did not ap-

pear until 1790, when it was executed by William Blake for Boydell's
Hogarth folio.

Hogarth's earliest surviving "paintings" are the monochrome water-
color drawings for *Hudibras*. *Hudibras's First Adventure* (fig. 63) shows
him still defining areas by lines in the manner of an engraver. The
earliest authenticated oil paintings are still painted in this manner.
They are small and meticulous, delicately painted, with a dark neu-
tral background, and the figures, rather stiff and angular, are indi-
cated by linear means. The style is particularly evident in the oil
sketch of *A Committee of the House of Commons* (fig. 64), which must
be the earliest version of the subject; and the linearity is carried over
into the finished painting (figs. 65, 66).

Within a year, however, Hogarth had developed from a style that
defined by lines to one that defined by volumes; the latter, essentially
alla prima painting, first appears in background figures, then in small,
independent sketches, and finally, with various degrees of finish, in
all his paintings. *The Christening* (fig. 84) clearly follows *The Denun-
ciation* (fig. 81) in this respect, because it shows the transition from
the hard, dry, linear style to the beginnings of a softer, more fluent
painting in volumes. The earliest painting in which Hogarth is com-
pletely at home in his medium, defining in the freest *alla prima* man-
ner, is the (perhaps significantly) unfinished transitional version of
The Beggar's Opera, probably of 1729 (figs. 61, 62).[40] This version,
with its mastery of paint, also demonstrates one of Hogarth's recur-
rent problems in his painting: to maintain the freshness of his origi-
nal idea in the finishing of the picture—or, for that matter, to know
when he is finished.

If the date 1729 inscribed on the final version (fig. 60) is accurate, it
shows that in little more than a year's time Hogarth had developed
from a groping, primitive painter to one unexcelled in the handling
of paint by any other English painter of the eighteenth century. It is
hard to believe that six paintings reflecting such improvement could
have been made between the spring of 1728 and the end of 1729, even
considering that all were repetitions of a single scene.

Hogarth's painting technique changed little thereafter. He painted
directly on the canvas without preliminary drawings, a departure
from the academic assembling of drawings for each figure or ob-
ject—and from the privileging of idea over execution. Many oil

sketches survive—discarded first thoughts; but the only two surviving drawings connected with paintings are the two for his earliest, the *Falstaff* and *Beggar's Opera* paintings. Within the basic sketched composition he would add figures of contrasting characters, accreting his design by means of parallel and opposing forms (and, correspondingly, concepts). He said to Charles Grignion when, after many trials, he was finally satisfied with Garrick's face: "I never was right save when I had been wrong." This used to be applied to the engraving of *Garrick as Richard III* (1746). In fact, it applies to the painting, where he finally cut out the face and sewed in another.[41]

His method of applying paint was important for the preservation as well as the effect of his paintings. He never attempted the systematic laying on of glazes—as Reynolds, for example, did after his return from Italy—but began with a thin monochrome underpainting, usually in cool grays and greens (occasionally in sienna). Over this, once dry (and sometimes before), he applied a relatively transparent painting of the actual colors intended, with no apparent science relating them to the underpainted colors, and then finished with highlights in rich, creamy, and occasionally impasto color. One consequence was that his relatively direct painting on the canvas produced works that have aged well. A cleaned Hogarth looks virtually as it must have when it left his studio.[42]

What chiefly distinguishes Hogarth's paintings stylistically into two groups is the point at which he stopped painting. His liveliest works in oil are the modelli and unfinished projects. He kept these, we may assume, because they, more than pictures that are "perfected," according to Roger de Piles, the great advocate of *Rubenisme,* "have more spirit, and please more than those that are perfected, provided their character be good. . . . The reason is, that the imagination supplies all the parts which are wanted, or are not finished, and each man sees it according to his own goût."[43] Connoisseurs sometimes collected oil sketches, but an English connoisseur was unlikely to collect English sketches. Horace Walpole was one of the few who collected Hogarth's, and these relatively unfinished works were the only Hogarth paintings he did gather. His concern was primarily with Hogarth's subject—murderesses, actors, and prison wardens—but he was undoubtedly not immune to the liveliness of expression. (He collected Hogarth's engravings on a large scale.) Hogarth himself obviously recognized his talent for immediate expression in oils, and

perhaps often felt disappointed with the final result. He kept these sketches first as modelli, perhaps as reminders of works that may have passed out of his hands, but also certainly because he appreciated their beauty. They were for himself. The story of his development as a painter is the search for a style that will pass for finished without losing the fluency of the underpainting.

6.

CONTEMPORARY HISTORY AND MARRIAGE, 1729

A COMMITTEE OF THE HOUSE OF COMMONS

Hogarth's next plainly datable project engaged contemporary history. For in 1729 he was drawn back to the scene of childhood memories, the Fleet Prison, and given an opportunity to paint the debtor-as-prisoner confronting his warden, with a committee of members of Parliament as audience: not the make-believe "prison" of *The Beggar's Opera* but the real one of the Fleet.

The Fleet Prison at this time was even worse than when Richard Hogarth languished there. In 1713 John Huggins, the crafty friend of Thornhill and the earl of Sunderland, had bought the patent for the wardenship, paying £5000 for his own and his son's lifetime.[1] By 1723 prisoners' petitions were accumulating to show that self-interest was guiding Huggins's operation of the prison. These petitions mainly concerned his extortions, far in excess of those settled by law in 1693, charging the same fee more than once, even demanding Christmas gifts of the prisoners, and conserving on his own outlay by letting the prison run down, failing to replace furniture and bedding or to repair drains, gutters, and necessary houses.[2] Answering the allegation that he detained the bodies of dead prisoners from their relatives or friends, often beyond putrefaction, until he was paid rent and fees due him, Huggins's characteristic response was that he knew nothing of the doings of his deputy.

The problem of Huggins's reliance on deputies came to a head in August 1728 when, having secured as much money as he needed (or discerning the storm clouds ahead) and feeling that he was "growing in years, and willing to retire from business, and his son not caring to take upon him so troublesome an office," he sold his patent to his

most recent deputy, Thomas Bambridge (an attorney by profession), and one Dougal Cuthbert for £5000.[3] Not long after, Robert Castell, architect and author of *The Villas of the Ancients Illustrated* (1728), refused to pay the exorbitant fees demanded of him by Bambridge, and for punishment Bambridge confined him in a sponging house adjoining the Fleet. This place was at the time raging with smallpox, which Castell told Bambridge he had never had, "and that he dreaded it so much, that the putting him into a house, where it was, would occasion his death, which, if it happened, before he could settle his affairs, would be a great prejudice to his creditors, and would expose his family to destruction." Bambridge accordingly put him there, and he caught smallpox and died.[4] Known among the Palladians for his architectural work, he was more importantly a friend of the M.P. James Edward Oglethorpe, who began agitation in the House of Commons.

In January 1728/29 Bambridge further overreached himself, picking on a baronet with connections: Sir William Rich, Bart., had been

> lodged on the Common Side, and the next Morning Mr. Bambridge, with several Assistants came to see him, when a Quarrel ensued (said to have been occasioned by a Demand for 5l. for a Baronet's Fee, and which Fee we hear Sir William had paid once before) and Mr. Bambridge was wounded, but it is thought not mortally.

Sir William was consequently "close confined in the strong Room, or Dungeon of that Prison, manacled and shackled, and a Centinal with a loaded Musquet at the Door."[5] The "strong Room" was a lightless underground vault, built over the common sewer, where the dead were placed before burial, and in which recalcitrant prisoners were lodged. Sir William's friends rose up, and on 8 February Bambridge was called to court "to shew Cause . . . why he iron'd Sir Wm. Rich, Bart."[6]

On the 25th a committee was appointed by the House of Commons on the motion of Oglethorpe to inquire into the state of the jails in England, and Oglethorpe was appointed chairman. On the 27th the committee of both Lords and Commons went to the Fleet "to examine into the State of that Gaol, in order for Relief of the Insolvent Debtors, &c. when the Irons were taken off Sir William Rich, Bart." They questioned Rich and the other debtors about their treatment, but Bambridge was so little affected that the next morning

when the committee returned it "found Sir Wil. Rich loaded again with Irons, considerably heavier than those he had on the Day before; for which Mr. Bambridge, the Warden of the prison, is taken into Custody."[7]

At the beginning of March Bambridge was indicted by the London Grand Jury, and on the 4th the committee of the House of Commons went again to the Fleet to hear prisoners' complaints and the newspapers began to leak hints of corruption: the exorbitant fees and the bribes that permitted prisoners to escape to the Indies. On the 5th the committee went again to hear complaints—"as the Committee are indefatigable in finding out the scandalous Abuses; It's not doubted but the poor Prisoners for the future will be treated with some Humanity," we read in the *Craftsman* (8 Mar.), which by now had made the scandal a political issue in its war on Walpole.

Then on 8 March "several of the Committee of the Honourable House of Commons, came to the Fleet Prison, where Mr. Bambridge was brought before them, and examined upon several Articles of Complaint exhibited against him."[8] This confrontation, or a subsequent one in the next week or two, was the occasion of Hogarth's oil sketch of the committee meeting in the Fleet (fig. 64). (Hogarth called the picture *A Committee of the House of Commons* in his January 1730/31 list of pictures, emphasizing the conversation picture aspect rather than the confrontation; figs. 65, 66.) The tenor of these confrontations can be imagined from accounts such as the one of Jacob Mendes de Sola, a Portuguese Jew who had been kept manacled and shackled in the "strong room" for nearly two months; when, during his testimony, a member of the committee hinted at a confrontation with Bambridge, "he fainted, and the blood started out of his mouth and nose."[9] He would appear to be the figure testifying in Hogarth's painting.

If Hogarth was not in the Fleet on that day, he attended at least one of the official confrontations in the House of Commons but transferred his setting back to the Fleet. In either case he needed an entrée to the committee, which at this time could have been through Sir Archibald Grant, who commissioned (or at least bought) the painting, or through Thornhill.[10]

Thornhill was not on the original committee that went to the Fleet and made the investigation, as he appeared only at the end of April on the committee that met with Lords over the act to disable Bambridge. This committee, a much smaller one, was apparently com-

posed of a selection of the Fleet Committee, including its chairman, plus a few Commoners who would not be biased by what the others had personally seen and heard of Bambridge at the Fleet. Thornhill was also on the list of the General Committee in the *London Journal* of 5 July, but by then the investigation had turned to other prisons.

Thornhill might have secured permission for Hogarth to sketch the proceedings even if he was not himself on the committee. It is not likely that he secured the permission after April, when he became a member, because by the end of March Hogarth's friendship with Thornhill suffered a serious, if temporary, setback. Moreover, Hogarth's scene shows no direct knowledge of the enquiry inside the Fleet. The actual chamber in which the enquiry took place was a paneled room in the Georgian style, whereas Hogarth turns it into a rock-walled prison.

Another possibility involves Sir Arthur Onslow, who was elected speaker of the House of Commons at the opening of the new Parliament on 23 January 1728, and within the next year or so he asked his friend Thornhill to commemorate his association with Walpole, some of his friends (including Thornhill), and even his clerks. The finished painting is dated 1730, with the heads of Thornhill and Colonel Richard Onslow, who was a member of the Fleet Committee, and perhaps one or two others, by Hogarth (fig. 67).

Thornhill's House of Commons painting had no influence on Hogarth's new work. Filling the foreground are large three-quarter-length portraits of Onslow and Walpole in their accustomed positions in the House, closely attended by the clerk; and in the background is a bank of heads of the "friends." The result is much more a portrait with attendant friends than one of Hogarth's conversation pictures and bears no relation to the Dutch portrait groups in which each figure is more or less equal to the others.[11] In fact, the pose of Onslow and Walpole bears the same prominence as the Oglethorpe and Bambridge of the Commons Committee painting (with Walpole in the Bambridge position)—without, of course, the wretched debtor who is the subject of their intense exchange.

There is a small oil sketch, *The Sleeping Congregation* (fig. 68), which carries the date 1728 on a plaque on the church wall. Stylistically it looks more like 1730 or later, and it was only engraved and published in 1736. But there is a curious, almost parodic resemblance between this composition and Thornhill's *House of Commons*. In *The Sleeping Congregation* Hogarth has raised the Onslow figure to a pul-

pit and reduced the Walpole figure to a sleeping young woman, and the clerk to the reader; the M.P.s have been reduced to tiers of the sleeping congregation—the group portrait in the House of Commons to one in a church. Perhaps Hogarth intended this sketch as a burlesque of Thornhill's painting in the manner of his anti-Walpole satires. If we imagine the House of Commons transformed into a church, with the common denominator of somnolence, these would be the equivalents. But if there was a political intention in the original oil sketch, it went the way of *The Beggar's Opera,* remaining unengraved until Hogarth could take up other aspects of the scene. Already Polly Peachum finds a slight echo in the pretty young woman who is the center of what attention there is in the sleeping congregation.

In the oil sketch of *A Committee of the House of Commons* (fig. 64) Hogarth puts Oglethorpe in a Choice of Hercules pose, with the evil Bambridge on one side and the persecuted prisoner on the other. But the scene is more closely related to *Falstaff Examining His Recruits* than to *The Beggar's Opera,* and presumably derived from it. The chairman, Oglethorpe, acting as a mediator between Bambridge the warden and the prisoner, provides the sort of role inversion explored in both paintings: a criminal warden opposes an innocent, persecuted prisoner; the real criminal is pitted against the reputed one, with a judge to choose between them and a polite audience looking on. The gesture is different from Falstaff's and the figures are not parallel to the figures around him, but the human relationship to which the scene draws our attention is the same.

The *Hudibras* committee scene showed fools in power seated around a table. The figures in the Shakespearean scene, echoing the *Hudibras,* also became fools in power. But the *Committee of the House of Commons* shows a situation of the dishonest warden confronted by the honest prisoner in front of an audience (a chairman, Oglethorpe-Shallow, and M.P.s). Hogarth has drawn upon the memory of Falstaff the dishonest impresser of soldiers, imperiously "choosing" two while accepting a bribe from behind his back and excusing two others. The innocents are being condemned and the guilty (the bribers) freed. How far Hogarth intended the notion of the dim-witted audience consisting of Shallow and Silence to carry over to the members of Parliament we can only speculate. But beneath the overlay of a dignified Choice of Hercules is the less complimentary Falstaff composition.

It is certain that the Falstaff scene was in some sense a preparation

for the *Committee of the House of Commons* and similar scenes that followed. For the basic situation is a Hogarthian not a Shakespearean one. The image in fact relates to Hogarth's own youth spent in the Fleet Prison and its environs, and this relationship between the prisoner and the warden, as between the innocent and the guilty, with an audience of supposed judges, or respectable spectators—a theatrical or a legal metaphor—becomes a basic structure of Hogarth's progresses, for example when the Harlot is threatened by the warden in prison (Plate 4, fig. 99). She is always surrounded by people who are ostensibly more respectable, but in fact more criminal, than she.

A *Committee of the House of Commons* can be connected with *The Beggar's Opera* as a drama with an audience in attendance or with *Falstaff* as a portrayal of people, still actors, in a public ceremony with witnesses and onlookers. In either case Hogarth is developing a new kind of portrait group which is quite consciously not portrait nor genre nor history painting but partakes of all three. He must have sketched the members of the committee, then in his studio produced the oil sketch modello, and showed it to the members. Within the blank faces of the modello he could insert the faces of whichever committee members were interested in a picture, producing as many pictures as were commissioned.

Several versions of the finished picture have been recorded, but the only one known to survive is in the National Portrait Gallery, London (fig. 65). The one documented commission, by Sir Archibald Grant, does not necessarily refer to this particular version; whoever commissioned it wanted a portrait-gallery effect instead of the dramatic scene portrayed in the modello. The finished painting was accordingly enfeebled—Hogarth dropped the prisoner to his knees and turned his back on Bambridge, turning the faces of several more committee members toward the viewer. The result is the loss of the central confrontation between jailer and prisoner, who have become props for the committee members. The figures make a stiff horizontal band across the canvas, which might as well have been painted by Gawen Hamilton or some other contemporary painter of conversation pictures.

Despite the failure of this surviving version of the finished picture, we can understand Hogarth's rationale for such a portrait group. It takes him beyond the stage of a theater to unfeigned actuality that is both historical and timeless—even though it may contain elements of feigning. Besides a particular portrait group representing a particular

moment in time, this picture offers memorials of the men presented and warnings of the evil warden or, in later groups, of the effects of intemperance or venality. And it draws critically upon the aesthetic of utility and emotional force propounded by Franciscus Junius and transmitted by Steele's *Spectator* essays on art.

With Hogarth's role in the Commons Committee's deliberations finished, we need only remark that the matter remained in the news during the spring and summer, helping to perpetuate that general public interest in crime, prisons, and prisoners which was also stimulated by criminal biographies of Sheppard and his like, and by *The Beggar's Opera*. On 20 March the committee's report was read in the Commons and it was resolved that the king be petitioned to direct the prosecution of Bambridge and Huggins, and ordered that they be committed to Newgate. On the 29th they were arrested, and in mid-April Bambridge was indicted and put in irons. On the 19th the Commons Committee was again examining prisoners in the Fleet, perhaps to make last minute additions to the published report, which appeared on 26 April, disclosing, as one paper put it, "a Series of Cruelty and Oppression, which the Spanish Inquisition is a Stranger to."[12] The pamphlet sold as well as criminal biographies, and it was shortly followed by *The Prisons Open'd. A Poem.*[13]

On the same day the report was published, a new committee was appointed to meet with Lords over the act for disabling Bambridge (i.e., to enable the king to grant the office of warden to someone else and to incapacitate Bambridge from holding that or any other office), and Thornhill was one member. On the 1st of May the Grand Jury met at the Guildhall and found a bill of indictment against Huggins (and James Barnes as his agent) for the murder of Edward Arne; the keeper of Newgate, we are told, "has caus'd Mr. Huggins to be put in Irons, and double Guard over him."[14] Old Huggins, though a greedy, unscrupulous man, does not appear to have been a cruel one like Bambridge; his crimes were bribes taken to free men, not sadistic treatment of the prisoners (the case of Arne was probably, as he claimed, and the court accepted, Barnes's doing, though he was probably cognizant of it at some point). At any rate, he was a very old man being piled with chains, and despite his wickedness Hogarth remained friends with him and his son in the years that followed, painting portraits of both.

By the middle of May Bambridge's disablement was passed and the committee had turned its attention to the Marshalsea Prison and Huggins was "greatly indisposed at Newgate." Both trials began in mid-May, and on 14 June when Bambridge's wardenship officially expired, "the Fleet Prisoners, having been some time preparing his Effigies, exalted the same fetter'd, in a Triumphal Chair, with a Daemon at each Shoulder, and the Paunch well stored with Gunpowder, in order to blow him up; proposing to be very merry on so solemn an Occasion."[15] This "crowd ritual" would not have gone unnoticed by Hogarth. Bambridge and Huggins, after long and tiresome hearings, were both freed (though Bambridge twenty years later cut his throat, and Huggins suffered real discomfort before his final release in November 1730).[16] Conditions in the prisons improved in some ways, worsened in others. The begging grate, for example, where prisoners could speak to friends or secure a few pennies from passersby, was after the investigation bricked up.[17] Lord Hardwicke later recalled to the duke of Newcastle that "the Gaol-committee, which your Grace perfectly remembers, who, from being appointed and united to enquire into the abuses of gaols, became banded together for factious purposes, and were a flying squadron upon most questions during the remainder of that Parliament."[18]

The story of the Fleet Prison has been pursued beyond the point where Hogarth was actually involved to indicate the continued interest in the issue—which helped to sustain the climate that later made the *Harlot's Progress* such a success—and the concerns that doubtless stayed with Hogarth during those months: he would have followed every development. For one must ask, why did he not exploit this interest by publishing a print? Why did he not engrave the *Commons Committee?* It was partly, no doubt, because he thought it would cheapen the painting projects he had in hand, partly because now of all times he did not want to involve himself in a transaction with the general public—and because he probably had other things on his mind.

JANE HOGARTH

Intervening between the oil sketch and the finished painting was a momentous personal event. While Hogarth was practicing painting

and making use of Thornhill's casts and pictures, and perhaps his influence in Parliament, he was, as he would have said, mixing pleasure with his studies. Thornhill's hospitality and academy provided an excuse for being near his daughter Jane, a girl of about fifteen when Hogarth (then twenty-seven) joined the academy in 1724, and by 1729 near the age of consent.

It is not known exactly when or where Jane Hogarth was born, where or how she spent her youth, or what kind of a girl she was— whether she stayed in the Thornhill house and sewed, or tried to live up to her father's title and wealth. Certainly she had always been well off, and even without the signs of punctilio in her father one would suspect a tendency toward social self-consciousness in the daughter. (Her brother John, although he evidently liked the company of Hogarth, as well as artisans and artists, nevertheless ended as the typical eldest son, doing nothing.) After Hogarth's death, however, Jane was apparently well able to conduct his business and zealous to defend his reputation and her social position. There is a story that "old Widow Hogarth" used to say to visitors at the Golden Head, showing the "Market Wench" (*The Shrimp Girl*), "They say he could not paint flesh. There's flesh and blood for you; —— them!"[19] This was also the woman who advertised against pirates in as strident a tone as Hogarth himself, secured a special addendum to the revision of his Engravers' Act in 1767 giving her an additional twenty years' copyright on his engravings, and fought Horace Walpole and John Nichols tooth and nail when they published passages on her husband that were less than glowing. But the most vivid impression is that of Sir Richard Phillips, who, as a boy, saw the old lady striding majestically up the aisle of the Chiswick church, with silk sacque, raised headdress, black calash, lace ruffles, and crutched cane, accompanied by her companion, Mary Lewis, and preceded by Samuel, her gray-haired servant, who had wheeled her to the church in a Bath chair; he carried her prayer book ahead of her, ushered her into her pew, and shut the door after her.[20]

From what is known of Hogarth's mother and Jane, they shared one characteristic—both were solid, capable women, pillars of strength for their husbands, if not indeed the kind of bulwark that becomes at times a burden for the one being supported: something on the order of Sarah Young in *A Rake's Progress*. But of course they were also very different; Hogarth undeniably married above himself when he took Jane. And yet if he was (as in the old apprentice story) marrying

his master's daughter, he may have recalled his father's marriage to his landlord's daughter. Love of Jane may have merged with desire to be son-in-law of a great and admirable man.

It could not have been entirely coincidence that he eloped with Jane immediately following the Commons Committee's exposé of the Fleet Prison, either just before or just after his commemoration of it in a painting: in one coup he would acquire a new father and exorcise his memories of the Fleet and the darker days of his youth. Thus on 20 March 1729, the day the House heard the Commons Committee's report and moved to prosecute Bambridge and Huggins, Hogarth took out a marriage license from the Faculty Office of the Arch-bishop of Canterbury: "William Hogarth, of St Paul's, Covent Gar-den, Middx. Bachr, above 25, & Jane Thornhill, of same, Spr, above 21; at same." [21] The marriage took place on the 23rd, but not, as stated in the license, at St. Paul's, Covent Garden. Instead, the couple traveled out to the village of Paddington and were married at Pad-dington parish church. It was the only marriage that day. [22]

Vertue remarked that Hogarth had married Sir James Thornhill's daughter "without his consent," and Nichols, possibly from an inde-pendent account, envisaged an elopement. [23] Thornhill may have been disturbed by the difference in their stations, but the age difference—he thirty-two, she at most twenty—and Hogarth's probably too convivial years on the town may also have given Thornhill pause. It should be noted that Jane was listed on the license as "above 21." If a woman were under twenty-one, the consent of parents was necessary for marriage. No birth record of Jane has been found, but Hogarth's early biographers said that she was not yet eighteen. When she died, her age was given as eighty, that is, born in 1709 and therefore twenty when married. The idea of an elopement is perhaps further strengthened by Hogarth's attack on contracted marriages in *Mar-riage A-la-mode*.

Far more important, however, was Thornhill's sense of social class. Born the son of a grocer, he had worked hard to regain his family's position: he had charged high prices, scrabbled for every extra penny, secured strong court patronage, and reaped the rewards of posi-tion, title, and influence—eventually overstepping when he sought the surveyorship in addition to the rest. The last was his unsuccessful attempt to move up from painting to architecture, a more prestigious because more "theoretical" occupation. The abrupt falling-off of his painting commissions in the mid-1720s, which Vertue attributes to

the influence of the Burlingtonians, was more probably the effect of two facts: the quality of his work declined markedly, and this was because he had virtually stopped painting himself.[24] He was increasingly (as in the last work at Greenwich) turning the execution over to assistants, less talented than he, because the pay was decreasing but also because a gentleman and member of Parliament avoids manual labor. (A decade later Hogarth was responding to attacks on Thornhill's paintings by attributing the flawed works to assistants; and the chief reason for Styles's refusal to accept Thornhill's paintings at Moor Park was, he claimed, their quality.)[25] His defeat over the commission to paint the Cube Room may simply have confirmed his decision to be a country gentleman and an M.P. Even spending the rest of his career copying the Raphael Cartoons (which Vertue thought was for lack of commissions) was probably regarded by Thornhill as a gentlemanly way to pass his retirement.[26] In this context, it is easy to see how Hogarth's elopement with his daughter would have affected him: such a misalliance was the worst fate that could befall him at this moment.

The marriage was noted in the *Craftsman* for 5 April: "Mr. Hogarth, an ingenious Designer and Engraver, was lately married to the Daughter of Sir James Thornhill, Kt. Serjeant-Painter, and History Painter to his Majesty."[27] By 5 April, then, the secret was out; Nicholas Amhurst, editor of the *Craftsman,* was a friend and would have learned of the marriage. (Incidentally, note that Hogarth is not yet referred to as a painter.)

Tradition has it that the Hogarths crossed the river to live in Lambeth, but it is more likely that after a honeymoon (or retreat) in Lambeth they returned to Hogarth's studio.[28] If we are to believe the story of their reconciliation with Thornhill (recounted by Nichols), their exile lasted nearly two years. Lady Thornhill is supposed to have advised Hogarth to place some of his *Harlot's Progress* paintings in his father-in-law's way.

Accordingly, one morning early, Mrs. Hogarth undertook to convey several of them into his [Thornhill's] dining-room. So beset, under the influence of such powerful attractions, had the father been possessed of less humanity than was imputed to him, the ingenious artist would most probably have been induced to acquiesce. When he rose, he enquired whence they came; and being told by whom they were intro-

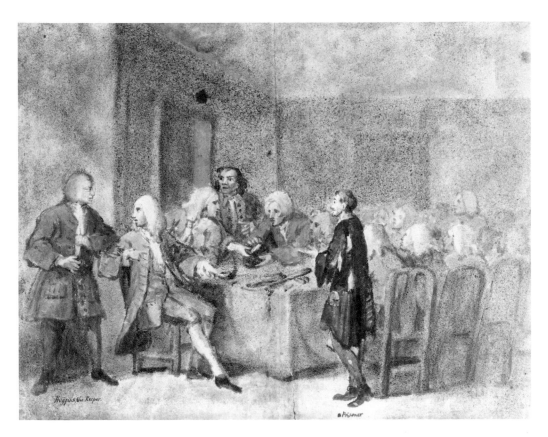

64. *A Committee of the House of Commons;* oil sketch on paper; 1728/29; 18½ × 23½ in. (Fitzwilliam Museum, Cambridge).

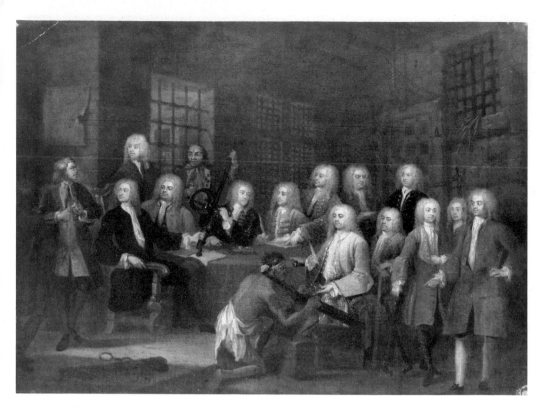

65. *A Committee of the House of Commons;* painting; 1728/29; 20 × 27 in. (National Portrait Gallery, London).

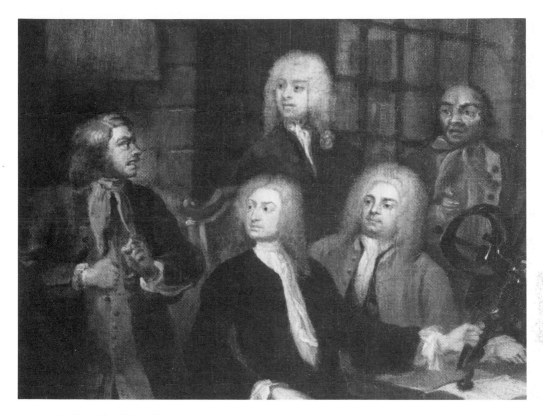

66. Detail of fig. 65.

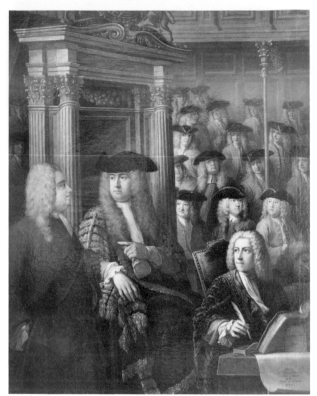

67. Sir James Thornhill and Hogarth, *The House of Commons;* painting; 1730; 50 × 40 in. (The National Trust, Onslow Collection, Clandon Park; photograph: Courtauld Institute of Art). The two heads at the right of the bottom row (Col. Richard Onslow and Thornhill) are the work of Hogarth.

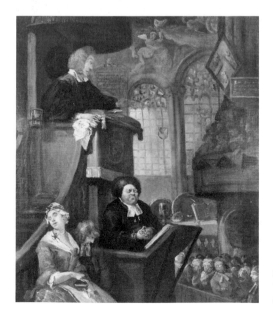

68. *The Sleeping Congregation;* painting; ca. 1730; 21 × 17½ in. (Minneapolis Institute of Arts).

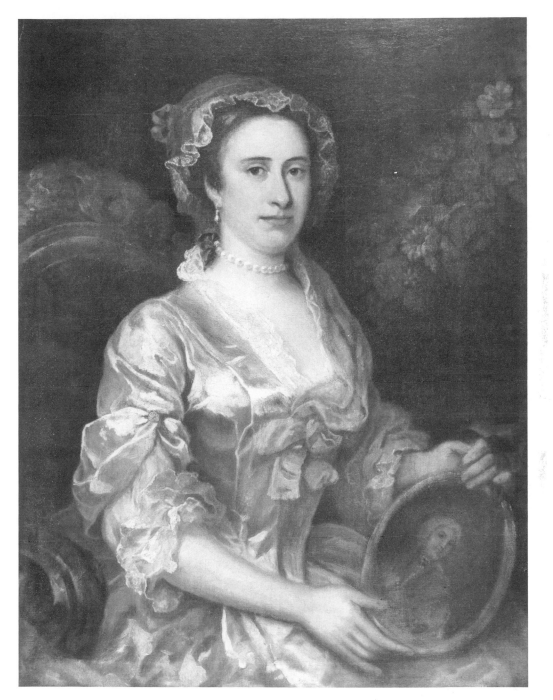

69. *Jane Hogarth;* painting; ca. 1738; 35½ × 27½ in. (Dalmeny House, Edinburgh; photograph: Courtauld Institute of Art).

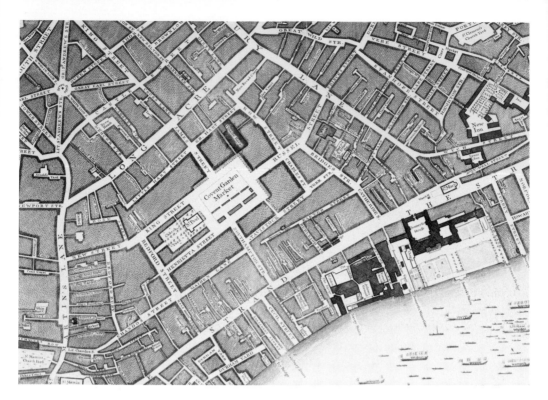

70. The Covent Garden area, detail of John Rocque's map of London; 1747 (courtesy of the British Museum, London).

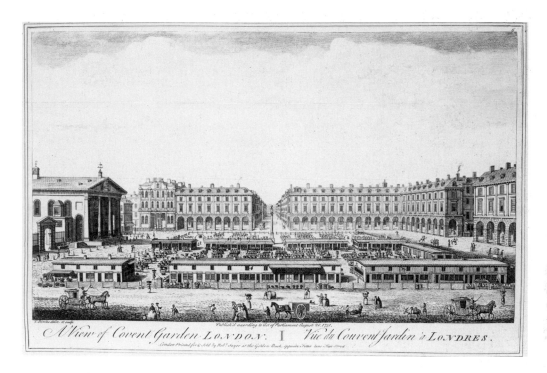

71. Thomas Bowles, *A View of Covent Garden;* 1751 (courtesy of the British Museum, London), but unchanged from 1730 except for the configuration of wooden sheds. As we look north, Thornhill's is the last private house at the northeast corner.

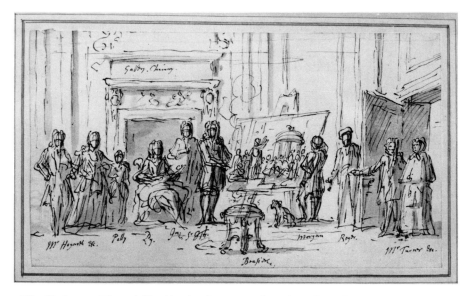

72. Sir James Thornhill, *Sketch of His Family;* ink and wash on paper; ca. 1730 (the Right Hon. the Marquess of Exeter).

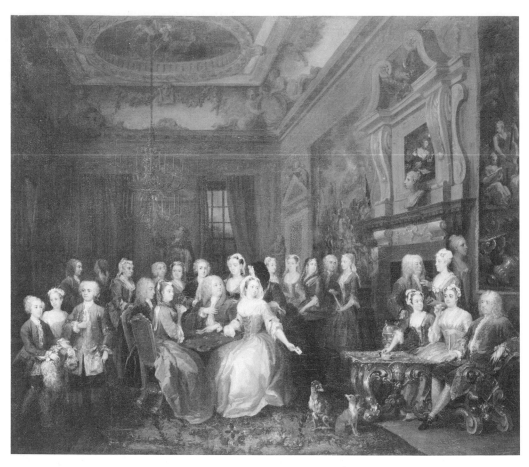

73. *An Assembly at Wanstead House;* painting; 1730–1731; 25 × 29¼ in. (Museum of Fine Arts, Philadelphia, John H. McFadden Collection).

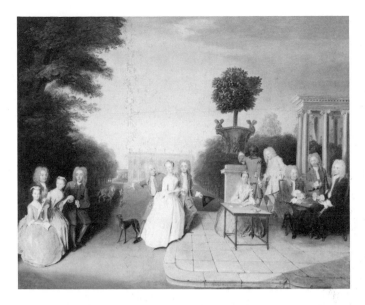

74. Philippe Mercier, *A Hanoverian Party on a Terrace with the Schutz Family, Cousins of George II;* painting; 1725 (Tate Gallery).

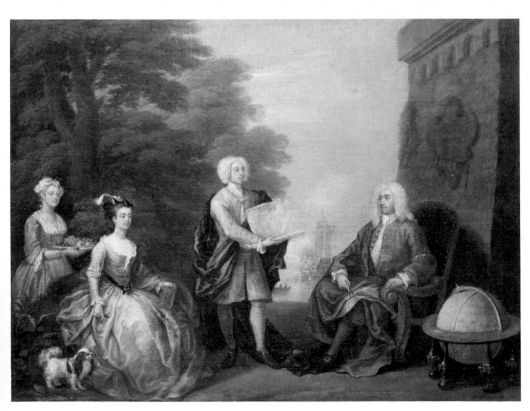

75. *The Woodes Rogers Family;* painting; 1729; 16½ × 22 in. (National Maritime Museum, London).

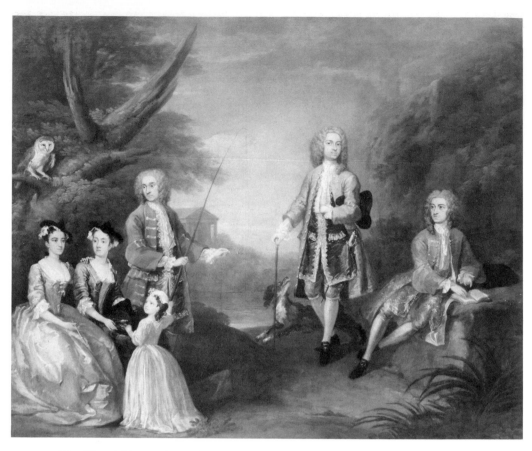

76. *The Ashley and Popple Families;* painting; 1731; 24¾ × 29¼ in. (Windsor Castle copyright 1990. H. M. Queen Elizabeth II).

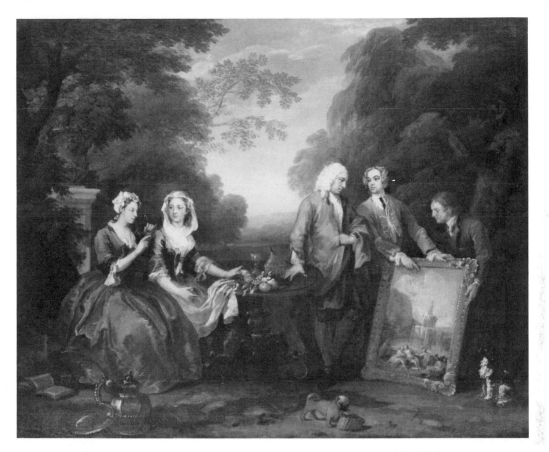

77. *The Fountaine Family;* painting; ca. 1730; 18½ × 23½ in. (Philadelphia Museum of Art, John H. McFadden Collection).

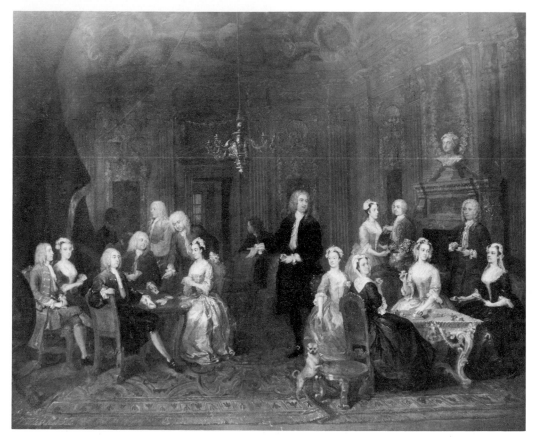

(Above)
78. *The Wollaston Family;* painting; 1730; 39 × 49 in. (executors of the late
H. C. Wollaston).

(Facing page, top)
79. *The House of Cards;* painting; 1730; 25 × 30 in. (National Museum of Wales,
Cardiff).

(Facing page, bottom)
80. *A Children's Tea Party;* painting; 1730; 25 × 30 in. (National Museum of
Wales, Cardiff).

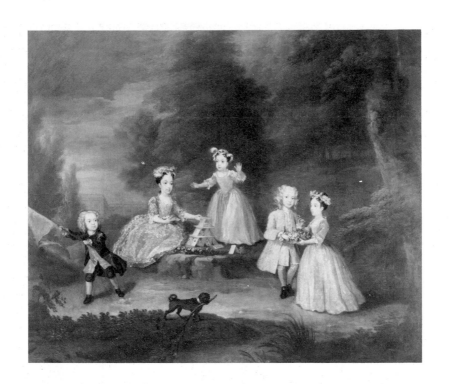

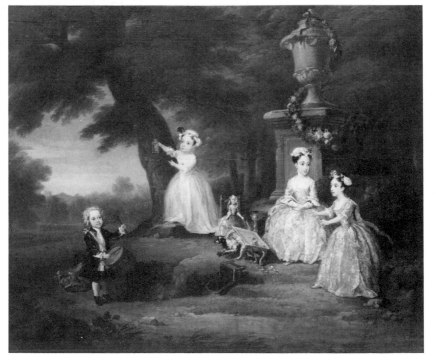

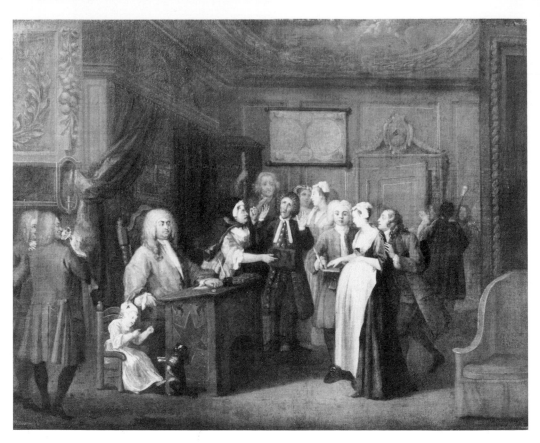

81. *The Denunciation, or A Woman Swearing a Child to a Grave Citizen;* painting; 1729; 19½ × 26 in. (courtesy of the National Gallery of Ireland).

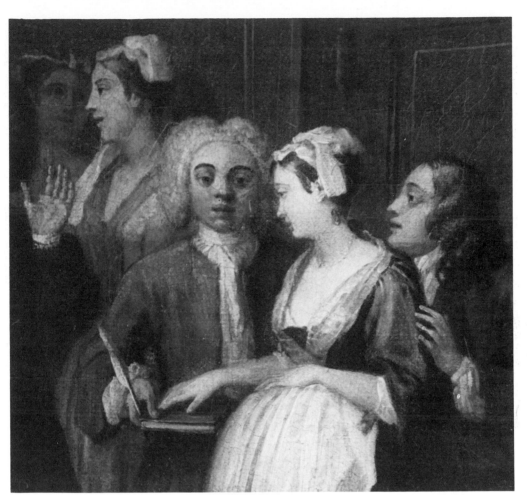

82. Detail of fig. 81.

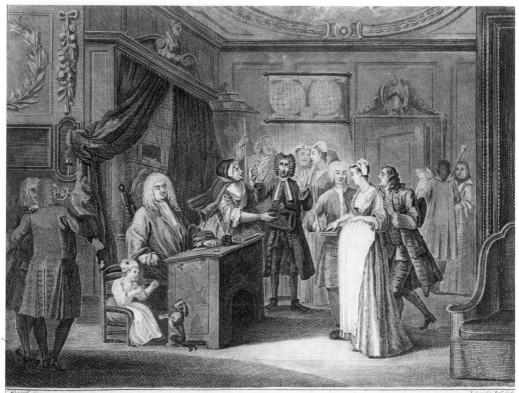

(Above)
83. *The Denunciation* (engraved by Joseph Sympson, Jr.); undated; 10¹/₁₆ × 13¼ in. (courtesy of the British Museum, London).

(Facing page, top)
84. *The Christening, or Orator Henley Christening a Child;* painting; 1729–1730?; 19½ × 24¾ in. (private collection).

(Facing page, bottom)
85. *The Christening* (mezzotint by Joseph Sympson, Jr.); date unknown; 11³/₈ × 15¾ in. (courtesy of the British Museum, London).

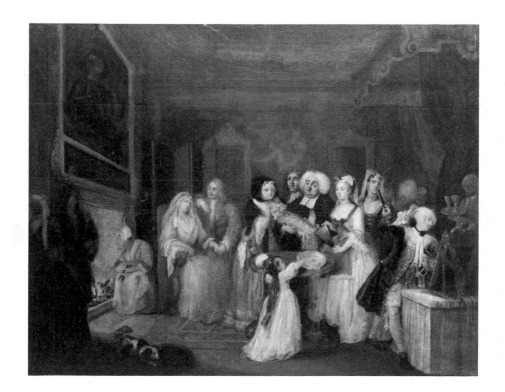

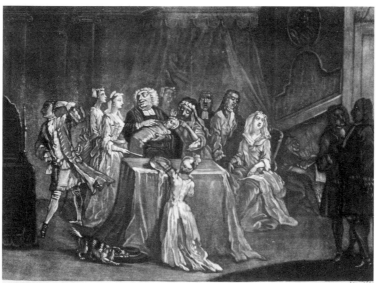

J. Simpson del. fed.

Behold Vertu lately brought to Bed,
Her Cheeks now Strumpets to their early Red,
Languid her Eyes, yet lovely her Appearance,
And oh what though her Lovely Visage wear,
The pampers't Youth, in which extended Arms
The female Infant lies, with swelling Charms

Seeming to ask the Name ere his Baptism,
Lifts he the Seraphim displays his womans Eye,
While joy O'erflowing, an accomplish'd life
In courtship's very dear forego on the Wife
The Midwife busied too with mighty Care,
Attends the day from Importing Pair.

Behold her stands the Christ, on whose aware Face
Shock Absorb cannot forbear to grace,
Past Mortal without thought great Gospel's Child
And oh the Flesh the Silly Women guild,
Borrows down the Air, the wailing semes of Eye,
And at the Fire the Nurse is warming cloth.

Cry cried enquire the Parson's Name, — says Vivacity
Why thus you have Sir — its Twig : Doctor Money

86. *Before* (outdoor scene); painting; 1730–1731; 14 × 17½ in. (Fitzwilliam Museum, Cambridge).

87. *After* (outdoor scene); painting; 1730–1731; 14 × 17½ in. (Fitzwilliam Museum, Cambridge).

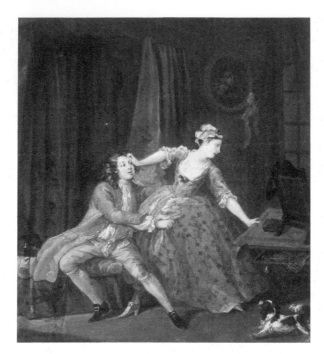

88. *Before* (indoor scene); painting; ca. 1731?; 15¼ × 13¼ in. (The J. Paul Getty Museum).

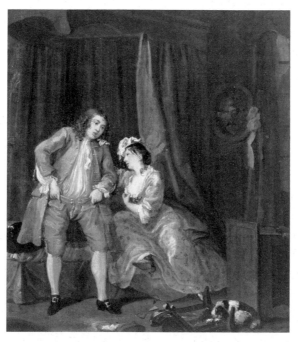

89. *After* (indoor scene); painting; ca. 1731?; 15¼ × 13¼ in. (The J. Paul Getty Museum).

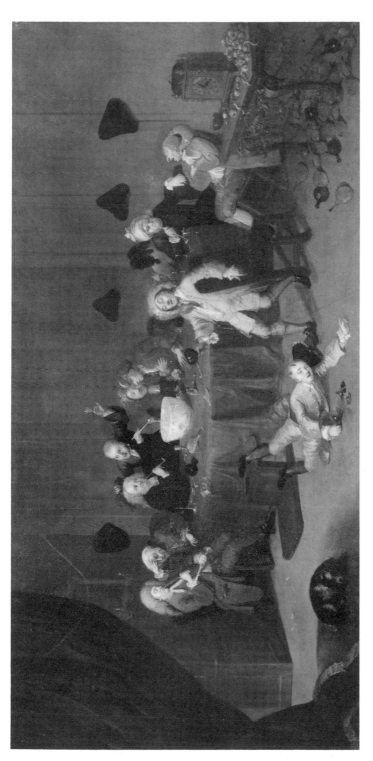

90. *A Midnight Modern Conversation*; painting; ca. 1730; 31 × 64 in. (Yale Center for British Art, Paul Mellon Collection).

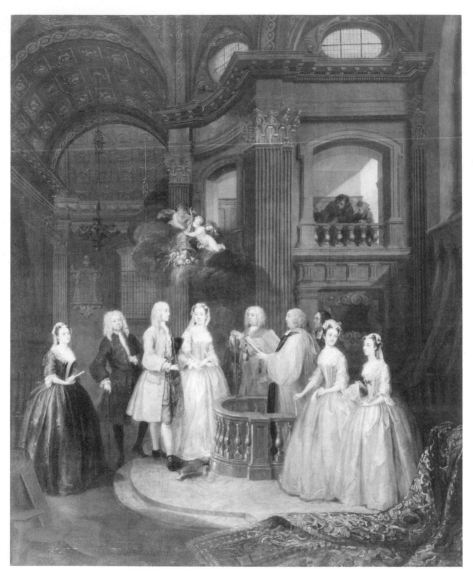

91. *The Wedding of Stephen Beckingham and Mary Cox;* painting; 1729; 50½ × 40½ in. (Metropolitan Museum of Art, Marquand Fund, 1936).

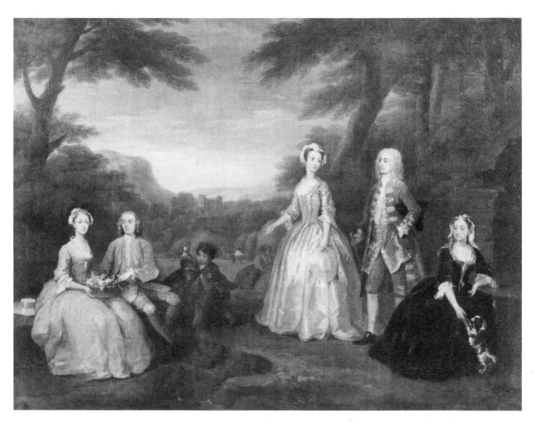

92. *The Jones Family;* painting; ca. 1730–1731; 27½ × 37½ in. (Sir Brooke Boothby, Fonmon Castle).

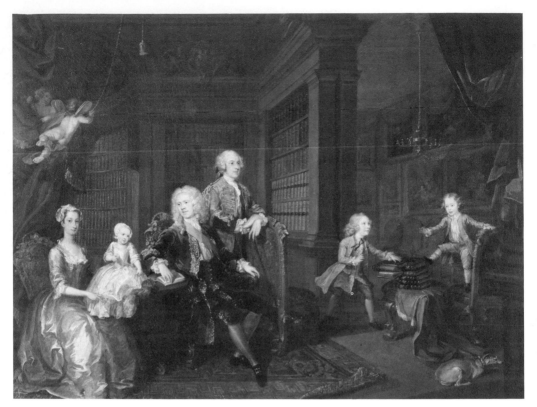

(Above)
93. *The Cholmondeley Family;* paint-
ing; 1732; 28 × 35¾ in. (the Right
Hon. the Marquess of Cholmondeley).

(Right)
94. Shop Card for Mary and Anne
Hogarth; 1720; 3⅝ × 4⅛ in. (courtesy
of the British Museum, London).

Mary & Ann Hogarth
*from the old Frockshop the corner of the
Long Walk facing the Cloysters, Removed
to ÿ Kings Arms joyning to ÿ Little Britain-
gate, near Long Walk. Sells ÿ best & most Fashi-
onable Ready Made Frocks, suites of Fustian,
Ticken & Holland, stript Dimmity & Flanel
Waftcoats, blue & canvas Frocks, & blue coat Boys Dr-
Likewise Fustians, Tickens, Hollands, white
stript Dimitys, white & stript Flanels in ÿ piece*
by Wholesale or Retale at Reasonable Rates.

duced, he cried out, "very well; the man who can furnish representations like these, can also maintain a wife without a portion!" He designed this remark as an excuse for keeping his purse strings close; but, soon after, became both reconciled and generous to the young couple; and lived with them in great harmony.[29]

Here is the arrogant Thornhill we have seen in other stories, and also the enterprising Jane (clearly her father's daughter) who—rather than Hogarth himself—conveys his canvases to the Thornhill dining room, acting as a sort of mediator, and persuading her father to be reconciled.

The portrait Hogarth painted of Jane in her late twenties or early thirties (ca. 1738, fig. 69) shows a handsome and statuesque rather than "pretty" or "beautiful" woman; he shows her prominently displaying an oval portrait of her father. Horace Walpole and others claimed that Hogarth painted her in his *Sigismunda* in 1759, and there may be other portraits of her in his works.

In the 1780s Jane Hogarth told the etcher Livesay that "Hogarth's portrait" appears in the print *Sancho's Feast* (fig. 50) "in the person of Sancho." The face does resemble Hogarth's other self-portraits in profile. But if Sancho is a self-portrait, our attention is drawn to the two women observing him on the left. The print might be datable as early as 1727, made in the wake of the *Hudibras* and *Don Quixote* illustrations, but it was not published (by Overton and Hoole) until as late as 1733 or 1734, following the success of *A Harlot's Progress*. Interestingly, Hogarth reworked the two women's faces before publication. The reworked version of the second face from the left resembles Hogarth's portrait of Jane. One wonders whether he replaced the first two faces—even more particularized, clearly likenesses—when he married Jane or when she requested (or perhaps demanded) that, before it was published, he replace them. One of them is a very pretty girl, the other an older woman, possibly her mother, duenna, or bawd (her face is generalized in the revision).

If *Sancho's Feast* is seen not in the context of the *Hudibras* and *Don Quixote* illustrations but of Hogarth's marriage to Jane, the scene becomes a reflection on the state of being Sir James Thornhill's son-in-law: which Hogarth parallels with the mock-elevation of the dumpy little plebeian Sancho, as if by magic, to what he has desired ever since his first meeting with Don Quixote, the governorship of an is-

land—in this case the landlocked "island" of Barataria. He focuses on the scene of Sancho's humiliation, in which he is feasted without being permitted to taste a morsel of the sumptuous cuisine.

The joy of the marriage must have been compromised by the trauma of Thornhill's reaction, even if it had been anticipated. Thornhill's disapproval of the marriage followed upon his obvious fondness for his young protégé. The fact remains that whenever in later years Hogarth turned to history painting from a literary text he chose a story that dealt with a trio resembling Thornhill, Jane, and himself.

A decade after his wedding, and shortly after Thornhill's death, Hogarth painted *A Scene from Shakespeare's "The Tempest"* (ca. 1736–1738, ill., vol. 2): he chose the second scene of Act I, the first meeting of Ferdinand and Miranda, which also includes Prospero, who serves to introduce the two parties and to hover over the scene as playwright-magician. Ferdinand, saved from shipwreck, recalls "Sitting on a bank, / Weeping again the king my father's wreck," and he repeats more than once the paramount fact that his father has drowned ("my drown'd father," "the king my father wreck'd"). Prospero has befriended him and now, in the scene Hogarth illustrates, introduces him to his daughter, with whom he immediately falls in love. The parallel is obvious. Hogarth's father had spent some years in prison and emerged a ruined man to die a few years later. Then Hogarth had met Thornhill and fallen under his spell—a spell we can recognize in the influence the older painter had on his assumptions about history painting of the sort being attempted in *A Scene from "The Tempest."*

But having introduced the young couple, Prospero says, aside,

> They are both in either's powers; but this swift business
> I must uneasy make, lest too light winning
> Make the prize light.

He therefore tests Ferdinand, accusing him of treason and attempting to turn him into another wood-toting Caliban. Ferdinand, outraged, draws his sword, which Prospero's magic prevents him from raising.

> *Mir.* O dear father,
> Make not too rash a trial of him, for
> He's gentle and not fearful.
> *Pros.* . . . Put thy sword up, traitor;
> Who makest a show but darest not strike, thy conscience

Is so possess'd with guilt:. . . .
 Mir. Beseech you, father.
 Pros. Hence! Hang not on my garments.
 Mir. Sir, have pity;
I'll be his surety.
 Pros. Silence! one word more
Shall make me chide thee, if not hate thee. What!
An advocate for an imposter! hush!
Thou think'st there is no more such shapes as he,
Having seen but him and Caliban: foolish wench!
To the most of men this is a Caliban
And they to him are angels.
 Mir. My affections
Are then most humble; I have no ambition
To see a goodlier man.

"Come on," says Prospero; "Obey . . .," and of course Ferdinand does carry out such menial tasks for Prospero as gathering wood.

Miranda is the woman who has never seen a man, shown by Hogarth with her aged father Prospero behind her and a lamb nearby. And so Hogarth gives her the colors of the Virgin Mary and a pose roughly like that of Mary at the Annunciation—crossed with Mary in a Nativity scene, thus relating Prospero to Joseph: a scene very like the parodic Annunciation used in *A Harlot's Progress* 3 a few years earlier (fig. 98).

There is no resemblance between the faces of Ferdinand and Hogarth or Miranda and Jane; only the "story" sounds like a witty private joke—though the fact of Thornhill's recent death might give one pause. Some of it sounds like a joke only Hogarth himself would have enjoyed. But the story was already present in the *Beggar's Opera* paintings (as a few years later in *A Scene from "The Indian Emperor,"* ill., vol. 2). The plot convention parodied by Gay in *The Beggar's Opera* has the father-king imprisoning the hero because he is in love with the king's daughter. Macheath's relationship to old Peachum is essentially the same, on a low level, as Montezuma's with the Inca or any of Dryden's rebellious tragic heroes with his king. Aspects of this fiction must have appealed to Hogarth in the years following 1728—when he had his own Polly and Mr. Peachum to contend with and was constructing his "modern moral subject." And he returns to it from time to time in the years to come. The question of course is:

did his interest in the story lead him to Jane or Jane (whom he would have known before January 1728 when *The Beggar's Opera* premiered) to the story?

The plot reappears in its most sinister form in the painting *Satan, Sin, and Death* (ill., vol. 2), made around the same time as *The Tempest,* though it's safe to assume a bit later. As in the *Tempest* painting, Hogarth chooses the aspect of the *Beggar's Opera* painting that makes Polly a mediator (rather than the other gestalt, of Macheath as Hercules choosing between his two wives, Polly and Lucy). But in *Satan, Sin, and Death* Sin's face is turned toward her father-lover and away from her son-lover, and—subsidiary figures eliminated—the woman is now unambiguously the central figure. The context makes it clear that the father and the son-lover are fighting for the daughter. They are not only held apart by her but are contending for her favors. By emphasizing the triangular psychological relationship Hogarth has not only lifted the trapdoor on the conflicting instincts at work in Milton's scene, hitherto unnoticed by illustrators, but he has also exposed the deepest level of conflict in his *Beggar's Opera* and *Tempest* paintings, and in his memories of the trauma of 1729. The story still haunted him in his last history painting, *Sigismunda* (1759, ill., vol. 3).

It is perhaps difficult to measure the extent to which it was Thornhill or Jane who possessed Hogarth's imagination. We know more about Thornhill: he idolized the Raphael Cartoons, and Hogarth uses them as a reference point in his comic as well as sublime history paintings. He prominently painted a Nativity (Wimpole) and a Last Supper (St. Mary, Melcombe Regis, Weymouth), and the Life of St. Paul (St. Paul's): Hogarth includes Nativities and Last Suppers in several of his works and makes references, direct and indirect, to the life of St. Paul. Unless we regard the paintings of *The Tempest* and *Satan, Sin, and Death* as ironic, and I do not think we can, Hogarth's satiric intelligence did not completely penetrate Thornhill's pompous self-image.

On 5 December 1730 an advertisement in the *Craftsman* (a friendly journal) locates Hogarth in the Broad Cloth Warehouse in the Little Piazza:

LOST,
From the Broad Cloth Warehouse, in the Little Piazza,
Covent Garden,
A light-colour'd Dutch dog, with a black Muzzlc, and answers to the
Name of Pugg. Whoever has found him, and will bring him to Mr.
Hogarth, at the said place, shall have half a Guinea Reward.

William Tothall, in his account of his life, remarked that "Hogarth lived some time in his house in the footing of a most intimate friend."[30] Tothall, who crops up again later in Hogarth's life, was another self-made man, of about the same age. Placed with a fishmonger uncle at an early age by his widowed mother, he could not stand fishmongering and ran away to sea, where he remained enduring a life of adventure until he was nearly thirty. Around 1727 he gave it up, returned to London, and began working for a woolen draper at the corner of Tavistock Court and the Little Piazza, Covent Garden, which corresponds to the address of the broadcloth warehouse mentioned in Hogarth's advertisement (fig. 70). His master helped him in various ways and began to take a fatherly interest in his enterprising employee, lending him money to start a sideline in shalloons and trimmings for the tailors who bought his yard goods and encouraging him to sell rum and brandy from the cellar of the house. At this time, then, he was living above his master's warehouse and Hogarth probably sublet a part of the quarters for himself.

Hogarth must have been living here, not at his former address in Little Newport Street, when he married Jane, since the marriage register gives St. Paul's, Covent Garden, as his parish; and if he was still at the warehouse in December 1730 he brought Jane back with him after their marriage—and indeed *this* was the place where he showed his first painting of *A Harlot's Progress*. By the beginning of 1730/31 he was preparing his subscription ticket for the series of six engravings. Here he and Jane apparently remained until they were invited by the Thornhills to move across the square and join them in quarters better suited to the daughter of a knight. In 1731, perhaps after the subscription for the *Harlot* had begun, Vertue locates them in Thornhill's house (see fig. 71).[31]

Hogarth never refers to this as a shop, though he was to engrave and vend the six plates of the *Harlot* and one or two others there. It

gave him a good address, the sort of studio appropriate to a portraitist, plus the advantages, already evident in his last shop, of a ringside seat at the center of London fashion, theater, gambling, and wenching—and also law enforcement. Gentlemen and highwaymen, ladies and women of pleasure strolled the arcades, passing from coffeehouse to theater to bagnio to auction rooms and china shops.

Since Thornhill's academy was long since defunct by the time the Hogarths moved in, it is probable that the son-in-law used the extra room as his studio. Thornhill spent his summers at his seat near Stallbridge, Dorset, but during these years he was also spending much of his time at Hampton Court Palace. For in March 1729, just before the elopement, he had obtained permission from the king to copy the Raphael Cartoons, and from then until completion in 1731 references to Thornhill place him at Hampton Court.[32] As Serjeant Painter he was probably assigned quarters in the palace while he worked—and perhaps he returned for part of each week to Covent Garden. His departure in March 1729 may have provided the lovers their opportunity to elope.

Thornhill's plan, a characteristic one, was to use the Cartoons as teaching aids; he intended to treat them analytically, copying out details of hands, heads, and feet as well as the general composition. In August 1729 Vertue visited Hampton Court while both Thornhill and Le Blon were working there. Thornhill's copies, he recorded, "are done with all the exactness possible the same size as the originals. he having now finisht two pictures & begun another." But he also noted "his several studies of the heads hands feet. separately &c. from these originals on paper drawn out lines some shaded. some not are surely the truest & justest demonstration of Raphael's merit" (3: 39).

Thornhill's plan seems to have been to make one set of full-size copies of the Cartoons as they were (the originals were deteriorating rapidly and were probably not expected to survive much longer, which was another reason for his project); a set of one-half size; and a set of one-quarter size, in which the missing parts would be reconstructed. Finally, he was to make a series of details, and these at least were to be engraved. The project is characteristic of both father- and son-in-law; certainly it was Thornhill who originally stimulated Hogarth's interest in the Cartoons, but the project to paint (i.e., restore, make available to contemporary Englishmen and artists) and engrave the Cartoons could have come equally from father- or son-in-law. The project continued, with frequent visits from interested

artists and connoisseurs, until in August 1731 the full-size copies were finished. The details of hands, legs, heads, and feet were never finished, though at least one etching remains (perhaps by Hogarth) and a number of drawings and tracings.[33]

Thornhill also needed something to occupy his mind during these years. In the last years of his life he witnessed the Italians once again securing the patronage of the Burlingtons and the great Whig lords. Vertue, commenting on his copies of the Raphael Cartoons, noted:

> its certain that after so much reputation. friends & meritt. as the most Excellent Native history painter, which is justly allowd at this present to be his character. he hath no great work, or imployment under-hand—is suggested to be the reason he has undertook to copy these workes of Raphael—it is however, happy for him. that his fortune, is very easy. (3: 38)

Not long after the reconciliation with Hogarth, and while he was at work on the large copies, Thornhill made a sketch in pen and violet wash (fig. 72), in preparation for a painting of his family and friends. He shows himself in the center pointing to one of his Raphael Cartoons on his easel, with his son John behind him and Lady Thornhill seated to his right, and beyond these a group labelled "Mr Hogarth &c.," the "&c." referring to Jane. The painting, probably intended for his country seat, with its ceiling self-portrait and column to George I, was never carried out.

7.

CONVERSATION PICTURES, 1728–1732

COMMISSIONS

In January 1730/31, as he was preparing to launch his subscription for the engravings of *A Harlot's Progress,* Hogarth made a list of the painting commissions he had not yet fulfilled.[1] Among these were three going back to 1728, and certainly among his very first; two of these were for personal friends, who had ordered more than one and had probably not pressed him too hard for delivery. John Rich had commissioned a family group on the strength of the first *Beggar's Opera* painting, and at least one other picture, the large *Beggar's Opera,* which was by this time finished. Christopher Cock, the auctioneer and a neighbor of Hogarth's in Covent Garden, had commissioned two pictures in November 1728, companion pieces. The third person was Thomas Wood, who had commissioned (besides one of his family) two other pictures from Hogarth, single portraits of his daughter and his dog Vulcan.

These were groups of four to six figures. The climactic commission was the remarkable one on 28 August 1729 of Lord Castlemaine for "an Assembly of 25 figures" (fig. 73). Sir Richard Child, who in 1718 had become Viscount Castlemaine in the Irish peerage, was heir to a great banking fortune and celebrated his status by building the first of the great Palladian palaces, Wanstead House, Essex, designed for him by Colen Campbell himself.[2] The scene is laid in the newly decorated ballroom—designed, as it happened, by none other than William Kent.

Like the *Beggar's Opera* and *Commons Committee* pictures, *An Assembly at Wanstead House* celebrated an event, Lord and Lady Castlemaine's twenty-fifth wedding anniversary. Therefore Hogarth, who

must have visited the house and sketched Kent's ballroom, also introduces marriage emblems: Lady Castlemaine holds out a winning card (the ace of spades) to her husband, a pair of whippets (= fidelity) look lovingly at each other, and the works of art illustrate wifely fidelity.[3] The first two would have been Hogarth's invention; the paintings and sculpture, surely not ordinarily in situ in that room, were either introduced by the painter or—possibly—by Castlemaine for the occasion of the wedding anniversary. I incline toward the former explanation, though Hogarth's assumption (as later in *Marriage A-la-mode* 1) may be that the collector-husband *did* display them there to put his personal imprint upon the scene and remind his wife of her duty. The subjects, Brutus's wife Portia and Pompey's wife Julia, both killed themselves (Portia by swallowing live coals) following the deaths of their husbands. Moreover, the meaning of the emblems is compromised by the chief formal and spatial features of the painting: while the conventional emblems of the proffered card and the dogs draw the wife and husband together, they are spatially separated by the chasm that yawns between them—Castlemaine is seated at the farthest right edge of the canvas. His pose (recalling that of Falstaff and anticipating that of Earl Squander in *Marriage A-la-mode* 1) makes the scene seem to unfold from his pointing forefinger, putting the seal of his power and possession on every object in the room.

It is possible, as Arthur Marks believes, that Hogarth has exaggerated the Kent furniture and decorations to the point of parody, and that the grisaille head on the side of the fireplace is a portrait of Kent himself.[4] It is unlikely that Castlemaine would have had his decorator's likeness in that place—if it is indeed Kent's head. But the odd formal fact is that the head, looking to the right out of the canvas, is balanced above by the bust of Julia on the mantle looking in the opposite direction—itself balanced by the opposite lunge of Portia in the painting above it, and below by the leftward profile of a young woman: the four heads make a strange dizzying play of right, left, right which might well be regarded as comic, especially since at the base of the torque is the three-quarters leftward profile of Lord Castlemaine himself.

Hogarth had the reputation for employing such detail. Horace Walpole, who knew him, recalled how portraiture was "the most ill-suited employment imaginable to a man whose turn certainly was not flattery, nor his talent adapted to look on vanity without a sneer."[5]

Part of Hogarth's joke was that none of the subversive play would have registered on the Castlemaines.

After visiting Wanstead, Hogarth must have laboriously collected sittings from all the rest of the "25 figures" in his Covent Garden studio—or by visiting their houses. It was the most impressive of the early commissions, perhaps the ultimate challenge, to get such a crowd into a canvas 29 by 24 inches and at the same time convey accurately the architectural splendor. As the list of January 1730/31 shows, the painting was not quickly finished. Hogarth must have realized that twenty-five figures was an excessive number; after a certain point, adding extra people became a mechanical process. Although his initial impulse seems to have been to put in more figures than any competitor, the best pictures are not the crowded ones but those in which a relatively few people are interestingly related.

Most of the conversation pictures are undatable as to commission if not completion, but there were at least two dozen of them between 1728 and 1731, by which time Hogarth had also nearly finished the *Harlot's Progress*. According to Hogarth's own words (written in the 1760s), he "then married and turnd Painter of Portraits in small conversation Peices and great success" (AN, 215–16). Even excepting *The Beggar's Opera* and *A Committee of the House of Commons,* and including only family groups, Hogarth forgets dated commissions and paintings as early as 1728.[6] The sentence, which must have carried some causal or symbolic truth for him or he would not have written it, stresses the need his marriage put upon him to be successful at painting. He was hard at work supporting his wife in a style to which she was accustomed and building up his reputation as a serious painter (no mere engraver).

As early as summer or autumn 1729 Vertue was commenting on "the daily success of Mr Hogarth in painting small family peices & Conversations with so much Air & agreeableness," which "Causes him to be much followd, & esteemed. whereby he has much imployment & like to be a master of great reputation in that way." Vertue then goes on to marvel (as he does more than once) at Hogarth's rise: "Tis much from no View at first of being a painter. but only bred to Grave small works *in Silver*." With the *Beggar's Opera* and *Commons Committee* paintings, Hogarth had become, in a way, a fashionable painter. His reputation, as Vertue noted, was for portraits "well painted & their likeness is observed truly"—"done with spirit a lively invention & an universal agreableness" (3: 40, 41).

Commissions came from various sources. Some were due to Hogarth's fame, but as a satiric engraver he must have had much resistance to overcome. Initially he drew on friends in the entertainment business such as Rich or auctioneers such as Cock. Rich's *Beggar's Opera* would have attracted attention, perhaps hanging in his theater. Thornhill—or friends in the Opposition or in the Walpole government (Hogarth seems to have had both)—helped with the *Commons Committee* paintings, and the commissions that followed were from both court and country parties. A chief source of commissions, it appears from Vertue's accounts, was Hogarth's public exhibition of his paintings in his studio above the Broad Cloth Warehouse in Covent Garden. I do not think that any firm inferences about political alignments can be drawn from the families who commissioned paintings. There were too many factors at work.

As an example, Lord Malpas (later third earl of Cholmondeley), who commissioned the portraits of his family (fig. 93), had sat on the Commons Committee and may have been included in one of Hogarth's versions of that conversation picture. He was also Sir Robert Walpole's son-in-law and a staunch supporter of the ministry. It is not known when he commissioned the picture, though it was signed and dated 1732, and the style of all but the figure of Lady Malpas conforms to that date.

Lady Malpas, the eldest daughter of Walpole, had died of consumption in southern France late in 1731, and on 15 April 1732 the grief for her loss was deepened by news that the ship returning her body from France had gone down.[7] Hogarth's picture shows the viscountess, looking very stiff and dead (not even quite on the same scale with the other figures), with angels fluttering over her head who also serve to draw back the curtain on this "scene," as if on a stage. The strange figure of Lady Malpas is balanced, boldly, almost grotesquely, by her terribly alive boys playing on the other side of the picture. The paintings hanging behind the boys are of a Nativity and (perhaps) Annunciation. This is a typical Hogarth conversation: it would delight some patrons and disturb others.

Starting with the representation of people in and within a play, Hogarth sought to convey character and social position by means of the relationships between people as (metaphorically) "actors" and "spectators" within a scenario. Then, as he moved from the stage

into the houses of nonactors, he conveyed these qualities by contrast-
ing adults and children, and by the "drama" of the resulting inter-
play. He saw that it was possible to define sitters more precisely by
depicting the objects they kept around them, their furniture and
paintings. He could ignore formal portrait poses, or—by relegating
them to pictures or sculptures in a room—utterly expose them *as*
poses. His group portrait defined not a heroic figure but a couple or a
group, and in terms of their interrelationships and their milieu.

The small conversation picture was the first real break with the
stereotyped portraiture of the time: the aim was not to produce an
effigy, or to observe the Renaissance pattern of depicting an ideal im-
age or one that conveys the sitter's whole spiritual and physical
being, but rather to catch the sitter in action in a particular moment
in his or her proper social setting, most often with a family.

The genre was another French import. The Watteau pastoral had
been transformed by Philippe Mercier, working in England in the
mid-1720s, into a portrait group with real country-house architec-
ture. Mercier and his English imitator, Bartholomew Dandridge,
show one direction in which this sort of picture could be carried:
Mercier's *A Hanoverian Party on a Terrace with the Schutz Family*
(1725, fig. 74) has clumps of people straggling in a roughly serpen-
tine line across a setting of foliage and terrace. Dalliance, a card
game, and conversation are in progress.

Hogarth may have learned directly from the master, Watteau—
from his paintings in English collections and from the wide range of
engravings and etchings after his paintings. From Watteau's *fêtes* he
took the use of pert animals (often in equivocal poses), self-references
or surrogates, and the background of sculptures and paintings. These
are often emblematic objects, some of which indicate "art" and
others (bagpipes or dogs, for example) "nature" at its animal ex-
treme. He shared with Watteau something of his robust and basically
plebeian wit. I suspect he would have liked the audience of knowl-
edgeable connoisseurs Watteau successfully developed in Paris, but it
was not forthcoming in London of the 1720s.

Hogarth began with a few outdoor scenes, but these lack the to-
tally unbroken flow of Mercier and Dandridge, the sense of people
like those who glide through a setting in Watteau's *Pèlerinage à
Cythère*. He replaced openness with a closed, stagelike composition,
with foliage or architecture closing the scene on either side like the
wings of a stage set, and in these terms he begins to define his sitters.

It is possible that he had another mediator, Joseph van Aken, a young man of about his age who is best known in art history as the drapery painter for all the fashionable London portraitists in the 1740s. But van Aken began around 1725 with conversation pictures in the Dutch manner: In *An English Family at Tea* (Tate Gallery) he places a sculpture of Bacchus behind a tea and chocolate service. The group appears to be portraits, but the Bacchus makes a comic comment on the serving of tea.

The same Bacchus reappears in an outdoor scene, *A Sportsman and His Servant in the Grounds of a Country House* (ca. 1725, Nathaniel Robertson Collection), at the intersection of paths, one leading into the forest, the other (indicated by the sportsman) to his country house.[8] These genre scenes, with sculpture ironically disposed, include Roman wrestlers above a transaction at a game stall and a Venus above a woman choosing fruit.

Compared with the *Beggar's Opera* compositions, Hogarth's first family groups were (to use Richardson's simile) more like "a great many single Grapes scatter'd on a Table" than a bunch;[9] and as paintings they were too industriously finished. One is immediately struck by the contrast between the solid bodies of the *Beggar's Opera* actors and the thin, doll-like ones of most of these gentlemen and (especially) ladies.

One of the more primitive is *The Woodes Rogers Family* (1729, fig. 75), with three main figures, widely separated. It contains indications of the two basic compositions that Hogarth gradually developed for his conversations: basically a pyramidal group and two groups separated by an inverted pyramid of space. There is a couloir between the two men, but if the figures were brought closer together a shallow pyramid would be formed. As it is, the figures are very small and scattered in a straight line across the canvas; the servant girl is jammed into the overcrowded left corner. A slight psychological involvement is apparent between the men: an adjutant shows Rogers the letters patent for his governorship of the Bahamas, for which he set out on 19 May 1729, and his wife watches. Behind the wife is her maid, and at her feet a dog. Besides the psychological involvement, there are symbols: behind Rogers a ship, a monument with his motto, and a globe, referring to his circumnavigation of the world and his impending voyage to the Bahamas. There is thus a suggestion of topicality, of the governorship and the impending departure, which both date the painting and establish immediacy. All these elements

go into the Hogarthian conversation picture, distinguishing it from the simple, relatively straightforward and decorative groups of Mercier, Dandridge, and their imitators.

The structure based on a couloir, or inverted pyramid, is developed in another outdoor scene, *The Jeffreys Family* (Mellon Collection, Yale), probably painted in 1730. A lake makes a hole in the middle of the canvas, and one person holds a fishing rod. The house on the other side of the lake, perhaps the Jeffreys', separates the mother, father, and one child from the other three children. *The Ashley and Popple Families* (commissioned 1730, SD 1731, fig. 76) uses the same structure as *The Jeffreys Family* but with more adults, and the two main figures are drawn together until they almost touch over the couloir (although the fishing pole and lake are still in evidence). *The Fishing Party* (Dulwich College) uses the same structure but with fewer figures—really only mother, child, and a maid. Here the relationship between humans and a natural setting has become important, the latter dominating; this is one of Hogarth's most French compositions—one which goes nowhere, however, in his subsequent work.

The conversation of the Fountaine family (ca. 1730, fig. 77) is the most complex of the inverted pyramid structures. The lake is gone but the central couple create the same effect by facing away from each other, making two little conversation groups. The wife is devoting her attention to another woman (presumably wife of one of the other men), the husband to a picture being shown him by a man who appears to be the picture dealer. A fourth man, who originally sprawled across the left foreground at his wife's feet, in the pose of a river or sea god figure, was at some later time painted out.[10] Since we know, from the provenance and the Parnassian fountain represented in the displayed painting, that this is a portrait commissioned by Sir Andrew Fountaine, the great collector, it becomes clear that it is *about* the collector (as *The Assembly at Wanstead House* proved to be about Lord Castlemaine). The central man (in gray) sufficiently resembles Louis-François Roubiliac's bust of Fountaine. The women, as represented by Hogarth, are clearly peripheral to Fountaine's interest in the painting he is being shown. The sprawl of the man in the foreground therefore must have been a comic comment on *that* sitter's indifference to art—an indifference that is carried even further in the pug who is breaking into a wicker basket.[11]

Formally, *The Fountaine Family* points to the structure Hogarth used in his large assembly, *The Wollaston Family* (1730, fig. 78), a painting praised by Vertue (3: 46). Two groups appear, linked by the host, William Wollaston, whose gesture unifies the disparate guests, relatives by blood and marriage. But the pyramid structure, which pulled families together, proved more serviceable than the inverted pyramid, and this was the main pattern used by Hogarth in his second phase of family groups. One of the significant examples was the two children groups (both dated 1730, figs. 79, 80). *The House of Cards* is an adaptation of the arrangement of the central figures in *The Beggar's Opera;* though the individual poses are different, the pattern is the same. But here both pictures are working toward a simpler, more stable pyramid. *A Children's Tea Party,* though still rather like the split compositions—boy-girl, girl-girl, connected by the tea table—makes an off-center pyramid. In this picture the figures' separateness, or unrelatedness (or the primitiveness of Hogarth's painting), is a virtue, suggesting something true about childhood, especially about children who are playing at being grownups. The two pictures are charming precisely because they reflect Hogarth's literary sensibilities: they are concerned with problems of illusion and reality, as was *The Beggar's Opera.* The run–of–the–mill conversation picture of the time, however, was not.

In the *Children's Party* in particular there is a curious interplay of irony and symbolism: the soldier boy with a toppled piece of masonry (heroism plus *vanitas*), one girl looking at him and pointing to a mirror, and another girl at the opposite side of the canvas moving toward him with outstretched arms. The dog knocking over the tea table fits into the general *vanitas* theme (and looks ahead to the overturning of the tea table in *Harlot* 2). *The House of Cards* has an additional boy engaging in some sort of mock marriage with the first girl, while the other boy, a mock soldier with a battle standard, leaves his girl, who shows emotion at his departure (or at the precarious balance of the house of cards separating the two couples), and a pug carries a dead branch in his mouth in imitation of the little boy who imitates a charging general.

In *The Vane Family* (ca. 1731?, Vane Collection) the father and mother are the apex and two children and a nurse are the sides of a triangle, still slightly off-center, as in *The House of Cards.* Vane is another Macheath figure, the center of all attention; the nurse, seen

from behind, is the stock figure Hogarth used in the *Beggar's Opera* pictures for Lucy Lockit. Picture after picture repeats the pattern, from *The Ashley Cowper Family* (1730–1732, Tate Gallery), with the urn at the apex, to *The Wesley Family* (SD 1731, Apsley House, London), in which the five figures make a flattened pyramid.

Those are small, intimate, increasingly polished conversations, and only in 1731 or later do they begin to achieve the monumentality Hogarth was striving for in his other works. In *The Broken Fan* (ca. 1730, Lord Northbrook) and *Woodbridge and Holland* (SD 1730, Marshall Field) the figures begin to grow larger in relation to the picture space, or at least appear less lonely, and this effect is still more noticeable in the elaborate *Family Party* (1730–1731, Mellon Collection, Yale). These pictures begin to anticipate the best of Hogarth's conversation pictures of the mid-1730s and his ultimate masterpieces of group portraiture, the Graham and MacKinen children pictures of the 1740s (ill., vol. 2). Nor were they all groups. There were small single full-length portraits on the conversation scale. One (private collection) shows a boy in a Watteauesque garden setting. He and a Cupid both point to the figure ten (presumably his age) on a sundial.[12]

As to success in the field, Vertue's various estimates tend to be inconsistent—he speaks more fervently of Dandridge, and later calls Gawen Hamilton the best of all conversation painters; but one may accept his factual comments on Hogarth's success in 1730: "Mr Hogarths paintings gain every day so many admirers that happy are they that can get a picture of his painting" (3: 41). Even if his volume of sales was no greater than that of Dandridge or others, it was nevertheless marked and sufficed to make the public aware of Hogarth as a painter.

From the financial point of view, these smaller pictures could be sold for less and so undersell the larger and flashier Kneller-like portraits. But then more of them had to be painted. What was a successful way to occupy the market space became also, for as restless an artist as Hogarth, more work than the income was worth. His own comments are succinct. His hatred of drudgery, he says, his failure to be a first-rate copper engraver, "and other reasons made him turn his head to Painting Portrait figures from 10 to 15 inches high" of subjects in conversation. But this kind of painting, "tho it gave more

scope to fancy than common portrait was still less but a kind of drudg-
ery"—that is, like the engraving he had escaped earlier (AN, 202).

PUBLIC AUCTION

But as Vertue noted, Hogarth was becoming successful in another
kind of work as well:

> a small peice of several figures representing a Christning being lately
> sold at a publick sale for a good price. got him much reputation. also
> another peice the representation of the Gentlemen of the Committee of
> the House of Commons. to jayles.setting upon the examination of
> those malefactors.well painted & their likeness is observed truly. (3:
> 40–41)

Hogarth had already turned from conventional conversations to
more congenial and independent subjects, which he sold at auction
or to visitors to his studio. A conversation, as Vertue, Hogarth, and
others used the term, included Dutch drolls as well as small parties in
polite society, *The Christening* and *A Committee of the House of Com-
mons* as well as *The Fountaine Family*. Vertue said that Heemskirk was
accustomed to refer to his "drunken drolls" as "Conversations," and
he applied the term to the works of Bruegel, Brouwer, and Teniers
(3: 128, 81). Small-scale portrait groups and social genre seem to
have been the criteria.

In 1729 Hogarth exhibited in his Covent Garden studio (or perhaps
"shop") and sold at auction *The Christening* (or *Orator Henley Chris-
tening a Child*) and, about the same time, *The Denunciation* (or *A
Woman Swearing a Child to a Grave Citizen*). John (Orator) Henley is,
according to tradition, the clergyman portrayed in the first and
Thomas De Veil the justice in the second.[13] Though there is no reason
to think that either of these identifications is true, Hogarth presum-
ably included recognizable portraits in scenes closer in spirit to the
Commons Committee conversation (and *Falstaff Examining His Re-
cruits*) than to *An Assembly at Wanstead House*.

In *The Denunciation* (figs. 81, 82, 83) a young woman is swearing
that the father of her baby is the respectable citizen opposite (whose

jealous wife is berating him). There is a magistrate, a guilty and an innocent party—an accuser and spectators: the familiar grouping. The emblematic element consists of a child coaching a dog to sit up, which parallels and informs the young man coaching his pregnant friend in *her* story. The innocent party, the respectable citizen is a zealous dissenter, whose piety is in jeopardy. Hogarth seems to be still associating piety, lechery, and business acumen. In *The Christening* (figs. 84, 85) even the officiant, whose sin is only concupiscence, is threatening in the context of bad clergymen and magistrates, officials who impose sanctions upon supposedly less respectable, helpless people.

This figure is not a parody Hercules choosing between vice and virtue, but (with Falstaff) a judge—a Solomon, the other side of the Hercules-choice topos—and so again the magistrate choosing between the two versions of the story of the pregnancy, the clergyman officiating over a baby who is either this lover's or that husband's. The shifting versions of the myth are all too evident, and they hinge on the interchangeability of choice and judgment, of defendant and judge—issues of great personal importance to Hogarth.

One of the conversations he painted was an auction, presumably with Christopher Cock presiding (private collection). The auction itself would have carried a resonance for Hogarth, recalling those held in coffeehouses like his father's. Financial events of a special kind, they joined the setting of prices and values with the theatrical presentation of an auctioneer and the dynamic reaction of an audience through bidding. The auction brought drama down to the sale of a commodity—one that is bid for, based on competition and the imitation of other bidders. The auction was for Hogarth—and became so for Fielding in his plays of the 1730s—a primal case of dramatic value setting.

SPECIAL COMMISSIONS

In early 1730/31 Vertue notes that Hogarth was commissioned to produce another work along the lines of *The Christening* (3: 50). The lord mayor, Humphry Parsons, had been sworn in in October 1730; Sir Isaac Shard, a famously "prodigious penurious Kt," had also be-

come sheriff that fall.[14] Parsons employed Hogarth to ridicule Shard's miserliness, and the result was a picture of Shard—

> in his habit and manner, being remarkably singular seated in a great chair in judgment as it were upon a Malefactor. that was brought before him. being a great Hungry dog who had stolne from his Honours kitching a piteous lean scraggy shoulder of Mouton which his cook had surpizd and taken from the dog. wherefore the dog was brought before this Honourable Judge. who pronounced the Sentence of death on him. M^rs Cook being highly enrag'd. appears to be his accuser and a certain old fellow a neighbouring Cobler the executioner who holds the dog in a String. and has laid down an old pair of shoes he has new cobled for the K^t his Master. with many other incidents remarkable for the Subject

—all of which, Vertue concludes, "made this picture an entertainment for all that saw it." For (apparently according to Parsons's plan) it was advertised in the newspaper "that a Curious and ingenius Painter. of reputation was painting a picture which when done would be hung up in justice Hall in the Old Baily." The advertisement in the *Daily Post* reads: "We hear an eminent Painter of this City is at Work upon a curious Piece of Painting, which is to be set up at Justice-Hall in the Old Baily."[15] It was in fact on display, Vertue comments, at the painter's, where the viewers "were mightily delighted with it"—implying, among other things, that Hogarth often opened his house during these years for such sights; the most famous such occasion was the showing of the first *Harlot* painting a year earlier. Hogarth had also found another use for the newspapers.

Though Sir Isaac himself "was too grave or too old to resent the affront," Vertue recounts that "his son took it upon him and came to see the picture at Hogarths and it being explain'd to him as to others. it raisd his spirit of resentment that he drew his sword & swore he would Sacrifice the Author or Painter of it. and immediately with a Penknife cut the picture at least the head out of it."

It is probable that after seeing Hogarth's *Denunciation* with its portrait of De Veil, and perhaps also the *Harlot* painting that was on exhibit in the spring or summer of 1730, Parsons thought Hogarth the likeliest candidate to satirize another notable justice: one recalls the story of his being approached by doctors to draw Mary Toft. And who knows, perhaps Parsons suggested that he also portray the third

notable justice of the time, Sir John Gonson, who by this time had found his place in the third painting of the *Harlot's Progress*.[16]

Hogarth's relations with his public at this time, as he began to consider a return from painting to engraving, must have been especially pleasant and intimate. He threatened a certain "uncommonly ugly and deformed" nobleman, who had refused to pay for his truthful likeness of him, with the same fate as Shard's, sending him a card that said:

> Mr. Hogarth's dutiful Respects to Lord ——. Finding that he does not mean to have the picture which was drawn for him, he is informed again of Mr. H's Necessity for the Money: If therefore his Lordship does not send for it in three Days, it will be disposed of, with the Addition of a Tail, and some other little Appendages, to Mr. Hare, the famous Wild-beast-man; Mr. H having given that Gentleman a conditional Promise of it for an Exhibition-Picture, on his Lordship's Refusal.[17]

Sir Isaac's example must have been still fresh, for the money apparently arrived, and "the picture was sent home, and committed to the flames."

There were, of course, other special commissions as well. The most notorious of these was from Mr. Thomson, probably the John Thomson (M.P. for Great Marlow) who was on the Commons Committee for the Fleet Prison and was associated with Sir Archibald Grant in the Charitable Corporation for the Relief of the Industrious Poor. This organization lent small sums upon pledges, until the corporation members decided to define themselves as industrious poor and borrowed corporation money on sham pledges for speculation. "Two little pictures" commissioned by the duke of Montagu, the prominent Freemason (who would have had contacts with Thornhill), appear further up the list than Thomson's: these were the indoor and outdoor versions of *Before* and *After,* Hogarth's most risqué experiment in the erotic.

The outdoor version (figs. 86, 87) must have come first. It is consciously French (like the Watteauesque *Fishing Party*) in landscape, color, and handling. The foliage is a much deeper green and blue green than Hogarth's ordinary background, and the brushwork corresponds to the penultimate version of *The Beggar's Opera* (fig. 60). The boy is wearing a blue suit with gray socks, and the girl has a red

dress and a blue ribbon in her bonnet; the rest of her outfit is white. But *Before* and *After* are based on the simple contrast of this versus that; and Hogarth uses the color pattern to reinforce, indeed convey, the pattern of meaning. He balances the colors quantitatively in the two pictures but rearranges their relative proportions in each, as if setting up a ratio. The dominant red of the girl's skirt, still down over her legs in *Before,* is appropriately displaced in *After* to the flushed faces of both boy and girl; her skirt is now reduced to a bare crescent over the exposed white of her petticoats and the pinks of her thighs. The blue of her long stocking replaces the dominant blue of the boy's suit in *Before,* now reduced and obscured by the appearance of his unruly linen.

Aside from the beauty of execution in these little pictures, they are chiefly notable for conveying their point by creatural realism. The pictures, in fact, contain the one such detail in Hogarth's surviving work. In *After* the boy's face has become very red—a brick red as if from heat exhaustion—and his trousers are open, revealing pubic hair and a penis inflamed to match his face.

The indoor version of the same subject is painted in the manner of the final version (Tate Gallery) of *The Beggar's Opera.* But more significantly, indoors Hogarth displaces the creatural realism to symbolic objects: an exhausted dog and a broken mirror (figs. 88, 89). But then he has also matured the figures into young man and woman. Inscriptions are visible on papers in the woman's dresser drawer, one discernible as "will agree she did not die a maid." This safer, more Hogarthian version of *Before* and *After* also employs the more characteristic color scheme of his later works: a lighter green in the curtains on bed and window, salmon trousers on the man (reflected in the color of the falling powder box), and ivory dress with a greenish foliage design on the woman, with just a touch of blue in the ribbons on her and on the mirror. The colors play no part in the meaning; they are simply repeated, and the elaborate contrast is displaced from "character" or incident to symbolic objects. The erotic scene was a genre that Hogarth, so far as we know, did not pursue further. When in the mid-1730s he engraved *Before* and *After* it was, not surprisingly, the more sedate indoor version.

It is thought provoking to consider that precisely the prominent men who were commissioning Hogarth's new kind of painting were the names that appear in Pope's satires of those years—whose flights,

bankruptcies, and prosecutions prevented them from claiming their paintings.

Thomson never picked up his *Before* and *After*. In October 1731 he made off with his embezzled profits and the company books of the Charitable Corporation, sailing to France and later turning up in Rome. Sir Archibald Grant stayed to face the music, but, with Thomson, was discredited and declared bankrupt, and in May 1732 was expelled from the House of Commons. As a result, Sir Archibald never claimed his pictures from Hogarth either; *A Committee of the House of Commons* went to William Huggins, son of Bambridge's old master, as did *The Beggar's Opera*. The other patron about whom something is known was John, second duke of Montagu, who had been grand master of the London Freemasons, apparently as odd a character as his successor the duke of Wharton. A courtier in high favor with George I and II, he was also the originator of the Haymarket Theatre hoax announcing that a man would squeeze himself into a quart bottle; and Sarah, duchess of Marlborough, his mother-in-law, characterized him thus:

> All my son-in-law's talents lie in things natural to boys of fifteen, and he is about two and fifty. To get people into his gardens and wet them with squirts, to invite people to his country house and put things in their beds to make them itch, and twenty other such pretty fancies.[18]

This was the patron who commissioned one of the *Before* and *After* pairs. It is hard to say to what extent Hogarth approved of or was repulsed by aristocratic high jinks that were shared in some respects by the lower orders: in the genre he was creating he appealed to both, and in his private life was reported to behave not too differently from Montagu, with whom he also shared a love of the theatricality of Freemasonry.

A drinking scene, later engraved and entitled *A Midnight Modern Conversation* (fig. 90), may be yet another of these "special commissions," painted around 1730. Generically a "Merry Company" picture (later, in his print *Battle of the Pictures*, Hogarth contrasted it to a classical bacchanal), it nevertheless probably contains recognizable likenesses of a group of drinking companions. It bears a resemblance to a smaller conversation, *A Club of Gentlemen* (Mellon Collection, Yale), which has a group of friends sedately drinking, one gesturing perhaps a bit grandiosely, but which also includes an overturned

chair and a drinker leaning over (away from the viewer) presumably
to vomit. A dog, like the one sleeping in *Midnight Modern Conversa-
tion,* is standing near him. By comparing these two pictures, it is easy
to see the way Hogarth moved from a portrait group, a "conversa-
tion" in that sense, to a picture with moral overtones as well as por-
traits. The title he chose for the picture a few years later may suggest,
besides an irony in the sedateness of the word "conversation," a
glance back at its origin and development at his hands.

A Midnight Modern Conversation typifies Hogarth's work as he un-
dertook the *Harlot's Progress.* His characteristic olive green is present
in the tablecloth and palely reflected in the grayish green walls; the
sprawling man's attire is a somewhat more garish version of the
salmon red Hogarth used in so many of his later paintings. He still
includes the theater curtain at the left (it was painted over some ar-
chitectural form), making the room look like a stage and the men like
actors in a play. The large spaces around the figures recall the conver-
sations and the final *Beggar's Opera* paintings rather than the works of
the 1730s with their rigorously filled picture space. Two tendencies
are already apparent; first, the use of a large square or block, here a
table, in some part of the picture. The perspective of the table is,
characteristically, slightly inaccurate, not quite closing. Second, there
is a restlessness in the figures, the standing man in the foreground for
example, whose coat has been lengthened. Painting directly on the
canvas, Hogarth often moved his figures about to achieve the right
result. As the *Midnight* canvas was cleaned, a head emerged above the
smoking parson and a door behind; also panels, a standing clock, and
a different table, closer to those in the print of 1733. The shapes of
the people were originally higher up on the wall. The change from a
pillar or something similar to the curtain and the adjustment of one
of the hats on the wall were made as the picture was being painted
and before the pigment was dry.

At this stage of his career, Hogarth does not seem to have intended
to engrave these canvases himself; he was keeping himself as painter
separate from the lower occupation of engraver. But he may not have
been averse to letting someone else do it. Although they were not
advertised, the two Joseph Sympson, Jr., prints—of *The Christening*
and *The Denunciation*—can be dated between 1729 (when the paint-
ing was sold) and 1733 when a reference to their purchase appears in a
bill for prints (dated 10 May) from Philip Overton to Lord Bruce,
for, among others, "the Christening and the Justices Shop," for *2s 6d*

(see figs. 83, 85).[19] The idea of reproducing *The Christening* in mezzotint may have occurred to Hogarth after seeing Elisha Kirkall's experiments, particularly his mezzotints after the young Heemskirk's animal-headed satires that were published around 1730.

Vertue makes Joseph Sympson, Jr., sound like a young man pushed by his ambitious father. Certainly his surviving work is mediocre, less competent even than his father's, but in 1727–1728 he attempted engravings of such sublime histories as Niccolò dell'Abbate's *Mars and Venus* and "A Large Print of the Tenth Book of Milton's *Paradise Lost,*" on a copperplate 25 by 23 inches, after Vanderbank's design. These were soon followed by a *St. Sebastian* after Filippo Lauri. At the beginning of 1728/29 he was working on another series, *The Actions . . . of the Riding School,* after Vanderbank's designs. It would seem likely, then, that his work appeared suitable enough to Hogarth, or that Joseph Sr. urged his son upon Hogarth (they would have known each other from Vanderbank's academy); and that an arrangement was made between Hogarth and the elder Sympson, who published the prints at his shop at the Dove in Russell Court in Drury Lane, and apparently in conjunction with the Overtons. It is even possible that these prints represent Hogarth's attempt to find an engraver for his projected "modern moral subjects," one experiment being in line engraving, the other in mezzotint. As he remarks in his autobiographical notes (7), mezzotint *ought* to be the best medium for reproducing paintings. The results were, however, stiff and awkward—not at all what Hogarth could have desired. Nor, in the case of *The Christening,* did mezzotint prove to be a satisfactory medium for Hogarth's comic prints.

What connects these comic scenes to the conversation pictures before them and the *Harlot's Progress* after is the important issue. One factor is the "liveliness" (Vertue's term) that Hogarth injected into the stuffy conversation picture of Mercier and Dandridge—something of the liveliness of Watteau himself.

LIVELINESS: THE DOG AND THE CHILD

The dog named Pugg, for whose return Hogarth advertised in the *Craftsman* for Saturday, 5 December 1730, may be the pug who appears in conversation pictures beginning with *The Wollaston Family*

and *The Fountaine Family;* this dog or another appears in *The Strode Family* and *Captain Lord George Graham in His Cabin* in the late 1730s and 1740s, and in the self-portrait of 1740 (see vol. 2). He was one of a series of pugs kept by Hogarth.

In *The Wollaston Family* (1730, fig. 78) the pug in the center foreground creates a small area of disorder, as if an artistic signature in a scene of social order, harmony, and unity (brought about by the gesture of Mr. Wollaston connecting the two groups of his friends). Dogs of course appeared in Dutch drolls both as lively touches (often devouring carelessly guarded food) and (connected with prostitutes) as an emblem of lust; and, in more exalted pictures, they served as an emblem of marital fidelity. But closest in spirit to Hogarth's use in his conversation pictures was Watteau's—in a *fête galante* like *The Shepherds* in which a dog lifts his leg to expose himself near an amorous pastoral couple, ultimately in the dog who is the animal end of a spectrum that connects nature and art in *L'Enseigne de Gersaint* (both, Schloss Charlottenberg, Berlin).

In *An Assembly at Wanstead House* (fig. 73) the paired dogs imply the unity of Lord and Lady Castlemaine, who are sitting apart, as the tapestry showing pastoral music makers designates harmony, presumably marital. But the pug in the Wollaston conversation stands with his paws up on a chair, mimicking the dignified pose of the host, and by doing so makes a wrinkle in the carpet. The innocent questioning of a dog confronts a world of imposed human order. (At the same time, a black servant, perhaps a slave, also stands out as an alert unassimilated presence in the group.) The dog may have belonged to the Wollastons, but his continued presence in Hogarth's conversations strongly suggests that this was Hogarth's signature— permitted, even perhaps encouraged by his sitters, who commissioned him expecting some touch of puggish liveliness. But one also wonders why, so early in his career, Hogarth insists on including himself, or an aspect of himself (however conventionalized), insistent though self-deprecating, in so many pictures.

In some conversations the pug is contrasted with the dog of the family Hogarth is painting. The pug who appears in *The Fountaine Family* (fig. 77), in the middle foreground, worrying a small wicker hamper, is balanced by the well-behaved spaniel of the household, who sits upright next to the painting at the right, joining his master to show his interest in "art." The pug in a much later conversation, *The Strode Family* (ca. 1738, ill., vol. 2), growls opposite the dog that

belongs to the family Hogarth is painting—who by contrast has a bone on his prosperous plate. Finally, this same pug will appear in the self-portrait *Gulielmus Hogarth* of 1740 (ill., vol. 2) alongside the artist's own face, which the dog's face clearly resembles.

The dog is one way Hogarth injects the natural, the instinctual—or himself—into a formally composed portrait group defined by the room, furniture, and possessions of a family. He stands out from the strong element of possession and property in the conversation picture: the pater familias plainly *owns* not only the paintings and furniture but also the dogs and black slaves, even the butlers and footmen. The Hogarth pug, the sign of the artist, distinguishes itself from the spectrum of property by its act of independence. From the start he compares himself physically and iconographically with his dog, as if to say that he and his art are the necessary element of independence and naturalness in an overrefined society.

Like the dog, the children also represent in Hogarth's conversation pictures a fresh, unsophisticated, unjaded view of the society in which they are placed. In *The Wedding of Stephen Beckingham and Mary Cox* (SD 9 June 1729, fig. 91) Hogarth introduces a pair of angels fluttering with a cornucopia over the heads of the bride and groom. Aside from the angels introduced (for a very different occasion) into *The Cholmondeley Family* (SD 1732, fig. 93), this was the only conversation in which a supernatural or decorative fantasy appears, something Hogarth went out of his way to avoid in his mature subject paintings; and we can only assume that it was dictated as part of the commission. In any case, Hogarth has balanced the two angels with a pair of urchins in the gallery directly opposite them, like them looking down on the wedding.

John Nichols seems to have been alluding to this painting when he wrote in 1782 that "an artist who, representing the marriage ceremony in chapel, renders the clerk, who lays the hassocks, the principal figure in it, may at least be taxed with want of judgment." Recent study has shown that the *Beckingham-Cox* picture originally had such a figure in the left foreground. The flatness of the figures may have been compensated for by a foreground figure, as a repoussoir. It is not impossible that the figure was painted out by another hand *after* Nichols's strictures were published.[20] It is a rather strange wedding in any case, with the hardly flattering profile of the officiant and the face of the sexton to his right: both figures, reversed, return in the bad-marriage context of *Rake's Progress* 5, where

a boy is shown laying a hassock for the elderly bride. (The pile of carpet in the right foreground can either have been added to replace the erased clerk and hassocks or to balance them.) The evidence suggests that a thin line separated a group like the *Beckingham-Cox Wedding* from *The Christening,* a comic conversation that implies an adulterous affair between the mother and a foppish gentleman.

The Jones Family, ordered in March 1730 but still undelivered on 1 January 1730/31 (fig. 92), shows in a garden setting a decorous family group consisting of Robert Jones and his elder sister Mary standing to right of center. To the Joneses' left is their widowed mother (in widow's weeds) and her dog standing on its hind legs trying to hold her attention. She is sitting next to a fountain, which may have emblematic import (like the punning fountain in *The Fountaine Family*) concerning the source of the Jones family or its fortune. On the left side of the scene, separated by the V-shaped prospect Hogarth sometimes employed in his conversations, are Jones's two younger siblings, Oliver and Elizabeth. His sister Mary turns toward him and his mother, gesturing as if to include them—ignoring or excluding what intervenes between the two groups.

The striking aspect of the picture lies within the V-shaped prospect: a peasant boy scuffling with a monkey—the monkey's cap apparently at issue (or his dish, since a pentimento suggests something pouring out of it). Further back are plebeian haymakers, and in the far distance a prone couple are making love on a haystack. There is only one way to interpret the prospect of fields being harvested: this is the property that replaces the paintings and furniture of the interior scenes; these are the people, receding into darkness, who by their labor set off—contrast—but also, implicitly, make possible the ordered life of the sitters on the picture plane. It is the boy in this case who introduces another dimension, not the dog (the family's dog), which is consoling its mistress. And the boy is clearly *not* a member of the family. Needless to say, this is not a detail found in the work of any other artist of the time, whether in England or on the Continent.

But the transitional work is the comic conversation *The Denunciation,* where (as in the *House of Cards* and *Children's Party*) the child and dog are not disordering the scene so much as parodying the adult masquerade, revealing something about adulthood without losing the animal, natural, instinctual truth they bring to it. They are essentially emblematic, expressing one of Hogarth's basic insights into his own society. They lead up to the courting dogs in *A Rake's Progress*

who underline the animal basis of the wedding between the penniless rake and the rich old one-eyed woman, and to the manacled dogs in *Marriage A-la-mode* who show us the true plight of the young couple who are being joined in this contracted marriage by their fathers, the older generation, respectively a merchant and an earl.

To return to the sheer disturbance: In *The Christening* a little girl spills the baptismal water. She does this in a scene of as many adult disruptions as that first scene of *Marriage A-la-mode:* the "father"-husband is primping before a mirror while in the rear the mother is being consoled by another man, presumably the infant's real father (as the young husband, the earl's son, in *Marriage A-la-mode* is absorbed in a mirror while his bride is being consoled by the family lawyer). Moreover, in *The Christening* the officiating clergyman lets his eyes wander away from his service to the low-cut dress next to him. In this context the child who tips the font is partly the older sibling looking for attention, but she is also drawing our attention to the mess at the bottom of all the hypocrisy and pretense of the "sacrament" of baptism. She is saying: Look, I can do the same thing you adults are doing. These are the two roles children play for Hogarth. There is, as we shall see, a real sense in which in *A Harlot's Progress* he takes the children of these early paintings and projects a story in which such a child is dropped into London in the 1730s.

The most mature and sophisticated conversation picture of this period was *The Cholmondeley Family* (fig. 93), painted (or at least completed) after he had finished the *Harlot.* The upbeat normative structure of the conversation genre can be formulated as the celebration of the family (including the recently dead mother, indicated by angels flying above her head). If children are present in such a scene, and are obstreperous like the two boys at the right, then the theme must be their nurture and/or civilizing.[21] If *The Cholmondeley Family* takes as its subject the formation of a "good society," then the juxtaposition of the staid grown-ups and the cutting-up youngsters must express a structure of before and after: first children, then adults, showing the process of civilizing. But before and after are, for Hogarth, spatially reversed; as in the two sets of paintings with those titles, before is always on the left (as on a printed page). The effect here is rather of adults and children contrasted, along the lines of the two angels and the two lower-class urchins watching from above the Beckingham-Cox marriage.

The two boys seem more likely intended to be complementary or a comment on the adults—on the civilizing process itself, on politeness and art versus *their* kind of yet untouched nature (specifically on the civilizing vs. the nurturing aspect of parenthood). They are cutting up dressed in the same finery as the grown-ups (as opposed to the shabby clothes of the boy in *The Jones Family*): one boy still wears his cravat, the other has already dispensed with it.

To see Hogarth's conversation pictures in terms of the "formation of the good society" (a reasonable paradigm for readers of Shaftesbury and before him Addison, for speakers of the discourses of civic humanism and politeness) is to notice the areas of disorder, which seem to be part of another Hogarthian spectrum of art and nature, with civility on the art end. If children are represented, they are usually doing something that suggests nature reacting against artifice and civility. The spectrum in *The Cholmondeley Family* runs from the dead mother at the left (resembling a funerary image) to the father and his brother, impeccably civilized, at the center, with absolutely ordered shelves of books making a geometrical pattern behind them. The boys are separated from the grown-ups by a strong vertical, the doorway dividing the two rooms. Then, as traces of disorder begin to appear, we see a chair turned around and a wrinkle (yet another) in the carpet. Brother James is looking in the parental direction, another sort of transition of memory or mere eye contact; one of his legs is still in the adult room. These details create a liminal area (like the one in *The Beggar's Opera* between spectators and actors) that introduces the first boy, his tie still on, and the second, more obstreperous boy, his tie gone, coat and shirt collar open, kicking over a pile of the books—related to the books in the geometrical bookcases that symbolize civilized order. Closing the boys at the right is the sleeping figure of the family dog and the stagelike curtain.

The two boys in this 1732 conversation picture echo precisely the putto and faun Hogarth represented around the same time in his subscription ticket for *A Harlot's Progress:* one restraining the other's disruptive act (fig. 107). Lifting Nature's veil to get a peek at her private (natural) parts proves to be another conversation picture gesture. To say that the boys are agents of disruption is, at least in the conversation pictures, less accurate perhaps than to say that—as in the complementary gestures of the two boys—they represent different stages of nature (opposed to art), one like the putto, the other like the

young satyr. (The satyr combines the boy's and the dog's function with its connotations of satiric disrespect and animal hunger.)

Finally, a word about the black boy, who is both peripheral and subversive, making a sharp comment on the grown-up English whites: he was standing in the background of *The Wollaston Family,* one of the possessions the host was shown among, but with a sharp twinkle in his eyes; and in the fourth painting of *The Beggar's Opera* he was the one figure intently watching the play, or rather Lavinia Fenton playing Polly Peachum. In *Captain Lord George Graham in His Cabin* of 1745 (ill., vol. 2) the black cabin boy is placed parallel to the Hogarth pug, who is trying on one of the officer's wigs: the black functions in the same way as the dog, the child, and later the harlot, apprentice, and other minority types in Hogarth's world.[22] But these figures also represent a distinctive point of view from which Hogarth looks at London—a fresh, unsophisticated, unjaded view which was also New Testament in flavor ("Whosoever shall receive this child in my name receiveth me," Luke 9:48).

There is, nevertheless, a tension in Hogarth's families—and a tendency thereafter in his "modern moral subjects" to see families as broken. The tradition of moralistic emblematic literature associated with Jacob Cats in the Netherlands depicted the good bourgeois family, and this model obviously hovered over the English conversation picture. Hogarth would have known this, as he would have known Gerard de Lairesse's description for the artists who have "no Taste in representing Things in the antique Way, and yet think the Modern too mean," to whom he recommends the "Picture of Virtue":

> In a good Family, a prudent and respected Father; a careful and good-natured Mother; obedient Children; and humble and honest servants; The Father gives the law; the Mother enforces it to the children; and both they and the Servants obey; Again, the Father punishes; the Mother reconciles; the children love and fear; A good Father is also liberal in his Support of his Family; the careful Mother manages with Frugality, yet with Honour: All is in Peace and Order, and Virtue their aim.[23]

Starting from "All is in Peace and Order," Hogarth gives us *dis*orderly children and animals, drawing on the countertradition of "Dissolute Family" pictures (by Jan Steen in Apsley House, London, for example).

But he had a more elegant model in the Watteau *fête galante* or *fête*

champêtre, a genre that had nothing to do with family, but rather with leisure. It was an extension of the personality away from a family, a marriage, even a couple, into love, liaisons, fantasy, and art, and often commented on by the animal naturalism of a dog. While Fragonard developed the Watteau *fête galante* in the most positive and expansive way, accepting the fantasy that Watteau himself qualified and questioned and turning it into a vision (on ever larger canvases) of leisure and desire satisfied, involving beautiful generalized figures, Hogarth turned Watteau's *fête* into a small portrait group, of specific people in a specific milieu, a room or a garden. He curbed, problematized, critiqued, and questioned the fantasy, inscribing it as threat, enclosing it in social particulars of furniture and art collections: in works of art collected and hung on the walls by unhappy people whose actions are determined by the fantasies they have collected. The first scene of *Marriage A-la-mode* (1745, ill., vol. 2) is Hogarth's reply to Watteau's final masterpiece, where he also enclosed the expansive world of his *fêtes* within paintings in a picture shop guarded by a stray dog, in the form of a signboard for his friend Gersaint (Berlin). In Hogarth's ultimate transformation of the conversation picture the paintings of martyrdoms and murders authorize the father's destruction of his son; the pair of dogs are manacled together as an emblem of the marriage that is being imposed on the two young people by their parents.

The family, when not broken, is repressive and destructive of the children, or of those youngsters who imitate their elders' actions or are jammed into an imitation or fulfillment of parental wishes and fantasies (as in *Marriage A-la-mode*). This tension may say something of Hogarth's politics, a subversive position from which he sees all structures of authority. At the same time it may say something of his aesthetics, in which terms his conversation pictures celebrate the variety-in-unity of the family, as opposed to the unity (in the theory of Shaftesbury and Francis Hutcheson) that subordinates variety.[24] Nor can the conversation picture be taken apart from the artist's search for a market: he attracted buyers and sitters by the hints of disorder, and perhaps by the gesture of his own artistic independence.

To this questioning of the family as a Good Society we have to add Hogarth's experience of the Fleet Prison (reflected in the *Beggar's Opera* paintings), an experience that offered the impressionable youth something quite other than a family unit of the sort he was asked to paint twenty years later. What he lived within there, rather than a

family, was a series of "collectivities, conglomerates, non-familial and a-familial groupings": "The fascination and the connections [were] . . . not with discrete individuals or with the familial group but with heterogeneous series, unpredictable aggregations, crowds and migrant collectivities."[25] And in Hogarth's case we must also add to the ruined father the more successful uncle, all the dead siblings, and the (apparently) capable mother—all of which decisively redefined "family" for him.

As we have seen, however, his "family" scenes often restructure themselves as a parody Choice of Hercules or a Judgment of Solomon. They begin, after all, with *Falstaff* and *The Beggar's Opera*, where the "family" is centered on a father as judge dispensing justice according to some arbitrary Law rather than merit and mercy; where it is a man with *two* "wives" and/or a woman with a father *and* a lover who define "family."

The marketability of Hogarth's conversations was due to more than just a touch of "liveliness": once the picture is hung, the children's antics are seen from the point of view of the parents, the patron, and the owner of the painting as a displacement of their own passions—perhaps the aristocratic tradition of a libertine youth—and so prompt their plausible, though fatuous, substitution of a moral for a satiric discourse. Hogarth allows for such reinscriptions.

If "conversation" implies something that extends beyond the conversing figures within the canvas to include the social group of spectators in the room where the picture hangs, then this concept of "conversation" includes also the sense, of which Hogarth makes so much in his "modern moral subjects," of more than one spectator or viewpoint, of a society both constructing itself and (by way of the Hogarthian touch) dissolving. The host who draws together his guests becomes the parody host dispersing them into the centrifugal effect Hogarth exploits in the *Harlot's Progress*.

PAINTING AND ENGRAVING, 1730–1731

The list of unfinished conversation pictures dated January 1730/31 was probably an indication that Hogarth was clearing the deck in order to devote all of his attention to the *Harlot*. The year 1730 had seen the completion (i.e., they are signed and dated) of the paintings

of the *House of Cards* and *Children's Party* and the Wollaston, Jones, and Ashley-Popple family groups. But it had also seen a number of uncompleted commissions: families for Vernon and Jones of nine and five figures respectively; a couple for Ashley Cowper; single figures for Kirkham and Sir Robert Pye. The Vernon was dated February, the Kirkham April. As late as November Hogarth accepted the commission for a portrait of Pye, and in December from John Thomson for *Before* and *After*. A group of five and "two little pictures," probably the other version of *Before* and *After*, were commissioned by the duke of Montagu.

In January 1730/31 Hogarth accepted a commission for a portrait head from Mr. Sarmond. The only other references to paintings in 1731 are to the Isaac Shard story and Mary (Granville) Pendarves's story of her presence in Hogarth's study in July while he painted the Wesley family group. He was characteristically mixing painting and instruction. On 13 July she wrote to her sister Anne how she disliked Mrs. Lafountaine's painting: "but I am grown passionately fond of Hogarth's painting, there is *more sense* in it than any I have seen." She refers to the Wesley family group, which Hogarth had just finished (1731, Apsley House), and remarks that she "had the pleasure of seeing him paint the greatest part of it; he has altered his manner of painting since you saw his pictures; he finishes more a good deal."[26]

The chief reason for keeping the paintings so long in his studio must have been the hiatus of the *Harlot* or the need properly to "finish" them when he was not yet sure when they were "finished." One of the characteristics of these early conversations, noticeable in *An Assembly at Wanstead House* and becoming more evident in *The Western Family* (1738, National Gallery, Dublin), is a beautiful, diaphanous quality in the faces. He had of course come to realize that finishing was desirable, and the contrast between the lovely handling of the accessories and the overly finished faces is less painful here than it was in the Ashley Cowper group.

The second fact Mary Pendarves records is Hogarth's fame for catching a likeness. She notes that she has released Lady Sunderland from a promise for a picture of herself by Christian Friedrich Zincke the enameler in order "to have it done by Hogarth." "I think," she goes on, "he takes a much better likeness, and that is what I shall value my friend's picture for, more than for the excellence of the painting."

Finally, she has clearly seen a little of Hogarth himself, and she

concludes: "Hogarth has promised to give me some instructions about drawing that will be of great use, —*some rules of his own* that he says will improve me more in a day than a year's learning *in the common way*" (emphasis added).[27] That last phrase sounds like the confident Hogarth of the 1730s and 1740s (or his father in the 1680s). He evidently made a conquest of Mrs. Pendarves.

Sometime around 1730 Hogarth made, on a small scale, another kind of conversation picture when he etched a shop card for his sisters (fig. 94). They had opened a milliner's shop in 1725 in Long Walk near the Cloisters, part of St. Bartholomew's Hospital, about a block away from their old home, Bartholomew Close. Anne, the younger sister, was in charge of the shop, or at least the shop was registered in her name. They were subtenants and do not appear in the Land Tax Books, but Anne Hogarth is mentioned in the books for collecting workhouse rates for the Parish of St. Bartholomew the Less. In 1726 Anne is listed with two shops or flats, and in 1727 Mrs. Hogarth is listed for one of them, suggesting that by this time she had moved from her house in Long Lane to live with her daughters.[28]

Long Lane was not a fashionable address. After the fire of 1666 Charles II had granted the governors of the hospital permission to recoup some of their losses by converting the rooms of the Cloisters into seventeen shops, using the rents to maintain sick and wounded soldiers and seamen. By the time the Hogarth women were living there, the Cloisters were taken up on both sides by seamstresses and millinery shops, and at fair time especially had a bad reputation. The narrow street was crowded with signs of the Anchor, Golden Ball, Seven Stars, Three Horseshoes, Three Pigeons, Porter and Dwarf, Three Welsh Harps, Three Golden Anchors, Black Boy, Indian Queen, Golden Key, and the Sun—all of which Hogarth would have studied with interest and admiration, for he enjoyed shop signs as other people did trees and gardens.[29]

In these years the hospital was undergoing a radical change. It had a very irregular form and the whole, according to the preamble to the subscription, "had hardly so much as the outward appearance of an hospital."[30] This pile was to be replaced by a regular square of four elaborate blocks of buildings. But first the old buildings, along with some adjoining buildings, had to be destroyed. (Later the problem of decorating them would be reached, and Hogarth would again enter

the picture.) Among other buildings, the Cloisters had to be torn down and the shops within the hospital removed. Tenants were given notice shortly after 25 September 1729 (when it was announced at a meeting of the hospital governors) that they must be out by Lady Day (25 March) next, 1730.[31] By that date the Hogarth women must have moved out, and Hogarth, to celebrate the opening of their new shops, etched a shop card for them making the announcement. It showed, in a stylized baroque frame, with the royal arms overhead (as it had appeared over the *Beggar's Opera* stage), the actual interior of a shop with bolts of material, clerks, and customers—a miniature version of a conversation picture, a small evocation of (or homage to) Watteau's *Enseigne de Gersaint*. The sisters moved just outside the hospital gate, doubtless still in one of the many buildings in Little Britain owned by the hospital, but still subtenants and so not in the rate books.

Up to 1730 Hogarth had engraved book illustrations himself, augmenting his income and keeping his hand in as an illustrator. The last of these was the pair of etchings for Lewis Theobald's *Persius and Andromeda,* published by Thomas Wood in January 1729/30. Because by this time he wished to identify himself with painting, he stopped engraving illustrations—the manual part of the operation—and supplied drawings, which were engraved in every case by Gerard Vandergucht, a talented (and probably more "elegant") engraver than Hogarth. But more important, Hogarth was by this time well enough known to add his name to an advertisement for a book and have another hand reproduce his drawing. In April 1730 James Miller's play *The Humours of Oxford* was published with a frontispiece (the advertisements announced) *"Design'd from the Life by Mr.* Hogarth, *and Ingrav'd by Mr.* Gerard Vandergucht";[32] and similar inscriptions appear in the announcements of the other books.

Prints allowed Hogarth to exploit the Renaissance art theory that isolated and defined separate parts of painting as *invenzione, disegno,* and *colore:* the first in particular validated art of the sort that he projected in his "modern moral subjects" that consisted essentially of prints rather than paintings. Thus his great concern to indicate precisely of which prints he was and was not the "inventor." The engraver ordinarily disseminated the *invenzioni* of Raphael or Rubens throughout the world. It was Hogarth's ambition to become the "in-

ventor" rather than—or as well as—the engraver. And the presence of Thornhill, and the marriage to Jane, made the situation even more urgent, explaining his utilization of Vandergucht and his attempts to employ another to engrave the *Harlot*.

The books he illustrated also serve to connect Hogarth's name with friends or artistic peers. In March 1730/31 he furnished a drawing for the frontispiece to Joseph Mitchell's *Highland Fair*. Although the book was published by John Watts, who was also responsible for two other books he illustrated (and a number of Fielding's books), the important association was with Mitchell, who had just published in February an "Epistle to William Hogarth," a eulogy of the artist. It was probably this rather than (or in spite of) Mitchell's close connection with Walpole (he was called "Sir Robert Walpole's Poet").

The first of *Three Poetical Epistles. To Mr. Hogarth, Mr. Dandridge, and Mr. Lambert, Masters of the Art of Painting,*[33] it was addressed to "Mr. Hogarth, An Eminent History and Conversation Painter" and dated 12 June 1730. One of the Scots circle that had connections with the poet Allan Ramsay and included Thomson and Mallet, Mitchell sums up the Hogarth who had put aside engraving to make a name as a painter. He claims to be a friend: "Accept the Praise a friend bestows, / A Friend, who pays but what he owes." (The latter could be a reference to a financial debt, given Mitchell's extravagance and habit of borrowing.)[34] He begins by emphasizing the fact that Hogarth is self-taught: "Hogarth, by Merit of your own, / A Candidate for first Renown . . . Self-taught, in your great Art excell." The most interesting passages praise his paintings:

> The Labours of your Hand present
> Our various Sense and Speech in Paint.
> Such vital Instinct each receives,
> We think one joys, another grieves!
> Here, the fond *Lover's* Pains appear;
> The *Hero's* Fire and Fury there!

> The silent *Hypocrites* exert
> Such Pow'r, and play so well their Part,
> That different Passions they bestow,
> Affright with Fear, and melt with Woe,
> Themselves unconscious what they cause,
> And our Hearts the Master draws.

> You have the Skill to catch the Grace,
> And secret Meanings of a Face;
> From the quick Eyes to snatch the Fire,
> And limn th'Ideas they inspire;
> To picture Passions, and, thro' Skin,
> Call forth the living Soul within.

Mitchell likes to make comparisons, and compares Hogarth to Elijah inspiring Elisha, Christ and the fishermen, Pygmalion, and Prometheus. Then he turns to the just portrayal of nature, which was to be the usual defense made of Hogarth, and ends with the conversation pictures in particular:

> Large Families obey your Hand;
> Assemblies rise at your Command;
> Your Pencil peoples where it goes
> And Worlds of new Creation shows.

Comparisons to Deucalion inspiring life in stones and Solomon impressing the Queen of Sheba lead to the peroration, with its somewhat invidious reference to Thornhill the father-in-law:

> *Shakespeare* in Painting, still improve,
> And more the World's Attention move.
> Self-taught, in your great Art excel,
> And from your Rivals bear the Bell.
> But, Rivals—you have none to fear—
> Who dares, in such a Style, appear?
> *Dutch* and *Italian,* wide Extreams,
> Unite, in You, their diff'rent Names!
> Still be esteem'd the First and Last,
> Orig'nal in your Way and Taste;
> Tho *Thornhill's* Self shou'd jealous grow,
> And try your Doings to out-do:
> But *Thornhill,* mingling Flame with Flame,
> Will view with Pride your rising Fame;
> Not, meanly hazarding his own,
> Attempt to rival your Renown,
> Lest He shou'd be by Fate pursu'd,
> Like *Saturn,* whom his Son subdu'd.

One wonders how Thornhill liked being compared to Saturn. But Mitchell's poem is noteworthy as the first contemporary work to introduce the ubiquitous phrase "in your Way": Hogarth was the greatest painter "in his way." And Mitchell calls Hogarth a history painter on the strength of his modern histories, long before Fielding developed the idea in his preface to *Joseph Andrews*. Mitchell seems to recognize (unless he has been coached by Hogarth) that such works must be honored with the name of history painting, and then they become the highest kind of art. Implicit here is a radical definition, which would not have been acceptable to many contemporaries, but which Hogarth was preparing to exploit graphically in the *Harlot's Progress*.

Mitchell was also the first to call Hogarth "*Shakespeare* in Painting," which referred to Hogarth's fecundity of invention ("Worlds of new creation"), his affinity with the theater, and his genius for likeness or "character." Hogarth had begun as a painter with a scene from Shakespeare, and there would be others; but the significant feature for Hogarth was summed up in the dedication to the Shakespeare Folios: "To the great *Variety* of *Readers*. From *the most able,* to *him that can but spell*." The words I have italicized could serve as rubrics for the intentions Hogarth had been adumbrating in his paintings and engravings up to this point.

8.

THE "MODERN MORAL SUBJECT"

A Harlot's Progress, 1730–1732

GENESIS

A red chalk drawing by Hogarth, the size, scale, and style of the *Hudibras* drawings (9 1/2 x 13 in.), shows an aging prostitute and her peg-legged servant in a shabby chamber (fig. 95). It closely resembles in style the drawing for *Hudibras Sallying Forth* (Royal Library) and is finished with the care he employed only on drawings preparatory to an engraving.[1] On the other hand, it is blocked (lined) off, as for enlargement into a painting. The picture fits nowhere in the *Hudibras* narrative but contains some of the elements present in the third plate of *A Harlot's Progress* (fig. 98): the cat and bundle of switches; the canopied bed and the pictures pinned to a wall; and the medicine containers on the table and the window sill. The woman is not young but retains some of her good looks. She is dressed, unlike the Harlot, as shabbily as her servant. Among the details purged from the finished picture are a pair of prophylactic sheaths and a hypodermic syringe on the whore's table: the latter was used at the time not to insert into a vein but into the male urethra (sometimes into the vagina) as a semiquack cure for gonorrhea.[2]

George Vertue recorded that in 1730 Hogarth was showing in his studio "amongst other designs of his in painting . . . a small picture of a common harlot, supposed to dwell in drewry lane. just riseing about noon out of bed. and at breakfast. a bunter waiting on her." His description is of the painting (destroyed by fire in 1755): "this whore's désabillé careless and a pretty Countenance & air.—this

thought pleasd many."[3] The rich creamy flesh colors and the pink of blooming cheeks (as witness the *Beggar's Opera* paintings) would have been much more evident in the painting than in the print, and the contrast more titillating between her appearance and the context of her corruption. She caught the attention of the visitors to Hogarth's studio, who, Vertue records, "advisd him to make another. to it as a pair. which he did. then other thoughts encreas'd, & multiplyd by his fruitful invention. till he made six. different subjects which he painted so naturally. the thoughts, & strikeing the expressions that it drew every body to see them—." Thus the series began with the third scene and grew from a contrast to a sequence of cause and effect, presumably in order to explain how the pretty young woman got where she was. By that time it would have been clear to Hogarth that the paintings should be engraved (figs. 96–101).

One point of origin for this scene, Michael Godby has argued, may have been an emblem of Temperance showing a female figure pouring water into a wine jar in order to dilute it; another showed a woman holding a bridle and the stay of a clock as symbols of moderation and regulation.[4] But the Harlot's bunter is pouring hot water into a teapot, not into a wine jar—there is no inebriation; and the Harlot dangles a *stolen* watch—a sign of *in*temperance. If the Temperance emblem is implicit in Plate 3, it has been introduced only to be subverted, rendered vestigial, or replaced by humanized structures of meaning that are plainly *anti*-emblematic.

Hogarth's scene relies for its effect on a number of literary texts. Steele's sentimental defense of prostitutes in *Spectator* No. 266 (4 Jan. 1711/12) projects the same mixture of pity, tenderness, and prurience. Mr. Spectator describes a young girl who stops him in the Covent Garden Piazza (near where Hogarth in 1730 was living):

> as exact Features as I had ever seen, the most agreeable Shape, the finest Neck and Bosom, in a Word, the whole Person of a Woman exquisitely beautiful. She affected to allure me with a forced Wantonness in her Look and Air; but I saw it checked with Hunger and Cold: Her Eyes were wan and eager, her Dress thin and tawdry, her Mien genteel and childish. This strange Figure gave me much Anguish of Heart.

The "progress" of a harlot outlined by Steele is essentially Hogarth's: innocent and "newly come upon the Town," "falling into cruel Hands," "left in the first Month from her Dishonour, and exposed to

pass through the Hands and Discipline of one of those Hags of Hell whom we call Bawds." Steele projects an image of the bawds and lechers as villains and the girls as pitiable victims. He also describes in detail, almost as instructions to a painter, the subject of Hogarth's first plate:

> The last Week I went to an Inn in the City, to enquire for some Provisions which were sent by a Waggon out of the Country; and as I waited in one of the Boxes till the Chamberlain had looked over his Parcels, I heard an old and a young Voice repeating the Questions and Responses of the Church Catechism. I thought it no Breach of good Manners to peep at a Crevise, and look in at People so well employed; but who should I see there but the most artful procuress in the Town, examining a most beautiful Country-girl, who had come up in the same Waggon with my Things. . . . Her innocent *forsooth's, yes's, and't please you's, and she would do her Endeavour,* moved the good old Lady to take her out of the Hands of a Country Bumkin her Brother, and hire her for her own Maid.

Thus the situation of Plate 1, down to the inattentive clergyman, reflecting no doubt Hogarth's impatience at Mr. Spectator's refusal, with all his awareness of the situation, to involve himself on the girl's behalf. He merely stays hidden in his box, as Hogarth's clergyman does behind his piece of paper. Hogarth even deprives his harlot of the "Country Bumkin her Brother," showing that her "lofing cosen in Tems Stret in London" has failed to meet her.[5]

Hogarth's more immediate sources were Defoe's *Moll Flanders* (1724) and Gay's *Beggar's Opera*. In the painting he added to the squalid realism of *Moll Flanders* (evident in his drawing) the contrasting youth, bloom, beauty, and apparent innocence from the Polly of his *Beggar's Opera* paintings: this was what had, according to Vertue, first caught the attention of visitors to Hogarth's shop. The pretty, pathetic Polly, who had assured the play's success on its opening night, was all the more piquant as a prostitute in sordid surroundings. Even the medicine bottles (retained from the drawing) imply that she is already diseased within, however lovely on the outside.

Polly was perceived by contemporaries as "a young, *innocent* Girl made up of nothing but *artless Simplicity* and *Nature,* very *fond* and *tender.*" She embodied for her first audiences the "idea of *artless Innocence.*" This is an idea Hogarth did not contradict in his paintings of *The Beggar's Opera,* though in the final version the dividing of her

attention between Mr. Peachum and, among the spectators, the duke of Bolton (she has turned her eyes and body away from her stage lover Macheath)—in other words, "the duplicitous involvement of Lavinia Fenton [as opposed to Polly Peachum] with a married man"—introduced a complication on the moral as well as the epistemological level: Polly-Lavinia is deceitful as well as part of a comedy of role playing.[6]

But Hogarth has taken Polly out of the *The Beggar's Opera,* which is dominated by Macheath, and centralized her; and for *this* Polly, he turns to Gay's sequel, the ill-fated *Polly,* suppressed before its first rehearsal in December 1728 but published in April 1729, where she *is* central. This play follows Polly as she pursues her wayward husband Macheath to the West Indies, where he has been transported, has escaped, has become a black-faced pirate, and is living with his new wife Jenny Diver. Here Hogarth found the situation that bridged the fictions of *The Beggar's Opera* and *A Harlot's Progress.* At the beginning of Act I we are introduced to a bawd Trapes talking with a rich old man Dukat about how she lures young women who have just arrived off the boat from England into service, where they are seduced or raped by such as old Dukat. Flimzy describes Polly to Trapes:

> Such lips, such eyes, and such flesh and blood! If you had seen her in *London* you could not fail of the custom of all the foreign Ministers. As I hope to be sav'd, Madam, I was forced to tell her ten thousand lyes before I could prevail upon her to come with me. (I.iii)

Trapes procures Polly in this way for Dukat, and a scene follows in which he tries to seduce and, when this is unsuccessful, to rape her.

This is the trio we encounter in Plate 1 of *A Harlot's Progress* in Moll Hackabout, the bawd Mother Needham, and her employer Colonel Charteris, who like Dukat stands in a doorway in order to inspect Polly (I.vi). As the spectator recognized Walker playing Macheath playing the Great Man, so in *Harlot* 1 Needham and Charteris play similar roles, with a baffled Lavinia-Polly-Hackabout caught in her conflicting roles: including the parallel story of how Lavinia Fenton was seduced and lured from the stage into keeping by the duke of Bolton.

Writing of the London stage in 1731, Robert Hume comments that, of all the theatrical genres, "legitimate comedy was moribund, mainpiece ballad opera was *passé,* and tragedy needed a new twist to

get away from its clichés. Burlesque and topical material had become good bets."[7] It was within this situation that Hogarth undertook his *Harlot's Progress*.

THE NEWSPAPERS

Both Hogarth and the newspaper-reading public he catered to would have read in *Fog's Weekly Journal* of 6 December 1729:

> It is reported about the Town, that a certain noble colonel lately attempted to rob a young Woman, a Servant Maid, of her Honour, and that to frighten her into a Compliance with his filthy Desires, he drew a Pistol upon her—He is to be sued for the Assault, and it is thought considerable Damages will be given against him, not only for putting the Young Woman in Fear of her Maidenhead, but for using a Weapon altogether unlawful upon such an Occasion.

This "noble Colonel" was well known about London, and the only surprise would have been elicited by the news of 26 February that Colonel Francis Charteris (or Chartres) had "surrendered himself at the Old-Bailey in order to his Tryal, a Bill of Indictment having been found against him at Hicks's Hall for ravishing Anne Bond, his Servant-Maid."[8]

Colonel Charteris was a man whose movements were reported in the papers as a matter of course. A year earlier *Fog's Weekly* had reported another rape for which he had "obtain'd a *Noli prosequi*: It is reported now, that he brags that he will solicit for a Patent for ravishing whom he pleases, in order to put a Stop to all vexatious Suits which may interrupt him in his Pleasures hereafter" (28 Dec. 1728). Allegedly worth over £200,000, gained through gambling and worse, he would also have recalled to Hogarth bitter memories of twenty years earlier when his father was petitioning for release from debtors' prison and the Insolvency Bill was creeping along in the House of Commons. In the winter of 1710–1711 Charteris was being investigated by the Commons for augmenting his income by exploiting the act that allowed debtors to escape confinement by enlisting in Her Majesty's armed forces; he took large sums of money from ruined tradesmen to put their names on his roster. Exposed, with over a

third of his company only names, Charteris was cashiered and taken into custody by the serjeant at arms of the House of Commons. On 28 February 1710/11, as the debtors' petition was pending, he was "brought to the Bar; where, upon his Knees, he received a Reprimand from Mr. Speaker; and was discharged out of Custody, paying his Fees"[9]—to return to his evil ways with his pockets well lined and no more than a verbal rebuke for cheating the government of thousands of pounds through his protection of fraudulent debtors, while innocent debtors still languished in confinement for honest losses. Or so it may have appeared to young William Hogarth.

The author of *The Life of Colonel Don Francisco,* a biography of Charteris published in March 1729/30, records that after leaving the army he turned to gambling for a livelihood. As he grew ever richer and older (some of his wealth owing to profits from South Sea speculation), he took to employing "some noted Procuress to furnish him from Time to Time with variety of fresh Country Girls, which were to be hir'd (to prevent any Suspicion) to live with him as Servants." An example was one Sarah Selleto, who came to London from the country, "a poor Country Wench, friendless and pennyless." One day as she was walking in Bow Churchyard, a bawd named Mrs. Prat came up to her and asked her what brought her to town. Learning that she wanted to go into service, Mrs. Prat offered to find her a position—and so she went to Charteris's house, where he made an attempt on her virtue, supported by a pistol clapped to her head. He kept her and gave her presents, but when he learned she was pregnant he turned her out (48). This pattern was repeated in the other cases enumerated in *The Life of Colonel Don Francisco:* a woman persuades a girl, often just off the Gloucester or York wagon from the country, to take a position at Charteris's house as a servant.

Charteris's trial for rape was held on 26 February 1729/30 and was attended by the duke of Argyle, the duke of Manchester, Sir Robert Clifton, "and others of the Nobility and Gentry."[10] Anne Bond, the plaintiff, testified that a woman unknown to her had offered to find her a place as a servant and had taken her to Charteris's house:

> that she was treated very civilly for about three Days: that then he tempted her to lye with him, and offer'd her a Purse of Gold; that he made the like offer to her several times, and told her, that he would give her fine Clothes and Money, and a House to live in, and also get her a Husband; she said, she refused all his offers, and told him, she

would not give in to any such thing; and she did not know his right Name till the third Day, when a Servant knocked at the Door, and call'd him by his right Name; that having heard of his Character she would not have come to him if she had known his right Name.

She could not escape: the street door was kept locked, and so she remained until 10 November, when the clerk of the kitchen sent her up at 7 o'clock in the morning to her master, who

bid her stir the Fire, and then he went to the Door, and shut it, and threw her upon a Couch, and had carnal Knowledge of her Body by force. She said, she cry'd out, and the Servants were in the Hall, which is the next Room, and might have heard her, but did not come to her Assistance; that upon her crying out, he stopped her mouth with his Night-Cap; she said, the Room was next the Street, a Ground-floor, and the Window-shutters open; she said, after he had ravished her, and she had got from him, she told him, she would tell her Friends, and that she would prosecute him; that then he threaten'd he would be the Death of her, if she told it; but she persisted she would, and soon after he whipp'd her with a Horse-whip over her Back and Head, and then he unlock'd the Door.[11]

Charteris's attorney argued that she fabricated the whole story to cover her discharge for stealing money; that she had known him in Lancashire (where he had large estates) and solicited the position herself, sending him a letter; that none of the servants heard any noises; and that she customarily slept on a truckle bed in his bedroom, some nights with another female servant. His witnesses' testimony, however, was shown to be full of inconsistencies and contradictions. After a trial of four hours, Charteris was capitally convicted and removed to Newgate.[12]

Thus did justice apparently catch up at last with the so-called Rape-Master General of Great Britain, whose name had been sufficient to identify him to Anne Bond. The verses that accompanied a print, *Portrait of Col. Francis Charteris on His Trial,* are heavy with irony:

> Blood! must a Colonel, with a Lords Estate
> Be thus obnoxious to a Scoundrel's fate?
> Brought to the Bar, & sentenc'd from yᵉ Bench
> For only Ravishing a Country Wench?

> Shall Gentlemen receive no more respect?
> Shall their Diversion thus by Laws be check'd?[13]

Two days after the trial "His Man, John Gourly, (commonly called trusty Jack)" was reported to have "gone express" to Scotland to bring down the earl of Wemys, Charteris's son-in-law, and already there were reports of work toward a reprieve: "We hear great Intercession has been made to save the Colonel's life, but as yet without effect. He is reported worth 200,000*l*.," wrote the *Gazette* of 28 February. "Great" refers to the Great Man himself, Sir Robert Walpole.

At this point a second strand appears in the story. On 25 February one Francis Hackabout, a highwayman, was convicted of robbing Aaron Durell and George Baily of money, a watch, and other items. On Saturday night, 28 February, sentence of death was passed on malefactors at the Old Bailey, and these included both Francis Hackabout and Colonel Charteris. The case of another highwayman, "the noted James Dalton," for robbing a Dutch merchant of £20 and other things of value, was postponed until the next session. This lady's man had been tried in January and found guilty of assaulting Dr. Richard Mead (the art collector) with intent to rob him, but since he had stolen nothing his sentence was a mere three years. On that occasion, "a Woman unknown took an Opportunity to throw a Bottle at his Head, which cut him very much, and caused such a Confusion among the Crowd, that two Fellons found Means to escape." Later, having cut a fellow prisoner "in a desperate Manner with a Knife," Dalton reappeared in court, where "he behaved himself before the Court with uncommon Insolence and Impudence." Other crimes from the past were dredged up, including the capital crime of robbing a person in the street of a waistcoat and 25 India handkerchiefs.[14]

On March 7 the *Life of Col. Don Francisco* was published with a portrait of Charteris for 1*s*.[15] The rest of the month burgeoned with pamphlets and prints about Charteris and his trial, as well as reports on his attempts to gain a pardon and his struggle to save his property from confiscation. The *Grub-street Journal* began a series of attacks along the lines of *The Beggar's Opera* on the immunity of the rich from the laws ("it is more difficult to get a rich man hanged than to save a poor fellow from the gallows"). Charteris was the symbol of those "Persons of considerable fortune, or quality, [who] tho liable to the same Capital penalties with those of a lower station, yet should

not have those penalties inflicted on them"—accompanied by many references to "great men" (12 March). On the 28th it was reported in the same periodical that a pardon would be forthcoming.

Charteris was also in financial troubles. At one point an estate worth £100,000, "including several Mannors and estates in *Lancashire*," and five or six thousand pounds of South Sea stock, were reported seized.[16] But on 9 April news reached Charteris from Lancashire that none of his property there had been confiscated, and the same day James Dalton was capitally convicted at the Old Bailey for robbing John Waller on the highway. The next day Dalton received sentence of death, and Charteris—his and his friends' endeavors having proved successful—was discharged from Newgate, pardoned by the king. He was freed on bail to plead his Majesty's pardon, a mere formality at the next Quarter Sessions. The next day the earl of Wemys was at court to thank the king for his father-in-law's pardon. On 13 April Francis Hackabout the highwayman was ordered to be executed the following Friday, the 17th; and all Charteris's effects at Newgate were removed in a hackney coach to his new lodgings in fashionable Leicester Fields. (In the list of those ordered to execution appears: "and Francis Hackabout likewise for the Highway. But Francis Charteris, Esq; hath obtained his pardon.") On Friday, as scheduled, Hackabout and four other malefactors were hanged at Tyburn. Dalton was executed on 12 May appearing "very resolute and undaunted," drinking "part of two Pots of Beer at the Place of Execution," and "utterly" denying his guilt.[17]

Charteris, meanwhile, had been attacked by a mob while riding in his coach, "for no other Reason than that there were two Women with him in the Coach." A print published shortly thereafter shows him ascending from a prison door up steps covered with purses of gold, toward a car with Venus and two nymphs she is offering him.[18] On 16 May Charteris successfully pleaded his Majesty's most gracious pardon before the Sessions and was officially freed. On 2 June, however, he was arrested in Fleet Street "at the Suit of a Messenger or Runner at Newgate for 50*l.* for Services pretended to have been done for the Colonel during his Confinement in that Prison," but was freed on bond. On 23 June Henry Fielding's farce *Rape upon Rape,* with a patent allusion to Charteris, was performed and published.[19]

Toward the summer of 1730, when the various strands of our story come together, yet another character appeared on the scene, as famous in his way as Charteris. Sir John Gonson, the Westminster

magistrate, was well known for his charges to the Grand Jury at the Quarter Sessions of the Peace of Westminster. His charges, often compared to sermons, were strongly pro-Walpole and came in for the criticism of the *Grub-street Journal* and other antiministerial publications.[20] But his greatest fame was for harassing gamblers and prostitutes, whom he committed to Bridewell Prison to beat hemp. During the spring of 1730 he was assiduously raiding gambling houses; by the summer he had turned his attention to brothels. On the night of 1 August he and several other justices of the peace for the City and Liberty of Westminster "met at the Vestry-Room of St. Paul's Covent-Garden, and committed the Keepers of several disorderly Houses (who were taken into Custody the Night before) to Tothill-Fields Bridewell to hard Labour, in particular Katherine Hackabout, alias Wooten, and Anne Lewis, alias Low, alias Brown."[21] The *Grub-street Journal* for 6 August prints accounts of the raid from various newspapers, including this from the *Daily Post* (3 Aug.):

> the 4th was the famous Kate Hackabout (whose brother was lately hang'd at Tyburn) a woman noted in and about the Hundreds of Drury, for being a very Termagant, and a terror, not only to the civil part of the neighborhood by her frequent fighting, noise, and swearing in the streets in the night-time, but also to other women of her own profession, who presume to ply or pick up men in her district, which is half one side of the way in Bridges-street.

Neatly juxtaposed in the adjacent column, the *Journal* prints a notice from the *St. James's Evening Post* of 4 August: "Colonel Chartres and his Lady being perfectly reconciled to each other, and having made proper dispositions for cohabiting together, he having cashiered his man trusty Jack [Gourly] and others of his evil agents; they are to be presented to their majesties one day this week on that occasion."

Here the apprehended prostitute Kate Hackabout, whose brother was condemned and hanged, appears in conjunction with the aged rapist, who started such women as Kate on their careers and was condemned along with her brother but, unlike him, was spared hanging. And together with the unsuccessful and the successful rogues was the indefatigable Justice Gonson who apprehended Kate Hackabout. For Hogarth, reading the *Grub-street Journal,* two threads of irony must have coalesced. One was the inconsistent justice meted out to high and low, expressed in Gay's *Beggar's Opera* but not with the particular

emphasis Hogarth was to give it, and summed up by Fielding in *The Grub-street Opera* (July 1731):

> Great whores in coaches gang,
> Smaller misses
> For their Kisses
> Are in Bridewell banged;
> Whilst in vogue
> Lives the great rogue
> Small rogues are by dozens hanged.[22]

The other was the unbalanced equation pitting Gonson and legal justice against the vulnerable prostitute. It seems very possible that on this day, 6 August 1730, the various themes, conventions, and characters floating about in Hogarth's memory came together to shape a history for the pretty harlot in her Drury Lane room. They would not, however, have been usable had they not been shared with the large body of newspaper-reading Londoners (the coffeehouse clientele of his youth).

The Harlot's name appears as "Md. Hackabout" on a letter in an open drawer in the third scene, and on her coffin in the final scene "M. Hackabout." (The "M" was extended to "Moll" in the subtitle of the pamphlet, *The Harlot's Progress, or the Humours of Drury Lane,* 1732, with no authority. "Md." is probably meant to stand for Madam; "M" could stand for Mary or Moll.) Hogarth puts a "fresh country girl" named Hackabout in her shabby room, holding a watch that registers (though reversed in Hogarth's engraving) 12:15, the time Kate Hackabout was arrested (according to the *Grub-street Journal,* between "12 noon and 1 o'clock").[23] She has James Dalton's unclaimed wig box above her head and portraits on her wall of Captain Macheath, Polly's lover and the robber who talked like a gentleman and got off scot-free, as well as Dr. Henry Sacheverell, the man who toppled a ministry with an incendiary sermon and rose thereafter from one lucrative benefice to another. (The Sacheverell case took place in 1710. A writer in the *Free Briton* as currently as 15 July 1731 demanded to know "Why was *Sacheverel* distinguished with a royal presentation, and why was that Parliament dissolved that condemned him?") And—the element that was not in Hogarth's original drawing and presumably painting—through the door at the rear stalks Gonson and the other justices of the peace for the City and Lib-

erty of Westminster. Then, returning to the Harlot's initiation in Plate 1, Hogarth shows the girl just off the York Wagon, met by a bawd, with Colonel Charteris and his pimp "trusty Jack" Gourly waiting in the background. All of these were easily recognizable portraits: Vertue identified Gonson, Charteris, and the bawd Mother Needham; Gonson's initials appear on the wall of Bridewell in Plate 4; Charteris's face can be compared with the portraits of him published at the time of his trial (by George White and Elisha Kirkall, for example); [24] and given Charteris, "trusty Jack" is a logical inference for his companion.

The Harlot's initiation and her apprehension by justices are of course conventional scenes. Hogarth could have built the scene in the innyard of Steele's *Spectator* No. 266 or on descriptions in Richard Head's *English Rogue* (1672) or any number of other fictional sources. But only through the particular events and characters, faces and names of 1729–1730 did his theme germinate and express itself. Hogarth's primary aim in *A Harlot's Progress* (as his subscription ticket confirmed) was to create an image that was without a literary text, based only on "nature," or on nature's current text the *news*paper, and its referent, particular living (or recently dead) people, events, and public signs in London. The recognizable presences within the framework of conventional scenes and relationships attracted buyers, lending the prints a sense of contemporary immediacy.

They also represented a level of allusion to the world of the respectable, rich, and powerful—the rake who can rape with impunity and the magistrate who hunts prostitutes as others hunt hares. Robert Hume makes the point—an important one—that "disgust over that [the Charteris] case was hardly confined to the opposition." [25] However, as in *The Beggar's Opera*, the "great" reach up to the Great Man himself, Sir Robert Walpole. Charteris was reported on 5 September 1730 to have "presented the R.H. Sir Robert Walpole with a horse-furniture of green velvet, curiously embroidered with gold of great value"—confirming a widely held suspicion about the connection between the two great men. [26] Charteris was also being described as a "great man" and as "A Favourite Worthy of Bobby the Great." [27]

Walpole's reprieve of Charteris cuts two ways, recalling both the function of Walpole the "Screen" (for his protection of the "great" of the South Sea Bubble) and references to Walpole himself as above the law. Gay's Captain Macheath, one of the Harlot's patron saints in Plate 3, alluded of course to Walpole, especially in his last-minute re-

prieve, a parody of Walpole's dismissal and reinstatement in 1727. Anyone perusing the newspapers of 1730–1731 will notice that the news about Charteris's South Sea profits coincided with the news of his rape of Anne Bond. Charteris the rapist was linked in the public mind with unscrupulous businessmen who also ruin the defenseless. So to the associations with Walpole were added those of the South Sea scandal, still linked with Walpole government.[28]

Another of the anti-Walpole images, employed in *The Beggar's Opera* and *Polly,* was based on the analogy between a lecher's ruin of a maiden and that reputed womanizer Walpole's ruin of the British nation. In *Polly* the same figures who "betraye and ruine an innocent girl . . . betraye and ruine provinces and countries" (I.iv). In "The Progress of Patriotism. A Tale" (ca. 1729), a "plain Country Girl, untainted, / Nor yet with wicked Man acquainted, / Starts at the first lewd Application, / Tho, warm perhaps by Inclination," is seduced by the "long assiduous Art" of Damon, and thereafter "Holds there's no Sin between clean Sheets, / And lies with every Man she meets."[29] And, more recently, in the *Craftsman* of 10 January 1730, a ruined maiden served as an emblem of Walpolean England: "A *bribed Corporation* is like a *Woman* debauch'd, and must expect to be turn'd off and left to shift for herself, when the Corrupter hath serv'd his Turn."[30] Thus a seduced and discarded woman is like the electors who succumb to Walpolean bribery. As scholars have identified Pope's and Swift's references to bad stewards who cheat both their masters and tenants with the prime minister's exploitation of both king and country, so it is possible to see an analogy between Charteris corrupting Moll and Walpole the country.[31]

It is no coincidence that the bishop of London, referred to on the paper being read by the inattentive clergyman in Plate 1 ("to the Right Reverend Father in God . . . London"),[32] was Edmund Gibson, known by the Opposition as "Walpole's Pope," his chief agent of ecclesiastical preferment and a propagandist for the ministry in his pulpit. Gonson was also a Walpole supporter in his addresses at the Quarter Sessions, and the Jew may have been Sir Sampson Gideon, whose connections with Walpole were well known. But this is not necessary, for among Walpole's own epithets were "Rabbi Robin" and "Prime Minister to King Solomon," the allusion being to his avarice and sharp practices, going back to his role as "Screen" in the aftermath of the South Sea scandal. Bishop Gibson was also called "a Son of Levi." (The Jew was also, of course, one of the villains in the

South Sea satires, included by Hogarth in his *South Sea Scheme*.) It seems possible that *A Harlot's Progress* is serving, in a secondary way, as part of the *Craftsman's* campaign against Walpole. It is certainly a fact that Hogarth chose to advertise the *Harlot* in the *Craftsman*.[33]

A question concerns Hogarth's silence on Walpole and his ministry from 1729 to 1732 due to the commission of the Walpole Salver, but also perhaps the influence of Thornhill, who was a Walpole supporter.[34] He has decidedly broken his silence in the *Harlot,* but he has done so by developing a new and original mode of representation. Passing beyond the Augustan satirist's analogy (a fictional character Macheath recalls Montezuma, Hercules, *and* the historico-political figure Walpole), Hogarth has employed real, newspaper documented people, places, and situations. He has thus recoded political phenomena in social and gender roles, as if to concretize the satires connecting Walpole and young women in the specifics of a contemporary case of social and gender discrepancy. On the one hand he circumvents Walpolean censorship; but on the other he introduces a new approach to the relationship of truth and fiction that will influence the emergent English novel of the 1740s. In a direct way Hogarth's strategy passes into Fielding's *Joseph Andrews* (1742), in a less direct but even more influential way into Richardson's *Pamela* (1740).[35]

But the events did not come to a stop in August 1730. As the summer turned to autumn, Gonson continued to raid brothels, and Anne Bond, together with a drawer at a Westminster tavern whom she had married in April, set up a tavern in Bloomsbury at the "Head of Col. Chartres for their sign."[36] The *Grub-street Journal* for 24 September quotes another paper for the 19th to the effect that Anne's husband had been arrested "in some sort of actions by persons employed in that affair [of the rape]," but "We are all assured that the Col. hath no hand in this affair." The *Grub-street Journal* adds an editorial comment: "I wonder at the assurance of my Brethren in vindicating the Colonel's reputation by such an Innuendo" (24 Sept.).

In the same paper, immediately below this notice, is an account of one Mary Muffet, "a woman of great note in the hundreds of Drury, who about a fortnight ago was committed to hard labor in Tothillfields Bridewell . . . she is now beating hemp in a gown very richly laced with silver . . . to her no small mortification . . . and bestows many hearty curses upon her lawyers, &c." The editorial comment,

"*This Lady's* Gown very richly laced with silver *does not well agree with* her no small mortification *in performing the Pennance of* beating hemp," suggests exactly the ironic contrast Hogarth introduces in his fourth plate, which shows the Harlot transported from her room in Drury Lane to Bridewell to beat hemp in as fashionable a gown as she was wearing in Plate 2.[37]

Mary Muffet and her richly laced gown fit into Hogarth's picture of the Harlot. It should be clear, recalling the actual details of Anne Bond and Kate Hackabout, that he has placed his Harlot somewhere between those extremes. She is not Anne Bond: the second plate is not her rape but her happy assumption of the role of kept woman. She is not the termagant Kate Hackabout: she never loses her air of Peachum gentility. With this pretty young woman, the gown worn in Bridewell indicates her remnants of gentlemanly keeping and, because she is still wearing it, her guiding motive. Beginning (in the painting of Plate 3) as part of a mock levee, she aspires to become a lady, manages only to be a harlot, and as a harlot thinks herself a lady. It may have been *Moll Flanders* that first planted in Hogarth's mind the image of a harlot as one who, like Moll, simply wants to be a gentlewoman—by which she means one who does not "go into service": like the lady down the street who "is a gentlewoman, and they call her madam" (the lady is in fact a prostitute).[38] Like Moll too, the Harlot has no character of her own, only reflecting the society in which she finds herself, both in wanting to be a gentlewoman—to have a gentleman at whatever cost—and in disguising herself as a gentlewoman or a widow in order to steal. Thus the Harlot keeps her gentlewomanly clothes, always has masquerade disguises around her, and ends with a funeral and funerary escutcheon unprecedented for one of her trade. She even imitates fine ladies by taking a young lover behind her "keeper's" back.

The Beggar's Opera was also of course about imitation—whores imitating ladies, highwaymen imitating gentlemen, and fences imitating merchants. Part of Gay's point was that "emulative spending, the indulgence in fashionable consumption" was coming to be regarded by many as advantageous to the British economy.[39] As early as the 1680s, John Houghton had written that "our High-Living so far from Prejudicing the Nation . . . enriches it."[40] Gay and Hogarth express the moralistic and economically conservative position for which *Luxuria* was still an evil.[41] Coincidentally, Bernard Mandeville, who put the position starkly for luxury, took the example of "a

poor common harlot [who] must have Shoes and Stockings, Gloves, the Stay and Mantua-maker, the Sempstress, the Linnen-draper, all must get something by her."[42]

The woman hanging out her laundry on the balcony in Plate 1 is the only indication in the series of an alternative way of life in London. Hackabout *could* be outside, with some space and air around her, washing clothes and airing chamber pots on the railing; but she prefers to live inside closed rooms, imitate the rich, and avoid physical labor.[43]

The bawd in the picture cajoling Hackabout was immediately identified by Vertue as Elizabeth Needham, the most famous procuress of the day and frequently linked to Charteris.[44] In 1727 when Mary Davys had needed a bawd in her *Accomplish'd Rake,* she called upon "Mother N-d-m" and showed her trying to peddle a girl "just come out of the country."[45] By March 1730/31 Gonson's inquiries had reached St. James's, and persons of quality from Park Place testified against "a notorious disorderly House in that Neighborhood," which proved to be Needham's; there she was apprehended and committed to the Gatehouse by Justice Railton.[46] On Friday 30 April, a month after Hogarth had begun his subscription for the *Harlot's Progress,* the "noted" Mother Needham stood in the pillory facing Park Place (the first of two times she was condemned to stand) and was so "severely handled by the populace" that she died on 3 May. The *Grub-street Journal* comments: "They acted very ungratefully, considering how much she had done to oblige them"[47]—a statement that Hogarth, given the donnée of his *Harlot's Progress,* would have found interesting. The same day Gonson and his cohorts were again meeting, examining, and committing undesirables.

Needham's fate can only have confirmed feelings already at work in the series. She is the Harlot's original corrupter, the bawd who usually escaped detention while her girls beat hemp; yet she is only an intermediary for the Charterises, and her death, like the Harlot's, is an ugly one, with the very people she had served clamoring self-righteously for her punishment. Hogarth could easily have replaced Needham's face, but he would have relished the irony of retaining her likeness in the published print. She is only one of at least three concentric circles of guilt in Plate 1: the Harlot herself; Mother Needham,

who is exploiting her; and Charteris, who is exploiting Needham and will no doubt be one of those who pelt her in the pillory.

The clergyman is also part of the guilt, turning his back on Hackabout, leaving her to Needham and Charteris. The reason for his absorption is the address of the bishop of London he is trying to make out on the paper in his hand: he is thinking about his own advancement rather than his pastoral duty. Hogarth also incriminates the girl's "lofing cosen in Tems Stret," to whom her goose is directed, and who has failed to meet her, leaving no one to protect the innocent from Needham. As her antagonists, the forces of pleasure and corruption are augmented by the entire social structure of family, law, order, and religion.

In Plate 3 the Harlot is pursued by a magistrate; in Plate 5 she is ignored by doctors; but clergymen are singled out, shown ignoring her in both the first plate, where the ambitious cleric turns his back, and the last, where the officiant at her funeral has his hand under the skirt of one of the surviving whores. Hogarth's comment on the clergy does not end here: in Plate 2 an Anglican bishop is shown stabbing Uzzah (in the painting of the Ark of the Covenant), and Bishop Gibson is alluded to again in the third plate, where the Harlot uses one of his *Pastoral Letters* as a dish for her butter. His first *Pastoral Letter* had been issued in 1729, his second in April 1730, and his third in May 1731. All three were attacks on the Deists, satirized by many as another sign of "Dr. Codex's" pomposity and self-esteem; but Hogarth intends also to parallel the clergyman who does not help the Harlot in her moment of need and the bishop (whom the clergyman is soliciting) who spends his time writing about "freethinkers" instead of attending to his flock.[48]

As a naturalization of the speculating whore in the South Sea satires, the Harlot recalls the connection of whore, clergyman (and other respectable citizens), sex, and financial speculation. The interchangeability of the high and the low, with a strong underlying equation of sexual and religious excitation is still felt in the *Harlot*. But the implication, Hogarth suggests (recalling his Fleet Prison paintings), is that conventional roles are inverted in the whore and the magistrate who apprehends her, as in the prisoner and warder, the sinner and clergyman.

If we bracket the issue of prostitution (which we can be sure Hogarth regarded as Steele did in the *Spectator*), Hackabout's "crimes"

are limited to cheating on the Jew and stealing a watch. The latter recalls the story of the boy stealing the watch in Gay's *Trivia,* where the reader's sympathy is with the boy, not the man whose watch is stolen, and sympathy turns to pity when he is caught and too severely punished by the men who pursue him.[49] He is a small paradigm of the Harlot's situation and our sympathy. There is also a significant detail: she does not (as was the usual practice, with the offspring of Moll Flanders and Roxanne and with the murdered children Captain Thomas Coram observed on his walks) abandon her illegitimate child—a bastard, unwanted and unsupportable.

Here then is the pattern of Hogarth's *Harlot's Progress:* an innocent, basically kindhearted country girl is drawn into the ambience of the "great," the fashionable, the respectable; turning against her own nature she imitates this "greatness," and comes to grief while the "great" themselves go their merry way. It is a satiric pattern, whether recalling the "Christ Mocked" of the graphic tradition or the fools of a Juvenalian satire who are surrounded and destroyed by knaves. It is the consequences and not Moll's folly which fill the stage. This can be seen in the last plate when, as a number of commentators objected, her story is already over. Rouquet argued that Plate 6 is "a farce of which the dead girl is more the occasion than the subject"; and Hartley Coleridge thought it a "satyricon appended to a fearful tragedy," and so an error in tone. Austin Dobson offered one answer: "In his [Hogarth's] experience, harlots were harlots to the end of the chapter—and after."[50] That is, long after her "sin," even her funeral, her escutcheon, her mourners, her clergyman, and her child continue to punish and—concomitant for Hogarth—define her. Throughout she has been defined in terms of consequences, and therefore of the people who in various ways administer them. In short, the "progress" of the suffering protagonist is only a pretext for the author's other subject, which is the people on whom she models herself, who exploit and destroy her, and who continue to flourish themselves.

It is easy to see how Mandeville's brutal insight in his *Modest Defence of Publick Stews* (1724) about the value of prostitution to society—concerning the butcher who saves his meat from the flies by "very Judiciously cut[ting] off a fragment already blown, which serves to hang up for a cure; and thus, by sacrificing a Small Part, already Tainted, and not worth Keeping, he wisely secures the Safety of the rest"—is reflected in Moll Hackabout, "a Small Part, already Tainted," by which Mandeville meant the women in brothels, i.e.,

the poor sacrificed to preserve the virtue of rich women and men.[51] In these terms the newsworthy death of Mother Needham was simply a final dotting of an *i* or crossing of a *t*.

Both Needham and Hackabout are synecdoches for the lower orders. It seems likely that the primary consequence of the South Sea Bubble for Hogarth (as for other contemporaries, notably Defoe) was disillusionment with the social hierarchy. The scandal and its aftermath revealed that the highest orders, far from serving as models, were themselves culpable; far from governing and protecting, they preyed upon, exploited, and victimized the lower orders. This lesson informed the *Harlot's Progress* and its pictures of clergy, magistrates, physicians, prison warders, and other "Great Men."

The date on Hackabout's coffin in Plate 6 is 2 September 1731. Hogarth may have wished to connect her death with the anniversary of the Great Fire of London (noted in newspapers of the 3rd): first, because of the popular associations of passion or syphilis with fire. In Plate 5, for example, a fire is blazing and the pot boiling over as the Harlot dies. As early as the twelfth century citizens were forbidden by law from having to do with whores suffering from the "burning."[52] In the second place, he may have intended us to see the Harlot's personal destruction in the wider context of national disaster; he may have wished to recall his use of the Monument to associate the Great Fire with the plight of England in 1720.[53] But most likely, this was the date on which he finished the last painting of *A Harlot's Progress*.

9.

CONTEXTS (VISUAL AND VERBAL) FOR THE *HARLOT*

THE GRAPHIC TRADITION

The ordinary reader of the *Harlot,* brought up on Bunyan, would have read a grim moral narrative in which the Harlot is justly punished. This reader would have been familiar with the popular print series (usually twelve plates), with the same left-to-right movement of causality from action to consequence and from crime to punishment found in the *Harlot.* Either a criminal's action leads to trial and execution, or a fool's marriage produces equally prolonged consequences. Another genre, however, which comes to infiltrate and dominate some criminal lives, is the graphic atrocity series in which condign punishment is replaced by a series of persecutions that go *un*punished. These produce an open-ended strip, a beginning and middle but no end, only continued examples of atrocities. Hogarth's *Harlot* partakes of both of these popular types.

In the sophisticating hands of Hogarth the question of closure or openness becomes deeply ambiguous. In the *Harlot's Progress* the second through sixth plates are all consequences, and we are by no means certain whether they should be regarded as satisfactory closure or unresolved openness—depending on whether the series is about the Harlot's misspent life or the people who exploit and transgress against her. In short, the direct causality of narrative structures is often accompanied by another kind of movement. In the lives of whores and rakes, the most sophisticated form attained by the popular series, there is a basic horizontal progression with relationships only of contiguity. In the Venetian *Mirror of the Whore's Fate* (ca. 1657)[1] the girl is cajoled by a bawd when her mother's back is turned. Hogarth substitutes a father figure, a clergyman, for the mother.

Once the girl is a whore, her worst error is to have two lovers at once and be caught in her treachery; this is the crux from which she declines into disease and death—and of course also from which Hogarth's Harlot declines. He could have found hints for his second plate in the picture of the Venetian *putana*'s young lover sneaking out a back door, while she diverts her rich keeper with a portrait she is having painted of herself as Minerva (Wisdom).

This is the point of contact at which popular and sophisticated art join. The *putana* has pictures on the walls, and her keeper, claiming to have descended from the emperors Claudius and Nerva, is ordering his own portrait. One of the captions even indicates that it was the Venetian whore's "lofty ambitions" that led her to overreach and caused her downfall. Whore was, in fact, a profession represented by Marcellus Laroon in his popular print series *The Cries of the City of London* (6th ed., 1711) as a young woman carrying a mask (in English, "London Curtezan," but in French "La Putain de Londres"). As Sean Shesgreen notes, "Her tiny ribbon cap, loose scarf, embroidered silk petticoat, and lace shawl give her the look of a fine lady."[2] If we are to believe Laroon, the trait of emulation Hogarth assigns his Harlot applies either to the whole class of prostitutes or—possibly, given the title—to a courtesan: a Roxanne as opposed to a Moll Flanders.

The several elements, here still in a primitive state, are developed in *Harlot* 2, where Hogarth turns his story into the search for a true or a false identity. The closer model is Defoe's naturalization of the Bunyan "progress," which centers on the problem of the self and the process of an individual defining and redefining himself or herself in time. Brought up like Defoe on nonconformist devotional literature, Hogarth shows an awareness that consciousness itself—and so the narrative flow—is not simply linear but layered. The distinction is between an allegorical world with allegorical figures in it and an allegorical world in which a Crusoe or a Harlot moves about uneasily, trying on different types or figures.

The first impression a viewer had before the six plates of *A Harlot's Progress* was of yet another—though compressed from twelve to six plates—popular series of the life of a prostitute. But the density of detail, the reproductive style of engraving, and the compositions would have recalled something between a Dutch genre print and the engraved copy of high-art paintings. The general disposition of the groups, and their scale in relation to the picture space, would have

suggested a conventional history-painting composition. The engraving style was in the general manner of Dorigny in his (somewhat larger) engravings of the Raphael Cartoons, with the same relative uninterest in texture (e.g., fig. 35), rather than the Dutch engravings of genre scenes or the low-life etchings of Ostade and others, which were in a looser, more spontaneous style.

When a Londoner in 1732 received his subscription set, what he saw was the latest in a series of ambitious English engraving ventures after well-known paintings. In the 1720s there had been the engravings of the Raphael Cartoons of *The Lives of the Apostles,* of Thornhill's *Life of St. Paul,* of Laguerre's *Battles of Marlborough,* and of the *Life of Charles I* by Vanderbank and others. These lives of heroic figures had been interrupted in 1726 by the twelve large engraved illustrations for *Hudibras* by Hogarth himself, which recounted the exploits of an antihero, but in the same reproductive-engraving style as if the subject were a hero and there were paintings somewhere from which they were copied.

Hogarth had moved from the particular text on the opposite page in the illustrated book to the large independent engraved illustration that assumes the viewer's memory of a text and reminds him by a few lines and references underneath. Now, perhaps recalling those imaginary texts projected by Cervantes behind his *Don Quixote,* he supposes the general text of a "Pilgrim's Progress," which proves to be not a spiritual but a criminal biography; and he implies a nonexistent history painting prior to his reproductive engraving. But the protagonist represents a comic disappointment of expectations, as does the literary text itself; for she is no fictional character but a contemporary prostitute, whose name is familiar to many readers, and she is surrounded by other recognizable people from the London of the 1730s.

Nevertheless, the first plate evokes the doctrines of history painting, in particular *l'expression des passions,* that go back to Alberti and were carefully formulated by the French academicians, who cited the practice of the Raphael Cartoons and the works of Raphael's French follower Nicolas Poussin. The central structure of history painting was a heroic action (here Hackabout's) filled out with the responses of secondary participants and spectators, which in the case of the Harlot overwhelm the hero's feebly inadequate acts.

A contemporary connoisseur, however, might have placed the paintings (and engravings) in the more recent tradition of the Wat-

teauesque conversation pictures. Not only the composition but the presence of portraits in the *Harlot's Progress,* as well as the light brush-work of Hogarth's paintings at the time, would have evoked that tradition. The basic gesture of the Hogarthian conversation picture is Mr. Wollaston's outstretched hand (fig. 78) which seeks to connect or unify the party of disparate people who have come together under his roof. This "family" gesture is also the bawd's in the first plate of the *Harlot,* where its blandishment conceals the breaking of "families": the Harlot has abandoned her family in the country and is ignored by her relatives in London. Her own gesture in the second plate indicates the breaking of another "family." The progress starts with a false conversation gesture of unification which proves insufficient to hold things together.

In fact, Hogarth draws on the memory of a particular Watteau composition: the two central figures in a 1727 engraving by Laurens Cars after Watteau's *La Diseuse d'aventure* (*The Fortune-Teller*).[3] Although the pose of the fortune-teller and her dupe can have been recognized by only the smallest fraction of Hogarth's audience, it is of no small significance that this representation of a fortune-teller rose to the surface of Hogarth's memory when he needed a figure of a bawd predicting a rosy future to a young countrywoman with city aspirations.

In particular, he builds upon his own *Beggar's Opera* conversation, where he took the small-scale portrait group into the theater and related its figures to actors engaged in a performance of a popular play. The *Beggar's Opera* elements consisted of a central figure, Macheath, choosing between his two "wives," Polly and Lucy; with his choice reflected in their choices between "husband" and father. These were recognizable portraits of the actors and the spectators seated on either side of them. Some of the audience (such as Lavinia Fenton's lover, the duke of Bolton) are intensely interested in the drama, while others (such as the woman turning to chat with a friend) are ignoring it. Hogarth's *Beggar's Opera,* we might say, was a parodic commentary on conventional conversation pictures, emphasizing the polite acting that informs any assembly or card party.

The *Harlot*'s young woman then is placed in a position of choice, like Macheath's, between the bawd on the one hand and the clergyman on the other. A scene is taking place in which the figures are actors in a little drama of temptation; and they are also actors in a second sense, for the bawd is playing a role in order to attract the girl

for her rakish employer, and the girl is playing another as she responds to her proposition. The Harlot performs as Lavinia Fenton did, uncertain of whether it is the role dictated by the playbook or by passion in everyday life (Polly fell in love with Macheath because he plied her with romances to read). The spectators are also present: the clergyman, like the woman in the audience of *The Beggar's Opera* who turns to talk to a neighbor, is ignoring the drama, while the other spectators are all too eager and interested.

The scene remains within the general intention of the conversation picture insofar as both are antiheroic responses to academic history painting (as Watteau's *fêtes* were) and to the Van Dyck tradition of portraiture. For while the conversation shifts the emphasis from the individual sitter to his place in a milieu, the mock history shifts from a hero who acts to the people around him who act upon him, depriving him of his freedom of action. When the Harlot has become, as in the last scene of the progress, a mere topic of conversation, a corpse (that is, a history has been *reduced* to a conversation picture), the audience has become the subject, and the result is a scene of pure response, as when, in *The Beggar's Opera*, we read the inscription over the stage, *Veluti in speculum,* and add ourselves to the audience.

UT PICTURA POESIS

Such contemporary critics as Joseph Mitchell, who had already called Hogarth the Shakespeare of painting, were writing from assumptions that he shared and fostered. They echoed the belief of Jonathan Richardson that a history painter "must possess all the good qualities requisite to an Historian," and beyond those he must have "the Talents requisite to a good Poet; the Rules for the Conduct of a Picture being much the same with those to be observ'd in writing a poem." Analyzing the Raphael Cartoons, Richardson asks the viewer to imagine words to go in the Disciples' mouths that would fit their actions.[4] With his constant references to the painter as a historian or a poet, and to the "story" he is telling, he offered a large sanction for the idea that the essential characteristic of history painting was storytelling.

Richardson echoed Shaftesbury ("that in a real history-painter, the same knowledge, the same study, and views, are required, as in a real

poet"), but both were simply restating critical assumptions on history painting that went back to the Renaissance. Alberti had argued that the painter must be learned in history, poetry, and mathematics, and that history painting is the highest mark at which the artist can aim, not only because it is the most difficult genre, requiring proficiency in all others, but also because it like an epic portrays human activities at their most heroic: "And I may well stand looking at a picture . . . with no less delight to my mind than if I was reading a good history; for both are painters, one painting with words and the other with the brush."[5]

As if it were an emblem, Hogarth introduces words into Plate 1, beginning with the title "A Harlot's Progress" just below the picture. This tells us that it is the *Progress* of a *Harlot,* not of a Pilgrim or of Wit or Poesie (though perhaps, by analogy, of Dulness); indeed, not of a whore or a prostitute but a *harlot.*[6] There is a slight mock-heroic quality here at the outset in the use of this biblical word. Inside the design, the words "York . . . gon" on the covered wagon at the left tell us that this was the conveyance that brought people all the way down from Scotland to London. It indicates how far the girl has come and supports the evidence of her rustic attire. On the trunk are the initials "MH." In the third plate the initials are fleshed into "Hackabout," and from the use of words to denote or supply information—from the newspaper accounts of Kate and Francis Hackabout—we move to their punning function. The *Dictionary of Cant* (1699) defines: "*Hacks* or Hackneys, hirelings. *Hackney-whores,* Common Prostitutes. *Hackney-Horses,* to be let to any body."

At the far right, attached to the goose's limp neck, is the inscription "For my lofing cosen in Tems Stret in London," which projects the story of the absent, delinquent relative; and opposite, at left, is the clergyman's paper, whose salutation indicates a place hunter and implicates the bishop of London, his master Walpole, and so on. In a very literary way, a plot is being generated and characters implied.

Hogarth also draws on the lexicons of physiognomy in which the young woman's expression denotes eager attention and the old rake's face denotes lust. But he confirms these in various ways, for example with the gesture of Charteris's right hand deep in his pocket, which signifies much more clearly than his facial expression that the sight of young Hackabout has stimulated him to masturbation. And he draws upon the adjunct physiognomic manuals that charted resemblances between human and animal faces. The peculiar feature of the young

woman's face is that it is in profile in this plate and in no other; our eye connects it with the shape that resembles it, the pointed profile of the goose hanging out of a basket. The same parallel appears in the second plate where the monkey's face, designating surprise or terror, resembles the face of the Harlot's keeper, who is responding to the tipping of the tea table (to divert his attention from the departure of her interloping young lover). The animal serves as an indication of the stereotypical human response.

But the parallel profiles of the girl and the goose also lead the spectator to *verbalize* "silly goose" (simpleton) or "green goose" or "Winchester Goose," contemporary slang for whore. The first is a middle-class term of sad affection ("foolish girl"), the second underworld argot, gross and precise. More generally, the relationship is verbalized as something like "her goose is cooked," referring to the consequences of her folly. In its location at the lower right corner, this small detail becomes an emblem informing the whole scene. It establishes the doubleness of our reaction to the Harlot—as both whore and poor silly goose—on which the series depends.

The cat frolicking at her feet in Plate 3 is on one level a demotic term for whore, as is evident in the cats Hogarth places atop the brothel in *The March to Finchley* (ill., vol. 2). As such, the cat may be sniffing at the hem of the Harlot's dress, as a "cat in heat." Recalling seventeenth-century Dutch emblem books, one could interpret the cat as an emblem of lust.[7] But it is more in the naturalistic, anti-emblematic spirit of the work to take *this* cat as we took the goose in Plate 1. For the cat is plainly kittenish, and the word *harlot* itself in the series comes to denote both Hackabout, or seller-of-her-own-body, and poor, playful, frisky, self-deluded girl. At no time is she associated with lust and being in heat, but rather with being exploited, the result of her "aping" the "great." There is no indication that she lusts after the young man leaving her room in Plate 2 (as the countess in *Marriage A-la-mode* is motivated by passion), only that having a young lover is another part of being a fine lady in London for this carefree young woman.

The doubleness is embodied in the knotted bed curtain as well: it forms a face that screams a warning at the Harlot or (given the way the knot is twisted around into the screaming mouth) serves as an emblem for her self-consuming folly.

In the second plate the monkey, inviting us to verbalize the common pun, is "aping" both the keeper's expression and (with his frilly

bonnet) the Harlot's dress. Applied to the keeper, he is also "making him the ape of" (the equivalent of our "making a monkey of") the young mistress and her lover. We verbalize the visual image in this way; as we also verbalize the visual pun of the sword and cane carried by the young lover who sneaks out behind the keeper, by an optical illusion seeming to be "stabbing [him] in the back"—a reading that is reinforced on the one hand by the parallel stabbing in the back that takes place in the Old Master painting of Uzzah and the Ark of the Covenant above the group on the wall, and on the other by the further optical pun of the wallpaper pattern behind the keeper's head, whose shifting figure and ground reveal antlers and verbalize as: he is making a cuckold of him.

But the mask, monkey, and mirror are all straight out of Cesare Ripa's *Iconologia,* where the description of Imitation includes "a woman holding a bundle of brushes in her right hand, a mask in her left, with an ape at her feet" (1709 ed., fig. 104). The ape is present, Ripa says, because of "its aptitude for imitating man with its gestures" (*ars simia naturae*), and the mask to suggest "the imitation, on and off the stage, of the appearance and bearing of various characters." Certainly "aping" and "masking," verbally and metaphorically, are present in the scene. On the level of narrative, the mask also implies that a masquerade was where the Harlot met her new lover; she has *worn* this mask. But the monkey is also a fashionable acquisition; acquisition itself, including acquisition of the black slave boy and the Harlot, is an aping of fashion.

Another emblem is the horse in Plate 1 eating the hay from under a pile of buckets, causing them to topple and fall. The parallel is with the clergyman and supports the written inscription on the paper he holds: the horse fills its stomach even though it causes the fall of the buckets, just as the clergyman seeks church advancement at the expense of the girl's "fall." In the process a pun on "fall" has been generated. The physical fall of the buckets connects through the posture of the clergyman with the metaphorical fall of the girl from the country, and we are forced to verbalize "fall" in its sexual sense, as in the "fall" of the frail china jar, of Shock, or of Belinda in Pope's *Rape of the Lock.*

Costume is another sign Hogarth relies upon for information and implication. The witches' or Quaker's hat hanging on the wall above her bed indicates that Hackabout has been to a masquerade and disguises herself. The Quaker's hat was the prototype of the "witch's

hat"; but whores were frequently represented dressed as Quakers to disguise their profession. Quakers were also, like other radical Protestant sects, accused of secret lechery. *The Quaker Opera* by Thomas Walker (1728) had both a lecherous Quaker and a whore named Nancy Hackabout.[8]

The signboard introduces yet another sign system to which Hogarth will return repeatedly: a popular one taken from the daily visual experience of all Londoners. The bell on the inn signboard hangs above the head of the poxed old bawd, ironically suggesting "belle," a recently imported Gallicism for "pretty young lady."[9] In a *Spectator* paper (No. 28) devoted to the iconography of London shop signs, Addison takes the example of Mr. Bell, who used the sign of a bell for his alehouse—but which, he adds, "has given Occasion to several Pieces of Wit" on the pun of bell-belle. He explains the sign of the "Bell-Savage," which showed an Indian standing beside a bell, as a corruption of the sign showing the beautiful woman found in the wilderness known as *la belle sauvage*. Bawds, Addison says elsewhere in this essay, ought not violate decorum by operating at the sign of the "Angel." All of this serves as context for the verbal activity of the bell, at the sign of which this bawd is practicing her trade.

But the bell is only superficially a punning emblem, referring to the bawd's bad looks. In fact it is her sign in a profounder sense, introducing into the *Harlot* a symbolic system of meaning—in this plate surrounded by the similar shape of the falling buckets, and in the next by the broken teacups. The verbal dimension is not, of course, absent, for the broken china recalls the "frail china jar" that stands for Belinda's loss of innocence in *The Rape of the Lock,* carrying memories of cracked crystal, the notorious china scene in *The Country Wife* where it is equated with the sexual act, and John Crowne's lines "Women like Cheney [china] shou'd be kept with care, / One flaw debases her to common ware." Fielding's contemporary song in *The Grub-street Opera* (Air XIX) opined:

> A woman's ware like china,
> Once flawed is good for nought;
> When whole, though worth a guinea,
> When broke's not worth a groat.

Out of the signboard principle of the punning visual equivalent (the name Archer represented by arrows) Hogarth projects a powerful,

yet almost subliminal, image which dominates (in, of course, a peripheral way) the whole series: the bell and clapper. The sequence, carried on in the teacups, ends bluntly in the Harlot's escutcheon on the wall in Plate 6 above her coffin, showing three faucets in which three spigots are inserted, *all proper.* This, like the bawd's bell, is the Harlot's "shop sign," designating her personal and professional emblem, the equivalent of a street number that identified one's house.

What the examples of these shop signs and escutcheons indicate is, first, the whore's need for respectability (seen also in the context of the fashionable dress she continues to wear in 3 and 4) and, second, the parodic relationship between popular signs and the heraldic arms of the nobility. The latter is an important part of Hogarth's play with the parallel-contrast between whores and gentle ladies, pimps and gentlemen (Mother Needham's elegant clothes and her ravaged face), and low and high art, which would eventuate, thirty years later, in Hogarth's Signboard Exhibition.

The art treatises, stressing the parallels of the "Sister Arts," ask that a painting, which deals in space rather than time, rival a poem in its temporal dimension. They show artists ways to represent a complete action in a single picture. In Le Brun's *Conférences,* while he places primary importance on *l'expression des passions,* he also argues that Poussin's *Fall of the Manna* demonstrates the movement through time in a single spatial image by showing the manna falling on the left side, while it begins to be noticed by the Israelites in the middle, and on the right they are picking it up off the ground and eating it.[10] Thus three stages of time are delineated in a single canvas—in a modernized, rationalized, or naturalized version of the medieval and early Renaissance device of simply showing three Christs in the same picture, one at the Last Supper, one at Gethsemane, and one on the cross.

In Hogarth's Plate 1, the composition is divided laterally into three areas that can be interpreted as past, present, and future: the York Wagon and the clergyman on the left imply the past, the trip to London from the north of England, as well as all the rural virtues and the authority of moral exempla. In the center is the Harlot, turning her back on the past and being tempted by the bawd, and on the right is the implied future consequence in the figures of Charteris and his pimp, substantiated in the second plate. In Plate 3, the print of Abra-

ham sacrificing Isaac on the left is followed by the Harlot with the stolen watch, and the magistrate who will take her to the prison shown in the fourth plate. She is *about* to be aware of the magistrate, as in *The Cholmondeley Family* (fig. 93) the imperturbable father on the left side is about to notice the violence of his sons on the right.

If, however, we see the transition from Plate 2 to 3 as a powerful example of action-consequence—the keeper has caught up with the Harlot's double-dealing and has cast her out—this pattern is complicated by the comparison in the same plates between the keeper's tea ceremony, his art collection, and in general his affectation (the monkey's "aping") and the Harlot's own poor equivalents in her shabby room—her tea service, dress, penny prints, even a parody servant. There is, therefore, as well as the diachronic movement a synchronic one, based not on action-consequence but on comparison-contrast. Besides the horizontal relationships of left to right there is an equally pressing vertical relationship of upper to lower.

This reading is urged by the parallel shapes of the rectangular picture space and the Old Master paintings on the walls; of the tea table below and the toppling Ark of the Covenant in the painting above, both falling (once again the motif of "falling" adumbrated in Plate 1), both at the same angle; and these shapes activate the allusion to the story of the Ark in 2 Samuel, which causes the viewer to draw imaginary lines to the parallel figures in the scene below. The Harlot's keeper is in the position of Uzzah, the young lover in the position of the bishop who stabs Uzzah in the back, and the Harlot in the position of the too frisky oxen who kick over the Ark as she kicks over the tea table (anticipating the kitten in 2). Like the oxen, the carefree Harlot kicks over her traces from exuberance, not evil intent—as opposed to the malice of the bishop who stabs Uzzah and of her vengeful keeper who will drive her out. The bishop is doubly significant, for he is Hogarth's one alteration of the biblical source. Uzzah was struck down by a wrathful Jehovah, while Hogarth substitutes a human agent, a clergyman.

The keeper's face is based on the physiognomic stereotype of the Jew, but without a beard. He has already shaved his beard and begun collecting Old Master paintings, the sure sign of a rise in social status; he wears a fashionable wig, holds his teacup elegantly, and owns a black houseboy, a monkey, and a Christian girl, the last his version of reaching to touch the Ark of the Covenant.[11]

We can almost imagine Hogarth's mind arriving at the scene: Dukat in *Polly* led to Shakespeare's Shylock crying "My daughter, my dukats," and so to the Jewish keeper of Hackabout.[12] But the reason for Hogarth's making the keeper Jewish is related to the emblem of ape/Imitation: the Jew was the most obvious example of the socially aspiring outsider, a vastly more successful equivalent of the Harlot. To raise his status he collects Old Masters, but because he conforms to the Jewish stereotype, they are Old Testament scenes of violence and harsh eye-for-an-eye judgment. They reveal his character and they predict the treatment he will accord the Harlot (in the future, between now and Plate 3) once he finds she has betrayed him. In the manner of the conversation pictures he was painting, Hogarth defines the Jew by his collection and implies that the Christian mistress is another possession like his paintings, intended to raise his status. (As Dukat said, Polly is "as legally my property as any woman is her husband's, who sells herself in marriage" [I.xi].) For Hogarth the Jew is an ambiguous figure. He is the one minority figure who is not normative, presumably because of his financial if not social assimilation to the ruling class. But he is also the hoodwinked lover—the wounded outsider, like the unfortunate Uzzah—and perhaps recalls poor Mendes de Sola in *A Committee of the House of Commons*.[13]

The other Old Master painting shows Jonah sitting next to a withered gourd with God's sun beating down on his head. God was punishing Jonah for wanting the people of Nineveh to be destroyed even after they had repented their sins—insisting that vengeance be carried out. As Hogarth's Jonah sits outside the city walls hoping to see the Ninevites destroyed, he clenches his fists in anger and looks in the direction of the stabbing of Uzzah in the other painting.[14] Whether Jonah is analogous to the Jew's desire for vengeance against his cuckolder or to divine justice against his own apostasy (taking a Christian woman), the contrast is between justice and mercy. Like Jonah, he will not forgive the Harlot when he discovers her transgression.

If, however (following the early Hogarth commentators from Lichtenberg on), the paintings are read from left to right, they apply equally well to the Harlot (as does the emblem of the monkey, dressed like her). She is under the protection of the Jew as Jonah was under the shade of the gourd, which withered in the morning leaving him unprotected under a fierce retributory sun. The painting of Uzzah also applies to the Harlot, for like her Jewish keeper she too is

reaching out to touch the forbidden. Both are climbing socially, and both suffer particularly human punishments. In her case the materialization of God's wrath in the form of a human bishop connects with Justice Gonson in the next plate, in which the distinction between human justice and divine mercy is further underlined.

The contrast between Plates 2 and 3 sums up the theme: the same serving of tea, the same elegant dress, the same situation, transferred from a setting of comfort to one of squalor. The point is the Harlot's emulation and the inappropriateness of her dress, the incongruity of being served in bed by her parody of a servant, in these grim surroundings, with her penny portraits and Old Testament engraving hanging on her wall in a sad parody of the Jew's art collection.

Perhaps for Hogarth the most important historical phenomenon of his time was the rise of art collecting and connoisseurship. It was inevitable that some painter should note the irony that the sitters in a conversation picture are often subordinated to the very milieu that is supposed to define them and their prosperity and status. These objects remain generic shapes in most of Hogarth's conversation pictures, but in the *Harlot* he begins to explore the possibilities of using surroundings to define the figure in a precisely meaningful way, while at the same time implicitly commenting on the folly of the collecting habit itself—which seeks old paintings, often copies or misattributions, rather than turning to the paintings of contemporary English artists.

But beyond his aesthetic message, Hogarth reveals their implications primarily as status symbols that are models for emulation. He is satirizing Jonathan Richardson's influential advice to gentlemen in his *Essay on the Theory of Painting* to keep portraits of the great, so that they "are excited to imitate the good actions, and persuaded to shun the vices of those whose examples are thus set before them." In fact they are objects that condition and shape, dominate and form the collector—inanimate objects that perversely control human lives. And so history paintings within the scenes incriminate the characters who collect them, who therefore behave like the people in the pictures. There is, therefore, a direct correspondence between the compositions in the pictures-within-the-picture and the picture itself.[15]

What then of the grotesque elements that were apparent in the frontispiece to the *Hudibras* plates? There are in fact no grotesque or allegorical figures in the *Harlot:* they have been toned down (the

bunter, whose chief peculiarity is her lack of a nose, suffers from natural causes) or, more importantly, displaced to actions or to the behavior of animals—horse, monkey, goose, kitten—or to inanimate objects like the knot in a bed curtain.

The heroic level, vestige of Augustan mock heroic satire, tends to represent the ideals that men seek to emulate, attempting to rise above their natural inclinations; the grotesque tends to remain in the irrational and subconscious: roughly speaking the character's id as opposed to the superego expressed in those pictures hung on the walls or the other trappings of gentility. If the pictures indicate the level of pretension, the dogs and cats, the grotesque shapes of punishment, sickness, and madness, the gesticulating doctors and the faces detectable in natural objects indicate the level of nature or natural consequences. In between is the character herself, capable of choice but constantly drawn into heroic or grotesque attitudes or patterns of behavior that are inappropriate on the one hand or violent and uncontrollable on the other.

We can outline the synchronic structure of reading in the *Harlot* as follows: the upper part with its pictures represents "art" in its various forms, while the animals in the lower part represent instinctual nature. This vertical relationship is one of consequence like the horizontal: the function of "art" (again, as in the conversation pictures) is to influence and control these people. Influence or imitation is the mode, down from the art and up from the instinctual forces.

CLASSICAL HISTORY PAINTING

A spectator familiar with the art treatises would have recognized, looking at the first plate, that the central group of the Harlot-clergyman-bawd invokes the familiar group of Hercules between Virtue and Pleasure. Shaftesbury's *Notion of the Historical Draught or Tablature of the Judgment of Hercules* (1713) had rejected the old emblematic and "hieroglyphic"iconography of history painting and called for a more commonsense approach.[16] Arguing that arbitrary and outdated images should be replaced by more probable ones, Shaftesbury presented the fullest treatment to that time of the "fruitful moment," the exact moment that will best convey the mean-

ing appropriate to a history painting. This moment, he concluded, should be one of choice, the primary subject of the history painter, and the particular choice he singled out was the Choice of Hercules, Heroic Virtue at the crossroads meeting two lovely women, Virtue and Pleasure. Hercules was a central ideal of the discourse of civic humanism to which Shaftesbury laid claim for English politics as well as art.[17] According to Shaftesbury's scenario, Hercules should be "plac'd in the middle" so that we cannot doubt that "his Agony, or inward Conflict . . . makes the principle Action," and he commissioned a painting of the correct scene by Paulo de Matteis, which was engraved to illustrate his treatise (1714, fig. 102).

Pleasure addresses Hercules: "Do you see, Hercules, by how difficult and tedious a road this woman conducts you to gratification, while I shall lead you by an easy and short path to perfect happiness?" "Wretched being," rejoins Virtue, "of what good are you in possession? Or what real pleasure do you experience, when you are unwilling to do anything for the attainment of it."[18] Taking the Choice of Hercules as the ideal historical subject, Shaftesbury wrote that "The Education" is perhaps as proper a title as "the Choice of Hercules," a hero's education through the dialogue of Vice and Pleasure. He urged that this image hang in a gallery or hall "where our young Princes should learn their usual lessons"—that is, a prince "who should one day come to undergo this trial himself" (19). Characteristically, Shaftesbury believed that the precise moment the artist should portray is either when the women first accost Hercules, at the midpoint of their dispute, or—best—when Virtue is beginning to win (33–34).

Hogarth sets out to fulfill the project Shaftesbury proposed but shows the way it would be in reality, as history painting, in London in the year 1731. The setting according to Shaftesbury should be "in the Country, and in a place of Retirement, near some Wood or Forest" to suggest "Solitude, Thoughtfulness, and premeditated Retreat." But Hogarth places *his* scene in busy London: *his* Hercules has come from the country to the city. He replaces the heroic male Hercules with a female, helpless herself and without assistance from friends or relatives. Far from choosing Virtue, she has little or no choice, and is shown succumbing.

A lazy, inattentive young lady, using only her eyes (languid, her body expressing "Ease and Indolence"), says Shaftesbury, should be used to represent Vice; a vigorously arguing, rational young lady, re-

sembling Pallas Athena, should represent Virtue. Hogarth arranges his central group so that the young woman has on one side of her the inattentive clergyman, his back turned, and on the other the bawd vigorously and successfully arguing her case.[19] In Choice of Hercules pictures, the arm of Virtue is always raised in a gesture toward the distant road up the hill to the Temple of Wisdom. Hogarth's clergyman lifts his arm but only to read a paper containing the address of the bishop of London.

In older emblems of the Choice of Hercules—of the sort Shaftesbury was trying to improve upon—Virtue is indeed represented by an old man and Vice by an old, false-seeming hag (fig. 103). Hogarth has blended the two versions, but essentially turned the tables on the male-female relationships of the original story.

Shaftesbury adds that it *is* permissible in terms of probability to use a bridle to symbolize forebearance, and so Hogarth puts his clergyman on a horse with his hand loose on the bridle, allowing the horse to effect the collapse of a pile of symbolic buckets, analogous to the effect his master is having on the Harlot.

The Choice of Hercules was a paradigm that derived from both the art treatises and the reading of the ordinary educated Englishman who would have been brought up on Prodicus's "Choice of Hercules" in Xenophon's *Memorabilia,* a text deeply rooted in the curriculum of the English schools. Addison's paraphrase in *Tatler* No. 97 was only one of many redactions of the story. Hogarth makes clear that he accepts Shaftesbury's claim that there is a need for a new, more probable iconography; and that choice between virtue and pleasure is the proper subject of history painting. But he also shows how minimal is freedom of action in the 1730s, with Virtue's back turned, the "lofing cosen in Tems Stret" missing, and Vice-Pleasure supported by the satyrish figures of her employers. The classical topos certainly does not fit Hackabout's situation, but its very unfittingness helps to define what her situation is.

But there are a number of other reasons for Hogarth's use of the Hercules topos. As a political symbol, Hercules as Heroic Virtue (formerly associated in France with Henry IV) had been associated in England—in paintings by, among other artists, Thornhill—with William III. Hercules of the Labors had appeared everywhere from the pediment of the East Facade of Hampton Court Palace to the royal carriage and the royal plate. When Shaftesbury, the grandson of

the great earl who founded the Whig party as an amalgam of City and Dissenter interests, chose the Choice of Hercules as the center of history painting, he must also have exploited this association. Thus a Hercules in the 1730s was a sad comedown—as a prime minister, a "Great Man," a woman, and so on (and perhaps especially to the late king's namesake).

But in a larger sense choice was the subject of the literature on which Hogarth was brought up: from *Paradise Lost* to Bunyan's *Grace Abounding* and *Pilgrim's Progress*.[20] Knowing and choosing were the two central actions on the minds of educated Englishmen in the age following the works of Bunyan, Milton, and Locke. Choice was the great English Protestant subject, focusing the two related aspects of temptation and conversion in the solitary individual. But if we may believe Hogarth's autobiographical notes of many years later, one of his own basic problems was not how to choose between but how to *combine* his "pleasures" and his "studies." The actor Spiller, caught between a tavern and a prison, is an extreme version of the pleasure-virtue dilemma (fig. 12), but the problem he diagramed in *The Lottery* is another (fig. 19). He also depicted Henry VIII standing between Anne Boleyn and Queen Catherine (fig. 54). The ambiguity of the choice was the point of the *Beggar's Opera* painting, where Macheath is in the position of Hercules choosing between Polly and Lucy, but unless one sympathizes with Lavinia Fenton as heroine of the play it is difficult to see any choice between virtue and pleasure. In the *Harlot's Progress* Hogarth has further subverted the heroic paradigm by making Virtue into a place-hunting clergyman and Vice into a bawd vigorously arguing the young woman into a life of pleasure.

But the crucial fact is that Hercules has been changed to a young woman, not Macheath but Polly. He is reduced to helpless femininity, as opposed to active male power and strength.[21] The Harlot is a travesty, but also a softened, sentimentalized (precisely in the sense of feminized) version of Hercules. Equally important, Hogarth has displaced (and degraded) the Herculean attributes (and he means specifically in the 1730s, the Great Man attributes, already associated with Walpole in his engraving of the Walpole Salver) to the supporting characters, to the men who destroy the young woman. The woman, stigmatized by her unrespectable profession, is destroyed by their male respectability as clergymen, magistrates, prison warders, and physicians.

NEW TESTAMENT HISTORY PAINTING

For this non-Hercules, the softened and feminized hero, the Harlot, Hogarth turns to a complementary figure—not classical and heroic, which now carries a negative charge, but Christian (positive like the associations around Polly, who, most significantly, *loves* Macheath), based on the New Testament Protestant art that was more acceptable to an English audience.

If one gestalt of clergyman-Harlot-bawd echoes a Choice of Hercules, another consisting of Harlot and bawd with Charteris standing in the doorway recalls Renaissance paintings and prints of the Visitation (Luke 1: 34–35): Mary being met by Elizabeth, with Zacharias in the doorway. (See fig. 105; Dürer's *Life of the Virgin* series, for example, would have been available to both Hogarth and his subscribers in printshops. Hogarth, never bothering to engrave in a mirror, always reverses the image he copies.) In the third plate, the Harlot appears in the position of the Virgin Mary in an Annunciation (see fig. 106), with the Word of God in front of her (Bishop Gibson's *Pastoral Letter*), seated on her tester bed, with the Angel of the Lord entering in the form of Justice Gonson and his bailiffs. And in the final plate, she has become the inanimate object around which a Last Supper arranges itself (precisely thirteen figures around the tablelike coffin).

If there was any doubt that Hogarth intended the parallels, he removed it in a later print, *The Battle of the Pictures* of 1745, the admission ticket he issued for the sale of the oil paintings for his engraved series (ill., vol. 2). Here he shows a penitent Magdalen, that other Mary, attacking the Harlot in her Annunciation scene.[22]

This allusion does several things, but for the moment I want to emphasize the way it complements the classically heroic Hercules with the New Testament biblical story. It serves to soften and feminize the heroic ideal that was expected in history painting of the sort that Hogarth was trying to remake for a modern English audience: a program he had made explicit in his *Hudibras*. Behind Hogarth's woman is Milton's undermining of the classical Choice of Hercules (indeed, the whole idea of classical heroism) with a woman and a rationally arguing and winning Vice, the serpent (like the bawd, successfully seducing). The hero who, in a positive sense, prefigures the Harlot is Milton's Eve.

While Macheath was represented in the topos of the Choice of Hercules, his "wives" on either side of him, Polly and Lucy, were shown to pivot between two *men*. Polly and Lucy were not choosing but attempting to mediate between Macheath and their respective fathers, Peachum the fence and Lockit the jailer. Choosing is a male action, quite clearly, while mediating is conventionally female. Hogarth's value system is shifting from the one to the other in the *Harlot's Progress* where he shows the male action of choice imposed (as an inappropriate role) on a young woman. It is the Harlot's tragedy that she gets her roles confused and behaves as if she were a Hercules instead of a Polly, choosing rather than mediating. But it is a comment on society that she is forced into such a role in the first place—both in the travesty sense that the men can no longer play anything but villains and in the aesthetic sense that she *is* a woman. This makes her a harlot and then, when she exerts her freedom of choice again in her keeper's house and takes a lover, she is cast out, and her descent thereafter is as short and certain as Eve's.

The point here is that the first plate of the *Harlot* introduces both classical-mythological and New Testament paradigms against the contemporary figures of Needham, Hackabout, and Charteris, indeed as shifting gestalts in just the way Hogarth had employed the Choice of Hercules and the daughters' mediation between their lovers and fathers in *The Beggar's Opera*. The primary effect of the juxtaposition is to make clear that the *Harlot* is not a series of Dutch genre scenes but something more. The sort of argument Godby makes for an emblematic lodgment in Plate 3 would push the scene toward Dutch genre, which often embeds such emblems in domestic scenes. But Hogarth's aim is the reverse. At the outset in Plate 1 he demonstrates that he is revising the two kinds of history painting, classical-mythological and New Testament (with the corrupting influence of Old Testament subjects consigned to pictures on the walls of the rooms).

THE SUBSCRIPTION TICKET

By the beginning of 1731 all six paintings must have been far enough along to be shown in Hogarth's studio. By early March 1730/31 the

subscription ticket was etched and in circulation: *Boys Peeping at Nature* (fig. 107) was an announcement, a come-on, an elaborate joke, and a statement of theory. The purchaser put half a guinea down, received the subscription ticket, and when the engravings were ready presented the ticket and the other half-guinea in order to receive the finished prints.

The style and iconography are very different from the matter-of-fact reproductive engraving of the *Harlot's Progress* itself and its contemporary subject. The print is lightly etched, in the French manner, with the classical iconography of putti and the figure of Nature, the *Diana multimammia* of the Ephesians, a female figure like the Harlot herself. At the center Hogarth places this image of natural fecundity adapted from Rubens's *Nature Adorned by the Graces,* probably as a compliment to his father-in-law, who owned the original painting;[23] but Rubens's three Graces, engaged in veiling the goddess, are reduced to a faun (a small satyr) who is *un*veiling her and a putto trying to restrain him. The image of the many-breasted Nature is also an allusion to Gerard de Lairesse's frontispiece to his *Art of Painting,* which showed her being copied by an allegorical figure of Painting. Thus Nature herself is being imitated, and no longer a literary text like the one that was being copied in the frontispiece to the *Hudibras* plates.

One putto is shown painting her: his version is cut off below her bust and has censored some of her numerous breasts. (Lairesse, in his "Emblematic Table of the Art of Painting," had specified that Nature have five breasts; de Piles specified four; whereas Hogarth's Nature has seven or eight, and the putto's has only three.) A second putto has turned his back on Nature and is drawing (or writing) ideal forms from his imagination. A young satyr is lifting Nature's skirt/veil to see and show her hidden, sexual parts. The satyr, embodying both satire (by way of the Greek *satyra*) and animal sexuality, takes up the dog's and child's function in the conversation pictures, as well as the dog's association with Hogarth the artist. His peeping at Nature carries us back to Hogarth's youthful procedure, as he strolled the streets, of seeing and recording new and immediate images, which—as he now realizes—incidentally involves unveiling and showing as well. But here the "natural" aspect is complemented by a more respectable putto who restrains him, creating a *concordia discors* that echoes Pope's advice: "Nor over-dress, nor leave her wholly bare."[24]

This new aspect of the artist—an early sign of such bifurcations in Hogarth's self-representations—tries to maintain decorum by preventing the faun from lifting and peering under Nature's skirt. As an imitator of nature then, an artist can expurgate Nature, ignore her altogether, present her unadorned, or create a tension of dress/undress.

This is a wry adaptation of the old iconographical tradition of lifting the veil from Nature to see her true beauties long concealed by convention (which later in the century became a revolutionary symbol).[25] He is, of course, alluding particularly to the subject of the series, a prostitute—and more generally to the seamy side of life.

The scuffling faun and putto are conventional symbols of sensual and spiritual love respectively: the former is to be the subject of the series.[26] The female Nature is a sculpture (and draped at that), the sort of model a student in an academy had to copy before he was allowed to work from life. A subreference may be to the running controversy in the drawing academies over the use of the nude female model; life classes "were . . . suspected of being held for immoral purposes."[27]

Significantly, it is still a convention of history painting that lifts the skirt. None of the grotesque figures introduced in the *Hudibras* frontispiece, Dutch low-life figures contrasted with the baroque forms of their composition, appear here; only the low gesture remains. Whereas in the *Hudibras* frontispiece a putto was copying a grotesque scene from a satiric text held by a satyr, here the contrast between history and the grotesque is minimized. And so the *concordia discors* of the putto-fawn demonstrates the necessity of including both the living, portrait-true, contemporary whore *and* the classical Hercules (and the biblical equivalent).

Lifting the skirt is an allusion to (1) the female personification of naked Truth (*nuda veritas*) and, at the same time, (2) the veil of allegory by which the poet traditionally protected the Truth he was conveying. Not just Nature, in other words, but Truth is at stake in the iconography. Not just Truth but (by way of the *concordia discors* of the fawn and putto) the unmentionable truth. The Elizabethan George Puttenham wrote that pastoral contrives "under the veil of homely persons, and in rude speeches to insinuate and glance at large matters, and," he adds, "such as perchance had not been safe to have been disclosed in any other sort."[28]

As his subscription ticket shows, Hogarth associates his plates

with the double meaning—a "plain literal Sense" and a "hidden Meaning"—of epic allegory. Addison is once again our authority because he emphasizes the "ordinary Reader" and indicates the breadth of Hogarth's projected audience: "The Story should be such as an ordinary Reader may acquiesce in, whatever Natural, Moral or Political Truth may be discovered in it by Men of greater Penetration" (*Spectator* No. 315). There will be a plain story of a prostitute, her crime and punishment, and then, for the "men of greater penetration," something closer to the naked Truth.[29]

The latter, as our reading of *A Harlot's Progress* has shown, refers to the Truth that is reached only by a winding path or through a labyrinth: "You must read, you must persevere, you must sit up nights, you must inquire, and exert the utmost power of your mind," as Boccaccio put it; and, closer to Hogarth's own time, the earl of Roscommon: "For if your Author be *profoundly* good, / 'Twill cost you *dear* before he's understood."[30] The literary concept of *difficultas* was adopted with much else by the Renaissance theoreticians of history painting, and, at the end of the seventeenth century, was summed up by John Dryden in his "Parallel of Poetry and Painting" (1690):

> The eye cannot comprehend at once the whole object, nor the mind follow it so fast; 'tis considered at leisure, and seen by intervals; Such are the subjects of noble pictures; and such are only to be undertaken by noble hands.[31]

In Hogarth's (and the *Spectator's*) terms, these viewers were the "men of greater penetration," as opposed to the "ordinary reader."

Difficultas includes also the playful readers Hogarth will sum up in *The Analysis of Beauty* (1753) as engaged in "the pleasure of pursuit": for example, the reader who remembered the passage at the very beginning of Locke's *Essay concerning Human Understanding*, in the dedicatory letter to the earl of Pembroke: "But there being nothing more to be desired for Truth, than a fair unprejudiced hearing, no body is more likely to procure me that, than your Lordship, who are allowed to have got *so intimate an Acquaintance with her, in her more retired recesses*" (emphasis added). "Recesses" referred in both poetic and midwifery contexts to the womb.[32]

In this model imagination is required on the part of the spectator to

infer the "recesses" of Nature (the Harlot's story) which are con-
cealed under the veil. But the most playful aspect of the imagination
projected in Hogarth's image is that in fact—as anyone knew who
was familiar with images of Diana of the Ephesians—it is not a full
body but a herm, only a column tapering downward from the head
and breasts, and there is nothing to see beneath the skirt but smooth
stone.

In representing his spectrum of imitation, Hogarth may have had
in mind Jonathan Richardson's words on painting as poetry (not mere
history) in his *Science of a Connoisseur* (emphasis added): that, "pro-
vided natural truth is *at the bottom, nature* must be *heightened and
improved,* and the imagination filled with *finer images* than the eye
commonly sees, or in some cases *ever can.*" Whereas history "is a
plain and just relation of facts . . . an exact picture of *human nature,*
. . . the business of painting is to *raise and improve nature.*" Such
painters "have peopled [their works] with *angels, flying boys,* nymphs
and *satyrs.*" Richardson also remarks that painters should "go to the
fountain head from whence the greatest men have drawn that which
has made their works the wonder of succeeding ages; they would
thus learn to go to *nature,* and to *the reason of things.*"[33]

The sculpture of Diana and the figures surrounding her are icono-
graphic conventions, and they are supported by learned epigraphs
from Virgil and Horace. From the Virgilian motto behind the putti—
Apollo's words to Aeneas, "Antiquam exquirite Matrem" (Seek out
your ancient mother—meaning, Go back to your homeland, your
sources, and refound the empire of Troy)[34]—we infer that this un-
adorned Nature is going to be the artist's model, and (from Hogarth's
pun) that the contemporary painter of history should seek inspiration
beneath conventional appearances, in the most earthy reality, in the
very womb of art.

The quotation beneath the design, from Horace's *Ars poetica*—the
crux of *ut pictura poesis* doctrine—is Hogarth's way of saying: here is
the text you will use to judge my work, with Horace's generic dis-
tinctions and ridicule of the mixed mode. But notice that Horace also
says: "necesse est / Indiciis monstrare recentibus abdita rerum, / . . .
dabiturque Licentia Sumpta pudenter" (It is necessary to present a
difficult subject in new terms . . . and license will be allowed if it is
used with care, ll. 48–49, 51).

Hogarth is manipulating these familiar Latin tags with the delight

of a schoolboy showing off, in this case, for his late father. Horace means by "abdita rerum" a difficult, abstruse subject, but read literally and placed in the context of the visual image, the putti, the words could be construed differently: it is necessary to show the hiding place (*abdo:* hide, conceal) of things by new disclosures or uncoverings (*indico:* disclose, reveal, display). *Licentia* and *pudenter* also take on a sexual meaning: the licentious will be allowed if it is undertaken with modesty; or precisely the message of the faun's *concordia discors* with the putto. In this context the most sexual of the meanings of "Antiquam exquirite Matrem" also demands attention, and indeed the putto's attempt to get under the shift is fulfilled in the last plate of the series by the clergyman, who does undertake licentiousness *pudenter* (the kitten in Plate 3 also seems to be peering under the Harlot's dress). One can imagine the fun Hogarth's contemporaries had with this ticket, as they did with the series itself. Another interpretation of "Antiquam exquirite Matrem," for example, might be: "[If you want to get under female skirts,] seek out your old Mother [Needham]"— "Mother" as the contemporary colloquial term for bawd.

The conjunction of the motto from Virgil above and the "dabiturque Licentia Sumpta pudenter" below suggests that the modest putto is here to hinder (but not preclude) the revelation of this subject; his restraining actions temper the thoroughly immodest approach of the faun. Taken together, the two epigraphs suggest that Hogarth is attempting in the *Harlot's Progress* something new and at the same time old, that is, traditional: sanctioned by ancient authority and derived from original, now forgotten (or ignored) sources—the "old mother." His particular method in the ticket is to contrast the putti with the faun, their various actions with his, and implicitly (and by style) the high art of the baroque, which employed these conventional putti, and the texts of Virgil and Horace, with the realistic subject matter and the bawdy innuendoes. The iconography of *Boys Peeping at Nature,* like the reversal of the Choice of Hercules in the first plate, demonstrates that Hogarth knows the tradition of history painting and is quite consciously altering it.

The noticeable omission in Plate 2 was of the other attribute of *Imitatio* (along with the mask, mirror, and ape), the artist's paint brushes. In life as in art imitation is good if of virtue; bad if of the upper classes, or in art if too literal like the Dutch and German artists of Addison's *Spectator* No. 83. For Hogarth, however, the paintings

within the scenes are also summed up by the mask and the ape; the brushes—symbol of the artist's proper imitation—he reserves for his subscription ticket, where they appear metaphorically in the putto's hand and literally on Hogarth's personal seal, impressed in wax, which shows a palette and brushes. He has displaced the theme of the artist's imitation from the social scene of the *Harlot's Progress*—the imitation of fashion, of the typical Londoner, the poor isolated woman—to the subscription ticket, which is about *artistic* imitation.[35] He consciously excludes himself from the Harlot's aping and the action of the scene, distinguishing this artist from those others. He has consistently associated himself in his paintings with the irreverent dog who never feigns. On the other hand, in Plate 2 it is the monkey—and not the dog—who makes the comment of nature. The monkey is an animal that can indicate both art *and* animal nature, joining the upper and lower parts of the room.

Thus the ticket alerts the buyer that (appearances to the contrary) this series is going to be in a classical style; that it is about a low subject, grounded in sexual desire; and that it is about imitation.

One can imagine a "reader of greater penetration," one of those who lifts Nature's skirt, pointing out to a companion the allusion to the Visitation in Plate 1. The story in Luke tells of Mary's going to see Elizabeth because the angel has told her, who cannot imagine that she can be pregnant never having known a man, that old and barren Elizabeth has also conceived: "For with God nothing shall be impossible." And, of course, Mother Needham's Christian name was Elizabeth.[36] The sight of Elizabeth is proof to Mary that the impossible can happen, that "he that is mighty" can do many "great things." And that refers at the moment to Colonel Charteris, the "great man" who has twice been pardoned on rape convictions. The biblical commentators saw the Visitation as embodying the lesson that "nothing is impossible with God," and the purpose of the meeting was "to strengthen [Mary's] own Faith, as to the Revelation which she has received" from the angel—that is, what brought the Harlot to London. If we infer nothing else from the allusion to the Visitation, the fact that Mary is going on a kind of pilgrimage to learn something from Elizabeth provides the suspicion that this young woman is not

just arriving in London but is here for a purpose, in some sense *seeking out* her ancient mother, Needham—a suspicion supported by the analogy with the goose as well as by the eager expression of her face (and that other source for the two figures, Watteau's *Fortune-Teller*).

The strangest aspect of the *Harlot*'s reading structure is the biblical parody—not so much that of the Old Testament, which was not highly regarded in England, but of the New Testament, the Annunciation, Visitation, and Last Supper. One possibility is that Hogarth may be using the Hackabout–Mary parallel much as Pope played off Christ against Lewis Theobald, an "anti-Christ of wit," and set up the activity of the goddess Dulness and her forces, through allusions to the Trinity and the *Pietà,* as an infernal parody of God and his creation. Thus Hackabout is a Hercules of our time, and a Virgin Mary of our time: she represents both the inappropriate model and the decline of standards.[37]

Pope's literary model was the parody Trinity of Satan–Sin–Death in *Paradise Lost,* followed by the parallel parody of Shadwell–Ascanius–Christ, with the same classical-religious parallels, versus Flecknoe–Aeneas–John the Baptist in Dryden's *Mac Flecknoe.* The allusion in the opening of *Dunciad* 2 is to the opening of *Paradise Lost* 2, relating Satan to Theobald–Cibber. On the other hand, the Popean parody of a *Pietà* in *Dunciad* 3 is *not* a scene that alludes to *Paradise Lost.* To Pope it would have signified Continental religious art, probably Roman Catholicism itself, carrying a positive charge. He puts into his poetry a good deal of God, Christ, and Mary, which Hogarth—as well as Swift, and of course Addison and Steele—takes pains to leave out. For the Roman Catholic Pope, the biblical as well as classical worlds lived in a positive way they did not for Hogarth. Pope read the *Iliad* and *Aeneid* typologically in relation to the New Testament, as the Fathers read Ovid or Virgil. But the classical world was more specifically the renewal of classical Rome in Renaissance (Counter-Reformation) Rome, where it meant both Continental ideals of art and Roman Catholicism.[38]

To Hogarth the Annunciation (or for example a *Pietà* in *Rake* 8) is more likely a parodic reference to Counter-Reformation baroque art, its mysteries and mystique, its iconography, and its mythologizing, into which the Harlot has sentimentally absorbed herself. If Moll–Mary Hackabout represents a decline of standards, she is also in the context of *The Beggar's Opera,* like Lavinia–Polly, an actress—a Mary

and yet not a Mary (or a Virgin or a Magdalen). "Mary" is merely a role that does not fit the actress. On the model of Hogarth's *Hudibras* illustrations, where he represented the little hunchback in compositions of heroic baroque processionals and battle scenes to show his Quixotic perception of the external world, we can see the Mary allusions as the Harlot's self-image—based on the portraits of Macheath and Sacheverell she keeps on her wall, followed by the poses, compositions, and iconography in which she places herself. She is romanticizing and sentimentalizing herself, in the same way that she continues to wear her fancy dress in her garret and in prison. (She is, through allusions to the Life of the Virgin, a Mary not as "Honour" in *The South Sea Scheme* was a Christ figure, persecuted with religious overtones, but as the ape aped an "Honour" figure by wrapping himself in Honour's cloak.)

A kind of typology is also being invoked by these images. The Old Testament (OT) subjects in art as role models on the walls are contrasted with the New Testament (NT) scenes being acted out beneath them by the Harlot, as a literalized typology (Isaac foreshadowing Hackabout, Abraham foreshadowing Gonson). But it is a weird typology that connects Isaac, the two Marys, and an eighteenth-century whore. Moreover, if we try to visualize the six plates hung on a wall, as they most often were (given the habit of hanging pictures two deep), we see the first three along one row and the last three below them in a second row, like two lines of type on the page of a book. We then notice that this arrangement sets up visual-spatial parallels between 1 and 4 and between 3 and 6, as well as between 1 and 3, and 4 and 6. These are the structuring pictures: two NT scenes, 1 and 3, involving Mary are related to two, 4 and 6, in which Mary is enacting the story of Christ's Passion. In 4, she is in a pose that has nothing to do with her own story, at least as reproduced in *Lives of the Virgin*. Rather she is in the composition of a Christ Mocked, with her suffering head flanked by the figures of a mocking woman (mocking her fashionable clothes, still worn in prison) and a warder who is threatening to flagellate her. (Over her shoulder the mallet with which she is beating hemp seems to be a cross she is bearing.) In the sixth plate, as we have noticed, she has become the passive element in a Last Supper.

Plate 3 illustrates the typological structure: on the Harlot's wall at the left are Abraham and Isaac, and at the right appears the fulfill-

ment (the antitype), Gonson and Company. The general message might be interpreted as: (1) The possibility of reform and her redemption is coming in through the door, and the Harlot misses it. (2) This is the way Gonson sees *himself,* as the Angel of the Lord (as Hackabout sees herself as Isaac; as Mr. Peachum saw himself as Christ saying "Noli me tangere"). Hackabout, however, will see him as the unmerciful hand of Jehovah vis-à-vis Isaac. (3) But these models or types are totally unfitting in the London of 1732. As in the case of the classical model, the Choice of Hercules, so in the biblical equivalent, the Annunciation from a Life of the Virgin: both are inappropriate.

The Abraham–Isaac painting brings together the OT/NT contrast that began with the Jewish keeper and his paintings: the story refers in OT terms to a God who demands that a father sacrifice his son, and, in the NT version, to a God who sacrifices his own son for man. The intervening angel mediates between the two versions. But the Harlot is (parodying typology) a sacrifice in both senses, the latter through the Christ references, emphasized by the eucharistic overtones of the final plate. Indeed, typology is a structure, like the emblematic one of Temperance diluting wine (in the same plate), which is presented only to be exposed as another self-limiting structure of contemporary society. Besides the sequence of promise and fulfillment, it presupposes dichotomies of old and new, death and life, letter and spirit, and law and mercy. By reading Uzzah as a type of the Jewish merchant Hogarth emphasizes a temporal dimension, and in particular the coercive aspect of typology—its pastness and its function as a predetermined role model imposed on the living by the dead.[39]

We might conclude that if Plate 2 introduces the Old Testament in the paintings on the walls (the typological mode, with the OT precedent, is established in 2, the top center picture, and spreads out to 1, 3, 4, 5, and 6), then 3 joins the *Old Testament* picture (Abraham sacrificing Isaac) on the wall with the *New* Testament scene of the Annunciation taking place in the actual picture space beneath. But 4 and 6 extend this NT iconography from the Life of the Virgin to the Passion itself. (In Plate 5 what may be a reference to the death of the Virgin is mingled with what is certainly a suggestion—already set out in *The South Sea Scheme*—of the casting of lots and dividing of Christ's garments at the foot of the cross.)

Hogarth has given no narrative order to the sequence of echoes; in

fact each pair is reversed temporally, precisely because he does *not* want to suggest a diachronic sequence so much as a set of analogies. The principle underlying the pattern shows Hogarth returning to a way of reading and interpreting, learned perhaps from a careful scrutiny of biblical illustrations, where identity is a transformational structure. The most obvious example was Michelangelo's Sistine ceiling, where the sinless Virgin, the mother of God, was related not only to the other Mary, Mary Magdalen, but to the sinful Eve, first daughter of God. The ordinary reference "Mary second Eve" (as in *Paradise Lost,* 10.183) makes it reasonable that Hogarth would have presented the girl from the country as faced by the temptation of Eve and in the pose of Mary.

Without losing the Choice of Hercules parody, it is possible to imagine Hogarth going to Book 9 of *Paradise Lost* with this classical paradigm (which Milton would have ridiculed *as* classical heroism), looking at the much greater and more profound choice Milton presents there, and noticing the discrepancy—as Milton himself does throughout, between the classical myth and the revealed Christian truth. The central temptation, he would have noticed, is of a woman, not a man, and her temptation is by a fair-seeming serpent who employs the "persuasive words, impregn'd with Reason" that Shaftesbury tells us Virtue uses to persuade Hercules of the correct choice. This serpentine Vice does not lie on the ground, langorous and passive, but stands up tall and reasons with Eve, as Needham does with Hackabout. Milton affords Eve no alternative voice, only the persuasive words of Satan. Eve has left Adam behind in *his* garden and retired into her own. God is elsewhere, indeed having already (as Blake, Godwin, and other radicals would argue later in the century) made the choice for her. The angel seems to have turned his back much as the clergyman does in the Harlot's first scene.

As the use of the Choice of Hercules topos suggests, the process of demythologizing in the *Harlot's Progress* is, in part at least (like Milton's), aimed at the heroic—or in contemporary terms, "Greatness"—and this is carried out through the feminizing of the heroic. Hogarth implies that a classical paradigm is being replaced by, on the one hand, a modern one, and on the other, by a Christian one, with the traditions of mythological and OT art replaced by NT art that was more actual to him and the English. The NT reference complements the heroic reference to Hercules with one that historicizes the

biblical story but also in a significant way softens and feminizes the heroic ideal.

The hero becomes a woman, as had happened in Rowe's She-Tragedies on one level, in Defoe's Moll Flanders on another, and, looking ahead, influenced by Hogarth's Harlot, in Richardson's Pamela and Clarissa. This represents a significant transition from an aristocratic to a bourgeois ethos by way of the female figure—from the active values associated with the male, and so with heroic virtue, to the passive values associated with the woman; as well as from politics to love and domesticity and from a master-servant relation to simple masculine versus feminine and a love affair.[40]

THE ACTS OF THE APOSTLES

The positive model for the *Hudibras* illustrations still hovers behind the *Harlot's Progress*: the lives of the Apostles, which began with conversions. In the Raphael Cartoons, St. Peter's conversion came through contact with Christ, St. Paul's through a seizure; one convert was raised from the life of a humble fisherman, the other struck down from the life of a persecutor, the killer of Stephen (in the tapestry that hung as pendant to *The Draught of Fishes,* not one of the Cartoons). Both apostles then faced antagonists, in fact were usually surrounded by them: in the case of Paul the idolatrous Gentiles and in the case of Peter the obstinate, disobedient, and avaricious Jews. Paul and Barnabas were themselves taken for gods in Lystra, and Peter struck dead the avaricious Jew Ananias and his wife.

Both of these terms define the people who surround the Harlot. The OT sense of "Harlot" was one who forsakes the true god to follow idols and false gods, like a harlot who abandons God her husband to chase after false gods. In *A Harlot's Progress* the theme of imitation and fashion is a modern equivalent of, in Protestant terms, idolatry. Worship of the woman by herself and by the men of her society as a "Harlot"—and the idols of society by the woman—is the subject of the series for someone like Hogarth, brought up on Anglo-Protestant iconoclasm, familiar with Swift's iconoclastic poems of diseased prostitutes dressing and undressing.[41] The woman, herself an idol to the men (related in Plate 2 to the Ark of the Covenant),

idolizes everything from her own mirror to the paintings and prints on the walls of the various quarters in which she lives.[42] The people around her either share her "idolatry" (her Jewish keeper) or seek mere personal profit (the clergymen, physicians, and bawd).

It is also possible to imagine a projection beyond the last of the Cartoons to the double martyrdom of Peter and Paul; or to regard ironically their victories as, in the present of 1730s England, defeats. In short, either as an extension to its obvious conclusion, or as an ironic inversion, we can see the Cartoons of the Acts of the Apostles as graphic material out of which Hogarth constructed his first progress series.

We might even suppose that in a sense Hogarth took what he needed from the Raphael story for the actions of his contemporary protagonists and then took from Michelangelo's Sistine ceiling (above the Raphael Tapestries) the transformational mode in which Eve, Judith, Esther, and Mary are linked, adapting it to his Harlot who appears in the pose of Mary the Mother, Mary Magdalen, or Eve. I do not suggest a direct parallel to the structure of the Sistine Chapel (the same system obtains in a ceiling like Rubens's in the Banqueting House), but in general the matter of the Michelangelo Old Testament appears *above* Hogarth's characters, on the walls in the framed paintings, and the matter of the Raphael New Testament appears below, in what to Hogarth is the privileged position. There is always an impingement by the higher on the lower, as there is (he repeatedly shows) by high art on the popular forms of English life and literature.

In the *Harlot's Progress* Hogarth imitated at a distance the engraved Lives of the Apostles in order to show the way in which the highest reach of Renaissance history painting will *now* look and serve an artist. He does this by mixing high and low materials in the manner of his *Hudibras* plates of 1726. The highest (even sacred) art-literature is juxtaposed with the lowest, as OT appears on the walls and NT in the actions of the characters. But the basic model, based on the high model of Raphael's Cartoons and the low of Defoe's novels, is conversion: X (St. Paul, Harlot, Rake) is in some sense converted, and then tries to carry out acts following from the conversion (that is, healing or ministering to others), is surrounded by evil idolatrous heathens and avaricious Jews and wins out in various persuasive or extralegal (or extrahuman) ways—or, alternatively, loses. (In fact, if in the *Harlot's* and *Rake's Progress,* the protagonist loses, in Hogarth's

later Raphaelesque works—*The Pool of Bethesda* and *Paul before Felix*— he does win out in a persuasive, extralegal way.)

The *Harlot's Progress* is, in an important sense, about such a conversion. One can almost hear "Mother" Needham in the pose of Raphael's Christ say to the young girl from the country: "Feed my sheep" or "Here are the keys of my kingdom" or "You are the rock on which I will found . . ." Hogarth's reading of Bunyan and Defoe would have found graphic confirmation in the Raphael Cartoons. Or rather, he would automatically have seen them in these strongly Protestant terms.

But two other consequences follow for his Harlot from the graphic context: she becomes a convert as an attempt at assimilation, in order to "whore after" false gods. And then, having been thus converted, she in fact falls among the heathens, the avaricious and idolatrous, and far from trying to win them over as Paul did at Athens, she is herself made a false god (as he was at Lystra) in the metaphorical sense that the Jew and her other clients make her one. Being a contemporary Paul or Peter, as also the Hercules from secular myth, she can only be overwhelmed by the people around her who (as in fact happened to poor Needham in the pillory) both worship and destroy her. She is, like Paul, confined in prison, and she dies (of the disease imparted by one of her worshipers) while the heathens go on as if she had never existed. The historical end of Peter and Paul is ironically materialized in the final plates.

The attributes of the Apostle bring together in one paradigmatic figure—the most emphasized symbol of the English Protestant tradition—the victim, orphan, bastard, rebel, criminal, and heretic; but an outcast who proves to be in another form the Father, Creator, and Judge. This becomes a figure of central importance to Hogarth's fictions, whose implicit presence explains something of his complex attitude toward the Harlot and other "criminals." The harlot complements the child, the dog, the black, and other marginal figures or outcasts, of which the Good Samaritan will be the most prominent New Testament example (1736–1738), himself a type of the saints Peter and Paul on their journeyings.[43]

But Hogarth's disruptive children have grown up to become the Harlot, who no longer says, Enough of this pretense! but only, Look, I can do the same thing you adults are doing. And so she retains a certain childlike innocence amid the experienced figures of society

around her, whom she parodies and who exploit and destroy, lit-
erally kill her. The child who survives the Harlot is the self-contained
urchin who ignores his mother's death throes in order to pick lice out
of his hair and a chop off the fire, but appears at her wake, among the
other pseudomourners, wearing a parody of mourning attire, al-
ready another "actor," and yet, typologically, the Christ.

WOOLSTON AND HOADLY

There are two other pictures, small portraits, on the Jew's wall in
Plate 2. A proof state of the plate, described by John Nichols and
George Steevens, labeled one of the portraits Thomas Woolston, and
in Giles King's copies, authorized by Hogarth, the two portraits are
labeled Woolston and Samuel Clarke.[44] Both Woolston and Clarke
were freethinkers and Deists, therefore appropriate on the wall of a
non-Christian; but Woolston, regarded by many as a madman and
by others as an infidel, was a more disreputable figure than Clarke.
One of the features of his *Fourth Discourse on the Miracles of Our Sav-
iour* (1728) and again his *Sixth* (1729) was that he adopted the mask of
a Jewish rabbi in order to ridicule the "miracle" of the Resurrection.
Woolston's was therefore an appropriate portrait for the Jew to hang
on his wall and for Hogarth to juxtapose with the Jew's head. More-
over, one of the rape pamphlets, *Some Authentic Memoirs of the Life of
Col. Ch. . .s* (1730), had associated him with Charteris as a free-
thinker, which led to his public denial and threat of a libel suit.[45]

Though Woolston could have been regarded by the Jewish mer-
chant as an ally, his more direct significance was the result of his
pamphlet war with Bishop Gibson. For Gibson not only attacked
Woolston in his *Pastoral Letters* as "false to the Author of our Faith,
and to the present Government,"[46] but pursued him into the courts.
The result was another demonstration of the oppressive Erastian
force of the Church of England. As Gibson's biographer Norman
Sykes has noted, his solution to the Deist problem was coercion.[47]

Most significant, however, was the tenor of Woolston's argument.
Woolston argued that the "miracles" of Christ (that is, his life) were
ridiculously improbable as facts and were only conceivable as alle-
gory. In effect, he was using an allegorical interpretation to discredit

the clerical interpretation of the NT "history." But under the disguise of this thesis about the real meaning of Christ's miracles, he launched an attack on the clergy. He allegorizes the "miracle" of Christ's chasing the money changers from the Temple (his first example) as the need to cleanse the Church of its mercenary clergymen ("Bishops, Priests, and Deacons"). This, the *First Discourse* (1727), was dedicated to Gibson and set the bishop on his punitive course of action.

In his *Defence of His Discourses* (1729) Woolston explains that he is only employing ridicule, not blasphemy, and justifies his method:

> Because some Sort of Stories are the proper Subjects of Ridicule; and because, *Ridiculum acri fortius & melius,* Ridicule will cut the Pate of an Ecclesiastical Numbskull, which calm and sedate Reasoning will make no Impression on (20).

He acknowledges that one of his aims in writing his discourses was "the Abolition of an hired and establish'd Priesthood," and he promises to write "a *Discourse* on the Mischiefs and Inconveniences of an Hired and establish'd Priesthood" (22–23).[48] It becomes clear, in short, that the figure of Uzzah refers also to the portrait of Woolston, halfway between Uzzah and the Jew's head, and is appropriately stabbed in the back by a bishop (Woolston writes of Bishop Gibson's "persecution" of "the Enemies of the Church").

Woolston had just missed an indictment for blasphemy in 1725 when he published *A Moderator between an Infidel and an Apostate,* which questioned the historical validity of the Resurrection and the Virgin Birth. Sir Philip Yorke, the attorney general, had consented to abandon this prosecution; but Woolston continued with a *Second Discourse* in 1727, a third, fourth, and fifth in 1728, and a sixth in 1729. After the fourth, the government resumed prosecution. On 4 March 1729 he was tried for blasphemy, with York prosecuting, convicted, and sentenced to a year in prison and a fine of £100.

In the midst of all the news about Charteris, Hackabout, and Gonson in the summer of 1730, one also read accounts of Woolston's follies and/or tribulations, depending on the point of view. In April Gibson's *Second Pastoral Letter,* "Occasion'd by Some late Writings, in which it is asserted, That Reason is a sufficient Guide in Matters of Religion, without the Help of Religion," was published attacking

Woolston.[49] Woolston's "irreligious nonsense" was attacked in a leader of the *Grub-street Journal* on 2 April, and again on 18 June and 9 July. By this time he was in fact languishing in the King's Bench Prison, where (unable to pay his fine) he died on 27 January 1732/33.[50] Samuel Clarke had endeavored to secure his release, but himself died a month after Woolston's incarceration (17 May 1729).

There is something obsessive about Hogarth's references to clergymen in these early prints. In *The South Sea Scheme* and *Royalty, Episcopacy, and Law* they are more interested in money than in their spiritual charges, and the clergyman who supervises the punishment of Lemuel Gulliver does so while his congregation is worshipping Pan. The list could be extended to include Cardinal Wolsey in *Henry the Eighth and Anne Boleyn,* who is doing his duty as first minister but not as a clergyman. It may be that, as with Wolsey, the clergyman is primarily another way of getting at the "great man," the first minister; but Hogarth focuses on a particular power or authority that is clerical.

Of course, there was agitation within the established church for stricter observance of pastoral duties by the clergy.[51] And perhaps Hogarth's bitterness might have been connected with some incident involving his father and Gibson, or only the discrepancy between their fortunes. But "Deists" such as Woolston shared one assumption, and that was that the clergy carried no divine authority. And many beyond Deists shared the feeling (expressed by Milton in "Lycidas" and by the Harlot in Plate 3) that the clergy could better have spent the energy employed to discredit a Woolston, a Collins, or a Toland, in succoring the poor and unfortunate.

The most relevant aspect of Woolston's "heresy" (as the *Grub-street Journal* called it) was his "allegorical" interpretation of Scripture, which had the effect of reducing mystery to common sense. Thus his confinement in the King's Bench Prison was merely an allegorical statement that he had brought a suit of clothes too small for him (9 July), and when he was reported to have secured a writ of habeas corpus, "It is disputed whether this is to be taken figuratively or literally." Applied to the life of Christ, however, his hermeneutics seemed reductive, and he was accused of treating "the most sacred person and the most sacred things, with a most audacious and blasphemous ridicule" (18 June). For example, the *Grub-street Journal* writes:

This invective of his against our blessed Saviour consists of such low jokes, and such opprobrious language that, if we may form a judgment of the wit of the Galilaean Fisher-man by that of the Fisher-men and Water-men on the Thames, Judas himself would have written with more vivacity and elegancy against the miracles of his master than the learned and ingenious Mr. Woolston. (2 Apr.)

It could be supposed that his "hatred of Jesus" would have endeared him to Jews. But it is possible that Hogarth had the hermeneutical as well as the Jewish aspect of Woolston in mind—and the persecution for the hermeneutics by Bishop Gibson—when he added Woolston's portrait to the allegorical pictures on the Jew's wall. Although Woolston was regarded by the *Grub-street Journal* as another denizen of the madhouse in Swift's *Tale of a Tub,* [52] it is possible that Hogarth may have felt some sympathy for the polemicist who allegorized the Gospel story of Christ driving out the money changers into a prophecy of the ejection of greedy bishops and priests from Christ's church. The reference to Woolston—and its suppression—may tell us something about Hogarth's attitude toward the typology he uses in the *Harlot,* as the pictures on the walls relate to the characters beneath them, and toward organized religion. Where, one might wonder, does an artist draw the line between travesty in the manner of Scarron or Butler (or Protestant iconoclasm) and blasphemy in the eyes of an Anglican bishop?

It is possible to regard *A Harlot's Progress* as a further allegorization of Woolston's pamphlet, both its attack on the clergy and its questioning of biblical narrative, and so it is appropriate that Hogarth cited him in Plate 2. But it is also understandable that he removed the name before publication. After all, Woolston quotes Gibson as proclaiming that it is "the Duty of the Civil Magistrate, at all Times, to take Care that Religion be not treated in a *ludicrous* or *reproachful* Manner" (*Defence,* 9). Hogarth must have seen the danger in his own evocation of the New Testament and not wanted anyone to detect a connection between his and Woolston's methods. Hogarth was later in his career to use other Woolston examples: the "miracles" of the Gadarene Swine (*An Election* 4) and the Samarian Woman (*The Analysis of Beauty,* 1); and the reference in *Election* 1 may well be to the Marriage at Cana, one of Woolston's most notorious examples, involving laughter at the Virgin's expense.

The question is why Hogarth removed the name Woolston from the portrait in Plate 2 (when he retained the names of Sacheverell and Macheath in Plate 3) but then permitted it in Giles King's copy that was published a month later. If he did not want to run the risk of having his allusions to the New Testament associated with Woolston in his own engraving, he might have felt the name could be included in King's plebeian copy along with his benefactor (and the safer) Samuel Clarke and the other immediately contemporary names that were also suppressed from the subscribers' edition of the *Harlot* (Charteris, Needham, and Gonson).

DIANA OF THE EPHESIANS

For the statue of Diana of the Ephesians in *Boys Peeping at Nature* we have referred to the context of art, in Lairesse's art treatise and in Rubens's painting. We have not yet mentioned the biblical context, emphasized by the Deist Charles Blount's notorious *Great Is Diana of the Ephesians: The Original of Idolatry* (1680). For Blount the "Diana"— Artemis, the Asian mother-goddess (thus, for Hogarth, "ancient mother")—was one of the "originals of idolatry"; another example he gave was the Ark of the Covenant.

The story in Acts 19:24–41 to which Hogarth alludes was about "a certain man named Demetrius, a silversmith, which made silver shrines for Diana, [who] brought no small gain unto the craftsmen [of Ephesus]." He warns "the workmen of like occupation" that Paul, by "saying that they be no gods, which are made with hands," will put them all out of business:

> So that not only this our craft is in danger to be set at nought; but also that the temple of the great goddess Diana should be despised, and her magnificence should be destroyed, whom all Asia and the world worshippeth.
> And when they heard these sayings, they were full of wrath, and cried out, saying, Great is Diana of the Ephesians.
> And the whole city was filled with confusion . . .

Thus we have the elements of the NT story: the idolatry of the Ephesians; the idol of the nature goddess (not the virgin huntress but a

fecund mother, suggesting a conflation in the *Harlot* of Virgin Mary and Mother); the commercial stake of the silversmiths, who disguise their concern for profit as concern for the honor of the goddess—and Hogarth's memories of engraving "monsters of heraldry" (which he regarded as aristocratic idols) for Ellis Gamble; the iconoclastic preaching of St. Paul; and, of course, the center of idolatry, the statue that is being "imitated" by the putti artists, and the biblical association of "Harlot" with idolatry. The story, according to the Church Fathers, by showing how Christianity threatened so influential a cult as that of Artemis of Ephesus, demonstrated its impact and triumph.

Hogarth is implicitly contrasting the pagan goddess with the contemporary Harlot (thus the joke about the nothing that in fact lies under the veil), and himself with St. Paul (not for the last time) as an iconoclast of the goddess, and therefore in opposition to the artists (the greedy silversmiths) who have a professional interest in keeping out the new religion he and Paul are preaching: the Christian religion versus pagan, the new history painting of a "modern moral subject" versus the history paintings of the Old Masters.

But also implicit in the figure of *Diana multimammia,* whatever position we assign to Hogarth on the subject, is the pantheist and materialist "Nature" of the Deists. For the 1720s were the heyday of the Deists. At a time when (in Maximilian Novak's words) "the text of the Bible was being probed for errors and ambiguities, at a time when [Anthony] Collins was insisting that only by an allegorical reading could Old Testament types be made the foundation of New Testament antitypes,"[53] Hogarth was playing with precisely such "allegorical" readings of the Bible. The loosely knit group known as Deists—freethinkers, rationalists, and skeptics—shared three major tenets: they held nature to be primary, they did not believe in mysteries, and they despised the clergy.

Above all, a Deist rejected Christian mysteries and the authority of Scripture. In the *Harlot* Hogarth questions mysteries, simply obliterates them, or reduces them to literal, everyday equivalents—combining Butlerian travesty with Deist demystification. While he respects the NT stories as stories of charity and mercy (as opposed to the OT stories of justice and punishment), he distrusts the authority of any scripture, as he does of the clergy. Indeed, one of the strongest signs of the freethinkers (though, of course, not limited to them) was the denial of the value of all books, authorities, or models. The ex-

tension of this paranoia from clergy to other authority figures is evident in a Deist like Toland, whose last pamphlet, written during his final illness, was an attack on physicians. His last words were supposed to have been, "I am Poyson'd by a Physician."[54]

Thus Hogarth's elimination of divine agency in the pictures of Uzzah and Jonah (Plate 2), which in a general way is an act of English Protestant iconoclasm,[55] could also be construed as a deistic refusal to admit a supernatural or revealed dimension to experience—a denial of revealed religion and the possibility of revealed knowledge.[56]

Seen in the context of the statue of Diana of the Ephesians and the allusion to Woolston, the veil of allegory summons up Toland's "exoteric and esoteric distinction" (or Shaftesbury's "defensive raillery," Anthony Collins's "irony," or the more precise and blunt term, "theological lying").[57] Shaftesbury's words come very close: "'Tis real Humanity and Kindness to hide strong Truths from tender eyes."[58]

Censorship then is also implicit in Diana's veil. Not only a political but also a religious dimension is being hidden from "tender eyes." In Collins's words, the freethinker will "sacrifice the privilege of irony" only when there is freedom of expression, or in Toland's: "considering how dangerous it is made to tell the truth, 'tis difficult to know when any man declares his real opinion."[59] Woolston had suffered under the Blasphemy Act of 1697 (9 and 10 William III, chap. 32), which declared it an offense to "deny any one of the persons in the Holy Trinity to be God . . . or deny the Christian religion to be true, or the holy scriptures of the Old and New Testaments to be of divine authority." Justice Gonson's addresses to the Grand Jury included heavy emphasis on this matter:

> Therefore you are to enquire of all offences against the Act of the ninth year of King William III, for the more effectual suppressing Blasphemy and prophaneness; and particularly of all books and pamphlets, wrote against the Christian religion, or the divine authority of the holy scriptures; there are several late writers, who go under the names of Deists, but are really atheists, without God in the world, renouncing his Providence, and even denying the Lord that bought them.[60]

Further evidence from the *Harlot* would include Hogarth's negative reference to Sacheverell, who was regarded by the orthodox as "the

last opportunity for the Church in danger" against Deism: "Here at last was a man standing for right and dignity."[61]

In Anthony Collins's *Discourse of the Grounds and Reasons of the Christian Religion* (1724) we read on typology:

> For if we consider the various *Revelations,* and *Changes* in Religion . . . we shall find them for the most part to be grafted on some old stock, or founded on some preceding *Revelations,* which they were either to supply, or fulfil, or retrieve from corrupt glosses, innovations, and traditions, with which by time they were encumber'd. (21)

Collins based this principle on a comparative study of religions. For him it followed "that the chief proofs of Christianity from the Old Testament, are urg'd by the Apostles in the New Testament," and thus he doubts that "these Proofs are valid"—and therefore Christianity has no "true Foundation" (26). Hogarth certainly gives no validity to the OT stories. While the NT stories are real, within the scene, the OT ones are dead images, icons, hanging on the walls.[62] In his case, typology refers to the *Aeneid* as well as the OT and NT: as he shows in both the subscription ticket and the prints themselves, he builds on and retains the typological shadows of the former "revelations," however corrupt.

In the crucial eighth chapter of part I of the *Discourse,* on "Allegorical Proofs," Collins focused on the example of the Virgin Birth, attempting to prove that "the literal, obvious, and primary sense of" the prophesy in Isaiah 7:14 "relates to Isaiah's own son," and has a perfectly natural application, and therefore the "Virgin Birth" is an allegory of a natural event (45).

Hogarth echoes two parts of the Virgin Birth, the Visitation and the Annunciation, and gives us the child, whom we last see in a Last Supper. The character of Christ, according to Collins, is based on his "doing miracles" and "appearing in a *low* state and *teaching the Poor*" (38). This is Hogarth's own mission, or the mission of his prints: so he demystifies the miracles—which subsume the art tradition—and attempts himself to carry out the instruction of the poor.

Whether Hogarth picked up all of this by listening to coffeehouse conversations, or by reading the Deist tracts, he clearly *knew* the assertions and counterassertions. He can be seen demystifying the Scriptures, rejecting or reinterpreting the Virgin Birth, the Annun-

ciation, and the Visitation in ways that removed their supernatural implications. It is well to remember, however, that for Hogarth, as for a Deist like Toland, the starting point was antipopery, the real enemy with its tradition, priesthood, and mysteries—as opposed to Protestantism, the Bible, and reason. And so in a sense all he is doing is rooting out the residue of papist superstition in England, whether it be in Old Master paintings or in the clergy or their mystification of the Bible.

What "Nature," as in Diana, meant at this time existed on more than one intellectual level. It persisted as the "art-nature" opposition, as in Addison's example of the garden in *Spectator* No. 414 (25 June 1712):

> Our British Gardens, instead of humouring Nature, love to deviate from it as much as possible. Our Trees rise in Cones, Globes, and pyramids. We see the Marks of Scissors upon every Plant and Bush. I do not know whether I am singular in my opinion, but for my own part, I would rather look upon a Tree in all its Luxuriancy and Diffusion of Boughs and Branches, than when it is thus cut and trimmed into a Mathematical Figure.

Recalling the tradition of the art treatises (summed up in Alberti's words criticizing the artist who paid "more attention to making paintings which were true to nature than to making them beautiful," above, p. 45), we may wonder whether Hogarth's emphasis on nature comes from the tradition of British empiricism out of Locke and Addison, or rather—given that neither Locke nor Addison would have made the religious application Hogarth makes in the *Harlot*—from the Deist "pantheists."

In William Wollaston's *Religion of Nature Delineated* (1722, 1725) "Nature" represented a world devoid of the Fall and Original Sin. Wollaston's example is Peter the Wild Boy, a natural (discovered in the German woods in 1725) who is educated and enabled to take his place in society. An answer (perhaps by Defoe), *Mere Nature Delineated: Or, A Body without a Soul* (1726), takes up Wollaston's example: "this poor Animal is represented as passive, weak, foolish, as well as wild" (8). The question is whether Nature—a state of nature—is a state of goodness (as Wollaston argues) or a fallen state: the author of *Mere Nature* defines "a State of Mere Nature" as one in which the

Wild Boy "is perfectly rude and uninform'd, . . . that he is untaught, so much as to speak, and not knowing either himself, or any thing else" (21).

The Wild Boy is brought to London, where once in society, he speaks "by Imitation" (25), and his success or failure therefore depends on whom he happens to meet. He is lucky enough to meet George I for example; but London, a city of fops and beaux, corrupts him: "As soon as he distinguishes of Wealth and Poverty, Avarice is the Consequence; he covets the first, fears and hates the last, and with coveting comes in a Thousand injurious and dishonest, nay, thievish Imaginations to compass it; No sooner doth he see Wealth, cloath'd with Power and Dominion, but Ambition, the first-born Child of Crime, the self-begotten Sin of Witchcraft, breaks out in the Soul . . . [etc.]" (43).

> Can anyone learn Religion in this Town? or come to the Knowledge of Him of whom they can receive no Notions from any about them? Who should teach him the first Notions of Religion here? Shall he be taught Religion by its Contraries? . . . How much better a State was he in, at the Forest of *Hamelen* . . .? (54–55)

—Or, Hogarth adds in the *Harlot,* in the north country of England? He sets up the situation in Plate 1 of the goods, including religion, that are *absent* in London, but possibly still present in the country. He uses *Mere Nature*'s version of the boy, not Wollaston's based on a deistic nature worship. Hogarth sees the Harlot as a fallen creature *capable* of being corrupted in the city—and the implication is that proper education (the presence of a *good* clergyman, good relatives, and so forth) was all that could have saved such a soul.[63]

Whatever his hermeneutics, Hogarth still takes his image of man from the Calvinists, from a Protestant past; but at the same time he puts more emphasis than the author of *Mere Nature* intends on the determinism, the absence of any appreciable agency in the Harlot's situation. *Robinson Crusoe* is about Crusoe's original sin, his fall and conversion; the Harlot's only sin is the emulation stressed in *Mere Nature* (as in Locke's *Thoughts on Education*), and she plays a poor second to the respectable Londoners she emulates.

This—whether Deism or some other term covers it—is the ideology expressed in *A Harlot's Progress.* The question is whether Hogarth sees himself as within or without the Church of England.

(Even Collins remained a communicating Anglican.) By the 1740s Hogarth had adopted a model more respectable than Woolston, one within the Church: Bishop Benjamin Hoadly. The Bangorian Controversy, begun in 1718–1719, had lasted in one form or another until 1721, just as Hogarth was struggling out of his apprenticeship. His portrait of Hoadly (1743), the protagonist of the controversy, was the only plate not engraved by himself or part of his "modern moral subjects" that was consistently included in his price lists and issued as a part of the folio of his engraved works. One folio assembled by Hogarth himself replaces his own self-portrait with Hoadly's portrait as frontispiece.[64] He would only have included a portrait of Hoadly in his folios as a symbolic reinforcement of his own position (although the allusion included his friendship with Hoadly himself as well as his sons Benjamin and John).[65]

But Hoadly was regarded by many as only a little better than Woolston:

> View here the pourtrait of a faction's priest,
> Who (spight of Proverbs) dares defile his nest;
> And when he shou'd defend the Church's cause,
> Barely deserts her, and arraigns her laws.[66]

The list made by one opponent of Hoadly's supporters included "Deists, Atheists, Arians, Freethinkers, Blasphemers, Church-Levellers, Town-Bullys, Ballad-Makers, &c."[67] He was also, perhaps significantly as well for Hogarth, extremely successful professionally, by this time bishop of Winchester. Hoadly's position on the Bangorian Controversy coincided in important respects with the deistic (and was supported by Toland, who saw a chance to cover himself with the cloak of ecclesiastical respectability): "that God's favor depended on sincerity rather than creed, that Christ's supernatural laws were not subject to interpretation by any ecclesiastical body and that, consequently, the church had neither doctrinal nor disciplinary authority."[68] In one of his earlier pamphlets, *A Preservative against the Principles and Practices of the Nonjurors* (1716), he had used the example of Colonel Charteris: even a person as evil as *he* could not be "damned" by the clergy.[69]

Given the inclusion of Sacheverell's portrait in her chamber, the Harlot must also be seen in the context of the Sacheverell Riots—and of Hogarth's experience of them at age thirteen. These riots, next to

the Gordon Riots the "worst disturbance of the century" in London, were significantly riots of a "Church" mob in support of a high church clergyman. The cry was "Sacheverell and High Church" as at the end of Hogarth's life it would be "Wilkes and Liberty," marking the two poles of his experience of the London crowd. Sacheverell's virulent rabble-rousing attack had been on dissenters, presumably including the Hogarths, and one of the mob's primary targets was Bishop Hoadly, both his church, St. Peter-le-Poor, and his house.[70]

My suspicion is that Hogarth was drawn to the Deists, who condemned the High Church and offered a realist reading of the magical stories of the New Testament. Among his friends were such libertine Deists as Thomas Cooke, James Ralph, and at this time (to judge by the memoirs of Mr. Wilson in *Joseph Andrews*) Henry Fielding—who, with much deistic hedonist talk of "pleasures," would also have supported the anticlerical bias. It appears that Hogarth was drawn to the low-hermeneutical assumptions of a Woolston but suppressed this model for a more respectable one, Bishop Hoadly, an emblem of a Latitudinarian divine of the Church of England. Whether or not he shared in practice the libertine assumptions of his friends is unclear (he did not share all of their politics), unless we are to read something of this into his *Before* and *After* or his actions on the "Five Days Peregrination"; but he plainly does not include any trace in his *Harlot*.

One part of his audience would have seen him carrying out an act of demystification along the lines of Woolston's *Discourses,* in which the "miracle" of the Visitation or Annunciation is historicized into procuring and adultery. But behind such "philosophers" was the popular culture of Smithfield in which Hogarth was raised. A subculture audience would not have recognized images of Dürer's *Life of the Virgin* or his *Passion* but they would have understood what Thomas Paine verbalized at the end of the century in his *Age of Reason:* "Were any girl that is now with child to say, and even to swear to it, that she was gotten with child by a ghost, and that an angel told her so, would she be believed?"[71] If, in this frame of mind, we look for a father of the Harlot's child (last seen in the position of Christ in her "Last Supper"), we may suspect that Hogarth intends to implicate the Jew, another cuckolded Joseph.[72] If we were to seek out a genuinely popular, subculture version of Dürer's *Life of the Virgin* and *Passion*, perhaps we could not do better than look at the plates of *A Harlot's Progress.*

What all of this comes to is that, moving in the context of these

echoes, removing the veil of allegory, Hackabout is the Mary for whom no angel comes—who is *not* a "chosen woman"; the Magdalen who never meets Jesus and so never repents. It is easy to see how Mandeville's assertion of the "necessity of sacrificing one Part of Womankind to preserve the other" could have led Hogarth to associate his Harlot, as he does, with both Marys: the Magdalen and the Mediator for fallen man. But she also shows that the meaning of these divine figures, in art and in life, has been lost or clouded, obscured in idealized versions distanced from human experience. Lifting Nature's skirt can be construed as an announcement that Hogarth is presenting the true demystified story underneath the New Testament fable, in that sense his "modern moral subject." But the "fable" itself gives depth and dignity to a prostitute's life, a life that would ordinarily seem "ruined and worthless."[73]

At the same time, none of this solemnity obliterates the spectator's experience of exploring the *Harlot's Progress,* including its theological conundrums, as the "pleasure of pursuit," an exuberant and—in this sense—comic work of the imagination.

10.

PUBLICATION, RECEPTION, AND SIGNIFICANCE OF THE *HARLOT*

PUBLICATION

Subscription publishing was not a new thing. By the seventeenth century John Taylor, the Water Poet, was collecting subscriptions for almost every pamphlet he brought out, accumulating 1600 names for one. Subscription was usually limited, however, to books too luxurious or too esoteric for the publishers to take a chance on. Walton's *Polyglot Bible* was published by subscription in 1654–1657, Tonson's reprint of *Paradise Lost* in 1688, Anthony Wood's *Athenae Oxonienses* in 1691. But the first important model of subscription publishing in England was Tonson's edition of Dryden's translation of the works of Virgil, which appeared in 1697. There were two series of subscribers: one paid five guineas and received a copy enriched with many engravings, with his own coat of arms printed beneath one of them; the other paid two guineas and got his name recorded on a list prefixed to the translation. Dryden was entitled to a proportion of the sums subscribed, so naturally went about recruiting subscribers; his total profit, which included the added earnings from sale of the manuscript, was £1400. As Alexandre Beljame has observed, Dryden's *Vergil* was a landmark in linking writer and publisher, "the author [contributing] his talent, the publisher his commercial experience; the one risking his labour, the other his capital, and both according to their desert and to their luck, good or ill, would have their share of failure or success."[1] Subsequently, in 1716 Prior's poems, published by subscription, brought him 4000 guineas, and Gay made £1000 on his in 1720.

The next advance occurred with Pope's *Iliad*. Bernard Lintot al-

lowed Pope the entire revenue from subscriptions, and in addition paid him £200 for each volume. He reserved for himself the profit from all subsequent editions. In other words, the subscription rights and £200 a volume were Pope's pay, by which Lintot bought his property. There were 575 subscribers who took 654 copies, and Pope made £5,320 4s. The whole work, both *Iliad* and *Odyssey,* brought him nearly £9000. Following Pope's example, writers saw their profits increasing: whereas the *Beggar's Opera* text brought Gay between £700 and £800, the subscription for the publication of *Polly* brought him £2000. Voltaire's English edition of *The Henriade,* published in London by subscription, brought in £6000, and Young's *Love of Fame* in 1728, £3000.[2]

Subscriptions were invited through advertisements in the newspapers, through mailing prospectuses to likely purchasers, and through the personal entreaties of the author and his friends. Partial payment was usually demanded with the subscription. One difficulty was that advertisements were too commercial for a proud poet, and the alternative, begging letters or calls upon the great, was no better: "the author placed himself in the importunate position which he had occupied in the old days of patronage."[3]

The artist who wished to break with patronage had more to overcome than the writer, whose words were easily registered by any printer on any page; the artist had a unique object, impossible to duplicate. The engraver, in a still more precarious situation, had naturally less leverage with his printseller than the author with his bookseller because he was essentially a middleman between artist and publisher. The artist and engraver were dependent on each other, and how the profits were distributed usually depended on whether the artist or the publisher controlled the engraver and the subsequent copperplate. Subscription publishing, nevertheless, was by no means limited to the bookselling world. The major subscriptions of engravings in the period preceding Hogarth's emergence were the various versions of the Raphael Cartoons, Laguerre's *Battles of Marlborough,* and the Thornhill decorations for St. Paul's. In the 1720s Hogarth's own *Hudibras* series was successfully sold by subscription, with the advantage that he was both inventor and engraver; but as with Pope's *Iliad,* the plates were bought by the printseller Overton, with the artist's profit presumably limited to the subscription or a percentage thereof.

95. *Sketch of a Garret Scene*; drawing in red chalk on paper; ca. 1730; 9½ × 13 in. (courtesy of the British Museum, London).

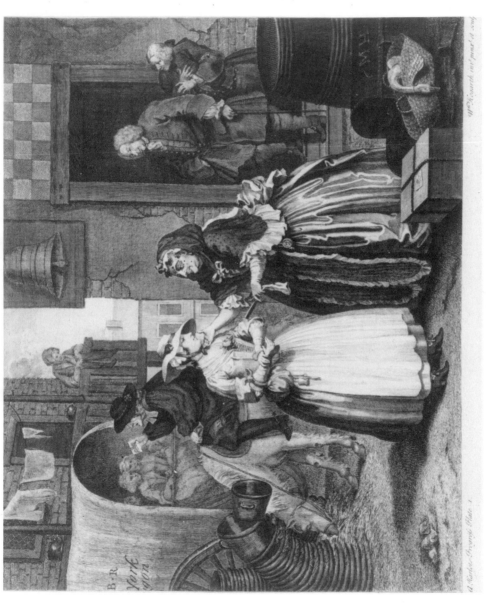

96–101. *A Harlot's Progress* (first state); Apr. 1732 (courtesy of the British Museum, London).
96. *A Harlot's Progress*, Pl. 1; 11¹³⁄₁₆ × 14¾ in.

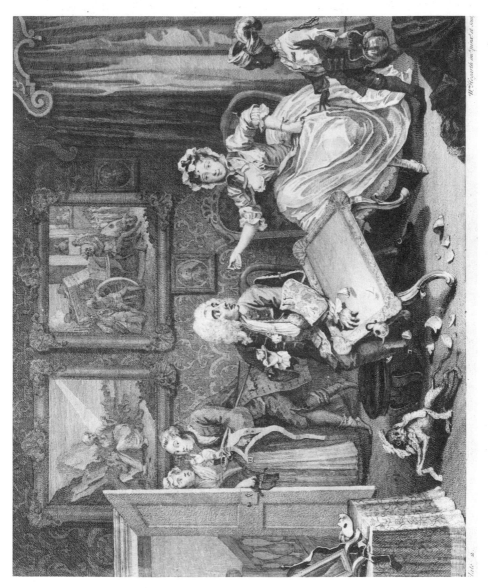

97. *A Harlot's Progress*, Pl. 2; 11⅞ × 14⅝ in.

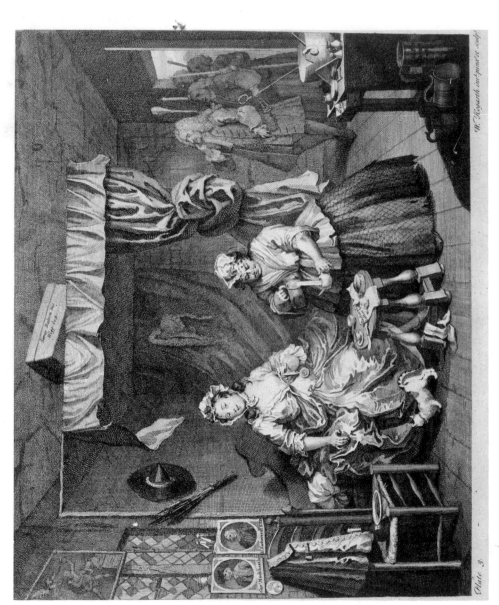

Plate 3.

98. *A Harlot's Progress*, Pl. 3; 11¹³⁄₁₆ × 14⅞ in.

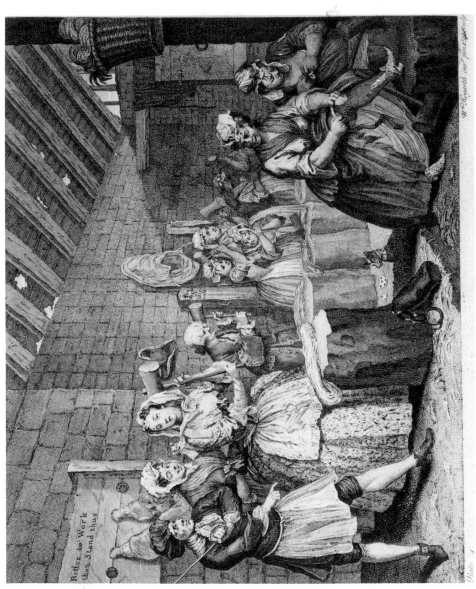

99. *A Harlot's Progress*, Pl. 4; 11⅛ × 14⁵⁄₁₆ in.

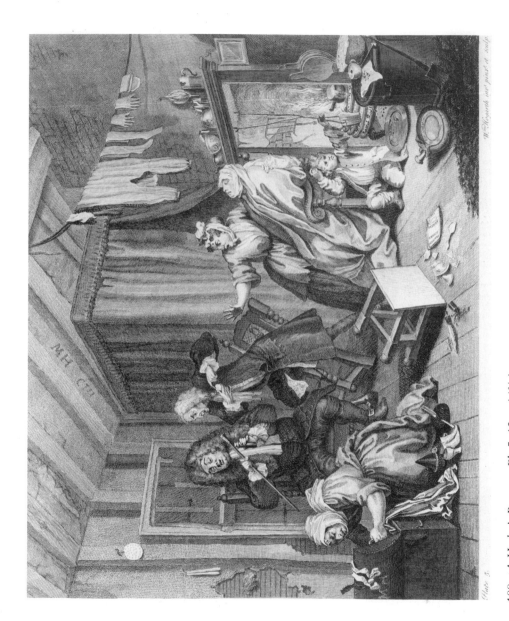

100. *A Harlot's Progress*, Pl. 5; 12 × 14¾ in.

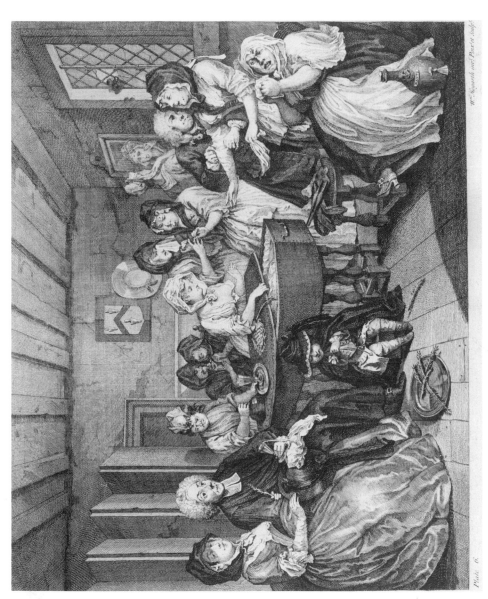

Plate 6. W.ᵐ Hogarth inv.ᵗ Pinx.ᵗ Sculp.ᵗ

101. *A Harlot's Progress*, Pl. 6; 11¹³⁄₁₆ × 14⅞ in.

TREATISE VII.

VIZ.

A NOTION of the *Hiſtorical Draught* or *Tablature*

OF THE

Judgment of *Hercules*,

According to PRODICUS, *Lib.* II. *Xen. de Mem. Soc.*

―――――――――――――――Potiores
HERCULIS ærumnas credat, ſævoſque Labores,
Et Venere, & cœnis, & plumâ SARDANAPALI.
Juv. Sat. 10.

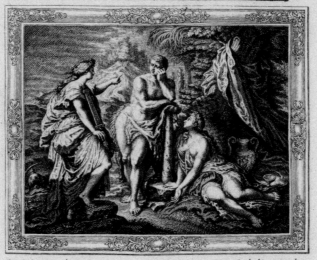

Paulo de Mattheis Pinx: *Sim. Gribelin ſculps:*

Printed firſt in the Year M. DCC. XIII.

102. Paulo de Matteis (or Mattheis), *The Choice of Hercules,* engraved illustration for the earl of Shaftesbury's *Characteristics;* 1714 (corr. 2d ed.).

103. *The Choice of Hercules,* Emblem, in George Wither, *A Collection of Emblemes* (1635).

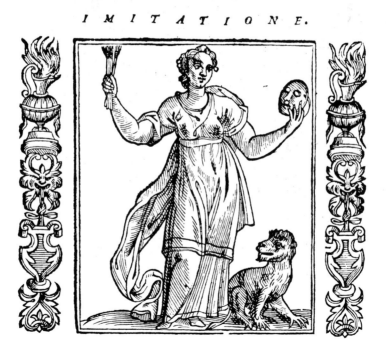

104. *Imitatione,* in Cesare Ripa, *Iconologia* (1611).

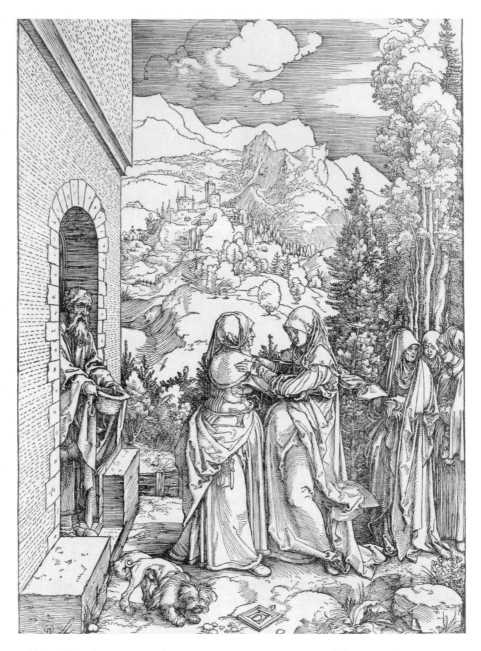

105. Albrecht Dürer, *The Visitation;* 1511 (courtesy of the British Museum, London).

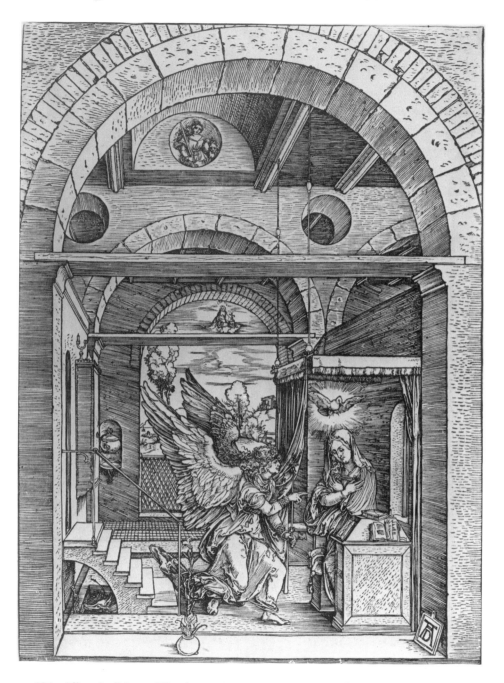

106. Albrecht Dürer, *The Annunciation;* 1511 (courtesy of the British Museum, London).

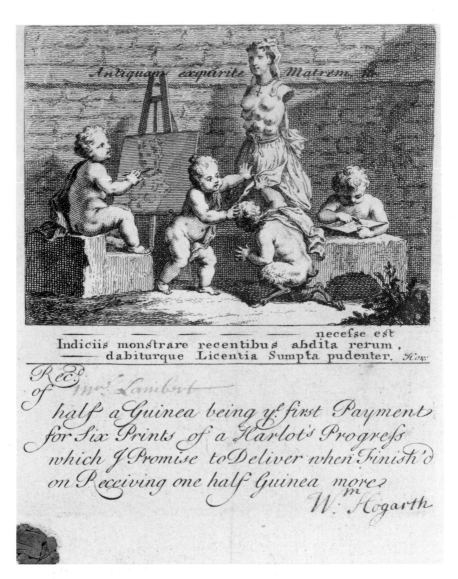

107. *Boys Peeping at Nature* (subscription ticket for the *Harlot*) (second state);
1730/31; 3½ × 4¾ in. (Royal Library, Windsor Castle copyright 1990. H. M.
Queen Elizabeth II).

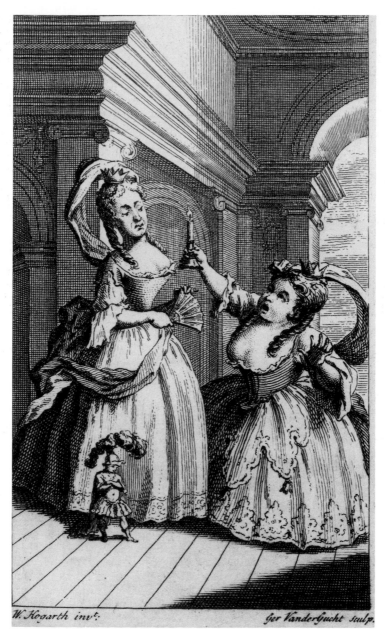

108. Frontispiece to Henry Fielding's *Tragedy of Tragedies* (engraved by Gerard Vandergucht); March 1730/31; 6³⁄₁₆ × 3¹¹⁄₁₆ in. (courtesy of the British Museum, London).

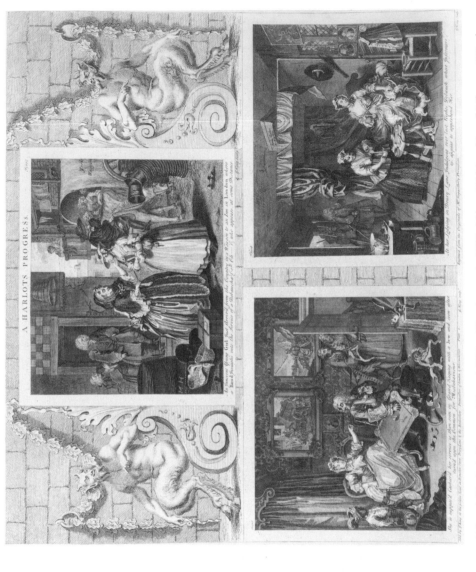

109. *A Harlot's Progress*, Plate 1 (Giles King's copy); 1732; 9⅛ × 12⅛ in. (Royal Library, Windsor Castle copyright 1990. H. M. Queen Elizabeth II).

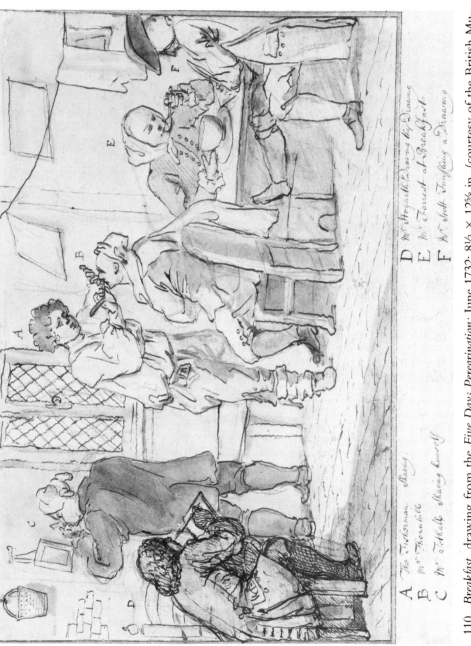

A The Tirkerman shaving
B Mr Thornhill
C Mr Tothall shaving himself

D Mr Hogarth drawing his Dream
E Mr Forrest at Breakfast
F Mr Scott Finishing a shaving

110. *Breakfast*, drawing from the *Five Days Peregrination*; June 1732; 8½ × 12⅝ in. (courtesy of the British Museum, London).

111. Frontispiece, *Peregrination;* 7⅞ × 12 in. (courtesy of the British Museum, London).

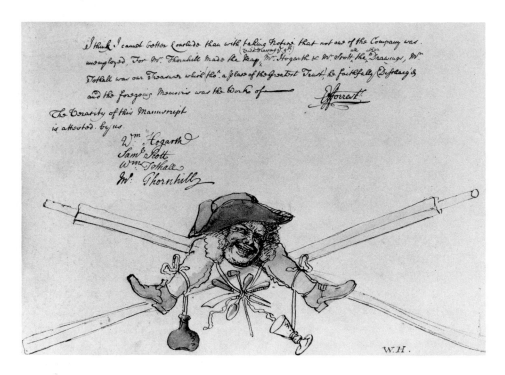

112. Tailpiece, *Peregrination;* 7⅞ × 12 in. (courtesy of the British Museum, London).

Hogarth's great advance with the *Harlot's Progress* was to eliminate the publisher, or rather assume the role himself. He kept not only all the profits from the subscription but also all subsequent profits, plus the profits from the sale of the paintings on which the prints were based and a percentage of the cheap authorized copies.

Hogarth's conception was that of a painter, not an engraver. The idea of having engravings made after his own paintings and selling them in large editions, for financial advantage as well as fame and glory, can be traced back at least as far as Rubens, who published his works himself or through firms in which he was a partner. Rubens often labored over the proofs to make sure the engraver conveyed the correct impression of his painting. That his new assumption of roles combined the artist and the merchant was, however, an insight that Hogarth did not immediately grasp. When he started his subscription of the *Harlot's Progress* he did not envisage subsequent printings, nor regard himself as anything but an artist who was eliminating the middleman printseller in order to reach his patrons directly.

Now a well-known painter, commencing his subscription in the spring of 1731, Hogarth published no advertisements to announce his proposals.[4] He carried out his subscription, as Vertue noted admiringly, "without Courting or soliciting subscriptions all comeing to his dwelling in common [Covent] Garden," presumably by word of mouth, through the contacts he had already made in Parliament, and by exhibiting his paintings in his studio, which of course was in an area much frequented by people of all classes looking for something new (and, it might be added, theatrical). The sophisticated subscription ticket also shows that he was aiming at a sophisticated audience, the same for which he painted his conversation pieces and his special subjects (*Before* and *After*), assuming perhaps that a combination of the two would appeal to a larger group than either by itself. His subscription price, as given on the ticket, was one guinea, half to be paid on subscription, the other half on receipt of the prints. This was the same price Thornhill had charged for his St. Paul's engravings. Indeed, Thornhill also had contrived to keep possession of the copperplates (they later passed to Hogarth, who sold impressions in his shop). The subscriptions were similar except for two fundamentals: Thornhill retailed his prints through printsellers, remaining unsullied by the merchandizing, and divided his profits with them;

and the printsellers continued to sell the prints after the end of the subscription, only raising the price from a guinea to 25s.

Hogarth's original intention, then, was to disseminate reproductions of his paintings in a deluxe edition. He intended to print off as many as were subscribed for and no more. Something of the ethics of subscription publishing of prints is suggested by J. T. Smith's comments on Robert Strange:

> [N]or could any publisher boast of more integrity as to his mode of delivering subscription-impressions. He never took off more proofs than were really bespoken, and every name was put upon the print as it came out of the press, unless it were faulty; and then it was destroyed, not laid aside for future sale, as has been too much the practice with some of our late publishers. Impositions, I regret to say, amounting to fraud, have been recently exercised upon the liberal encouragers of the Art, by sordid publishers, who have taken hundreds of proofs more than were subscribed for, purposely to hoard them up for future profit. Nay, I am shocked, when I declare that some of our late print-publishers have actually had plates touched up after they have been worn out; and have taken the writing out, in order that impressions might be taken off, which they have most barefacedly published and sold as original impressions! (2:181)

Hogarth may also have assumed that a subscription would exhaust the finer capabilities of the copperplates.

Further, he intended to have the series engraved for him—in the manner of Thornhill's St. Paul's paintings. His feelings about engraving when he began the projected *Harlot's Progress* were probably expressed in the *Spectator*'s remark, "an Engraver is to the Painter, what a Printer is to an Author." As his designs for book illustrations in this period show, he wanted to be a painter and not an engraver; he wanted to move above the craft. But he also needed to spend much of his time in 1731 (as his list of unfinished paintings indicates) finishing up work already contracted and half paid for. He may have tried Joseph Sympson, Jr., as a mezzotinter, to see whether the most painterly of media would adequately transmit his paintings. But the samples Sympson produced in this medium and in straight etching-engraving were disappointing.[5] He may have turned to Vandergucht, who had etched a number of his small designs, but Vandergucht's elegance was even less suitable to the *Harlot* than Sympson's crudity. Over the next ten months after his subscription began Hogarth must

have searched in vain for an engraver and finally he undertook the job himself.

By eliminating the reproductive engraver as well as the publisher, he saved himself a great deal of money. To give some idea of the cost that would have been involved if he had paid another engraver to reproduce the *Harlot's Progress,* one might note that in 1725 Jacques Parmentier paid Dubosc £100 to engrave his *Solomon Giving Directions to His Chief Architect Hiram,* and in 1726 John Wootton paid Bernard Baron £50 a plate and £3 for each copperplate for the *Four Prints of the Sport of Hunting.*[6] Hogarth's own engraving, once under way, proceeded slowly; a reproductive effect, a fully covered plate that tonally resembled a painting, was called for, and this was quite a different thing from the *Hudibras* plates.

On 14 January 1731/32 he announced in the *Daily Journal* and the *Daily Post*:

> *The Author of the Six Copper Plates,*
> representing a Harlot's Progress, being disappointed of the Assistance he proposed, is obliged to engrave them all himself, which will retard the Delivery of the Prints to the Subscribers about two Months; the particular Time when will be advertised in this Paper.
> N.B. No more will be printed than are and shall be subscribed for, nor Subscriptions taken for more than will receive a good Impression.

Identical notices were repeated on 15, 18, 19, 20, and 21 January and in the *Craftsman* for the 29th. It is interesting that neither in this nor in subsequent advertisements did Hogarth identify himself except as the "Author." In advertisements inserted by booksellers for works illustrated by Hogarth his name appeared prominently; but presumably he considered such emphasis indecorous in an ad inserted by the artist himself.

Beginning on 8 March he ran a new announcement (which doubled as advertisement) in the *Daily Post:*

> The six Prints from Copper Plates, representing a Harlot's Progress, are now Printing off, and will be ready to be deliver'd to the Subscribers, on Monday, the 10 Day of April next.
> N.B. Particular Care will be taken, that the Impressions shall be good. Subscriptions will be taken in, till the 3d Day of April next, and not afterwards; and the Publick may be assured, that no more will be printed off than shall be Subscribed for within that Time.

This was repeated on 9, 10, and 11 March; it was picked up by the *Daily Journal* on the 13th and the *Daily Advertiser* on the 15th, and ran in all three journals up to the last day of the subscription, 3 April. The *Craftsman* and *Fog's Weekly Journal* carried the advertisement on 18 and 25 March. On 27 March, the following notice was added at the end: "N.B. The Hours of delivering out the Prints, will be from 9 to 12 in the Morning, and from 3 till 6 in the Evening."

Vertue emphasizes the wide base of the *Harlot*'s popularity: it "captivated the Minds of most People persons of all ranks & conditions from the greatest Quality to the meanest" (3:58). By March Hogarth may have become aware of how wide a popularity his subscription was enjoying; but with the prints themselves on display, of course, the subscription was building to a climax. These advertisements, sounding like notices to already enrolled subscribers, were in fact designed to solicit subscriptions; no address is given where the subscriptions may be taken, and the general impression of the individual advertisement is that a private party is inserting a personal column. The effect is very reticent, subdued, dignified, and detached; this is an artist speaking to his patrons, not a merchant soliciting strangers. But the effect loses credibility with the repeated printing of the advertisements. One might conclude that Hogarth considered it vulgar to advertise, but at the same time wanted to sell more subscriptions, and so promulgated a mystery which would create talk and curiosity ("What is this *Harlot's Progress*? Who is the 'Author'?"), like the earlier enigmatic notice in the paper about Sir Isaac Shard. His notices imply either a coterie audience or the assumption that *everyone* knows about the *Harlot;* their repetition suggests that he wants to reach beyond either to a much larger public—as large a public as possible.

He may have been encouraged, and his subscription boosted, by the remarkable success of George Lillo's *London Merchant* at the Drury Lane Theatre during the summer of 1731. It too dealt with "low" subject matter, and Lillo in his dedication speaks of "the novelty of this attempt"; Theophilus Cibber remembered it as "almost a new species of tragedy, wrote on a very uncommon subject."[7] Although its ostensible protagonist was a London apprentice, George Barnwell, its most striking character was Sarah Millwood, the London prostitute who, in a climactic scene, turns upon her accusers (who are lamenting her "abuse of such uncommon perfections of mind and body") and exposes them as the origin of her evil: "If such I had, well may I curse your barbarous sex, who robbed me of 'em,

ere I knew their worth, then left me, too late, to count their value by their loss! Another and another spoiler came, and all my gain was poverty and reproach." The scene has much in common with the message of Hogarth's *Harlot*. Lillo also shared with Hogarth the belief that the value of a work (for Lillo a tragedy) is directly proportionate "the more extensively useful the moral . . . it is more truly august in proportion to the extent of its influence and the numbers that are properly affected by it"—by which he means that a tragedy should focus on ordinary people rather than princes because it will have a wider application and a wider audience.

On 1 January 1731/32 Henry Fielding opened his farce *The Lottery* (itself an allusion to Hogarth's print) at Drury Lane. His hero Lovemore comes to London seeking his sweetheart, and when he finds her living in fine lodgings in Pall Mall, explodes: "Ha! by all that's infamous, she is in keeping already; some bawd has made prize of her as she alighted from the stage-coach.—While she has been flying from my arms, she has fallen into the colonel's." By this time the theater-going part of London—surely an important segment of Hogarth's buyers—could be expected to recognize an allusion to the pictures displayed in Covent Garden.[8]

According to Hogarth's friend William Huggins, Christopher Tilson, one of the four chief clerks of the Treasury, told him that at a meeting of the Board of Treasury "held a day or two after the appearance of" the third plate, "a copy of it was shewn by one of the Lords, as containing, among other excellences, a striking likeness of Sir John Gonson. It gave universal satisfaction; from the Treasury each Lord repaired to the print-shop for a copy of it."[9] Since it is probable that no prints would have been released before the subscription was over, Huggins's story would seem to refer to the day Plate 3, or its painting, was first exhibited in Hogarth's "print-shop"; perhaps the account was brought by word of mouth, and the Lords went over to subscribe. Whatever the facts, however, the story, like the reference in *The Lottery,* indicates something of the excitement with which Hogarth's *Harlot* was received.

Two newsworthy events probably sold further subscriptions. Just as Hogarth was finishing his prints, the town was talking about the case of the Jesuit Jean-Baptiste Girard and his "harlot" Catherine Cadière, about whom Fielding wrote a comedy that appeared that same spring. Transcripts of the trial were published, as well as pamphlets, and, more to the point, a series of prints portraying the

couple's lovemaking. One, a series of thirty-two etchings, may have been partly after designs by Gravelot. These "obscene Pieces of Impiety," to be sold in printshops, were attacked by newspapers, and may have led Hogarth to remove the obscenities that appeared on early impressions of the fifth plate.[10]

Subscriptions in early March must also have been assisted by the death of Colonel Charteris, which had taken place on 24 February at one of his northern estates; he was buried on the 30th, leaving a fortune estimated at £80,000. While his death adds a curious irony that Hogarth could not have foreseen (even villains die), it was a natural death and can have had no effect on the artist's intention. The previous October Charteris had been reported ill in the *Grub-street Journal*: "Sat. last Col. Charteris was taken very dangerously ill, and still continues so at his house near Hanover-square, where he is attended by Dr. Pringle, and other Physicians." And the irreverent *Journal* adds its comments: "*Had the* Col. *put on the infallible* Anodyne Necklace [i.e., the hangman's halter] *some time ago, as was generally desired,* this dangerous illness had been prevented"[11]—perhaps Hogarth at this point added the Anodyne Necklace in the fifth plate. But news of the Colonel's death and disgraceful funeral, at which garbage and dead dogs and cats were thrown by the outraged populace into the grave after his coffin, combined with the likeness of the old sinner displayed in Hogarth's shop, must have sold subscriptions.

Although there was no further announcement in the papers, the finished prints were doubtless delivered as scheduled on 10 April. If by the time the prints were delivered Hogarth had become aware that his true audience lay in the great mass of ordinary purchasers, he kept his promise to his subscribers. In his subsequent advertisements, he always notes that all his prints are available at his shop "except the Harlot's Progress." For twelve years he kept his word, and presumably the value of impressions rose steeply; and then on 8 November 1744 he announced in the *Daily Advertiser:*

> WHEREAS Mr. HOGARTH, in the year 1731, published by Subscription a Set of Prints, call'd *The Harlot's Progress,* and according to the Conditions of his Proposals printed off no more than were then subscribed for; and
>
> Whereas many of the Subscribers themselves, (having either lost, or otherwise disposed of their Prints; and being desirous of completing their Sets, and binding them up with his other Works) have frequently requested and sollicited him for a second Impression:

The Author (in Compliance with their Desires, and presuming that he shall be indulged by the rest of the Subscribers, with their Permission to print the Plates again) proposes to publish a second Impression of

The Harlot's Progress:

And begs Leave to conclude, (unless it be otherwise signified to him before the 1st of December next) that he hath the general Consent of all his Subscribers to the present intended Publication.

William Hogarth

He distinguished the second impression by a cross centered beneath the design on each plate, and by minor revisions.

It is also clear that when he engraved the *Harlot's Progress* he had no intention of vending his own wares. He still considered himself a painter, not a merchant, and when the subscription was over he remained a painter. His plan was to have an engraver-printseller, Giles King, make authorized copies. Although it is not impossible that King came to him with the plan, the particular form King's copies took shows Hogarth's guiding hand. Here he was consciously addressing a lower, less-educated audience—the audience he turned to in the prints of the late 1740s. The scenes were now graced with explanations and simple, moral captions, like those in *Industry and Idleness*: Plate 1 (fig. 109) is glossed with *"An Innocent young* Girl *Just arriv'd from the Country in a Waggon to an Inn in* London *where a* Baud *Inveigles into the Service of a Debauchee {Co.¹ Ch—r who appears at some Distance"*; or Plate 3, *"At her Lodging in Drury Lane Indulging over last Nights Debauch where Informers {S.ʳ In.º G—n &c, appear to apprehend Her."* Plate 6 has the laconic title, *"Her* funeral *Properly Attended."* Even a picture like that of Jonah in Plate 2 has its inscription, "Ionah Why are thou Angry?"

The upshot was that King sold the nonsubscription *Harlots* in a cheaper engraving (4*s*,5*s* on "super-fine Paper," to Hogarth's one guinea) from his shop, and Hogarth presumably took a percentage. On 18 April appeared King's first advertisement, with the first mention in the papers of Hogarth's name in connection with the *Harlot's Progress*:

Speedily will be publish'd, the Six Prints of A HARLOT'S PROGRESS: Copied from the Originals of Mr. Hogarth. By Permission. With Ornaments and Explanation to each Print.

Specimens to be seen at the Engraver's, at the Golden Head in Brownlow-street, Drury-Lane.

N.B. These being nigh completed, if any other Copies are publish'd, or offer'd by the Hawkers or their Accomplices before the Publication of these, they will be Impositions and bad Copies, there not having been Time enough to finish them neatly.

Already the possibility of pirates exists, but they are scolded only for the unfinished quality of their work—a curiously roundabout attack. On 21 April, three of the prints were published, and on the 28th the other three.[12]

It is difficult to estimate how much Hogarth made out of the *Harlot's Progress* before his second impression in 1744. But it was clearly considerably more than 1200 guineas. If 1240 sets were actually printed, as Vertue was told by the printer, Hogarth received that many guineas. His sole costs were his printing assistants and around 65 advertisements at 2s each. One can only speculate on the percentage and the size of sales from Giles King's copies. The many pamphlets, poems, stage productions, and the like which drew upon the *Harlot* must have stimulated sales that could be satisfied only by King or one of the pirate printsellers. On the other hand, as Hogarth must have recognized with regret, King's set had little to recommend it over the pirates'—Kirkall's deluxe mezzotint series was a distinct improvement. He must have seen how much money was slipping through his fingers because he could not sell any more of his original product. The lessons of the pirates and the viability of his own product were not lost upon him: within a year he had corrected his error.

The audience he had discovered with the *Harlot's Progress* went beyond the connoisseurs and picture buyers; in fact the number that subscribed to these prints, with the number that must have bought King's and the pirates' sets, suggests an audience closer to that of the *Spectator,* which by mid-March 1711 had reached a daily distribution of three thousand (and a readership of sixty thousand).[13] As to the actual makeup of what he later called "the public in general," whose support he retained in large part until the end of his career, it included not only the ordinary purchasers of art prints—those who bought Dorigny's *Raphael Cartoons* and Vandergucht's engravings of Thornhill's *Life of St. Paul*—but also the wits who bought Swift and Pope, the clergymen who bought moral prints, and the professionals

and tradesmen who bought occasional comic or political prints. He reached beyond the landed gentry to the lawyers, soldiers and sailors, teachers and scholars; and evidently his appeal with the commercial interest—the merchants, shopkeepers, and small businessmen—exceeded his anticipations. But the full range of his "public in general" extended to the great substratum of the servants, clerks, and apprentices who saw and appreciated these prints, bought the piracies when they could not afford the originals, for whom King's copies were intended, and who in time were often given sets by their employers for Christmas presents. The overwhelming significance of the *Harlot* lay in the fact that, as Vertue noted, its popularity stretched from the highest to the lowest. Within a short time Vertue was reporting a rumor (false as it happened) that the paintings were sold to a nobleman for 30 guineas each, and the grossest copies were being handed out for a few pence each.[14]

This was a mass audience never reached by an earlier printmaker, at least with any regularity, and by few English writers. The range of the audience is important because to retain it intact Hogarth had in the future to produce prints that worked on several levels, and yet keep them from being mutually contradictory. In the *Harlot's Progress* he set the pattern by attracting the most naive audience with his topicality and his simple moral tale, the art audience with his pretensions to history painting, and the witty literary audience with the interplay of the two and the allusive readability of the series. This particular combination, expressing his own complex of intentions, was partly accidental and in the future would pose a difficult juggling problem. As time went on he would (so he thought) lose the art fanciers from his audience; and his prints would veer between the literary and the popular, sometimes meaning rather different things to each audience. The Augustan ironists in prose and verse habitually addressed two audiences, but one was false and the other true, and the irony excluded the former. Hogarth at his best derived his strength from reaching both simultaneously.

On 21 April, little more than a week after the *Harlot*'s publication, a shilling prose pamphlet appeared called *The Progress of a Harlot. As she is described in Six Prints, by the Ingenious Mr. Hogarth.*[15] This Grubstreet work, the first of such parasites to flourish on the *Harlot*'s

popularity, had apparently been written by someone who knew that the series was in preparation but had not bothered to go to Hogarth's studio to have a look; or perhaps it was a typical harlot's life that was lying around awaiting an occasion for publication. The hack in question attached a title page alluding to Hogarth's series and changed the ending to conform with the *Harlot's*—the practice Swift observed, of attaching to a work the name of "which ever of the Wits shall happen to be that Week in the Vogue."[16]

Three days later appeared *The Harlot's Progress, or the Humours of Drury Lane,* a shilling pamphlet based on Hogarth's series and including a series of small copies. This verse redaction defined all the implied grossness of the prints, and much more; and was so popular that it went through four editions in little more than two weeks, by which time its price had gone up to 2s.[17] The second edition, out on 6 May, added an epistle "To the Ingenious Mr. Hogarth," which ends with a reference to Thornhill, reminiscent of Mitchell's effusion:

> Happy Sir *James,* in such a Son,
> By whom *Apelles* is outdone;
> His Work is Marvellous, and fine,
> But not miraculous, like thine:
> Thy Canvas tells its Tale as plain,
> As can be told by Tongue of Man:
> Fame first design'd to make thee known,
> In being Sir *James Thornhill's* Son;
> Then Heav'n its mighty Pow'r to shew,
> Gave thee Sir *James's* Genius too.

Encouraged by the success of this work, the author put together by 5 May *The Progress of a Rake, or the Templar's Exit,* in ten hudibrastic cantos this time—the logical transition from a harlot to a rake which Hogarth himself made a year later.[18] In the same *Daily Journal* that advertised *The Progress of a Rake,* one Cox identified his shop as being in Covent Garden, "under the Middle-Piazza, near Mr. Hogarth's." By the end of June Mr. Gamble, at the Golden Fan in St. Martin's Court, was advertising in conjunction with Giles King: "Six Prints of the Progress of a Harlot on a Fan, three on each Side, curiously-Engrav'd; wherein the Characters are justly preserv'd, and the whole not varied from the Originals. Printed in divers beautiful Colours. Price 2s. 6d."[19]

Meanwhile, as early as 16–18 May, three days before the first of King's authorized copies appeared, the *London Evening Post* was advertising the Bowles brothers' copies as "this day published," "the same Size as Mr. Hogarth's"—engraved by Fourdrinier, who also engraved William Kent's designs for book illustrations, "and other the best Masters in Town"—adding that country booksellers could also be supplied. No price is given, but these were followed by piratings by the Overtons at 6*s* a set (King's sold at 4*s*). In November, also under the sponsorship of the Overtons, Elisha Kirkall issued his green-tinted mezzotints, with explanations under each plate, at 15*s*.[20] The result was, like many of Kirkall's works, attractive, but much too soft and painterly for the clear reading required by Hogarth.

Joseph Gay (i.e., John Durant Breval) dated his preface to *The Lure of Venus; or, A Harlot's Progress. An Heroi-comical Poem. In Six Cantos,* a 1*s* 6*d* pamphlet, 30 November 1732, not long after Kirkall's piracy appeared. He condemns piracy in art and literature, remarking that "whenever a curious painting is finished, we are sure of a number of paltry copies," but his own redaction includes copies of Hogarth's prints. Though dated in November, the earliest advertisement for the pamphlet was 1 May 1733.[21]

Progresses of all kinds followed, and it was inevitable that the Opposition should pick up the idea and use the analogy that offered itself. In April 1733 *Robin's Progress* was published "(With Eight curious Copper Plates) . . . in Eight Scenes; from his first coming to Town, to his present Situation." Other satires on Walpole that adopted Hogarth's form included *The Statesman's Progress; or, Memoirs of the Rise, Administration, and Fall of Houly Chan. Premier Minister of Abensadir, Emperor of China. In a Letter from a Spanish Father Missionary to his Friend at Madrid,* published on 7 June.

The relation between Hogarth's progresses and the stage has often been pointed out. I have noted that two characteristics of the English theater in Hogarth's period were intimacy (the closeness and smallness of the stage) and frequent changes of scene, and in a sense Hogarth's works satisfied the viewer as a stage play might—whatever the exact degree of the stage's influence on Hogarth's conception of the *Harlot*. Certainly the *Harlot*'s theatrical possibilities were quickly realized. On 13 November 1732 the *Daily Advertiser* noted that *The Harlot,* a comedy by Charlotte Charke, "shortly to be acted," had been printed by Curll. On 5 February 1732/33 the *Daily*

Advertiser announced publication of *The Decoy, or The Harlot's Progress* (on 14 February called *The Jew Decoy'd*), a new ballad opera, said to be performed at Goodman's Fields. On 15 March there was a "new Pantomime Entertainment" at Sadler's Wells called *The Harlot's Progress;* and on 17 April Theophilus Cibber's *The Harlot's Progress, or The Ridotto-Al-Fresco* was performed at Drury Lane, and proved a great success that helped to bolster the shaky fortunes of the company through the next year and a half.[22] These plays open with the tableau presented by Hogarth and then, like the explication, fill in all the implied action surrounding it. Much more important, however, was the influence the *Harlot* exerted on Henry Fielding, whose new farce, *The Covent Garden Tragedy,* was played on 1 June.

HENRY FIELDING

The most momentous of the associations Hogarth made as a backdrop to his *Harlot* was with Fielding. In March 1730/31, not long before he launched his subscription, Fielding published the expansion of his popular play *Tom Thumb* as *The Tragedy of Tragedies,* with "a curious Frontispiece design'd by Mr. Hogarth" (fig. 108): the only illustration published with a Fielding work during the author's lifetime (unless we count the headpiece for his *Jacobite's Journal,* also by Hogarth).[23] Fielding was the theatrical phenomenon of 1730, a name with which Hogarth wished to associate himself as he prepared to launch the *Harlot.* Indeed, chief among the popular phenomena of the 1730s in London were Fielding's plays and Hogarth's progresses. In the 1720s the equivalent publishing events had been Pope's "Homer" and *Dunciad,* Gay's *Beggar's Opera,* and Hogarth's theatrical satires and *Hudibras* series—all of which strongly influenced Fielding.

Twelve years Hogarth's junior, son of a brigadier general in the army, with a gentlemanly schooling at the most elite of public schools, and afterward at the University of Leyden, Fielding was also the most brilliant writer of his generation. He shared with Hogarth wit, conviviality, and Latin with some classical learning. There is no telling exactly how or when they met, but Fielding would have been aware of Hogarth's satiric prints of the 1720s and by 1730 Hogarth would have been aware of Fielding as the most original and successful

comic dramatist in London—and both were developing the forms and insights of Gay's *Beggar's Opera*.

They also shared an ambivalence about the two most powerful figures of the older generation, Alexander Pope and Sir Robert Walpole, the Great Poet and the Great Man. Like Hogarth, Fielding vacillated in his attitude toward Pope, but one hears the sharp voice of his second cousin and patroness (his contact with the court) Lady Mary Wortley Montagu on the subject—as also, in his early poems, her praise of Walpole. Like Hogarth, Fielding must have admired the poetry of Pope and internalized his satiric techniques but distrusted the man: self-serving, Tory-Jacobite, Roman Catholic, and, in the case of the *Odyssey* and Shakespeare scandals, somewhat dishonest. It is probably not surprising, considering Hogarth's friendship with several of Pope's "dunces" and his disapproval of Pope's friends Burlington and Kent, that he never painted a portrait of Pope (who was painted by almost every other portraitist).

As to Walpole, the important point is that both Hogarth and Fielding seem to have been willing to accept Walpole's patronage when he offered it and withhold satire—in Fielding's case actually praise him. But Walpole, like Pope, was a large part of the contemporary landscape in England, and when Hogarth and Fielding are not attacking him they are nevertheless "representing"—in some sense *celebrating*—aspects of him.

Fielding drafted (but never published) an attack on Pope the Opposition satirist and a defense of Walpole in the second half of 1729, during the period of Hogarth's silence following the commission of the Walpole Salver. In 1730 his "humorous, begging verse epistle" (as the Battestins call it), "To the Right Honourable Sir Robert Walpole" was published—in which he also linked himself to another of Walpole's "bards," Hogarth's eulogist Joseph Mitchell.[24]

The year 1730 marked Fielding's first full season in the London theater, an "annus mirabilis" that occurred just as Hogarth was painting his *Harlot's Progress*. On 30 March *The Author's Farce* was first performed at the New Theatre in the Haymarket and the success was so great that it continued through the spring and the text was published on 31 March. Here, despite his attacks on Pope (and Pope's *Grubstreet Journal*'s persistent attacks on him), Fielding declares himself to be in the tradition of Pope and Swift, calling himself "Scriblerus Secundus." With equal justice, however, he could have laid claim to an

emblematic satire based on Hogarth's *Just View of the British Stage,*
Masquerades and Operas, and *The Lottery.*[25]

On 24 April *Tom Thumb* was added to the bill, with the Walpole
figure of the Great Man as the mock-heroic protagonist—and played
by a tiny actress. *Thumb* may have suggested to Hogarth the idea of
attacking not Walpole but the ethos of the Great *Man,* and so inventing
a protagonist who is a helpless young woman. At the latest Hogarth
and Fielding would have been acquainted by February 1730/31 when
the expanded version of *Tom Thumb* was published with Hogarth's
frontispiece. The illustration depicted the confrontation of Glum-
dalca, Huncamunca, and Thumb, in a parody of Cleopatra–Octavia–
Mark Antony in Dryden's *All for Love,* which itself had been parodied
in Gay's Polly–Lucy–Macheath in *The Beggar's Opera.*

In mid-June 1730 Fielding launched *Rape upon Rape: or, The Justice
Caught in His Own Trap,* and announced *The Modern Husband* for
September (though it was delayed until February 1731/32). In these
works Fielding expresses his awareness that the burlesque *Tom Thumb*
was a lesser work than a "regular comedy." In the same way, Hogarth,
with his *Harlot's Progress,* announces that his "drolls" (*Masquerades
and Operas,* for example) were not the equal in prestige of history
paintings. Although *Rape upon Rape* remained a conventional in-
trigue comedy, Fielding wrote a prologue in which he asserts that his
subject is now Vice, which "hath grown too great to be abus'd" and
requires "the Heroick muse who sings To-night, / Through these ne-
glected Tracks attempts her Flight," and "combats with her Pen" a
Vice that is "cloath'd with Pow'r." In one sense he is merely antici-
pating the Juvenalian tone of Pope's verse satires of the 1730s; and in
fact only two things set off *Rape upon Rape* from his earlier plays: it
omits the fantastic allegorical figures from Smithfield Fair who graced
The Author's Farce and *Tom Thumb,* and it subordinates its copia to a
central image of evil, rape by the very magistrates who should be ad-
ministering justice. Vice "cloath'd with Pow'r" is what most directly
connects Fielding's "heroic" comedy and Hogarth's *Harlot,* as the re-
versal of roles in Justice Squeezum and Ramble recall Hogarth's *Com-
mons Committee* and *Falstaff Examining His Recruits:* magistrates not
only believe that "It is better for the public that ten innocent people
should suffer, than that one guilty should escape," they commit the
very crimes for which they punish the innocent.[26]

The inspiration of the Charteris affair may inform *Rape upon Rape,*

but only in the most general way. There is not the slightest resemblance to *A Harlot's Progress*. Fielding attempts, however, the same transition Hogarth carries out from his 1720s theatrical burlesques and the grotesqueries of *Hudibras* to the relative naturalism of the *Harlot's Progress* and by way of the "heroic muse" celebrated in *Boys Peeping at Nature*. A new genre, "heroic" comedy, is to supplement his burlesque rehearsal plays (his "drolleries"). Thus Hogarth is jacking up in dignity his low story of a harlot with heroic references at the same time that Fielding, probably looking at Hogarth's paintings of the Harlot, is jacking up his new plays. A public interaction between this writer and painter was clearly taking place, and would continue to do so for the next twenty years.

Fielding's genius remained, however, with the earlier mode of *The Author's Farce* (perfected in *Pasquin* and *The Historical Register* in 1736–1737), and he did not produce his own *Harlot's Progress* until he turned to prose fiction. He resumed the burlesque mode in *The Welsh Opera*, which opened on 22 April 1731. For the first time he emerges as a satirist of the ministry and court—though evenly balancing the folly of the ministry with the folly of the Opposition. (The chorus thus sings, "Sing tantarara, Bobs all, Bobs all"—that is, the Pulteneys are as bad as the Walpoles.) The mode is again allegorical and analogical; and perhaps for this reason (among others) its revision, *The Grub-street Opera*, was withdrawn in June: either Walpole suppressed the play or bought Fielding.[27] But by the appearance of *The Modern Husband*, Fielding's brush with Walpolean patronage had turned into an ironic dedication in the manner of Pope's imitation of Horace's epistle "To Augustus" (of two years later) and the relatively naturalistic representation that, as Hogarth showed, is harder for the censors to pin down.

It is interesting that just as Hogarth launched his indirect representation of the ethos of the Great Man, Fielding was beginning to come out of the muffled closet of vacillating praise and blame. In the plays that followed *The Welsh Opera* the subject was precisely the same ethos presented in the *Harlot;* and by the mid-1730s, when Hogarth was publishing his *Rake's Progress,* Fielding was writing unabashed Walpole satires for the stage.

Fielding's *Covent Garden Tragedy,* played on 1 June 1732, shows at once the impact and the popularity of the *Harlot.* Like Hogarth, Fielding includes a Mother Needham character: Mother Punchbowl,

who makes her relationship to Needham obvious by rehearsing her sad end in the pillory. Stormandra summons up Plate 1 when she cries, "dost think I came last week to town, / The waggon straws yet hanging to my tail?" Lovegirlo recalls Plate 2:

> I'll take thee into keeping, take the room
> So large, so furnish'd, in so fine a street,
> The mistress of a Jew shall envy thee;
> By Jove, I'll force the sooty tribe to own
> A Christian keeps a whore as well as they.

Plate 3 is alluded to when Stormandra reminds Bilkum of all she has done for him: "Did I not pick a pocket of a watch, / A pocket pick for thee?" And the fourth plate is evoked by various mentions of hemp beating, as when Mother Punchbowl observes that "The very hemp I beat may hang my son." Even the Harlot's funeral is in the air when news is brought in of Stormandra's "death": "Stormandra's gone! / Weep all ye sister-harlots of the town . . ." There may also have been allusions in the sets and costumes. The *Grub-street Journal* noticed the similarity when, in its unsympathetic discussion of Fielding's new play, it linked Stormandra with Hackabouta as whores Fielding paraded on his stage; and in his introduction to the printed text of his play, Fielding added "A Criticism on the Covent-garden Tragedy, originally intended for The Grub-street Journal," in which he refers to "several very odd names in this piece, such as Hackabouta, &c." Either the *Grub-street Journal* introduced the Harlot's name as a hint that Fielding was playing on Hogarth's popularity, or Fielding had actually used the name in his play but changed it in the printed text.[28]

In *The Covent Garden Tragedy* Fielding for the first time has his characters consistently allude to their social superiors as models of emulation. In *The Welsh Opera* the low were viewed as analogues of the great, but even then not much is made of the idea: the Apshinkens are of the country gentry, and the only low characters are the servants, Robin the butler, William the coachman, John the groom, and Thomas the gardener (equaling Walpole, Pulteney, and so on). Their language, though in general patterned after that of their masters, is more mock pastoral than anything else; Fielding makes no attempt to suggest that these characters behave as they do in imitation

of the royal family, the prime minister, and so forth. This idea becomes explicit only in *The Covent Garden Tragedy,* with the bawds, whores, and their clients assuming the poses and diction of their superiors without their superiors' success. Whether Fielding is puffing the *Harlot's Progress* or benefiting from it, the presence is heavily felt, and it remains in the poor characters who follow Fashion and imitate "greatness" in *Pasquin, Eurydice,* and the later farces, even more in *Jonathan Wild,* and in a modified form in *Joseph Andrews.*[29]

If Fielding's imitation in *The Covent Garden Tragedy* was in some sense a recognition of what Hogarth was up to, his actual formulation of this theme did not occur until the *Champion* essay of June 1740 and the preface to *Joseph Andrews* in 1742. The earliest indication that Hogarth's intention was recognized by a contemporary is James Ralph's essay on painting in his *Weekly Register* No. 112, 3 June 1732:

> Now nothing is a greater Objection to the genius of the Painters than their Want of Invention; few of them have Spirit enough even to touch upon a new Story, or venture on a Subject that has not been very often handled before. . . . But fewer still have commenc'd Authors themselves, that is to say, invented both the story and the Execution; tho' certainly 'tis as much in their Power as the Poet's, and would redound as much to their Reputation, as the late *Progress of a Harlot* by the ingenious Mr. *Hogarth* will sufficiently testify.[30]

THE "FIVE DAYS PEREGRINATION"

On Friday, 26 May, Hogarth and some of his close friends spent the evening at the Bedford Arms Tavern, at the corner of the Little Piazza facing St. Paul's Church. They were in such high spirits that, instead of returning home for the night, they merely stopped off at their respective houses for a change of linen, set off on foot toward the Thames, and did not return until the 31st—just in time for Hogarth to catch a breath and make the first night of Fielding's *Covent Garden Tragedy* on 1 June. Around one in the morning they took a boat to Gravesend, arriving at dawn after a rainy and windy trip down the Thames. From there they proceeded, wandering on foot or by water, in the general direction of the Kent coast. The first day

they crossed Gad's Hill to Rochester and Chatham, to Upnor, and over the hills to Hoo and Stoke. The next day they visited the Isle of Grain and crossed the salt marshes and the Medway to Sheerness (this was on Restoration Day, and the batteries were saluting). Then to Queensborough, and the next day to Minster, and back to Sheerness, by boat to Gravesend, back to Billingsgate, and finally to the water gate behind Somerset House. They ended again at the Bedford Arms, "in the same Good Humour wee left it to Set out on this Very Pleasant Expedition."

The weather was probably good; it might have been one of those late English springs when it suddenly becomes apparent that the weather has changed and one has to be outdoors. But it was, for Hogarth at least, a jaunt that celebrated the completion, publication, and extraordinary success of *A Harlot's Progress*. His actions throughout the trip suggest release from great pressure—but at the same time, in the context of his friends, one might conclude that he was behaving as usual.

This outing, preserved in a journal by one of the travelers, Ebenezer Forrest, was no doubt one of many enjoyed by Hogarth and his friends. The plan was evidently Forrest's, though it may have begun with Hogarth's sketching a porter at Puddle Dock—a confirmation of the stories that describe him sketching an interesting face on the spot. For the remainder of the trip, Hogarth drew pictures of their stops, and Forrest kept notes, which he turned into a parody of an antiquarian tour, transcribing inscriptions from monuments and old churches and recording old wives' tales told them by the natives. Forrest was a lawyer with literary inclinations. He shared Hogarth's love of the theater and was, like him, inspired by Gay's *Beggar's Opera,* producing an imitation, a ballad opera called *Momus Turn'd Fabulist; or, Vulcan's Wedding,* which their mutual friend John Rich produced and gave a successful run of two weeks in 1729. According to the story that either he or his son told John Nichols (in the early 1780s), he finished making a fair copy of the manuscript of the journey, had it bound, and read it at the Bedford Arms two days after their return. The result is a long, thin folio of nineteen sheets bound in brown leather and stamped in gold on the cover, "Travels, 1732. vol. 1," as if other travels were to follow. On the title page it is called a "Five Days Peregrination," and this is what the trip has been called ever since.[31]

Hogarth made five drawings and a head- and tailpiece; he was assisted in one drawing by Samuel Scott, the marine landscapist, and two more were added. Scott too was engaged on an important commission—the painting of six views of East India Company settlements to decorate the Court Room of East India House in Leadenhall Street. He comes through the clearest of the group: testy, short-tempered, a natural butt for the jokes of the others. A longtime resident of Covent Garden, he probably lived at this point with Robert Scott, a relative, in the last house at the southeast corner. Like Hogarth, he was a little man, under five feet, and, as Horace Walpole noted somewhat later, "extremely passionate and impatient."[32]

The fourth member of the "peregrination" was Hogarth's brother-in-law, John Thornhill, who at this time was living in Red Lion Court, a block north of Covent Garden.[33] He must, in a vague way, have been interested in art: he furnished the map that documents the route of the peregrination. Not long after he returned to London, in July, his father resigned the serjeant paintership in his favor, and he held the position, living off its perquisites, until within a few months of his death when he resigned it in favor of Hogarth. No clear picture of him emerges from the journal.

The fifth member, the only altogether nonliterary or artistic one, was Hogarth's old friend William Tothall, the woolen draper and rum dealer, with whom he had lived before and perhaps after his marriage. The year 1732 was a red-letter one for Tothall too: early that year he had bought out the woolen draper business from his retiring master, who allowed him to make his payments out of profits. (Tothall did the same with his own shopman, retiring when he was under fifty in 1746.) At the same time he took over a house next to Scott's in "Bedford Ground facing the Market."[34] Hogarth later gave his shop a free advertisement in the first plate of *A Rake's Progress* and may have portrayed him in *A Chorus of Singers*.

This then is the party of five that sets out from the Bedford Arms on the night of 26 May. They clearly like to eat and drink a good deal—gin, beer, or whatever comes to hand; a typical meal consists of "a Dish of Soles & Flounders with Crab Sauce, a Calves heart Stuff'd And Roasted y^e Liver Fry'd and the other appurtenances Minc'd, a Leg of Mutton Roasted, and Some Green pease, all Very Good and well Dress'd, with Good Small beer and excellent Port."[35] They like equally well to sing and play games. Their favorite songs,

which they sing whenever they need to demonstrate their vocal power (they are vanquished, toward the end, by some powerfully singing sailors), are "Sir John got him an ambling Nag" to the tune of "John Dory" and something called "Pishoken." The games are generally scuffling contests. At one point Hogarth plays hopscotch with Scott, but more characteristic is the "Battle Royall with Stocks pebbles and Hog's Dung" at Upnor Castle, Tothall getting the worst of it ("this occasion'd Much Laughter"), and the series of skirmishes at Lower Stoke, first with water from a well and then "with Soft, Cow Dung," which leave Tothall and Scott in a sad condition.

If there is a main character it is Scott, complaining about the muddy ground, not wanting to show his companions the drawing he has made, getting his clothes soiled, being upset at the loss of a hand-kerchief lent him by his wife, losing his penknife, leaving behind a greatcoat he borrowed, and grumbling at his sleeping accommodation but making no objection when Tothall offers him his own.

With Scott the antihero of the trip, Hogarth is less visible (with one or two notable exceptions) but always calmly in control—an agent and not, like Scott, a victim. At the outset he sketches the porters at Puddle Dock and posts the drawing. On the boat down the Thames he falls asleep, "But soon awaking, was going to relate a Dream he had, but falling asleep again, when he awak'd had for-gott he had Dream'd at all." Dreams return—a strange subject for Hogarth, one might think—and Sunday morning in Rochester he and Scott relate their dreams, and all "entered into a Conversation on that Subject in Bed, and," (Forrest adds, giving his own view of the affair) "left off, no Wiser than wee begun." So we have Hogarth dreaming, and talking with interest about his dreams; Hogarth em-phasizing his own short, squat stature in his sketches; not to men-tion, following the battle of sticks, pebbles, and cow dung, having a bowel movement in a churchyard. As with the dung throwing in the shadow of Upnor Castle, Forrest again carefully transcribes the in-scription on a wooden rail over a grave, and then goes on:

> Hogarth having a Motion; untruss'd upon a Grave Rail in an unseemly Manner which Tothall perceiving administered pennance to ye part of-fending with a Bunch of Netles, this occasion'd an Engagement which Ended happily without Bloodshed and Hogarth Finish'd his Business against the Church Door.

Anyone familiar with the role of clergymen in *A Harlot's Progress* would not wonder at Hogarth's gesture "against the Church Door." Similarly, at the Sheerness fort, "Scott was Laughd at for Smelling to The Touchholes of Some of the Guns lately Discharged and so was Hogarth for Sitting Down to Cutt his Toe Nails in the Garrison." Thus Hogarth fits quite readily in Forrest's juxtapositions of historic monuments and nature.[36]

In Queensborough, having discovered several pretty women with whom they conversed, they returned to their inn, "got a Wooden Chair and plac'd Hogarth in it in the Street where he Made the Drawing No. 6: and gather'd a great Many Men Women and Children abt. him to see his performance"—which was no doubt what they intended. Finally, both Scott and Hogarth got seasick in a squall.[37]

In the narrative compiled by Forrest, the erudite examination of churches and the antiquarianlike drawings made by Hogarth and Scott are constantly undercut by what appears to be the real focus of the trip: eating, drinking, defecating, and high jinks. As in so much of Hogarth's life, it is impossible to say where nature leaves off and art begins. The peregrination was primarily a vacation of dung throwing and letting off steam; the occasional encounters with churches and landmarks, which curiosity made them view and Hogarth draw, were purely incidental. But when they got back and Forrest began to write up the narrative, the incongruity between the topographical drawings and the actual trip must have been evident; at any rate, they placed their journey in the context of a serious endeavor (anticipating the picaresque of Fielding and Smollett), and Hogarth's final comments were the head- and tailpiece which he added, altogether on his own authority, after the manuscript was complete (figs. 111, 112).

The head- and tailpiece showed a pair of figures: first Mr. Somebody, a body without a head, surrounded with antiquarian objects, and at the end Mr. Nobody, a grinning head with no body, hung with knives, forks, spoons, glass, and bottle, all implements of the table. Here Hogarth introduces the popular tradition that ran just below the surface of the *Harlot's Progress*. He would have remembered Somebody and Nobody from his early contact with Bartholomew Fair and the crowded stalls of London; as recently as 1730 Henry Fielding had employed puppets of Somebody and Nobody to dance in his play *The Author's Farce*. There Somebody served as the em*bodi-*

ment (you might say) of "knaves or fools, in coat or gown" (that is of the "great," or those associated with the "Great Man"), and, the other extreme, Nobody was the "jolly Nobody"

> Who during his life does nothing at all
>> But eat and snore
>> And drink and roar,
> From whore to the tavern, from tavern to whore,
>> With a laced coat, and that is all (Air VII).

Fielding will eventually embody this elemental popular contrast in the conflicting reputations of Blifil and Tom Jones, but it underlies all of his plays. Hogarth associates Somebody with the antiquarian ("studies") aspect of the peregrination and Nobody with the "pleasures" of release. Somebody transcribes epitaphs from gravestones, Nobody relieves himself on the grave. Somebody is the patron, connoisseur, and collector, the figure who also recapitulates in popular imagery Hogarth's general feeling about the Somebodies as against the little people, the Nobodies, who only eat and drink but nevertheless—he makes clear, as in his marginal figures of dogs and children—approximate "nature."

This example brings together Hogarth's first great "progress" and his lived experience (though subsequently inscribed on paper) in the basic polarity of Somebody and Nobody, which takes the form in the *Harlot's Progress* of Bishop Gibson, Colonel Charteris, Justice Gonson, and other "great men" of respectability who destroy the poor Harlot (in the final plate literally a Nobody). Hogarth dramatizes an aspect of society's demonizing of Otherness, in this case of sexuality—which it nevertheless controls and exploits to its own ends.

What Hogarth saw as uniquely pernicious in the Somebodies was their influence as a model for the lower orders; and he was more interested in the person who tries to behave like a gentleman or lady than in the gentleman or lady. But in the final analysis, his desire to have his cake and eat it, to expose the evil of the ruling class without alienating it, cannot altogether be elided; and one way to achieve this was to make his malefactor a member of the lower orders who tries to act like one of the upper with disastrous results. Not that Hogarth is to be condemned for using surrogates and displacements (the poor harlot for the great bishop, the bishop for the prime minister). He

worked out his solution within a range of possibilities which was not unlimited: the satiric conventions of his day as well as the realities of the social structure, personal and public patronage, and his own private concerns.

If the Harlot (beginning as Polly Peachum) is Hogarth's paradigmatic figure, then his fiction of the artist involves low subculture work that aspires to the status of high art—as the Harlot aspires, and later Pamela (or earlier Moll Flanders) to dominant cultural status—and that is consequently absorbed and assimilated (contained), sometimes brutally and fatally, into the "dominant" society, literature, or art. The Harlot herself represents the attempt of Hogarth's nouveau genre, the "modern moral subject" that ignores the principle of canonicity, to gain acceptance in the hierarchy of art. Hogarth's graphic work offers one solution to the problem of containment which thematizes the problem in the figure of a social climber; and another that transforms the low materials, by way of the central woman's—and by way of the artist's own—manipulation, into a new definition of the art work.

Is it possible at this point to say anything useful about Hogarth in terms of "class"? Historians such as J. H. Plumb have seen him as the exemplar of the rising bourgeoisie, the celebrator and promulgator (and exploiter) of the "pursuit of happiness" sought by upwardly mobile Londoners with free time to fill. He was one of the geniuses who grasped the opportunities of the quickly expanding consumer society.[38]

Lance Bertelsen has read the incident in the churchyard as the "spectacle of Hogarth (that great cultural entrepreneur and bourgeois ideologue) defecating on a church door for the edification and amusement of his middle-class friends," and so absorbs the irreverent and rebellious gesture within the "ethical frames of reference available to the middle class" (by which we mean, besides the irreverence, the temptations of social aspiration and the "anti-aristocratic" values of hard work, prudence, piety, and mercantile "method").[39] But I think we have seen that this was less a class than a specifically religious gesture, directly supporting—materializing—the view of the clergy expressed in the *Harlot's Progress*.

The question remains whether in the *Harlot* itself Hogarth was characteristically bourgeois, ridiculing aristocratic values (and/or flaunting vulgar vestiges of his class—for the complex notion of

"middle class" included "archaic" elements of the subculture), or that he was being consciously plebeian, trying to *épater* the bourgeois Somebody by being the plebeian Nobody. Perhaps he is only the bourgeois rebel, the bohemian artist who affects the lower-class ethos. The stories of Hogarth's dressing as a dandy, for example, correspond to his storytelling of *A Harlot's Progress* in the important sense that "such role-playing allows the rebel simultaneously to parody the aristocratic aspirations of the middling and lower classes, and to affront the essentially middle-class values of prudence, method, and economic calculation."[40] This explanation, which has the virtue of relating him socially to his most famous protagonist, reminds us of his mixed class status with a father who aspired to the dignity of a Latin scholar, but it overlooks his determining adolescent experience in the world of prison and apprenticeship. The one undeniable feature of Hogarth's case is that he lived in a fragmented social structure, one in which a "middle class" was yet unformed: he himself continues to express the ideology of the apprentice, which is subversive but still desirous of becoming (and being) a master.

Hogarth was the particular case of an apprentice who never completely abandoned his apprentice's assumptions—the emotional feel of deprivation but also of youthful energy and natural forces restrained by ordinary "custom." He always retained the assumptions of Bartholomew Close where he was born; he looked up from the position of the apprentice and journeyman—at best the small artisan—a role he never quite lost the terrible insecurity of, any more than of the debtors' prison. Just below was the abyss of the lowest order of society—the porters, sailors, chairmen, day laborers, street sellers, and casual workmen.

His point of view was based on hostility to the gentry and capitalists, stockjobbers and middlemen, the "respectable" and "pious." Hogarth shows in all of his work the subculture's traditional attitude toward "them," "their" morality, and "their" authority in all its forms, while touting the myth of the "freeborn Englishman." His circumventing the middlemen, as he was careful to make clear, did not make him one of them. He distinguished himself as independent artisan (one who makes his own product but also sells it) from the printseller on the one hand and the aristocratic connoisseur—even patron—on the other. For Hogarth, this meant being a "freeborn Englishman," but not losing touch with the radical tradition which goes back to the Ranters and Seekers, whose violent oaths and sexual

freedom were reactions against the gentility and sobriety of the Puritan ethos, as well as a bizarre common ground shared with aristocratic rakes.

THE PRISON CELL

It is often nevertheless only the artist's self-fiction that is accessible to us. Hogarth's perspective of the apprentice is complemented by his story of the "apprentice" who is adopted by his aristocratic master, a second father, presented with his dazzling daughter, and then, denied her because he has not lived up to expectations, he must steal her away.

One final detail in *Harlot* 2 remains to be mentioned: in the painting of Uzzah and the Ark of the Covenant David is shown dancing before it, and directly above his head is a window in which appears a figure. The Uzzah story is in 2 Samuel 6:6–7, while the story of David dancing is in 6:14–16; the last verse reads:

> And as the ark of the Lord came into the city of David Michal Saul's daughter looked through a window, and saw king David leaping and dancing before the Lord; and she despised him in her heart.

Why, one wonders, did Hogarth portray this particular moment in *Harlot* 2? On the day of David's greatest triumph, when he brought the Ark of Jehovah into Jerusalem, Michal turns on him: "she despised him in her heart," and all sexual relations between them ceased. The only reason given is her anger that he "uncovered himself today in the eyes of the handmaids of his servants, as one of the vain fellows shamelessly uncovereth himself" (6:20–23). In other words, Michal is chiding David, as he dances before the ark, because he has committed adultery.

The reference applies in one sense to the Jew (spiritually an "adulterer"), but then we also recall that Michal's father was King Saul: David, originally engaged in a lowly capacity as harper to Saul, became his master's close companion, best friend of his son Jonathan, and lover of his daughter, and finally succeeded him as king of Israel. To secure Michal's hand David was required to slaughter a hundred Philistines for Saul; to impress him David doubled the number. Shortly thereafter, Michal saved him from the assassins her father—

anxious over the fact that David was destined to replace him as king—had sent to kill him (1 Sam. 19:11–17). Saul in fact forced her to marry another, and David only reclaimed her after Saul's death (1 Sam. 25:44; 2 Sam. 3:13–16). This tiny, almost invisible allusion anticipates the personal matrix of the Ferdinand–Miranda–Prospero triangle with a personal allusion to the relationships of David–Hogarth, Michal–Jane, Saul–Sir James Thornhill (even, with Jonathan–John Thornhill, Hogarth's close personal friend who accompanied him on the "Peregrination"). But the weight here comes down on Michal, her husband, and her husband's sexual lapses.

Hogarth's fiction of the apprentice, his master, and his master's daughter was one plot or myth he liked to retell, but it only begins to inform his work in a major way following the success of the *Harlot's Progress* (which supposedly worked the reconciliation with Thornhill). In the *Harlot* he tells another, a prior story: the story of high hopes, emulation, failure, and imprisonment.

To begin with, Hackabout's name also recalls "*Hackney-Scriblers*, Poor Hirelings, Mercenary Writers."[41] The word links prostitute and bookseller's hack and may contain a submerged memory of Richard Hogarth, or an inscription of Hogarth's own hard case with the printsellers: the method of production he inaugurated with the *Harlot* was aimed against the mediation of the printseller (the equivalent of the harlot's bawd), a constant threat to his livelihood.

Behind the public newspaper-derived facts of Anne Bond, Kate Hackabout, and Mother Needham, there was also Hogarth's father, who had come down to London (perhaps with the future Bishop Gibson, perhaps on the same York Wagon used by the Harlot) and tried to live by London standards. The lad from the north country, attempting to be a Latin scholar and schoolmaster, ended as a literary hack and an inmate of debtors' prison, driven (as Hogarth recalled bitterly half a century later) to his death by the exploitive London booksellers. It was Jean André Rouquet's puzzling explanation that the clergyman in Plate 1 is Hackabout's father. Rouquet may have read into the scene the commonplace that many prostitutes were (in Fielding's words) "the Offspring of the Clergy" or "the greatest Part of the *London* Prostitutes are the Daughters of Parsons." But if (as was apparently the case) Hogarth told Rouquet what to say, it may also reflect his need to assign the clergyman yet another significance, not at all evident in the image itself: the Harlot is rejecting a definition of the self conferred by father and family. Hogarth's father in

one sense was represented by the susceptible young innocent but in another—vis-à-vis Hogarth himself—by her clergyman-protector father figure (and especially with the connection between his father and Edmund Gibson, and perhaps between his father and his more successful brother *Edmund* Hogarth).[42]

Equally relevant is Hogarth's own refusal to accept his status as a silver engraver's apprentice, his rejection of his indentures, his struggle to survive against the same booksellers who ruined his father. A decade later all of this tinctured the day-to-day events he read of in the newspapers—Charteris, Hackabout, Gonson, and Woolston. Even the profession espoused by the Harlot when she first arrives in London recalls Hogarth's sisters, who were also milliners.[43]

The unveiled, most naked level of allegory in the Harlot's story reveals a personal pattern: Hogarth's need to have both his pleasures and his studies. In Addison's retelling of the Choice of Hercules in *Tatler* No. 97 (22 Nov. 1709) it is precisely the choice between "Pleasure" and (Pleasure's term) "Business" ("all the Noise and Disquietude of Business") that Hogarth remembered as his own when he recalled his early years. Virtue reveals that the "Truth" (which Hogarth places under Nature's skirt) is "that there is nothing truly valuable which can be purchased without Pains and Labour." Pleasure replies that the way to Virtue's "pleasures is long and difficult, whereas that which I propose is short and easy." *Difficultas* is both the way of the "reader of greater penetration" in the *Harlot* and the way of its author. But the pleasures proposed by Pleasure, Virtue reminds Hercules, are to "eat before you are hungry, drink before you are a-thirst, sleep before you are tired . . . ," all those "vices" celebrated in the Mr. Nobody of the *Peregrination*. It would seem that Hogarth is exorcising in the Harlot those pleasures he nevertheless insisted on retaining within his portfolio: the Harlot is the William Hogarth who chose *only* her pleasures and ignored her studies.

One wonders whether Hogarth had read (though one can hardly doubt it) Defoe's preface to *Serious Reflections during the Life and Surprising Adventures of Robinson Crusoe* (1720), where Defoe–Crusoe affirms of *Robinson Crusoe* "that the story, though allegorical, is also historical," that is, a "real history":

All these reflections are just history of a state of forced confinement, which in my real history is represented by a confined retreat on an island; and it is as reasonable to represent one kind of imprisonment by

another, as it is to represent anything that really exists by that which exists not.[44]

One wonders if this aim—essentially the goal of self-discovery as the *finding* of the self by *losing* the self—explains the way Hogarth rationalized the "allegory" of the *Harlot*. The story of the closed rooms with which he filled the Harlot's story suggests the representation of "one kind of imprisonment by another," and recalls the *Grub-street Journal*'s joke that Woolston's confinement in the King's Bench Prison was merely an allegory of a suit of clothes he had bought that was too small for him.

No English artist painted more prison interiors than Hogarth. His first major painting was of Newgate and his second of the Fleet. His own experience in prison is inscribed in these scenes. At first a prison appears only at a distance and seen from the outside. Although he shows a prisoner in the stocks or tied to a stake or being whipped, he places him outside in an open space (fig. 12).[45] The first representation of a prison was *The Beggar's Opera,* where the prison was not a real one but a painted set on the stage of a theater. A play gave Hogarth his subject and offered him an excuse to portray the inside of a prison, and only a *play* prison at that. But there is a real prison of sorts all the same, for though Macheath is standing in the middle of an obvious stage, his legs are fettered and he is hemmed in by Polly and Lucy, each demanding that he acknowledge her as his wife. He is also hemmed in by their fathers, who want to see him hanged, and beyond them by the audience sitting on either side of the stage itself, who want him to fulfill the entelechy projected by theatrical conventions.

If *The Beggar's Opera* allowed Hogarth to experiment with the idea of a prison, a year later the House of Commons investigation gave him as subject an actual prison—his father's prison—one in which a prisoner is confronting the warden in the presence of a higher authority, the committee. Something real is happening here, and yet Hogarth has arranged the scene as theatrically as *The Beggar's Opera,* with the same essential elements including an audience.

But with his first series of invented pictures, he abandons all sense of play and makes us aware of an enclosure—a room that appears to be a drawing room or a boudoir but is a prison. The Harlot is imprisoned in Bridewell, but from the second to the final plate she is in spaces that are ever more closed and confining, and these are meta-

phorical equivalents for the confining choice she makes in Plate 1. Only the first scene is out-of-doors; the young girl is just off the York Wagon, in which we see a great many anonymous women packed like sardines; *she* has emerged as an individual into open space. The sky is open, but the buildings already encroach and nearly close it. Daylight and the space of her native north country are already only memories, and she is about to pursue the life of a "lady" in London, following the bawd into the dark, narrow doorway; and in the next scene she is in a heavily furnished room in the City. The only access remaining to the outside world is a half-open door, out of which her lover is escaping. Otherwise, the only exit-windows are the paintings on the walls, which of course only appear to be windows—and for the characters, both the Harlot and her keeper who collected them, are escapes into biblical scenes that are illusion, fantasy, or self-justification.[46] In the third plate, now cast out by her keeper, she is in a shabby whore's quarters, and though the door is open it is blocked by the entrance of the magistrate and his constables who have come to arrest her—carrying her off to the prison of Plate 4; and thence to the closer confinement of the sweating blankets wrapped about her body in 5 and finally the "narrow house" her coffin in 6.

In these rooms the openings are windows and doors that open only onto closed scenes or are pictures on the walls that may appear to the characters to be outlets but are in fact equally closed; they do not look out into the natural world but only into a world of art—that category capped by the prison itself—which constrains the people within the room.

In each case, one asks, what gets the person into this real or metaphorical prison cell? Macheath got himself into his by pretending to be the only love of each "wife," and the debtor in Hogarth's Fleet Prison painting—any debtor—by living beyond his income, trying to be a gentleman on the income of a coffeehouse proprietor or poet.

The problem of confinement, originating presumably in childhood trauma, is discernible in almost every aspect of Hogarth's life and career: one example is his determination to break the closed monopoly of printsellers on the distribution of the engraver's product and of patrons on the painter's. The closed room can certainly be related to his inbred hatred of confinement by rules, precepts, academic assumptions, or whatever constricts the individual. He wanted the least structured sort of an art academy—a democratic one, where the young simply came and learned and the mature artist taught and

worked. The rules of the art treatises on how to draw and paint, and the categories in which kinds of painting were placed, were all anathema to him.

And yet he always worked within the institutional framework, for example, of the art academy. He did not simply go out and paint what he liked but defined a new genre in terms of the highest established genre. The traditional elements always remain, however ridiculed, modified, or absorbed. He never deigned to deal with lower forms on the academic scale of excellence, though he enjoyed painting still-life and landscape details; far less did he allow anyone to suggest that the scenes he painted were drolls or caricatures, which were lower yet on the scale. While displaying a sense of artistic liberty far beyond his contemporaries, he nevertheless worked within the system. He never himself ventured completely outside the confines of contemporary assumptions. His career, we might say, was devoted to exploring the limits of confinement as well as the dangers and challenges of life outside that ordered structure.

It is not possible to assign precisely the debt to Hogarth's own conscious and unconscious and to the determinations of his time, place, and culture. But the closed room—the haunting image of his work, the source of its most intense reverberations—is certainly connected with the age's fear of prisons, confinement, and compulsion. An anthology could be constructed which extends from such criminal accounts as Defoe's of Jack Sheppard's escape, but also Robinson Crusoe's island, to the cell in Pope's *Eloisa to Abelard;* from Addison's "The mind of man naturally hates everything that looks like a restraint upon it, and is apt to fancy itself under a sort of confinement, when the sight is pent up in a narrow compass" (*Spectator* No. 412) to Richardson's Pamela and Clarissa, whose cells are Hogarth's drawing rooms and boudoirs.

This retrospect of the prison cell is an attempt to get at something of the mythic power of Hogarth's *Harlot's Progress* for the eighteenth century. In art-historical terms, what he depicts in its final emblematic *reductio ad absurdam* is the closed single-point perspective box of Renaissance art. That it confines and contracts, that at the same time the humans cannot always be quite contained by their closed boxes, is his point. We have seen how this perspective box, essentially a proscenium-arch stage filled with furniture and emblems, could serve as the traditional memory structure seen from the spec-

tator's perspective (as well as the artist's; above, 46). Robert Boyle formulated the idea of a "conclave mnemonicum," a "certain Room, Artificially furnish'd with Pictures or other Images of things," the most ordinary and everyday objects, seen as visual aids.[47] But the archetypal room, of course, reaches back to Plato's cave and up to Newton's and Locke's "dark room."[48] Hogarth produced for his contemporaries the definitive image of that dark room of the mind by which Locke figured the process of perception in his *Essay concerning Human Understanding* (1690). The individual's world is a closed room that has little access to the outside and is stocked with the impressions, the objects and collections, which make up the owner's character, or (in Lockean terms) his ideas. The imprisonment is self-imposed in that he has chosen these ideas himself, but they determine his every action, and they are themselves imposed on him because they are what he has seen when looking out through those narrow chinks upon the world—often seeing only his own reflection in the images of older, crueller times he collects and hangs on his walls.

Although Locke allows for an internal light of reason in the dark chamber of the mind (sometimes called the "Candle of the Lord" or "bright sunshine"), still the implications were gloomy and equivocal. In the most powerful of many passages, one that Swift could have written, Locke uses the chamber to curb man's pride:

> He that will not set himself proudly at the top of all things, but still consider the immensity of this fabric, and the great variety that is to be found in this little and inconsiderable part of it which he has to do with, may be apt to think that, in other mansions of it, there may be other and different intelligible beings, of whose faculties he has as little knowledge or apprehension as a worm shut up in one drawer of a cabinet hath of the senses or understanding of a man . . . (2.2 3; 1: 146)

In Hogarth there is always the tragicomic disparity between the little, cluttered, illusory world of the room and the real world outside, of hard truths such as the law, disease, unpaid bills, and the unstructured crowd in the street. This is the larger Newtonian world of gravity, extension, and motion, which is felt within the room as physical consequences—and of course also on those rare occasions when one ventures into the out-of-doors. In the engravings, toward which the paintings were directed in these early years, and in which

the Hogarthian world view was most forcefully expressed, it is also the colorless world of primary qualities only, of geometry and geometric perception, in which curving human shapes roam helplessly.

For to go one step further, Locke's metaphor of the human mind is ultimately the tabula rasa, which presupposes the importance of education and persuasion on the unformed mind;[49] of sensation and observation over innate principles; of relativism, Latitudinarianism, toleration, balanced government, and clarity over absolutes of various sorts, from obiter dicta and aprioristic assumptions to the authority of either a system of literary/artistic rules or a monarch. The image Locke uses is a "*white paper,* void of all characters, without any ideas; how comes it to be *furnished?*" he asks. "Whence comes it by that vast store which the busy and boundless fancy of man has *painted* on it with an almost endless *variety?*" (2.1.2; 1: 121, emphasis added).

All the Hogarthian terms are here: the answer from experience, the example, the sheet of white paper for writing (or canvas for painting), filled by boundless fancy and characterized by endless "variety," the "variety" Hogarth will make a keystone of his aesthetic theory in *The Analysis of Beauty.* Later (1:125), when Locke refers to the tabula rasa as a stone on which inscriptions are made, experience takes the form of either image or inscription, or (as in Hogarth's case) both. But note also the word "furnished"—that is, supplied, filled with furniture, decorated (or "stored," 1:91): all of which imply a room, and anticipate the "dark room."

The contexts in which Hogarth's *Harlot* was conceived and made its appearance were Newtonian and Lockean. The empiricist emphasis was on sight and induction from particular observations. At the threshold of the period was Locke's *Essay,* in which words cause confusions correctable by empirical observation; in which the sight is "the most comprehensive of all our senses." In the words of the great popularizer of Lockean assumptions, Addison (in *Spectator* No. 411): "We cannot indeed have a single image in the fancy that did not make its first entrance through the sight." Vision provides Locke with more than a metaphor for the processes of knowledge: it is just this analogy with sight that is necessary to make sense of many of his claims for intuition and judgement, faculties that testify, respectively, to "the visible or probable agreement or disagreement of ideas." Knowledge, he says again and again, depends on a *visible* connection of ideas.[50]

Hogarth "furnished" Locke's "dark room," however, with the paintings from *The Science of a Connoisseur* in which Jonathan Richardson recalled the uncivilized brute "inhabiting between bare walls" (it is implied, a cave) and advocated the pleasure and instruction to be gained by decorating these walls with pictures.[51] Hogarth materializes *this* room, inhabited by a "connoisseur" and hung with the pictures of his "collection," because for him, as an artist, the central phenomenon of the first half of the eighteenth century in England was the rise of aesthetics. The emphasis of the art treatises had shifted, after 1700, from the poet or painter and the making of a painting to the judgment or taste of the connoisseur. The model was firmly in place by the end of the 1720s, when all of the treatises of Shaftesbury and Richardson were in print. The Shaftesburyian-Richardsonian connoisseur, a sublimation of the Whig politician, was a civic humanist Man of Taste, the enlightened, moral, and aesthetically sensitive landed proprietor. He was essentially Shaftesbury's Hercules at the Crossroads, reasonable, disinterested, and impartial; who also understands that the function of art in polite society is to be collected, hung on the wall, and emulated. In his secular version of Bunyan's conversion narrative, Richardson showed man defining himself in terms of the art objects (the models) he lives among, in effect turning from salvation to self-realization.[52]

But if Hogarth's model of human identity is based on Shaftesbury-Richardson's emulative syndrome, it is mediated by Bernard Mandeville's satiric response to it in *The Fable of the Bees* (1724 ed.). For he replaces Shaftesbury's polite Man of Taste in the closed room with the Mandevillian egoist, driven by powerful, egoistic passions, which are expressed in his Richardsonian choice of paintings. The Harlot hangs portraits of Macheath and Sacheverell on her wall, and thus steals her client's watch and hopes she will escape the law as easily as they did.

Mandeville's "Enquiry into the Origin of Moral Virtue" (introducing *The Fable of the Bees*) provided Hogarth with the metaphor of "rising" and of high and low which he materializes in the relationship of paintings to their collectors in his rooms: Mandeville ironically opposed the "lofty," "higher qualities" of the ruling class to the "grovelling" of the "abject, low-minded People."[53] The higher or "superior" class creates morality in order to govern the lower or "inferior" ("inferior Brutes"); and the lower tries to "emulate" the

higher, in both the sense of subservience and the sense of endeavoring ("rising") to recreate a simulacrum of that status: a paradigm materialized on the walls of Hogarth's rooms. Thus virtue and vice are arbitrary power designations, "the Contrivance of Politicians" rather than "the pure Effect of Religion," as the civic humanist (in effect, the ruling class) discourse of Shaftesbury claims: they are "art" rather than the nature (or truth) of the actual life and death of a prostitute.

Mandeville's view is deistic insofar as he is pointing out that it is only the function of Christianity to excite men to virtue, and thus make them subservient, which sets it above other (classical) religions.[54] Both Shaftesbury and Mandeville were widely recognized as Deists: in their antithetical ways both replaced the deity with art (or custom or belief or some other emulative form). The equivalent of God versus Nature in the discourse of religion is, of course, in aesthetic discourse *Art* versus Nature, and Hogarth consistently privileges Nature in both discourses.

What *A Harlot's Progress* dramatized for the 1730s in a uniquely powerful way was the intersection of art and nature, because it placed this basic dichotomy in a young woman, located inside the "dark room," identifying her with city evil and pastoral innocence, ugliness and beauty, aristocratic exploitation and lower-class vulnerability. Hogarth's Harlot is in many ways the great mythic figure of the 1730s (as Pamela will be the mythic figure of the 1740s): If in one aspect she is feminine beauty threatened and destroyed, in another she is woman as at once human and commodity. She is both bought and sold by consumers and cruelly punished by the law; she can be a pampered courtesan or a miserably diseased streetwalker; she enjoys liberty (financial and otherwise) unknown to other women of the age and a power over men, but she is also utterly vulnerable, exploitable, and expendable.

Almost incidentally, the *Harlot* ushered in the first age of English painting, characterized not only by visual demonstration and persuasion but by empirical observation becoming, in the two great English genres of portrait and landscape, sentimental memory. It established the strong literary—or conceptual or intellectual—tradition of English painting. It showed English artists how to paint in an English way, by assimilating the native verbal English culture, both high and low, and by using the great foreign tradition parodically or subordinating it to their own.

NOTES

ABBREVIATIONS AND SHORT TITLES

Analysis	William Hogarth, *The Analysis of Beauty* (1753), ed. Joseph Burke (Oxford, 1955).
Antal	Frederick Antal, *Hogarth and His Place in European Art* (London, 1962).
Apology for Painters	Hogarth's *"Apology for Painters,"* ed. Michael Kitson, Walpole Society, 41 (Oxford, 1968): 46–111.
AN	William Hogarth, "Autobiographical Notes," in *The Analysis of Beauty,* ed. Joseph Burke (Oxford, 1955).
Beckett	R. B. Beckett, *Hogarth* (London, 1949).
Biog. Anecd.	John Nichols, George Steevens, Isaac Reed, et al., *Biographical Anecdotes of William Hogarth* (London, 1781, 1782, 1785).
BL	British Library
BM	British Museum
BM Sat.	*British Museum Catalogue of . . . Political and Personal Satires* (London, 1873–1883).
Cobbett	Pitt Cobbett, *Parliamentary History* (London, 1810 ff.)
Commons	*Dictionary of the House of Commons: 1709–1754,* ed. Romney Sedgwick (London, 1970); *1754–1790,* ed. Sir Lewis Namier and John Brooks (London, 1964).
Croft-Murray	Edward Croft-Murray, *Decorative Painting in England, 1537–1837, 1: Early Tudor to Sir James Thornhill* (London, 1962).
Dabydeen 1985	David Dabydeen, *Hogarth's Blacks* (Kingston-on-Thames, 1985).
Dabydeen 1987	David Dabydeen, *Hogarth, Walpole and Commercial Britain* (London, 1987).
Davies	Martin Davies, *National Gallery Catalogues: The British School* (London, 1959).
DNB	*Dictionary of National Biography,* ed. Leslie Stephen and Sidney Lee, 66 vols. (London, 1885–1901).
Dobson	Austin Dobson, *William Hogarth* (London, 1907 ed.)

De Voogd	P. J. De Voogd, *Henry Fielding and William Hogarth: The Correspondences of the Arts* (Amsterdam, 1981).
Edwards, *Anecdotes*	Edward Edwards, *Anecdotes of Painters who have resided or been born in England . . . Intended as a Continuation to the Anecdotes of Painting of the Late Horace Earl of Orford* (London, 1868).
Gen. Works	John Nichols and George Steevens, *The Genuine Works of William Hogarth,* 3 vols. (London, 1808–1817).
George	M. Dorothy George, *English Political Caricature to 1792* (Oxford, 1959).
GM	*The Gentleman's Magazine*
HGW	Ronald Paulson, *Hogarth's Graphic Works: First Complete Edition,* 2 vols. (New Haven, 1965; revised eds., 1970; London, 1989).
HLAT	Paulson, *Hogarth: His Life, Art, and Times.* 2 vols. (New Haven, 1971).
HMC	*Historical Manuscripts Commission*
J. Ireland	John Ireland, *Hogarth Illustrated,* 3 vols. (London, 1791–1798; 1805 ed.)
S. Ireland	Samuel Ireland, *Graphic Illustrations of Hogarth,* 2 vols. (London, 1794–1799).
Jarrett	Derek Jarrett, *The Ingenious Mr. Hogarth* (London, 1976).
Lichtenberg	Georg Christoph Lichtenberg, *The World of Hogarth: Lichtenberg's Commentaries on Hogarth's Engravings,* trans. of the *Ausfürliche Erklärung* by Innes and Gustav Herdan (Boston, 1966).
Lindsay	Jack Lindsay, *Hogarth: His Art and His World* (London, 1977).
LM	*The London Magazine*
Mellon, Yale	Mellon Collection, Yale Center for British Art
Mitchell	Charles Mitchell, ed., *Hogarth's Peregrination* (Oxford, 1952).
Moore	Robert E. Moore, *Hogarth's Literary Relationships* (Minneapolis, 1948).
J. B. Nichols	J. B. Nichols, *Anecdotes of William Hogarth* (London, 1833).
Nichols, *Literary Anecdotes*	John Nichols, *Literary Anecdotes of the Eighteenth Century,* 9 vols. (London, 1812–1815).
Oppé	A. P. Oppé, *The Drawings of William Hogarth* (London, 1948).
Paulson 1975	Ronald Paulson, *The Art of Hogarth* (London, 1975).

Paulson 1982 | Paulson, *Book and Painting: Shakespeare, Milton, and the Bible* (Knoxville, 1982).
Paulson, *E & E* | Paulson, *Emblem and Expression: Meaning in English Art of the Eighteenth Century* (London and Cambridge, Mass., 1975).
Phillips | Hugh Phillips, *Mid-Georgian London* (London, 1964).
Plomer | Henry R. Plomer, *Dictionary of the Printers and Booksellers who were at Work in . . . England from 1668 to 1725 and . . . from 1726 to 1775*, 2 vols. (Oxford, 1922–1932).
Pye | John Pye, *Patronage of British Art* (London, 1845).
Quennell | Peter Quennell, *Hogarth's Progress* (New York, 1955).
Rouquet | Jean André Rouquet, *Lettres de Monsieur ✶✶ à un de ses Amis à Paris* (London, 1746).
J. T. Smith | J. T. Smith, *Nollekens and His Times* (1828), ed. Wilfred Whitten, 2 vols. (London, 1917).
Spectator | *The Spectator*, ed. Donald F. Bond, 5 vols. (Oxford, 1965).
Survey of London | *London County Council Survey of London*, ed. J. R. Howard Roberts and Walter H. Godfrey (London, 1900–).
Tate | Elizabeth Einberg and Judy Egerton, *Tate Gallery Collections, II: The Age of Hogarth, British Painters Born 1675–1709* (London, 1988).
Trusler | John Trusler, *Hogarth Moralized* (1768), ed. John Major (London, 1831).
V & A | Victoria and Albert Museum, London.
Vertue | George Vertue, *Notebooks*, 6 vols. (Oxford, 1934–1955).
Walpole, *Anecdotes* | Horace Walpole, *Anecdotes of Painting in England*, 4 (1771, released 1780), ed. James Dallaway (London, 1828).
Waterhouse | Ellis Waterhouse, *Painting in England, 1530 to 1790* (London, 1953).
Whitley | W. T. Whitley, *Artists and Their Friends in England, 1700–1799*, 2 vols. (London, 1928).

PREFACE

1. Many of these are registered in *HGW* 1989. But they also extend to attributions of paintings. For example, the moment I saw the painting of Frederick, Prince of Wales, in a decent light at the Tate Hogarth exhibition of 1971, I knew it was not by Hogarth; the moment I saw the *Samson and*

Delilah I had mentioned as perhaps Hogarth's, I knew it was not by him—it was by Corneliis Troost (*HLAT,* 1: 390, 424–25). On the other hand, I have still not found the record (if it exists) of Richard Hogarth's birthplace. We know the date from the family Bible but not the exact place. (The pages from the most probable registers are missing.)

2. Frederick Antal, "Hogarth's Borrowings" (*Art Bulletin,* 29 [1947]: 36–47). But I also refer the reader to Leo Steinberg's brilliant and witty essay, "The Glorious Company," in the catalogue of the Whitney Museum's exhibition, *Art about Art* (ed. Jean Lipman and Richard Marshall [New York, 1978], 8–31).

3. Benedict Nicholson offered me the opportunity to write up my reactions to the exhibition in a *Burlington Magazine* review (94 [1972]), and *this* aspect of Hogarth informed *The Art of Hogarth* (London, 1975).

4. I refer to *Emblem and Expression* (London and Cambridge, Mass., 1975), a study of post-Hogarthian art in England; *Popular and Polite Art in the Age of Hogarth and Fielding* (South Bend, Ind., 1979), where a subversive Hogarth, a proto-Tom Paine who contradicted the comfortable political "truths" that sometimes lie behind the reactionary face of the popular, emerges; *Book and Painting* (Knoxville, 1982), which fills in literary and art historical context; *Literary Landscape* (New Haven, 1983), *Representations of Revolution* (Baltimore, 1983), and *Breaking and Remaking* (New Brunswick, 1989) turn their attention to aesthetics and politics.

1. SHADES OF THE PRISON HOUSE

1. Daniel Defoe, *A Tour thro' the Whole Island of Great Britain,* 1 (1724): 124, 126; 2 (1725): 108; 3 (1727): 223.

2. See *HLAT,* Appendix A.

3. John Nichols has this account from Adam Walker; see *Gen. Works,* 3: 315–17; Walker's letter about the Hogarths first appeared as a footnote in *Biog. Anecd.* (1781) and, slightly revised, was reprinted as an essay in the *Cumberland Pacquet,* 24 July 1781. For Bishop Gibson and his family, see Norman Sykes, *Edmund Gibson, Bishop of London, 1669–1748: A Study in Politics & Religion in the Eighteenth Century* (Oxford, 1926).

4. The full title describes the contents: "Thesaurarium Trilingue Publicum: Being an Introduction to English, Latin and Greek. In Two Parts. The First, Teaching Orthography, and the exactest Way of Pointing yet extant: also Two Lessons for every Day in the Week for Children, and an Alphabetical Table of most Primitive words, both Grammatically and truly divided; with a Catalogue of such words, as being the same in Sound differ in Spelling and Signification. The Second, containing a Method for the more Speedy attaining the Greek Tongue, and the true Accenting thereof; so plain that an English Scholar may (for the most part) Accent any Greek

truly according to Grammar: With an Excellent Prosodia, and several other things fit for those that desire to learn Greek. [Quotations from Horace's sermones and Lucian's epigrams.] London. Printed by J. L. and are to be Sold by Randal Taylor, near Stationers-Hall. MDCLXXXIX." Publication was announced in the term catalogues for May 1689 and again for November (*The Term Catalogues, 1668–1709,* ed. E. Arber [London, 1905], 261, 290); copies are in the London and Harvard libraries.

5. BL Add. Stowe 747, f. 74. Full title: "Gazophylacium Anglicanum: Containing the Derivation of English Words, Proper and Common; each in an Alphabet Distinct: Proving the Dutch and Saxon to be the Prime Fountains. And likewise giving the similar Words in most European Languages . . . Printed by E. H. [Elizabeth Holt] and W. H. [W. Horton]; sold by Randall Taylor. London, 1689." The book was advertised as published in the *London Gazette,* 4–7 Nov. 1689; copies are in the BL, Boston Public Library, and university libraries at Yale, Duke, and Cornell. The Clark Library in Los Angeles claims it was reissued in 1691 as *A New English Dictionary shewing the etymological derivation of the English Tongue* (Clark, Univ. of Texas, New York Public).

6. AN, 201, 204.

7. I have found no advertisement or notice of his school in any contemporary newspaper, although many schoolmasters did so advertise, and Richard and Anne Hogarth advertised other enterprises.

8. The following information is based on the records of war tax assessment for St. Bartholomew the Great, marriage assessments, and tax assessments (Guildhall Record Office). For detailed references, see *HLAT,* 1: 505–6. For an independent but undocumented use of many of these records, see William Le Hardy, "William Hogarth—A New Biography," in *The London & Middlesex Historian No. 2* (Dec. 1965), 1–10.

9. BL C.45.3.15; see *HLAT,* Appendix B.

10. St. Bartholomew the Great Burial Register (Guildhall).

11. For the Hogarths' children's births, see Guildhall Lib. MS. 6778/1 and the family Bible.

12. They are all identified in the Nonconformist Register (no. 4), Guildhall Lib. 6780; for the bishop of London's property, see the rate books.

13. For the then rector of St. Bartholomew's, see E. A. Webb, *The Records of St. Bartholomew's Priory and the Church and Parish of St. Bartholomew the Great, West Smithfield* (London, 1921), 2: 324–31, 528.

14. Register no. 4, Guildhall Lib. MS. 6780, 17A.

15. Walter Wilson, *The History and Antiquities of Dissenting Churches and Meeting-Houses in London* (1808), 3: 370; Webb, *Records,* 2: 167–71.

16. Richard Sibbes, *The Christian Work,* in *Works,* ed. Rev. Alexander Grosart (Edinburgh, 1862), 5: 123; John Robinson, *The Birth of a Day* (1655), 5–6.

17. Henry Lukin, *An Introduction to the Holy Scriptures* (1669), 174; John Bunyan, *Pilgrim's Progress,* ed. J. B. Wharey (Oxford, 1960), 34.

18. For the complete Latin text and English translation, see *HLAT,* Appendix C. This edition of Malpighi's *Opera Posthuma* was published in London in mid-December 1696 (when it was advertised in the *London Gazette,* 17–21 Dec.), though dated on the title page 1697. For Gale, see *DNB* and Nichols, *Literary Anecdotes,* 4: 536ff.

19. Reprinted in *HLAT,* Appendix C. I am indebted for new information on the Carlisles to Charles Saumarez Smith, *The Building of Castle Howard* (London, 1990), 7–8, who cites "Mr. Nevil Ridley's Accounts 1692 to 1701" (Castle Howard MSS. HI/I/3).

20. *Term Catalogues,* 3: 276. I have not located a copy.

21. St. Sepulchre's tax assessment, Guildhall Lib. MS. 9109/38–39.

22. In 1702 a son, Timothy Helmesley (misspelled Hensley), was registered as "born ye 4th of May 1702 att widow Gibbons' house in Bartholomew Closte" (Nonconformist Register, Guildhall MS. 6780, 54A, repeated 55A). Timothy was followed by John (baptized 29 Nov. 1703), Frances (15 July 1705, buried 26 July), a second Frances (15 Aug. 1708), and another Timothy (born 14 Apr. 1710, baptized 30 Apr., buried 18 Aug. 1711). A son Richard exchanged notes with William's brother Richard and his sister Anne in the family Bible; he must have been the eldest of the Helmesley children, born before they settled in the hospital cloisters around 1703. A third Timothy Helmesley, born presumably after 1711 when the second Timothy died, grew up to be a prosperous London merchant, a benefactor, and, with William Hogarth, a governor of St. Bartholomew's Hospital, and died in 1765 (will, Somerset House, Rushworth, 57).

In 1703 the Widow Gibbons moved with the Helmesleys to the adjoining parish of St. Bartholomew the Less, probably living within the precincts of the hospital. There she remained until her death in 1724 (land rate books, Guildhall Lib. MS. 11316, 9054/2). She was buried in the St. Bartholomew the Less churchyard on 28 October (Parish Register, St. Bartholomew's Hospital archives).

23. St. Sepulchre's Baptismal Register, Guildhall Lib. MS. 721/3.

24. The Hogarths paid their rates in 1702 and 1703, and were still living in St. John's Street on 20 April 1703, but Richard's name was crossed out sometime before 13 June 1704, when the list was checked over (Guildhall Lib. MS. 9101/40–41). For Thomas's baptism, see *A True Register of All the Christenings, Marriages, and Burialles in the Parishe of St. James, Clerkenwell,* ed. Robert Harenden (London, 1885), 2: 15.

25. The advertisements appear in the newspapers beginning in 1699. It is possible that Richard taught there earlier and moved to be nearer the school.

26. See C. Foster Watson, *English Grammar Schools to 1660* (London, 1908), 5–7.

27. Quoted (but unidentified), Aytoun Ellis, *The Penny Universities: A History of the Coffee-Houses* (London, 1956), 44, 46–47.

28. *The Conference on Gregg's Ghost* (1711), 11.

29. See Terry Eagleton, *Function of Criticism* (London, 1984), 9; and Peter Stallybrass and Allon White, *The Politics & Poetics of Transgression* (Ithaca, 1986), 82–83.

30. James Howell, *Coffee-Houses Vindicated,* in Ellis, *Penny Universities,* 56; and Stallybrass and White, 94–98: the coffeehouse (vs. alehouse) "replaced 'idle' and festive consumption with *productive* leisure" (98).

31. See P.G.M. Dickson, *The Financial Revolution* (London, 1967); J.G.A. Pocock, *The Machiavellian Moment* (Princeton, 1975), chaps. 13, 14, and *Virtue, Commerce, and History* (Cambridge, 1985), chap. 6.

32. See J. A. Downie, *Robert Harley and the Press* (New York, 1979).

33. John Redwood, *Reason, Ridicule and Religion: The Age of Enlightenment in England 1660–1750* (London, 1976), 41; and Bryan Lillywhite, *London Coffee-houses,* 751, Item 2001. For a warning against two kinds of Deism, the Deism that appears in print and the less decorous, more daring Deism that was spoken in coffeehouses, see T. E. Jessop, introduction to George Berkeley's *Alcyphron, or the Minute Philosophy* (1732).

34. See Henry Morley, *Memoirs of Bartholomew Fair* (London, 1859), 144ff.

35. *The London Spy,* ed. A. L. Hayward (London, 1927), 177–99.

36. *Spectator* No. 44, 20 Apr. 1711; 1: 191.

37. Sir Robert Southwell's letter to his son Edward, dated 26 Aug. 1685, is quoted in Morley, *Memoirs,* 288–91.

38. Charles Howard, second earl of Carlisle, lived in the square, and it seems probable that his family kept the house there after his death in 1684. There may still at this time have been some connection between the Carlisles and Richard Hogarth.

39. Gilbert Burnet, *History of His Own Time* (London, 1838 ed.), 849.

40. The copy (1684, the first collected ed.), with his signature in pencil on the verso of the title page, was sold by Maggs Bros. Ltd., cat. no. 937 (*Association Books,* 1971), no. 63.

41. He purchased his freedom of the Haberdashers' Company on 8 February 1705/06 by redemption (no information appears in the records about his parentage), and so must have been apprenticed around 1698. On 12 August 1707 he secured a license to marry Sarah Gambell, thirty, a spinster of St. Swithin's parish. His own age is given as thirty-five (which would put his birth in 1672). His age suggests that either he was apprenticed later than the usual age or could not afford to purchase his freedom of the company for some time after his apprenticeship. See records of the Parish of St. Magnus the Martyr (first noted in Le Hardy's "William Hogarth"; records of the Haberdashers' Company; Bishop of London's Register, *The Publications of*

the Harleian Society, 26 [1887]: 336; Joseph Foster, ed., *London Marriage Licenses* [London, 1887]: 694; Marriage Records of All Hallows-in-the-Wall). The exact location of his shop can be found in the insurance policy he took out from the Sun Company: on his shop, 14 Sept. 1713 (3: policy no. 3288) and on his dwelling house, without a different address, 14 May 1714 (3: policy no. 3947).

42. Edward Hatton, *New View of London* (1708), 283. The present church was built in 1788.

43. *A True Register of all the Christenings, Marriages, and Burialles in the Parishe of St. James, Clerkenwell,* 2: 24. The minister at this time was Dewel Pead, M.A. (d. 1726/27).

44. John Dussinger identified a Hogarth MS. (now in the Univ. of Illinois Library) that is a direct, largely uncorrected, and very fluent translation of a French text: *William Hogarth's Translation of Watelet on Grace* (Chicago, 1983).

45. A painter named John Dalton is listed in the baptismal registers as living nearby in Bartholomew Close, and a Mr. Rogers, painter, appears in the St. Bartholomew's churchwardens' reports. In the "Autobiographical Notes," near the reference to the "neighbouring Painter," Hogarth refers to a "Mr. Woolaston" who "had a relation who used to miscall colours all his life time yet otherwise his sight was clear and his Judgment good" (204). A John Wollaston (born ca. 1672) is mentioned by George Vertue and did live near St. John's Gate. He played violin and flute and performed with Thomas Britton, the "musical small-coal man," in Jerusalem Passage, and painted his portrait (Webb, *Records,* 2: 528; Vertue, 2: 67; 5: 95–96).

46. Sale Catalogue (1734), no. 4, second day's sale.

47. In the nineteenth century a painting attributed to Heemskirk hung in the Old Baptist's Head Tavern, just down the street from St. John's Gate; it is all that connects Heemskirk with the Clerkenwell area, but for want of other evidence, it is not totally inconclusive. See W. J. Pinks, *The History of Clerkenwell,* 2d ed. (1881), 255. For what little is known about Heemskirk, see Vertue, 2: 128–29; Roger de Piles, *The Art of Painting and the Lives of the Painters* (London, 1798 ed.), 383; F. Saxl, "The Quakers' Meeting," *Journal of the Warburg and Courtauld Institutes,* 6 (1943): 214–16; William I. Hull, "Egbert van Heemskirk's 'Quaker Meeting,'" *Bulletin of the Friends' Historical Association,* 27 (1938): 17–33, 57–58. Paintings by Heemskirk are frequently listed in sales during the first two decades of the century (see e.g., *Post Man,* 10–13 Dec. 1709).

48. *Daily Courant,* 23 and 25 June 1707. See *Post Man,* 28 June–1 July; *Daily Courant,* 30 June [shortened]; also in the *Term Catalogues,* July 1707 (3: 563), where Hogarth's coffeehouse is also mentioned.

49. *Daily Courant,* 19 Mar. 1708/09, for a sale on the 28th at 5 P.M.

50. See W. S. Holdsworth, *A History of English Law* (London, 1903), 8:

229–45; Hatton, *New View*, 2: 745; Charles Gordon, *The Old Bailey and Newgate* (London, 1902), and John Ashton, *The Fleet: Its River, Prison, and Marriages*, 2d ed. (London, 1888). See also John Bender, *Imagining the Penitentiary* (Chicago, 1987).

51. Old Bailey Precinct, St. Sepulchre's Parish, Land Tax Books, Guildhall Lib. MS. 11316.

52. The early Hogarth commentators insisted that he had a school in Ship Court, west of Old Bailey Street, named after the Ship Tavern, and one writer specifies a house "three doors from Newgate-street on the west side," as if taken down from the only possible source, William Hogarth's memory. See Peter Pindar (John Wolcot), in a letter of correction to the 1782 ed. of *Biogr. Anecd.*, in *GM*, 55, pt. 1 (1785): 343. Nichols repeats the story in the 1785 ed. (4) and in *Gen. Works*, 1: 12. H. B. Wheatley, in *London Past and Present, Based on Peter Cunningham's Handbook of London* (London, 1891), 2: 612, adds the precise location. None of these writers shows any awareness of Richard's confinement.

53. If they had died before the Hogarths left Clerkenwell, they would have appeared in the St. James's register. They do not appear in the St. Bartholomew's registers, which include the Hogarths again after their return from the Fleet.

54. BL, Portland Loan, Harley Papers, 26 (1710): 172: "To the Right Honourable Robert Harley esqr. one of the Commissioners of her Majesty's Treasury at his House in York Buildings / humbly / present"; and it is endorsed "Mr Hogarth / Sept. 23 1710 / Latin." An abstract is printed in the *Portland Papers, HMC*, 15th Report, Appendix, pt. 4 (1897): 598. I do not know who Charles H—— and his brothers were (unless it is a reference to Charles Montagu, third earl of Halifax). The Latin text is reproduced in *HLAT*, Appendix C, 2: 486 (there are two typos: l. 12, "pos*s*um"; l. 31, "nemini*s*i").

55. That that shadowy freethinker John Toland—like Richard from the far north, a literary hack trying to survive in London—was a protégé of Harley's is a suggestive fact. He was renewing contacts with Harley at just this time, largely on the strength of Harley's Whig and dissenter background and sympathies. Richard might have done the same. But Toland's violent attacks on Sacheverell—with paranoid visions of the Sacheverell crowd, "the brutish masses pommeling the reasonable few"—served to distance him from Harley once the latter had risen to power. See Robert E. Sullivan, *John Toland and the Deist Controversy* (Cambridge, Mass., 1982), 55.

56. *Commons Journals*, 16: 445.

57. 12 January, followed by 16, 17, 19, 22, 26, 31, and on into February (*Commons Journals*, 16: 455, 457–58, 461–64, 467, 471, 476, etc.).

58. *Public General Acts, 8–10 Anne, 1709–11*, 307–11.

59. *Sessions Books, special ledger for Insolvent Debtors, 1712*, in the Guild-

hall Record Office. William Gibbons was born in 1669 and died intestate in 1717; administration of his estate was proved 12 December 1717, at which time he was identified as a citizen and cutler of St. Thomas, Apostle, Parish; his wife, Ruth, was to administer the estate (Guildhall Lib. MS. 9050/20, f. 205; *Act Book,* 20). Helmesley was a shopkeeper in St. Bartholomew's Cloister (see records of St. Bartholomew the Less, now in St. Bartholomew's Hospital). He died 15 Feb. 1718/19, according to the Hogarth family Bible, but there is no record of it in either St. Bartholomew's or St. Sepulchre's registers or in the will indexes. His general absence from records makes one suspect that he was a nonconformist.

60. In the painting the name is discernible: "T Linowa [?] prisoner in the Fleet."

61. See Defoe's *Review,* 8 Mar. 1708/09; *Commons Journals,* 28 Feb. 1710/11, 16: 528; *History and Proceedings of the House of Commons* (1742), 4: 184–86. For contemporary arguments pro and con, see *The Case of Lieutenant-Colonel Charteris* and the other pamphlets relating to the case collected in the BL (pressmark 816.m.7 [11–21]).

62. The title page is in parallel columns of Latin and English; the English half reads: "Grammar Disputations: or, an Examination of the Eight Parts of Speech by way of Question and Answer, English and Latin, Whereby Children in a very little Time will learn, not only the Knowledge of Grammar, but likewise to Speak and Write Latin, as I have found by good Experience. At the end is added a short Chronological Index of Men and Things of the greatest Note, Alphabetically digested, chiefly relating to the Sacred and Roman History, from the beginning of the World to the Year of Christ 1640, and downwards. Written for the Use of the Schools of Great Britain. By Richard Hogarth, Schoolmaster. London: Printed by J. G. for W. Taylor at the Ship in Pater-Noster Row, MDCCXII." The book was announced "This Day publish'd" in the *Post Boy* for 18–20 Dec. 1711; further advertisements, 20–22, 22–25 Dec.; *Post Man,* 14–16, 23–26 Feb., 15–18 Mar. 1711/12. A copy is in the BL. Taylor, one of the largest publishers of the period, was the son of John Taylor, and possibly a relation of the Randall Taylor who had published Richard's *Thesaurarium.* He joined his father in partnership in 1700, and in 1711, the year he published Richard's new book, set up for himself in Paternoster Row.

63. Reprinted, C. Foster Watson, *English Grammar Schools,* 288–89.

64. Plomer, 322.

65. Judging by his own words in his letter to Harley, Richard also drew on *Prosodia Henrici Smetii . . . promptissima, quae syllabarum positione diphthongis carentium quantitates, sola veterum poetarum auctoritate, adductis exemplis demonstrat* (London, 1615). This popular textbook was reprinted in London ten times between 1628 and 1705, to cite only copies in the BL. The first

volume of Richard Hogarth's dictionary belonged to John Ireland, the second to one James Bindley (*Gen. Works,* 1: 67). One of these was sold at Puttick's (lot 924), 13 Dec. 1850. The present location of both volumes is unknown.

66. The one genuinely "Great Man" whose name has figured in this narrative was, of course, Robert Harley, but he was in no position to help Richard after the summer of 1714 when his ministry fell and he was himself lodged in the Tower.

2. "THE MONSTERS OF HERALDRY"

1. Gamble was not, as the authorities on gold- and silversmiths have claimed, the son of William Gamble, a well-known London goldsmith. See Le Hardy, "William Hogarth," 1. I am grateful to J. W. Woolley of the Merchant Taylors' Company for verifying the dates in the Merchant Taylors' records.

2. *Matrimonial Allegations before the Bishop of London,* Guildhall Lib. MS. 10091/46, f. 525; St. Martin's Marriage Register: both on 15 Sept. 1710. In the *Allegations* Gamble is said to be around twenty-five years of age.

3. See J. F. Hayward, *Huguenot Silver in England, 1688–1727* (London, 1959), xx; Charles Oman, *English Domestic Silver,* 4th ed. (London, 1959), 8–9; Joan Evans, "Huguenot Goldsmiths in England and Ireland," *Proceedings of the Huguenot Society of London,* 19 (1933); and Walter S. Prideaux, *Memorials of the Goldsmiths Company, 1335–1815,* 2 vols. (1896–1897).

4. See C. M. Clode, *Memorials of the Guild of Merchant Taylors* (London, 1875), 208; O. J. Dunlop, *English Apprenticeship and Child Labour* (London, 1912), 157–71; Hatton, *New View,* 2: 611–12.

5. The Merchant Taylors' records give that address for Gamble in March 1712/13; he first appears in the rate books on 30 September 1714 when the second rate was paid, and so may have sublet a shop before becoming a householder. See the St. Martin-in-the-Fields poor rate books (Charing Cross Division), in the Westminster Public Library (MSS. F445–8, 450, 452, 454, 5536, 5554).

6. *Boyd's Register of Apprentices,* Guildhall Lib., 2017, 4501. Hogarth does not appear in this index, not having completed his service.

7. See Dunlop, *English Apprenticeship,* 172–98.

8. Old Nollekens's recollection of "frequently" having seen "Hogarth, when a young man, saunter round Leicester-fields, with his master's sickly child hanging its head over his shoulder" must be judged against the facts that Nollekens did not come to England until 1733 and that Gamble appears to have had no children before or during Hogarth's apprenticeship, though there were some in the 1720s. (Told by J. T. Smith, never too reliable him-

self, 2: 270.) As to the Gamble children: St. Anne's Baptismal Register shows that Thomas was born 29 Mar. 1725 and baptized 6 Apr.; and Margaret was born 19 Feb. 1725/26 and baptized 20 Feb. (Westminster Public Library).

9. Daniel Defoe, *Complete English Tradesman* (1738 ed.), 143. For runaway apprentices: *Daily Courant,* 27 Feb. 1717/18, 10 Sept. 1714 (he stole gold, silver, and "a parcel of linen and other goods") and 11 Sept. 1714; *Flying Post,* 14–16 Sept. 1714; *Post Boy,* 23–25 Sept. 1714 and 5–7 Oct. 1714; and *London Gazette,* 30 Mar.–2 Apr. 1717.

10. *Post-Boy,* 17–19 Dec. 1713.

11. See Lincoln B. Faller, *Turned to Account: The Forms and Functions of Criminal Biography in late Seventeenth- and Early Eighteenth-Century England* (Cambridge, 1987).

12. *Gen. Works,* 1: 24; also in the earlier editions.

13. Pliny, *Historia Naturalis,* 34.61; Plutarch, Overbeck, no. 1480; Ernst Kris and Otto Kurz, *Legend, Myth, and Magic in the Image of the Artist* (New Haven, 1979), 14–15.

14. Nichols describes his informant as a "person of indisputable character, and who continued his intimacy with Hogarth long after they both grew up into manhood" (Felix Pellett?). *Gen. Works,* 13–14.

15. *Della Pittura,* in *Leone Battista Albertis kleinere kunsttheoretische Schriften,* ed. Jantischek, 151; trans. Anthony Blunt, *Artistic Theory in Italy 1450–1600* (Oxford, 1964), 15.

16. Sir Joshua Reynolds, *Discourses on Art,* ed. Robert R. Wark (New Haven, 1975), 124.

17. For the Simonides story, see Quintillian, *Institutia Oratorio,* 11.11.14–16. See Frances Yates, *The Art of Memory* (Chicago, 1966). On these matters I am indebted to my student Veerle Thielemans's exhaustive research.

18. See the relevant Sun Insurance Policies, Guildhall Library; my thanks to S. B. Turner and R. B. Barker.

19. Gamble's bankruptcy was announced in the *London Gazette* of 2–6 and 16–20 Jan. 1732/33; see also *GM,* 3 (1733): 48.

20. See Tessa Murdoch, *The Quiet Conquest: The Huguenots, 1685 to 1985* (Museum of London, 1985).

21. See Oman, *English Domestic Silver,* and Ann Forester, "Hogarth as an Engraver on Silver," *Connoisseur,* 152 (1963): 113–16. Panton Betew, according to J. T. Smith, "a silversmith of the old school" who also dealt in pictures and drawings, "was intimate with Hogarth, and frequently purchased pieces of plate with armorial bearings engraved upon them by that artist, which he cleared out for the next possessor; but, unfortunately for the Stanleyean Collection, without rubbing off a single impression. This was

not the case with Morison, a silversmith, who at that time lived in Cheapside; he took off twenty-five impressions of a large silver dish, engraved by Hogarth, which impression he not only numbered as they were taken off, but attested each with his own signature" (J. T. Smith, 1: 164).

22. Rate books for St. Bartholomew the Great, Guildhall Lib.; St. Bartholomew's Burial Register, Guildhall Lib. MS. 6781/1, 5. His burial at St. Bartholomew's proves that he lived on the south side of Long Lane, the only part that lies in the St. Bartholomew's parish. Administration of his estate was dated 23 May 1718, and Anne was named his executor (Guildhall Lib. MS. 9050/20, 237). "Widow Hoggarth" is assessed 0/15/2 in 1718; 1720, 0/6/6; 1723, 0/10/10; and 1724, 0/10/10. There are no more poor rate books until 1734, by which time she had gone. But she continues to appear in the Land Tax Books as late as 31 Aug. 1728; she is gone by the next assessment, 20 Sept. 1729. Guildhall Lib. MSS. 11316/80: 1725, assessed 8*s;* 11316/83: 1726, 8*s;* 11316/86: 1727, 15*s;* 11316/89: 1728 (31 Aug.), 12*s;* 11316/92: 1729 (20 Sept.), her name has been replaced by a Wm. Jarvis, at 12*s.*

23. Edmund Hogarth's will was probated 27 Feb. 1718/19 (Records of the Archdeacon's Court; Guildhall MS. 9051/11, f. 119–22). He writes, "being sick and weak in body" but of sound mind, he bequeaths to his niece Ann Arey, £30; to niece Abigail Arey, £10; to brother William Hogarth "one Shilling if lawfully demanded and nothing else of mine"; and the same to his sisters Agnes (wife of Richard Rose), Anne, and Anne Hogarth. All the rest went to his widow Sarah, and the will was signed and witnessed 14 February 1718/19. Sarah Hogarth's will, signed and witnessed 9 June 1719, was probated 12 June 1719 (ibid., ff. 198–201).

24. Gerard de Lairesse, *Het Groot Schilderboek* (Amsterdam, 1707), trans. J. F. Fritsch, *The Art of Painting in All Its Branches* (London, 1738), bk. 12, 630; Richardson, *An Essay on the Whole Art of Criticism as it relates to Painting* (1719), in *The Works of Jonathan Richardson* (1773), 233.

25. This is what William M. Ivins called "a sort of rudimentary grammatical or syntactical system" for engravers (*Prints and Visual Communication* [London, 1953], 66).

26. Ibid., 67.

27. See *Post Boy,* 29 Aug.–1 Sept. and 15–17 Dec. 1713; *Daily Courant,* 26 Jan. or 2 Feb. 1711/12.

28. *Analysis,* 9.

29. Quoted, Nichols, *Literary Anecdotes,* 8: 653.

30. William Faithorne, *The Art of Graveing, and Etching, wherein is exprest the true way of Graveing in Copper. Also the manner & method of that famous Mr. Callot, & Mr. Bosse, in their Severall ways of Etching* (1662), opp. 22.

31. On Toland's relations with Harley, see 345n55; on Hogarth's deistic tendencies, see below, chap. 9; see Thomas B. Howell, ed., *A Complete Col-*

lection of State Trials and Proceedings . . . (1809–1828), 13: 918–30; and Sullivan, *Toland*, 10–22.

32. For a full account, see *HGW*, nos. 28–42 [19–33].

33. *Daily Courant*, 18 Feb. 1723/24; *Daily Post*, 17 Mar.

34. Reprinted in *Universal Museum* (1764), 549, and in *Gen. Works*, 1: 15.

35. *Gen. Works*, 1: 15.

3. "THE BAD TASTE OF THE TOWN"

1. Of all the Bubble prints listed in *BM Sat.* (roughly from nos. 1610 to 1722), no more than two or three are in any sense original, and these too may derive from lost Continental originals. For my remarks on the political situation at this time, I am indebted to Nicholas Rogers, "Popular Protest in Early Hanoverian London," *Past and Present*, No. 79 (May 1978), reprinted in Paul Slack, *Rebellion, Popular Protest and the Social Order in Early Modern England* (Cambridge, 1984), esp. 292–93. For the account of the South Sea Bubble, see John Carswell, *The South Sea Bubble* (London, 1960), esp. 141–42.

2. Thornhill's signature is on a transfer of £2000 of South Sea stock (Maggs Cat., 1925, no. 2413, in Whitley Papers, BL). Unless he reinvested, he came out of the South Sea Bubble ahead.

3. One wonders if Hogarth meant something "more" by "Destruction" in his superimposition of the "South Sea" on the Roman Catholics on the Fire Monument: both were associated with (and derived from) France. Daniel Defoe's *Journal of the Plague Year* (1722) played on the same analogy between London's disasters to the City of the 1660s (in his case, the Great Plague of 1665) and the moral and political disaster of 1720.

4. On one of the innumerable packs of Bubble cards three priests are shown dealing in stocks; one of them says that "the Care of Stock is better than the care of Souls." A poem of 1720 makes the equation Hogarth makes between shepherd and flock: "The Country Pastor leaves his slighted Flocks, / Hastes to the *Change,* and barters in the Stocks" (J. B., *A Poem Occasion'd by the Rise and Fall of South Sea Stock* [1720], 15).

5. Dabydeen 1987, 21–27.

6. For this thesis, see Dabydeen 1987. *The South Sea Scheme* also offers one source—and the earliest in Hogarth's published work—for the biblical analogy that runs through the *Harlot* (as *The Lottery* can be said to introduce the classical analogy that also informs the *Harlot*). But these facts about *South Sea Scheme* had been pointed out long ago; Dabydeen's contribution is to connect them specifically with the body of South Sea satires of 1720–1722.

7. On a satiric card reproduced in J.R.S. Whiting, *A Handful of History* (London, 1978), 171; cited, Dabydeen 1987, 31.

8. As in the satiric print, *Britannia Stript by a South Sea Director* (*BM Sat.* 1720), which shows "how a crafty vile Projector picks / Britannia's purse, by South Sea shams and tricks"; or in Defoe's reference to men who "turn Cheats and Pick-Pockets in *Exchange-Alley*" who would be honest citizens anywhere else (*Commentator,* 10 June 1720, quoted by Paula Backscheider, *Daniel Defoe* [Baltimore, 1989], 453).

9. *Daily Post,* 8, 11 June 1720; *Original Weekly Journal,* 16 July 1720, 3 Sept.; *Weekly Journal,* 5 Mar., 3 Sept. 1720; *Applebee's Original Weekly Journal,* 3 Sept. 1720; cited by Dabydeen 1987, 30.

10. First identified by Nichols in *Biog. Anecd.* (1785), 177.

11. Attributed to Richard Morley: see J. V. Guerinot, *Pamphlet Attacks on Alexander Pope, 1711–1744* (London, 1969), 80–82.

12. Thomas Cooke, whose *Hesiod* he illustrated a couple of years later, attacked Pope in *The Battle of the Poets* in 1725.

13. The surviving advertisement for *The Lottery,* identified only as by the author of "the Taste of the Town" (*Masquerades and Operas*), gives the outlets as "the corner of Hemmings Row[,] in Little Newport-street, and most other print Shops." Hemmings Row was (as the *Masquerades and Operas* ads show) the address of Hennekin. The Little Newport address was Hogarth's (*Daily Post,* 19 Sept.).

14. See Vincent Carretta, *The Snarling Muse: Verbal and Visual Political Satire from Pope to Churchill* (Philadelphia, 1983), e.g., 26.

15. *Shaftesbury's Second Characters,* ed. Benjamin Rand (Cambridge, 1914), 48, 58.

16. *Pasquin,* 18 Feb. 1723/24; *Daily Courant,* 24 Feb.

17. E.g., *The Conduct of the Stage Considered, with Remarks on the Pernicious Consequences of Masquerades* and *An Essay on Plays and Masquerades.*

18. *Spectator* Nos. 8, 14; cf. Henry Fielding, *The Masquerade* (1728), 3. For a larger interpretation of the significance of the masquerade in this period, and especially applicable to Hogarth, see Terry Castle, *Masquerade and Civilization: The Carnivalesque in Eighteenth-Century English Culture and Fiction* (Stanford, 1986).

19. *A Sermon Preached before the Societies for the Reformation of Manners,* 6 Jan. 1723/24; quoted by Norman Sykes, *Gibson,* 188.

20. See *Mist's Weekly Journal,* 15 Feb. 1718; also Phillips, figs. 111, 366; "Memoirs of J. J. Heidegger," *LM,* 48 (1779): 452–53.

21. *Weekly Journal or Saturday's Post,* 21 Sept. 1723.

22. It is important to notice that Hogarth shows the Lincoln's Inn Fields Theatre, with its western entrance, which stood in the center of the south side of Lincoln's Inn Fields (see Phillips, 192, fig. 262). He does not show

Drury Lane, as he might have been expected to, considering the books being carted away. The question of Drury Lane's particular problem apparently did not engage his interest until the fiasco of *Harlequin Sheppard* (see fig. 33).

23. *Daily Post,* 1 Mar., 18 May; *Daily Courant,* 18 Oct.; *Daily Post,* 16 Dec. 1723.

24. Hogarth's solution was later picked up by Fielding in *The Author's Farce* (1729): "since everyone has not time or opportunity to visit all the diversions of the town, I have brought most of them together in one" (III. 37–39).

25. *Daily Courant,* 28 Sept. 1723; also *Weekly Journal or Saturday's Post,* 2 Feb. 1722/23.

26. *London Journal,* 2 Feb. and 2 Mar. 1722/23.

27. *Weekly Journal, or Saturday's Post,* 9 Mar. 1722/23 and 24 Aug. 1723; *London Journal,* 19 Oct. 1723.

28. *Weekly Journal or Saturday's Post,* 5 Jan. 1723/24, and again 9 Feb.

29. See "List of Subscribers to the Royal Academy of Musick," P.R.O., LC. 7/3; *Gen. Works,* 2: 26.

30. See, e.g., *BM Sat.* 1718, 1611, 1612, 1621, 1627. The connection is made by Dabydeen 1987, 44.

31. *The Battle of the Bubbles* (1720) had lamented that Englishmen "ran Mad and Transfer'd all their Wealth and Substance to Foreigners and Strangers."

32. *Weekly Journal, or Saturday Post,* 5 Jan. 1722/23; *London Journal,* 2 Mar. 1722/23, which notes that opera tickets "are traded in at the other End of the Town, as much as Lottery Tickets are in Exchange Alley." See also *Daily Courant,* 18 Apr., where the disposal of the South Sea directors' libraries is followed by news of a new opera at the Haymarket, and 6 and 8 August for juxtaposed notices of pantomimes and sales of ex-directors' property; cited, Dabydeen 1987, 44–45.

33. *London Journal,* 28 Dec. 1723.

34. See Roger de Piles, *The Art of Painting* (London, 1798 ed.), 18; *Spectator* Nos. 229, 244, and 592.

35. Jonathan Richardson, *An Argument in Behalf of the Science of a Connoisseur* (1719), 6.

36. James Lees-Milne, *Earls of Creation, Five Great Patrons of Eighteenth-Century Art* (London, 1962), 227–28. For Kent, see Margaret Jourdain, *Work of William Kent* (London, 1948) and also Michael I. Wilson, *William Kent: Architect, Designer, Painter, Gardener, 1685–1748* (London, 1984).

37. Lees-Milne, *Earls of Creation,* 104–12, 229–30.

38. Iolo A. Williams, "Sir James Thornhill's Petition," *Bookman,* 86 (Apr. 1934). For the perpetuation of the myth, see, e.g., H. M. Colvin, *The*

History of the Kings Works, 5 (London, 1976): 199, who also claims that as Serjeant Painter, Thornhill had a right to the job.

39. The "Letter concerning Design" was not published until it was appended to the fifth edition of the *Characteristics* in 1732. One can assume, however, that it was read in manuscript by the dedicatee, Lord Somers, and his circle; and that its contents were known to a larger circle. (See *Shaftesbury's Second Characters,* xvi–xvii.)

40. *Second Characters,* 20–22.

41. For Kent's history paintings for Burlington House, see Croft-Murray, "Decorative Paintings for Lord Burlington and the Royal Academy," *Apollo,* 89 (1969): 14–16, figs. 6–8.

42. See J. M. Beattie, *The English Court in the Reign of George I* (Cambridge, 1967), 113–15. I am also indebted to Alan Fausel (see 354n2).

43. See H. M. Colvin, ed., *The History of the King's Works,* 5 (London, 1976): 72. For Vertue on Thornhill's attempt: 3: 114; and Vanbrugh's response, see H. M. Colvin, *A Biographical Dictionary of British Architects 1660–1840* (London, 1978), 825–26.

44. See a drawing by Thornhill for the Cube Room in the V & A: Colvin, *History of the King's Works,* 198. At Moor Park between 1725 and 1727, he painted canvases that were set into the architecture rather than painting directly on the wall (as had been his custom). A drawing for the hall at Moor Park is reproduced by Edgar de N. Mayhew, *Sketches by Thornhill in the Victoria and Albert Museum* (London, 1967), no. 37. The same procedure was followed in the chapel at Wimpole: see Brian Allen, "Thornhill at Wimpole," *Apollo,* 122 (1985): 204–11.

45. See *The Birth of a Consumer Society: The Commercialization of Eighteenth-Century England,* ed. Neil McKendrick, John Brewer, and J. H. Plumb (Bloomington, 1982), esp. chaps. 1 and 5.

46. Thomas Davies, *Memoirs of the Life of Garrick,* 3d ed. (1781), 331, 92.

47. *The Case of Designers, Engravers, Etchers, &c. stated. In a Letter to a Member of Parliament* (n.d., probably late 1734 or early 1735); a copy is in the V & A.

48. *HGW* 1965, 1: 92; *HGW* 1989, 39–40, 47; *Daily Courant* 24 Feb. 1723. No record, of course, survives in the rate books since Hogarth would have been a subtenant. There are unsubstantiated traditions that he spent some time in 1719 in Cirencester at the Ram Inn (*Notes & Queries,* 6th ser., 63 [1881]: 25, 71, 72, 136, 156) and at the Elephant and Castle in Fenchurch Street (a print, showing the house front, was published by A. Beugo, 38 Maiden Lane, Covent Garden, 6 Apr. 1812; in the Nichols Collection, Fitzwilliam Museum, vol. 5). He is also supposed to have lived at one time over the shop of a colorman named Robb at No. 64 St. Martin's Lane (Holden Macmichael, *Charing Cross* [London, 1906], 321) and has been connected

with the "Bull and Bush" Inn at North End, Hampstead, where a yew bower in the garden was attributed to his planting (W. Baines, *Hampstead* [London, 1890], 233).

4. A NATIVE ENGLISH HISTORY PAINTING

1. William Aglionby, *Painting Illustrated* (1685), xiv.

2. The day is given on the portrait by Richardson in the BL. The basic work on Thornhill's life is still the dissertation by W. R. Osmun, "A Study of the Works of Sir James Thornhill" (Univ. of London, 1950), but Alan Fausel is working on a more accurate and up-to-date account (a Stanford doctoral dissertation), to which I am also indebted. The earliest contemporary biography is contained in Antoine Dézallier d'Argenville's *Abrégé de la vie des plus fameux peintres* (Paris, 1745), 2: 227–30. Dézallier knew Thornhill in London (he gives his birth date as 1676) and describes his father's gentlemanly poverty. The second life of Thornhill, in J.B., *The Lives of the Most Eminent Modern Painters who have lived since, or were omitted by, Mons. De Piles* (London, 1754), 136–39, is merely a translation of Dézallier with a few added facts and corrections (e.g., that Thornhill had a son and daughter, not daughters only). For fuller annotation of the pages on Thornhill, I refer the reader to the first edition of *HLAT* and to Osmun's and Fausel's dissertations. Croft-Murray's first volume is also useful for information on Thornhill's various projects.

3. For his family, which went back to the thirteenth century, see John Hutchins, *The History and Antiquities of the County of Dorset,* 3d ed. (London, 1861–1873), 4: 73. His mother was daughter of William Sydenham, a parliamentary colonel and member of Cromwell's government; his apprenticeship was purchased with the bequest of Dr. Thomas Sydenham. See Kenneth Dewhurst, *Dr. Thomas Sydenham (1624–1689): His Life and Original Writings* (Los Angeles, 1966), 23, 56; Hutchins, *History and Antiquities,* 4: 417. For evidence of his father's abandonment, see Joan Brocklebank, "The Childhood of Sir James Thornhill," *Somerset Notes and Queries,* 30, No. 301 (March 1975): 73–82.

4. *GM,* 40 (Nov. 1790): 992.

5. See Osmun, 167; P.R.O. Patent Rolls, No. 15, 3d ser., 13 Apr. 1720; 6th year of George I, Index/6821.

6. *Minute Books of the Painter-Stainers Company,* 2: 1649–1793, 430; Guildhall Lib., M.S. 5667/2. Thornhill obtained membership also for his son John by redemption, but Hogarth, despite his close connection, never involved himself with the Painter-Stainers. (He is not to be confused with the William Hoggard, a tea warehouseman of Bow-Lane, who was admitted 18 November 1729 [Guildhall Lib. MS. 5667/2, 470].)

7. Thornhill wrote on one of his drawings, now in the Witt Collection, "Library Ciel, for Huggins, for a lady &c." (Croft-Murray, 1: 270); see *Gen. Works,* 1: 44. The date of the work is unknown, and it may have been done for son William, to whom John gave Headley Park, ca. 1725. See L. F. Powell, "William Huggins and Tobias Smollett," *Modern Philology,* 34 (1936): 183. More interesting, however, either Vertue had forgotten that the history paintership came two years before the knighthood, or he was suggesting that Huggins was responsible from the start for Sunderland's patronage of Thornhill.

8. Colvin, *Biographical Dictionary,* 824–26.

9. See Hutchins, *History and Antiquities,* 3: 625. His political patron was George Bubb Dodington, for whom he had painted a ceiling at Eastbury Park: See *DNB,* 16: 166.

10. According to Hutchins, *History and Antiquities,* 3: 675.

11. *Daily Courant,* 30 Oct. 1719; 5 Feb. 1719/20; *Post Boy,* 3–5 May 1720.

12. For the framed set, see Jane Hogarth's sale catalogue (25 Apr. 1790), no. 64, plus a great many sets, presumably inherited from Sir James (nos. 61–63, 67).

13. Vertue, 3: 7; 6: 168–69.

14. Whitley, 1: 13; though, as usual, Whitley does not give his source, and I have not found it.

15. Lord Michael Morris Killanin, *Sir Godfrey Kneller and His Times, 1646–1723* (London, 1948), 26. Again, no source is given.

16. Walpole Society, 22 (Oxford, 1934): 92; Whitley, 1: 12–13.

17. Vertue, 3: 74.

18. Whitley, 1: 14.

19. *Apology for Painters,* 93; Vertue, 6: 170.

20. Vanderbank was born 9 Sept. 1694 (Baptismal Register of St. Giles in the Fields, 16 Sept.). See Vertue, 3: 15; 6: 170; H. A. Hammelmann, "A Draughtsman in Hogarth's Shadow: The Drawings of John Vanderbank," *Country Life,* 141 (1967): 32–33; H. A. Hammelmann, "Eighteenth-Century English Illustrators: John Vanderbank," *Book Collector,* 17 (1968): 285–99. The portrait of Sanderson was painted for Martin Folkes, engraved by Faber (Chaloner-Smith, no. 316); for the staircase of No. 11 Bedford Row, see Croft-Murray, 1: 260, pls. 122–24. A self-portrait, a pen sketch, is in the V & A.

21. Vertue, 3: 22; Croft-Murray, 1: 244; will, in French, dated 25 Jan. 1723/24, codicil 14 Jan. 1724/25 (P.C.C., Romney, 1301). Vertue says he was an original member of Kneller's academy (3: 68), but does not include him in his list (6: 168–69).

22. Rate books, Parish of St. Martin in the Fields, Westminster Public Library.

23. Perhaps most readily available to Hogarth in *Conférences . . . sur l'expression générale et particulière, enrichée de figures gravées par B. Picart* (Amsterdam and Paris, 1698; trans. London 1701). Hogarth comments on Le Brun's "Characters of the Passions" in his *Analysis,* 138.

24. Thomas Page, *The Art of Painting* (1720), 17.

25. Anthony Blunt, *Art and Architecture in France 1500–1700,* 2d ed. (London, 1957), 201.

26. *Analysis* (rejected passages), 185.

27. *Analysis,* 184; AN, 207–08, 202.

28. *Gen. Works,* 1: 242, 24; Oppé, Introduction, esp. 13, and cat. nos. 30, 88.

29. *Analysis* (rejected passages), 185.

30. *Analysis,* 185, 195.

31. John Elsum, *The Art of Painting after the Italian Manner* (1703), 66, 138.

32. Lairesse, *Het Groot Schilderboek,* trans. *Art of Painting,* chap. 2, 102.

33. Richardson, *Works,* 119.

34. Vertue, 3: 138, and for the following paragraph: 3: 62, 39, 54, 33, 37.

35. See Louise Lippincott, *Selling Art in Georgian London: The Rise of Arthur Pond* (New Haven, 1983).

36. Vertue, 6: 170; Hogarth, *Apology for Painters,* 93.

37. *Apology for Painters,* 93, 95; see also Vertue, 3: 21.

38. Thornhill is mentioned every year in the poor rate books from 1722 till his death in 1734 as living on the north side of Covent Garden east of James Street. Until 1726 the house next to him was owned by his political patron, George Bubb Dodington (overseer of the Poor Accounts, 1722–1735, Westminster Public Library). Thornhill appears listed in the Freeholders' Book for 1728 (Middlesex County Record Office), so must have owned the property by that time. The room that he added, according to E. Beresford Chancellor (*Annals of Covent Garden,* [London, n.d.], 249), faced on James Street. But this is impossible to connect with the house attributed to him in the rate books.

39. Vertue, 3: 30 (written in 1726).

40. Attributed to Thornhill by Matthew Prior, *Wren Society,* 17 (1940): 11–12. Thornhill included portraits of the "club"—besides Prior, the second earl of Oxford, Christian the seal engraver, Tudway the musician, Gibbs the architect, and Bridgeman the gardener. (See Sir John Hawkins, *A General History of . . . Music* [London, 1776], 5: 93; Vertue, 3: 27.)

41. *Weekly Journal or British Gazetteer,* 9 May; *Daily Journal* and *Daily Post,* 11 May 1724.

42. *A Tale of a Tub* (1704), ed. A. C. Guthkelch and D. Nichol Smith (Oxford, 2d ed., 1958), 79.

43. See *BM. Sat.* 1620, 1630, etc.; cited by Dabydeen 1987, 49–50, who

makes the connection between this print and the South Sea satires.

44. When I first discovered this print I speculated (*HGW* 1965, no. 9) that it might celebrate the semireconciliation of the Prince of Wales with his father in April 1720, which was given much publicity at the time. Derek Jarrett (58–59) took up my suggestion and argued strongly for this date, which I had come to question in the earlier edition of this biography (*HLAT*, 1: 124). Dabydeen discovered a second version of the design, by another artist (BL, G13, 782/1–8), and has argued for the earlier date (1987, 18–19, 151–58). My response was in *Eighteenth-Century Studies* (*ECS*), 22 (1988): 90–95, and *HGW* 1989, no. 54 [9]. There is not really any evidence in the print for the occasion of the "reconciliation." And to suppose the dating of spring 1720 one has to suppose too much: that Hogarth executed this fairly complicated original print in the same month he issued his shop card, before any other datable print. We also have to suppose that he worked so rapidly as to learn of the reconciliation on 23 April (St. George's Day) and have it out before the sham was exposed. Finally, what first led me to assign the later date: the style is clearly not before the *South Sea Scheme* but around the time of *The Lottery*.

45. See "The Minutes of the Grand Lodge of Freemasons of England 1723–1739," introduction and notes by W. J. Songhurst, in *Quatuor Coronatorum Antigrapha*, 10 (1913). Thornhill appears in the MS. List of 27 Nov. 1725 (Lodge no. 25 in the Engraved List of 1729; see 40, 69, 198). This lodge was constituted in 1723 but does not appear in manuscript lists until 1725 (xiii). It is safe to assume that Thornhill had been a member since its organization, and further, that he chose Greenwich because he had lived there while working on the hospital.

46. The first MS. list in which Hogarth appears is that of 27 Nov. 1725 (Lodge no. 41 in the Engraved List of 1729; see 43). See Songhurst, *Quatuor*, 43, and Eric Ward, "William Hogarth and His fraternity," *Ars Quatuor Coronatorum*, 77 (1964): 1–18.

47. Margaret Jacob, *The Radical Enlightenment: Pantheists, Freemasons and Republicans* (London, 1981), 111; see chaps. 4 and 5. For an account of John, duke of Montagu, see 132–33; for the duke of Wharton, see 128–29 and notes. There were radical, subversive elements in the Freemasons (as well as Jacobite), but Freemasonry was not itself "ever perceived as a threat to the established institutions of either church or state" (113). See also A. S. Frere, *The Grand Lodge, 1717–1967* (Oxford, 1967).

48. Jacob, *Radical Enlightenment,* 116, 119.

49. Ward, "William Hogarth," 1.

50. See Dorothy Ann Lipson, *Freemasonry in Federalist Connecticut* (Princeton, 1977), 39.

51. Wharton did emigrate to France and became the first grand master of French Freemasonry (see Jacob, *Radical Enlightenment,* 128–29).

52. See, e.g., Alciati's *Emblemata* (1661), emblem 7; Apuleius, *Metamorphoses*, 8.

53. Gould, *Concise History*, 288; repeated by Ward, "William Hogarth," 15.

54. Judith Colton drew my attention to this aspect of Freemasonry in an unpublished paper. See also Douglas Knoop, G. P. Jones, and Douglas Hamer, *Early Masonic Pamphlets* (Manchester, 1945), 105–7, 185–93.

55. *Weekly Journal or Saturday's Post*, 24 Oct.; *Daily Journal*, 10 Nov. 1724.

56. David Piper, *The English Face* (London, 1957), 182. Another example of Thornhill's interest in the contemporary is his inclusion in the vestibule at Greenwich of grisaille paintings of orphans in contemporary dress, used as supporters of the list of benefactors of the hospital.

57. The drawing in the BM (1400–10–18–4) is of head and shoulders only; I know of no other surviving drawing, and there was apparently no painting. The delicate, effeminate Sheppard was indeed sometimes played by actresses because of the narrow spaces through which he had to crawl to make his famous escapes.

58. *Weekly Journal or Saturday's Post*, 5 Dec.

59. Ibid.; also *Daily Journal*, 5 Dec., and *Daily Post*, 9 Dec., which adds "Price 1 *s.*"

60. *Daily Post*, 30 Nov.

61. See John Loftis, *Steele at Drury Lane* (Berkeley and Los Angeles, 1952), 74–85, also 88–89.

62. Thornhill's dilemma as history painter was perhaps more complex than I have suggested: seventeenth-century academic theory of decorum required a certain degree of accuracy. If George had landed in the winter, ice should be on the water, and the number of those landing with him should not be falsified (see, e.g., André Felibien, *Entretiens*, 2d ed. [Paris, 1685–1688], 2: 381).

63. *The Conversion of Paul* is freely based on Rubens's versions of the story (Berlin and Munich). The figure of Paul is closest to the Munich Rubens, but using Raphael's Paul (*Paul Preaching at Athens*) for the upper torso, Thornhill has raised the arm (receding from the spectator in Rubens) so that it is over Paul's head in the same plane with his body.

64. Sydney Freedberg, *Painting of the High Renaissance in Rome and Florence* (Cambridge, Mass., 1961), 4.

65. Bird had connections with the Kneller academy, probably with Gibbs, and also certainly with Thornhill through the work on St. Paul's and their mutual patron Edward Harley, second earl of Oxford (see Margaret Whinney, *Sculpture in Britain* [Baltimore, 1964], 77).

66. Even in the Greenwich ceiling, Thornhill replaced the infinite opening of the heavens by confining it within an oval frame, showing everything frozen in a kind of divine stasis within a relatively shallow perspective space. The limitless height is canceled by a canopy over the main group, cutting

them off visually from the heavens. What we see there is a lowering and controlling, in effect a humility, that is both Protestant and a mundane version of what could be seen in Italy and France.

67. *Trivia* 2.488.

68. Mario Praz, *Studies in Seventeenth-Century Imagery* (2d ed., Rome, 1964), 1: 155.

69. *Emblemata* (1571 ed., Leyden, 1593), 17–25.

70. Cesare Ripa, *La novissima iconologia* (Padua, 1625), sigs. B–B2.

71. Thornhill must have told Steele what to write (in *The Lover,* 11 May 1714) about the complex Greenwich iconography and then based the hospital's pamphlet on Steele's essay. Steele's explanation covers only the Painted Hall. The *Explanation* by Thornhill was first ordered to be printed in one thousand copies by the directors on 10 December 1726, and again on 20 August 1730 and 4 July 1741. It was printed in English with French on the facing page. This may have served as the authority and model for Hogarth's explanations of his prints that began to appear in French in the 1740s.

72. See No. 226 on art as a moral instrument; he refers to his earlier pleas in Nos. 142 and 172.

73. Defoe, discussing the Cartoons in his *Tour* (1: 10–11), singles out *Paul Preaching* and the *Death of Ananias* because of the passions depicted; Sir Richard Blackmore also draws attention to Ananias "struck dead in an Instant by the breath of an Apostle," which serves to give the viewer "awful Impressions of Divine Vengeance" ("The Parallel between Poetry and Painting" in *The Lay Monastery,* 1714, 188).

74. Again in No. 244 Steele talks (in a feigned letter) about the Cartoons: "Other Pictures are made for the Eyes only, as Rattles are made for Childrens Ears; and certainly that Picture that only pleases the Eye, without representing some well-chosen Part of Nature or other, does but shew what fine Colours are to be sold at the Colour-shop, and mocks the Works of the Creator."

75. See Albert Rosenberg, *Sir Richard Blackmore* (Lincoln, Neb., 1953), 81–83.

76. The major passages are: *Works* (1773), 62–63, 96, 252, 276. For his praise of Thornhill, a "Friend of ours (Mr. Thornhill, an excellent history painter)," and an elaborate analysis of Poussin's *Trancred and Erminia,* in Thornhill's collection, see *Essay on the Art of Criticism,* in *Works,* 192.

77. *Science of a Connoisseur,* in *Works,* 274.

78. I am indebted to Thomas Crow, *Painters and Public Life in Eighteenth-Century Paris* (New Haven, 1985), 4.

79. Mercier, *Tableau de Paris,* paraphrased by Crow, 21.

80. See above, 19, on this sort of travesty in the London fairs.

81. Hogarth had some of these; see Jane Hogarth's sale catalogue, no. 30.

82. *Analysis*, 132n; see also Dézallier, *Abrégé*, 229.

83. P.R.O., Treasury Papers, 252, (June–Dec. 1725).

84. P.R.O., Treasury Minutes Book, 25, (1725–May 1727): 113.

85. Announced, *Daily Courant*, 10 Sept.; I have used the text printed by Nichols, *Gen. Works* 1: 457–63.

86. That Kent's altarpiece remained in the vestry room and was there in 1789 is attested to by *GM,* 59 (1789): 391.

87. In the Yale University library; reproduced, C. F. Burgess, *The Letters of John Gay* (Oxford, 1966), 53–54.

88. Kent's close association with Gay and Pope was not without effect. As Jeffrey P. Eicholz ("William Kent's Career as Literary Illustrator," *Bulletin of the New York Public Library,* 70 [1966]: 520–46) has argued, Kent grasped and conveyed Gay's intention in his plates for *The Shepherd's Week*—an intention not unlike Hogarth's in some of his independent plates.

89. Joseph Burke, *English Art 1714–1800* (Oxford History of English Art; Oxford, 1976), 96.

90. For *Paradise Lost,* see *HGW* 1989, nos. 64–65. The illustrations, though evidently intended for an edition Jacob Tonson the younger was bringing out, found no buyer. Thornhill had furnished designs for Tonson and may have been Hogarth's sponsor. To correct *HGW:* the 1725 edition had only a frontispiece portrait of Milton by Vertue. The 1727 may have been the one for which Hogarth projected his sample illustrations; it was the right size and appeared with illustrations signed P. Fourdrinier, copies of the Henry Aldrich illustrations (1688) and not the subjects Hogarth chose. (There is also an allegorical frontispiece engraved by Vertue.) The 1730 edition uses the same designs but reduced and reengraved. Hogarth's two plates would thus seem to have been an attempt at new subjects and new designs that did not convince Tonson, who retained the old, tried ones. A 1724 edition was published by George Grierson in Dublin with fold-out plates, the ones for Books 2, 4, 5, and 7 signed "James Gwin sculpsit" (3 3/4 × 6 3/4 in.).

91. See Paulson, *Satire and the Novel* (New Haven, 1967), 115–21; and Paulson 1982, 13–24. The historical question of the way a theory of comedy (as opposed to satire) developed in the eighteenth century is mentioned in *Satire and the Novel,* but the locus classicus is Stewart Tave's *Amiable Humorist* (Chicago, 1960).

92. See *Post Boy,* 13–16 July 1728.

93. *Second Characters,* 136–37.

94. Freedberg, *Painting of the High Renaissance,* 279.

95. For further detail, see *HGW* 1989, no. 83; and Laurel Brodsley's "Hogarth's Illustrations to *Hudibras*" in her Ph.D. diss. (UCLA, 1970), 92–102.

96. A copy of the subscription list for *Hudibras* is in the BM print room;

some of the names are reprinted in *Gen. Works,* 3: 321. These include Lord Compton, the earl of Derby, Sir Arthur Haslerigge, and Lord Newell; Alderman John Barber and other City names, and the engravers Kirkall, Vandergucht, and George White.

97. See Burns Martin, *Allan Ramsay, A Study of His Life and Works* (Cambridge, 1931); Alastair Smart, *The Life and Art of Allan Ramsay* [the younger] (London, 1952), 1–17. For further information on Ramsay the elder (his own ambition to be an artist, and his interest in painters and painting, especially in popular, native traditions on poetry and painting), see Iain Gordon Brown, *Poet and Painter: Allan Ramsay, Father and Son* (Edinburgh, 1984).

98. See *Christ's Kirk o' the Green,* 3: 1–9, in *Poems of Allan Ramsay* (London, 1800), 1: lxxxiii–lxxxiv, 82.

99. William Ward was the son of Thomas Ward of Houghton and matriculated at Trinity College, Oxford, 25 May 1688, aged sixteen; so he was born ca. 1672 and was roughly a classmate of Richard Hogarth's colleagues, Noble and Gibson. He was a student of the Middle Temple in 1696 and became a London barrister. He married Catherine Last sometime before 1695, when her father, Andrew Last of Thor-Underwood, died and left her his manor house of East Haddon Hall, Northampshire. Ward was evidently dead by 1737 when his son Thomas sold the house and furnishings. See *Foster's Inns of Court Register;* George Baker, *History and Antiquities of Northampton* (1822–1830), 1: 163–64.

100. *The Evening Post,* 5–7 Oct. 1725. The other references that follow are to the *Post Boy,* 30 Nov.–2 Dec., 4–7 Dec., 3–5 Feb., 26 Feb.–1 Mar. (1725/26), 30 Apr.–3 May (1726).

101. H. S. Ashbee, in *Transactions of the Bibliographical Society,* 1 (1893): 123–24. See H. A. Hammelmann, "John Vanderbank's 'Don Quixote,'" *Master Drawings,* 6 (1969): 3–15, and pls. 1–10.

102. Announced, *London Journal,* 27 Mar. 1725. Vandergucht was advertising twenty-two *Don Quixote* prints for sale in his shop in 1728 (*Daily Post,* 6 Dec.).

103. Carteret to Sir Benjamin Keene (ambassador in Madrid), accompanying a copy of Oldfield's "Advertisement" and a set of the prints, 24 Aug. 1737, in *Private Correspondence of Sir Benjamin Keene,* ed. Sir Richard Lodge (Cambridge, 1933), 7.

104. One wonders why Hogarth engraved his own designs and Vanderbank passed his on to Vandergucht (a practice Hogarth followed from 1730 on). A possibility is that Hogarth withdrew to give Vanderbank the whole commission. The latter was so seriously in debt between 1724 and 1729 that he was arrested several times and was forced to live within the Liberties of the Fleet, a situation that would have struck a responsive chord in Hogarth. Vertue has unfavorable things to say about Vanderbank as a friend, and we

have no way of knowing how his friendship with Hogarth continued, but Vanderbank must have represented to him an example of wasted talents.

105. These six plates had traditionally been dated 1738 because it was only in April of that year that Carteret's *Don Quixote* finally appeared. Carteret had a copy on 20 Apr. (*Private Correspondence,* 11); the subscription was over by 7–9 Feb. 1737/38 (*London Evening Post*); and it was published on 28 Apr. (*Daily Gazetteer*). The delay was partly due to the expense of such a large undertaking, and perhaps to Carteret's multifold activities of those years; also, there were sixty-eight illustrations, and Vandergucht's engraving of them must have taken some time, though not ten years. The excessively long delay was apparently due to the "life" of Cervantes that had to be compiled and written (Jacob Tonson's edition of Racine had also included a "life") and was not delivered until Feb. 1736/37. (See Carteret to Keene, 20 Apr. 1738; 26 Mar. 1737, in *Private Correspondence,* 11, 7.)

106. The conception may go back as far as 1724, when Hogarth first saw Beauvais's engravings of Coypel's designs; *Sancho's Feast* appears in this set in a somewhat different form, but it is plainly the model for his composition.

107. Letter from Livesay to Lord Charlemont, 18 Sept. 1786, *HMC, 13th Report,* Appendix, pt. 8, 2: 40. Cf. Hogarth's other self-profiles in *Gate of Calais* and *Hogarth Painting the Comic Muse* (paintings *and* engravings) in 1748 and the 1750s.

108. See *HGW,* no. 100 [119]. Overton published *Sancho's Feast* in conjunction with J. Hoole. They remained in partnership until 1734.

5. LEARNING TO PAINT

1. See J. B. Nichols, 349–50. The location of the *Hudibras* paintings owned by William Ward is now unknown, though others have come to light which have been dubiously attributed to Hogarth.

2. For Morris, see V & A *Catalogue of Tapestries* (1924), 19, 20; *Country Life,* 55: 656; A. F. Kendrick, *English Decorative Fabrics* (1934), 74, 76, 82; *Burlington Magazine,* 30: 147; 31: 157; 32: 210–17; W. G. Thomson, *History of Tapestry* (1930), 491–92.

3. The brief of the defendant (i.e., Morris) in the case that followed, from which I quote, is reproduced in *HLAT,* Appendix D.

4. A large lot of tapestry hangings, chairs, and fire screens belonging to Morris was advertised to be sold 15 May 1729 next door to the Golden Ball in Pall Mall (*Daily Post,* 15 May 1729). This may have included Hogarth's ill-fated painting, which at any rate has never come to light.

5. On the other hand, Moses, said to be even more profligate than John, can have had little to do with the business, which he sold in or around 1729.

His only known work is an altarpiece in Yorkshire and a single book illustration. He went bankrupt in 1734 (H. A. Hammelmann, "Vanderbank," *Book Collector,* 299). John seems the more likely, assuming he was out of debtors' prison at the time.

6. See Vertue, 3: 27. See Edith A. Standen, "Studies in the History of Tapestry: Some Exotic Subjects," *Apollo,* 113 (1981): 44–54.

7. Vertue, 3: 35–36, 46. No record of a trial between Styles and Thornhill appears for the years 1727–1730 in the Docket Books of Plea Rolls at the P.R.O.

8. Vertue, 3: 63, written in 1732. At some later time the Thornhill canvases, now cut into segments, were framed and hung along the gallery above the hall. They were not mentioned at all by Horace Walpole in his *Visits to Country Seats* (Walpole Society, 16 [1927–1928]: 24). For views (not facts), see H. A. Tipping, *English Homes, Early Georgian, 1714–60* (London, 1921), 169–82; and *Victorian Country Houses: Hertfordshire* (London, 1908), 2: 377.

9. *Gen. Works,* 1: 44; Croft-Murray, 1: 220.

10. Thornhill's assistants included Dietrich Ernst André (ca. 1680–1734?, Vertue, 4: 145) and perhaps Hogarth's friend John Ellys (Vertue, 3: 47).

11. Oppé, nos. 23, 24; pls. 20, 21. The reason Hogarth used such dark blue paper may have been because he was in a darkened theater. In the relative darkness, it would draw less attention than white.

12. Robin Simon argues, unconvincingly it seems to me, for earlier stage decorations painted by Hogarth for Bartholomew Fair ("Hogarth and the Popular Theatre," *Renaissance and Modern Studies,* 12 [1978]: 13–25).

13. For the dates of production, see C. B. Hogan, *Shakespeare in the Theatre* (Oxford, 1952), 1: 187n, and *The London Stage, 1660–1800* (Carbondale, Ill., 1960–1968).

14. See Piper, *English Face,* 136; and, for what follows, 44, 104.

15. Ibid., 130. See Lely's portrait of Barbara Villiers and her illegitimate child as the Madonna and Child; other mistresses were painted as the Magdalen and St. Barbara (copies in the National Portrait Gallery, London, and the collection of the duke of Grafton).

16. See below, 270–271.

17. See *HGW* 1965, 1: 137 (cat. no. 116). A puppet show of 1728 on the same subject was called *Mother Shipton, and The Downfall of Cardinal Wolsey.*

18. See Charles B. Realey, *The Early Opposition to Sir Robert Walpole, 1720–1727* (Lawrence, Kans., 1931), 187–92, 193–95.

19. Archibald S. Foord, *His Majesty's Opposition, 1714–1830* (Oxford, 1964), 120; *Observations on the Craftsman* (1730), 11.

20. *Daily Post,* 3 Dec. 1726 and *Evening Post,* 8 Dec. *Gulliver's Travels* was announced as published 28 Oct. (*Daily Journal, Daily Post,* etc.). There

was no advertisement for *The Punishment of Lemuel Gulliver* in the *Craftsman*, but then it published no advertisements to speak of at this time.

21. *Gen. Works*, 1: 37; 2: 52.

22. *Weekly Journal*, 19 Nov. 1726.

23. *London Journal*, 3 Dec. 1726; *Daily Journal*, 12, 23 Dec. 1726, 11 Jan. 1726/27; *Daily Courant*, 14–15, 20 Dec.; *London Journal*, 17 Dec.; and *Daily Post*, 16, 27 Jan. A flood of political pamphlets followed, including *The Anatomist Dissected; or the Man-Midwife finely brought to bed. . . By LEMUEL GULLIVER* as well as *An exact DIARY of what was observed during a close Attendance upon MARY TOFT . . . By Sir RICHARD MANNINGHAM, Kt.*, the physician who had exposed the fraud. "An Anatomical Farce" called *The Surrey Wonder* was being staged by Rich, and John Laguerre published a mezzotint portrait he had made of Mrs. Toft. For the South Sea imagery, see, e.g., *BM Sat.* 1650; Dabydeen 1987, 58–59.

24. *Political State of Great Britain*, 32 (1726): 600–601; *London Journal*, 3 Dec. 1726. Dabydeen (1987) points out that the "sooterkins" Hogarth mentions also recall *The Battle of the Bubbles* (1720), for example, in which the proliferation of projects was compared to monstrous conceptions. Avaritia, the mother of these Bubble creatures, was "a Dutch Woman, Famous for having Teem'd with many and most ill-contriv'd Sooter-kins, and that long before she curs'd the World with the Infamous Litter whereof I now treat" (58).

25. For example the portrait at Houghton of Walpole fox hunting, from the late 1720s, or Bickham's caricature (1740, BM Sat. 2458).

26. *Craftsman*, Letter to Caleb D'Anvers, dated Inner-Temple, 25 July 1727; and again, 19 June 1731 and 23 Mar. 1734. The production itself showed little sense of timing in relation to the crisis, which took place in June 1727: there was one performance in September, and not another until a year later. See *Craftsman* Nos. 8, 23, 84, 107, 136.

27. *An Explanation of the Paintings in the Royal Hospital . . .* , 8.

28. *Daily Post*, 12 Mar. 1728.

29. Richard Sothern, *The Georgian Playhouse* (London, 1948), 20.

30. Richardson, *Works*, 6. Cf. Abbé Dubos's *Critical Reflections on Poetry, Painting and Music* (1719; trans. Thomas Nugent, 1748), 1: 131–42. Hogarth's words, e.g., "Subjects I consider'd as writers do / my Picture was my Stage and men and women my actors . . ." (*AN* 209; also 210, 212, 215), virtually translate Roger de Piles's "On doit considérer un Tableau comme une scène, où chaque figure jouë son rôlle" (*Abrégé de la vie des peintres* [Paris, 1699], 43).

31. Gay, however, had a third dimension, untranslatable for Hogarth: while Macheath is standing in the pose of Hercules, singing "Which way shall I turn me?", his tune is an obscene song called "Tom Tinker's my true

Love," the chorus of which goes: "For of all the Young Men he has the best luck,/ All the Day he will Fuddle, at Night he will f . . ." By this device both classical Hercules and the contemporary gentlemanly romantic Macheath are reduced to animal libido. Gay's allusions are not emphatic; for example, he incorporated into the overture a tune known as "Walpole," but *that* title was not so well known as an earlier one, "The Happy Clown"— also applicable to Walpole—and when the tune reappears later as Air XLVII (sung by Lucy) it carries its original and best-known title, "One evening having lost my way."

32. See Hogarth's MS. list of January 1730/31, BM Add MS. 27995, f. 1. Rich must have had the *Beggar's Opera* painting by January 1730/31 or it would have been on Hogarth's list.

33. Walpole's identification is attached to the stretcher of the Rich painting, now in the Lewis Collection (Yale). For identifications of Paunceford and the others in the fifth version, see John Boydell's "key" attached to William Blake's engraving for the Hogarth folio of 1790. Walpole owned this key and it is possible that his identifications were based on it. In other words, the identifications are by no means certain.

34. Or in terms of the pastoral controversy of Pope versus Ambrose Philips, he was adopting Gay's solution in *The Shepherd's Week* of employing *both* high diction and low action.

35. *To Diabeloulomenon: Or, The Proceedings at the Theatre-Royal in Drury Lane* (1723) refers to the Lincoln's Inn Theatre and connects it with *Veluti in speculum*.

36. Antal, 60.

37. See Robert D. Hume, *Henry Fielding and the London Theatre, 1728–1737* (Oxford, 1988), chap. 2.

38. *Thievery A-la-mode*, 23–24. For pictures on fans, see *Daily Journal*, 23 May 1728; for screens, *Daily Journal*, 2 July.

39. Marvin A. Carlson, "A Fresh Look at Hogarth's *Beggar's Opera*," *Educational Theatre Journal*, 27 (1975): 30–39.

40. This is the basis of my main argument against various clumsy, thickly painted canvases that have been attributed to Hogarth's "apprenticeship" to painting. My answer to Lawrence Gowing's complaint that I had not treated Hogarth's "juvenilia" appeared in "Hogarth the Painter: The Exhibition at the Tate," *Burlington Magazine*, 114 (Feb. 1972): 71–79. There is no evidence for these canvases which is not (like Gowing's) impressionistic, based on internal evidence. The main bases for attribution are: (1) the superficial resemblance to *A Paviour's Sign* (Mellon, Yale), which is usually accepted as Hogarth's work; (2) the subject matter—*The Doctor's Visit* and *The Carpenter's Yard* show people working at professions, sometimes in what seem to be Hogarthian poses; and (3) the fact that they are painted in an impasto

version of the sketchy style of the fourth *Beggar's Opera* painting (fig. 61). To accept these works, one need not suppose that Hogarth painted much before 1727; the supposition required is that he began to paint in thick paint in the "bold manner" he later used with thin paint. But the crucial fact is that they do not resemble the earliest authentic painting, the Lewis version of *The Beggar's Opera* (fig. 59). (Nor do they resemble the *Falstaff*, but this painting seems to have been worked on until 1732.) For a convincing attribution of *The Doctor's Visit* to Heemskerk the Younger, see Elizabeth Einberg in *Tate*, no. 164, 237–38.

The *Paviour's Sign*, which does appear to be Hogarth's work, *could* be an early attempt at painting—or it could be an attempt from the 1760s at a consciously primitive style for a signboard, executed around the time of the Sign Painters' Exhibition of 1762.

41. This was my discovery at the 1971 exhibition at the Tate: see "Hogarth the Painter," 76.

42. There are a few exceptions such as the ruinously restored *Southwark Fair*: Hogarth's highlights have been replaced clumsily by a twentieth-century restorer.

43. *Art of Painting* (1798 ed.), 46.

6. CONTEMPORARY HISTORY AND MARRIAGE

1. *Report on the Committee on the Fleet* (1729), in Cobbett, 8: 708–31; J. S. Bunn, *Fleet Registers* (London 1833); *A Brief Account of the Ancient Prison called 'The Fleet'* (London, 1843), 9. For a general account, see Ashton, *The Fleet*, 230–35.

2. See John Mackay, *A True State of the Proceedings of the Prisoners in the Fleet-Prison, in Order to the Redressing of Their Grievances before the Court of Common Pleas* (London, 1729), which consists of prisoners' petitions to the Lord Chief Justice and Huggins's replies.

3. Cobbett, 8: 711; see *Weekly Journal or the British Gazetteer*, 14 Sept. 1728.

4. Cobbett, 8: 716–17.

5. *Daily Post*, 29 Jan.; the encounter took place on the 25th. See A. A. Ettinger, *James Edward Oglethorpe* (Oxford, 1936), 90.

6. Cobbett, 8: 719; *Daily Post*, 8 Feb.; *Daily Journal*, 11 Feb.

7. *Commons Journal*, 21: 237–38, 247; Cobbett, 8: 707n; *Daily Journal*, 28 Feb.; and *Craftsman*, 1, 8 Mar.

8. *Weekly Journal*, 15 Mar.

9. Cobbett, 8: 719.

10. Quennell, 77, but the only evidence is Grant's commission several months later, in November 1729, for this picture and a *Beggar's Opera*.

11. Another group portrait by Thornhill has survived (sketch *and* painting, of a somewhat earlier date, drawn to my attention by Alan Fausel), of himself in the familiar pose with arms akimbo (fig. 23); Addison is on the left and Steele on the right, with (?) Garth and Tickell between (painting, Sotheby's, July 1985). It is more in the Dutch style of half-lengths of men seated around a table than in the conversation picture mode.

12. *Commons Journals,* 21: 274–83; *London Universal Spectator,* 29 Mar.; *Weekly Journal or the British Gazetteer,* 19 Apr.; *Craftsman,* 26 Apr.; *London Journal,* 26 Apr.; *Weekly Journal,* 26 Apr.

13. *Daily Journal,* 16 May; *Daily Post,* 17 May.

14. *Weekly Journal,* 26 Apr.; *Commons Journals,* 21: 350.

15. *Commons Journals,* 21: 376–87; *Weekly Journal or British Gazetteer,* 17 May and 21 June (on the prisoners' celebration); *Daily Journal,* 24 May; and *Daily Post,* 24 May.

16. See Richard Gough, *Anecdotes of British Topography* (1789), 1: 63.

17. *Remarks on the Fleet Prison or Lumber-House for Men and Women. Written by a Prisoner* (London, 1733).

18. Quoted, Sir Lewis Namier, *England and the Age of the American Revolution* (London, 1930), 216–17. William Huggins, who did not accept his father's guilt, was convinced that politics had led to the enquiry and his father's trial. He wrote a letter to Smollett, trying to correct his account in his *History of England* (1748, 4: 527–28). See L. F. Powell, "William Huggins and Tobias Smollett," *Modern Philology,* 34 (1936–1937): 179–92.

19. Undated clipping in the Forster Collection (V & A, F.10E.3.no. 174).

20. Sir R. Phillips, *Morning's Walk from London to Kew* (London, 1817), 213.

21. *Publications of the Harleian Society,* 29 (1886): 252.

22. Marriage Register, Paddington Parish Church, in London County Council Record Office: "Married William Hogarth and Jane Thornhill both of the Parish of Saint Paul Covent Garden in the County of Middlesex by License."

23. Vertue 3: 38; *Biogr. Anecd.,* 1782 ed., 23–24.

24. Thornhill had twenty-one commissions between 1715 and 1725, and only one between 1725 and his death in 1734, finishing work on his last project in 1728. In the early 1720s he began to take a more gentlemanly approach to painting, and this meant on the one hand becoming the Raphaelesque idea man, and on the other the gentleman architect.

25. See Hogarth's "Britophil" essay, *St. James's Evening Post,* 7–9 June 1737, reprinted, *HLAT,* 2: Appendix F. For Styles's suit against Thornhill in 1728, see Vertue, 3: 35, 46; and T. P. Hudson, "Moor Park, Leoni and Sir James Thornhill," *Burlington Magazine* (1971): 675.

26. Vertue, 3: 38; cf. Croft-Murray, that Thornhill was filling his "en-

forced leisure" (1: 77). I am indebted to Fausel for the above interpretation of Thornhill's "decline."

27. I have found notices in no other paper. The marriage is mentioned in the *Historical Chronicle* for March 1728/29, calling Hogarth again "an eminent designer and engraver," but its account is copied from the *Craftsman*.

28. According to H. B. Wheatley (*London*, 2: 364), they resided in Lambeth Terrace, Lambeth Road. The story of living in South Lambeth goes back to Nichols, who, however, says only that Hogarth spent his summers there (*Gen. Works*, 1: 46).

29. *Gen. Works*, 1: 43–44.

30. Reported by Dr. Ducarel, *Gen. Works*, 1: 522–23. One Mr. Monger had an auction room over the broadcloth warehouse in 1732 (*Daily Journal*, 17 Nov.).

31. Vertue, 3: 58. On 5 May 1732 one N. Cox, a bookseller, advertised his shop as "under the Middle-Piazza, near Mr. Hogarth's" (*Daily Journal*).

32. Vertue, 3: 38, 39.

33. Vertue, 3: 38, 39. See *HGW* 1989, no. 264; and in the V & A a box of small (appx. 17.5 × 11 cm.) drawings; for a set of large tracings, see *Notes & Queries*, 7th ser., 7 (20 Apr. 1889): 306.

7. CONVERSATION PICTURES

1. BM Add MS. 27995, f. 1. The bottom part of the list, cut off by someone offended by mention of *Before* and *After*, is now in the Huntington Library. The whole is reprinted in J. Ireland, 3: 21.

2. See especially Arthur Marks, "Assembly at Wanstead House," *Philadelphia Museum of Art Bulletin*, 77, no. 332 (1981): 2–15; Richard Dorment, *British Painting in the Philadelphia Museum of Art from the Seventeenth through the Nineteenth Century* (Philadelphia, 1986), no. 39; 157–62. See also Fisk Kimball, "Wanstead House," *Country Life*, 74 (1933): 605; Howard E. Stutchbury, *Architecture of Colen Campbell* (Cambridge, Mass., 1967), 27–30; Jourdain, *Kent*, 93.

3. Marks, "Assembly"; Dorment, *British Painting*, 160.

4. Marks, "Assembly," 5.

5. Quoted, *Gen. Works*, 1: 19–20.

6. Dorment unaccountably accepts the 1729 date, although he cites earlier dates without noticing the contradiction (cf. *British Painting*, 157, 165).

7. *London Evening Post*, 14 Jan. 1731/32; *Universal Spectator*, 15 Apr. 1732.

8. David Solkin pointed this painting out to me at the "Manners & Morals" exhibition at the Tate in 1987, noting the resemblance to a Choice of

Hercules composition. He argues that in some cases at least these are purely imaginary emblematic scenes, alluding to (or illustrating) texts of Shaftesbury. I eagerly await the results of Solkin's research. The paintings I refer to below are *A Game Stall* and *The Fruit Seller,* photographs in the Witt Library, London.

9. Richardson, *Works,* 55.

10. Clearly the erasure took place within the purview of the Fountaine family and probably had nothing to do with Hogarth, but it does indicate a fact of the conversation picture genre: Richard Dorment tantalizingly notes that Captain William Price "is not buried beside his wife and children at Narford," and so he may have been painted out for dynastic reasons (Dorment, 167).

11. The second gentleman, however, has been identified as Christopher Cock or William Hogarth, as well as Captain Price; the man holding the picture has been referred to as a servant, but this presupposes a social standing for the auctioneer Cock that might not correspond to reality. The prone man has more plausibly been identified as Price (though in a later version the same figure, modified, has been identified as John Rich). The question of identification is of interest only because the face of the man in red does resemble Hogarth's; the stories make red a plausible color for his costume; and it is more likely that he rather than the auctioneer Cock would be in that prominent position, unless Cock had commissioned the picture. On the other hand, the figure is taller and thinner than Hogarth elsewhere represents himself (if, for example, he is Sancho in *Sancho's Feast*), and Hogarth is already represented by his pug. (See Dorment, *British Painting,* 167–70.)

12. He has been traditionally identified as Horace Walpole. But with Walpole born in 1717, if he is the subject, the portrait cannot be later than 1727–1728. W. S. Lewis accepted it as a portrait of Walpole, and it certainly is by Hogarth. But Walpole never mentions having been painted by Hogarth; the provenance does not connect Walpole with the picture; and it could be another delicate child. See Lewis and C. Kingsley Adams, "The Portraits of Horace Walpole," *Walpole Society,* 42 (1970): 23.

13. Henley was identified in the verses attached to Sympson's mezzotint copy. The reason, if this *is* Henley, for his inclusion was the preacher's notoriety and his Whistonian views on baptism, one of the tenets that made his orations scandalous. See Graham Midgley, *The Life of Orator Henley* (Oxford, 1973), 65–66. *The Denunciation,* incidentally, is signed "W. Hogarth pinxt 174[1]." This refers to its not being finally sold until 1741—or to Hogarth's retouching it in that year—when it was bought by John Palmer. The same happened with the *Falstaff.* Throughout his career, Hogarth seems to have dated paintings when they were "finished." See Robert Crowley,

"A Revised Date for Hogarth's *The Denunciation*," *Notes & Queries*, 231 (Dec. 1986): 504-7.

14. For Shard (d. 1739), see *Burke's Landed Gentry* (London, 1937), s.v. Shard. Shard's inquiries are mentioned in the *Daily Journal* 21 Oct. 1730. Again, 9 Jan. 1730/31: Shard and another sheriff went to the Wood Street Compter and distributed "a very considerable Sum of Money to the poor Prisoners confined in the said Prison for Debt."

15. *Daily Post*, 13 Mar. 1730/31. This was, of course, just about the time the subscription for the *Harlot's Progress* was begun. See Chap. 10.

16. Something of this sort is also presumably intended in Hogarth's reference to Parsons in the advertisement announcing *The Enraged Musician* (*London Daily Post and General Advertiser*, 24 Nov. 1740). See *HGW* 1989, no. 152 [158].

17. Recounted in the *Public Advertiser*, 18 July 1781.

18. For Thomson, see the *Daily Post*, 30 Oct. 1731; *Daily Journal*, 1 Nov.; *London Evening Post*, 4-6 May 1732; *Daily Post*, 9 Nov. His bankruptcy sale was announced in the *London Gazette*, 24-27 Feb. 1732/33. Sir Archibald Grant, second Bart. (1696-1778), about Hogarth's age, had represented Aberdeen County, Scotland, in Commons since 1722 (and may be another sign of Hogarth's Scottish connections). For his expulsion from Commons, see *Commons Journal*, 21: 915. For the duke of Montagu, see *DNB*.

19. *HMC, 16th Report*, Appendix pt. 7 (1898): 233. For the Sympsons, see Vertue, 3: 77.

20. Elizabeth Einberg supposes that Nichols's reference may have been to a lost scene of Hogarth's "Happy Marriage" series; and that Hogarth himself painted out the figure in the *Beckingham-Cox Wedding* (*Manners & Morals: Hogarth and British Painting* [London, 1987], no. 53, 75).

21. I am attempting to meet the argument of David Solkin here; and I thank him for our interesting conversation in front of the picture in the December 1987 Tate exhibition.

22. See Paulson 1982, 80-82, and Dabydeen's much fuller discussion (1985).

23. *Het Groot Schilderboek*, English ed., 143.

24. This is a subject I will take up in the third volume, discussing *The Analysis of Beauty*.

25. David E. Musselwhite, *Partings Welded Together: Politics and Desire in the Nineteenth-Century English Novel* (London, 1987), 160-61, and citing Deleuze and Guattari, 97.

26. Mary Delany (then Pendarves) to Anne Granville, 13 July 1731, in *The Autobiography and Correspondence of Mary Granville, Mrs. Delany*, ed. Lady Llanover (London, 1861), 1: 283. There is no Lafountaine in Waterhouse's *Dictionary of British 18th Century Painters*, though there is a George Fountain(e) (129).

27. Mary Delany, *Autobiography,* 1: 283.

28. Records of St. Bartholomew the Less, in St. Bartholomew's Hospital. My reason for concluding that "Anne" and "Mrs. Hogarth" are two different people, daughter and mother, is that in the entry for 1727 both names appear, "Ann Hogarth" and "Mrs. Hogath" (both sic). The first tenement was appraised at 6*s*, the second at 8*s* for the poor rate. The references appear in the poor rate books for 1725 and 1726, the scavengers' payment for 1729, and the constable books for 1725, 1726, and 1727.

29. *Calendar of State Papers, 1668–69,* 139; James Peller Malcolm, *Anecdotes of the Manners and Customs of London during the Eighteenth Century* (1808), 313; E. A. Webb, *St. Bartholomew the Great* (London, 1921), 2: 286. For the shop signs, see the entry in the journal of the meetings of the governors of St. Bartholomew's Hospital, for 10 May, 24 July 1729.

30. Norman Moore, *The History of St. Bartholomew's Hospital* (London, 1918), 2: 845.

31. Journal of the meetings of the governors, 25 Sept. 1729. See *Fog's Weekly Journal,* Sat. 25 Apr. 1730: "Monday last [20 Apr.] the Workmen began to pull down Part of St. Bartholomew's Hospital; the Shopkeepers in the Cloisters have taken Shops in the Long Walk (as it is call'd) between the said Cloisters and the Blue Coat Hospital; but there will be a free Passage kept open, and clear from Dust, during the time the Workmen are employ'd there."

32. *London Evening Post,* 11–14 Apr. 1730. Thornhill seems to have promoted Vandergucht as an engraver, and this probably explains Hogarth's use of him: See letters from Joseph Crosthwait to Abraham Sharp, in Francis Baily, *An Account of the Reverend John Flamsteed, the First Astronomer Royal* (London, 1835–1837), Appendix, 333–68.

33. Advertised as published, 13 Feb. 1730/31, *Daily Journal.* Mitchell's *Highland Fair,* advertised "With a curious Frontispiece, design'd by Mr. Hogarth," was published 23 Mar. (*London Evening Post,* 20–23 Mar.).

34. One example was Aaron Hill, who relieved Mitchell and was therefore effusively thanked in verse. In 1729, in his *Poems on Several Occasions,* Mitchell was still expressing his gratitude, while also making overtures to Walpole: he wanted to be governor of Duck Island in St. James's Park, poet laureate, and secretary of state for Scotland. See Theophilus Cibber, *Lives of the Poets of Great Britain and Ireland* (London, 1753) 4: 347ff., 5: 197; David Erskine Baker, *Biographica Dramatica* (1782), 1: 520; Alexander Chalmers, *Biographical Dictionary* (1812–1817), vol. 22; James Johnson, *Scots Musical Museum,* 4, ed. David Laing (1853); Dorothy Brewster, *Aaron Hill, Poet, Dramatist, Projector* (New York, 1913), 170. Antal (14), without documentation, asserts that Hogarth "appears to have commissioned a poet, Joseph Mitchell, to write an epistle in his honour in which he is placed above his rivals."

8. THE "MODERN MORAL SUBJECT"

1. See Oppé, cat. no. 32, fig. 17.

2. My thanks to Roy Porter for this information (Boswell so employs a syringe in his *London Journal*).

3. The paintings were supposedly destroyed in the Fonthill fire of 1755. Two canvases in the Rosebery Collection, corresponding to Plates 2 and 4, may be survivors of the fire (from which Hogarth's *Rake* did survive). These were first drawn to my attention by Brian Allen in 1986. While some of the faces and drapery could be by Hogarth, untouched by the fire, much of the surface has been repainted, presumably as the result of fire damage. The interesting feature of these canvases I pointed out to Allen is their shape: they are 18 by 24 1/2 inches, the elongated shape of the *Hudibras* prints and the ur-*Harlot* drawing, as well as of the painting of *A Midnight Modern Conversation* of roughly the same time. If so, Hogarth may have begun with the drawing, painted the *Harlot* in the Hudibras shape, and then tightened the engravings into the shape we now know. They are also, as we would expect of Hogarth, the reverse of the engravings. It is unlikely that a copyist of the engravings would have reversed and changed their shape in this way. Perhaps another bit of evidence for Hogarth's authorship: in the surviving painting for the third scene the falling table is silver, an extraordinarily showy possession, which helps to characterize the upward-aspiring Jew, as well as implying a noisy clatter. The argument against attribution would begin with the shape of the canvas represented by Hogarth in *The Battle of the Pictures* (1745, ill., vol. 2); but then the proportions of *A Midnight Modern Conversation* do not correspond to the surviving painting, and both scene and proportions of the engraved *Morning* (1738, ill., vol. 2) bear no relation to its painting. The two *Harlot* paintings are reproduced in the catalogue *William Hogarth, Dipinti Disegni Incisioni* (Venice, 1989), pls. 128, 129.

4. This is Michael Godby's thesis in "The First Steps of Hogarth's *Harlot's Progress*," *Art History*, 10 (1987): 23–37. He refers to George Wither's *Collection of Emblemes, Ancient and Modern, quickened with Metrical Illustrations, both morall and divine* (1635), Bk. 4, emblem no. 34.

5. *Spectator* No. 66 was probably also floating in Hogarth's memory: a letter tells of "a young Country Kinswoman of mine who is lately come to Town . . . is very pretty, but you can't imagine how unform'd a Creature it is. She comes to my Hands just as Nature left her, half finish'd . . ."; and she recalls for him precisely the *belle sauvage* of No. 28 (see Chapter 9).

6. *Daily Journal*, 13 Nov. 1736; cited by Toni-Lynn O'Shaughnessy, "A Single Capacity in *The Beggar's Opera*," *ECS*, 21 (winter 1987–1988): 217, 223.

7. Hume, *Henry Fielding*, 109.

8. *Daily Courant,* 27 Feb. 1729/30.

9. *Commons Journals,* 16: 528. See also *Scotch Gallantry Display'd: or the Life and Adventures of the Unparallel'd Col. Fr-nc-s Ch-rt-s* (1730), 10.

10. *Daily Courant,* 27 Feb. 1729/30.

11. *The Proceedings at the Sessions of the Peace . . . upon a Bill of Indictment found against Francis Charteris, Esq; for committing a Rape on the Body of Anne Bond, of which he was found Guilty* (1730), 4–6.

12. *Daily Courant,* 27, 28 Feb. 1729/30; *Grub-street Journal,* 5 Mar. 1729/30, carried notices from several papers.

13. *BM Sat.* 1840.

14. *Daily Journal,* 17, 21 Jan. 1729/30; *Daily Post,* 21 Jan.; *Daily Courant,* 25 Feb. Back in 1728 Dalton had been famous enough to prompt a book advertised from his cell in the Wood Street Compter: "A promiscuous Mixture of Iniquity, Ingenuity, and facetious Drollery, being A Genuine Narrative of all the Street-Robberies committed since October last, by James Dalton and his Accomplices . . ." (*Daily Journal,* 8 May 1728).

15. *Daily Journal,* 7 Mar. 1729/30, which also advertised *The Whole Trial at large of Colonel Francis Charteris* (2 Mar.), *The Rape. An Epistolary Poem. Addressed to Colonel Francisco* (3 Mar.), and *Some Authentick Memoirs relating to the Life, Amours, and other notable Actions of Col. Ch——s, Rape Master General of Great-Britain. By an Impartial Hand* (10 Mar.), *An Emblematic Print, entitled Col. Francisco; or the British Satyr* (17 Mar., *Daily Post*), *The History of Col. Francis Chartres* (18 Mar., *Daily Journal* again), *Col. Don Francisco's Letter of Advice to all his Beloved Brethren the Votaries of Venus* (20 Mar.), and *The Art of Pimping, in Imitation of Horace's Art of Poetry* (21 Mar., *Daily Post*).

16. See Dabydeen 1987, 93.

17. *Daily Post,* 9, 11, 13 Apr.; *Daily Journal,* 10, 15 Apr.; *Daily Courant,* 11, 14 Apr.; summed up in the *Grub-street Journal,* 16 Apr.; also *Daily Post,* 18 Apr. 1730. On the 20th was published *The Reprieve: An Epistle from J-ck K-ch to C——l C———s* (*Daily Journal*). For Dalton, see *Weekly Journal, or the British Gazetteer,* 16 May; *Craftsman,* 16 May. On 29 April the *Daily Journal* announced publication of the second number of *The History of Executions,* which included an account of "Francis Hackabout, a Footpad . . . Likewise how Col. Charteris was pardoned for a Rape committed on Anne Bond." The *Grub-street Journal* of 30 July wrote of Walpole: "Knighthood's shield [i.e., screen] protects the *Squire of Dames,*" and on 10 September carried reports from newspapers of Charteris's lavish gift to Walpole. See also B. A. Goldgar, *Walpole and the Wits* (Lincoln, 1976), 97, 106–07.

18. *BM Sat.* 1841. See also James Miller's *Harlequin Horace* and Swift's "An Excellent New Ballad: or the True English Dean."

19. *Post Boy,* 17 May, *Grub-street Journal,* 15 May, *Weekly Journal, or British Gazetteer,* 6 June; for *Rape upon Rape,* see the *Daily Post,* 23 June. Char-

teris's pardon is denounced by Worthy, who ends: ". . . and Gold hath been found to cut a Halter surer than the sharpest Steel."

20. *Grub-street Journal*. 8 Jan. 1729/30; Fielding puts him in the 1734 version of *The Author's Farce* as Sir John Bindover, who replaces Murdertext in the original version and ends by dancing with Dr. Orator (Henley). For samples of Gonson's "Charges," see *Political State*, 25: 50; and 36: 314, 333.

21. *Daily Journal*, 3 Aug.; *Daily Post*, 3 Aug. 1730.

22. *Grub-street Opera*, Air xxxv; used again in *Tumble-down Dick* (1736), Air ii.

23. *Grub-street Journal*, 6 Aug. 1730 (as above, p. 246). See Barry Wind, "Hogarth's Fruitful Invention: Observations on *Harlot's Progress* Plate III," *Journal of the Warburg and Courtauld Institutes*, 52 (1958): 268.

24. For White, see *BM Sat.* 1840 (1720) and Elisha Kirkall, *The History of Col. Francis Charteris* (1730).

25. Hume, *Henry Fielding*, 73.

26. *Daily Journal*, 31 Aug.; *St. James's Evening Post*, 5 Sept.; *London Evening Post*, 5 Sept.; all cited in *Grub-street Journal*, 10 Sept., 1730. The *Craftsman* of 8 Aug. called Walpole the "Friend, Confidant, and Patron" of Charteris.

27. *Some Authentick Memoirs relating to the Life, Amours . . . of Colonel Ch———s, Rape Master General of Great-Britain* (1730), 2; the ballad "On Colonel Francisco Rape-Master General of Great Britain," in Milton Percival, ed., *Political Ballads* (Oxford, 1916), Ballad xiv, 34–35. See also the *Grub-street Journal*, 30 July and 10 Sept. 1730; and for the general connection between Charteris and Walpole in satires of 1730, see Goldgar, *Walpole and the Wits*, 97, 106–07.

28. Dabydeen 1987 (93–94) interprets this, quite correctly I think, as an integral part of the background of the *Harlot's Progress*.

29. *Robin's Panegyrick. Or, The Norfolk Miscellany* (London, ca. 1729), 103; see H. C. Howard, "The Poetical Opposition to Sir Robert Walpole" (Ph.D. diss., Ohio State Univ., 1940), 169.

30. Cited, Dabydeen 1987, 95.

31. See Howard Erskine-Hill, *The Social Milieu of Alexander Pope* (New Haven, 1975), 243–59.

32. The "London" was added, presumably for those with short memories, after Hogarth had reissued the series in the mid-1740s.

33. For "Walpole's Pope," see C. B. Realey, *The Early Opposition to Sir Robert Walpole 1720–1727* (Lawrence, Kans., 1931), 148. Gideon's dealings with Walpole went back to the South Sea Bubble and Walpole's legalizing a land deal for Gideon through a special Act of Parliament. See Cecil Roth, *A History of the Jews in England* (Oxford, 1941), 207n; M. F. Modder, *The Jew in the Literature of England* (Philadelphia, 1929), 47; John Eardley Wilmot, "A Memoir of the Life of Samson Gideon Esq. of Spanding Co. Lincoln and Belvedere, Kent," in *Illustrations of the Literary History of the Eighteenth Cen-*

tury, ed. John Nichols (London, 1817–1858), 6: 279, 283; and Lucy Suther-
land, "Samson Gideon: Eighteenth-Century Jewish Financier," *Transactions
of the Jewish Historical Society of England,* 17 (1953): 79–90. There is little re-
semblance, however, in the only portrait I have seen, by Allan Ramsay from
some years later. See also *BM Sat.* 2140 and Mabel B. Hessler, *The Literary
Opposition to . . . Walpole,* 69. Dabydeen has recently suggested that we
could extend the list of Walpole associations to include not only the Jewish
merchant but the prison warder in 4 and even the quack in 5 (1987, 120–29).

34. The fame of Hogarth reached Broadway in December 1989 (by way
of the London Royal Shakespeare Company) in a play by Nick Deer called
The Art of Success, based on the facts of *HLAT* (without acknowledgment in
program or in printed text) but, relying largely on the story of the Walpole
Salver, interpreting it so as to make Hogarth out to be a compromiser who
sold out to Walpole, his reward being the Engravers' Act.

35. See Nancy Armstrong, *Desire and Domestic Fiction: A Political History
of the Novel* (New York, 1987), e.g., 11, 21; for the "news" aspect, Lennard
Davis, *Factual Fictions: The Origins of the English Novel* (New York, 1983);
and for a full discussion, vol. 2.

36. *Grub-street Journal,* 23 Apr. 1730.

37. Cf. *Daily Journal,* 28 Nov. 1730, which apparently refers to the same
person, but here calls her Mary Freeman, alias Talboy: "She beats hemp one
day in velvet, and another day in a gown richly trimm'd with silver." —
One wonders if the gamester is not also a portrait—the face appears to be
individualized. The only gambler singled out during this period is "one
Boucher, a Notorious Gamester, [who] was taken in Lincolns-Inn-Fields,
playing at unlawful Games; and being carried before a Magistrate, was com-
mitted to Tothill-fields Bridewell" (*Daily Advertiser,* 6 Apr. 1730).

38. A purported continuation, *Fortune's Fickle Distribution* (1730), added
a life of "Jane Hackabout," Moll's governess.

39. Neil McKendrick, John Brewer, and J. H. Plumb, *The Birth of a Con-
sumer Society: The Commercialization of Eighteenth-Century England* (Bloom-
ington, 1982), 14–20.

40. John Houghton, *A Collection of Letters for the Improvement of Husban-
dry and Trade* (1681), 60. Fashion, said Nicholas Barbon, "occasions the Ex-
pence of Cloaths before the Old ones are worn out" (see Joyce Appleby,
"Ideology and Theory: The Tension between Political and Economic Liber-
alism in Seventeenth-Century England," *American Historical Review,* 81,
no. 3 [1976]: 506).

41. See John Sekora, *Luxury: The Concept in Western Thought, Eden to
Smollett* (Baltimore, 1977).

42. *The Grumbling Hive* (1705, ed. London, 1970), 118–20. See Gordon
Vichert, "The Theory of Conspicuous Consumption in the 18th Century,"
The Varied Pattern: Studies in the 18th Century, ed. Peter Hughes and David

Williams (Toronto, 1971), 253–69; and McKendrick, Brewer, and Plumb, *Birth of a Consumer Society,* 15–20.

43. This detail was first noticed by Lichtenberg, 9.

44. See *The Life of Colonel Don Francisco* (ca. 1730), 17; *Don Francisco's Descent to the Infernal Regions, an Interlude* (1732); and *Mother Needham's Lamentation. In an Epistle to a certain Nobleman* (8 May 1730, *Daily Journal*).

45. Reprinted in W. H. McBurney, *Four before Richardson* (Lincoln, Neb., 1963), 301. While Vertue identifies Mother Needham (3: 58), *The Harlot's Progress, or the Humors of Drury Lane* (April 1732) calls her Mother Bentley, probably because Needham was by this time dead and Bentley was the new bawd of the moment.

46. *Weekly Journal,* 15 Oct. 1726; ibid., 20 Mar. 1730/31; *Daily Courant,* 23 Mar. 1720/21; *Grub-street Journal,* 29 Apr., citing *Daily Courant* and *Daily Post,* 26 Apr.

47. *Grub-street Journal,* 6 May 1731, citing *Daily Journal, Post Boy,* and other papers for May 1; ibid., 6 May, citing papers for 4 May. On 8 May was published *Mother Needham's Lamentation* (*Daily Journal*).

48. Sykes, *Gibson,* 260–61. The *Pastoral Letters* were widely circulated, and there were many satiric allusions to them (e.g., *The Bishop or No Bishop,* and the *Craftsman,* 16 Nov. 1728; see Sykes, *Gibson,* 254–55).

49. *Trivia,* 3.56–76. The relationship of Gay's *Trivia* to Hogarth's work, especially *The Four Times of the Day,* will be discussed in vol. 2.

50. Rouquet, 10; S. T. Coleridge, *Essays and Marginalia* (London, 1851), 2: 212; Dobson, 39.

51. *A Modest Defence of Publick Stews* (1724), xi–xii. The *Harlot's Progress* abounds in echoes of Mandeville's *Modest Defence* but also of his *Fable of the Bees*—as when he defines such men as Gonson or the prison warder, "rais'd [to] exert himself in the Commission of the Peace, or other Station, with Vigilance and Zeal against the Dissolute and Disaffected . . . till he becomes at last the Scourge of Whores, of Vagabonds and Beggars, the Terrour of Rioters and discontented Rabbles, and constant Plague to Sabbath-breaking Butchers." This figure Mandeville ironically hails as "such a bright example," "how shining and illustrious his Virtue" (1: 93).

In the *Modest Defence* one finds, for example, Mandeville's enumeration of the consequences of being a whore as opposed to "a *Colonel,*" a prime minister, a churchman, a lawyer, and a physician (18). But one also recalls the horse in Plate 1, when Mandeville cites Plato on our "one disobedient and unruly Member, which, like a greedy and ravenous Animal that wants Food . . ." (iii).

52. See Guy Williams, *The Age of Agony: The Art of Healing c. 1700– 1800* (London, 1975), 128.

53. Dabydeen makes the point (1987, 96–97) that Charteris's birthdate,

in some of the pamphlets attacking him, was given as 1666, the year of the Fire.

9. CONTEXTS (VISUAL AND VERBAL)

1. *Lo Specchio al fin de la Putana* by Curio Castagna (ca. 1657); see David Kunzle, *History of the Comic Strip*, 1 (Berkeley and Los Angeles, 1973): nos. 9–19, 278–80. Kunzle also reproduces examples of the other types of strips discussed here.

2. Sean Shesgreen, *The Criers and Hawkers of London* (Stanford, 1990), 176.

3. The painting is in the Palace of the Legion of Honor in San Francisco (reproduced, Paulson, *E & E*, 42, pl. 18).

4. Richardson, *An Essay on the Theory of Painting* (1715), in *Works*, 9–10, and passim. Among other contemporary writings that emphasize the painter-poet analogy, see the *Free-Thinker* No. 63 (1718); *St. James's Journal*, 20 Apr. 1723; Walter Harte, "Essay on Painting," in *Poems on Several Occasions* (1727), 3; and James Ralph, *Weekly Register* No. 122, 3 June 1732. For the famous pronouncements by later critics on "reading" Hogarth, see William Gilpin, *Essay upon Prints*, 2d ed. (1768), 24, 164–71; James Barry, *An Account of a Series of Pictures in the Great Room of the Society of Arts* (1783), 162–64; Horace Walpole, *Anecdotes*, 4: 126; and Charles Lamb, "On the Genius and Character of Hogarth," *Reflector* No. 3 (1811).

5. Shaftesbury, *Notion of a Draught*, in *Shaftesbury's Second Characters*, ed. Rand, 59; for Alberti, see Blunt, *Artistic Theory*, 12. For the *ut pictura poesis* tradition as it affected history painting, see Rensselaer W. Lee, "Ut Pictura Poesis: The Humanistic Theory of Painting," *Art Bulletin*, 22 (1940): 197–269; and, on the literary side, Jean Hagstrum, *The Sister Arts* (Chicago, 1958).

6. By the time he had chosen his title, the word "progress" was in the air: besides of course, *Pilgrim's Progress*, which was probably his primary allusion, there were such titles as *The Universal Spectator, and Weekly Journal: Containing the Progress of Wit, Humour, and Other Polite Subjects* (*London Evening Post*, 3–5 Dec. 1728), *The Progress of Wit* (1730), and *The Progress of Patriotism, a Poem* (1730/31), the last two by Gamaliel Gunson.

7. De Voogd, 65.

8. See, most notably, Gay's *Trivia*, 3.279–80, though the reference is to the Quaker's hood rather than pointed hat (see also *Spectator* No. 8). For the conical hat worn by Quaker women, see Heemskirk's *Quaker Meeting* paintings and Hogarth's engraving of *The Sleeping Congregation* (ill., vol. 2). The point about Plate 3 was made by Barry Wind, "Hogarth's Fruitful Invention: Observations on *Harlot's Progress* Plate III," *Journal of the Warburg and Courtauld Institutes*, 52 (1989): 268–69. A sourcebook for costumes of the

lower orders was Laroon's *Cries of the City of London* (see above, n. 2).

9. See Pope, *Rape of the Lock*, 1.8 and 2.16.

10. On the advantages of a series of pictures, see Dubos, *Réflexions critiques* (1719), 425–26, where he argues that plays and poems have the advantage over painting because they can show earlier and later scenes. Hogarth's series may have been in part a response to Dubos's statement.

11. This room is presumably the Jewish keeper's quarters, and the Harlot has smuggled in the lover while he was away. If it were her own quarters, the pictures would have to have been supplied her by her keeper as warnings to her. The hat under the Jew's arm could suggest that he is visiting her; but its primary meaning is that he has just returned and sat down to tea with his mistress.

12. *The Beggar's Opera,* source of so much of the *Harlot,* also offered a hint for this scene: Mrs. Slammekin says, "I, madam, was once kept by a Jew; and bating their religion, to women they are a good sort of people" (II.iv).

13. For an example of the common associations of the Jew with cruelty, see Shaftesbury, *Characteristics,* ed. J. M. Robertson (London, 1900), 1: 22: "The sovereign argument was Crucify, Crucify."

14. Jonah's irascible temper as a subject of ridicule was discussed by the Deist Anthony Collins in *A Discourse concerning Ridicule and Irony in Writing* (1729), 23.

15. Richardson, *Works,* 8. Richardson starts with the "savage and uncomfortable" stage of "always inhabiting between bare walls," corrected by "ornaments" and in an eminent degree," by paintings: "But pictures are not merely ornamental, they are also instructive. . . . Our walls, like the trees of Dodona's grove, speak to us, and teach us history, morality, divinity; excite in us joy, love, pity, devotion; if pictures have not this good effect, it is our own fault in not chusing them well, or not applying ourselves to make a right use of them" (*Science of a Connoisseur, in Works,* 268–69).

For examples of sixteenth- and seventeenth-century English portraits in which portraits on the wall "function . . . as an emblem of the sitter's mind," see Richard Wendorf, *The Elements of Life: Biography and Portrait Painting in Stuart and Georgian England* (Oxford, 1990), 78. Paintings appear on the walls in, for example, Vermeer's rooms, but they serve a very general pluralizing purpose: in *Woman Weighing Pearls* (National Gallery, Washington), for example, a painting of the Last Judgment on the wall introduces a *vanitas* theme. (See Lawrence Gowing, *Vermeer* [London, 1952], 49–52.)

16. The *Judgment of Hercules* was first published in French, in the *Journal des Sçavans* for Nov. 1712; translated into English in 1713, and published in the *Characteristics* of 1714 as Treatise VII. See *Shaftesbury's Second Characters,* xxii. G. P. Bellori's description and analysis had already focused critical attention on the Choice (*Vite,* Pisa [1821 ed.], 36–39).

17. By the middle of the century Henry Hoare was decorating his Pantheon at Stourhead: the only surviving Hercules sculpture from antiquity was of Hercules at rest after his labors, and so Hoare placed the copy he had commissioned by Michael Rysbrack between sculptures of Ceres and Flora, equivalents of Virtue and Pleasure, and so simulated a situation of choice.

18. Xenophon, *Memorabilia*, 2.1.21. See E. Wind, "Shaftesbury as a Patron of Art," *Journal of the Warburg and Courtauld Institutes*, 1 (1938): 185. For a discussion of the Choice of Hercules tradition, see Erwin Panofsky, *Hercules am Scheidewege und andere antike Bildstoffe in der neueren Kunst* (Leipzig, Berlin, 1930); Joan Hildreth Owen, "The Myth of Hercules' Choice in English Literature of the Enlightenment," *Enlightenment Essays*, no. 3/4 (1973): 42–62. For the dramatic precedent of Dryden's *All for Love*, see Hagstrum, *Sister Arts*, 190–97.

19. One of the basic images of the whore was as a pleasing orator. "The Whores Rhetorick is nothing else, but the art to multiply insinuating words, and feigned pretenses to persuade, and move the minds of these men, who falling into their nets, do become the trophies of their victories" (*The Whore's Rhetorick* [1683], 36).

20. My point is best made by quoting the opening sentence of Barbara Lewalski's book on *Paradise Lost:* "*Paradise Lost* is preeminently a poem about knowing and choosing—for the Miltonic Bard, for his characters, for the reader" (*"Paradise Lost" and the Rhetoric of Literary Forms* [Princeton, 1985], 3).

21. There is, of course, a precedent in the story of the effeminized Hercules, who, out of love for Omphale, dressed as a woman while she wore his lion pelt (Ovid, *Heroides* IX.54 ff.; Lucian, *Dialogues of the Gods* 13; and Plutarch, *On Whether an Aged Man ought to Meddle in State Affairs* 4). My thanks to Joshua Scodel.

22. That contemporaries were aware of Hogarth's borrowing of motifs from the Continental tradition may be deduced from Paul Sandby's *Burlesque sur le burlesque* (1753), in which Hogarth is shown painting at his easel, to which are attached "Old-prints from whence he steals Figures for his design." On the advantages of borrowing from the Old Masters (but with no sense of allusion), Hogarth would have known Richardson's opinion in *Theory of Painting* (*Works*, 47).

23. Now in the Glasgow Art Gallery, it was evidently the most celebrated or prized picture in Thornhill's collection. The detail of Nature was used on the cover of his sale catalogue following his death, two years after the *Harlot* appeared. The painting *Nature Adorned* was no. 99 in the second day of the sale. One of Thornhill's headpieces for *Addison's Works* (1721, 2: 187) also copied this motif from *Nature Adorned by the Graces*.

24. *Epistle to Burlington*, l. 52.

25. See the frontispiece to Pierre Le Lorrain, abbé de Vallemont's *Cu-*

riositez de la nature et de l'art sur la végétation (1703, trans. 1707); and cf. Frank Manuel, *The Eighteenth Century Confronts the Gods* (Cambridge, Mass., 1959), 268.

26. Hogarth may have known the sculptures of François Duquesnoy (to whom he refers in *The Analysis of Beauty*) of putti trying to restrain a goat, an emblem of lust, which appears in paintings by Gerard Dou and, more recently, Watteau and Chardin.

27. Edwards, *Anecdotes of Painting* (1808), xx.

28. George Puttenham, *Arte of English Poesie* (1589), ed. G. D. Willcock and Alice Walker (Cambridge, 1936), 38 (I have modernized the spelling). For the tradition of unveiling Nature, see Plutarch, *Isis and Osiris,* chap. 9. The figure of Nature appears in Ripa's *Iconologia,* "Invention," no. 168 in the English edition: Invention is holding a representation of Nature as a herm of Diana of Ephesus (better illustrated in some of the foreign editions). Hogarth may have known any number of adaptations of the Ripa image—for example, the illustration to the Fourth Dialogue of Vincente Carducho's treatise on painting, *Dialogos de la pintura* (Madrid, 1633, 4: fol. 64), which shows Diana–Nature being copied by figures representing both Poetry and Painting. Hogarth takes only the motif of different "artists" copying Nature from Carducho. From the other sources, beginning with Ripa, he takes the herm. Salvator Rosa also picks up the Ripa image in his Figurina of a man regarding a representation on canvas of Nature (signed with Rosa's own monogram).

29. See Michael Murrin, *The Veil of Allegory* (Chicago, 1969).

30. Roscommon, *Essay on Translated Verse* (1684), in J. E. Spingarn, *Critical Essays of the Seventeenth Century* (Oxford, ed. 1957), 2: 302.

31. Dryden, "A Parallel of Poetry and Painting," in *Essays of John Dryden,* ed. W. P. Ker (Oxford, 1926), 2: 132. For the relationship between *difficultas* and the labyrinth, see John Steadman, *The Hill and the Labyrinth: Discourse and Certitude in Milton and His Near-Contemporaries* (Berkeley, 1984).

32. William Walker has drawn attention to this image of Truth as a woman; for "recesses," cf. Abraham Cowley, "Ode to the Royal Society," where philosophy is a male and nature female, and the former presses his sight into her "privatest recess." And "recess" was also a term for womb in Restoration and eighteenth-century midwife books. See *An Essay concerning Human Understanding,* ed. Peter H. Nidditch (1975; rpt. Oxford, 1979), 3, italics added; also 48, 285; Walker, "Locke Minding Women: Literary History, Gender, and the *Essay,*" *ECS,* 23 (1990): 261–62; Robert Erickson, "'The Books of Generation': Some Observations on the Style of the British Midwife Books 1671–1764," in *Sexuality in Eighteenth-Century Britain,* ed. Paul-Gabriel Boucé (Manchester, 1982), 81, 84); and Steadman, *The Hill and the Labyrinth,* 137–41.

33. *Science of a Connoisseur,* in *Works,* 253, 256, 280.

34. *Aeneid,* 3.96: "And there you and your ancestors will *rule,*" the passage continues, introducing a metaphor of power that also probably lies beneath the surface of Hogarth's assertions of new empire for British painting. He would also have been aware of the possible irony in using this allusion, given Pope's parody of Aeneas's removal of Troy to Rome in *The Dunciad.*

35. It has been displaced to the subscription ticket as the gods in the traditional *Four Times of the Day* will be displaced from Hogarth's series to the pendant, *Strolling Actresses Dressing in a Barn* (1738; ill., vol. 2).

36. The other bawd's name suggested in the 1730s was Elizabeth Bentley; but the Christian name was the same.

37. Of course, to be a Virgin Mary of our time is to be a Magdalen—the other, the fallen Mary. The art historical context of a series of pictures of a woman's life included not only the subliterary lives of prostitutes but the religious prints of the Life of the Virgin, inverted into a life of the Magdalen. In terms of a Magdalen of our times, she is a Magdalen who does not repent. Mary Magdalen was the traditional representative of both prostitute and penitent sinner. The two Marys are inextricably mingled in Christian iconography, and various popular lives of prostitutes were also lives of an anti–Mary, playing off her perfection against the inverted story of the prostitute. See Helen M. Garth, *Saint Mary Magdalene in Medieval Literature,* in *Johns Hopkins University Studies in Historical and Political Science,* 67 (1950), pt. 3: 80–81; Marjorie M. Malvern, *Venus in Sackcloth: The Magdalen's Origin and Metamorphosis* (Carbondale, Ill., 1975), 90–95, and, for her appearance in plays, chaps. 8 and 9.

38. See Paulson, *Breaking and Remaking,* 191.

39. On typology, see Paul Korshin, *Typologies in England, 1650–1820* (Princeton, 1982).

40. See Armstrong, *Desire and Domestic Fiction.*

41. Swift, "The Progress of Beauty" (1719) and "A Beautiful Young Nymph Going to Bed" (1734).

42. The mirror and dressing table in Plate 2 recall not only emblems of Imitation but Belinda's adoration of her goddess (herself) in Pope's *Rape of the Lock.*

43. I refer to Hogarth's Good Samaritan painting in St. Bartholomew's Hospital, painted in 1737–1738 (ill., vol. 2).

44. *Biogr. Anecd.* (1781), 90; *Gen. Works,* 2: 101.

45. *Some Authentick Memoirs,* 45; the newspaper notice was reproduced in *Scotch Gallantry Display'd: or The Life and Adventures of the Unparallel'd Col. Fr-nc-s Ch-rt-s,* 35.

46. In Woolston's own words, *Mr. Woolston's Defence of His Discourses on the Miracles of Our Saviour* (1729), 32. The *Sixth Discourse* was followed by

An Answer to the Jewish Rabbi's Two Letters against Christ's Resurrection (1729) and *An Impartial Examination and Full Confutation of the Argument Brought by Mr Woolston's Pretended Rabbi* (2d ed., 1720).

47. Sykes, *Gibson,* 260–61.

48. One sentence would have carried special meaning for Hogarth, remembering his father's attempt to get out of prison: "The Church-Lands would go a good, if not a full Step, toward the Payment of the Nation's Debts."

49. *Daily Journal,* 11 Apr. The *Third Pastoral Letter* appeared in May 1731 (*Daily Journal,* 11 May), went through many editions, and all three *Pastoral Letters* were published in "a neat Pocket Volume" in November (*Daily Post,* 25 Nov.).

50. See *Daily Post,* 11 June, 2 July; *Grub-street Journal,* 15 Oct., where it appears that he was being transferred by a writ of habeas corpus to the Fleet.

51. See, e.g., *The Origine of Atheism in the Popish and Protestant Churches* (1684), 1–23.

52. For the most extended account of Woolston—still regarding him as a madman—see Leslie Stephen, *History of English Thought in the Eighteenth Century* (1876; New York, 1962), 1: 192–96.

53. Maximilian Novak refers to "the great deistic offensive of the 1720s" in "The Deist Offensive during the Reign of George I," in *Deism, Masonry, and the Enlightenment,* ed. J. A. Leo Lemay (Newark, Del., 1987), 93–108. The quotation is on page 102.

54. *Daily Journal,* 13 Mar. 1721/22.

55. The same recurs in *Marriage A-la-mode* 1 in his copy of Domenichino's *Martyrdom of St. Agnes* and in *The Sleeping Congregation* in the royal motto: God is removed. I have discussed this as an act of iconoclasm in *Breaking and Remaking,* 149–54.

56. It is well to remember that one of the sources of this aspect of Deism was the revival of classical philosophy, including skepticism: the possibility is open that Richard was a dissenter in this, rather than the more conventional, sense. Recall also the reputation of coffeehouses as centers of freethinkers (above, 17). On the "Whiggish deism of organized Grand Lodge Freemasonry," see Roger L. Emerson, "Latitudinarianism and the English Deists," in *Deism, Masonry, and the Enlightenment,* 22. On freethinking in the clubs and unregulated lodges of speculative Freemasons see Jacobs, *Radical Enlightenment,* 23–27.

57. Toland, "Clidophorus; or of the Exoteric and Esoteric Philosophy," in *Tetradymus* (1720); Shaftesbury, *An Essay on the Freedom of Wit and Humour* (1709). For the last term I am indebted to David Berman, "Deism, Immortality, and the Art of Theological Lying," in *Deism, Masonry, and the Enlightenment,* 61–78.

58. Shaftesbury, in Berman, "Deism," 63.

59. Collins, *A Discourse concerning Ridicule and Irony in Writing* (1729), 24; Toland, *Tetradymus*, 95; cited, Berman, "Deism," 62.

60. *The Third Charge of Sir John Gonson to General Quarter Sessions of the Peace for Westminster* in *Three Charges to the Several Grand Juries* (1728), 91. Archbishop Wake's Blasphemy Bill of 1721 had gone to a second reading but was defeated by the lukewarm support of his own bishops.

61. Redwood, *Reason, Ridicule and Religion*, 174, 175.

62. Toland criticized the OT—as did the Latitudinarians in general, as well as the Deists—for its bloody eye-for-an-eye morality and its fanaticism. More circumspectly, Toland questioned the NT, primarily questioning its canon, especially the books concerning Paul and the Apostles.

63. See *Mere Nature*, 61–62; and the ninth of the Thirty-Nine Articles, which asserts the "Fault and corruption of the nature of every man that naturally is engendered of the offspring of Adam."

64. Collection, Richard and Paula Greenberg, New York (see *HGW* 1989, 20).

65. Fielding was also an admirer of the bishop and a close friend of the sons. His acquaintance with the younger Benjamin goes back at least to 1730 (Martin and Ruthe Battestin, *Henry Fielding* [London, 1989], 104).

66. Quoted, Redwood, 175.

67. *A Muster-Roll of the B. of B-ng-r's Seconds* (1720); quoted, Sullivan, *Toland*, 268.

68. Sullivan, *Toland*, 35. As Leslie Stephen has written, Hoadly was a "clergyman who oppose[d] sacerdotal priviliges"; one who "supported the political pretensions of the dissenters"; and was therefore "the best-hated clergyman of the century amongst his own order" (*History of English Thought*, 2: 129).

69. *Works*, 1: 594.

70. Geoffrey Holmes, "The Sacheverell Riots: The Crowd and the Church in Early Eighteenth-Century London," *Past and Present*, No. 72 (Aug. 1976), reprinted in Slack, *Rebellion, Popular Protest and the Social Order*, 236. For Hoadly, see Battestin, *Fielding*, 152–57; Hogarth and the Hoadlys (the bishop and his sons Benjamin and John) will be discussed in vol. 2.

71. Paine, *Age of Reason* (1795; London, 1937), 4.

72. Jews fill this role in some of the Charteris stories (Westminster Public Library e.2576, no. 103). Otherwise, we may find a sign of the child's father in James Dalton's wig box atop the Harlot's tester bed in the scene in which the magistrate breaks in to arrest her, as the angel entered in the Annunciation.

73. Lindsay, 63–64.

10. PUBLICATION, RECEPTION, AND SIGNIFICANCE

1. Alexandre Beljame, *Men of Letters and the English Public in the Eighteenth Century*, trans. E. O. Lorimer (London, 1948), 363.

2. Letter from Gay to Swift, 20 Mar. 1728, in *Letters of John Gay*, ed. C. F. Burgess (Oxford, 1966), 72; Samuel Johnson, *Lives of the Poets*, "Gay," "Young"; Voltaire, *Oeuvres* (Paris, Garnier ed.), 5. For Pope, see George Sherburn, *The Early Career of Alexander Pope* (Oxford, 1934), 188, 253–59.

3. Marjorie Plant, *The English Book Trade*, 2d ed. (London, 1965), 230.

4. One can be virtually certain of this: none appears in any of the papers he later used for advertising the end of the subscription.

5. *Spectator* No. 226. It is also possible, however, that Sympson's mezzotint of *The Christening* followed Kirkall's mezzotints of the *Harlot*. For Sympson, Jr., and his engravings after Hogarth, see above, chap. 7.

6. See Vertue, 3: 28, 29; *Daily Courant*, 2 June 1725; *Daily Journal*, 14 Jan. 1726/27. Vertue's note that Hogarth tried to employ engravers but was dissatisfied with their work (3: 58) may have been derived from Hogarth's advertisements rather than personal contact.

7. Cibber, *Lives of the Poets*, 5: 339.

8. See the *Daily Post*, 31 Dec. 1731.

9. *Gen. Works*, 1: 56.

10. BL pressmark P.C. 31.k.14: *Reed's Weekly Journal, or British Gazetteer*, 29 Jan. 1731/32; *Gen. Works*, 2: 101.

11. See *Reed's Weekly Journal*, 11 Mar., which says he died at his house, Stony-Hill near Edinburgh; *Craftsman*, ibid., which says he died on 19 February at Hornby Castle near Lancaster. For the earlier report: *Grub-street Journal*, 15 Oct. 1731. The report of his funeral was in the *Grub-street Journal*, 30 Mar. 1732.

12. *Daily Journal*, repeated 12, 20 Apr.; *Daily Advertiser* and *Daily Journal*, 21, 28 Apr., and frequently repeated thereafter.

13. See Calhoun Winton, *Captain Steele* (Baltimore, 1964), 132, 151.

14. Vertue, 3: 58. If it is by Hogarth, the little painting of the Harlot taken from Plate 3 (later Lord Charlemont, now Mellon, Yale) was presumably painted for someone who wanted a memento beyond the prints.

15. *Daily Journal*, 21 Apr.; *Grub-street Journal*, 27 Apr.

16. *A Tale of a Tub* (Oxford, 1958), 207.

17. *Daily Post*, 24 Apr.; 2d ed., *Daily Journal*, 4 May; 4th ed., which now has the cuts ("N.B. Any Gentleman who has bought the former Editions, may have the cuts alone, for 1 *s*."), *Daily Journal*, 15 May; 5th ed., *Daily Journal*, 29 Nov. The bawd is here identified as Mother Bentley, perhaps because Mother Needham was dead; Charteris and Gonson are identified. The second plate is based on Giles King's copies, with the two extra portraits on the wall, and mentioned as Woolston and Clarke in the text.

18. *Daily Journal,* 5 May 1732.

19. *Daily Advertiser,* 20 June; *Daily Journal,* 3 July.

20. *London Evening Post,* 16–18 May; *Craftsman,* 18 Nov. Vertue writes: "a Student in the Accademy. from very small beginnings in graving contrivd a mixt manner of graving of plates Etch'd, wood Cutts & Metzotint" (6: 188), adding that he was "an Industrious man." Kirkall was known for his illustrations for Rowe's Shakespeare edition. His illustrations for Tom Brown's *Works* drew on Hogarth's illustrations for Gildon and Butler. He was also, like Hogarth, a great advertiser of his projects (*Weekly Journal or Saturday Post,* 12 Sept. 1724; *Daily Journal,* 12 June 1725; *Daily Journal,* 4 Nov. 1725; and *London Journal,* 20 Nov. 1725).

21. *Daily Journal,* 1 May 1733. This pamphlet, following *The Humours of Drury Lane,* identifies the bawd as Mother Bentley, also Charteris, John Gourly, Woolston, and Clarke; Dr. Jean Misaubin is identified as the "meagre Quack" in pl. 5, and Mother Bentley is again identified in pl. 6.

22. *Daily Advertiser,* 13 Nov. 1732; and 15 Mar. 1732/33; see also Moore, 36. It was being performed in the summer of 1733 at the Theatrical Booth of Lee, Harper, and Petit (*London Journal,* 4 Aug.).

23. In October Hogarth's name was on a frontispiece for a translation of *The Miser,* one of the Molière comedies that had been adapted successfully for the stage by Fielding. This and a second frontispiece, for *Sganarelle,* were published in James Miller's *Select Comedies of M. de Molière* (whose *Humours of Oxford* Hogarth had illustrated), which Fielding puffed in his preface to another Molière adaptation, *The Mock Doctor.*

24. See Battestin, *Fielding,* 78, 79.

25. James Ralph, who had attacked Pope and defended the dunces in *Sawney* (1728) and so was incorporated into the 1729 *Dunciad,* was a friend of both Fielding and Hogarth. He had written the prologue to Fielding's *Temple Beau* (Jan. 1730), and his treatise, *The Touch-Stone: or, Historical, Critical, Political, Philosophical, and Theological Essays on the Reigning Diversions of the Town* (1728), sets out the aims and methods of Fielding's *Author's Farce* of 1730. On the other hand, this book echoes Hogarth's visual images, covering much the same territory as Hogarth's graphic satires of the 1720s—operas, masquerades, theater, pantomimes, fairs, and the bear gardens.

26. *Rape upon Rape,* II.v., ed. W. E. Henley (London, 1903), 9: 99.

27. The latter is the Battestins' explanation (121–22).

28. *Grub-street Journal,* 8 June 1732; see also Moore, 97–99. Though not produced until June, the play may have been ready as early as 4 Apr. (Moore, 96; Hume, *Henry Fielding,* 130, 133), but in any case Fielding would have seen the paintings as early as the subscription in spring 1731. Fielding's play, unlike Hogarth's progress, met with a negative response, presumably because he focused on the brothel and bawd rather than the girl and the outside world.

29. See Paulson, *Satire and the Novel* (New Haven, 1967), 78–85.

30. Almost these exact words were picked up by Ambrose Philips in a letter to "Joseph Gay," which was reproduced in the newspaper advertising *The Lure of Venus,* and opposite the title page of the book (*Daily Journal,* 1 May 1733).

31. *Biogr. Anecd.* (1781), 68; in the 1785 ed. Nichols gives the source as "Mr. *Forrest*—dead," which by this time could have been either Ebenezer the father (d. 1783) or Theodosius the son (d. 1784). The manuscript of the "Peregrination" is in the BL; I follow Mitchell's edition of 1952.

32. A daughter, Anne Sophia, was baptized at St. Paul's Covent Garden, 6 May 1724 (*Registry,* ed. W. H. Hunt, 1: 201); for Robert Scott, see St. Paul's Covent Garden poor rate book (Westminster Public Library). Samuel Scott is not mentioned himself in the books till 1739. He remained till 1747, when he moved to Southampton Street and Richard Wilson took over the Covent Garden house. See Walpole, *Correspondence,* 9: 61; 10: 329–31.

33. By 1738 John Thornhill was living on the east side of Long Alley, a narrow passage leading to the Strand, where Agar Street now runs; he leased it in 1738. (See *London Survey, St. Paul's Covent-Garden.*)

34. St. Paul's Covent Garden poor rate books. For the "Memoir of Tothall," see *Gen. Works,* 1: 522–23.

35. Mitchell, 5.

36. Mitchell, 3, 5, 7, 10, 12.

37. Mitchell, 16.

38. See, e.g., J. H. Plumb, *The Pursuit of Happiness* (New Haven, 1977).

39. Lance Bertelsen, *The Nonsense Club: Literature and Popular Culture, 1749–1764* (Oxford, 1986), 256.

40. The story of Hogarth the dandy was told by James Barry to J. T. Smith's father (J. T. Smith, 2: 270). The quotation is from Bertelsen, *Nonsense Club,* 257.

41. Cf. *Analysis,* 184.

42. Rouquet, 4; Fielding, *Convent-Garden Journal* No. 57, 1 Aug. 1752; and *Jacobite's Journal* No. 32, 9 July 1748 (see also No. 31).

43. Whoring had come to be associated with milliners. For example, *The Life and Intrigues of the Late Celebrated Mrs Mary Parrimore* (1729) tells the story of a Hampshire girl who comes to London, sets up as a milliner in Exchange Alley (the South Sea Bubble serves as informing context), and becomes a whore.

44. Daniel Defoe, *Works,* ed. G. H. Maynadier (Boston, 1903), 2: ix, xii.

45. See *Hudibras in Tribulation,* "Honesty" and "Honour" in *The South Sea Scheme.*

46. In *Spectator* No. 83, his description of the picture gallery, Addison explains how "when the Heavens are filled with Clouds, when the Earl swims in Rain, and all Nature wears a lowring Countenance, I withdraw

my self from these uncomfortable Scenes into the Visionary Worlds of Art, where I meet with shining Landskips, gilded Triumphs, beautiful Faces, and all those other Objects that fill the Mind with gay *Ideas,* and disperse that Gloominess which is apt to hang upon it in those dark disconsolate Seasons."

47. Robert Boyle, *Occasional Reflections on Several Subjects* (1665), xxi.

48. Newton, *Optics* (1690), i.1., Prop. II; Locke, *Essay concerning Human Understanding* (1690), 2.11.17 (ed. A. C. Fraser [New York, Dover ed., 1959], 1: 212).

49. Also relevant is Locke's *Some Thoughts concerning Education* (1693).

50. Locke, *Essay,* e.g., 2.9. See Marjorie Hope Nicolson, *Newton Demands the Muse* (Princeton, 1946), chap. 1.

51. *Science of a Connoisseur,* in *Works,* 269 (see above, 378 n15). This subject will be treated in greater detail in vols. 2 and 3.

52. See Jackson Lears, "From Salvation to Self-Realization: Advertising and the Therapeutic Roots of the Consumer Culture, 1880–1930," in Richard W. Fox and Lear, eds., *The Culture of Consumption* (New York, 1983), 3–38.

53. *Fable of the Bees,* ed. F. B. Kaye (Oxford, 1924), 1: 43–57.

54. Mandeville would seem to have been a prudent Deist who could claim to be a Latitudinarian. See his chapter "Of Mysteries" in *Free Thoughts on Religion, the Church, and National Happiness* (2nd ed., 1720), esp. 79–82 (on clergy), and 85, 87–88, and 93–95 (on reason/mysteries). For his definition of the difference between Deism and atheism, see 3. See also Hector Monro, *The Ambivalence of Bernard Mandeville* (Oxford, 1975), 171.

General Index

Abbate, Niccolò dell', 222
Adam, Robert, 88
Addison, Joseph, 73, 75–76, 98, 122, 136, 227, 264, 271, 277, 329, 332, 334, 367n11; on art vs. nature, 296; on European schools of painting, 133, 279; on the picture gallery, 386–87n46; on theater, 182
Aglionby, William 95–96
Aikenhead, Thomas, 61
Alberti, Leon-Battista, 45, 258, 261, 296
Alciati, Andrea, *Emblemata,* 130
Amhurst, Nicholas, 93, 165, 198; *Terrae Filius,* WH's illustrations for, 165
Amigoni, Jacopo, 126, 158
Anderson, James, 115, 117, 118; *The Constitutions of Free Masons,* 115, 116–17
André, Dietrich Ernst, 363n10
Anne, queen of England: Board of Works under, 85–86; engraving during reign of, 49, 56; era of, 42, 96; representations of, 111, 113
Antal, Frederick, *Hogarth and His Place in European Art,* xv, xxi–xxii
Apuleius, *Metamorphoses,* 93, 94, 117, 141
Archambo, Peter, 39

Argyle, John Campbell, 2d duke of, 242
Arne, Edward, 194

Baily, George, 244
Bambridge, Thomas, 189, 192, 220; committee to investigate, 189–91, 194; prosecution of, 194–95, 197
Barnes, James, 194
Baron, Bernard, 58, 60, 99, 305
Bassano, Jacopo, 57
Battestin, Martin and Ruthe, 315
Beauvais, Nicholas de, 99, 142, 362n106
Beckett, R. B., *Hogarth,* xxi, xxii
Beljame, Alexandre, 301
Benson, William, 85, 86
Bentley, Mother Elizabeth, 376n45, 384n17, 385n21
Berain, Jacques, 49, 58
Berchet, Pierre, 97
Bernini, Giovanni Lorenzo, 129
Bertelsen, Lance, 325
Betew, Panton, 348n21
Betterton, Thomas, 159, 161, 163, 364n30
Bickham, George, 142, 154
Bindley, James, 347n65
Bird, Francis, 128, 358n65
Blackmore, Sir Richard, 359n73; *Hymn to the Light of the World,* 134

Blake, William, 185, 365n33

Blount, Charles, *Great Is Diana of the Ephesians*, 292

Blunt, Sir John, 80

Boccaccio, Giovanni, 277

Bolingbroke, Henry St. John, 1st viscount, 93, 165

Bolton, Charles Paulet, 3d duke of, in WH's *Beggar's Opera*, 176, 181, 183, 184, 240, 259

Bond, Anne, 241, 242–43, 249, 250, 251, 328, 373n17, 386n42

Booth, Barton, 78, 121

Bosse, Abraham, 58, 59, 60

Bowles, Thomas, *A View of Covent Garden* (fig. 71), 203

Bowles brothers, 22, 111, 121; piracy of WH prints, 90–91, 313

Boydell, John, 126, 185

Boyle, Robert, 333

Breval, John Durant (pseud. Joseph Gay), 313

Brewer, John, 88

Broughton, John, 24

Brouwer, Adriaen, 108, 215

Bruce, Lord, 221–22

Bruegel, Pieter, the elder, 120, 215

Bullock, William, 18, 19

Bunyan, John: as source, 125, 256, 257, 287, 377n6

—*Grace Abounding*, 128, 272

—*Pilgrim's Progress*, mark on WH, 10–11, 272, 335

Burke, Joseph, xx

Burlington, Richard Boyle, 3d earl of, 315; art and politics, 77–78, 87, 118; Burlington House, 75, 77, 78, 81–82, 83, 86–87, 120; circle of, 68, 77, 139, 151, 158, 198; as Kent's patron, 82–85, 138; and Palladian style, 75, 83, 85, 88

Burnet, Gilbert, 20

Butler, Samuel, 140, 141, 148, 166; satires of, 21, 68; *Hudibras*, 59, 61, 69, 140, 142–43, 146–47. *See also Hudibras* illustrations *in* INDEX OF HOGARTH'S WORKS

Cadière, Catherine, 307–8

Caldwell, R., 72

Callot, Jacques, 57, 58, 68; *Misères de la guerre* (figs. 17, 18), 59–60, 70–71, 141

Campbell, Colen, 206; *Vitruvius Britannicus*, 85, 86

Carducho, Vincente, *Dialogos de la pintura*, 380n28

Carlisle, Anne Howard, countess, 12–13

Carlisle, Charles Howard, 2d earl of, 343n38

Carlisle, Charles Howard, 3d earl of, 12, 13

Caroline, queen of England, 150

Carracci, Annibale, 120

—*Choice of Hercules*, 174

—*Marriage of Bacchus and Ariadne* (fig. 45), 144

—*Temptation of St. Anthony*, 83

Carracci brothers, 56, 57

Carteret, John, 2d baron, 150–52, 362n105

Castagna, Curio, *Mirror of the Whore's Fate*, 256–57

Castell, Robert, 189

Castello, Bernardo, 150

Castlemaine, Richard Child, viscount, 83, 212; commission by, 206–8, 223

Catenaro, Juan-Batiste, 97

Cats, Jacob, 228

Cave, Edward, 14

Cervantes, Miguel de, *Don Quixote*: illustrations of, 117, 118, 141, 150, 362n105; WH and, 114,

117, 140–42, 147, 164, 170–71, 258; WH's project for, 150–54. *See also* Coypel, Charles-Antoine; Vanderbank, John

Chandos, James Brydges, 1st duke of, 83, 155–56

Charke, Charlotte, *The Harlot*, 313

Charles I, 9, 58; and High Renaissance art, 125, 126; life of, 103

Charles II, 9, 126, 145, 232

Charles XII, king of Sweden, WH etching of, 58

Charteris (or Chartres), Col. Francis, 250, 252, 288, 289, 298, 376n53; arrest, trial, and pardon of, 241–44, 245, 248–49, 373n17, 373–74n19, 374n26; death of, 308; in *Harlot*, 32, 240, 248, 253, 261, 265, 273, 280, 292, 329, 384n17, 385n21; writings about, 242, 243–46, 346, 373n15, 383n72

Chatsworth, 96

Cheron, Louis, 64, 97, 101, 102, 103, 109

Chilcott, Mrs., 72

Cholmondeley family. *See* Malpas, Lord and Lady

Cibber, Colley, 78, 121, 162, 164–65

Cibber, Theophilus, 306; *The Harlot's Progress*, 314

Clarke, Samuel, 288, 290, 292, 384

Claude Gellée or Lorraine, 57

Clifton, Sir Robert, 242

Cock, Christopher, 206, 209, 216, 369n11

Coke, Thomas, 82–83, 84

Coleridge, Hartley, 254

Coles, Elisha, 35

Collins, Anthony, 9, 290, 294, 298; *Discourse on the Grounds and Reasons of the Christian Religion*, 295

Congreve, William, 78, 88

Cooke, Thomas, 299

Correggio, Antonio, 57; *Noli me tangere*, 174

Cortona, Pietro da, 57, 83, 124

Covent Garden (maps, figs. 70, 71), 110, 203–4; Theatre, 175, 176, 184

Cowper, Ashley, commissions for, 214, 231

Coypel, Charles-Antoine, 364n30; *Don Quixote* illustrations, 141–44, 150–53, 362n106; *Don Quixote Demolishing the Puppet Show* (fig. 29), 117, 118

Craftsman, The, 72; anti-Walpole campaign, 165–66, 168, 170, 172, 190, 249, 250; WH advertisements in, 202–3, 250, 305, 306

Crow, Thomas, 135, 136

Curll, Edmund, 91, 313

Cuthbert, Dougal, 189

Cuzzoni, Madam Francesca, 79, 80, 89, 168

Dabydeen, David, xvi

Daggastaff, George, *The Diverting Muse*, 26

Dahl, Michael, 71, 109, 158

Dalton, James, 244, 245, 247, 373n14, 373n16, 383n72

Dalton, John, 8, 344n45

Dandridge, Bartholomew, 109, 210, 212, 214, 222

Davies, Thomas, 89

Davys, Mary, *Accomplish'd Rake, The*, 252

de Hooch, Pieter, 108

de Piles, Roger, 186, 275

De Veil, Sir Thomas, 215, 217

Decoy, The, 314

Deer, Nick, *The Art of Success*, 375n34

Defoe, Daniel, 41, 42, 359n73; on London, 1; novels, 286, 287
—*Essay on Credit,* 29
—*Journal of the Plague Year,* 350n3
—*Moll Flanders,* 239, 325; and the *Harlot,* 251, 254
—*Review,* 17, 31
Desaguliers, John Theophilus, 115, 117, 118
Devonshire, William Cavendish, 3d duke of, 96
Dictionary of Cant, 261
Dobson, Austin, *William Hogarth,* xix, 254
Dodington, George Bubb, 355n7, 356n38
Dodsley, Robert, 152
Doggett, Thomas, 18–19
Domenichino, 83; *Martyrdom of St. Agnes,* 382n55
Dorigny, Nicholas, engravings of Raphael (fig. 35), 58, 128, 137, 258, 310
Dorment, Richard, 369n10
Dou, Gerard, 57, 380n26
Drew, Humphrey, 60
Drury Lane Theatre, 18, 78, 124, 175; Shakespeare's plays at, 159, 164–65; WH's attacks on, 122, 351–52n22
Dryden, John, 121, 160; on art, 127, 277; as satirist, 21, 61, 172; translations of the classics, 88, 181, 301
—*All for Love,* 175, 316
—*Indian Emperor, The,* 201, 250
—*Indian Queen, The,* 175
—*Mac Flecknow,* 281
Dubos, Jean-Baptiste, 378n10
Dubosc, Claude, 58, 60, 99, 305
Ducerceau, Paul, 49
Duquesnoy, François, 380n26

Durell, Aaron, 244
Dürer, Albrecht, *Life of the Virgin* series (figs. 105, 106), 273, 299

Egleton, Mrs., 175
Ellys, John, 109, 363n10
Eyre, lord chief justice, 157, 158

Fagg, Sir Robert, 176, 183
Faithorne, William, 55, 59
Fawkes (or Faux), Isaac, 77, 78–80
Fenton, Lavinia, 175, 176, 181, 183, 228, 239–40, 259, 260, 272
Fielding, Henry, 141, 170, 216, 234, 383n65; farces, 88, 94, 168; Molière translations and productions, 385n23; and Pope, 71, 315; and WH, 250, 299, 307, 314–19
—*Author's Farce, The,* 315–17, 323–24, 352n24, 374n20, 385n25
—*Covent Garden Tragedy, The,* 314, 317–19, 385n28
—*Grub-street Opera, The,* 247, 264, 317
—*Jacobite's Journal, The,* 314
—*Joseph Andrews,* 24, 236, 250, 299, 319
—*Lottery, The,* 307
—*Love in Several Masques,* 172
—*Modern Husband, The,* 316, 317
—*Rape upon Rape,* 245, 316
—*Tragedy of Tragedies (Tom Thumb),* 316; WH frontispiece for (fig. 108), 314
—*Welsh Opera, The,* 317
Figg, James, 24
Fleet Prison (map, fig. 4), 27, 98; House of Commons inquiry into, 33, 188–91, 194–95, 197, 218; and Richard Hogarth, 26, 30, 39; in WH's work, 32, 33, 188, 191, 193, 197, 229

Forrest, Ebenezer: *Momus Turn'd Fabulist,* 320; narrative of "Peregrination," 320–23, 386n31
Fountaine, Sir Andrew, 212
Fourdrinier, Peter, 313, 360n90
Fragonard, Jean Honoré, 229
Frederick Lewis, Prince of Wales, 53
Freedberg, Sydney, 126–27

Gale, Thomas, 11–12
Gamble, Ellis, 103, 347n1; family, 39, 347–48n8; life and career, 38–39, 47–48, 171, 347n5; shop card (fig. 8), 48, 52; WH's apprenticeship with, 38, 39–41, 48–52, 60, 293
Garrick, David, portrait of, 56, 186
Garth, Sir Samuel, 21
Gay, John, 71; as satirist, 61, 88–89, 139–40
—*Beggar's Opera, The,* 72, 89, 159, 244, 302, 364–65n31; premiere, 175, 202; significance, 180–82, 184; as source and inspiration, 172–76, 179, 183–84, 201, 239–40, 246, 248–49, 251, 314–15, 316, 377n12
—*Poems on Several Occasions,* 84, 301
—*Polly,* 302; as source, 240, 249, 267
—*Shepherd's Week, The,* 68, 360n88, 365n34
—*Trivia,* 68, 71, 72, 254, 376n49, 377n8
Gentlemen's Magazine, 14, 97
George I, 52, 65, 85, 99, 116, 171; representations of, 122–24, 367n11; and South Sea Bubble, 67; WH's satire of, 111–13
George II: accession of, 165,

168–69, 172; as Prince of Wales, 67, 79, 80, 83, representations of, 111, 113, 169
Gibbons, Anne (WH's maternal grandmother), 5–7, 13, 342n22
Gibbons, John (grandfather), 5–6, 13, 30
Gibbons, William (uncle), 30, 32, 33, 346n59
Gibbs, James, 17, 86
Gibson, Edmund, 1–2, 76–77; in *Harlot,* 2, 112, 249, 253, 289, 328–29; vs. Woolston, 288, 289–90; *Pastoral Letters,* 2, 253, 273, 289–90, 376n48, 382n49
Gibson, Thomas, 101
Gideon, Sir Sampson, 249, 374n33
Gildon, Charles, 94; *The New Metamorphosis,* 93; WH illustrations for (fig. 22), 93–94, 117, 141, 183, 385n20
Gillot, Claude, 136–37
Gillray, James, 76, 167
Girard, Jean-Baptiste, 307–8
Godby, Michael, 238
Golden Rump, The, 166
Gonson, Sir John, 374n20; in *Harlot,* 218, 247–48, 268, 273, 292, 307, 329, 384n17; as magistrate, 245–46, 249, 250, 252, 283, 289, 294, 330
Goupy, Louis, 109
Gourley, John, 244, 246; in *Harlot,* 248, 385n21
Grafton, Charles Fitzroy, 2d duke of, 137–38
Grand Mystery of Freemasons Discover'd, The, 116, 117
Grant, Sir Archibald, 190, 370n18; and Charitable Corporation, 218; commissions by, 175, 178, 193, 220

Gravelot, Hubert, xvii, 308

Greenwich Hospital, Thornhill's
paintings in (fig. 27), 96, 97, 100,
101, 107, 111, 113, 122–24, 126,
129, 131, 136, 137, 159, 358n56,
358–59n66, 359n71

Gribelin, Simon, 39, 50, 56

Grub-street Journal, 252; attacks on
Fielding, 315, 318; attacks on
Woolston, 290–91, 330; and
Charteris, 244–45, 246, 250, 308;
on Walpole, 246, 373n17

Hackabout, Francis, 244, 245, 246,
261, 373n17

Hackabout, Kate, 246, 247, 251,
253–54, 255, 258, 261, 289, 328,
329, 346

Hamilton, Gawen, 193, 214

Hampton Court Palace, 125, 204,
271

Handel, George Frideric, 77–78,
79, 179

Hardwicke, Philip Yorke, 1st earl
of, 195

Harlequin Sheppard, 121, 352n22

Harley, Edward, 2d earl of Oxford,
53, 358n65

Harley, Robert, 1st earl of Oxford,
26, 347n66; Richard Hogarth's
petition to, 26, 28–30, 34, 35;
and Toland, 345n55

*Harlot's Progress, The, or the
Humours of Drury Lane,* 247, 312,
376n45, 385n21

Harper, John, 162

Hatton, Edward, 23

Hayman, Francis, 163–64

Head, Richard, *English Rogue,* 248

Heemskirk, Egbert van, the elder,
25, 215, 344n47; Quaker Meeting
paintings (fig. 3), 25, 377n8

Heemskirk, Egbert van, the
younger, 25, 222

Heidegger, John Jacob, 77, 79, 81,
89, 168, 169

Helmesley, Richard (WH's cousin),
23, 342n22

Helmesley, Timothy (uncle), 32,
346n59; family of, 13, 23, 342n22

Henley, John (Orator), 215,
369n13, 374n20

Highmore, Thomas, 96, 98

Hill, Aaron, 116, 117, 371n34

Hoadly, Benjamin, 383n68; attacks
on, 298, 299; WH's portraits of,
298

Hoare, Henry, 379n17

Hogarth, Anne (sister), 13, 20, 23,
342n22, 371n28; occupation, 24,
329; shop card for (fig. 94),
232–33

Hogarth, Anne Gibbons (mother),
32, 349n22, 349n23; character, 6,
28, 196–97, 230; residence and oc-
cupation, 20, 26, 33, 52, 232–33

Hogarth, Edmund (brother), 22,
23, 28, 343–44n41

Hogarth, Edmund (uncle), 27, 329,
343–44n41; death and will of, 22,
52, 349n23; and WH, 22, 39, 52,
230

Hogarth, Jane Thornhill (wife), 35,
155, 328; background and charac-
ter, 10, 95, 196–97, 199;
courtship and marriage, 95,
196–202, 205, 208, 234; portraits
of (figs. 50, 69), 199; on WH's
work, 153, 196, 199

Hogarth, Mary (sister), 7; occupa-
tion, 24, 329; shop card for (fig.
94), 232–33

Hogarth, Richard (brother), 7, 23,
342n22

Hogarth, Richard (father): back-
ground and character, 1–2, 36–
37, 328; career, 2–5, 11–12, 24,
33–36, 345n52; death of, 51–52,
349n22; family Bible, 6, 23, 339–
40n1, 342n22, 346n59; imprison-
ment, 26–32, 38, 328; Latin-
speaking coffeehouse, 14, 24, 26,
61; marriage and children, 6, 7, 9,
13, 23, 28; petition to Harley, 26,
28–30, 34, 35, 346n65; and reli-
gion, 7–10, 382n56; residences,
5–7, 13–14, 27–28, 35, 342n24;
WH and, 15, 24, 32, 35–37, 38,
91, 200, 230, 278–79, 328–29
—*Compendium of Geography, A,* 13
—*Disputationes Grammaticales,* 5, 9,
13, 15, 33, 35, 346n62
—*Gazophylacium Anglicanum,* 4
—*New School Dialogues,* 34–35
—*Thesararium Trilingue Publicum,*
2–3, 5, 15, 340–41n4, 346n62
—unpublished Latin dictionary, 35,
346–47n65
Hogarth, Sarah (aunt), 39,
343–44n41, 349n23
Hogarth, Thomas (brother), 13, 28
Hogarth, William, life and career
—and the academies, xvii, 36–37,
100–109, 110, 134, 144, 331–32
—appearance and character,
110–11, 223, 321, 329, 385n20
—apprenticeship to Gamble,
38–41, 55, 65; anecdotes about,
44–45; and early drawing,
42–43; end of, 51–52
—and Augustan satirists, xv, xvi,
61, 68, 71–72, 88–89, 94, 166,
172–73, 219, 269
—biographies and works on, xv,
xvi, xix–xx
—childhood: birth and baptism,
7–8; classical training, 11, 15,
24–25; early interest in art, 25,
42; early life, 63–64; family
Bible, 6, 95; and uncle, 22, 39,
52, 230; surroundings and enter-
tainments, 15–24, 323, 363n12
—courtship and marriage, 95,
196–202, 205, 208, 234, 368n27
—and the Deists, 253, 293–300
—as engraver and etcher, 48–50,
52, 53, 60–64, 67, 155, 171–72,
233, 293, 348–49n21, 361n104
—and Engravers' Act, 30–31, 196,
375n34
—and father, 15, 24, 32–33,
35–37, 38, 91, 200, 230, 278–79,
328–29
—finances, 51–52, 93, 155, 214
—on the "Five Days Peregrina-
tion," 299, 319–23, 325
—and Freemasonry, 114–19, 220
—modern play about, 375n34
—as painter, 198, 221; assistance to
Thornhill, 158–59, 191; commis-
sions, 155–57, 175, 176, 190,
193, 206, 208, 209–14, 216–21,
225, 230–31; court cases, 157;
idea of invention, 233–34, 236;
maturation of technique, 160,
185, 231; motivation, 155–56;
style, 156–57, 180, 185–87, 221
—place in art history, xxii, 332–33,
335
—praise of, in poetry, 234–36, 312
—and printsellers, 72–73, 89–93,
328, 331
—and his public, 134, 135–36, 218,
310–11
—and public taste, 77, 78–81, 88,
122
—and his pugs, 203, 222–24, 275,
369n11

Hogarth, William (*continued*)
—residences, 93, 110, 198, 202–3, 368n28; childhood home, 14, 20–21, 97
—and social class, 325–27
—sources of information on, xix–xxii
—studios, 198, 203, 204, 209, 237–38, 274, 307
—and the theater, 46–47, 76, 159, 160, 168, 173, 313
—and Thornhill, 37, 95, 99–100, 110–13, 125, 129, 155, 158, 171, 172, 191–92, 198–99, 200, 202, 203, 209, 235–36, 328, 360n90, 371n32
—views and theories: apprenticeship as engraver, 41–43, 48–49; art vs. nature, 45–46, 76, 227; Line of Beauty, 37, 50–51, 170; and organized religion, 10, 291, 295–96, 297–98; "pleasures" and "studies," 25, 43–44, 47, 103, 106, 272, 329
Hollar, Wenceslaus, 55
Homer: illustrations of, 140; translations of, 88, 301–2, 314, 315
—*Iliad*, 71, 281
—*Odyssey*, 315
Hopthrow, Richard, 38, 40
Horace, *Ars poetica*, 278, 279
Houbraken, Arnold, 56
Houghton, John, 251
Howard, John, 167
Huggins, John, 27, 98, 220; and Fleet Prison, 188–89, 194–95, 197, 367n18; house of, 158, 355n7; WH's portrait of, 194
Huggins, William, 98, 307, 355n7, 367n18; and WH's paintings, 220; WH's portrait of, 194
Hume, Robert, 240–41, 248
Hunt, Gabriel, 106

Hutcheson, Francis, 229
Hysing, Hans, 109, 118

Ireland, John, 347n65; *Hogarth Illustrated*, xx, 35
Ivins, William M., 349n25

Jacobs, Margaret, 114
James I, representations of, 126
James II, 9, 116
Jephtha's Rash Vow, 19
Johnson, Samuel, 62, 172
Jones, Inigo, 86, 118
Jonson, Ben, 78, 88
Junius, Franciscus, 194

Kendal, Ehrengard Melusina von der Schulenburg, duchess of, 52
Kensington Palace, decoration of, 84–85, 87–88, 137–39
Kent, William, 109, 313; conflicts with Thornhill, 82, 84–88, 137–40, 158; decorative paintings, 86–87, 120; and Italy, 79, 82–83, 89; in *Masquerades and Operas*, 81, 82; Wanstead House designs, 206, 207; and WH, 84, 139, 207, 315
—altarpiece for St. Clement Danes, 138–40
—*Banquet of the Gods* (fig. 21), 86–87
King, Giles, copies of *Harlot* (fig. 109), 288, 292, 309–10, 312, 313, 384n17
King, Thomas, 157
Kirkall, Elisha, 222, 248, 310, 313, 361n96, 384n5, 385n20
Kitson, Michael, xx
Knapton, George, 109
Kneller, Sir Godfrey, 71, 113; academy of, 101–2, 109, 355n21,

358n65; conflict with Thornhill, 100–102; portraits by, 160, 161

Knight, Robert, 66, 67, 80–81, 157

La Calprenède, Gauthier de Costes de, *Cassandre,* WH's illustrations for, 141

La Motraye, Aubrey de, *Travels,* WH's illustrations for (figs. 13, 14), 61–63, 141

Laguerre, John, 162

Laguerre, Louis, 56, 96, 97, 101, 102, 109; *Battles of Marlborough,* 58, 62, 137, 141, 258, 302

Lairesse, Gerard de, *Art of Painting,* 54, 107–8, 228, 275

Lambert, George, 60

Lamerie, Paul de, 48, 52, 171

Laroon, Marcellus, *The Cries of the City of London,* 257

Lauri, Filippo, 222

Law, John, 66

Le Blon, Jacques Christophe, 204

Le Brun, Charles, 56
—*Battles of Alexander,* 137
—*Conférences,* 133, 265; *l'expression des passions,* 105, 133, 160, 265, 356n23
—*Elements,* 156

Le Hardy, Col. William, xix

Le Sueur, Eustache, *Life and Death of St. Bruno,* 137

Leggatt, Bartholomew, 18

Lely, Sir Peter, 160, 161, 363n15

Lewalski, Barbara, 379n20

Lewis, Mary (cousin and companion of Jane Hogarth), 35, 196

Lewis, W. H., 369n12

Lichtenberg, Georg Christoph, 267

Life of Colonel Don Francisco, The, 242, 244

Life of the Late Celebrated Mrs. Elizabeth Wisebourn, The, 71

Life of the Virgin, 273, 282, 283, 284, 299

Lillo, George, *The London Merchant,* 306–7

Lincoln's Inn Fields Theatre, 78, 81, 122, 175, 351n22, 365n35

Lindsay, Jack, *Hogarth: His Art and His World,* xvi, 89

Lintot, Bernard, 301–2

Littleton, Adam, *Linguae Latinae,* 35, 36

Livesay, Richard, 199

Locke, John, 88, 297; *Essay concerning Human Understanding,* 277, 333–35

Lockley, David, 62

London, 1, 23, 42; fairs and theatricals, 18–20, 22, 47, 136–37; Fire Monument, 12, 69, 70, 81, 350n3; Great Fire, 20, 255, 376–77n53; riots in, 20–21, 184, 298–99; Smithfield area (map, fig. 1), 5, 17–18, 20–21, 299; in WH's pictures, 69, 70, 73. *See also* St. Paul's Cathedral

Louis XV, 116

Lowe, Solomon, *Grammar of the Latin Tongue,* 34

Lubinus, Eilhardus, 15

Lucas van Leyden, 54

Lucian, 93

McKendrick, Neil, 88

MacSwiney, Owen, 77

Mallet, David, 234

Malpas, Lord (3d earl of Cholmondeley) and Lady, 209, 226, 227

Malpighi, Marcello, *Opera Posthuma,* 11–12, 342n18

Manchester, William Montagu, 2d duke of, 242

Mander, Karel van, *Het Schilderboek,* 119–20

Mandeville, Bernard, 251–52, 300
—*Fable of the Bees, The,* 335–36, 376n51
—*Modest Defence of Publick Stews, A,* 254–55, 376n51, 387n54
Maratta, Carlo, 83
Marks, Arthur, 207
Marlborough, Sarah Churchill, 1st duchess of, 85, 97, 220
Marot, Daniel, *La Prison d'Amadis,* 176
Massingberd, Burrell, 83, 138
Matteis, Paulo de, *The Choice of Hercules* (fig. 102), 174, 270
Mead, Dr. Richard, 177
Memoirs of the Right Villainous John Hall, The, 120
Mendes de Sola, Jacob, 190, 267
Merchant Taylors' Company, 38, 39, 51
Mercier, L.-S., 136
Mercier, Philippe, 160, 212, 222; *A Hanoverian Party* (fig. 74), 210
Mere Nature Delineated, 296–97
Michelangelo Buonarroti, 56, 57, 81, 125, 163; Sistine Chapel ceiling, 127–28, 163, 169, 284, 286
Mignault, Claude, 130
Millar, Oliver, xv–xvi
Miller, James: *Humours of Oxford, The,* WH's frontispiece for, 233, 385n23; *Select Comedies of M. de Molière,* 385n23
Miller, Josiah, 162
Mills, John, 18
Milton, John, as source, 125
—*Paradise Lost,* 71, 222, 272, 273, 281, 284, 379n20; reprinting of, 301; WH's illustrations for, 141, 150, 202, 360n90
Mitchell, Charles, xix

Mitchell, Joseph
—"Epistle to William Hogarth" (*Three Poetical Epistles*), 234–36, 260, 312, 371n34
—*Highland Fair,* WH's frontispiece for, 234, 371n33
—*Poems on Several Occasions,* 371n34
Molière (Jean-Baptiste Poquelin), 140; translations with WH's illustrations, 385n23
Montagu, John, 2d duke of, 115, 218, 220, 231
Montagu, Lady Mary Wortley, 315
Moor Park, 157–59, 353n44, 363n8, 367n25
Morris, Joshua, 151, 155–57, 160, 362n4
Muffett, Mary, 250–51
Mynde, J., 142, 154

Necromancer, The; or, Harlequin Dr. Faustus, 78, 80–81
Needham, Mother Elizabeth, 240, 248, 265, 279, 280–81, 292, 328, 376n45, 376n47; death of, 252, 255, 384n17
Newgate Prison, 119, 120, 194, 245
Newton, Sir Isaac, 88, 333
Nichols, John, 224, 228; and Jane Hogarth, 196; *Biographical Anecdotes,* xix, 35, 63, 158, 197, 198, 320
Noble, Thomas, 1–2, 4, 12
Norris, Henry, 18
Novak, Maximilian, 293

Oglethorpe, James Edward, 189, 191, 192
Old Creation of the World, The, 19
Oldfield, Dr. John, 151–52, 361n103

Oldham, John, 21

Onslow, Arthur and Richard, 191

Oppé, A. P., xxi

Ostade, Adriaen van, 57, 108, 258

Overton, Henry and Philip, 142, 149, 154, 221, 222, 302, 313, 362n108

Oxford, Edward Harley, 2d earl of. *See* Harley, Edward

Oxford, Robert Harley, 1st earl of. *See* Harley, Robert

Page, Thomas, *Art of Painting,* 104–5

Paine, Thomas, *The Age of Reason,* 299

Painter-Stainers' Company, 96, 98, 354n6

Parmentier, Jacques, 305

Parsons, Humphry, 216–18, 370n16

Paunceford, Maj. Robert, 176, 183

Pellegrini, Antonio, 97, 126

Pendarves, Mary Granville, on WH's portraits, 231–32

Penkethman, William, 18, 19

Philips, Ambroise, 365n34, 386n30

Phillips, Sir Richard, 196

Picart, Bernard

—*Cérémonies et coutumes,* 62–63, 119

—*Monument Dedicated to Posterity, A* (fig. 16), 68, 70, 71, 73

Piper, David, 120, 162

Plumb, J. H., 88, 325

Political Stage of Great Britain, The, 168

Pond, Arthur, 109

Pope, Alexander, 72, 84, 136, 169, 219, 249, 275, 310, 365n34; WH's ambivalence toward, 71–72, 315

—*Dunciad, The,* 72, 78, 88–89, 94, 136, 172, 181, 281, 314, 381n34, 385n25

—*Eloisa to Abelard,* 72, 332

—*Epilogue to the Satires,* 170

—*Rape of the Lock, The,* 68, 71, 263, 264, 381n42

—translations of Homer, 88, 301–2, 314

Portrait of Col. Francis Charteris on His Trial, 243–44

Poussin, Nicolas, 126, 258

—*Fall of the Manna, The,* 265

—*The Seven Sacraments,* 137

Price, Capt. William, 212, 369n10, 369n11

Prior, Matthew, 301

Prisons Open'd, The, 194

Progress of a Harlot, The, 311–12

Progress of a Rake, The, 312

Pulteney, William, 1st earl of Bath, 165, 317

Puttenham, George, 276

Pye, Sir Robert, 231

Quick, John, meetinghouse of, 9–10

Racine, Jean, 150, 362n105

Raimondi, Marcantonio, 54

Ralph, James, 299, 319, 385n25

Ramsay, Allan, 166, 234, 375n33; Bubble poems, 69; *Hudibras* dedication to, 147–49

Raphael, 81, 130; as model, 73, 103, 144–47, 163

—Cartoons, 56, 57, 156, 260; engravings of (fig. 35), 58, 137, 233–34, 258, 302, 310; praise for, 131–34; as source, 124–28, 131, 141, 285–87; and the spectator, 128–29; and Thornhill, 128–31, 198, 204–5; *Death of Ananias,*

Raphael (*continued*)
133, 359n73; *Paul and Elymas*
(fig. 36), 128–29, 133; *Paul
Preaching at Athens* (fig. 35), 128,
358n63, 359n73; *Sacrifice at
Lystra,* 133
— *Disputa,* 73
— *School of Athens,* 73, 74
Read, Ben, 106
Recueil de cent estampes, 62
Rembrandt van Rijn, 57, 108
Reni, Guido, 57
Reynolds, Sir Joshua, 186; *Dis-
courses,* 45–46
Ricci, Marco, 86, 126
Ricci, Sebastiano, 86–87, 97, 120,
126
Rich, John, 77, 122; and *The Beg-
gar's Opera,* 175–76, 183, 209,
365n32, 365n33; pantomimes
and theater productions of, 78,
81, 88, 89, 121, 320, 364n23
Rich, Sir William, 189
Richardson, Jonathan, 82, 109, 211;
doctrines of art, 45, 85, 127, 134,
152, 260–61; on engraving, 54;
on painting and theater, 173–74
— *Essay on the Theory of Painting,*
268, 379n22
— *Science of a Connoisseur, The,* 278,
335, 378n15
Richardson, Samuel, 41
— *Clarissa Harlowe,* 332
— *Pamela,* 325, 332, 336; WH's in-
fluence on, 250
Ripa, Cesare, *La novissima iconologia*
(fig. 104), 130–31, 263, 380n28
Robertson, William, *Phraseologia
Generalis,* 35, 36
Robinson, Sir Thomas, 176
Rodwell, William, 111
Rosa, Salvator, 57, 380n28

Roscommon, Wentworth Dillon,
4th earl of, 277
Roubiliac, Louis-François, 103, 212;
bust of WH, 110
Rouquet, Jean André, 254, 328
Royal Academy of Music, 77, 80,
89–90
Royal Naval Hospital. *See* Green-
wich Hospital
Rubens, Peter Paul, 56, 233, 303,
358n63; baroque style, 144; ceil-
ing at Whitehall, 125–26, 127,
129; *Nature Adorned by the Graces,*
275, 379n23

Sacheverell, Dr. Henry: in *Harlot,*
184, 247, 282, 292, 294–95; riots
by partisans of, 20–21, 184,
298–99; and Toland, 345n55
St. André, Nathaniel, 167, 168
St. Bartholomew the Great, 6–10,
17, 23; records of, 51, 349n22
St. Bartholomew's Hospital: recon-
struction of and changes to,
17–18, 232–33, 271n31; WH's
paintings in, 17–18, 20, 381n43
St. Clement Danes Church, Kent's
altarpiece for, 138–39; WH's bur-
lesque on (fig. 38), 139
St. John's Gate (fig. 2): Hogarth
residence at, 14, 20–21, 97; and
square, 20–21
St. Martin's Lane Academy, xvii,
83, 84, 85; subscribers to, 109;
WH in, 100, 103, 106–9
St. Paul's Cathedral, 97, 128; church-
yard, 22, 34; decorations by
Thornhill, 97, 99, 107, 124, 128–
31, 358n65; and WH, 21–22, 69,
70, 81. *See also* Thornhill, Sir
James, *Life of St. Paul*
St. Paul's School, 9, 11–12, 35

Sanderson, Nicolas, 103, 355n20
Schaub, Sir Luke, 158
Scott, Samuel, 386n32; on "Five Days Peregrination," 321–23
Settle, Elkanah, adaptation of *The Siege of Troy,* 19, 139–40
Shaftesbury, Anthony Ashley Cooper, 3d earl of, 227, 294, 336; doctrine of art, 45, 46, 135, 143–44, 229, 260–61; influence, 151, 335
—*Characteristics,* 85
—"Letter concerning Design," 85–86, 353n39
—*Notion of the Historical Draught or Tablature of the Judgment of Hercules,* 74, 86, 163, 174, 269–72, 335, 378n16
Shakespeare, William, 77, 78, 88; illustrations of, 125, 236, 385n20; as source and inspiration, 125, 164–65, 168, 200–201, 267; stage representations of, 159–64; WH compared to, 235–36, 260. *See also Falstaff Examining His Recruits in* INDEX OF HOGARTH'S WORKS
—*Tempest, The,* 160, 200–201; WH's painting of, 200–202
Shard, Sir Isaac, 216–18, 231, 306, 370n14
Sheppard, Jack, 332; pantomime of, 121; Thornhill's portrait of, 119–21, 358n57; WH and, 120–21, 194
Shesgreen, Sean, xvi, 257
Simon, Robin, 363n12
Simondau, (?), 99
Skerrett, Maria, 169, 175
Skinner, Stephen, *Etymologicon Linguae Anglicanae,* 4, 341n5
Smith, J. T., 304, 347–48n8, 348–49n21

Smith, Robert, 62
Solkin, David, 368–69n71, 370n21
Some Authentic Memoirs of the Life of Col. Ch . . . s, 288
Somers, John, baron, 353n39
Sothern, Richard, 173
South Sea Company, 66–67, 113, 248–50; Bubble, prints and satires about, 17, 61, 67–68, 72–73, 255, 350n4, 350n6, 364n24
Southwell, Sir Robert, 19
Spectator, The, 73, 122; on art, 75–76, 131–34, 179, 194, 279; on prostitutes, 238, 248; on shop signs, 264; on the theater, 182; and WH's *Lottery,* 73
Spiller, James, benefit ticket for (fig. 12), 60–61, 272
Steele, Sir Richard, 98, 367n11; on art, 131–34, 143, 158, 179, 194, 359n71, 359n74; defense of prostitutes, 238–39, 248, 253; and Drury Lane, 122; *Christian Hero,* 128
Steevens, George, xix, 288
Sterne, Laurence, 172
Strange, Robert, 304
Styles, Benjamin Heskin, 87, 157–58, 198, 367n25
Sunderland, Lady, 231
Sunderland, Charles Spencer, 3d earl of, 87, 98, 188, 355n7
Swift, Jonathan, 151, 285, 310; as satirist, 61, 68, 71–72, 73, 88, 141, 172, 249, 315
—*Gulliver's Travels,* 112, 165, 166, 363n20; WH's illustration of (fig. 55), 72, 166–67, 168, 169, 290, 363–64n20
—*Tale of a Tub, A,* 112, 291
Sykes, Norman, 288
Sympson, Joseph, Sr., 109, 222

Sympson, Joseph, Jr., 109; engravings by, 222, 304; prints of WH's works (figs. 83, 85), 221, 369n13, 384n5

Tasso, Torquato, 150
Tate, Nahum, revision of *King Lear,* 163
Taylor, George, 24
Taylor, John, 301, 346n62
Taylor, Randall, 346n62
Taylor, William, 33, 34, 346n62
Teniers, David, 57, 215
Tenison, Thomas, 97
Theobald, Lewis, *Persius and Andromeda,* WH's illustrations for, 233–34
Thievery-A-la-mode, 184
Thomson, James, 234
Thomson, John: and Charitable Corporation, 218, 220; commission by, 218, 220, 231
Thornbill, Sir James (father-in-law), 354n2, 354n3; academies of, 100–102, 108, 110, 114, 160, 196, 218, 312; art collection, 25, 111, 275, 379n23; career and commissions, 66, 87–88, 96–100, 101, 156, 197–99, 202, 271, 353n24, 355n9, 363n8, 367n24, 367n25; conflicts with Kent, 82, 84–88, 137–40; court cases, 157–58, 367–68n25; on Fleet Committee, 190–91, 194; and Freemasonry, 114, 118, 357n45; and history painting, 95–96, 122–24, 358n62; and money matters, 24, 87, 97, 99, 137, 157, 159, 197; residences, 99, 175, 203, 204, 356n38; as Serjeant Painter, 87, 95, 98, 138, 204; subscriptions, 302, 303, 304; WH, influence on, 95, 99–100,
111–13, 125, 129, 159, 171, 172, 191–92, 200, 202, 250; WH's attachment to, 37, 95, 97, 110–11; and WH's career, 209, 235–36, 360n90, 371n32; and WH's marriage, 196, 197–203, 205, 234
—decoration of St. Paul's, 97, 99, 107, 124, 128–31, 358n65
—*Fall of Phaeton, The,* 96
—Greenwich Hospital paintings, 96, 97, 100, 101, 107, 111, 113, 122–24, 126, 129, 131, 137, 159, 358n56, 358–59n66, 359n71
—*George I and His Family* (figs. 23, 24), 110, 111–12, 367n11
—*Hercules Defeating Calumny, Detraction, and Envy* (fig. 27), 113
—*House of Commons, The,* with WH (fig. 67), 191–92
—*Landing of George I, The* (fig. 34), 122–24
—*Life of St. Paul* (fig. 37), 99, 125, 128–31, 136, 358n63; engravings of, 58, 99–100, 141, 258, 302–4, 310
—portraits: Jack Sheppard (fig. 32), 119–21, 122, 136; Richard Steele, 131, 358n57; self- (figs. 23, 34, 72), 110, 124, 205
—*Sketch of His Family* (fig. 72), 205
—sketches (figs. 30, 31), 119–20
—*Zephyrus and Flora* ceiling, 158
Thornhill, Jane. *See* Hogarth, Jane Thornhill
Thornhill, John (brother-in-law), 196, 205, 354n6, 386n33; on "Five Days Peregrination," 321, 328
Thornhill, Judith, Lady (mother-in-law), 198–99, 205
Thurmond, John, *Harlequin Dr. Faustus,* 78, 121
Tilson, Christopher, 307

Titian (Tiziano Vecelli), 56, 57

Toft, Mary, 167–68, 217, 364n23

Toland, John, 8, 290, 294, 296, 298, 383n62; protégé of Harley, 345n55; *Christianity Not Mysterious,* 61

Tonson, Jacob, 150–52, 360n90, 362n105; subscription publications, 301

Tothall, William, 203; on "Five Days Peregrination," 321–23

Trusler, John, 10

van Aken, Joseph, 211

Van Dyck, Anthony, 56, 58, 161, 260

Van Gunst, Pieter, 56, 58

Vanbrugh, John, 13, 86, 87, 118

Vanderbank, John, 156, 157, 362–63n5; academy of, 64, 73, 82, 102–3, 108, 109, 134, 160, 222; career, 102–3; designs and engravings, 222, 258; illustrations for *Don Quixote* (fig. 48), 150–51, 152, 153, 361n104

Vanderbank, Moses, 157, 362–63n5

Vandergucht, Gerard (fig. 29), 58, 60, 61, 150, 152, 304, 310, 361n96, 361n99, 361n104, 362n105, 371n32; as engraver of WH's works (fig. 109), 233, 234, 371n32

Vandergucht, Michiel, 53, 56, 99

Vermeer, Jan, 108, 378n15

Verrio, Antonio, 56, 96, 124

Vertue, George, 62, 361–62n104, 385n20; on the academies, 101–4, 109–10; career as engraver, 52–56, 57, 360n90; on engraving, 48, 54, 58–60; on Kent, 82–85; on Thornhill, 87, 97, 98, 157–58, 197–98, 203,

204, 205; on WH, xx–xxi, 48, 97, 154, 155, 203, 214, 215, 217, 222, on the *Harlot,* 237–38, 239, 248, 252, 303, 306, 310, 311, 376n45, 383n6

Virgil, 278–79; illustrations of, 140; translations of, 301
—*Aeneid,* 281, 295, 381n34
—*Georgics,* 71

Viviano (Viviani), 57, 83

Voltaire (François Arouet), *The Henriade,* 302

Walker, Thomas, 169, 174, 175, 177, 240, 264

Walker, William, *Dictionary of English and Latin Idioms,* 34

Walpole, Horace, 176, 363n8, 369n12; on portraiture, 207; as WH collector, 186; on WH, 176, 196, 199, 365n33

Walpole, Catharine (Shorter), Lady, 169, 175

Walpole, Sir Robert, 96; associations with, in *Harlot,* 248–50, 374–75n33; in *Beggar's Opera,* 169, 174, 175; and Charteris, 248–49, 373n17, 374n26; government of, 96, 169, 209; portraits of, 169, 191; propaganda and satires against, 17, 72, 112–13, 165–70, 190, 248–49, 313, 316, 317; Salver, commission of, 171–72, 250, 272, 315, 375n34; WH and, 166, 169–70, 174, 184, 192, 272, 315

Walton, Brian, *Polyglot Bible,* 301

Ward, Ned, *London Spy, The,* 18

Ward, William, 149, 155, 361n99, 362n1

Waterhouse, Ellis, xv–xvi

Watteau, Antoine: etchings of, 58; *fêtes,* as model, 135, 137, 176–77,

Watteau, Antoine (*continued*) 183, 210, 223, 228–29, 260; influence and tradition of, 160, 218, 222, 258–59, 380n26
—*Bal champêtre,* 177
—*Discuse d'aventure, La,* 259, 281
—*Enseigne de Gersaint, La,* 223, 229, 233
—*French Comedians,* 177
—*Italian Comedians,* 177
—*Pèlerinage à Cythère,* 210
—*Shepherds, The,* 223
Wemys, earl of, 244, 245
Wharton, Philip, duke of, 115, 116, 117, 220
White, George (fig. 32), 121, 248, 361n96
White, Robert, 55–56
Whitehall Banqueting House, 125–26, 127, 129
Wilks, Robert, 78, 121
William III, 6, 7, 9, 113, 271; representations of, 122, 124
Wollaston, William, 213, 259, 296–97

Wolsey, Thomas, cardinal, 164, 165, 169, 170, 290
Wood, Anthony, 301
Wood, Thomas, 206, 233
Woolston, Thomas, 288–92, 294, 298, 299, 329, 330; in *Harlot,* 288–92, 385n21; as source for WH, 291
Wootton, John, *Four Prints of the Sport of Hunting,* 305
Wren, Sir Christopher, 96, 118; design for St. Paul's, 21; Palladians vs., 85–86
Wyat (or Wyatt), John, 34–35
Wycherley, William, *The Country Wife,* 264

Xenophon, *Memorabilia,* 271

Yorke, Sir Philip, 289
Young, Edward, *Love of Fame,* 302

Zincke, Christian Friedrich, 231

INDEX OF HOGARTH'S WORKS

I. PAINTINGS, ENGRAVINGS, DRAWINGS (GENERAL)

audience for, 134, 135–36, 303, 310–11

book plates, 60

catalogues, xxi
conversation pictures, 184, 208, 258–59, 268; auction of, 215–16; comic, 159–62, 178, 215–17, 222, 225–26; dogs and children in, 222–28; link to stage representation, 159–62, 178, 209–10; problems of completion, 208, 230–31; sources for genre, 210–11; success of and praise for, 214–15, 230, 231–32, 235; style of, 209, 211–14, 220–21

exhibitions, xv, 209, 265, 366n40; showing of works in studio, 237–38, 274, 307

graphic sources and models
—Bible, New Testament, 125, 127, 174, 201, 273–74, 295–96; Acts of the Apostles, 127–29, 131, 285–87; conversion story, 44, 128, 285, 286–87; Diana of the Ephesians, 275, 278, 292–94, 380n28; echoes and parodies, 73, 273, 280–85, 291, 299–300, 381n37
—Bible, Old Testament, 126–27, 184, 253, 263, 266–67, 282–83, 295, 327
—classical art, 73–74, 127, 130, 174, 269–72
—contemporary life, 130–31, 177, 178, 180, 182, 188–89, 299, 248
—English history painting, 87, 95–96, 108, 124–25, 140–41, 145
—European schools, 133; Dutch, 56, 61, 68, 73, 74, 119–20, 145, 215, 223, 228; French, 58–59, 68, 135–37, 160, 210; High Renaissance (Italian), 56, 57, 73–74, 125–29, 130, 144–45
—literary tradition, xvii–xviii, 10–11, 88, 125, 140–42, 159–65
—newspapers and journals, 75–76, 241–50. See also Gay, John, The Beggar's Opera, Polly; Raphael; Shakespeare, William; Spectator, The; Thornhill, Sir James; Watteau, Antoine

history painting: changes in by WH, 279; concept of hero in, 145, 270, 272–73; with contemporary action, 94, 123–24, 236;

history painting (*continued*)
 feminization of hero in, 272, 273,
 284, 379n21; link to stage repre-
 sentation, 160, 177, 179, 200;
 tradition of, 87, 95–96, 108, 120,
 140, 158, 160–61, 258, 260 61.
 See also Thornhill, Sir James

Latin inscriptions, 15, 24, 278–79

paintings: detail in, 207; early, 60,
 180, 185, 365–66n40; engraving
 of, 184, 221–22; use of color in,
 179, 183, 218–19, 221, 238, 369.
 See also conversation pictures;
 history painting
portraits and portraiture, 161–62,
 193–94, 207; groups, 193–94,
 208, 221; praise for, 231–32;
 self-, 153, 199, 223, 224,
 362n107, 369n11

role of art collecting, 268

subject matter
—Choice of Hercules, 44, 73–74,
 171–72, 174–75, 192, 202, 216,
 230, 269–72, 283–84, 329,
 364–65n31, 368–69n8, 379n17
—fairs and spectacles, 20, 24, 323
—family, 228–30; father/daughter/
 son-in-law, 200–202, 328
—Judgment of Solomon, 216, 230
—legal injustice, 32, 164, 193, 216,
 246–47
—marriage, 224–26, 229
—political satire, 67–90, 94,
 111–14, 163, 165–71, 172
—"progress," the, 128, 173, 182,
 238, 254, 258, 286–87, 324,
 377n6
—prostitution and the Harlot,
 69–70, 193, 247, 250–55, 328.

See also Harlot's Progress, A, below
—South Sea Bubble, 17, 65–68,
 255, 350n4, 350n6, 364n24
—theatrical presentations, 159, 160,
 179, 200, 363n11, 363n12
subscriptions and subscription tick-
 ets, 147–49, 273, 302–6,
 360–61n96

technique: engraving, 58–60; mne-
 monic, 42–43, 44, 46–47, 106
themes, motives, visual images
—animals, 210, 212, 213, 222–26,
 261–63, 269, 280
—audience, 260
—blacks, 223, 228
—children, 213, 224, 225–29,
 287–88
—clergy, 69–70, 89, 112, 141, 165,
 166, 184, 216, 253, 290, 328–29
—grotesque, the, 143, 268–69, 276
—high and low materials, 145, 253,
 286, 324–25, 335–36
—illusion vs. reality, 213
—imagination, 277–78
—imitation, 251, 285
—imprisonment, prisons, and
 criminals, 32–33, 120, 145, 188,
 194, 229, 330–32
—Jew, the, 249–50, 266–68, 283,
 288, 291, 299, 327
—life as a stage, 179, 182–83
—luxury and spending, 251–52
—Nature, 227, 275–78, 293, 297,
 336, 380n28
—recognizable portraits and topical
 allusions, 70, 71, 73, 80, 81, 89,
 94, 131, 144, 161, 162, 164–65,
 215, 217–18, 228
—royalty, 112–18, 166
—satyrs, 143, 176, 227–28, 275.
 See also graphic sources and
 models; subject matter

II. PAINTINGS, ENGRAVINGS, DRAWINGS (INDIVIDUAL WORKS)

After. See Before and After

Amhurst's *Terrae Filius,* illustrations for, 165

Analysis of Beauty, The, 291

Ashley Cowper Family, The, 214, 231

Ashley and Popple Families, The (fig. 76), 212, 231

Assembly at Wanstead House, An (fig. 73), 206–8, 212, 215, 223, 231

Auction of Pictures, An, 216, 220

"Bad Taste of the Town, The." *See Masquerades and Operas*

Battle of the Pictures, The, 273, 372n3

Beaver's *Roman Military Punishments,* illustrations for (figs. 10, 11), 59

Before and After, 220, 231, 299, 303; indoor version (figs. 88, 89), 218–219; outdoor version (figs. 86, 87), 218–19

Beggar's Opera, The, six versions (figs. 59–62), 152, 161, 206, 208, 221, 230, 365n32; dating, 159–60; first version, 175–76, 365n32, 365n33, 366n40; inspiration for, 172–77; link to *Harlot,* 259, 260; in other works, 184, 239; political allusions in, 169, 170, 171; and the prison, 33, 188, 194, 229, 230; publication of, 184–85, 192; real people in, 169, 174–77, 181, 183, 228, 239–40; style, 177–79, 185–86, 211, 213, 214, 218, 233, 238; subject and themes, 145, 180–84, 201, 206, 227, 272

Benefit Ticket for Spiller (fig. 12), 60–61

book illustrations, 59, 61–64, 93–94, 117, 140–41, 150, 165, 233–34, 304, 314, 379n20, 385n20, 385n23. *See also, below, Don Quixote; Hudibras; Don Quixote in* GENERAL INDEX

Boys Peeping at Nature (fig. 107), 107, 317; style and iconography, 71, 143, 275–80; as subscription ticket for *Harlot,* 46, 143, 203, 227–28, 248, 275

Broken Fan, The, 214

Burlesque on Kent's Altarpiece, A (fig. 38), 138–41, 149

Captain Lord George Graham, 223, 228

Characters and Caricatures, 144

Children's Tea Party, A (fig. 80), 213, 225, 231

Cholmondeley Family, The (fig. 93), 209, 224, 226, 227, 266

Chorus of Singers, A, 321

Christening, The (fig. 84), 185, 215, 216, 225, 226; print of (fig. 85), 221–22, 384n5

Club of Gentlemen, A, 220–21

Committee of the House of Commons, A (figs. 65, 66), 195, 197, 208, 209, 215, 220, 267, 316; arrangement of figures, 190, 192–94; background and sources, 33, 188–91; oil sketch (fig. 64), 185, 190, 192; as prison scene, 330; subject, 190, 192, 206

Cunicularii, or the Wise Men of Godlimen in Consultation (fig. 56), 167–68

Curate and the Barber Disguising Themselves, The (fig. 49), 153

David Garrick as Richard III, 56, 186

Denunciation, The (figs. 81, 82), 185, 215, 217, 225–26, 369n13; print of (fig. 83), 221–22

Dox Quixote, six illustrations for (figs. 46, 47, 49–51), 150–54, 170–71, 199, 361n104, 362n105. *See also, below, Sancho's Feast*

Election, An, 291

"Element of Earth, The" (lost), 155–57

Enraged Musician, The, 76

Falstaff Examining His Recruits (fig. 52), 152, 186, 192, 207, 316; as conversation piece/history painting, 160–62, 230; date, 159–60, 369n13; and other works, 192–93; portraits in, 162, 215; themes, 162–64, 169–71

Family Party, A, 214

Fishing Party, The, 212, 218

Fielding's *Tragedy of Tragedies,* frontispiece for (fig. 108), 314

Five Days Peregrination, The, illustrations for (figs. 110, 111, 112), 323–24

Fountaine Family, The (fig. 77), 212–13, 215, 223, 225, 369n10, 369n11

Four Times of the Day, The, xvi, 376n49, 381n35; (1) *Morning,* 372n3; (2) *Noon,* 21; (4) *Night,* 145–46

Freeing of the Galley Slaves, The (figs. 46, 47), 152

George, Prince of Wales. See His Royal Highness George, Prince of Wales

Gildon's *New Metamorphosis,* illustrations for, 117, 141, 385n20; frontispiece (fig. 22), 93–94, 183

Great Seal of England, The (fig. 58), 171–72, 250, 375n34

Gulielmus Hogarth, 223, 224

Harlot's Progress, A (figs. 96–101, 109)

—artistic and literary models and contexts, 238–41, 248, 256–61, 272–74, 284–87, 334, 350n6

—audience for, 303, 308, 310–11

—and *The Beggar's Opera* painting, 179, 184, 248–49, 251, 259, 281, 377n12

—concept of Harlot in, 251, 253, 257, 259–60, 270–71, 272, 281, 287–88, 325, 329, 336

—contemporary life in, 2, 32, 112, 144, 195, 218, 226, 236, 240, 248, 252, 274, 292, 324

—engravings, copies, piracies of, 203, 234, 238, 288, 292, 304–5, 309–10, 312–13, 384n5, 384n6, 384n17

—evaluation and significance, 254, 267, 299–300, 310, 311, 324–26

—genesis and dating, 237, 255

—ideology, 145, 297–98

—mode and style, 73, 74, 177, 221, 230

—motifs and sign systems in, 69–70, 76, 89, 213, 238, 261–65, 268–74, 280, 282

—newspaper accounts and contemporary events in, 32, 241–51, 252, 289, 328, 329, 372n5

—paintings of, 236–37, 372n3, 384n14; showing of, 217, 237–38, 239

—pamphlets and plays based on, 311–14, 317–19, 385n28

—pictures on the walls in, 263, 266–68, 281–83, 291, 295, 299, 327–28, 331, 378n15

—publication, 301, 303–6, 308

—reception, resonance, success of, 154, 199, 306–7, 310, 317, 320, 336

—social context, 240–41, 246–47, 254–55

—subscription ticket for. *See, above, Boys Peeping at Nature*

—and Thornhill, 198–99, 203, 328

—time sequence in, 265–66

Henry the Eighth and Anne Boleyn (fig. 54), 60, 113, 169, 272, 290; as political satire, 164–65

His Royal Highness George, Prince of Wales (fig. 26), 113–114, 169, 171, 356 n44

House of Cards, The (fig. 79), 213, 225, 231

House of Commons, The, with Sir John Thornhill (fig. 67), 191–92

Hudibras illustrations, 73, 119, 141, 147, 149–52, 154, 164, 177, 180, 199, 282, 286, 302, 305, 317, 362 n1, 372 n3, 385 n20; as history painting, 143–47, 273; link with *Don Quixote,* 142, 147; model and material for, 136, 144, 285

—(1) 17 small plates, 59, 61, 141, 142–43, 152, 305

—(2) 12 large illustrations, 60, 62, 155, 183, 258, 276

—Frontispiece (fig. 40), 93–94, 143, 176, 183, 268

—*Burning the Rumps at Temple Bar* (fig. 43), 145, 149

—*Committee, The* (fig. 53), 162–63, 192

—*Hudibras's First Adventure* (figs. 9, 42, 63), 24, 185

—*Hudibras Sallying Forth* (fig. 41), 146; drawing for, 237

—*Hudibras and the Skimmington* (fig. 44), 145, 149, 163

—*Hudibras Wooing the Widow* (fig. 39), 141

"Indian Emperor, The," A Scene from, 201

Industry and Idleness, 51, 171, 309

Jacobite's Journal, The (Fielding), headpiece, 314

Jane Hogarth (fig. 69), 199

Jeffreys Family, The, 212

Jones Family, The (fig. 92), 225, 227, 231

Just View of the British Stage, A (fig. 33), 119–22, 159, 316

La Calprenède's *Cassandra,* illustrations for, 141

La Motraye's *Travels,* illustrations for (figs. 13, 14), 61–63, 141

Lottery, The (fig. 19), 60, 73, 114, 307, 316; motifs, 73–74, 112, 272, 350 n6; sale of, 72, 351 n13; style, 73, 108–9

March to Finchley, The, 262

Marriage A-la-mode, 22, 144, 207, 262; engravings of, 59; sources for, 126, 197; themes and motifs in, 226, 229, 382 n55

Masquerade Ticket (fig. 57), 169

Masquerades and Operas (fig. 20), 84, 87, 113, 159, 316; motifs and themes, 76–82, 136, 168, 169; new mode of satire in, 88–90, 94; piracies of, 90–91, 93; success, 72–75, 93, 142; Thornhill and, 120

Midnight Modern Conversation, A (fig. 90), 220–21, 372 n3

Miller's *Humours of Oxford,* 233, 385 n23

Milton's *Paradise Lost,* illustrations for, 141, 150, 202, 360n90

Mitchell's *Highland Fair,* frontispiece for, 234, 371n33

Molière translations, illustrations for, 385n23

Moses Brought to Pharoah's Daughter, 126

Mystery of Masonry Brought to Light by the Gormogons, The (fig. 28): and *Don Quixote,* 117, 118, 142; sources for, 116–18; and Thornhill, 114

Paul before Felix, 171, 286–87

Paviour's Sign, The, 365–66n40

Pool of Bethesda, The, 286–87

portraits, individual: Garrick, David, 56, 186; Hoadly, Benjamin, 298; Hogarth, Jane, 199; Huggins, John and William, 194; WH (frontispiece), 223, 224

Punishment Inflicted on Lemuel Gulliver, The (fig. 55), 72, 166–69, 290, 363–64n20

Rake's Progress, A (fig. 5), 91, 286, 317, 321, 372n3; contemporaries in, 144, 196; sources, 32, 136; theme and settings, 23, 224–25

Royalty, Episcopacy, and Law (fig. 25), 114, 171, 290; influence of Thornhill on, 111–12; as satire, 111–13, 166

Sancho's Feast (figs. 50, 51), 153–54, 170–71, 362n106, 362n108; Jane Hogarth and WH in, 199–200, 369n11

Satan, Sin, and Death, 202

Self-portrait (frontispiece)

Shakespeare's "The Tempest," A Scene from, 200–201, 202

shop cards: for Gamble (fig. 8), 48, 52; for Mary and Anne Hogarth (fig. 94), 232–33; WH's (fig. 7), 49, 51, 52, 99

Shrimp Girl, The, 196

Sigismunda, 158, 199, 202

Sketch of a Garret Scene (fig. 95), 237

Sleeping Congregation, The (fig. 68), 191–92, 382n55; engraving of, 377n8

South Sea Scheme, The (fig. 15): atmosphere and setting, 72–73, 81, 89; sale of, 72; sources and models for, 17, 68–69, 70–71, 100, 249–50; style, 73, 108; themes and motifs, 69–71, 89, 112, 141, 282, 283, 290, 350n4, 350n6

Southwark Fair, 19, 162, 179, 366n42

Strode Family, The, 223–24

Strolling Actresses Dressing in a Barn, 129, 179, 381n35

Tatton Arms, engraving (fig. 6)

Terrae Filius, frontispiece for Miller's *Humours of Oxford,* 233, 385n23

Theobald's *Persius and Andromeda,* illustrations for, 233–34

Times of the Day, The Four. See Four Times of the Day, The

Vane Family, The, 213–14

Wedding of Stephen Beckingham and Mary Cox, The (fig. 91), 178, 224–25, 226

Wesley Family, The, 214, 231